Gutenberg in Shanghai

A Study of the Weatherhead East Asian Institute

Studies of the Weatherhead East Asian Institute, Columbia University
The Weatherhead East Asian Institute is Columbia University's center for research, publication, and teaching on modern and contemporary Asia Pacific regions. The Studies of the Weatherhead East Asian Institute were inaugurated in 1962 to bring to a wider public the results of significant new research on modern and contemporary East Asia.

Gutenberg in Shanghai

Chinese Print Capitalism, 1876-1937

Christopher A. Reed

UNIVERSITY OF HAWAI'I PRESS
HONOLULU

Published in paperback 2004 in the United States by
University of Hawai'i Press
2840 Kolowalu Street
Honolulu, HI 96822

First published by
UBC Press
The University of British Columbia
2029 West Mall
Vancouver, BC V6T 1Z2

Printed in Canada by Friesens

Library of Congress Cataloging-in-Publication Data

Reed, Christopher A. (Christopher Alexander), 1954-
 Gutenberg in Shanghai : Chinese print capitalism, 1876-1937 /
Christopher A. Reed.
 p. cm.

 Originally published: Vancouver, B.C. : UBC Press, c2004. Includes
bibliographical references and index.
 ISBN 0-8248-2833-X (alk. paper)

 1. Book industries and trade—China—Shanghai—History—19th century.
2. Book industries and trade—China—Shanghai—History—20th century.
3. Printing industry—China—Shanghai—History—19th century. 4. Printing
industry—China—Shanghai—History—20th century. 5. Publishers and publish-
ing—China—Shanghai—History—19th century. 6. Publishers and publishing—
China—Shanghai—History—20th century. 7. Shanghai (China)—Intellectual
life—19th century. 8. Shanghai (China)—Intellectual life—20th century.
I. Title. Z462.86.S46R44
2004 070.5'0951—dc22
 2003017888

To Lihua

... one man loved the pilgrim soul in you,
And loved the sorrows of your changing face ...

W.B. Yeats

and with gratitude to Jimmy Carter and Deng Xiaoping,
who without whose efforts in 1978-79,
she and I probably would not have met in 1991

The common people remember and tell what they are able to grasp and what they are able to transform into legend. Anything else passes them by without deeper trace, with the dumb indifference of nameless natural phenomena, which do not touch the imagination or remain in the memory. This hard and long building process was for them a foreign task undertaken at another's expense. Only when, as the fruit of this effort, the great bridge arose, men began to remember details and to embroider the creation of a real, skilfully built and lasting bridge with fabulous tales which they well knew how to weave and to remember.

– Ivo Andric, *The Bridge on the Drina*

Contents

Illustrations

Tables

On the cover: (top) Gutenberg, the inventor of cast movable type (*Yiwen yinshua yuekan*/*The Graphic Printer* [Shanghai] 2, 2 [1939]: 14; (bottom) "Printers" by Chen Shuliang, *Woodcuts of Wartime China, 1937-1945* (Shanghai: Kaiming shudian, 1946), 22.

Acknowledgments

In the early 1970s, concern about the relationship between modern science, technology, and nationalistic politics as well as the tendency of disciples of all three to impose an apparently unquestioned uniformity on the world led me to specialize in European philosophy and intellectual history at McGill University, Montréal, Québec. There, it became clear that the universalistic claims of science and the modern nation-state could be opened to question, but what about those of technology? After all, no less a figure than Francis Bacon, "the father of the scientific method," claimed that technology (three technologies in particular: printing, the compass, and gunpowder) was what made our world different from that of the ancients.[1] Precisely because more recent technologies have appealed to so many worldwide, it also seemed important to question received opinion regarding technology's role in shaping the modern world since Bacon's day, although I did not formally start that process until much later.

In the late 1970s, however, I witnessed first-hand one aspect of the international confluence of culture and technology when I lived with the family of John Yi-fang So, an engineer, in the southern Taiwan industrial port of Kaohsiung while teaching English at the city's YMCA night school. John So's parents, Taiwanese Presbyterians, operated a good-sized printing business on the first and second floors of their shop house. Each time I entered or left the house, I passed through a whirl of printing workers and printing presses, all sounding, as André Malraux once wrote about another printing shop in his novel, *Man's Fate (La condition humaine)*, "like an enormous ventilator in bad condition."[2] Questions of the sort that I address in this book, such as "Where did these machines come from?," "How were they modified to print the Chinese language?," "How important is the Christian context?," and "Is this society changed by Western machinery?" occurred to me in those days, even though I then had no real means of answering them.

While studying Soviet political economy at Adam Smith's University of Glasgow, in one of modern Europe's great industrial, scientific, and technological centres ("The Workshop of the World"), I began to see how politics, economics, and culture could influence each other. Learning about the Soviet Union as a functioning economic system and about its varying degrees

of replication in Central Asia and Eastern Europe raised as many questions in my mind about the history of capitalism and industrialization and their multiple national forms as it gave me insight into what many in the Soviet orbit regarded as the universalistic values of scientific socialism. My reading also alerted me to the field of business history, which offered a means of studying national differences in economic organization while simultaneously holding open the door of comparative generalization.

At the University of California at Berkeley, I first encountered Lucien Febvre and Henri-Jean Martin's *The Coming of the Book (L'apparition du livre)*. Febvre and Martin helped me to understand the origins of Western book culture, its link with early technology, capitalism, and higher learning, and their combined social effects through history. At about the same time, in a casual conversation with Frederic Wakeman, Jr., on the question of how knowledge circulated in imperial China, I learned that scholars could not yet supply an answer. During my research intended to help explain that process, he, Wen-hsin Yeh, and James Cahill supplied inspiration and guided me toward issues, texts, and documents that proved to be fundamental to my project. In particular, without their efforts to place me at both the Inter-University Program in Chinese Language in Taipei and the Institute of History of the Shanghai Academy of Social Sciences (SASS), this book could not have been completed. Also, although I had begun by researching Beijing's eighteenth- and nineteenth-century publishing industry, Wu Xiaolin of the Institute of Literature, Chinese Academy of Social Sciences, via David Johnson, suggested that I turn my attention to Shanghai. I am very grateful for this advice.

My research on the history of a key modern Western civilian communication technology, the printing press, and interpretations of its worldwide impact began in Berkeley's libraries, at Stanford University's Hoover Institution, and at the University of San Francisco's Ricci Institute. Later, the SASS Institute of History opened the doors of its own library and those of the Shanghai Municipal Archives and the Shanghai Municipal Library to me. SASS also arranged permission for me to use the San Zi (Three Selfs) Protestant Library, Huadong Teachers' University Library, and the Shanghai Research Institute of Printing Technology Library. Working in these surroundings made clear for me the importance of proposing a new narrative to take the place of largely implicit or unexamined assumptions about the "triumph of Western technology" in non-Western environments.

The following persons assisted me in this effort in different ways while I was in Shanghai: Tang Zhijun, Xiong Yuezhi, Zhou Yuangao, Cheng Zai, and Wu Jianxi, all of the SASS Institute of History; Wang Zhen, a SASS alumnus and assistant researcher at Shanghai Cishu Publishing Company,

which inherited Zhonghua's editorial library; Feng Shoucai and Ma Changlin of the Shanghai Municipal Archives; Song Yuanfang, president of the Shanghai Publishers Association and vice president of the Publishers Association of China, as well as director of the Publishing Materials section of the Shanghai Local History Office, and his assistant Qiu Ping; Li Yihai, of the SASS Foreign Affairs Bureau; and, of course, his unforgettable colleague, Monsieur Zhao Nianguo.

Two of my greatest resources at SASS were the book kiosk and its manager, Cao Jiming. He frequently found published materials for me. Moreover, Mr. Cao alerted me to the existence of the New Fourth Army History Research Group's Printing and Banknote Organization, an unofficial people's organization *(mintuan)*. I am grateful to the seven elderly members of that organization for sharing their memories and publications with me. Also, at the very beginning of my research in Shanghai, sitting at the New Long Bar of the Portman Hotel, fellow Glasgow alumnus and Shanghai scholar Brian G. Martin gave me invaluable advice concerning the ins and outs of conducting research in that city. Near the end of my research, Patricia Stranahan introduced me to members of the Historical Research Group of the Shanghai Communist Party, who in turn alerted me to new sets of documents.

In Shanghai, Zhang Shunian spoke to me extensively about his father Zhang Yuanji and arranged a tour of the Commercial Press's rebuilt Baoshan Road printing plant. When the Commercial Press celebrated its ninety-fifth anniversary in 1992, Mr. Zhang invited me to the commemorative conference, held in Haiyan, Zhejiang, Zhang Yuanji's hometown. Dr. Fei Chengkang of the SASS Institute of Law also opened many doors for me in both Shanghai and Suzhou. Together, Dr. Fei, a native of Suzhou, and I visited the Publishing History section of the Suzhou Local History Office, whose members, led by Xu Peiji, answered my questions about the Suzhou Booksellers' Guild while also working to complete their own draft history. Dr. Fei and I joined forces again to interview the manager of Suzhou's Classics Bookstore, who had run a rare book business prior to 1949. Talking with him reminded us that book people have long memories, whether or not they are historians. When the manager first saw my name card with the University of California logo, he said he wondered whether we had come to pick up an outstanding order for the Berkeley library. He had not been able to fill it in the late 1940s, he apologized, because the Communist revolution had intervened.

When I hunted down an original edition of the *Dianshizhai Pictorial* in the Shanghai Drama Institute's library, I received a particularly poignant lesson of a different sort in the ways that scholars can have a beneficial effect on the preservation of historical sources in a country with a lot of them. I had

assumed that the *Pictorial* would be useful in stage design and so would be valued particularly highly by a drama library. I sought out the librarian and made my request. It seems that I got there just in time. The librarian found that someone had decided to weed out the entire series from the main collection. It had been moved from its place on the shelf to a stack of items intended to be incinerated. The apparent reason: "It was old." Needless to say, a foreign historian's interest guaranteed that it was saved from the flames.

As important as advisors, institutions, and serendipity are to the initiation and pursuit of scholarly projects, the support and camaraderie of one's fellow students and friends are essential to the completion of such undertakings. I began graduate school at Berkeley with one outstanding cohort of graduate students, including Mark Elliott, Blaine Gaustad, Melissa Macauley, Julia Strauss, and Tsao Jr-lien, and finished with another, namely, Carlton Benson, Sarah Fraser, Mark Halperin, Keith Knapp, Timothy Weston, and Marcia Yonemoto. Each in his or her own way enriched my time at Berkeley and/or in Shanghai. Also, from my research period in Shanghai I would like to thank my friends Li Yi, Li La, Cao Tongyi, Wang Yaping, Chen Haiyan, Du Kelei (Clay Dube), and He Ailian (Ellen Hertz). Back in Berkeley after Shanghai, I received help in material and spiritual ways from Daniel Cornford, Hsing-yuan Tsao, Steven and Mary Diamond, and Jane Turbiner.

From my year of teaching at the University of Oklahoma, I am grateful to Mikael Adolfson, Sidney Brown, Sandie Holguin, David Levy, Roberta Magnussen and Kip, Donald Pisani, and Melissa Stockdale for their support and friendship. At Reed College, as befits one of America's great liberal arts institutions, Douglas Fix, Hsieh Ting-hua, Hyung Rhew, David Harris Sacks, and Charles Wu Qianzhi recalled me from my preoccupation with the professional and administrative sides of writing a book to the broader intellectual value of historical research. After a hiatus of two decades, this project also brought me back in contact with my old Montreal university friends, Siu Tong Kwan and Elbert Lee of Hong Kong and Gordon Sui-Kwong Lee, now of Columbus, among whom I had first discovered the satisfaction that comes of asking big questions about culture and values and then turning for answers to written or printed texts.

It is a pleasure to acknowledge the inspiration and support that I received in various ways, including substantial comments on manuscript chapters, from my Ohio State University colleagues Julia F. Andrews, Kenneth Andrien, James Bartholomew, Alan Beyerchen, Mansel Blackford, Philip Brown, Chang Hao, Xiaomei Chen, William Childs, Samuel Chu, Stephen Dale, Kirk Denton, John F. Guilmartin, Jane Hathaway, K. Austin Kerr, and Randolph A. Roth. Along with these persons, I must recognize the aid given to me by

my former PhD student, research and teaching assistant, and now professor, Liyan Liu. Other research assistants who aided me at Ohio State included Ying Bao, Ying Chua, and Su-hsing Lin. The staffs of Ohio State's East Asian library, of Ohio's superb library consortium known as OhioLink, and of the Big Ten's library consortium Committee on Institutional Cooperation (CIC) also advanced my research in substantial ways.

From the Columbus phase of this project, I would like to single out Patricia Sieber and Cynthia J. Brokaw for their special interest in my project. Each saw the project through to completion in a different way. Purely fortuitous good fortune brought Pat and me separately to Ohio State, where we have each written books related to issues of Chinese print culture. Our two intense years of intellectual and editorial exchange constituted one of the scholarly high points of my time in Columbus. Pat read every page of my manuscript, some of them more frequently than she or I would care to recall, and offered consistently sound counsel. A nonnative speaker of English who speaks and writes the language with greater control and precision than many of us born into it, Pat helped me to rekindle an old love for the pursuit of expository clarity that had fallen dormant. Cynthia J. Brokaw came to Ohio State during my fifth year here. She read multiple versions of this text and offered trenchant suggestions and insights based on her own research into an earlier period of Chinese print culture and print commerce. This book is much tighter thanks to her comments.

Outside Ohio State, numerous people read chapters and various versions of the manuscript. Those who offered extended criticism and suggestions included David S. Barker, Robert Culp, James Huffman, Pieter Keulemans, Joseph P. McDermott, Andrea McElderry, Kristin Stapleton, and Patricia Stranahan. Former Ohio State graduate student David Wittner, now a professor and scholar of Japanese industrialization, also provided a trenchant critique. In addition, my father and my mother, Russell A. Reed, EdD, and Regina B. Reed, PhD, both of whom are retired from teaching, encouraged me so enthusiastically and for such a long period that they gave new meaning to the term "active retirement." With the publication of this book, to fill their new-found spare time they may have to take up golf.

I offer thanks to the United States and Taiwan Fulbright Graduate Student (Institute of International Education) research grant program and the Inter-University Program at National Taiwan University for financial support in Taiwan in 1990-91. The American Committee for Scholarly Communication with China awarded me a grant for research in Shanghai in 1991-92 and extended it for half a year, for which I am especially grateful. In 1999, the United States and Taiwan granted me a Fulbright-Hays Senior

Scholar fellowship, which I used at the Institute of Modern History and Institute of Literature and Philosophy, Academia Sinica; National Library; Sun Yat-sen Library; Kuomintang Party Archives; and at Nanjing's Second Historical Archives. During both of my Fulbright periods, Taiwan's Foundation for Scholarly Exchange, directed by Dr. Wu Jing-jyi and supported by a superb staff, epitomized the best in international academic exchange program administration. In addition, Taiwan's Chiang Ching-kuo Foundation awarded this project a publication grant. The Ohio State University supported my research with a Seed Grant in 2000-1 and Special Research Assignments in the fall of 2000 and the spring of 2001 that were invested in this book. Ohio State's College of Humanities and Institute of Chinese Studies also helped production of this book with publication subventions.

I would like to thank my UBC Press editors, Emily Andrew, for having endorsed this project in the first place, and Holly Keller-Brohman, for her flexible but efficient supervision of its progress from manuscript to book. Their involvement with *Gutenberg in Shanghai* extended far beyond the written page. In particular, the book benefited from Emily's ability to find knowledgeable readers capable of passing on balanced insights and suggestions in a timely manner. The ability to give constructive criticism dispassionately is an unsung talent in today's world, and so I would also like to acknowledge both of the anonymous reviewers for their efforts to do so.

These two reviewers were not the only anonymous persons who aided completion of this book. It is fitting that I acknowledge here the invaluable help that I received from an Ottawa, Ontario businessman whom I met in the Shanghai Conservatory of Music's foreign student dormitory in 1991. After listening to me describe my project in a hallway conversation, when he left to return to Canada, he generously left me a copy of a Chinese-English printer's dictionary that he had picked up in a Shanghai bookstore. I myself never did come across a copy of the dictionary on sale in any bookstore. Without it, however, I would still be looking up technical terms. Not knowing his name, but still believing that he advanced this project in an immeasurable way reminds me of the debt that we historians owe to anonymous individuals and organizations of the past along with those that we can name.

When all is said and done, however, the person who helped me the most with this book is my wife, Leah Lihua Wong. Lihua and I met and married during my two-year research stay in Shanghai, where she was teaching at the Shanghai Drama Institute. The welcome that I received at the homes of Lihua's parents, Wang Rongbin and Ye Jingfen of Qingdao, Shandong province; her brother, Wang Zhijun of Shanghai; and her sister, Wang Hui, now of Los Angeles, gave me respite from the trials of extended archival and

library research. Once we left China, Lihua accompanied me, invariably with an openness to possibilities and discoveries, over the next four years to Berkeley, California; Norman, Oklahoma; Portland, Oregon; and finally to Columbus, Ohio. Her irrepressible optimism, sense of humour, creativity, intelligence, and wisdom inspired me in ways that I lack the vocabulary to express. An oil painter by training, she first encountered the potential of computers in Pasadena in 1993 and has gone on to become an award-winning graphic designer while continuing to paint and teach. She designed the book cover and created the graphics used inside this book.

I can only hope that these individuals and the organizations that helped me satisfy my curiosity about the relationship between modern technology, economics, culture, and politics in late imperial and Republican China find that this book justifies their investments. Needless to say, any errors of judgment or fact in this book are now mine alone.

Author's Note:

Birth and death dates for individuals are indicated in parentheses in the text when they are available. Dates of most non-Chinese have been omitted unless they have special relevance to the subject of this book or to Chinese history in general.

Permission to reprint material from a previous article written by me, en-titled "Sooty Sons of Vulcan: Shanghai's Printing Machine Manufacturers, 1895-1932," is gratefully acknowledged. It appeared in *Republican China* [now known as *Twentieth-Century China*] 20: 2 (April 1995): 9-54. Permis-sion to quote from Wu Woyao, *Vignettes from the Late Ch'ing: Bizarre Happen-ings Eyewitnessed over Two Decades,* trans. Shih Shun Liu (Hong Kong: Chinese University of Hong Kong Press, 1975), is appreciated, as is permis-sion to reprint images from Don J. Cohn, *Vignettes from the Chinese: Litho-graphs from Shanghai in the Late Nineteenth Century* (Hong Kong: Chinese University of Hong Kong Press, 1987). Permission to reprint their photo-graphs in the book was received from the Shanghai Municipal Archives. A reasonable attempt has been made to secure permission to reproduce all material used. If there are errors or omissions they are wholly unintentional and the publisher would be grateful to learn of them.

Gutenberg in Shanghai

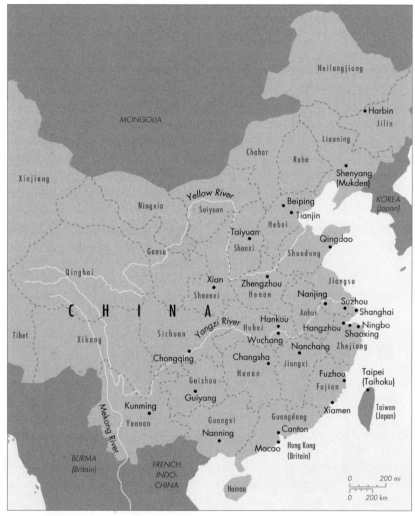

Map 1 Map of China, c. 1930.

Introduction

In March 1949, when Mao Zedong set out for Beijing from Xibaipo, the remote village where he had lived for the previous ten months, he took along four printed texts. Included were the *Shiji* (Records of the Grand Historian, c. 100 BCE) and the *Zizhi tongjian* (Comprehensive Mirror for Aid in Government, c. 1050 CE), two works that had been studied for centuries by emperors, statesmen, and would-be conquerors. Along with these two historical works, Mao packed two modern Chinese dictionaries, *Ciyuan* (*The Encyclopedic Dictionary,* first published by the Commercial Press in 1915) and *Cihai* (Ocean of Words, issued by Zhonghua Books in 1936-37).[1] If the two former titles, part of the standard repertoire regularly reprinted by both traditional and modern Chinese publishers, are seen as key elements of China's broadly based millennium-old print culture, then the presence of the two latter works symbolizes the singular intellectual and political importance of two modern industrialized publishing firms. Together with scores of other innovative Shanghai-based printing and publishing enterprises, these two corporations shaped and standardized modern Chinese language and thought, both Mao's and others', using Western-style printing and publishing operations of the sort commonly traced to Johann Gutenberg.[2]

As Mao, who had once organized a printing workers' union, understood, modern printing and publishing were unimaginable without the complex of revolutionary technologies invented by Gutenberg in the fifteenth century. At its most basic level, the Gutenberg revolution involved the adaptation of mechanical processes to the standardization and duplication of texts using movable metal type and the printing press. This new process resulted in the far-flung proliferation of printed matter throughout each society that it influenced. Simultaneously, the Gutenberg revolution also transformed business and social relationships, bringing forth, among other changes, one of the world's earliest capitalist enterprises, the print shop, with its attendant class divisions.

In Mao's day, China, like numerous countries, was still striving to come to grips with the Gutenberg revolution. What sets China apart from other

countries, however, is that the full story of its complex relationship with the modern Western intellectual and material culture epitomized by that revolution is still far from widely known. Scholarly works that have examined China's modern intellectual culture have tended to focus on Western missionary educational institutions after 1860, on Chinese-sponsored changes in the education system between 1895 and 1949, or on the impact of Western political philosophies on the Chinese after 1895. Very few, however, have studied the material culture, particularly the communications technology, that was a necessary, if not sufficient, cause of this intellectual change. This book seeks to redress the imbalance by examining the Shanghai-based printing and publishing system that delivered words, texts, and ideas to a new mass audience preoccupied with aiding China's twentieth-century quest for wealth, power, and international stature.[3]

Broadly speaking, this book studies the reciprocal influences of material and mental culture that were a central part of the social history of Shanghai life between 1876 and 1937. These were the years between which ever-increasing numbers of Chinese invested in and worked with capital-intensive Western printing technology. Spreading outward from Shanghai, the technological functions of modern printing and the intellectual culture of publishing also had a major impact on the country as a whole. The continuum from material to intellectual culture, from printers to publishers, and from publishing companies to government patrons and reading audiences provides the framework for this book. Together printing and publishing formed a knowledge-based micro-economy that merged a modern mechanized industry with the ancient literary culture of China while simultaneously advancing the organizational practices of the corporation, industrial trade association, and copyright protection in China. The evolution from traditional Chinese woodblock printing (xylography) to Western-style mechanized printing is an important part of that story as is the transformation of traditional Chinese print culture and commerce into modern Chinese print capitalism.

From the Xylographic to the Mechanical Age:
Print Culture, Print Commerce, and Print Capitalism

In recent years, three concepts – print culture, print commerce, and print capitalism – have had a profound impact on the efforts of historians to understand the mental and social context of national development. Of the three, the reach of print culture is the most comprehensive. As Roger Chartier, a major proponent of this historiography, has explained, "print culture" is a term rooted in the efforts of European historians to understand the social implications of the Gutenberg revolution of early modern Europe.[4] In the

case of China, conversely, study of print culture generally involves examination of the impact of woodblock printing from its development in the early Tang dynasty (618-907), nearly eight centuries before Gutenberg's birth, its proliferation during the Song (960-1279), the Yuan (1279-1368), and the Ming (1368-1644) dynasties, and then its climax under the Qing (1644-1912) dynasty. Both in this broad form, as well as in Chartier's narrower sense of "the set of new acts arising out of the production of writing and pictures in a new form,"[5] the historiography of print culture has profoundly changed the ways that social and cultural historians of China perceive that empire's mental culture.

Western-language studies of premodern Chinese print culture have been loosely divided between those that address the official noncommercial and those that analyze the private commercial publishing realms, although the precise relationship between these two sectors is still the focus of debate.[6] Official noncommercial publishing largely supported the imperial orthodoxy. As is well known, Zhu Xi's (1130-1200) rearrangement of the Chinese Classics into the Four Books, as well as his commentaries, became, from the Yuan period down to Qing times, the core curriculum for the highly competitive civil service examination system and remained so until the abolition of that system in 1904-5. That system set Qing China's meritocratic personnel selection system apart from the aristocratic systems found throughout most of the world and contributed to the development of a broadly based print culture and publishing system in advance of that which developed in Europe after Gutenberg.[7] In a summary of publishing output that underestimates the real numbers of books in circulation, Tsuen-hsuin Tsien observes that "It is estimated that 253,435 titles are registered in various dynastic and other bibliographies from Han [206 BCE to 220 CE] to the 1930's; 126,649 were produced under the [Qing]."[8] This output was produced chiefly for the literate public whose preoccupation was success in the imperial civil service examinations and in gaining a place in the administration directing the vast Chinese empire.[9]

The national audience for printed texts in late imperial China, especially but by no means exclusively of examination-related materials, was sizable. In one view, between 30 and 45 percent of China's total male population and as much as 10 percent of its female population were functionally literate in the eighteenth and nineteenth centuries.[10] By implication, according to this view, out of a nineteenth-century population of 450 million, perhaps half could read with some degree of ease. Others estimate late Qing China's literacy rate at between 20 and 25 percent overall, a figure that still yields a reading public of between 90 and 110 million, albeit concentrated in urban areas.[11] Very few of these literates were actually officials, but many people

were familiar with parts of the official curriculum and its anticommercial physiocratic ideals as well as with other reading materials.

While the presses of the emperors, both in Beijing and in the provinces, produced mountains of finely crafted editions of encyclopedias, classics, histories, literature, and books of scholarship, the similarly "not-for-profit" presses of bibliophiles and scholars followed suit. Over the course of the Qing, private collectors created more than 750 famous libraries.[12] By that time, independent study, book collecting, and philanthropic printing and publishing had all long been recognized as part of elite Chinese life. True to the common conception of publishing as the civic-minded pursuit of literati, such men produced books for the love of learning, out of respect for the past, and to gain the respect of others. Sun Congtian (c. 1680-1759) was airing a widely held view when he wrote in his *Cangshu jiyao* (Bookman's Manual) that "Books are the most valuable treasure in the world. For it is in books that we find discriminated the good and the bad in human nature and the strong and weak points in the ways of the world. In this world of ours, it takes well-read men to 'cultivate their persons' and consequently to 'govern rightly their states.'"[13]

If print culture provides a loosely structured means of understanding elite Chinese intellectual life, the concept of "print commerce" enables inquiry into the world beyond the imperial state and its noncommercial, or even anticommercial, ideology. Scholars have recently begun to uncover an initially sizable, and eventually huge, commercial publishing sector in late imperial China, separate from the well-known elite worlds of imperial and philanthropic publishers and bookmen.[14] In her study of the commercial publishers of Jianyang (Fujian), for instance, Lucille Chia covers the six centuries from the Song through the Ming.[15] Timothy Brook, Dorothy Ko, and Kai-wing Chow discuss the intellectual and cultural effects of print commerce in the late Ming and early Qing. Ellen Widmer has studied the market-driven Hangzhou/Suzhou publishing house Huanduzhai from the 1620s to the 1690s.[16] Cynthia J. Brokaw takes the story of commercial publishing into back-country Fujian in the eighteenth and nineteenth centuries,[17] and James Flath examines the adaptation of north China's commercial *nianhua* (New Year's prints) craft business to historical changes of the nineteenth and twentieth centuries.[18]

These works illustrate that, from the late Ming onward, the expanding national economy stimulated and directed commerce in printed commodities. In this period, print commerce was already widely scattered throughout the Chinese empire, demonstrating the existence of a national market in books long before the appearance of Shanghai's Gutenberg-influenced printing, publishing, and marketing system. Already by the mid-Ming,

important literati publishing and marketing centres were found in the two capitals, Nanjing and Beijing, as well as in Hangzhou, Huizhou, and Jianyang.[19] In the late Ming and early Qing, the elite trade moved decisively to the lower Yangzi, just west of Shanghai. Suzhou was the leading seventeenth century site, followed by Hangzhou, Nanjing, and Yangzhou.[20]

Initiative shifted north in the late eighteenth century when Beijing's Liulichang booksellers' district appeared. By the early nineteenth century, Liulichang was well known throughout China and East Asia as the empire's leading antique, art, and book emporium. There the anticommercial values of the Chinese literati rubbed up against the economic realities of the marketplace without, however, rupturing social relations in any particularly novel or dramatic fashion. Nonetheless, something more than mere connoisseurship underlay the success of the Liulichang shops, as indicated by the epitaph of an elite bookseller. The eulogy reveals a public rationale that seeks to justify monetary profit as a natural by-product of society's pursuit of learning:

> With regard to trading books with people, we did not calculate profits too closely. If the books that [others] received [from us] were valuable, we would take ten taels [ounces of silver] and only sell them for a small amount over that. If the books we got were less valuable, we would sell them for only a little more. We took a long-term view and in this way earned more. "We sought profit, and made a living. We liked profit but also let those who bought books get their profit, too. Who is not like us in desiring profit? If we had concentrated only on profit, then goods would not have circulated, and this would have been the same as losing profit."[21]

In the 1870s, the redoubtable English ambassador Sir Rutherford Alcock made his way to Liulichang.[22] He confirmed the existence of a great deal of private commercial printing taking place there in the nerve-centre of the world's most populous empire.

The mixed attitude toward profit expressed in the eulogy cited above provides one hint of a problem that plagued Liulichang despite its success as the empire's largest bookselling district: a high rate of business failures.[23] If profit was not the primary raison d'être of Liulichang's and other elite booksellers and publishers throughout China, profitability was nevertheless a necessity of survival. During Liulichang's first century of existence, an uncertain supply system, limited numbers of high-quality editions, forgeries, and changing consumer tastes all constantly threatened to bankrupt the district's book dealers and publishers. By the end of the nineteenth century, however, bankruptcy was less of a threat than competition emanating from

Shanghai, which had historically been a cultural backwater. Thanks to a drastic realignment of intellectual and technological forces, by the first decade of the twentieth century, Shanghai had succeeded in marginalizing Beijing and all other Chinese publishing centres.

Thus, the commercial perspective modulates our view of post-Tang print culture as a by-product solely of imperial publishing. It adds a vital material context to the moral economy of imperial officials and their print culture. It also suggests that books, even the same book, and other printed matter could be simultaneously repositories of moral values and material objects of pecuniary value. In the first instance, books yielded existential insight or influenced behaviour. In the second, they fetched profits of a more metallic sort that could be turned to various objectives, regardless of the refinement of those who acquired them. These trends and characteristics continued into the nineteenth and twentieth centuries, when Shanghai ratcheted them all up several notches through its joining of Western printing technology with Chinese print culture and commerce.

In contrast to the concepts of print culture and print commerce, the term "print capitalism," which often appears side by side with discussions of European print culture, has had less impact on scholarly analysis of China. In part, this omission reflects uncertainty about the nature of print capitalism, a term first popularized by Benedict Anderson.[24] Perhaps because print capitalism is a concept placed in service to his theme, nationalism, Anderson never really defines it, not even in the "concepts and definitions" section of his book. Generally, though, it may be inferred that, for Anderson, print capitalism refers simply to the commercialized, secularized, nongovernmental, and nonphilanthropic production of texts for a popular audience. However, this definition is historically so imprecise that it could easily apply to the entire long history of late imperial Chinese book production, dating back to at least the Song. During the nine centuries that followed, Chinese workers carved blocks and used them to print all kinds of secularized, nongovernmental books. Their craft-based, handmade books then circulated commercially throughout China, without, however, establishing print capitalism.

Anderson's notion of print capitalism was presaged by Lucien Febvre and Henri-Jean Martin's discovery that the European print shop was the world's first capitalist enterprise.[25] Many elements of what we today call capitalism have indeed been widely present in Western society since Gutenberg's day. However, they did not come together in a consistent and replicable international format until the late nineteenth century.[26] Although Karl Marx, the first serious analyst of the modern mode of production, focused on the economic and social relations that defined what later came to be called

capitalism, he also acknowledged, like Febvre and Martin, that technology was a critical part of the capitalist system. Specifically, Marx argued that the development of machinery marked the genesis of the Industrial Revolution, "And to this day [technology] constantly serves as such a starting point, whenever a handicraft, or a manufacture, is turned into an industry carried on by machinery."[27]

Print capitalism, I argue in this book, is an offshoot of the process of mechanization in the printing and publishing sector. Print capitalism may be said to have arrived when commercialized, secularized, nongovernmental, and nonphilanthropic printing came to be done, not as a handicraft, but as a form of "industry carried on by machinery." Historians have become more aware of the roles of commerce and even industry in the late imperial Chinese world, but few demarcate the discontinuity between commerce and capitalism as acutely as Marie-Claire Bergère. In her study of the Chinese bourgeoisie in the early twentieth century, for instance, Bergère argues that "capitalism [did] not spring from a multiplication of markets nor even from their more or less organised integration, but from the introduction of mechanisation into a highly commercialised society."[28] In addition, she maintains, mechanization laid a groundwork for the Chinese bourgeoisie.

Similarly, I argue that mechanization laid the material foundation that made Chinese print capitalism possible. At the same time, however, Chinese print capitalism required operating capital and a sizable market. Capital was obtained via the joint-stock limited liability corporation and from Shanghai's modern banks, two organizational entities borrowed from the West that contrasted with the strongly familial enterprises of China; a large market was available only outside Shanghai, making the Shanghai publishers financially dependent on a national clientele to whom their new products, particularly textbooks, scholarly works, reference books, etc., could be sold. That patronage was regulated by tumultuous, frequently changing political regimes situated beyond the confines of the treaty port. Protection of the intellectual and manufacturing effort needed to produce printed commodities was an important part of the print capitalist process. Likewise, the creation of specialized managerial leadership led to employment of an adjunct workforce, a new form of skilled labour that turned out to be less vulnerable to patriarchal domination by management than traditional printers had been.

To date, just as print capitalism has received little attention from China scholars,[29] so too the important changes in China's publishing sector brought on by adoption of Western technology have been largely overlooked. With a history stretching back to the early Tang dynasty, xylographic printing and publishing had become widely dispersed by the late imperial period.

Traditionally, blocks were made from treated pear, jujube, or catalpa wood, all of which were widely available.[30] During the Song dynasty (960-1279), the block-carving craft reached such heights that engravers were able to imitate individual calligraphic styles while still working within the Kaishu, or "plain written hand," script. Three centuries later, during the Ming, xylographic innovations, such as three-colour printing, were added to the older techniques, but by then block-carving had spread widely throughout the empire and book printing encompassed a broader range of quality and genre.[31] By the nineteenth century, the process of carving wooden blocks had become so widespread and simplified that, at printing's lower reaches, illiterate women and children were hired to perform the task.[32] The xylographic printing process, itself even simpler than that of carving, also promoted dispersal. In each case, a sheet of paper, most likely a common southern bamboo paper such as *lianshi*, was laid over an inked block and rubbed with a "long brush" *(changshua)* or "printing burnisher" *(cazi)*[33] to transfer the watery Chinese ink from block to paper, which was then peeled off and hung to dry. The tools themselves were rustic and easily obtained or adapted from other uses.

Nineteenth-century technological changes not only created the context for the rise of print capitalism, but also transformed the geography of Chinese publishing. To be sure, xylographic printing continued throughout that century and much of the next, but from the late nineteenth century on Shanghai was unquestionably the single most important centre of Chinese publishing, largely because it was the site in which most new printing technology was introduced. This technological revolution, as Perry Link has pointed out, encouraged the growth of China's modern literature and made possible the expansion of commercially driven readership markets.[34] Scholars such as Leo Ou-fan Lee and Andrew J. Nathan[35] have traced the origins of Chinese mass culture to Shanghai and its modern publishing industry, observing that, after 1895, political news and new ideas were delivered to the Chinese people "almost exclusively through the press"[36] and modern periodicals.

Indeed, successful Shanghai publishers turned what Daniel R. Headrick, a Western historian of technology, and Zhang Xiumin, the leading historian of Chinese printing, both might call "a civilian tool of Western empire-building"[37] into one of the most efficacious devices underlying the multiple reconstructions of Chinese cultural life and state-building in the twentieth century. As we will see in this book, Chinese modernity was multifaceted and did not follow a simple straight line. This book problematizes our understanding of the Chinese and the Western, the traditional and the modern,

and shows them working constructively together rather than counter-productively against each other.

The intellectual influence of early-twentieth-century Shanghai periodicals is undeniable. However, in the period after 1895, books, particularly textbooks and reference books, but works of fiction and social science as well, were at least as important as periodicals in shaping long-term Chinese opinion. In fact, textbooks consistently reached more people than periodicals and presented a more stable message. As a result of their devoted pursuit of an expanded readership, Shanghai's comprehensive publishers, particularly the Commercial Press and Zhonghua, were forced into the technological vanguard of Shanghai's printers and publishers. In contrast to the decentralized traditional publishing business, the technological foundation on which their national intellectual leadership depended also granted Shanghai's book publishers an industrial supremacy unrivalled by other publishing centres.

For all the importance of new foreign machines in redefining and centralizing printing and publishing in Shanghai, older Chinese cultural values and practices did survive the arrival of that technology. In his enterprise history of the Commercial Press, Jean-Pierre Drège emphasizes that, in pre-1949 China, unlike in Western publishing operations in the same period, the three functions of editing, printing, and distribution were all united under one publishing roof. Just as significant, reminding us of the influence that noncommercial moral ideals of the literati had on modern Shanghai publishers, Drège also stresses, against Febvre and Martin's view of the post-Gutenberg Western publisher as an early capitalist dependent on machinery, that "there were ... two essential aspects in [Chinese] publishing, the idealistic aspect and the commercial aspect, and the reputation of a house depended in large part on reconciling them."[38] Here Drège is hinting at the prominent role of an inherited set of cultural values in influencing modern Chinese publishing business practices. This present work will extend Drège's conclusions to demonstrate the continuing influence of a traditionalistic print-culture mentality on the decisions of the modern industrial print capitalists who directed late Qing and Republican China's leading corporate publishing firms.

Late Qing and Republican Shanghai's printing and publishing world illustrates the merger of the three worlds of Chinese print culture, commerce, and capitalism. Shanghai tied culture and commerce together through a machine-based industry and provides us today with an ideal setting for studying their influence on each other. No other cultural industry was as central to the self-identity of the Chinese elite as the one that produced

books, and no other was as close to the heart of the Chinese state. For this reason, almost no other Chinese-owned industry was modernized as quickly as this one, with the result that Gutenberg was himself a familiar figure to literate Chinese of the 1920s and 1930s.

Gutenberg in Shanghai

Although his progeny, in the form of typography, printing presses, and printing machines, appeared in Shanghai in the nineteenth century, Johann Gutenberg (1400?-68) himself did not figure as a recognizable name or noteworthy personality in the Shanghai consciousness before the mid-1920s.[39] His appearance then reflected growing public awareness of the importance of technology in national development as well as the widespread dissemination of the industrially manufactured book and journal. Gutenberg was absent from China's first modern dictionary, *Xin zidian* (New Dictionary) issued by the Commercial Press in 1912. Likewise, he did not appear in the Commercial Press's 1915 phrase dictionary, *Ciyuan*, or in *Zhonghua da zidian* (Zhonghua Big Dictionary), issued the same year by Zhonghua Books.[40] Nonetheless, all three modern dictionaries, the most important to appear in Chinese since *Kangxi zidian* (Kangxi Dictionary) of 1716, were printed using technology that could be traced to Gutenberg.

The absence of Gutenberg's biography from these reference works reflected venerable literary conventions that began to change in the 1920s. Traditional biography *(zhuanji, liezhuan)* typically focused on the public accomplishments of noteworthy Chinese officials, artists, and writers. Certainly not a Confucian official, painter, or writer, Gutenberg was also a foreigner, a group rarely treated by Chinese biographers. Even Chinese naturalists, scientists, and inventors seldom merited entries in early-twentieth-century dictionaries, not to mention older ones. By the mid-1920s, however, "foreign" historical categories such as science, technology, invention and inventors, and important Western historical figures did begin to appear in the published Chinese consciousness.[41]

After a period of adjustment that lasted from the mid-1920s to the mid-1930s, Chinese biographical entries started to focus on newly important themes such as the creation of individual scientific achievements, individual technological accomplishments that led to public benefits, and the inventiveness of the working class. By the 1930s, in the profile of Gutenberg presented to the reading public, older didactic qualities began to merge with newer concerns. In some cases, these themes also helped to support the view that China should be given credit for its contributions to world scientific and technological civilization.

When Gutenberg's name finally did appear in Chinese discussions of printing history, it was initially in the context of defensively assertive claims about China's contributions to world printing history. Such discussions reflect the almost immediate impact that Thomas Francis Carter's now-classic study in comparative history, *The Invention of Printing in China and Its Spread Westward* (1925), had in China, even in the original English-language edition. Convinced, and even inspired, by Carter's argument that the source of one of the distinguishing technologies of Europe's modern period lay in China, the Chinese now began to lay emphasis on their country's central place in world technological history in general and, more specifically, in printing history.

In 1927, for example, a well-known Shanghai journalist named Ge Gongzhen (1890-1935) issued China's first modern history of journalism under the imprint of the Commercial Press. Ge's work displayed some of the defensive posturing typical of this period. Discussing the art of printing, Ge stated that "Westerners take the German *Gu-teng-bao* (Guttenberg [sic]) as the ancestor of civilization and do not know that his invention of movable type was already 500 years late."[42] In fact, said Ge, "Printing was one of the technologies passed from China to the West. The book *The Invention of Printing in China*, written by the American Mr. Ka-de [Carter] records this in particularly great detail."[43] His nationalistic rhetoric aside, Ge's citation of Carter's book marks one of the first acknowledgments in a modern Chinese publication that printing technology was deemed an important element in national identity.[44]

Four years after Ge Gongzhen's book appeared, He Shengnai, the Commercial Press's colour-printing supervisor, wrote that Chinese printing technology spread first to Japan (in the eighth century) and eventually to Europe, where the German, Gutenberg, was influenced by it. Like Ge Gongzhen, He Shengnai stated that his source for this insight was Carter, who "read our ancient printing history and really worshipped our previous eras' spirit of creative progress."[45] Nonetheless, Gutenberg was important to He, as he was to Ge – only as a means for making claims about China's past greatness.

In the 1930s, however, as China's modern education system became increasingly Westernized, bringing with it the popular ideal of technological progress,[46] Gutenberg grew more recognizable to the Chinese for the lessons that he could teach. For example, a discussion of Gutenberg could be found in the essay "Zhongguo yinshua yu *Gu-deng-bao*" (Chinese Printing and Gutenberg),[47] which appeared in the journal *Kexue de Zhongguo* (Scientific China) in 1934. The author showed interest in Gutenberg as the first to create "Western" movable type. Like his predecessors, this author also qualified

his observation with the statement that a Chinese (Bi Sheng, in 1040) had developed movable type four centuries earlier.[48]

Nonetheless, here Gutenberg emerged as a creative personality who had overcome hardship to make his contribution to society. Readers learned, for instance, that the inventor had come from a wealthy family, one that "spent money like water," yet had not succumbed to this temptation. Further moralizing revealed that, during his time in Strasbourg, Gutenberg had avoided the problems with drink that were common there. "He had an extremely fertile imagination, was good in action, clever in thought, behaved in a secretive manner, was quite short-tempered, and for this reason was long criticized by people,"[49] the writer concluded.

By the time Zhonghua Books issued its landmark dictionary, *Cihai*, in 1937, Gutenberg merited a full entry alongside outstanding Chinese literary and historical figures, foreign statesmen, and important historical and cultural events. Here, in a dictionary that took the place of the three cited above and reflected increased Chinese awareness of the non-Chinese world, Gutenberg was identified as the *German* inventor of movable type. More interestingly, readers were told that he had originally been a machine worker *(jixie gongren)*. In 1450, Gutenberg entered Fust's metal workshop and founded the first print shop using movable lead type,[50] says the dictionary. Implicitly, the status of machine workers now approached those of literary and official figures.

In 1939, in a multipart, illustrated translation series, Shanghai's and China's leading graphic arts journal, *Yiwen yinshua yuekan/The Graphic Printer*, continued to explain Gutenberg's historical significance to Chinese printers. Like the authors of the three articles discussed above, the translator reminded his readers of Bi Sheng and China's ancient contribution to Gutenberg, whose importance, he said, stemmed not only from his movable type and printing press but also from a technique for double-sided printing. Even with improvements over the following 487 years, "his general idea is still like it was in the old days,"[51] a statement that established Gutenberg as the fountainhead of all ideas advancing the craft since his own day.

Introducing Gutenberg via one of his many purely imaginary portraits (see Figure I.1), *The Graphic Printer*'s article went on to discuss Gutenberg's experiments with his inventions after 1439.[52] Following a failed lawsuit in Strasbourg, readers were told, Gutenberg moved back to Mainz, where he set up a print shop with Johann Fust's help. Now he put his invention to work. Calling Fust "a disciple with evil designs," the article presented a cautionary tale in which Fust installed his son-in-law in Gutenberg's print shop. Once the son-in-law mastered Gutenberg's techniques, readers were

Figure I.1 Gutenberg, the inventor of cast movable type.
Source: Yiwen yinshua yuekan/The Graphic Printer (Shanghai) 2, 2 (1939): 39.

told, Fust called in his loans and, when Gutenberg could not pay, confiscated the print shop. Still, the authors stressed, Gutenberg's spirit would not be subdued. With the help of Conrad Hummery, Gutenberg started up another printing operation, but unfortunately he died in 1468 before he could make a success of it.

From these evolving Chinese views of Gutenberg, several conclusions can be drawn. First, and most significant, Chinese initially became aware of his general importance to Western cultural history through an interpretation of their own printing history undertaken by a foreign scholar, Carter.[53] Second, their initial interest had less to do with Gutenberg himself and more to do with Carter's enthusiasm for China's own ancient role in the development of what the world acknowledged to be an important technology. Third, openness to Carter's argument eventually led Chinese writers to accept the view that technological advance, led by those who invented and paid for it, as well as by those who built and worked machines, was an important part of national development with key moral lessons to be learned by all.

These changing images of Gutenberg, influenced by varying Chinese habits, needs, and choices, suggest a parallel with the history of China's adaptation of his technological legacy. Among civilian technologies of the nineteenth

century, printing presses of the sort that Chinese of the 1930s believed could be traced to Gutenberg had arrived in China with a variety of more recent technologies. These newer technologies overcame the limitations of his original conception even as they incorporated many of his original ideas. Unlike Europeans who had grown accustomed to incremental technological advance, a process that designated the latest technology as the best technology, however, nineteenth-century Chinese had encountered an extensive range of European technologies from which they had chosen the best for their purposes. In the process of choosing, culture and history had inevitably influenced the technological choices that they had made along with the intellectual ones.

Furthermore, China was unlike most other non-Western regions that had experienced the Gutenberg revolution. Where indigenous print culture was absent or limited in range, the role of local culture and history was minimized in the absorption of this technological revolution. By contrast, late Qing and Republican China offers an outstanding opportunity to show how technologies, deemed to be universal because they are thought, ipso facto, to be "culturally neutral," are reshaped by the societies to which they are passed. Except for the Chinese, few other civilizations in world history prior to the mid-twentieth century have been the ancestral homeland of a technology that was transferred to the West and then itself became the recipient of a later generation of that technology.[54] Discussing the influence of China's traditional and modern culture on its choices of industrial technology will alter our categories of universals and particulars. We will find that China's millennium-old print culture profoundly influenced its modern technological choices, enabling traditional systems of values to live on in the modern era.

Origins of Shanghai's Booksellers' District (Wenhuajie)

On 29 August 1842, the Treaty of Nanjing was signed onboard HMS *Cornwallis*, moored in the Yangzi River, ending the First Anglo-Chinese War (a.k.a. Opium War, 1839-42). The first of a long series of unequal treaties between the Qing dynasty and foreign powers, this document opened five treaty ports to foreign residence and trade. Located a few kilometres from the sea on the Huangpu River, Shanghai, then an administrative and commercial centre of some 230,000 residents,[55] was one of the five.[56] By the end of the century, there would be 100 or so treaty ports scattered throughout China. Shanghai, however, by then inhabited by about one million persons, would tower over all of them.[57] Most inhabitants were Chinese and they joined the foreign merchants and missionaries who occupied the Anglo-

American International Concession and the French Concession. The Westerners created self-governing settlements that were defended against Qing interference by a series of regulations, including extraterritoriality, and security forces.[58] Chinese were drawn to the concessions by various factors, including the benefit of having a *cordon sanitaire* between themselves, the deteriorating Qing state, and then the weak Republican governments.[59] Among the Chinese who crowded into the settlements were numerous heirs to the print-culture and print-commerce traditions of the surrounding Jiangnan region.

Two inimical systems of values, the literati and the commercial, both rooted in China's late imperial past, vied for influence among Shanghai's booksellers. Between 1876 and 1937, the city's modern publishers transmuted China's millennium-old print culture and three-century-old print commerce into modern industrial print capitalism. The public stage on which this drama played itself out was Wenhuajie. The name Wenhuajie (Culture-and-Education Streets) is a creation of the 1920s and 1930s. Already after the 1880s, however, along Henan Road (originally known as Qipanjie, or Chessboard Street), and soon spreading westward into Fuzhou Road (today still also known as Simalu, or Fourth Avenue), right in the middle of the Anglo-American International Concession, assembled all of China's major trade and journalistic publishers. They were joined by their retail outlets and trade associations, along with jobber printers, stationers, calligraphers, and painters. Numerous shops sold traditional literature and antiquarian books. Several others specialized in the traditional "four treasures" of the scholar's studio (*wenfang sibao:* namely, brushes, ink, paper, and inkstones) or marketed paintings and stele rubbings.

From this commercial district of low-rise, high-density structures piled up just behind the financial arsenals of the Bund,[60] the directives guiding late Qing and then Republican China's intellectual fashions and products were issued. Proximity to financial power promoted the growth of the modern publishing media. Throughout the late nineteenth and early twentieth centuries, some 300 major and minor publishing firms and bookstores assembled there (for an inventory of the district during its heyday, see the Appendix, "A Bird's-Eye View of 1930s Shanghai's Fuzhou Road/Wenhuajie District"). At the same time, Wenhuajie's location, concentrated between the banks and counting houses along the river and the sales depots of fabrics, jewellery, perfumes, and other luxuries, situated farther out along Nanjing and Canton Roads, symbolized the ambiguity of the book trade in Shanghai's consumer economy (see Map 2).[61] The intellectual middle ground, symbolized physically by the Fuzhou Road neighbourhood and politically by its location

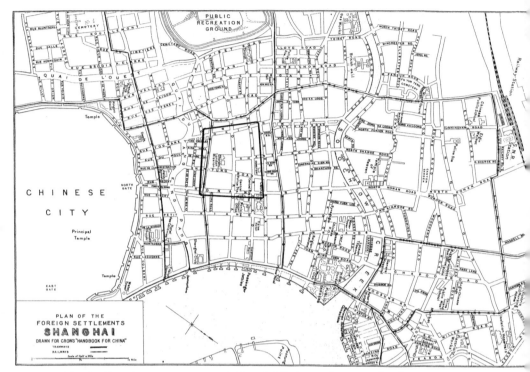

Map 2 Shanghai concessions in 1916, with Wenhuajie district outlined.
Source: Carl Crow, *Handbook for China*, 2nd ed. (Shanghai: Kelly & Walsh, 1916), between 82-83.

in the concession, placed Chinese booksellers and publishers in the fore-
front of both cultural conservation and cultural transformation.

In recent historical scholarship, so much attention has been paid to com-
mercialization of the late imperial economy that awareness of the older
anticommercial Chinese literati service ideal, essential for understanding
Shanghai's booksellers, has nearly been eclipsed. Yet the moral economy of
the Chinese literati counterbalanced commodification of print culture in a
historically and intellectually significant way between 1876 and 1937. Both
of these dynamics – the inherited and the acquired – injected values and
social patterns into what became Wenhuajie. Late imperial bookmen were
vital to the creation of Shanghai's print capitalism at the end of the Qing dy-
nasty. Their equivocality, by which they claimed links both to an elitist cul-
tural past and to a commercial present, continued into the capital-intensive,
industrialized printing and publishing era of Republican China and sug-
gests the continuing, if irreconcilable, vigour of both.

A satirical novel published in Shanghai in the middle of the period dis-
cussed in this book sheds light on the survival of literati ideals in late-

nineteenth- and early-twentieth-century Shanghai. In Wu Woyao's (1866-1910) *Ershinian mudu zhi guai xianzhuang* (Vignettes from the Late Qing), books, print culture, and print commerce play just as important a role as anticommercial literati values.[62] In the face of the commodification of print culture, Wu reminds us of the continuing vitality of the deeply ingrained service ethic that underlay China's late Qing literati world and suggests why such values survived in Republican Shanghai's Wenhuajie.

Vignettes from the Late Qing first appeared in book form in 1909 through the Shanghai publisher Guangzhi shudian. Assuming a pose of high dudgeon, author Wu Woyao[63] strikes directly at early-twentieth-century Fuzhou Road and the behaviour, whether foul, praiseworthy, or humorous, of its denizens. In particular, Wu fires salvos at two major groups that he believed bore responsibility for China's crisis of belief in his day. Commercially driven booksellers, marketing useless ancient writings and modern fluff, are shown to distort the proper ends of learning for private gain at the expense of the public realm. Narrow-minded, overeducated readers also use books as an escape from public responsibility. From the standpoint of Wu's novel, both publishers and readers need to rectify their attitudes.

The meeting of the book's chief protagonist with the moral hero of the story provides a glimpse of Wu's view of the ambiguous men who worked in Shanghai's early-twentieth-century book industry. Wu also reveals insight into booksellers' own ambivalence about their careers in commerce. An episode involving a bookseller occurs just after the narrator (Wu) has arrived at his Shanghai hostel, likely located in the Fuzhou Road district that became Wenhuajie. The narrator enters a neighbouring room to inquire about buying a couple of *tao* (sets of books) from the elderly northern bookseller occupying it. The bookseller turns out to be Wang Boshu, both the narrator's relative and a former prefect of Datong, Shanxi. Handicapped by his nearsightedness and, more important in the narrator's view, by his honesty, the old man once made the mistake of criticizing the governor of Shanxi province to his face without knowing to whom he was speaking. Given the situation, Wang felt obliged to request medical leave. He has been working in the book trade ever since, buying lithographically printed books *(shiyin shu)* in Shanghai, reselling them in Beijing, and then using his profits to market more Shanghai-lithographed works.[64]

After relating experiences that allude to the triumph of merchant self-seeking over anticommercial literati ideals, Wang Boshu presents the narrator with the gift of a book. The text, a Chinese translation of a Japanese work entitled *Fuguo ce* (Plans for Enriching the Country), is given in the hope that the narrator can gain "some practical knowledge and free [himself] from the dilemma of those impractical old-style scholars *[mingshi]* who do

not know how high the sky is and how thick the earth is."[65] Wang then goes on to describe those "impractical old-style scholars." As a former official himself, Wang insists that officials are simply high-profile representatives of learned Chinese as a group. Whether viewed from a southern or a northern perspective, all of these well-read persons are just as pernicious: "There is a group of people who are colloquially referred to in Shanghai as 'poisonous scholars [*shu du tou*],' and who are known in the north as 'bookworms [*shu daizi*].' Just imagine, after they study their books, which are good things in themselves, they get 'poisoned' and they become mere 'bookworms.' How can they attend to their duties when the time comes?"[66]

Moving on to address his chief anxiety, Wang explains that the Western powers are not only poised and ready but also able to partition China. Its first line of defence, a narrow-minded officialdom, is not prepared either practically or intellectually to resist the onslaught, he laments, precisely because of the controlling influence of these poisonous bookworms on officialdom.

The fault of poisoned officialdom lies in "ancient books," which can no longer provide an adequate guide to officials, Wang then observes. In the modern world, China's traditional domestic cultural diplomacy revealed in the Twenty-Four Dynastic Histories, by means of which foreign invaders such as Mongols and Manchus were sinicized, is inadequate. Modern Western countries first conquer foreign lands politically and then rob them of their cultural identities. Shocked by this hair-raising information, the narrator asks Wang, "'Could China one day sink so low? If so, what can be done to avert that?'" Given the heavy moralizing owing at least partly to the literati tradition, Wang has a ready answer: education. Yes, avoid unnecessary waste, secure the borders, but above all else, he insists, China needs to "establish schools for every subject under the sun." While still an official, he petitioned the governor of Shanxi on the issue but achieved nothing, "So, I got into the book trade," he announces. "This was done with a definite purpose in mind ... The ordinary book-vendors were all uneducated and ... all ... they were after was profit. They did not know, nor did they care, which books were useful. My object was to sell only books that are useful."[67]

Wang Boshu, a failed but still high-minded moralist, entered the book trade with the best of intentions but naïve about the height of the obstacles facing him, as he freely admits. Before long, he discovered that "the purchasers of books were just as unenlightened as the book-vendors." They sought only old-style romances or miniaturized editions useful for the examinations of the sort marketed by the Shanghai-based lithographic publishers.[68] When presented with practical works of the sort that Wang gives the narrator, they showed no interest: "If one day these men were lucky enough to enter the official world, what would happen to our country?"[69]

Replying to the narrator's comment that not all such readers can become officials, Wang laments the fact that readers worse than they have already become officials. Referring to the well-known phenomenon of selling degrees that accelerated after the Taiping Rebellion (1851-64) and its insidious influence on public culture and learning, Wang reports "As to those who have bought their titles ... they are an even worse lot. Far from serving the country ... they're in business just as much as I am, but their search for profit is even keener than that of businessmen ... What will become of the country?"[70] Wang's only hope for China's future, its youth, is a predictable cliché in the early twenty-first century. At the time of the book's publication, though, he anticipates an elite, youth-led rejection of conventional late imperial values that would not be realized until the New Culture Movement of 1915-21. It is not surprising that that attack was only the first in a series of attacks on the profit-driven publishers of Shanghai's Wenhuajie.

In fact, already in Wu Woyao's day, some actual Shanghai publishers, as opposed to the fictitious ones of his novel, were trying to produce the "useful books" for which Wang Boshu calls. By 1909, when Wu's complete novel appeared, the print commerce that Wu describes had already given way to a print capitalism based on the industrial production of "useful books." Publishers such as the Commercial Press, for instance, had been manufacturing texts intended to school a new, post-civil service examination generation in modern, morally just principles for some time already. The public service ethic of such publishers was motivated, not by profit-free philanthropy, but by what they deemed the enlightened pursuit of industrial profits made from printed works for sale in what would soon be known as Wenhuajie. At the same time, the intellectual and material impacts of their activities would reverberate well beyond it.

In Wu's day, Chinese print capitalism still had half of its six-decade lifespan ahead of it. As innovative and inventive as Shanghai-based Chinese print capitalism demonstrated itself to be between 1876 and 1937, however, turmoil from 1937, when China's second modern war with Japan began, to 1949, when the Republic of China collapsed, irremediably weakened its viability and its centrality in China's economy. If print capitalism itself did not survive, however, both the Commercial Press and its chief competitor, Zhonghua, outlasted the Republican government and were present figuratively, via publications such as *Ciyuan* and *Cihai*, at the founding of the People's Republic of China.

Even more important historically, the Chinese chapter in the technological dimension of the Gutenberg revolution proved to be irreversible. Since Mao Zedong's declaration of the People's Republic on 1 October 1949, China has again become one of the world's preeminent book cultures. Even the

Cultural Revolution, conventionally viewed as a profoundly anti-intellectual and antibook movement, promoted large-scale book production and consumption. No symbol of the Cultural Revolution itself compares with the potency of *Mao Zhuxi yülu* (*Quotations from Chairman Mao*), the infamous "Little Red Book." The first edition, after editing by Minister of Defence and Marshal Lin Biao (1907-71) that began in 1961, was published by the Political Department of the People's Liberation Army (PLA) in May 1964. The same bureau also promoted the movement to study Mao's longer writings. Over the next three years, one modern historian has estimated, the PLA "printed nearly a billion copies of the *Quotations* along with some 150,000,000 copies of Mao's *Selected Works*."[71] The technological means by which these books reached a national audience of hundreds of millions were those of a modern industrialized publishing industry whose roots lay in the period studied here.

Organization of This Book

Gutenberg in Shanghai is a chronologically organized, problem-oriented, analytical history of the Shanghai printing and publishing industry that focuses on the period from 1876 to 1937. Combining the approaches of the history of the book and print culture, the social history of technology, and business history, it examines the origins of China's modern print media industries in the late Qing dynasty and their development in the Republican period. It argues that traditional Chinese print culture and print commerce influenced Chinese technological choices and created a narrative of adaptation at odds with the conventional Western history of print capitalism. At the same time, the material cost of Gutenberg's and subsequent technology imposed an organizational imperative that transformed conventional Chinese printing and publishing organizations along with workplace relations in them.

Presented through the eyes of Chinese commentators of the 1920s and 1930s, Chapter 1 explains how the system of printing technology associated with Gutenberg's name was transformed by the late-eighteenth- and nineteenth-century European Industrial Revolution and how the Gutenberg revolution came to China. This chapter provides the first-ever detailed English-language account of how the inventions of König, Walter, Mergenthaler, and others that influenced the book-publishing trade came about and were introduced to China via Shanghai. Central to this story is the role of the Commercial Press, which, like the *Times* of London in early-nineteenth-century England, was important for subsidizing and promoting new machinery in China. In spite of having its roots in an illegal effort at

ideological subversion, this process marks the nineteenth and early twentieth centuries as one of world history's most fertile periods of international technological transfer prior to the post-World War II era.

Chapter 2 shows how the conservative motivations of traditional Chinese publishers and booksellers were reflected in Shanghai's lithographic industry starting in 1876. Reversing the conventional narrative, for the first time in either Chinese- or English-language scholarship, this chapter demonstrates that lithography, not letterpress (movable lead type) printing, was the industry that brought about the transition from traditional woodblock printing to mechanization. For the first time in China scholarship, it shows that China's traditional culture influenced its modern technological choices in constructive ways. Despite their conservatism, the lithographers simultaneously raised treaty-port Shanghai's intellectual profile and brought about new social and commercial forms that set the stage for the comprehensive lead-type printing and publishing industry that, in turn, superseded but did not wholly replace lithography or even xylography.

The following stage in China's mastery of the nineteenth-century European revolution in printing technology is examined in Chapter 3, which studies Shanghai's printing-press manufacturing industry. In this period, lasting from about 1895 to 1937, the Chinese learned how to manufacture their own printing presses and other machines, providing domestic printers and publishers with an alternative to many lines of imported machinery. In time, the success of Shanghai's machine-makers contributed to the spread of Gutenberg's revolution well beyond the confines of treaty-port Shanghai, but not before the Chinese gained a sense that they had sinicized this modern Western invention rooted in the technology of medieval China. Combining technological with social history, the chapter delves into the shadowy world of apprentices and masters, showing that the brutality of the printing machine trade created conditions that radicalized its workers.

After Chapters 1, 2, and 3 establish the importance of printing technology to the creation of modern Shanghai-based publishing, Chapter 4 investigates the development of Shanghai's multivalent modern publishing enterprises from the 1880s to approximately 1911. Their origins are traced to the reformist Chinese gentry, particularly to the contradictory influences of the imperial service ethic and the modern demand for adequate compensation for intellectual labour. This latter influence resulted from the high costs of mechanization, particularly from the price of adopting Western-style movable-type presses. High costs, in turn, promoted the awareness of textual property symbolized intellectually by the copyright and organizationally by the industrial trade association. In spite of the high rate of failure, by

adapting the joint-stock limited liability corporation to Chinese conditions, publishers in this phase also laid the groundwork for the industrial, commercial, and cultural bonanza that followed.

Building on the discussion of joint-stock firms, Chapter 5 details the rise of the three most important corporate publishers of Republican China in the context of the physical and symbolic development of Shanghai's Fuzhou Road/Wenhuajie booksellers' district. Wenhuajie was a highly meaningful cultural symbol to the Chinese of the Republican period. More than any other group among the scores, if not hundreds, of Shanghai publishers, the three big joint-stock companies (Commercial Press, Zhonghua Books, and World Books) studied here dominated the district and promoted its image as a national cultural centre. No mere cultural district, however, it was also a commercial one inseparably linked to Shanghai's industrial suburbs, as the chapter shows for the first time. Chapter 5 also demonstrates that the professionalization of publishing, by the 1930s, represented the culmination of the evolution away from late imperial literati print culture and created a new kind of Chinese intellectual.

The final section pulls all these topics and themes together into a summary and conclusion. Here the importance of Shanghai's printing and publishing industry as a first step toward understanding modern Chinese intellectual, cultural, and social history is highlighted. Print culture, technology, and the business organizations of print capitalism are all vital parts of this story and suggest the value of empirical research in overcoming the limits of nostalgic views of the past. Where many works imply that technological diffusion and change, along with social transformation and adaptation to that change, are best left unexamined, this book deliberately seeks to problematize them. The traditional Chinese printing and publishing industry was widely dispersed across the Chinese empire, partly for cultural reasons and partly because of the nature of its technology. Making sense of the meaning of the centralization that occurred when Shanghai came to dominate the modern industry is possible only when that industry can be compared both to what came before it in China and to what was common in other parts of the world.

1 Gutenberg's Descendants: Transferring Industrialized Printing Technology to China, 1807-1930

Printing can be said to have been "reinvented" in Europe and America several times throughout the nineteenth century. In fact, a major distinction between the print commerce of the early modern era and the print capitalism of the late modern period was the growth of mechanization and industrialization. This reinvention, partly fostered by publishers themselves, expanded the contours of the broad printing revolution usually traced to Johann Gutenberg. In turn, the industrial transformation of Western-style printing created a new publishing industry, one that sought the patronage of millions of purchasers and readers worldwide, not merely that of a few thousand early modern European elites. True modernity in printing and publishing emerged only when the processes were mechanized and industrialized in the nineteenth century.

Still, the significance of Gutenberg's invention and later innovations that built on it cannot be adequately understood unless we analyze its distribution and adaptation across times, spaces, and civilizations far broader than those so far examined by scholars. This technological transformation did not remain solely the preserve of Western nations. It became a global development that included China and Chinese inventors. Starting with the small number of print workers and Christian converts discussed in this chapter, the Gutenberg revolution eventually expanded to include the legions of printers and publishers involved in Chinese print capitalism, most of whom congregated in Shanghai between 1876 and 1937. They themselves contributed in a major way to the modification of Western printing technology by adapting it to the Chinese language and local print commerce, with Shanghai's Chinese book publishers usually acting in advance of their colleagues in the newspaper and general printing businesses.

This chapter examines the diffusion of printing media, printing presses, and printing machines from Britain, America, and, to a lesser extent, France and Germany to China between 1807 and the early 1930s. Through a combination of governmental and private efforts, Japan's printing industry reached a high level of expertise in Western-style printing in advance of that of late Qing China, with the result that Japan, too, figures significantly in

the later phases of this story, starting in the early 1900s. Inter alia, the various forms of motive power available for bringing the media, presses, and machines together will be discussed. As this Chinese phase in the Gutenberg revolution unfolded, Western printing technologies were typically absorbed first in Macao, Canton, Hong Kong, Shanghai, and other treaty ports along the southeastern littoral, areas where missionary organizations, both Protestant and Catholic, were most active. By the end of the nineteenth century, however, only one of these multiple locations – Shanghai – turned out to be propitiously enough situated and to have adequately educated Chinese leadership to combine Western printing technology with Chinese publishing culture in order to create a new Chinese industry.

Christian missionary printing appears as only the first of several important steps in this process. When it began, with the goal of producing textual and visual materials for proselytizing, Sino-foreign relations were still regulated by the restrictive Canton System (1756-1842). The missionaries operated in spite of the fact that their activity was illegal in China before 1844, by which time the Opium War had forcibly opened five treaty ports to them, and was only just tolerated by the Qing government after that.[1] To compensate for limited manpower and restricted inland travel and to maximize the impact of their message, many missionary organizations experimented with numerous printing technologies, both indigenous and Western, that could be used to produce Chinese-language texts.

Although printing machinery initially developed or imported by foreign Christian missionaries did lay early material conditions for the Chinese print capitalism that developed in Shanghai, missionaries were not axial to later developments. After 1807, expensive, technically demanding Western mechanical printing technology began trickling into China. Not surprisingly, for six decades, it made little headway against cheap, far more convenient native printing techniques. Then, in a striking reversal of their initially lukewarm interest in Western printing technology, starting in the 1870s and culminating in the 1930s, the Chinese enthusiastically embraced the printing press as a distinct form of Western machinery. Chinese who encountered Western printing technology now acknowledged the need to understand the advantages of modern industrial manufacturing processes, particularly the ways in which the respected cultural work of publishing could be combined with it. In this period, missionaries largely dropped out of the technological vanguard, replaced by Chinese print capitalists.

As we will see in this chapter and in the next two, there was nothing inevitable about either the Chinese "reinvention" of Western printing technology or the sequence in which it was adopted. The Chinese made conscious choices. A society's willingness to accept the *value* of certain kinds of

technology when presented with various options all at the same time, rather than sequentially, as happened in the West, is influenced by its own history and culture. Although Western printers surmounted multiple difficulties in creating serviceable early Chinese type fonts, their efforts were eventually thwarted by Chinese emphasis on the aesthetics of calligraphy in particular. As a result, from 1876 to 1905, Chinese visual sensibility led to major Chinese investments, not in movable-type letterpress printing operations, but in lithographic ones. On the one hand, lithography, the most important Western technological alternative to techniques of casting and setting type for use with printing presses, provided a culturally sensitive compromise between the limitations of both Chinese xylography and imported typography. On the other hand, after 1905, Chinese-designed type fonts, which could be harnessed to fast letterpress printing presses, edged out both lithography and the old missionary fonts just in time for use in late Qing educational and revolutionary movements.

Thus, in the long run, in one of history's more striking ironies, the missionaries' printing technology itself turned out to have a much greater impact on the Chinese than the religious messages it was intended to convey. It is well known that the technological revolution that began with Gutenberg in the fifteenth century eventually undermined the unquestioned hegemony of Roman Catholicism in Europe. Just as significantly, Western printing technology provided anti-Qing and anti-Nationalist reformers and revolutionaries with the printing hardware that enabled them to spread their messages broadly, quickly, and relatively anonymously. In doing so, Western printing technology contributed, not to the creation of the Christian kingdom that nineteenth-century missionaries longed for, but to the Communist Party's establishment of the People's Republic of China.

An Era of Metal, Steam, and Chemistry; Printing Media, Presses, and Machines

The full range of nineteenth-century Western printing media comprised surfaces in relief (letterpress), surfaces that were planographic (lithography), and surfaces that were in intaglio (gravure printing, etching, engraving) (see Table 1.1). Overlapping and used with these three kinds of inked print media were three varieties of presses (see Table 1.2). All involved "pressing" in the sense that the machines in each stage all used some sort of pressure, whether with two flat surfaces (a typeform and a platen), one flat surface (typeform) and one curved surface (impression cylinder), or two curved surfaces (typeform and impression cylinder), to transfer an imprint of ink from type to paper. Given this broad range of printing technologies, the Chinese faced a number of options. Contrary to popular belief, the mode of printing passed to the Chinese was not limited to a single medium. Even

Table 1.1

Western print media in China, 1700-1931

Media name	First recorded use for Chinese-language printing	First recorded user
Relief media (Ch. *tuban yinshua*)		
Cut type (Ch. *diaoke huozi*)	1814	Cai Gao, London Missionary Society (LMS), Malacca Peter Perring Thoms, East India Company (EIC), Macao
Cast-type matrices/ movable types (Ch. *zimo/huozi*)	(1) 1838 (2) 1845	(1) Samuel Dyer, LMS, Penang (2) Richard Cole, American Presbyterian Mission Press (APMP), Ningbo
Clay stereotype (Ch. *niban*)	1845	Richard Cole, APMP, Ningbo
Plaster stereotype (Ch. *shigao*)	c. 1860s	J.M.W. Farnham, Qingxin Hall School, Shanghai
Electrotype (Ch. *diandu tongban*)	1860	William Gamble, APMP, Ningbo
Papier-mâché stereotype (Ch. *zhixing*)	c. 1885-95	Xiuwen yinshuju, Shanghai
Photoengraving (Ch. *zhaoxiang tongziban*)	1900	Tushanwan Print Shop, Shanghai
Boxwood/yellow poplar (Ch. *huangyang ban*)	1904	Commercial Press, Shanghai
Three-colour (Ch. *sanse ban*)	c. 1908-12	Commercial Press, Shanghai
Planographic media (Ch. *pingban yinshua*)		
Stone-based lithography (Ch. *shiyin*)	(1) 1832 (2) 1876	(1) Qu Ya'ang, LMS, Canton (2) Tushanwan, Shanghai
Collotype (Ch. *keluo ban, boli ban*)	c. 1875-85	Tushanwan, Shanghai
Stone-based photolithography/ zinc-plate (Ch. *zhaoxing shiyin*)	no later than 1882	Dianshizhai, Shanghai
Stone-based chromolithography (Ch. *caise shiyin*)	1904	Wenming Books, Shanghai
Tinplate (Ch. *makoutie*)	1918	Commercial Press, Shanghai

▶

◀ Table 1.1

Offset lithography (Ch. *xiangpi ban, jiao ban*)	1921	Commercial Press, Shanghai
Facsimile (Ch. *chuanzhen ban*)	1931	Commercial Press, Shanghai
Intaglio media (Ch. *aoban yinshua*)		
Copperplate (Ch. *diaoke tongban*)	(1) c. 1700 (2) 1885-95	(1) Kangxi emperor, Beijing (2) Jianghai Customs Printing Office, Shanghai
Photogravure/ heliogravure (Ch. *yingxie ban*)	1923	Commercial Press, Shanghai
Colour photogravure (Ch. *caise yingxie ban*)	1925	Commercial Press, Shanghai

from among the media and processes taken to China, the Chinese made conscious decisions about what they would adopt and reject. Those choices changed over time as the demands placed on written texts changed.

When letterpress printing and lithography arrived in Shanghai in the 1870s and 1880s, each technology was influenced by a largely noncommercial, philanthropic sectarian affiliation. Since early in the century, Western Protestant missionaries had coalesced around relief media and Catholics around planographic ones. However, the next phase in Western-style printing in China would not be a noticeably Western, Christian, or philanthropic one at all but a Chinese, secular, and industrial one that reflected the historical, cultural, and financial predispositions of Shanghai's Chinese printers. Using lithography, which appealed to them for special historical, cultural, and financial reasons, Shanghai's Chinese printers would take the first significant step in undermining, if not totally replacing, Chinese xylographic printing and establishing print capitalism.[2]

From 1807 to 1876, however, Protestant missionaries and some of their Chinese converts dominated mechanical printing on the south China coast. Strikingly, nearly every well-known nineteenth-century Protestant missionary account of China discourses to some extent on printing technologies. A handful of them also discuss the importance of choosing from among multiple competing technologies. In this way, they anticipate Chinese concerns while reaching different conclusions. One of the first such discussions of print technology appeared in 1833 in a missionary journal summarizing the views of the Reverend Samuel Dyer (1804-43). Revealing both the limits of early Protestant missionaries' knowledge of written Chinese, as well as

Table 1.2

Western printing presses and printing machines in China, 1830-1925

Name of press	First recorded use for printing Chinese	First recorded user in China
A. Relief (Ch. tuban) (letterpress, typographic) printing presses and machines		
Platen (*pingzhuang yinshuaji*)		
Washington?	(1) 1830-31?	(1) American Board, Canton
	(2) 1861	(2) American Methodist Episcopal Mission (AMEM), Fuzhou
Albion	1833	unknown, Macao and Canton
Columbian	1850-56	American Board, Canton
Self-inking Washington	1878-79	AMEM, Fuzhou
Cylinder printing machines (*lunzhuan yinshuaji*)		
Unknown	1862	APMP, Shanghai
Unknown	1860s, before 1867	LMS, Shanghai
Harrild & Sons bed-and-platen	1872	*Shenbao*, Shanghai
Double royal cylinder	1895	AMEM, Fuzhou
Wharfedale	1906	Hushang shuju, Shanghai
Ya-er-hua-de (Walter press?)	1911	Commercial Press, Shanghai
Miehle	1919	Commercial Press, Shanghai
Rotary printing machines (*lunzhuan yinshuaji*)		
Walter press	c. 1900	Hushang shuju, Shanghai
Ba-De (Baensch-Drugulin?)	1914	*Xinwen bao*, Shanghai
Osaka-Asahi (Marinoni)	1916	*Shenbao*, Shanghai
Ai-er-bai-tuo (Albright? Heidelberg?)	1922	Commercial Press, Shanghai
Vomag	1925	*Shibao*, Shanghai
B. Planographic/lithographic (pingban, shiyin) presses and machines		
Mitterer's star-wheel	(1) 1832	(1) Qu Ya'ang, LMS, Canton
	(2) 1850	(2) APMP, Ningbo
	(3) 1876	(3) Tushanwan, Shanghai
Lead-plate	1908	Commercial Press, Shanghai
Four-colour lead-plate	c. 1912	British-American Tobacco (BAT), Shanghai
Harris offset	1915	Commercial Press, Shanghai
Mann two-colour offset	1922	Commercial Press, Shanghai

the primitive state of the missionaries' Chinese typography, Dyer wrote that "Chinese metal types [sic] are exceedingly desirable, in order that we may be able *to combine* the Chinese character with the European" (emphasis added).[3] Combining then still imperfect Chinese type with English words in the same text would eventually improve compositors' ability to correct proofs, one of the chief advantages of movable type, by making single character changes possible.

Among these assessments of competing technologies, Walter Henry Medhurst (1796-1857), who apprenticed to a printer of Gloucester, England, at age fourteen and was running London Missionary Society printing operations in Malacca seven years later in 1817, offered the most articulate evaluation in a widely distributed 1838 publication.[4] Later statements by Protestant missionary printers indicate that Medhurst's analysis, which combined commentary on cost, technology, and missionary linguistic limitations into an argument favouring letterpress, remained paradigmatic among them until the end of the Qing period.

Printing Christian books and tracts for clandestine circulation in China occupied Medhurst's early days in the South China Sea and the Straits of Malacca. Basing his presentation on his printing experiences among Chinese populations at the British colonies of Malacca and Singapore and the Dutch one of Batavia (Jakarta), Medhurst compared the costs of the three different printing options then available (xylography, lithography, and letterpress) for missionary publishers wishing to produce 2,000 copies of a large book such as a Chinese Bible in octavo. Medhurst concluded that the cost of xylographic printing would have been £1,900 and that three years would have been needed to complete the job. Included in the final price were the costs of hiring nine Chinese blockcutters and five printers and binders; the blocks, tools, transcription, cutting, paper, ink, and binding were also included in his calculations.[5] Lithography, a newly invented technology of which Medhurst was an atypically enthusiastic pioneer among Protestant missionaries, would have been significantly cheaper and somewhat faster than xylography for the same job. The cost for two lithographic presses, stones, materials, transcription, paper, printing, and binding, along with six employees, would have totalled £1,262 and taken two years rather than three. According to Medhurst's estimate, printing the same Bible with metal type would have taken seven workers one year, and the whole price would have been £1,515.

In the view of Medhurst and other Protestant missionaries, although the cost benefit and some time advantages seemed to lie with lithography, long-term considerations actually favoured letterpress. Their reasoning is instructive, partly because it became a pattern among Protestant missionaries in

China. To Medhurst, xylographic blocks would have been limited to a single run of perhaps 2,000 high-quality copies. With lithography, only the presses and stones, badly worn, would have remained after printing. Conversely, with letterpress, the newly invented iron press and a set of punches and matrices that could have been used to cast more type would have remained to produce up to fifty more runs.[6] Like Medhurst, John C. Lowrie of the American Board of Commissioners for Foreign Missions in Canton emphasized the mechanical efficiency and logic of letterpress, writing in 1843 that "We live in an era of metal and steam ... hence, I am strongly in favor of giving a full and fair trial to our Chinese metal type."[7] Lowrie might have added that Qing prohibitions against Chinese collaboration with the missionaries may have enhanced the value of letterpress, a technology whose control they may have believed would remain in their own hands.[8]

Medhurst's and Lowrie's discussions of xylography, lithography, letterpress, printing stones, and the iron press recall the complexity of the nineteenth-century Western printing industry. Many of the questions confronting Chinese printers would turn out to resemble those that Medhurst first articulated in the 1830s regarding technological choices, costs, durability, and even aesthetics, although, almost inevitably, Chinese answers would differ from those reached by Westerners. By the 1920s, Chinese were increasingly aware both of the nineteenth-century renewal of European printing hardware and of the part that Chinese had played in introducing it to China. In their view, three key phases – relief, planographic, and intaglio – in the development of Western printing media and presses culminated in the options available to Chinese printers then.[9] To understand the blend of old and new technologies brought to China between 1807 and the 1930s and the effects of its diffusion on a society with its own printing history, we must first understand the Gutenberg revolution itself as well as subsequent changes in printing technology. The following survey of nineteen forms of printing technology reveals the complexity of the choices that Chinese made in the course of the nineteenth and early twentieth centuries.

Relief Media (Chinese, *tuban yinshua*)

In the 1930s, Gutenberg was best remembered by Chinese writers on printing history for having developed a means of manufacturing movable, cast, lead type. Yet three operations were critical to the mechanical duplication of texts in both the pre-industrial and the industrial ages: type-casting and/or cutting (commonly called engraving, despite the fact that type was created in relief, not in intaglio), typesetting, and printing. All three operations were central to the process of adapting Gutenberg's technology with its later forms to Chinese conditions.

活字鑄造情形

（由斯特矮孟氏繪）

Figure 1.1 Jost Amman's "Casting Movable Type," 1568.
Source: Illustration by Amman (Frankfurt, 1568), reprinted from *Yiwen yinshua yuekan/The Graphic Printer* (Shanghai) 2, 3 (1939): 39.

Influenced both by Western scholarly views of the day and by actual printing practices, Chinese assumed Gutenberg's method of casting type to have used a mould and a matrix (see Figure 1.1).[10] Gutenberg's process involved first cutting a letter in relief onto a hard steel punch, then used to create a matrix (a reversed intaglio version of the letter) in a softer metal, probably copper.[11] The concepts of both punch and matrix predated Gutenberg. The matrix formed the bottom of a casting mould, which is what Gutenberg actually created, into which a molten lead alloy was poured to cast shanks of metal of a standardized height.[12] Once the type cooled, it had a uniform height (with a letter in relief at one end) but was of variable breadth (depending on the width of the letter).

Separate pieces of type could then be used to make up words, lines, and paragraphs, on up to half-pages. Because words in European languages differ in length, line ends were made even, or justified, using blanks. Since type was of a standard height, it could be placed in a galley, which was locked into a frame, or chase, to produce a rigid printing surface, the form. Using Gutenberg's casting mould and a tiny beaker of molten tin and lead, one worker could cast about 4,000 pieces of Roman alphabet type in a ten-hour day.[13] Hand-cast movable metal type was soon supplemented with type

stamped out using dies. These two kinds of type became the chief printing medium for the centuries between 1450 and 1800.[14]

Using both type-casting and type-cutting techniques that dated from Gutenberg's era, Europeans sought to reproduce Chinese texts in print as early as the sixteenth century.[15] The letterpress printing of Chinese, a non-alphabetic language with some 40,000 characters,[16] required the creation of standard-size, indivisible *logo*type ("word" type), rather than mere letters used to make up words, a requirement that stymied early foreign efforts. Although the Chinese had intermittently cast movable type using various metals since the fourteenth century, even they did not do so consistently prior to the arrival of Europeans in the nineteenth century.[17] Furthermore, regardless of whether a Chinese character had few or many strokes, all characters had to be the same size on the printed page to look acceptable to Chinese readers.

Four centuries of European type-founding notwithstanding, European missionaries in Asia initially *cut* their Chinese fonts. Type-*casting* of Chinese characters using engraved dies and Gutenberg-style moulds began in 1814 but was not fully successful until 1838. Depending on what needed to be printed, missionary printers determined that they could narrow the number of typefaces down from the full range of 40,000 to between 4,700 and 6,600.[18] Even this reduced number was a significant obstacle to early efforts to produce fonts of cast type, however.

One successful, but still only partial, font of Chinese characters was cut between 1805 and 1810 by Baptist missionaries at Serampore in Bengal; they first used it to print a New Testament. The same basic font (see Figure 1.2) was reused to print *Elements of Chinese Grammar* (1814), written by the Baptist missionary Dr. Joshua Marshman (1768-1837). The author told his readers not only about the technology used but also something of its convenience, its aesthetic, and the expenses involved in its creation: "The Chinese characters in this work are printed from Metal Types [which], when brought to perfection, will essentially promote the cause of Chinese literature, as well as the dissemination of the Holy Scriptures; as while they add greatly to the legibility if not to the beauty of the Chinese characters, their being *moveable* enables us to print ... any Chinese work whatever, at an expense too by no means immoderate."[19]

Reflected in Marshman's comments is the view that the aesthetics of his printed Chinese characters had been sacrificed for the convenience of being able to print English and Chinese side-by-side. Secondly, at least by implication, Marshman suggests that metal type allows the printer to correct individual errors, albeit at great overall expense.[20] Both capacities were lacking from the manufacture of wooden blocks, a Chinese technology with

Figure 1.2 "On the [Chinese] Characters," 1814.
Source: Joshua Marshman, *Elements of Chinese Grammar* (Serampore: [Baptist] Mission Press, 1814), 64.

which Marshman was familiar. A glimpse at his text reveals the slashed, choppy, unbalanced appearance of the Chinese characters, an appearance typical of early on-site nineteenth-century European attempts to print Chinese.[21] Nonetheless, Marshman was one of the first Westerners to point out that the aesthetics of the text were important to Chinese readers.

Marshman's cut font was followed in 1814 by another partial cut font created in Malacca, Britain's Malayan colony that predated the founding of Singapore (1819). In Western accounts of Chinese-language printing with metal type, Englishman Dr. Robert Morrison (1782-1834) and Scotsman Dr. William Milne (1794-1821) are typically given credit for the creation of this second partial font. Morrison and Milne were members of the London Missionary Society, an interdenominational organization formed in London in 1796. Morrison had arrived in Macao in 1807 and worked for the

East India Company (EIC) as a translator in Canton until 1815. Milne arrived in Macao in 1813. He then proceeded to Canton, where he worked briefly with Morrison before leaving to missionize the Chinese communities in Java and Malaya.

In 1818, Morrison and Milne established the London Mission Press, affiliated with Malacca's Anglo-Chinese College,[22] of which Milne became principal. Clearly, part of their objective was to circumvent Qing, Catholic, and even EIC restrictions on Protestant printing in Macao. The following year, they finished printing their Chinese New Testament, again using hand-cut type.[23] In 1824, a complete Chinese Bible was issued at Malacca. The London Mission Press would remain in the Straits, distant from China, for another two-and-a-half decades, until settlements following the Opium War permanently opened Canton to it and foreign merchants.

Writing in 1931, Commercial Press printer He Shengnai (active 1920s-1930s) corrected Western accounts of the beginning of this printing operation to emphasize that the Malacca font was probably cut by the Chinese Christian convert Cai Gao (1787?-1818).[24] He did concede that Cai was likely supervised by Morrison and Milne. The lack of a foundry at Malacca is what necessitated painstaking cutting of the characters (in reverse).[25] The characters were cut using much the same technique as woodblock cutting, a process with which Cai may have been familiar. After being outlined on transparent paper, the reversed characters were drawn on type blanks, and then unnecessary metal was cut and filed away.

Although religious literature intended to be smuggled into China had to be printed at Malacca, Morrison did manage to print his famous *Dictionary of the Chinese Language* at Macao with assistance from the EIC, his onetime employer.[26] Although the EIC trading monopoly feared that religious publications would destabilize its relationship with the Chinese empire, it found practical commercial value in the dictionary and supported the project. In 1814, an EIC printer-translator named Peter Perring Thoms (active 1814-51) brought movable type, blanks, and other essentials from London to Macao at the trading company's expense to assist in printing the Morrison dictionary.[27] The dictionary combined the largest number to date of Chinese characters with extensive English text. Employing Chinese assistants, Thoms arranged to cut two partial Chinese fonts using a tin alloy. The first part of the dictionary was printed in 1815, 1822, and 1823, and the second and third parts appeared in 1820 and 1822, all on Chinese paper.[28]

In the "Advertisement" to the first part of the dictionary, written when Morrison, then at Canton, was separated by 140 kilometres from Thoms in Macao, Morrison refers to the challenges of producing such a work under those conditions. Not only did he have to work in China, distant from

Western printing supplies, but even those sent to him from England were in peril: "The First [part] appears under disadvantages, from the whole of the Italic Types having been stolen before they were landed from the Ship which conveyed them from England."[29] Furthermore, says Morrison, Thoms had had to work largely alone, serving as compositor, pressman, reader, and corrector, "aided only by Natives who understood not the English language."[30]

Later, in the "Introduction" to the same volume, Morrison discusses the influences, both intellectual and orthographic, on his dictionary. Stating that "Letters and the Press constitute a mighty engine,"[31] he notes that his dictionary borrows heavily in arrangement from the *Kangxi Dictionary* (1716), using its system of 214 radicals to organize the entries in the first part. After criticizing Étienne Fourmont's (1683-1745) *Linguae Sinicae grammatica* (1742) for its frequent erroneous use of printed characters, Morrison praises C.L.J. de Guignes's 1813 Paris-published Chinese dictionary printed from the manuscripts of Catholic missionaries, a dictionary that he calls "the most useful book, on Chinese, yet Printed in Europe."[32]

In spite of the virtues of that work, avers Morrison, the French dictionary was marked by severe limitations that his own dictionary surmounts. For example, the French dictionary featured only 13,316 main character entries, he says, and the "examples" (i.e., binomes and phrases) did not include Chinese characters. By implication, the limitations were typographic; printing Chinese in the examples would have required the creation of a second font. In the case of Morrison's dictionary, "this material defect" is addressed: two fonts were used, a large main entry and a smaller font with examples (see Figures 1.3 and 1.4).[33] All told, the number of entries, following the example of the *Kangxi Dictionary*, is about 40,000.[34]

Like Marshman, Morrison acknowledges that the aesthetic appearance of the Chinese character on the printed page is of utmost importance. For Morrison, the reason for stressing aesthetics is tied to the way that the character works on the mind of the reader: "To convey ideas to the mind, by the eye, the Chinese Language answers all the purposes of a written medium, as well as the Alphabetic system of the West, and perhaps in some respects, better ... The Character ... is considered beautiful and impressive. The Chinese fine writing ... darts upon the mind like a vivid flash; a force and a beauty, of which Alphabetic Language is incapable."[35] Given that the character itself is acknowledged to be a thing of great potential beauty, Morrison stresses the importance of producing type that would flatter it. After briefly tracing the evolution of the various forms of writing characters, he notes that, about 300 CE, the so-called Kaishu (plain written hand) form of the character developed. Eventually, says Morrison, it was joined by the Song character, which derived its name from the Song dynasty.[36]

In the "Preface" to the second part of his dictionary, printed in 1819 with more recently created fonts, Morrison repeats the view that the aesthetics of the font can enhance or detract from the appeal of a printed Chinese book. Indeed, blame for the ugliness of the font used in this part, Morrison says, can be laid at the foot of misguided policies emanating from the Manchu

Figure 1.3 Morrison's "Entries for 'Shang' and 'Hëĕ,'" 1815.
Source: Robert Morrison, *Dictionary of the Chinese Language* (Macao: East India Company Press, 1815), 1: 1, 16, 305.

court in Beijing, which prohibited Chinese assistance in the production of Western-printed texts:

The Chinese Letters in this part of the Dictionary, are confessedly deficient in elegance of form. The large ones in the first Part of the Dictionary, are in

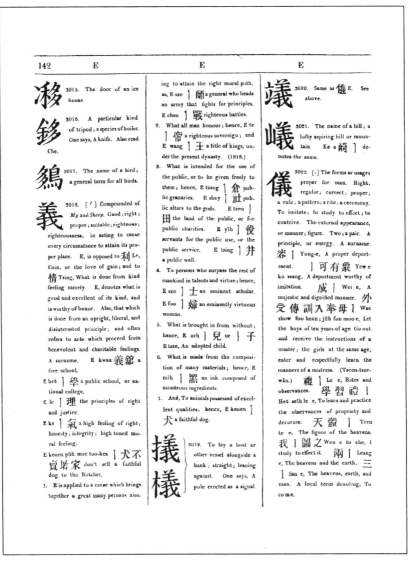

Figure 1.4 Morrison's "Entries for 'E,'" 1819.

Source: Robert Morrison, *Dictionary of the Chinese Language* (Macao: East India Company Press, 1819), 2: 1, 142.

general, beautifully written; but those in this volume, though correct, are some-
times rather clumsy. The difference was occasioned by an Act of the Chinese
Government; – it said, "You may learn our language if you can, but we will
afford you no facilities; our subjects shall not cut letters for you." In conse-
quence of this decision, it became necessary for an English Printer [Thoms]
to write the Characters, and to employ Portuguese subjects to cut them. And
for some time, neither the Writer, Printer, nor Type Cutters, had any native
assistance.[37]

Over the next forty years at Macao, Thoms's numerous assistants cut
more than 200,000 characters,[38] with over 20,000 compound words, in two
font sizes. In addition to the multivolume Morrison dictionary, Thoms and
his Chinese workers printed two small dictionaries and twenty bilingual
books. Sadly, during the chaos that ensued in Canton at the start of the
British-provoked Arrow War in 1856, the hand-cut Morrison (or, more ac-
curately, Thoms) font was lost.[39] Eventually, one missionary publication,
after concluding that the "Morrison fonts" of 200,000 type, with "each
character ... carved on the face of the block [or 'slug']," were "among the
most costly fonts of type ever made,"[40] hinted at the reason – cost – why
casting of Chinese type began to occupy the concerns of missionary print-
ers who could not draw on the resources of the EIC to have type cut for
them. Although Morrison's characters cut in the Song face were said to be
"stiff," the face came to be widely used in printing missionary books (see
Figures 1.3 and 1.4, which show the main entries in the Kaishu form and
the examples in the Song form, albeit with qualitative differences between
those cut by Chinese [Figure 1.3] and those done by Portuguese [Figure
1.4] assistants; both are clearly great improvements on Marshman's font).[41]
 Thoms was also the first to create Chinese-type moulds of the sort that
Gutenberg had pioneered for European printing. First used around 1815 by
Marshman, Thoms's own moulds did not catch on with a wider public and
did not spread into China.[42] Like the original cut Serampore and Malacca
fonts, Thoms's new East India font, in the 1833 words of a missionary
writer, is "not only inelegant, but possess[es] an air *so foreign*, that it is by no
means advisable to print the Scriptures and tracts with them, while we can
obtain woodenblocks [sic]; for these latter far surpass anything we have yet
seen printed with metal, either at Macao, Malacca, or Serampore."[43]
 In 1827, Samuel Dyer, the nonprinter who had arrived at the London
Mission on Penang Island the year before, began research into producing a
font of Chinese type more cheaply than Thoms's Morrison and EIC fonts.
Dyer immediately undertook tests with stereotyping (Chinese, *qianban*), a
major alternative to printing with individual type. Stereotyping was then

about a century old.[44] To produce individual type after creating plaster moulds and lead-alloy plates, Dyer cut out small squares from the plates, a method that produced coarse type that would last only five or six years before it had to be remade.[45]

Eventually, in 1838, Dyer made Chinese type the Gutenberg way, by casting. Supervising Chinese workmen cutting steel Chinese type punches (in relief) for use with softer matrices, Dyer developed punch fonts that sold for £400, not cheap but still a tenth of what he had once estimated they would cost.[46] At the time of his death in 1843, 1,845 punches, out of the needed 4,700 to 6,600, had been completed.[47] Combined with a small casting-furnace, the punches allowed isolated missionary stations to begin casting their own Chinese-character type. For missionary printers, Dyer's success in this latter technique settled the issue of producing Chinese fonts until the late 1850s. Dyer's Penang font, remade by Richard Cole in Hong Kong in 1851, remained the standard for Chinese printing until it was replaced by William Gamble's in 1859, created by a totally new process.[48]

Meanwhile, conditions for missionary printing and publishing within Chinese territory improved following the Opium War. In the early 1840s, Scottish missionary and sinologist-to-be James Legge (1815-97) relocated the London Mission Press (by then called Mohai shuguan in Chinese) from Malacca to Hong Kong, newly acquired by Britain in the wake of the Treaty of Nanjing.[49] In 1846, Dyer's punches arrived in Hong Kong.[50] Thereafter, the London Mission Press, under Legge's supervision, but thanks also to Richard Cole,[51] an Indianapolis type maker, established itself as the centre of Protestant publishing efforts in East Asia.

In 1847, Cole was engaged to superintend a new type-foundry and printing business at the London Mission on Hong Kong island. Cole completed two sets of small type matrices, numbering 4,700 each, in 1851. Known as the Hong Kong font, it involved recutting many of Dyer's Penang punches. Each set included enough characters to be useful for printing not only religious materials but also some ordinary Chinese-language works.[52] According to the missionary who excitedly announced the creation of the font, "For symmetry of form and beauty of style, these two fonts exceed any type yet made by either Chinese or foreigner."[53] Cole left for California in 1852 and was replaced as superintendent by Huang Sheng (Huang Pingfu, also Wong Shing [active 1848-74]).[54] In 1873, Beijing's Tongwenguan, the interpreters' school (directed by another Indiana-bred missionary, W.A.P. Martin [1827-1916]) affiliated with the Zongli Yamen, China's new foreign affairs bureau, began to use Cole's Hong Kong font.

In addition to their Hong Kong operation, the London Missionary group opened a second publishing house on Shandong Road in Shanghai in 1843

or 1844.[55] Run at first by Walter Henry Medhurst, in 1847 operation of the Shanghai mission press passed to Alexander Wylie (1815-87).[56] Wylie remained in charge until 1860. The Shanghai branch closed around 1864, by which time all of its printing had been passed over to the American Presbyterian Mission Press.[57] The Hong Kong press was sold in 1873 to Superintendent Huang Sheng and Wang Tao (1828-97), the Shanghai branch's Chinese editor, for Mexican $10,000.[58]

Previously, in 1830, with the London Mission Press still based in Malacca, the American Board of Commissioners for Foreign Missions, a Congregationalist missionary organization formed at Andover Seminary in 1810, had boldly ignited renewed enthusiasm for founding a Western-style printing establishment inside China itself. American Board missionary Elijah Coleman Bridgman (1801-61) had written home from China in 1830, arguing that a printing press would enhance the goals of a mission in Canton.[59] Within a year, a printing press, most likely a Washington (see Table 1.2A), had been sent to Canton from the United States, and with it the American Congregationalists had established the first, if illegal, modern, nonprofit, Western-style printing/publishing house inside China. In 1833, this early Washington press had been joined by an Albion.[60]

Used initially by Bridgman to issue the *Chinese Repository*, a missionary journal, in 1833 the American Board presses had been taken over by Dr. S. Wells Williams (1814-84), a trained printer. Williams ran the presses until 1856 when, along with Thoms's type, they were destroyed by fire. Initially, all printing was done in English, partly because of uncertainty about whether Westerners would be able to evade restrictions on printing in Chinese within China. Just as important, however, were technical considerations. According to a report issued in 1879, "At that time [early 1830s] Chinese metallic types had not been provided except by the laborious and expensive process of *cutting*. There was no *foundry* provided with the requisite matrices from which a font of type could be secured" (emphasis added).[61]

In 1833, having been invited by a group of New Yorkers to send a Chinese text for experimental stereotyping, Canton's American Board missionaries decided to forward a Chinese translation of "Sermon on the Mount." Chinese woodblocks cut with the text were sent to Boston, where they were stereotyped and then used to issue the sermon in tract form.[62] The first Chinese work to be printed in the United States, the tracts were then sent back to Canton for distribution. Stereotypes ensured greater consistency, reliability, and quantity, and avoided the problem of wear on the wooden blocks. Aside from the fact that the woodblocks might not have withstood the pressure of iron Western printing presses, however, one should not lose

sight of the fact that both woodblocks and stereotypes were relief media that duplicated entire pages.[63]

Although the New York sponsors of the project concluded that stereotyping was the ideal alternative to the as-yet unresolved challenge of creating serviceable Chinese type, in the end the American missionaries in Canton decided that stereotyping was not the solution to their needs. Great efforts were made to develop a full range of metallic type, including purchasing them from Penang, but the American Board Mission Press turned increasingly to readily available Chinese technology. Indeed, the Canton operation continued printing Chinese-language religious tracts using woodblocks until 1854, two years before it closed.[64]

In 1844, the dominance of Hong Kong's London Mission Press was challenged by the American Presbyterian Mission Press (Meihua shuguan, hereafter APMP).[65] Founded at Macao by Richard Cole, the American Presbyterians' presses were operated by three Chinese workmen. All of the type came from Paris, based on a new composite font created by M. Marcellin LeGrand, one of the most expert type founders in France.[66] Between 1834 and 1836, under the patronage of the Paris-based Société Asiatique, Marcellin LeGrand had developed a new system of Chinese matrices by reducing the total number needed to print the 214 Kangxi radicals and another 1,100 common characters.[67] These 1,314 characters could then be combined to make compound characters. Marcellin LeGrand's matrix font, which eventually reached 3,000, was cut by Chinese students in Paris and produced a smaller imprint than Dyer's. When combined, however, Marcellin LeGrand's font could make a total of 22,741 characters.[68]

Under the conditions of the Treaty of Wangxia (America's first unequal treaty with China, it was signed 3 July 1844), Americans shared in the privileges of the Treaty of Nanjing (1842) won by the British. Losing little time in asserting those rights, in 1844 or 1845, Cole moved the APMP and its Paris font to Ningbo. There five Chinese workmen were engaged to print mostly religious tracts, now reluctantly tolerated by the Qing government.[69] In this way, the APMP became the third foreign, the second American, and the first "legal" movable-type Christian publishing house to open in China.

From the moment the APMP arrived in Ningbo, efforts were made to expand its Chinese font.[70] On-site clay stereotyping *(niban)* was introduced to the Chinese mainland to augment the APMP type supply.[71] Also, a new press, electrotyping equipment, and a type-casting furnace arrived in 1846, foreshadowing the end of cut type. The same year, a Qing civil official in Ningbo requested that the APMP print for him an abridged Chinese history, so impressed was he by the quality of the Chinese printing being done

at the missionary press. The APMP refused to print the official's book because doing so would have compromised its noncommercial self-image.[72]

Despite these early advances, prior to 1858, the Ningbo press apparently did not make rapid strides. One matter of great concern to its directors was the publishing house's inability to attract a trained Western printer. Before 1858, all metal Chinese fonts in use in East Asia, except Dyer's 1843 Penang font and Cole's 1851 Hong Kong font,[73] had been produced by cutting. Indeed, lack of foundries for casting type fonts as well as a shortage of professional printers in the missionary ranks continued to hamper the development of Western-style printing in China until the late 1850s. Until the end of their days in China, Western printers also remained dependent on imported materials and presses. Eventually, they passed this dependency on to early Chinese printers.

Meanwhile, in the early 1850s, as Catholics also returned to mainland China in the wake of the Opium War, French Jesuits opened a woodblock printing shop at their new orphanage in Caijiawan, near Shanghai.[74] After losing a priest to the Taiping army, which attacked Caijiawan in August 1860, the Jesuits moved first to Dongjiadu near the wall of the native city. In 1864, they established a second orphanage for 342 children at Tushanwan, Xujiahui (Sikkawei/Zikawei), in what is now a southwestern district of metropolitan Shanghai. To support their missionary efforts and to teach their charges a useful livelihood, the Catholics opened a print shop there, too. By 1869, the Tushanwan orphanage had added a woodblock printing shop,[75] and in 1874 the Jesuits introduced metal type to their printing facilities there.[76] Exactly what method they used to create the type is not clear, but it seems likely that they may have purchased machines and type from Shanghai's other printing shops as well as a set of Marcellin LeGrand's font from Paris.[77] Among their publications were linguistic, scientific, and educational works, along with Shanghai's third newspaper.[78]

The influence of Tushanwan's Catholic orphanage notwithstanding, British and American Protestants continued to be the main source of Western letterpress technology and technique in nineteenth-century China. By 1870, the plaster *(shigao)* stereotype plate had been introduced to Shanghai thanks to the efforts of American Presbyterian J.M.W. Farnham (1829-1917). Farnham was the director of Shanghai's Qingxin Hall (Qingxintang) school, located outside the Great Southern Gate (Da Nanmen) of Shanghai's preconcession Chinese city (Nanshi).[79] Farnham seems to have modified the plaster technique, first cutting intaglio characters or illustrations directly into a flat piece of plaster. This negative intaglio mould was then used to make a positive relief plate that could be used on a standard printing press. At about the same time, a "Mr. Liu," working at the Jiangnan Arsenal's

Translation Bureau, located within walking distance of the Qingxin school, created printworthy illustrations for the Arsenal's scientific translations using the same technique.[80]

In Shanghai, despite the easy availability of papier-mâché *(zhixing)*, paper moulds (flong), another relief technique, were not used until the mid-Guangxu era (i.e., 1885-95). A Japanese firm, with the Chinese name Xiuwen yinshuju, then adopted the practice.[81] In 1921, the Commercial Press bought a faster, high-pressure version of the papier-mâché mould technology. It soon spread from the book publisher to the newspapers.[82]

In 1846, says He Shengnai,[83] a newer form of printing plate known as electrotype *(diandu tongban)* was developed in Europe as an alternative to stereotyping. Electrotypes were created by making a wax mould of the type-form; after the mould was separated from the form, copper or nickel was precipitated onto the inside of the mould. The new copper or nickel matrix was separated from the wax and given a type-metal backing.[84] Electrotypes produced a finer imprint, for a longer period of time, than did stereotypes, which is why they appealed to book printers. They could also produce the halftone pictures and images that stereotypes could not.[85]

Although the APMP had made trials with electrotypes as early as 1846, when it was still an experimental technology, success came only in 1860, first at Ningbo and, later that year, in Shanghai.[86] In October 1858, William Gamble (1830-86), an Irish Presbyterian immigrant who had trained in publishing houses in Philadelphia and New York,[87] arrived in Ningbo. He brought the APMP the equipment and know-how finally to create Chinese typefaces by means of electrotyping. Gamble modified the new electrotyping process to make type matrices and to speed up Chinese-language printing. In so doing, he superseded Dyer's, Cole's, and Marcellin LeGrand's casting methods, all of which depended, as we have seen, on processes dating back to Gutenberg.

Gamble's electrotyping required both a calligrapher to draw the desired character on boxwood (a.k.a. yellow poplar, hence *huangyang ban*)[88] and a type cutter to execute the design. The character was then imprinted on a plastic matrix that was in turn electrotyped.[89] When completed, "the characters were more finished and possessed more of the caligraphic [sic] excellence prized by the Chinese than could be obtained by steel punches,"[90] relates one European account from 1895. Nonetheless, as we will see below, within a few years of this statement, Chinese printers would start searching for even more calligraphic alternatives to Gamble's font.

News of Gamble's successful new Chinese matrices spread quickly, leading unnamed Ningbo-area Chinese printers to approach the Presbyterian press with the intention of purchasing sets for their own use. Their purchase

implies that the Chinese intended to use the matrices with Western printing presses, although it is also conceivable that they set them up in a chase and printed the traditional Chinese way – that is, with Chinese ink and a *changshua* or a *cazi*. In 1875, however, discussing a type-making process similar to that practised by Gamble, and with a knowledge of printing that now reflected just how far the technology had come since Lowrie's 1843 comment about it involving only metal and steam, the Shanghai-Hong Kong publisher Wang Tao pointed out that "the making of type and plates ... with chemistry [is] really the most modern of new methods."[91]

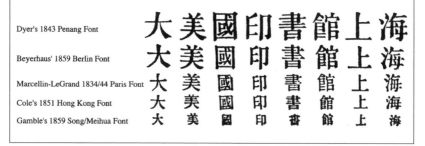

Figure 1.5 Western-created mid-nineteenth-century Chinese fonts.
Source: S. Wells Williams, "Movable Type for Printing Chinese," *Chinese Recorder* 6 (1875): 30.

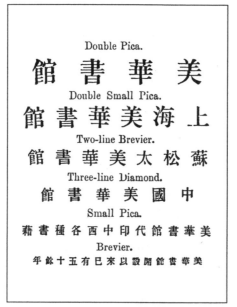

Figure 1.6 Gamble's APMP type fonts.
Source: Gilbert McIntosh, *The Mission Press in China* (Shanghai: APMP, 1895), 27.

Gamble's method considerably reduced the time previously spent to produce type. Type size also became more easily varied, allowing Gamble to make seven different styles of typeface. His type is known both as "Song type," after the book-printing style thought to have been developed in the Song dynasty, and as "Meihua type," after the APMP's Chinese name. Eventually, Gamble electrotyped Double Pica, Small Double Pica, Small Pica, Brevier, Two-Line Brevier, Three-Line Diamond, and Small Ruby fonts,[92] which the press then began to sell independently of Gamble's matrices (see Figures 1.5, 1.6, and 1.7).

Gamble's second innovation at Ningbo took a year-and-a-half of experimentation and was completed in 1860. Deciding that compositors, using the type cases developed thirty years before in Malacca, took an excessive amount of time to set up a page of type, Gamble redesigned the type racks

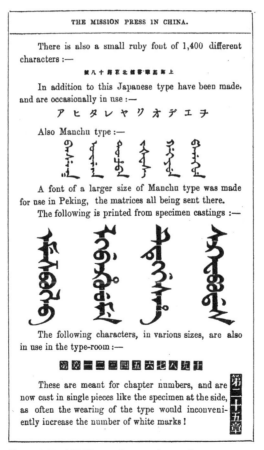

Figure 1.7 APMP supplemental type fonts.
Source: Gilbert McIntosh, *The Mission Press in China* (Shanghai: APMP, 1895), 28.

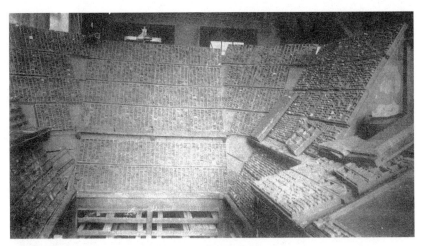

Figure 1.8 Gamble's type case arrangement, Shanghai, 1895.
Source: Gilbert McIntosh, *The Mission Press in China* (Shanghai: APMP, 1895), opposite 20.

used in printing Chinese (see Figure 1.8). Multiple type fonts totalling about 160,000 characters were rearranged according to the radicals used in the *Kangxi Dictionary*[93] and placed into eighty-eight reduced-size type cases. Twenty-four cases of frequently used characters were arranged on a rack in front of the typesetter, with another sixty-four cases placed on racks to his sides, the whole arrangement making up the shape of the letter U. As a result, a compositor's work could be accomplished in a third of the original time.[94] By 1879, Gamble's type display was the only kind in use in Chinese or foreign printing firms[95] and remained so until well into the twentieth century, when it was replaced by two new arrangements, including the unitary long rack (*tongchang jia;* see Figure 1.9), both introduced at the Commercial Press.[96]

In December 1860, after the Taiping rebels drove Chinese woodblock publishers and others out of Suzhou and surrounding areas and into Shanghai, Gamble closed down the Ningbo publishing house. By then, Shanghai had already displaced Ningbo as the leading Western entrepôt. In Ningbo, moreover, it had become increasingly difficult to obtain supplies from abroad.[97] Likewise, the shipping of completed publications out of the city, which does not provide ready access to inland China, had also become difficult.[98] Over a three-week period, the APMP, its five presses, its electro-typing equipment, its fonts, and all of its Chinese workmen relocated to North Sichuan Road, Shanghai. At this point, the publishing firm was printing eleven million pages per year.[99] The demand for English-language printing rose rapidly after the Presbyterians arrived in Shanghai, and three Chinese boys from a mission school, most likely Farnham's Qingxin Hall, were soon apprenticed to provide the firm with a new generation of trained printers.

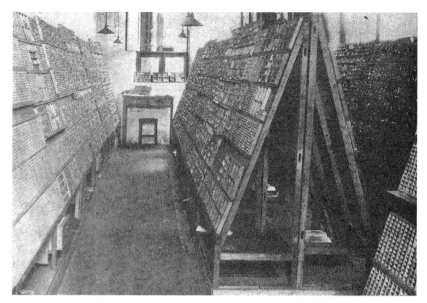

Figure 1.9 Unitary long type rack, Shanghai, c. 1905.
Source: Yiwen yinshua yuekan/The Graphic Printer (Shanghai) 1, 7 (1937): 25.

Between 1862 and 1875, the APMP moved to larger Shanghai quarters and increased its output considerably. By the end of 1876, matrices had been created to cast fonts in "five sizes of Chinese type, five varieties of Japanese, one Manchu, and two English, while a [font] of music type was imported."[100] Fonts were supplied steadily to the Shanghai *daotai* (circuit intendant), the American Board Press (now reopened in Beijing), the I.M. Customs' Statistical Department, as well as several Chinese printing firms,[101] all of which must have found, like the Ningbo official back in 1846, that Western processes yielded finer, easier-to-read results than xylography, even if the fonts were not yet all they would become under Chinese leadership in the early twentieth century.[102]

In 1869, electrotyper William Gamble resigned from the APMP and was replaced by several directors in succession.[103] During his tenure from 1871 to 1876, J.L. Mateer supervised the firm's further expansion into permanent quarters. When he resigned to return to the United States, Mateer left the APMP with a large, new, three-storey edifice (see Figure 1.10) at 18 Beijing Road, Shanghai. On the premises were a foundry, a bindery, and a library. In the rear could be found lodgings for the printers as well as the firm's chapel.[104]

When Mateer left, the Reverend W.S. Holt was named director of the APMP. That year the missionary publishing firm had eight hand presses in use, operated by sixty to eighty Chinese workmen.[105] Three years later the

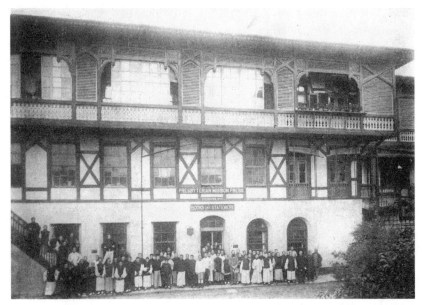

Figure 1.10 American Presbyterian Mission Press, 18 Beijing Road, Shanghai, 1895.
Source: Gilbert McIntosh, *The Mission Press in China* (Shanghai: APMP, 1895), frontispiece.

firm's inventory revealed one hundred fonts of metal type, including ten of Chinese, nine of Japanese, and one of Manchu.[106] The firm had also built a large business selling type (see Figure 1.11); the APMP disseminated Gamble's typefaces widely, selling them to Shanghai newspaper offices, including *Shenbao* (Shanghai journal, founded 1872), to the Zongli Yamen, and finally to Japan, England, and France.[107] China was now exporting type to the world.

Just as the lack of a type-foundry had slowed the growth of the American Board Press in Canton in the 1840s, and just as the lack of a professional printer had slowed expansion of Ningbo's APMP until the arrival of William Gamble in 1858, Holt's operation of the APMP at Shanghai was hampered by a shortage of skilled foundry workers. Despite its expansion and the publisher's apparent successes, in 1879 Holt noted that the APMP "is now working up to its full capacity in all departments except the foundry."[108] The shortage of needed foundry workers impeded the further expansion of the publishing work of the firm, suggesting that, by the late nineteenth century, the cultural work of publishing and the industrial manufacturing processes involved in printing were inseparable. Holt was neither the first nor the last China printer to reach this conclusion.[109]

Holt also stated that the APMP assisted printing offices in Beijing, Suzhou, Ningbo, Canton, and Shanghai to secure presses and printing material from

abroad. Just as this dependence on imported machinery had limited the operations of Malacca's, Hong Kong's, and Shanghai's London Mission Press, of Canton's American Board Press, and of the APMP in Ningbo and Shanghai, so too foreign dependency would prove debilitating to the Chinese letterpress industry until the early twentieth century. At that point, however, Chinese foundry workers would have mastered the difficult electrotyping techniques pioneered by William Gamble to develop type matrices. More important, they would have also learned to duplicate many Western printing presses.

The APMP would have a major indirect impact on China's modern printing industry in the mid-1890s. Then the Presbyterian publisher would hire

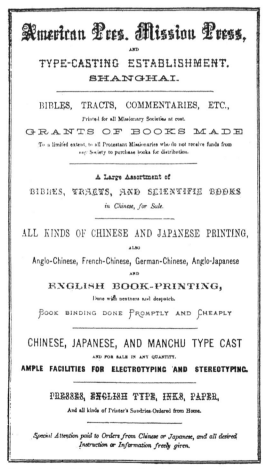

Figure 1.11 Advertisement for the American Presbyterian Mission Press and Type-Casting Establishment, Shanghai, 1875.
Source: Chinese Recorder 6 (1875): back cover.

Xia Ruifang (1872-1914) and the two Bao brothers, all of whom were gradu-
ates of Farnham's Qingxin Hall Presbyterian missionary school. At Qingxin
Hall, the three men had learned the major elements of the Western-style
printer's trade. At the APMP, they joined the largest (now with 126 employ-
ees, 116 of them directly involved in printing and binding) self-supporting,
all-purpose missionary printing-publishing operation in China. After per-
fecting their skills and watching how the APMP conducted what was by
then an all-purpose commercial publishing operation, the three would leave
the APMP to found the Commercial Press in 1897. Eventually, they also
took one of the APMP's Chinese managers with them.[110]

By the end of the nineteenth century, nineteen other lead-type printing
enterprises would join the missionary publishers and the Commercial Press
in Shanghai.[111] Among them were both Western- and Chinese-owned firms,
most of them commercial in orientation. Along with Shanghai's British-
owned, English-language *North China Herald* and Chinese-language *Shenbao*
newspapers, well-known lead-type firms were *Shenbao*'s subsidiary Shenchang
shushi and Tushujicheng shuju, the Arsenal's print shop, the Guangbaisong
zhai (founded by Xu Run [1838-1911], the famous Cantonese compradore,
around 1898; it will be discussed further in Chapter 2), and Xu Shigeng's
Luyin shanfang. Wang Licai, a former itinerant bookseller in Nanjing and
Kaifeng, both locales where he had failed the civil service examinations, and
Xia Songlai (Qingyi) founded the late Qing firm Kaiming shudian as a lead-
type printing house in Shanghai.[112] Feng Jingru, a follower of Sun Yat-sen
(1866-1925), and He Chengyi, a disciple of Liang Qichao (1873-1929),
founded Guangzhi shuju. Guangzhi, with a branch in Beijing's Liulichang,
was in operation for over three decades.

Other lead-type firms from late Qing and early Republican Shanghai were
the Zuoxinshe, started by Sun Yat-sen's anti-Qing Xingzhonghui (Revive
China Society); Zhongguo tushu gongsi (Chinese Library Company); Guoxue
fulunshe; and Shenzhou guoguangshe.[113] All these other operations notwith-
standing, by the Republican era, the lead-type trade would come to be domi-
nated by "the three legs of the tripod" *(sanjia dingli)* – that is, the three
leading comprehensive publishers: the Commercial Press (founded in 1897),
Zhonghua Books (Zhonghua shuju, also Chung Hwa, 1912), and World
Books (Shijie shuju, 1921).[114]

Mechanical Type-Casting
Type-casting was the necessary first step in letterpress printing. Manual
type-casting was also the phase on which Gutenberg left his particularly
large mark. In the division of printing labour, however, composition, or
typesetting, was closely related to type-casting. Typesetting by hand was a

glacially slow process. Moreover, it could frequently be held up by manual type-casting. With the advent of steam-powered printing at the London *Times* in 1814, the combination of manual type-casting and manual type-setting began to create a critical bottleneck in the printing and publishing business.[115] Nonetheless, it would be seven decades before casting and composition were combined into one mechanical process, bringing both into line with rapid power-driven printing presses.[116] The solution to this two-part problem fell to Ottmar Mergenthaler (1854-99), another of the many Germans who figure in the long history of printing.

Until the 1830s, alphabetical type was cast chiefly by hand. In 1838, a New Yorker patented the first functioning type-casting machine *(zhuzi ji)*.[117] The type-caster that William Gamble brought to China in 1858 was almost certainly a version of it. At that time, hand-casting of Chinese type was still achingly slow; a good worker could probably produce no more than ten Chinese characters an hour, resulting, in the course of a ten-hour workday, in about the same number of characters that a woodblock cutter could produce in a day.[118] However, Gamble soon adapted his type-caster for making Chinese type. Over the years, Chinese printers, using hand- or foot-powered casting machines, would boost their rate to 700 or 800 characters an hour, modifying the original technology based on Chinese matrices and adding a degree of speed to the process that could not be matched by woodblock cutters. By 1895, sixteen years after Holt began selling Gamble's type, the APMP added missionary presses in Beijing, Fuzhou, Ningbo, and Korea, as well as the German Imperial Printing Press in Berlin, to its growing list of clients,[119] presumably using Gamble's type-caster to supply them.

In 1913, the Commercial Press started to use Thompson automatic casters *(tangmusheng zidong chouzi ji)*, which could spit out more than 15,000 Chinese characters a day. The publisher's machine shop also began to replicate the Thompsons. After witnessing the publisher's success with the automatic casters, more and more of China's lead-type printers began to buy supplies from the Commercial Press. Various new "Commercial Press" fonts gradually eliminated the leading nineteenth-century missionary fonts (Cole's Hong Kong and Gamble's Song/Meihua). Although Gamble's font in particular was useful and historically momentous, many educated Chinese, having long familiarity with and appreciation of calligraphy, thought it unappealing. Between 1908 and 1921, Chinese typographers, led by the Commercial Press, searched widely for alternatives to the Hong Kong and Song/Meihua fonts. By the mid-1920s, four main styles (see Figure 1.12), all regarded by Chinese as aesthetically superior to the Western-created fonts, had come to dominate Chinese-language printing. Of the four, Zhengkai and an early version of Cu ti were developed by Commercial Press typographers

		（頭號）	（二號）	（三號）	（四號）	（五號）	（六號）
Zhengkai Font (1909)	正楷字	藝文	藝文	藝文	藝文	藝文	藝文
Cu Font (n.d.)	粗體字	藝文	藝文	藝文	藝文	藝文	
Fangsong Font (1917)	仿宋字	藝文	藝文	藝文	藝文	藝文	
Song Font (mid-1920s)	宋體字	藝文	藝文	藝文	藝文	藝文	藝文

Figure 1.12 Major Republican Chinese fonts.
Source: Based on Wu Tiesheng and Zhu Shengyu, "Guanggao he xiandai yinshua shu," *Yiwen yinshua yuekan/The Graphic Printer* 2, 6 (1939): 21-31.

or by traditional calligraphers in their employ. Fangsong was developed by Zhonghua Books.[120] It is not clear who created the popular Song font.

By the 1930s, at least three Shanghai machine firms were manufacturing and selling their own type-casting machines. Chong Shing (Mandarin, Changxing), Jianye Machine-Making Company, and Ruitai Machine Shop all advertised their type-casting machines in *Yiwen yinshua yuekan/The Graphic Printer* (see Figures 1.13, 1.14, and 1.15 (top), China's only nationally distributed, Chinese-language, printing trade journal. Strikingly, Chong Shing stressed the links between its machinery, lead-type printing, and cultural progress: "Printing is a tool for advancing culture ... lead type is the most important part of printing, and an outstanding automatic type-caster is the best product to advance the business ... it can do the work of eight or nine men, producing 150 type an hour ... we guarantee you will be satisfied."[121]

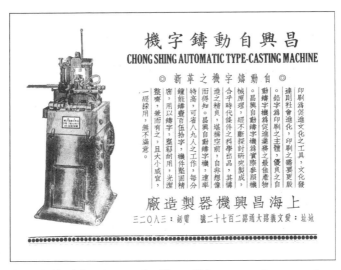

Figure 1.13 Advertisement for Chong Shing automatic type-casting machine, Shanghai, 1940.
Source: Yiwen yinshua yuekan/The Graphic Printer (Shanghai) 2, 8 (1940): 52.

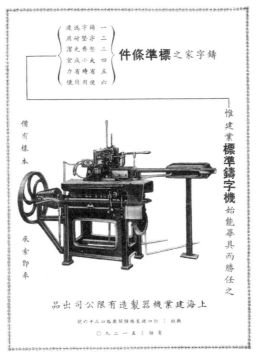

Figure 1.14 Advertisement for Jianye Machine-Making Company type-caster, Shanghai, 1937.
Source: Yiwen yinshua yuekan/The Graphic Printer (Shanghai) 1, 7 (1937): 7.

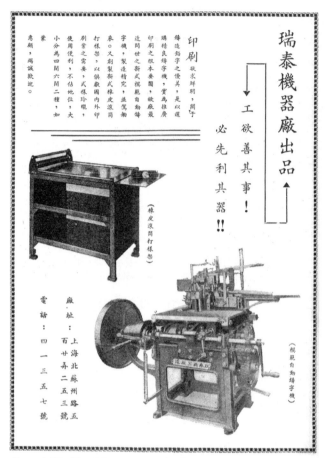

Figure 1.15 Top: Advertisement for Ruitai Machine Shop type-caster, Shanghai, 1937; *bottom:* Advertisement for Ruitai Machine Shop offset cylinder proofer, Shanghai, 1937.
Source: Yiwen yinshua yuekan/The Graphic Printer (Shanghai) 1, 3 (1937): 6.

Clearly, insofar as printing did advance culture, the efforts of the machinists in the Commercial Press who had converted the Thompsons to produce Chinese type were advancing it more rapidly than those at Chong Shing.

At about the same time, Zhu Tian, a former head of Zhonghua Books' Song facsimile book department and then manager of Zhongguo fanggu yinshuju (Chinese Book Facsimile Publishers; see Figure 1.16), advertised that he had developed new-style Song type matrices for use with type-casting machines. Boasting twenty-five years of far-ranging experience with the pros and cons of the lead-type printing industry, Zhu said that his highly aesthetic matrices were now ready for sale.[122] This is an indication that, even as

Figure 1.16 Advertisement for new Song-style matrices,
Shanghai, 1937.
Source: Yiwen yinshua yuekan/The Graphic Printer (Shanghai) 1, 3 (1937): 4.

utilitarian Western technology was adapted to Chinese printing needs, it was
turned in a direction that appealed to the discerning eye of the Chinese reader.

Hand-casting gradually declined in the West after the 1840s, and in 1886
Gutenberg's greatest invention was superseded by Linotype. In that year,
Ottmar Mergenthaler created the first real advance since the fifteenth cen-
tury in setting individual lines of type. A mechanical wizard, Mergenthaler
combined type-casting and typesetting into a one-person, one-step process.
His new Linotype machine *(Lainuo zhupai ji,* also *Laina paizi ji)* made it
possible for a keyboard operator to punch out an entire "line o' type" and set
it up for immediate printing or rapid conversion into stereotypes. First used

at the *New York Tribune* and rapidly circulated to other newspaper companies, the Linotype had limited appeal for book printers because of their need for frequent proofreading and correcting. By 1899, though, the era of hand-cast type for book printing initiated by Gutenberg essentially came to a close with Ohio-born Tolbert Lanston's (1844-1913) invention of the Monotype *(Monuo zhupai ji, danzi zhupai ji,* also *Mana paishaoji).*[123] This new machine adapted the typist's keyboard for mass production of individual pieces of type and brought the type-casting and typesetting innovations of the entire nineteenth century to bear on book printing, allowing for both increased speed and the flexibility to correct texts. Furthermore, the range of classic type fonts made available by the Monotype Corporation appealed broadly to book printers.[124]

Chinese printers employed in printing non-Chinese-language periodicals and books utilized both Linotype and Monotype machines for many years.[125]

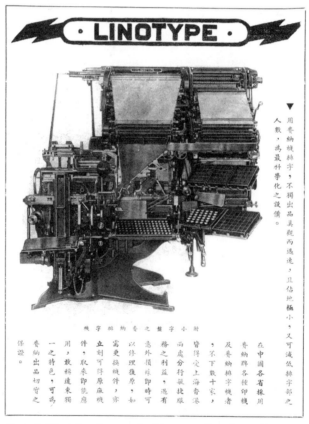

Figure 1.17 Advertisement for Linotype, Shanghai, 1937.
Source: Yiwen yinshua yuekan/The Graphic Printer (Shanghai) 1, 7 (1937): 4.

By the late 1930s, a Shanghai advertisement would claim that there were Linotype-brand printing and typesetting machines in every Chinese province, with service and parts available from branches in Shanghai and Hong Kong (see Figure 1.17). English-language Monotype machines were discussed at some length in the same publication.[126] At this time, Japanese-made versions of Monotype were also available in China.

In 1926, a Chinese named Wang Longyou began experimenting with a Chinese-language version of the Monotype.[127] Wang's type-casting and type-setting machine, known as the Sinotype *(Huawen paishaoji)*, was said to have been modelled on the Monotype.[128] An important indicator of the Chinese awareness of the publishing bottleneck that resulted when type-casting, typesetting, and printing were not uniformly mechanized, Wang's experiments with the Sinotype did not lead to its mass production during the Republican era. Hence, in Shanghai, and in China generally, letterpress printing, which now used machine-made plates (stereotypes, electrotypes), along with automatic machine-cast type, had advanced significantly beyond Cai Gao's and Morrison's/Thoms's efforts of the early nineteenth century. Although mechanized type-casting of Chinese type was achieved in the late nineteenth and early twentieth centuries, no means of combining Chinese type-casting mechanically with typesetting was put into operation until the late 1950s.[129] Continuing commitment, stretching through the Second Sino-Japanese War (1937-45) and the Civil War (1946-49), to resolving the challenges that remained reveal the continuing impact of the Gutenberg revolution on China.

Relief Illustrations

For printing illustrations, three main categories – halftone, photoengraving, and boxwood prints – were available to Chinese printers in the early 1900s; one of the three processes, the last, may have been perfected in China. Illustrations in relief media became possible on letterpress machines only when the halftone *(bansi tiao)* was developed in Vienna in 1877.[130] Halftones arrived in New York in 1880,[131] where *Harper's Magazine* famously adopted them.[132] Colour printing developed as a three-colour (and black) process *(sanyuanse zhiban*, originally *sanse ban)* about 1900 in the West. The three-colour relief process arrived in Shanghai fairly rapidly sometime in the Xuan-tong reign (1908-12) via the Commercial Press.[133] Three-colour process printing, however, became important in China only after the Commercial Press sent You Hengta to the United States to study printing around 1920.[134]

A second relief illustration technique, photoengraving *(zhaoxiang tongziban)*, was developed by the Frenchman M. Gillot in 1855 and improved by the German Georg Meisenbach (1841-1912). Photoengraving was one of the

important Western printing techniques imported by Shanghai's Tushanwan Jesuits.[135] Although "Mr. Liu" of the Arsenal Printing Office had had some success photoengraving books for the Arsenal and for the Guanggangyan shuguan, also probably in the 1870s, few outsiders knew about it. Then, in 1900, a man called "Disciple Xia" (Xia *Xianggong*) from Tushanwan began to experiment with photoengraving. The next year, a team made up of Father Fan and Disciples Cai and An started to get significant results. Soon Fan, Cai, and An were able to teach two others, Gu Zhangquan and Xu Kangde, their technique, which took six to seven days to produce one photoengraved plate.[136]

In 1902, Yu Fu (Zhonghuan), Lian Quan, and Ding Fubao (1874-1952) opened Wenming shuju (Wenming Books), the largest and most important Chinese-owned general publishing firm of the early 1900s, in Shanghai. Zhao Hongxue, who had watched plates being made for Western books, was hired to photoengrave plates for Wenming's Chinese textbooks. The next year, Shanghai's Commercial Press became a Sino-Japanese joint venture when the Japanese publisher, Kinkōdō (Chinese, Jin'gangtang) invested 150,000 yuan.[137] Perhaps taking advantage of the company's new tie to Japan's modern publishing industry, the Commercial Press hired two Japanese technicians to set up their photoengraving section the same year.

In 1906, Gu Zhangquan left Tushanwan and joined the Zhongguo tushu gongsi (Chinese Library Company) in Nanshi, Shanghai, to run its photoengraving department. Then Xu Kangde entered the photoengraving section of the Commercial Press, where he worked on textbooks.[138] Xu was soon joined by an American photoengraver. Xu, together with the Japanese and the American, developed a new process considered to have been faster and more productive of fine results than the original Tushanwan process. This was not the first time Tushanwan lost inventive printers to the city's vibrant capitalist printing sector.

Boxwood blocks *(huangyang ban)*, a means of printing images from the same dense wood that Gamble had used for electrotyping matrices, were adopted by the Commercial Press in 1904.[139] Possibly reflecting its new link to Kinkōdō, the Commercial Press then hired a Japanese named Shiba Den to come to Shanghai to teach the new process to the firm's Chinese printers. Shiba used a photosensitive emulsion to put on wood an original image that resembled a photograph. Next he cut the wood through the image. According to He Shengnai, the results were deemed "as good as copperplate." Some practitioners used a direct photographic method, with a result "similar to [that of] photoengraving."[140] Although boxwood blocks could be used for both monotone and colour printing, their high price retarded widespread adoption of this technique, even at the Commercial Press.[141]

Planographic Media (pingban yinshua)

Planographic (lithographic) printing processes differ from letterpress in that printing is done using a flat surface medium manipulated on the principle that water and grease repel each other. As the nineteenth century advanced, Wang Tao's comment about chemistry being the most modern printing process became increasingly valid. Historically, the earliest planographic process was stone-based lithography, also the first to arrive in Shanghai, followed by zinc-plate lithography (zincography, also photozincography) and finally by offset (rubber-plate or -blanket) lithography. The fundamental technique of production involved in this method of printing remained constant throughout the lithographic era and was so influential that its original name (meaning "stone-printing") was employed to the end of the period.[142]

Today lithography is known chiefly as a technique employed by artists and printmakers, but this view obscures the history of an important nineteenth-century industry. Invented in 1798-99 by Alois Senefelder (1771-1834), who called his new process "chemical printing," lithography was the first really new text-printing technology developed after Gutenberg's inventions.[143] Throughout the nineteenth century, European printers carried on a wide-ranging and highly inventive search for nonrelief methods to produce books. Printers sought technologies that could print nonalphabetical texts such as musical scores and visual images. New technologies for printing these classes of works emerged and jockeyed for position with relief-based techniques, such as woodblocks, dating from the late-medieval period. Once Senefelder perfected lithography, the new printing technique spread rapidly throughout Europe and Britain.[144] In France, for example, by 1838, lithography was a fully formed national industry.[145] As a result, for the next century, lithography reigned as the printer's single most important alternative to setting texts in movable type.

Similar efforts were made by the China missions to find alternatives to the time-consuming process of creating enough Chinese type to supply a printing operation. In 1829, the London Missionary Society's Walter Henry Medhurst, superintendent of printing at Malacca, began lithographing Chinese books at Batavia. Medhurst was drawn to the technology by its efficiency and low cost. In the 1830s, he concluded, "the art of lithography ... rendered the missionaries independent of native type-cutters and was found to be much cheaper than the former mode of printing by means of wooden blocks."[146] Medhurst soon opened a lithographic print shop in Macao. By 1832, his operation had spread to Canton, where it was directed by the Chinese convert, Qu Ya'ang (active 1810s-40s).[147] Two years later, the missionaries' lithographic press enabled the new British free-trade commissioner, Scottish peer Lord William John Napier (1786-1834), to respond quickly

with Chinese-language placards criticizing the Qing for suspending trade after he had insisted on its liberalization.[148] In 1850, Ningbo's APMP acquired a lithographic press.[149]

The quest for improved printing technology was brought to Shanghai by the Jesuit printing masters who ran the Tushanwan Printing Office. Most Shanghai Chinese commentators overlook Qu Ya'ang at Canton. For them, Chinese lithographic printing began at Xujiahui's Tushanwan print shop in 1876,[150] nearly eighty years after Senefelder had invented it. After its arrival, it was quickly commercialized by the Dianshizhai Lithographic Studio, which was then joined by 148 other lithographic printing shops and publishers before 1911.[151]

First developed in Europe around 1850, stone-based colour lithography (chromolithography, *caise shiyin*) did not arrive in Shanghai until 1904, the same year that the third major form of lithography, offset lithography (discussed below), was developed.[152] When Shanghai's Wenming Books acquired its colour lithographic press in 1904 and needed assistance in its lithographic shop, like other Chinese firms of that era, not surprisingly, it turned to Japan, where lithography had developed early and rapidly.[153] Wenming hired three Japanese technicians, who rapidly began to issue "light and shade" colour plates *(nongdan seban)* of fairly high quality.[154]

Contrary to their use in everyday Chinese speech, the terms "photomechanical printing" and "photo-offset"[155] *(yingyin, also zhaoxiang zhiban)* refer to a broad category of processes rather than to any single process. The most widely known process in this category is photolithography *(zhaoxiang shiyin, also known in English as zinc-plate, zincography, and photozincography)*. Photography, dating from 1840, was first applied to printing via photolithography, developed in 1859. By 1882, photolithography, involving the projection of photographic negatives of book pages onto a stone treated with a photosensitive emulsion, had become one of the main processes in the single most important branch of Western-style printing in Shanghai.[156]

Possibly reflecting its Protestant lineage, the Commercial Press was no more than a minor player among the early photolithographers. In 1905, it hired eight Japanese colour lithography masters to teach the firm's printers how to execute the photolithographic process,[157] used to print old paintings of landscapes, flowers and grasses, and figures.[158] The combination of lithographic plates with newer cylinder presses led to heightened mechanical precision. Now it became possible for a wider range of printers to use planographic media without extended apprenticeships. The Commercial Press reorganized its lithographic studio in 1920.[159] The next year, it hired an American technician to bring colour photolithography to China.[160] Then, in

1931, the Commercial Press, seeking to overcome the limitations of printing with gelatine-based photomechanical processes, began to use facsimile printing *(chuanzhen ban)* which became even more popular than the older zinc-plate process.[161]

Offset lithography *(jiaoban, xiangpi ban)*, a different process altogether from photo-offset, was developed by Ira Rubel and Harris Brothers.[162] Offset lithography was a process that worked with three cylinders: a design was created, sometimes by photography, on a positive plate and then transferred to a rubber blanket or roller as a negative before finally being printed as a positive on paper.[163] The great advantage of offset lithography was that the image could be exposed "right-reading."[164] The Commercial Press brought offset lithography to Shanghai in 1915.[165] A photograph of a web-fed offset litho press found in Ge Gongzhen's (1890-1935) 1927 history of Chinese journalism (see Figure 1.18) likely features this offset printing machine at the Commercial Press. Shanghai's famous magazines of the 1930s, *Liangyou* and *Meishu shenghuo*, were published using offset presses.[166] By then, offset technology was being manufactured in Shanghai by Ruitai, as indicated in Figure 1.15 (bottom).[167]

機　印　祇　捲　板　平

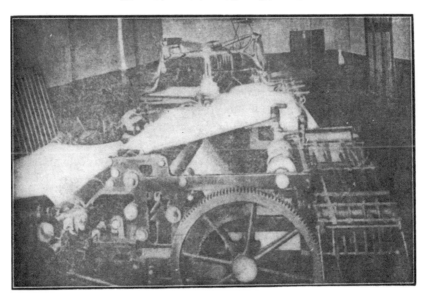

Figure 1.18 Web-fed offset lithographic press, Shanghai, 1927.
Source: Ge Gongzhen, *Zhongguo baoxue shi* (Shanghai: Commercial Press, 1927), 201.

After lithography, a second major planographic process of great popularity in Shanghai was collotype[168] *(keluo ban, boli ban),* invented in Germany in 1869. The fine tone and delicate shading produced by collotype gave it wide appeal,[169] which may explain why Tushanwan's Catholic printers brought it to Shanghai at about the same time as lithography.[170] At Tushanwan, collotype was used to reproduce images of the Holy Mother.[171] Yu Fu's Wenming Books, the Shenzhou guoguangshe, Youzheng shuju, and Yanguangshe were other Shanghai printer-publishers that eventually specialized in collotype reproductions of paintings, stele inscriptions, and Song/Yuan woodblock books.[172] Youzheng's staff, in particular, studied with a Japanese technician. In 1902, Wenming's Zhao Hongxue succeeded in printing with collotype. The Commercial Press founded its colour collotype operation in 1907. The next year, it sent Huang Zixiu to Japan for advanced study of the process.[173]

Finally, tinplate *(makoutie)* reproduction of illustrations, the third major lithographic technique, was already widely available by 1870 in France. Tinplate techniques arrived in England in 1872 but did not reach Shanghai until 1918. In that year, tinplate was implemented by a Japanese technician hired for the job by the Commercial Press.[174] The next year, a Chinese printer named Tang Chongli took over from his Japanese supervisor. From the Commercial Press, tinplate printing passed to the preserved and canned goods labelling industry.[175]

Intaglio/Gravure Media (aoban yinshua)

In contrast to relief media, whose printing surfaces protrude, and planographic surfaces, which are flat, the printing surfaces of intaglio media are etched or engraved. The best-known examples of intaglio media are those used to print early maps as well as financial instruments. Dies for printing currency, bonds, stamps, etc., are mostly intaglio media; by and large, intaglio media were used for printing images or images with a small amount of text.

Reversing the more ordinary process of technological adoption in nineteenth-century China, in which new printing technologies were usually absorbed first in Macao, Hong Kong, and Shanghai, the north took the lead in developing intaglio printing. The reasons for this anomaly developed in the political realm. Qing state sponsorship underlay the first major uses of intaglio printing. During the reign of the Kangxi emperor (r. 1662-1722), Jesuit mapmakers brought the first Western intaglio medium, the copperplate *(diaoke tongban),* to Beijing. By 1716, each province had been surveyed and mapped according to Jesuit instructions. In the following year, a copperplate atlas of China was printed. Other copperplated maps were completed in 1747, 1774, and 1783.[176]

Intaglio processes did not become significant again until after the administrative reforms of 1901, when, again, imperial politics played an important role in introducing modernized Western processes. Zhili Viceroy Yuan Shikai (1859-1916) appointed Yan Fansun and Hu Yuefang to supervise the modernization of Beiyang education. Possibly influenced by statist reforms in Japan and by private efforts in Shanghai, after establishing their offices in Tianjin, Yan and Hu opened schools and printed textbooks and official newspapers. They also ordered a number of letterpress and lithographic printing machines to print money and books. Soon they were imitated by the Board of Revenue in Beijing which established a Board of Revenue Printing Office (Duzhibu yinshuaju).[177] In 1908, Chen Jintao (1870-1939), after becoming deputy director of the Bureau of Printing and Engraving, decided that American printing methods thwarted stamp counterfeiters more effectively than those of other Western countries. Chen invited William A. Grant (1868-1954) of the American Banknote Company and Lorenzo J. Hatch (d. 1913), a highly skilled illustrator and master engraver, to come to China to supervise the Bureau of Printing and Engraving.[178] Grant remained with the bureau until his retirement in 1924, having trained several hundred Chinese in steel engraving and printing. Hatch, after designing much Chinese currency, died in Beijing. His apprentices carried on his work, creating plates for postage stamps, government seals, and other security instruments.[179]

Another example of intaglio printing is gravure printing *(zhaoxiang aoban)*, first developed in England in the late eighteenth century with the use of copperplates *(diaoke tongban, tongke ban)*. The Shanghai Customs Printing Office (Jianghaiguan yinwuchu) adopted gravure printing after a native of nearby Yuanhe, Wang Zhaohong, who had studied mapmaking in Japan in the 1880s, returned to Shanghai. In 1889, Wang published his *Tongke xiaoji* (Brief Account of Copperplating), one of the earliest modern technical manuals authored by a Chinese.[180]

In 1852, Englishman W.H. Fox Talbot (1800-77) invented the first mechanical intaglio process, known as heliogravure or photogravure *(yingxie ban)*.[181] Commercial exploitation was slow to develop. In 1902, five decades after Talbot, a German by the name of Mertens perfected the process, which was particularly good for reproducing paintings, an application of great interest to the Chinese. Photogravure printing was adopted by the Commercial Press in 1923.[182]

In 1924, the British American Tobacco (BAT) printing plant in Pudong, across the river from Shanghai, sent its master printer and two others to Leiden's Dutch Heliographic Printing Company to learn the photogravure

technique. While there, the three bought a colour photogravure *(caise yingxie ban)* press and shipped it to Shanghai. It arrived in May or June 1925, just as the May Thirtieth Movement commenced in the city. BAT's business suddenly collapsed, and there was no way to set up the new press. As an unintended consequence of the political disruption, the Commercial Press acquired BAT's press. In this accidental way, photogravure became another Western printing technique mastered by the Commercial Press's Chinese printers in advance of the city's newspaper and general printers.[183]

Printing Presses and Machines

As we have seen, historically, as well as taxonomically, there were three major categories of printing media or processes in Western-style printing: relief (letterpress), planographic (lithography), and intaglio (etched, engraved). Each process had its own origin and evolutionary trajectory. Each process also required a different kind of press, which had to be bought separately and called upon a special kind of expertise from its pressman. Although the Chinese, particularly the Chinese state, had had repeated experience with metal type, they had had no experience with printing presses before the arrival of the Western press. The high cost of cutting thousands of individual movable type was widely discussed by missionaries and scholars. As seen in the earlier section, Western casting methods accelerated the duplication of type and reduced its cost.

To date, however, neither Western nor Chinese scholars have discussed a startling printing phenomenon encountered by missionaries in south China – namely, the high rate at which Chinese-language metal type could become worn and damaged when they were used, not with Western printing presses, but with traditional Chinese ink, paper, and, especially, stiff-bristled brushes such as the *changshua* and *cazi*. This innovative blending of Western-style typographic technology with Chinese printing techniques was first mentioned in 1850 in a comment on a Chinese printer-publisher-bookseller and type-maker named Tang, from Foshan, outside Canton.

Using a clay matrix method (to make tin type) that Tang claimed to have invented, he prepared two (or three, depending on the source) fonts totalling 150,000 (in some versions, 200,000) Chinese type. The project cost $10,000 and was completed around 1850 (alternatively, between 1850 and 1852). The initial motivation was to print two varieties of lottery tickets. Tang printed them himself using Chinese ink and paper "in the ordinary Chinese way *with a brush*" (emphasis added).[184] According to the missionary source, the "long brush" wore the type out more quickly than use of the Western press would have done. The next year, discussing the condition of Tang's font after it was used to reprint the 120-volume Song work *Wenxian*

tongkao (Antiquarian Researches, 1851) by Ma Duanlin (c. 1254-c. 1323), the same missionary source concluded that the tin type was "much worn by the friction of the brushes used in taking the impressions, and therefore do not look as well as those previously given, which were nearly new."[185] By contrast, Dyer's stereotypes lasted five to six years using a printing press; cast type probably lasted at least as long.

For this reason, it is arguable that the lack of indigenous printing presses[186] in China and the process of "brushing" the ink rather than "pressing" it into place may have been important, if heretofore unacknowledged, factors militating against long-term Chinese use of movable metal type prior to the nineteenth century. If so, then the arrival of the Western printing press must be regarded as having been just as historically momentous as the development of rapidly duplicable type in advancing the Gutenberg revolution in China. In what follows, I survey the most important letterpress and planographic presses in their countries of origin and their diffusion to Shanghai.[187]

Relief *(Chinese, tuban)* (Letterpress) Printing Presses

Relief or letterpress printing presses, the sort of device with which the early modern European historian is most familiar, were built in three basic varieties. The platen press, initially known as the screw press and, later, as the common press, dates from Gutenberg's era. It was followed, historically, by the flatbed or cylinder press (1812) and then by the rotary press (1847-48). The development of the latter two presses coincided with the steam era, but only the rotary press had to be used with nonmanual power.

Platen Presses *(pingzhuang yinshuaji)*

Not until 1798 did the wooden screw press familiar to Gutenberg (see Figure 1.19) finally begin to give way to substantially newer models. Seeking to put a strong new industrial product, cast iron, at the service of printers, Charles Mahon, Third Earl of Stanhope (1753-1816) developed the first modern platen about 1800. Although much sturdier than the old wooden presses, Lord Stanhope's iron press was still hand-operated and capable of printing no more than the wooden press's upper quota of 250 pages an hour. For the first time, though, the common press began to print both halves of a single side of a sheet,[188] reducing printing time by half. As a result, the *Times* of London bought a number of Stanhopes[189] at double the cost of a wooden press.[190] These presses formed the core of its printing plant until 1814. From that time on, the *Times*, anticipating the roles that Japan's Meiji government and then the *Osaka Asahi*, as well as Shanghai's Commercial Press would play in China, began to promote and sponsor improved printing machinery.[191]

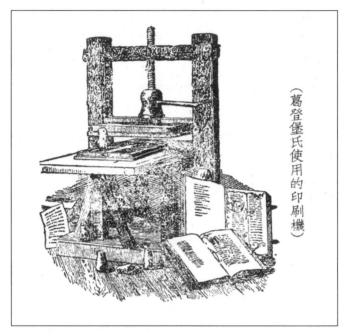

Figure 1.19 Gutenberg's printing press, fifteenth century.
Source: Yiwen yinshua yuekan/The Graphic Printer (Shanghai) 2, 3 (1939): 40.

A famous American version of Stanhope's iron platen press was the Columbian press, first developed in Philadelphia in 1814. Technically, the Columbian reduced the physical demands on the printer with an ingenious combination of new levers adapted from the principles of the Newcomen steam engine of 1712 and from Stanhope's press while also applying great pressure on the platen.[192] The Columbian eliminated Gutenberg's screw altogether, using a hinged elbow-joint and counterweights, which included a spread-winged American eagle that rose high into the air each time the lever was pulled, to lower and retract the platen.[193] In 1817, the American producer set up an English workshop to serve as a branch of the main Philadelphia manufactory. Soon twenty-five different British firms were copying the Columbian press, minus the American eagle that soared on its top beam, and it remained in use for more than a century in Europe and North America.[194] The Columbian reached Qing China sometime around the middle of the century.

Philadelphia's Columbian was followed in 1821 by the Washington press, developed by a New Yorker. Improved by 1829, the lightweight Washington could be disassembled for shipping, eventually making it the press that conquered the American frontier. It was also most likely the sort of press sent to the American Board at Canton in 1830-31. In 1835, R. Hoe & Company[195]

of New York and London, one of the most prolific builders and inventors of printing machinery in the nineteenth century, acquired the patent. Almost immediately, Hoe began to manufacture the Washington in seven different sizes.

In 1861, the American Methodist Episcopal Mission at Fuzhou acquired one of Hoe's Washington presses.[196] The Fuzhou missionaries also bought a font of Double Pica Chinese type from the London Mission Press in Hong Kong.[197] They purchased a Hoe Hand Press with a font of Three-Line Diamond Chinese type in 1863. A dozen years later, in 1875, the Fuzhou mission bought two type fonts from the APMP in Shanghai. Hoe developed an important modification to the Washington in 1847 with the self-inking apparatus.[198] Presses of this sort must have first reached China fairly soon thereafter. The American Methodist Episcopal Mission Press in Fuzhou bought one in 1878-79, by which time it was employing ten Chinese workmen.[199] A larger self-inking Hoe press was purchased in 1886.[200]

Of equal importance historically was the British version of the Columbian, the 1820 Albion press, for which a self-inking apparatus was developed in 1825. Unlike the Columbian, the early Albions used a spring to lower the platen.[201] Like the Washington press, however, to which it was also related, the Albion was manufactured to be taken apart for easy mobility throughout the British Empire. The Albion, predictably, replaced the American eagle with royal insignia.[202] The first explicit mention of an Albion in China occurred in 1833 at Macao, after which the press was moved to Canton. In 1869, American missionaries took it to Ningbo.[203] The smudged ornamentation at the top of the press shown in Figure 1.20 suggests the Albion's insignia. The location of the press in the figure is unknown, but it was probably in Ningbo or Shanghai. The photograph, which shows men with queues dressed in traditional *magua* (hemp) outfits, was most likely taken before 1912. The caption reads "Earliest imported Western printing press," a claim that is historically and generally accurate.

Cylinder or Flatbed Printing Machines (lunzhuan yinshuaji)

In the early 1800s, two Germans, Friedrich König (1774-1833) and Andreas Bauer, developed the first modern printing *machine* (as opposed to the platen press).[204] Patented in 1810, König and Bauer's cylinder printing machine (flatbed press) was first manufactured successfully in 1812,[205] a dozen years after Stanhope modernized the platen press. Unlike the platen press, which had employed two flat surfaces, the cylinder press used a flat surface and a curved one. Because the area of contact between the two was narrowed to the thin band of the cylinder that touched the platen, the amount of pressure needed to transfer the ink from the flat typeform to the curved cylinder

最 初 由 西 洋 輸 入 中 國 之 印 機

Figure 1.20 Earliest imported Western printing press, pre-1912.
Source: Ge Gongzhen, *Zhongguo baoxue shi* (Shanghai: Commercial Press, 1927),
pre-1912.

that held the paper was reduced. The 1812 cylinder printer produced a
record-breaking 800 impressions of book printing an hour. Four years later,
the world's first book produced on a printing *machine* appeared.[206] In the
same year, König and Bauer built the world's first perfecting (two-sided)
printer, capable of producing 900-1,000 perfected – that is, two-sided –
sheets per hour.[207]

Eventually, König's machine was updated by what was called the "bed-
and-platen" press. One reason that such presses were needed was that cheap
and efficient steam engines did not become widely available to general print-
ers until the 1840s;[208] previously, use of such engines had been limited to
deadline-driven, high-volume newspaper printers. The first successful bed-
and-platen press, used to print high-quality book work, was developed by
Daniel Treadwell of Boston in the 1820s. In addition to printing more quickly
than the hand press, it could be turned by horses if steam power was not
available.[209]

Shanghai's London Mission Press was supplied with three double-cylinder
printing machines, two hand presses, and a lithographic press.[210] The press
that Wang Tao saw there in 1848 was a bed-and-platen of the sort that
Treadwell had invented. In his diary, Wang wrote:

As soon as we came up the [Huangpu River], I suddenly found myself in a different world ... The foreign scholar Medhurst was at the time in charge of the London Mission Press, which was printing books by a machine from movable type. This was considered to be a great novelty and I specially went to pay him a visit ... I was brought into a room the walls of which were covered with bookcases full of Chinese books ... After that, Mr. Medhurst took me to see where the printing was done. The press was turned by a water buffalo and could produce several thousand impressions a day. The office had glass windows and was very bright and clean. The type was arranged in cases according to the order of the dictionary.[211]

Details recorded by Wang are perhaps the earliest articulate Chinese evaluation of Western printing technology. The reference to movable type is straightforward, as is the mention of the mission library. Just as important is Wang's reference to the buffalo, an obvious Chinese stand-in for the horse, and the press's production rate, all of which strongly suggest that a bed-and-platen press is being described.

In the 1840s, Henry Ingle of London developed a simple, light, bed-and-platen press that remained in wide use until the end of the century. The bed-and-platen cylinder press (see Figure 1.21) was generally used in Europe to print books (with movable type). The very unfamiliarity of its name reminds us that the nineteenth-century printing revolution was effected partly by many dozens of individually owned proprietary firms whose names are now forgotten. Harrild & Sons, the London printing firm founded in 1801, began manufacturing its own bed-and-platen presses in the 1860s.

Nearly thirty years after Wang Tao's first mention of Shanghai's London Mission Press, Wang's *Yingruan zazhi* (Yingruan Records, 1875) describes a scene that Wang could have witnessed no later than about 1864, when, according to APMP records, Shanghai's London Mission Press closed. In Wang's view, the press, his employer from 1849 to 1861, had been the most renowned of numerous Western missionary printing firms then active in China. Regarding its press, we read that it used type cast from poured lead and ink made from clear glue and soot that were simmered together.[212] We are also given a verbal picture that calls a larger model of Figure 1.21 to mind:

[The press] used iron to make a printing cart bed that was ten Chinese feet [about twelve English feet] long and perhaps three Chinese feet [three and a half English feet] wide. On the side are two heavy wheels with teeth. On one side stand two men overseeing the printing, using a buffalo to turn it. There are two big empty cylinders hanging there using a leather belt to make them

啓者本行專造印字所需大小印字各架及小汽機架鑄字架菲零碎各件久經

內外馳名天下　四洲無不變易茲因中國近來漸開活字之法故本行已託申報

主人美查在中國裏爲經理本行之事如有　骨宏欲辦買機器需赴彼　處間價

看圖可也

光緒二年五月廿二日

倫敦印字機器行夏兒意布告

Figure 1.21　Harrild & Sons cylinder press, Shanghai, 1876.
Source: Gezhi huibian (Shanghai) (1876): 21.

turn and to forward the paper. With each turn, two sides are printed. It is quite simple and fast[213] ... The end of the printing bed has an ink trough and uses an iron pivot to rotate it, sending ink onto the flat plate. At the side, there are several ink rollers laid out. They wipe the flat plate with ink, sending it onto the type form with uniform thickness ... There are two kinds of book-printing machines in Western countries, one large and one small. The large one uses a buffalo to turn it, the small one uses a man to rotate it. The one rotated by a man is also very cheap. For no more than a hundred pieces of [silver] money, you can buy one.[214]

It was not the accelerated production rate that most impressed Wang Tao. Rather, like the Ningbo official who had approached the APMP in 1846, Wang found the selling point of the cylinder press-printed books to be the quality of the product. Wang concluded his account with praise for the precision of the instrument: "In every case, the ink has a clear impression from the type and [so] these are not Mount Sha [Shashan, Fujian] books [i.e., smeared due to the use of softwood blocks and perhaps unskilled carvers]."[215]

Other Chinese who came to visit the London Mission Press were just as impressed by the mechanical printing operation. Rather than describe the process through prose, though, some indulged in the literati convention of lyricizing facets of daily life. Sun Cigong, one literati visitor to the London Mission Press, composed a wry poem about the mission's cylinder press that calls on conventions of contrast that would have been clear to any educated reader of the time:

> The cart stirs up the sea of ink as it turns the axle round,
> A hundred marvellous writings are passed on to the world
> The busy old buffalo has yet to comprehend
> He's not ploughing a hillside for grain, but planting a paddy field for books.[216]

Rather than focusing on the new, as Wang Tao had done, Sun alludes to the conventional Confucian contrast between those who work with their minds – that is, via book culture – and those who labour with their bodies to provide the other class with its products. In this case, a water buffalo provides motive power to a printing press rather than labouring to provide grain. Nonetheless, both products, books and grain, were essential for the sustenance of the nonlabouring literati. Sun's poem also enthusiastically promotes the expansion of China's literary culture through the mechanical multiplication of "a hundred marvellous writings."

In 1872, Shanghai's Chinese-language *Shenbao* newspaper company in-stalled a hand-operated cylinder press and signed on as Harrild's local agent. The hand-operated cylinder press could produce about 100 pages an hour, whether of book work or newspapers. Soon after this hand-powered press came to Shanghai, it was joined by similar presses driven by steam engines (*zhengqi yinjin*) and even automatic gas engines (*zilaihuo yinjin*), which, along with replacing the attendants, also doubled printing speed.[217] No later than 1876, we know from an advertisement (see Figure 1.21) in a Shanghai sci-entific newspaper, the *Gezhi huibian/Chinese Scientific and Industrial Maga-zine*,[218] Harrild's bed-and-platen press was being marketed to prospective Chinese printers.[219] Although the platen press produced finer work, the bed-and-platen offered lightness and convenience when those virtues were more important than product quality.[220]

The Ingle cylinder press, mentioned above, was followed by William Dawson's Wharfedale, the most popular bed-and-platen press, as well as one of the most famous and popular presses of any sort, of the nineteenth century. Its use became widespread because Dawson never patented it. Wharfedale cylinder presses, similar to the König press but named after the Yorkshire town where Dawson first developed them in 1858, eventually became the standard book press throughout the British Empire. Wharfedales were capable of printing from 1,000 to 1,500 single sides of paper (i.e., two pages of a book) an hour. Before long, the Wharfedales were supplemented by lighter, more transportable, and easier-to-assemble presses from North America built using similar principles.

Four cylinder machines, along with one platen, can be seen in Figure 1.22, which shows the APMP's Shanghai press room in 1895. Eleven years later, in 1906, nearly four decades after the Harrild, the electric Wharfedale (Huafutai *dangun tongji*, literally "Wharfedale single-cylinder press") itself reached Shanghai. A British Wharfedale of this type was purchased by Hushang shuju.[221] Since it came from England, the Wharfedale was also known to Shanghai pressmen as "The Big English Press" (*Daying ji*), which could print 1,000 pages an hour.[222] Five years later, in 1911, *Shenbao* bought the Ya-er-hua (Walter?) Company's double-cylinder press (*shuanglun zhuanji*), whose output was 2,000 pages an hour, not a staggering rate by world stan-dards, but it was faster than anything else in Shanghai at that time.

In 1887, Chicago's Miehle Printing Press and Manufacturing Company put into production a multiple-cylinder press that rapidly became the in-dustry standard.[223] It still used the same kind of type as the platen press, lying flat and locked into a chase.[224] In 1919, the Commercial Press became the first Chinese publisher to purchase an electric Miehle. Because the Miehle's printing cylinder never stopped between imprints, the Chinese

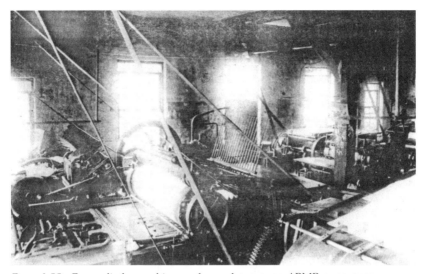

Figure 1.22 Four cylinder machines and one platen press, APMP press room, Shanghai, 1895
Source: Gilbert McIntosh, *The Mission Press in China* (Shanghai: APMP, 1895), opposite 29.

called it a double-turning cylinder press *(shuanghui lun zhuanji)*. Apart from the single-colour Miehle press, the Commercial Press had also obtained a two-colour Miehle and a Miehle perfecting press for printing books before 1931.[225]

Rotary Presses *(lunzhuan yinshuaji, also juan ban juanzhi yinji)*
In 1872, one of the earliest Chinese-language discussions of new Western printing technology appeared in the Beijing-based missionary journal *Zhongxi jianwen/Peking Magazine* (literally, "Chinese and Western knowledge"; see Figure 1.23). The article set out to explain the benefits of rotary printing on the Walter press (Walide'er *lunzhuanji*) or "Steam-Powered Printing-and-Folding Machine."[226] Most important among its advantages, in the eyes of the missionary journal, was speed. Every hour, one man could print 1,700 large pages using type arranged on rollers. Adding more printing rollers increased the speed to as high as 10,000 pages per hour, insisted the journal.[227] In addition to emphasizing the extraordinary speed and precision of the Walter press, the article was one of the first to present its subject to Chinese readers via a schematic drawing, then a new form of visual communication in Europe and North America.[228] Unfortunately, no responses that Chinese readers of the journal may have had to this illustration survive.[229]

Efforts to produce a rotary press had begun in England nearly six decades earlier. In 1816, London *Times* engineers had begun to experiment with

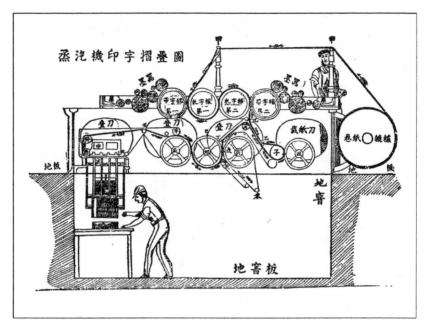

Figure 1.23 A steam-powered printing-and-folding machine, Beijing, 1872.
Source: Originally in *Zhongxi jianwen* (Beijing), 1872, reprinted from Zhang Jinglu, ed., *Zhongguo jindai chuban shiliao, er bian* (Shanghai: Qunlian chubanshe, 1954), 393.

curved stereotype plates of the sort that would make possible, by 1847-48, their first rotary press, capable of printing 10,000 sheets an hour,[230] or 35,000 newspapers a day.[231] Rotary press machines using stereotypes in place of movable type were also developed in France and the United States. Rotary presses further reduced the amount of pressure exerted on the paper by eliminating almost all friction caused by the flat platen of the cylinder press and substituting a curved one. By 1850, rotary presses were printing with two curved surfaces.[232] The minimized stress on the paper reduced the need for dense, smooth paper, and the web (or roll) of pulp paper was now introduced.[233] In 1868, only four years before it was advertised in the Beijing journal, the Walter press, which the *Times* had patented in 1866, began to set a new standard for rotary presses with the capability of printing 12,000 perfected copies per hour.[234]

The first Chinese printing and publishing firm to purchase a rotary press was Shanghai's Hushang shuju, which bought a cut-rate, Japanese-made, European-style electric rotary press at the turn of the twentieth century,[235] approximately the same time that it bought its electric Wharfedale cylinder press. In 1914, the city's *Xinwen* newspaper plant installed a two-tiered Ba-de [Baensch-Drugulin?]-style rotary press.[236] In 1916, however, *Shenbao*

bought its own Japanese-made, Marinoni-style rotary press, presumably that marketed as the Osaka-Asahi. Even at 8,000 pages an hour, it was slower by more than half the world standard, and it lacked a folding machine.[237] In 1918, *Shenbao* secured a three-tiered American rotary that could print 10,000 copies of a twelve-page section each hour.

In 1922, the Commercial Press finally bought a perfecting Ai-er-bai-tuo (Albright?, Heidelberg?) Company rotary press from Germany. Complete with its own folding machine, it could print 8,000 perfected pages an hour, the equivalent, says He Shengnai, "of ten Miehle presses."[238] The Commercial Press's plant was quickly overtaken in 1925 when the *Shibao* newspaper plant installed a German Vomag colour rotary press that could do several colours at once. Ge Gongzhen's 1927 history of Chinese journalism includes a photograph of a web-fed rotary press installed in Shanghai (see Figure 1.24), probably from the early 1920s.[239] In He's view, these three firms, the *Shenbao* and *Shibao* newspaper plants and the comprehensive publisher, Commercial Press, were without peer in East Asian printing, thanks to these rotary presses.[240]

By the 1930s, Miehle was actively pursuing an advertising campaign in Shanghai to sell its double-cylinder rotary press (see Figure 1.25). In addition, in the late 1930s, Duplex Tubular Plate rotary presses became available in Shanghai through the Linotype and L & M Machinery Company

捲 板 卷 紙 印 機

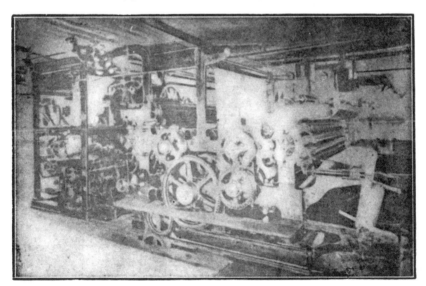

Figure 1.24 Web-fed rotary press, Shanghai, 1927.
Source: Ge Gongzhen, *Zhongguo baoxue shi* (Shanghai: Commercial Press, 1927), 201.

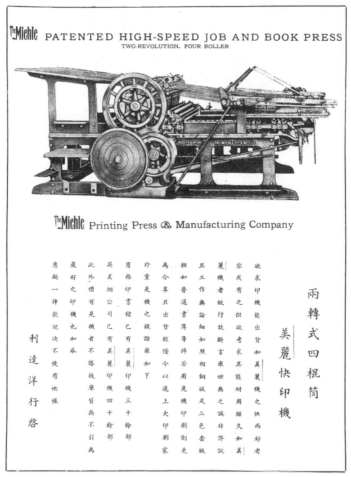

Figure 1.25 Advertisement for Miehle high-speed job and book press, Shanghai, 1937.
Source: Yiwen yinshua yuekan/The Graphic Printer (Shanghai) 1, 4 (1937): 4.

(Lai-nuo yinzhu jiqi zhizaochang), an offshoot of Britain's Linotype company.[241] The same company's Number 3 rotary press was popularly known in Shanghai as "an English Miehle (*Yingguo* Mi-li-ji)."[242]

Physically, these latter presses resembled the schematic illustration shown in Figure 1.23. They were available in various sizes and speeds, ranging from a single-cylinder machine that could print 40,000 single-colour or multi-colour perfected pages *(quanfen)* an hour to one that could do 30,000 and another that produced no more than 6,000.[243] The last-mentioned press could work with flat lead plates or movable type. From its Shanghai plant, L & M also sold a press that printed 2,800 sheets an hour.[244] With their

acquisition of these rotary presses, Shanghai printers had clearly become part of the modern world of mass printing and publishing.

Planographic Presses *(pingban, shiyin)*

Senefelder's lithographic hand press of 1796, known as the "pole," "lever," and "gallows" press, was quickly surpassed technologically by the wooden "cylinder" or star-wheel press, created in 1805 by Hermann Josef Mitterer (1764-1829).[245] By the 1820s, Mitterer's star-wheel press, with its sliding bed, had become the standard for fine printing. Over the next half century, numerous modifications on it were made in Germany, England, France, Italy, and even America,[246] though not in China. Although regularly modified by others, Mitterer's hand press remained the industry standard until 1852, when the first steam-powered press was built in Vienna.[247] Between about 1850 and 1880, flatbed cylinder machines were developed that permitted striated zinc plates (the earliest "photomechanical" plates) to be substituted for the cumbersome stones, "and machines were so greatly improved in precision and in speed that lithographic firms increased in number all over the world,"[248] according to one historian of printing.

In 1876, stone-based lithography reached Shanghai. The Jesuit directors of the Tushanwan lithographic shop were the Frenchman mentioned in the Chinese documents simply as "Disciple" or "Brother" Weng Shouqi (his original name has been lost) and the Chinese Qiu Zi'ang.[249] Their early efforts at printing were limited to reproducing Catholic religious materials. Unlike that of the Protestants, the Catholic objective was to create illustrations that would appeal to semiliterate or illiterate converts. The Jesuits' lithographic presses were initially all made of wood, and workers rotated them by hand, suggesting that they were a version of the star-wheel press.[250] One early commentator, the Shanghai writer Mao Xianglin, penned an ironic, most likely contemporary, account of the process in a chapter titled "The Ink-Eating Stone": "The West has an ink-eating stone. If one uses ink to write characters onto paper and then presses them onto the stone, after a short while, the inked characters seep into the stone. Then they apply more ink, and only the places where there are characters absorb the ink, whereas blank spaces do not."[251] By 1900, Tushanwan's manual star-wheels had been replaced by advanced industrial lithographic presses (see Figure 1.26) manned by a total of twenty to thirty workers specialized in the production of book illustrations and religious pictures. The latter were sold throughout China, in the Pacific region, and even into the Americas.[252]

Just as the Jesuits were setting up their lithographic studio in 1876, however, across town, English merchant Ernest Major's compradore, Chen Huageng (also Shengeng),[253] had begun to search for ways to supplement the income

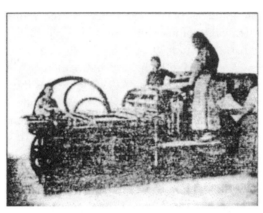

Figure 1.26 Tushanwan's mechanized lithographic
press, Shanghai, c. 1900.
Source: Gu Yulu, "Shanghai Tianzhujiao chuban gaikuang,"
Chuban shiliao 10 (1987:4): 30.

generated by Major's newspaper, *Shenbao*. Ernest and his brother Frederick
had come to Shanghai in 1859 after the failure of their Italian silk filature.
In Shanghai, the Majors invested in a wide variety of ventures, including a
tea-trading firm, a chemical works, a silk-reeling operation, a soap factory, a
match factory, and an oil press operation.[254] When Ernest returned to Eng-
land in 1889, his investments were said to be worth 30,000 taels.[255]

Shenbao had been Chen Huageng's idea. After gaining Major's approval for
the newspaper enterprise, Chen had invited his fellow Jiangxi provincial Wu
Zirang, to assume the position of chief editor. Major and Chen then sent
Qian Zheng, Wang Tao's son-in-law, to study Wang's Hong Kong printing-
publishing operation. After Qian's return, they started up *Shenbao,* which
first went to press on 30 April 1872.[256] In addition to printing the news-
paper with lead type, from 1872 to 1895, *Shenbao* issued lead-type printed
books.[257]

Meanwhile, Chen had convinced Major to invest in the lithography busi-
ness. Together they lured the Tushanwan lithographer Qiu away from the
Jesuit fathers to their shop on Nanjing Road at the corner of Sinza Road
(now Liuhe Road).[258] Thus was born, in 1877, what would become the
Dianshizhai Lithographic Bookstore,[259] managed, much as its companion
newspaper *Shenbao* was, by its Chinese employees. Beating the Tushanwan
Jesuits to the punch, Dianshizhai would be the first privately owned com-
mercial Shanghai lithographer to print books.

Major and Chen bought twelve hand-cranked lithographic presses. Two
hand presses and five hand-cranked (by teams of four workers) flatbed,

photolithographic presses (still using stones) can be seen in Figure 1.27 drawn by Dianshizhai's famous illustrator, Wu Youru (1840?-96?).[260] Wu's illustration itself was printed lithographically for a Shanghai miscellany, *Shenjiang shengjing tu* (Scenic Spots of Shanghai). Although Wu Youru's drawing features a full range of early and later, more sophisticated lithographic printing technology, from the perspective of the more efficiency-conscious 1930s, He Shengnai pointed out that, originally, "Each press [required] eight men, divided into two groups taking turns rotating [it]. One person fed in the paper, two received it. The process was troublesome and full of surprises. Its output was barely several hundred pages per hour."[261] Figure 1.28, taken from a late-1880s or early-1890s advertisement announcing Dianshizhai's fine printing of Chinese books, pictures, and stele rubbings, provides a close-up view of the three printing workers that He describes manipulating the paper. The lithographic press seems to be suspended from a belt leading to a power source, somewhere off-stage; starting with gas engines in 1890, Dianshizhai gradually mechanized its operations.

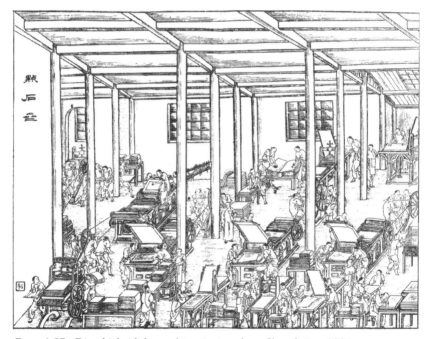

Figure 1.27 Dianshizhai lithographic printing plant, Shanghai, c. 1884.
Source: Wu Youru, *Shenjiang shengjing tu, juan shang* (1884), 60, in Zhang Jinglu, ed., *Zhongguo jindai chuban shiliao, er bian* (Shanghai: Qunlian chubanshe, 1954), opposite 361.

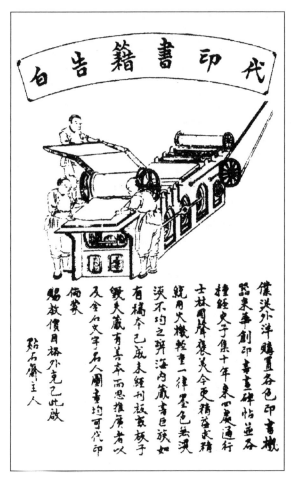

Figure 1.28 Dianshizhai book-printing notice, Shanghai,
c. 1890.
Source: Don J. Cohn, ed. and trans., *Vignettes from the Chinese:
Lithographs from Shanghai in the Late Nineteenth Century* (Hong Kong:
Chinese University of Hong Kong Press, 1987), back cover.

A different, more positive appraisal of lithography was offered by Huang
Shiquan, a late Qing writer closer in time to the phenomenon that he de-
scribed than was He Shengnai. Just as Wang Tao had offered positive evalu-
ations of the London Mission Press's printing technology, Huang, in his
Songnan mengyinglu (Account of Dream Images in Wusong, 1883), wrote
specifically of Dianshizhai and sounded more enthusiastic than had He:
"Lithographed books use stone plates from the West, rubbed smooth like a
mirror. Using an 'electric lens' *(dianjing)*, they project images of the charac-
ters onto the stone, and then they lay on mucilage and print using an oily

ink. Millions of pages of books are not hard to do in one day, [all of them printed] fine like an ox's hair and sharp as a rhinoceros horn."[262]

Like the book publisher Dianshizhai, the Commercial Press probably started out with stone-based lithographic presses, attracted to their fine, clear printing. By 1908, however, it had replaced them with lead-plate flatbed lithographic presses. Using a Japanese advisor and the flatbed principle, the Commercial Press increased productivity from a few hundred to 1,500 impressions an hour.[263] At the start of the Republican period, the BAT in Pudong acquired four-colour lead-plate presses that it used for printing advertisements.[264] After the Commercial Press bought its Harris offset press in 1915, it hired an American, George Weber, to supervise its operation. In 1922, the Press also bought an English George Mann two-colour offset press.[265]

Summary and Conclusion

Based on what Shanghai printers and publishers of the 1920s and 1930s wrote, it is clear that they regarded themselves as Gutenberg's heirs. Although Gutenberg was first identified for general readers only in the *Cihai* dictionary of 1937, he had been known to Chinese printers, publishers, and writers since at least the mid-1920s. All the writers would likely have shared *Yiwen yinshua yuekan/The Graphic Printer*'s view that, even with the changes and innovations during the centuries since Gutenberg, "his general idea is still like it was in the old days." At the same time, they were also aware that printing had been reinvented in the nineteenth century. For this reason, China's Gutenberg revolution must also be traced to the subsequent innovations of Senefelder (1796-99), Stanhope (1800), König (1814), Miehle (1888), and others, including the manufacturers of these machines, such as Hoe, Harrild & Sons, etc. Just as important were the efforts of both Japan's exporting printing-press manufacturers and Japanese printing technicians who came to Shanghai at the end of the Qing. All of these factors combined to set the stage for China's own printing press manufacturers, who will be discussed in Chapter 3.

China's Gutenberg revolution started off far from auspiciously. The first Chinese type cutter and letterpress printer, the shadowy Cai Gao, was banished from Canton to labour in Malacca for his involvement with the Protestant missionaries. Qu Ya'ang, the Christian convert and early Canton lithographer, had a similarly obscure career. Not even the name of the Ningbo official who approached the APMP to print a history book remains for the historian who would trace the early history of Western-style printing. Among these Chinese who stamped their imprints on the early history of Western printing in China, the Shanghai-Hong Kong editor and publisher Wang Tao, starting in the late 1840s, left the most articulate record. Even Wang,

however, was a marginal figure, stained by his involvement with foreigners and by the alleged appeal to the Taipings that required him to leave Shanghai for what, in his eyes, was a repulsive exile in Hong Kong. In short, only one of these figures, the Ningbo official, had any real stature within the still viable nineteenth-century Chinese world of officials and Confucian learning, and the APMP had shunned his invitation to compromise its nonprofit status by printing his book.

Estimating generously, by 1895 there were no more than another 250 Chinese print workers in a total of eleven Protestant mission presses scattered throughout China.[266] Of that total, 126 were concentrated in Shanghai. Partly through the experience of these anonymous workers, other Chinese began to see that they could benefit from Western printing technology, but not before the chief "Catholic" technology, lithography, initiated the real beginning of *Chinese*-mediated Western printing, that is, the large-scale use of Chinese-owned industrial machines by Chinese printers.

The development of relief and lithographic media and presses for printing Chinese was possibly the most important and lasting conversion ever effected by nineteenth-century Protestant and Catholic missionaries in China.[267] In the long term, only small numbers of Chinese turned enthusiastically to the Christian texts originally produced by Western printing along the southeastern China coast from Macao to Shanghai. Hong Xiuquan (1814-64), the antiliterati Taiping leader who claimed to be the younger brother of Jesus, was the most famous Chinese influenced by early Western-style printing, but, in light of the thirty million who died during his thirteen-year rampage against the Qing state and Confucian culture, he might not be the preferred model of someone influenced by a Christian text. The paucity of genuine Christian converts aside, nonetheless, the technology that these early law-breaking Christian missionary subversives brought to China eventually produced significant Chinese "converts" of its own. However, these disciples turned Western technology to their own purposes.

Summarizing Tables 1.1 and 1.2 shows that various Western printing technologies advanced into the Chinese heartland right along with Western missionaries. Zhang Xiumin, China's leading scholar of printing history, has written that "imperialism coupled hard tactics with soft ones: cannons and printing presses intersected and were each useful, intimately complementing each other."[268] The early targets of the missionaries' soft tactics were Macao, Canton, and Hong Kong, followed by Ningbo, Fuzhou, and Shanghai, and then other northern and inland ports. As the missionaries advanced, it is clear, they experimented with a wide variety of Chinese xylographic and European letterpress and lithographic printing techniques.

The tables also reveal the overwhelming centrality of Shanghai in this

technological diffusion from the West to China. By the end of the nineteenth century, Shanghai was the most important of over 100 treaty ports acquired through both hard and soft tactics. In Shanghai, the tables show, the Commercial Press was the single most vital enterprise, Chinese or Western, in advancing China's twentieth-century Western-style printing industry. Among Chinese firms, the Commercial Press was joined in the technological vanguard by Wenming, Hushang and, after 1912, Zhonghua. Unlike England's *Times* and Japan's *Osaka Asahi*, in China these comprehensive book publishers together, more often than not, acquired advanced printing technologies ahead of Shanghai's newspaper and general printing enterprises, suggesting the primacy of the book-publishing mentality among the Chinese.

Of the nineteen kinds of relief, planographic, and intaglio media whose genesis in China has been traced in this chapter, thirteen were first used in Shanghai and seven of those by the Commercial Press. With regard to the first recorded use of twenty-one kinds of printing presses and machines (platen, cylinder, rotary, and lithographic), fifteen were first used in Shanghai, the city's relatively late arrival (and hence its total absence from the platen category) on the printing scene notwithstanding. Of the sixteen presses, six, even including printing machines typically used in newspaper printing, were first adopted by the Commercial Press, founded only in 1897.

These tables focus on "the first use" of a particular technology. A larger sample, presented in the following chapters, will confirm the general contours of these data, revealing the great importance of both Shanghai and the Commercial Press throughout the nineteenth- and early twentieth-century phases of China's Western-style printing revolution. Not shown in the tables are the activities of missionary presses, such as the American Board in Canton and the National Bible Society of Scotland at Hankou, presses that, like most nineteenth-century Chinese, favoured xylography over both letterpress and lithography for long periods.

The missionaries and early Chinese printers and publishers discussed in this chapter contributed to the overall decline of China's xylographic craft printing and its gradual replacement by industrialized lithographic and letterpress printing and publishing. This evolution was not lost on later Chinese commentators. Indeed, as Liu Longguang (b. 1913) of *Yiwen yinshua yuekan/The Graphic Printer* pointed out in 1937, "[D]uring the Tongzhi [r. 1862-74] and Guangxu [r. 1875-1907] eras ... China's door gradually opened. The West's new-style printing crafts were introduced, and, naturally, China's old-style printing crafts could not compete ... So-called new-style printing was nicknamed 'mechanical printing,' and the so-called old-style printing was nicknamed 'manual printing.' The result of the contest between manual

and mechanical printing was that the [manual] frequently [succumbed] to natural selection."[269] In this context, however, one is struck by the fact that the two earliest missionary printing operations, the London Mission Press and the APMP, joined those that succumbed to "natural selection" when they were bought out by Chinese publishers.

In the 1870s, Huang Sheng and Wang Tao converted Hong Kong's London Mission Press into their China Printing Company. Fifty years later, in 1923, the Chinese owners of the Commercial Press merged their old employer's firm, the APMP, into their own, symbolizing the thorough sinicization of Gutenberg and his missionary descendants. By then, growing numbers of Chinese printers and publishers had come to regard both relief and planographic technology as *theirs*. At the end of the Qing, reflecting themes of mechanization and modern processes first introduced by Medhurst and Lowrie, and sustained by Wang Tao, a Chinese magazine such as *Shanghai tuhua ribao* (Shanghai Illustration Daily) could write, "Printing books *by machine* is really convenient. You can print a big pennant in a flash, saving effort and money, and it is both exquisite and fresh"[270] (emphasis added), suggesting that at least some heirs to China's literati culture had embraced Western printing as a means of disseminating that tradition to wider audiences.

Although both Hong Kong's China Printing Company and Shanghai's Commercial Press relied heavily on lead-type fonts made from matrices of the sort that can be traced to Samuel Dyer on Penang, Richard Cole at Hong Kong, and William Gamble at Ningbo, not one of those particular Western Chinese fonts remained popular with twentieth-century Chinese. The four major nineteenth-century Western-created fonts (Dyer's, Cole's, Gamble's, and Major's) were abandoned by Chinese printers, particularly those at the Commercial Press and Zhonghua Books, as they began to make their own decisions about an industrialized, Chinese typographic aesthetic. Regardless of the fonts' appeal to missionary printers, these fonts never became attractive to Chinese, in part because they lacked calligraphic qualities.

Consequently, from the vast array of Western printing technology (nineteen kinds of media, of which seven were available by the 1870s, and matching presses) that they encountered, Chinese printers and publishers searched for alternative means to achieve their ends. Through their choices, lithography, not letterpress, became the first real step in China's embrace of Western printing technology. Contrary to received wisdom, nineteenth-century Chinese were making constructive choices when it came to identifying the Western technology closest to the literary and aesthetic culture that they

venerated. Their choices were influenced by the range of literati values discussed in this chapter, particularly those concerned with calligraphy and relevant to extending the life of calligraphic and manuscript culture.

As a result, and as we will see in the next chapter, culture determined technology in the late Qing. By the 1920s, when the Commercial Press absorbed the APMP, Chinese print capitalism, created through the synthesis of Chinese intellectual and cultural traditions and Western technology, was already five decades old. As we will also find, it began with lithography, not letterpress, which could be made more easily to reflect Chinese aesthetic concerns. While it unfolded, Chinese print capitalism revealed the unexpectedly strong influence of China's own publishing culture on the technological decisions taken by Chinese printer-publishers.

Just as important, by the time the flurry of international political events overtook slow-moving lithographic printing, Chinese type makers would find their own aesthetic in cast metal, allowing them to replace missionary fonts with those of their own design. Those new fonts would then be used to print the secularized works of a new generation of antidynastic political activists and educational reformers, among others. Western printing presses and machines, adaptable to new Chinese-designed fonts, would continue to appeal to Chinese printers and publishers, just as they did to those in the West. The nineteenth century had turned out to be, just as Lowrie and Wang had put it, "an era of metal, steam, and chemistry." By the mid-1920s, Western-style printing, by then blending the calligraphic aesthetics of the Chinese literati with the technology of the Gutenberg revolution, would become an inseparable part of China's modern civilization.

2 Janus-Faced Pioneers: The Golden Age of Shanghai's Lithographic Printer-Publishers, 1876-1905

For Chinese who lived through the period of transition from woodblocks to Western-style printing, modernization and the growth of print capitalism did not involve a clear break from the past. Only when the transition was nearly complete did it occur to some of those involved to comment on the process. Bao Tianxiao (1876-1973), a writer and editor, was one who recalled his first exposure to the new printed culture emanating from Shanghai in the mid-1880s. Bao wrote that, while still a student preparing for imperial China's civil service examinations, he first became aware of the modern world via exciting new Western-style Shanghai publications such as the *Dianshizhai huabao* (Dianshizhai Pictorial, 1884-98). "Shanghai, that place!" he commented, "was where new styles began; new foreign inventions and new businesses were all first spread to Shanghai."[1] Bao went on to declare, "Shanghai had printing shops [and] lithography,"[2] the latter being, in his eyes, the most appealing among these sparkling new inventions and businesses that were changing his mental world.

In 1897, approximately a dozen years after the period that Bao was describing, the well-known Qing literatus, writer, and reformer Kang Youwei (1858-1927) visited Shanghai. The next year, thanks to his access to the Guangxu emperor (r. 1875-1908), Kang would lead the doomed movement known as the 100 Days of Reform (June–September 1898). In the meantime, though, Kang recorded his own, quite different impression of the city's lithographic enterprise. While making the rounds of the city's lithographic publishers, Kang reported, he was discouraged to learn that the only books selling well recently were model examination essays *(bagu wen)* and novels. Although undoubtedly marked by overstatement, Kang's anecdote suggests that, rather than promoting the modernization and innovation outlined by Bao Tianxiao, by the late 1890s Shanghai's capitalistic lithographers were stocking bookstore shelves with essentially the same texts as their competitors, the traditional woodblock printers.[3]

Although Bao and Kang appear to disagree about the creativity of Shanghai's lithographic business, both clearly suggest that lithography played an important role in the city's cultural history. Surprisingly, in light of these

and other surviving comments and evidence, Western analysts of Chinese printing and publishing have largely overlooked the need to reach an understanding of Shanghai's nineteenth-century lithographic industry.[4] The Western perception has been distorted by our awareness of the impact of letterpress printing on post-Gutenberg civilization. The persuasive arguments of writers from Lucien Febvre to Elizabeth Eisenstein have led us to overemphasize, at the expense of alternative trajectories, those phases of modern printing in non-Western parts of the world that conform to the central European narrative. Chinese experience with modern printing techniques makes passive acceptance of the Eurocentric narrative untenable, however.

Simply put, Chinese history changed course when Shanghai publishers, influenced by their own culture and history, began to place new demands on Western printing technology. The phase of technological development that distinguished China's, and especially Shanghai's, early Westernized printing industry was that involving lithography. Lithography provided the means by which the *Dianshizhai Pictorial* as well as books mentioned by Bao, Kang, and others were produced. At the same time, one must not lose sight of the fact that Chinese printers had a wide array of options available to them but chose to use lithography at the expense of other technologies.

Central to this chapter is the thesis that lithography was more than just a random foreign transplantation on the banks of the Huangpu River. Lithography should be seen as a compromise technology that Shanghai's Chinese printer-publishers selected as appropriate for their goals. Late-nineteenth-century Chinese publishers favoured it for three reasons: the relatively low initial investment required, the aesthetic appeal of the texts printed with it, and the limited changes in publishing outlook, particularly with regard to industrialization and textual aesthetics, that it seemed to demand of publishers. At the same time that lithography provided these opportunities, it helped to initiate industrialized print commerce and new forms of institutional organization in the Shanghai region.

Shanghai's lithographic printer-publishers were the first Chinese to buy significant quantities of foreign printing machinery, to set up printing plants, and to seek out a broad-based clientele willing to turn away from wood-blocked editions. The new technology enabled them to undersell woodblock publishers, to create a new market for innovative products, particularly reduced-size editions of works important to degree candidates, and to preserve the calligraphic component of original texts. All these accomplishments are modalities that letterpress printing techniques had failed to achieve. In this way, the Chinese lithographers supplanted Chinese woodblock printer-publishers and promoted a mechanized, Western-style form of printing to a wider Chinese audience.

Moreover, thanks in part to lithography, Shanghai began to emerge as a distinctive cultural centre in its own right. As Chinese lithographic publishing developed, the groundwork was laid for a minor local printing industry to become a major national publishing one. Most significantly, lithography helped to foster the Chinese identification of Shanghai with the technological innovation that underlies modernity. This identification stemmed in part from the lithographers' publications, in terms of both technique and content, but also from the new organizational and commercial forms that the lithographic industry brought to Shanghai's International Concession.

Although lithography was a worldwide industrial phenomenon in the nineteenth century, the conditions under which lithography was employed and the forms in which it flourished in China were unique to Shanghai. Its prosperity was closely related to the preponderance of reprints in China's commercial publishing industry. A nearly insatiable market demand for works deemed necessary for success on the triennial imperial examinations gave impetus to the reprint industry on which Chinese lithography was based. In addition, Viceroy Zhang Zhidong (1837-1909) called, in the 1880s, for wholesale reprinting of large collections of traditional works, an appeal that inspired both traditional and modern publishers. In an influential annotated bibliography, Zhang exhorted his contemporaries to public service, pointing out that "if a person can afford to do something worthwhile, but lacks prestige and scholarship, the best way for him to win a lasting reputation is to reprint old works."[5] Dependence on the reprint market also contributed to the economic and political vulnerability of the lithographers, however. The abolition of the traditional educational curriculum and of the civil service examination system in 1904-5 meant that, just as the necessary adjustments had finally been settled into, Chinese modernity was redefined with an emphasis on "new-style" learning and books that addressed political and social problems with reference to Japan and the West, rather than to China's ancient greatness.

To establish the full spectrum of dynamics set in motion by Shanghai's Chinese lithographic printers, and to reveal the impact of the industry on society, this chapter will provide profiles of the treaty port's most important lithographic publishers of the late 1870s, 1880s, and 1890s: Dianshizhai, Tongwen shuju (Tongwen Press), and Feiyingguan (Feiying Hall). By sifting through the details of Shanghai's forgotten lithographic "golden age," from 1876 to 1905, one can get a sense not only of the process by which woodblock printing disappeared from Shanghai but also of one of the ways by which Western machinery and print capitalism were adopted by the Chinese printing industry.

However, because these Janus-faced pioneers *unintentionally* laid the social, commercial, and industrial foundations for Shanghai's late Qing and early Republican capitalist printing and publishing industry, the industrial, social, and cultural history of lithography is just as important as the industry's technological development. Much like the contrasting views of Shanghai's lithographic industry left by Bao Tianxiao and Kang Youwei, the lithographic publishers faced forward and aft, effecting great socioeconomic changes while remaining essentially traditional themselves. During the golden age of lithography, the port's lithographic printer-publishers, just as much as better-known later Shanghai newspaper publishers such as Liang Qichao (1873-1929) and Yu Youren (1879-1964), initiated Shanghai's bid to dominate a new national market of readers, both high and low. From the 1870s to the early 1900s, the lithographic publishers were both more numerous and more influential than Shanghai's letterpress printers. Retail outlets and factories such as Dianshizhai, Tongwen Press, and Feiying Hall provided a beachhead for the Chinese printing industry of the twentieth century, and they are the key to understanding the origins of print capitalism and modern publishing in Shanghai.

Janus-Faced Pioneers: Shanghai's Lithographic Printer-Publishers

Furthermore, unlike Shanghai's nineteenth-century lead-type printing shops, which were either foreign-owned and produced articles of limited appeal to the Chinese reading audience or were run for state purposes, the city's lithography shops, with one important exception, were Chinese-owned and -operated private enterprises.[6] These firms were also the forerunners, organizationally and technologically, of the comprehensive Chinese publishing companies of twentieth-century Shanghai that produced later generations of well-known magazines.[7]

For example, to publish its own magazine, a firm such as the Commercial Press, which issued the *Dongfang zazhi/The Eastern Miscellany*, first had to grasp the value of lithography and to open a lithographic printing department along with its letterpress one. Without the social and technological background, it would be difficult to know why, or how, it did so. All Chinese-operated, early lithographic factories discussed here produced works that were sold commercially throughout China. Through the mechanization of their industry, the establishment of early printing factories, and the creation of a class of printing workers, these Chinese proprietors took the first step in the Westernization of Shanghai's Chinese printing industry.

Most people, when they think of the modernization of a national printing industry such as China's, naturally assume that lead-type printing must

have been the only foreign technology of choice. Viewing China's adaptation of Western printing techniques under both the influence of the Western narrative and the efflorescence of Shanghai's post-1895 book-and-newspaper publishing businesses, many have inferred that what came after had also come before. However, the success of Shanghai's letterpress industry in the post-1895 period should not be allowed to obscure the fact that, in the late nineteenth and early twentieth centuries, economically and socially, as well as culturally, letterpress printing was much less significant to China than lithography.

In light of the scarcity of sources for the pre-1895 period, a variety of alternative sources, approaches, and informed speculation becomes especially important in ascertaining the extent of the industry. By combining scattered information, we can make sound inferences about the importance of Shanghai's lithographers during the "golden age" from 1876 to 1905. In what follows, the European background to Shanghai's lithographic efflorescence will be reviewed to suggest continuities between the two. In the next section, discontinuities between Europe and China, and between xylography and lithography, both influenced by Chinese choices, will be highlighted.

An important industry, still largely ignored by researchers, underlay nineteenth-century Europe's well-known fascination with lithographic publications. Lithography arrived in France, for instance, around 1800, only a year after Alois Senefelder finished inventing it and in the same year that he gained a British patent for the process. By 1838, there were 262 lithographic firms in Paris alone, including one founded by Senefelder, and 634 in the provinces, for a total of nearly 900 firms.[8] Almost immediately after its arrival in France, lithography was put to work producing political journals, many of them under the ownership of the radical republican, Charles Philipon.

Between 1800 and 1830, eleven new lithographed political journals appeared in France. Such publications came into prominence only during and after the Revolution of 1830, when satirical journals such as the short-lived but influential weekly *La Caricature* (1830-35) and its sister publication, the long-lived daily *Le Charivari* (1832-1937), appeared. Both were partially owned by Philipon, who had a share in seven others as well. He employed some of the greatest illustrators of the age, including Honoré Daumier, and he also worked with Aubert, Paris's most prominent lithographic print shop.[9] In time, the visual potential of lithography led illustrators and artists to strike out on their own, and lithography assumed the profile that it has today as an artist's medium, largely independent of printed textual matter.

Senefelder conveyed lithography to England at the same time that it was expanding in France. Half a century later, in London alone, lithographers made up the second most numerous category of print shops after general

printers; this situation prevailed until 1900. In roughly the same period as Shanghai's golden age of lithography, the number of London lithographers grew from 412 (in 1876) to 488 (in 1896) and then declined slightly in 1900 to 462.[10] As in France, in Britain lithographers put the stones to work printing various categories of illustrated magazines and newspapers.

In Britain, however, such works never became as popular as they were in France. The best-known early British illustrated magazines, such as the *Illustrated London News* (1842-present), *Punch* (1841-1992), etc., used woodcut rather than lithographically printed images, at least until photography took over in the 1870s and 1880s.[11] As a result, in Britain, and almost simultaneously in America, instead of appealing to an elite of political radicals, as did French lithographers, lithographic publishers developed a broad market for less explicitly political, occasionally humorous, lithographed newspapers.[12] The earliest of such works was issued fortnightly in 1825-26 and combined prominent illustrations with short textual passages, a layout that directly anticipated Shanghai's *Dianshizhai Pictorial*.[13]

In Britain and America, lithographed newspapers and pamphlets that combined illustrations with text continued to appear until the end of the nineteenth century. Just as notable, however, were individual lithographs issued by magazines such as *Vanity Fair* (1868-1914) and, in particular, by travel writers and publicists. One of the first travel writers to issue such works was the Scotsman David Roberts who collaborated with the prominent lithographic illustrator, Louis Haghe, on Roberts's *Egypt, Syria, and the Holy Land*.[14] This monthly work was issued from 1842 to 1849 to a select list of 600 subscribers, thereby satisfying the yearnings of armchair travellers for lithographs of foreign lands, curiosities, and exotica.

In the United States, Currier and Ives of New York (1834-1907) was a standout firm that filled a similar hunger for pictorial accounts of faraway events. Indeed, Nathaniel Currier was one of the first to grasp the commercial value of linking illustrations and current events. Initially selling pictures of fires, shipping tragedies, and other local disasters, Currier's business hit the jackpot in 1846 when his artists began to illustrate the Mexican-American War (1846-48), the first and last American war to be visualized solely via lithographs.[15] The firm's success in what was then a highly competitive field enabled it to employ large numbers of recognized illustrators.[16] After first working out the illustrations on lithographic stones, Currier and Ives's artists passed their prints on to legions of young girls, deployed in assembly-lines, to colour in the prints by hand. The New York firm, after branching out into a variety of other illustrational fields, continued this division of labour right to its end in 1907, when new printing technologies and a change of personnel combined to put the firm out of business.[17]

In addition to illustrating the news, lithography was used to print entire books. In Britain, in 1863, Colonel Sir Henry James of the Ordnance Survey Office, Southampton, completed a thirty-five-volume reproduction of the Domesday Book. Subsequent British antiquarian projects were so successful that, by 1880, lithography had become the technology of choice for facsimile reproductions. In the view of Michael Twyman, five categories of books now began to be created using lithography: (1) works produced in limited numbers for noncommercial use, most of which were illustrated; (2) in-house publications, particularly instructional or reference manuals such as those used by the military; (3) "works requiring considerable use of non-[L]atin characters that were not available from letterpress printers"; (4) "collections of *facsimiles* of early printed books"[18] (emphasis added); and (5) works that used lithography simply because of the excitement that the new process fostered.[19]

With modifications, this set of five categories characterizes the books produced by Shanghai lithographers. Broadly speaking, lithography in Shanghai was used to produce illustrated and instructional works, some of which were new, most of which were reprints, and all of which employed non-Latin characters. In addition, the Chinese proprietor of Shanghai's Tongwen Press was one of those attracted to lithography thanks partly to his excitement over the new process.

Two missionary schools stand out as the cradles of China's first generation of Western-style printers. Chronologically, the first was the Qingxin Hall School established in 1861 by the New York Presbyterian missionary and printer-publisher J.M.W. Farnham (1829-1917). Of greater significance for the growth of the lithographic industry in Shanghai, however, was the impact of printing instruction at Xujiahui's Tushanwan orphanage run by the Jesuits. Shanghai's lithographic printing began in the print shop there in 1876;[20] it quickly spread to Nanjing Road, thanks to English merchant Ernest Major (d. 1908).

Major, founder of Shanghai's Chinese-language newspaper, *Shenbao* (1872), initiated the commercialization of Shanghai's lithographic publishing operations when he opened the publishing house affiliated with his newspaper, Dianshizhai, which began publishing book reprints in 1877. Before Major arrived in Shanghai in 1859, he had run a silk filature in Italy. Although documentation is lacking, it is reasonable to suppose that, while in Europe, Major probably encountered continental lithographed newspapers and journals of the sort that the French had been producing since early in the century. Another influence on him would have been the lithographed journals and books of his native Britain. British publications possibly appealed to the international entrepreneur for their relative lack of savage political

content and their emphasis on book reprints, current events, and exotica, all of which must have suggested possibilities for Major's Shanghai publishing operations.

Among Major's employees, the lithographic artist Wu Youru (1840?-1893?) was chief illustrator of the *Dianshizhai Pictorial*. Wu's drawing of the Dianshizhai print shop and its machinery was mentioned at the end of the previous chapter. Wu, a native of Suzhou, may be regarded as the Daumier of Shanghai's lithographic illustration business. Wu embarked on his career via an apprenticeship preparing inexpensive calligraphy and paintings for sale to local peasants in his native city's Yunlange Mounting Shop.[21] The local painter Zhang Zhiying recognized the talent informing Wu's sketches and began to promote the young man's career. Local gentry quickly drew parallels between Wu and the well-known Ming painter, Qiu Ying (c. 1498-1552), whose early life, like Wu's, was overshadowed by poverty.

Thanks to a recommendation from Zeng Guoquan (1824-90), the younger brother of Viceroy Zeng Guofan (1811-72), who had vanquished the Taiping rebels at their capital of Nanjing in 1864, the Qing court granted Wu an extraordinary honour, inviting the artist to Beijing to paint *Zhongxing gongchen tu* (Images of Meritorious Officials of the Post-Taiping Restoration). Upon his return to the Jiangnan region, Wu converted his imperial accolade into a commercial opportunity when he took charge of illustrations for Shanghai's new lithographed journal, Major's *Dianshizhai Pictorial*. There Wu and Zhang worked together. Like Daumier, who led a group of outstanding illustrators working for the publisher Charles Philipon, Wu began his work for the *Dianshizhai Pictorial* with a staff of eight assistant illustrators.[22]

The *Dianshizhai Pictorial* disseminated Wu's illustrations to readers from 1884 to 1890, when Wu left the firm (the journal continued to appear until 1898 without his direction). Wu also got involved with other lithographic publications, such as *Shenjiang shengjing tu* (Scenic Spots of Shanghai), mentioned in the previous chapter. Around 1890, he began to issue his own *Feiyingge huabao* (Feiyingge Pictorial), a lithographed magazine that closely resembled the *Dianshizhai Pictorial*. Wu hired his old patron and colleague, Zhang Zhiying, to assist him with his new magazine.[23]

By August 1893, Wu had changed the name and format to *Feiyingge huace* (Feiyingge Album) and devoted the short-lived new series to illustrations alone, executed in the traditional format of line drawings *(danxian baimiao)*. Where the *Dianshizhai Pictorial* was characterized by illustrated and captioned news stories, Wu's own *Feiyingge Pictorial* eliminated news and current events, catering instead to conventional Chinese interest in traditional stories, pictures of famous beauties, and boudoir scenes with text.[24] The *Feiyingge Album* died with Wu in 1893.

Gong Chanxing, in one of the most provocative of the short studies of Wu Youru available, quotes from the *Feiyingge Album*'s Foreword to explain why Wu issued the new publications. Wu launched the *Feiyingge Pictorial*, Gong says, to provide the *Dianshizhai Pictorial* with some competition. After three years of operation, however, in 1893, Wu changed his objective and terminated publication of the *Feiyingge Pictorial*. The new *Feiyingge Album*, as an illustrated journal, was intended to provide Wu with an artistic outlet rather than to stimulate competition with his former employer, and, in Wu's view, it was more closely aligned with the book world than with periodical culture.

> I received a kind letter from a reader of the paper which raises [the issue] of my news illustrations. They [news illustrations] are like trying to write examination poems. Even if you try really hard to hit the meaning, in the end you have to drop it because of time limits, and it is very hard to hand them down [to later generations]. But if you illustrate books, as with famous authors' works, you can reveal a new aspect [of them], yielding unique thoughts and providing a [new] starting place. Why not start over and follow new tracks, discarding the weaknesses [of illustrated periodicals], and adopt the strengths [of the *Feiyingge Album*] assisting like-minded persons in their aims?[25]

Using an analogy that would have made immediate sense to his educated audience, Wu compared the restrictions imposed by news illustrating to examination writing. He also revealed his preference for "unique thoughts," an allusion to a literati fantasy of life unencumbered by official duties. Indeed, the artistic topics covered by the *Feiyingge Album* suggest that Wu was seeking access to the Chinese reader who was concerned less with the print commodities of news or entertainment than with traditional literati interests in brushwork and scenery.

Predictably, the Shanghai lithographers' publications fell into two broad categories, ephemera and books, that paralleled the French, British, and American lithographic business.[26] Periodicals such as the *Dianshizhai Pictorial*, although more durable than other forms of ephemera, such as newspapers, calendars, maps, brochures, pamphlets, and advertisements, were short-lived unless they were outstanding examples of their genre. Lithographed newspapers, such as Liang Qichao's (1873-1929) twenty-page semiweekly *Shiwubao* (Chinese Progress, founded in 1896), have been preserved thanks only to their political importance.[27] Books, of course, were of greater durability and longevity than either periodicals or ephemera,[28] and it was with books that Shanghai's Dianshizhai had gotten its start.

Introducing Lithography to Shanghai

Between 1842, when Shanghai was first opened to Western traders and missionaries, and the 1870s, Shanghai's Chinese commercial printing industry was small-scale and dispersed throughout the Nanshi (old Chinese city). Surviving sources do not describe it in detail.[29] Just as earlier in the Qing, technology was limited to woodblock duplication of texts that ranged from the literary to the popular. There was also a thriving business, centred on the Old Parade Ground (Jiujiaochang) inside the North Gate, involved in the preparation of *nianhua*-style (New Year's picture-style) playbills, a genre that came to Shanghai from Suzhou probably during the dislocations of the Taiping period.[30]

The duplication of books depended upon access to what are known in the European manuscript tradition as exemplars, already-existing texts of recognized and acceptable quality and accuracy.[31] Along with access to ample supplies of wood, ink, and paper, woodblock printers needed a sizable editorial library of accepted exemplary texts. The exemplar system persisted with the arrival of lithography. The lack of supplies, both material and textual, as well as the vigour of nearby publishing centres such as Suzhou and Hangzhou, limited the scale of Shanghai's woodblock printing industry prior to the Taiping Rebellion (1851-64).[32]

Even thirty years later, in 1894, in terms of both investment value and the numbers of workers employed, Western-style printing and publishing of all kinds were only a minor contributor to Shanghai's economic activity. Investments in the paper and printing industries, not including Major's *Shenbao* newspaper, equalled only 1,250,000 taels, about 10 percent of all investments in light industries.[33] The number of workers employed in the paper and printing industries was even less significant when compared to other light industries such as brick-, tile-, or even ice-making, not to mention woodworking and cigarette manufacturing.

Nonetheless, in Sun Yutang's view, there were 1,300 workers in seven of Shanghai's Chinese lithographic shops by 1894, 430 more than there were letterpress printers in *all of China* (including Shanghai) in both Western and Chinese firms.[34] Sun's figures do not include forty-five additional lithographic publishers that I have determined were founded by 1894 but that Sun overlooked.[35] If Sun is correct in assuming that each shop employed 150 to 200 workers,[36] then a conservative estimate of 150 employees for each of the undiscovered forty-five additional publishing firms would boost his figure to 8,050, yielding a total of 7,180 more lithographic printing workers in Shanghai alone than there were Chinese letterpress printing workers in all of China, *including* Shanghai, in 1894. Conversely, it is highly conceivable

that these forty-five additional shops either hired out their printing or had only one machine apiece and employed only the three to eight workers necessary to run it. In any event, there were at least 430 more workers in the Shanghai lithographic industry in 1894 than there were in the entire Chinese letterpress enterprise, a suggestive indicator of its economic importance at that time.

Given the fact that the lithographic shops, when they appeared in the 1870s and 1880s, were in direct competition with the xylographic printers in the reprint business, one may conclude that lithographers, along with letterpress printers in a later era, contributed to the displacement of the woodblock industry. In fact, in this period, this displacement occurred in two sectors, prices and employment, but it is still not clear how prices and employment were related.

Regarding prices, Shanghai's lithographic establishments, unlike the local woodblock enterprises, were able to produce long runs of high-quality works relatively quickly and cheaply. According to a January 1889 article in the *North China Herald*, "the extension of photo-lithographic [photographic projection onto stone] establishments in Shanghai, which have been pouring out native books almost by the million, has been disastrous to the native [woodblock] book trade ... after the autumn examinations many of the [native] book stores had to close their doors."[37] The article goes on to state that inexpensive lithographic books were available throughout the empire and that woodblocked editions could not compete in the markets patronized by examination candidates.

Five months later, in May 1889, the *North China Herald* printed a three-column article profiling Shanghai's lithographic industry, leading off with the comment that "the printing of Chinese books in Shanghai by lithography is rapidly becoming an extensive branch of trade." One press could turn out so many printed sheets, so rapidly, "that Chinese capitalists [sic] find it profitable to invest money in this enterprise." What's more, "the cheapness of the books thus produced is a great recommendation in a country where reading is a very common accomplishment."[38]

In another instance, a *North China Herald* article records that the newspaper had recently acquired a "very neatly got up map" of the Shanghai region produced in a Chinese merchant's lithographic shop at 627 Hubei Road and printed with English place names. The commentator goes on to observe, "That such an excellent work should be issued from a Chinese lithographic establishment is a very convincing answer to those who assert that the Chinese have made little or no progress in the peaceful arts of the Western 'barbarians,' for the work in question might have been, as far as external appearance goes, issued with credit by any firm at home."[39] The

newspaper reporter praises the draftsman's understanding of distances, directions, and the spelling of place names. This map, intended for foreign sportsmen and travellers in the country around Shanghai, came in the wake of a coloured map of Shanghai's urban districts produced by the same shop a month before. That earlier map "would have been perfect if the names of the streets had been added in English";[40] that the publisher then accommodated the *Herald*'s opinion by printing the second map in Chinese and English suggests that the firm was seeking a more cosmopolitan clientele.

Half a year later, the newspaper's tone had become less condescending. By way of praise for the lithographers' development of the miniaturization market, the *North China Herald* observed that reduced-size lithographic publications appealed most strongly to examination candidates and students: "The buyers of these lithographed editions are students who have young eyes and read fast. To them broad margins and large type are no advantage and they prefer to have books in portable boxes suited for travelling. All students have to travel and they like to take books with them ... Most of the printing done is extremely small in size and the wonder is that so many persons should be willing to buy what it needs magnifying power to read with comfort. Yet at present these institutions [publishing houses] have the appearance of busy prosperity."[41] The lithographers' successful exploitation of the markets identified by the *Herald* eventually brought them to the attention of the missionary publishers, who were concerned with the issue of prices as well.

In 1890, the Reverend Ernst Faber (1839-99), stationed in Qingdao, shocked the General Conference of the Protestant Missions of China, held in Shanghai, with his observation that Protestant publications were now inferior to those produced by Chinese publishers using Western technology: "[W]e have to acknowledge the fact that the printing done by some Chinese establishments is, by the use of modern processes, ahead of our mission presses ... Our illustrations are still very defective ... [O]riginal Chinese pictures ... cannot be obtained before lessons in drawing ... are better attended to in mission schools. Block-cutting, wood-engraving, lithography, zincography [i.e., photolithography], etc., should be taught to Christian boys in connection with the mission presses."[42] Faber went on to praise the Roman Catholics for their superiority in producing block-cutters, lithographers, photolithographers, etc., that is, workers in the chief Chinese printing media of the day.

Faber's comments incited Gilbert McIntosh, a Scot, erstwhile superintendent of Shanghai's American Presbyterian Mission Press (APMP) printing plant, and at that time associated with the Society for the Diffusion of Christian Knowledge (Chinese, Guangxuehui), to reply, "I would like to

refer to what Dr. Faber has said in his paper with regard to the printing by some Chinese establishments being, 'by the use of modern processes, ahead of our mission presses.' I think this superiority is largely attributable to the use by the Chinese of photo-lithography, which is well-adapted for many kinds of Chinese works."[43] McIntosh, himself a printer, directly attributed the superiority of Chinese publishers' work to their implementation of photolithography, which the Scotsman acknowledged was "well-adapted" to the kinds of works that Chinese publishers wanted to print. Moreover, like Faber, McIntosh believed that lithography placed Shanghai's Chinese printer-publishers ahead of the missionary houses in some major fields of printing.

McIntosh went on to comment that the cost of photolithographing books would have necessitated retail prices above missionary rates. At the same time, profits gained from the sale of these works produced by photolithography made it possible for capitalistically inclined Chinese to import a "quantity and quality of [printing] goods ... from Western lands ... so as to make a missionary printer feel envious."[44] The only lithographically printed works not sold at prices unacceptably high in missionary eyes were those that were "for idolatrous and superstitious purposes, and those which [have] a directly immoral tendency"[45] but were in great demand. In other words, Shanghai's capitalistic lithographic publishers were using the vast Chinese marketplace of earnest civil service aspirants and other, more frivolous readers seeking sexual titillation to underwrite their purchase of foreign printing technology.

The APMP, at this time still the most vigorous of the missionary publishers, quickly acknowledged the truths contained in Faber's and McIntosh's comments. In the APMP's *1891 Annual Report*, the editors commented that "printing offices and consequent competition have multiplied among the Chinese, and ... photo-lithography has been much utilized."[46] In the same publication, the APMP complained of Chinese piracy of its works: "A notable feature of the past year and characteristic of the growing desire for light and the native endeavor to get some financial benefit from it, has been the reproduction by the photo-lithographic process of a number [of] education works, originally printed at the [APMP] ... [S]uccessful attempts have been made to restrain this unauthorized reproduction, [not from] desire to limit the issue of good books, but to make it impossible for books to be issued from native presses containing a large part of western learning with the application left out."[47] The reference to "financial benefit" is striking confirmation that, by the early 1890s, Chinese printer-publishers were lithographing books of all sorts, whether Chinese- or Western-language, for profit; at the same time, one is left wondering which Chinese lithographers reproduced what were probably textbooks at the foreign publishers' expense.

In addition to textbooks, the Chinese lithographers issued semi-pornographic publications that led missionary publishers to the conclusion that Western technology was being misused, possibly with the malfeasance of Shanghai's concession police. The missionary Reverend Ernest Box, for one, lumped the periodical *Dianshizhai Pictorial* into the same class as a journal called *Qinglou huabao*, known in English as the *Illustrated Brothel Newspaper*. This latter paper was issued from a lithographic shop on Fuzhou Road, close to the concession's Central Police Station and in the midst of the city's entertainment district.

Box's hostility to the lithographed magazines produced by Chinese residents of the International Concession was not representative of the Western community's views, however. In fact, many Westerners, including other missionaries of that era, had genuine respect for the accomplishments of the Chinese lithographic craftsmen and actually did more to publicize lithography as a viable industry than did Chinese lithographers themselves. Even Box, outraged by "a few papers ... circulated chiefly, though not exclusively, in Shanghai [that] depend for their success on the skill which they display in pandering to the vicious tastes of a section, not small, we fear, of the native community,"[48] must nevertheless be acknowledged for bringing these papers to the attention of historians.

Inexpensive lithographic book pricing undermined Chinese xylographers and even missionary letterpress printers. In 1889, the *North China Herald* commented that a *Kangxi Dictionary* cost from $1.60 to $3 in lithographed versions and from $3 to $15 in xylographed ones.[49] The threat to xylographic printers continued into the early twentieth century. A book catalogue, one of the earliest surviving sources of its kind, issued by the woodblock and lithographic publisher Saoye shanfang in 1917, reinforces views advanced by the *Herald* and missionaries Faber and McIntosh that lithography lowered the selling prices of books relative to those formerly printed with woodblocks.[50] An ancient publisher from Suzhou forced by the Taipings to flee to Shanghai about 1860, Saoye shanfang opened its new office on Caiyi Street in Shanghai's old Chinese city while retaining its head office in Suzhou.[51] Around 1898, it acquired lithographic presses. By 1917, there was a second branch of Saoye shanfang in Shanghai on Henan Road at the corner of Canton Road, a third in the neighbouring city of Songjiang, and a fourth up the Yangzi River in Hankou. The firm also did business by mail throughout China and abroad. It survived until at least the early 1940s. In 1917, however, Saoye shanfang was printing and publishing some 490 titles lithographically. Some of the best known were collections and annotations of old poetry, tales of wonder, novels, calligraphy models and manuals, compendia of the epistolary arts, and medical works.[52]

Prices for all categories of books listed in the catalogue are clearly recorded. In the first section, which lists small collections containing from two to twenty volumes *(ce)*, prices start as low as fifteen cents (one mao five fen) at a time when noodle soup in a cheap Fuzhou Road restaurant nearby cost forty cents, wonton noodle soup cost sixty cents, a *jin* (1.3 pounds) of ham cost four mao four fen, and a whole duck cost seven to eight mao.[53] Most Saoye shanfang prices did not reach even one Chinese dollar (yuan), and only a very few went as high as five dollars; one or two items cost twelve or fourteen dollars. Section two of the catalogue has a few more expensive items, but prices such as thirty-two yuan for 204-*ce* sets were rare. The well-known litho-graphic illustrator Wu Youru's works were already being reprinted in 1917, one finds, and were not cheap at sixteen yuan. Dianshizhai and Shizhuzhai (Ten Bamboo Studio, a firm that recycled the name of the highly esteemed seventeenth-century Nanjing art publisher) collections of illustrations were also available (at two yuan five mao and one yuan two mao, respectively).

Woodblock editions in section three of the catalogue were uniformly more costly than the lithographed ones listed in sections one and two. There were almost no prices less than one yuan, and many cost from five to ten yuan. The highest woodblock price was 160 yuan for a 480-*ce* collectanea *(congshu)*, and there were several others for ninety, sixty, fifty, forty-eight yuan, and so on. From this price list, there is no doubt that lithographed books were generally cheaper than woodblock ones. Still, neither traditional xylographic works nor modern lithographic books were within the reach of the very poor; Saoye shanfang's lithographers, like its woodblock printers, catered to the reasonably well-off, especially to those with more than a passing tradi-tional literary culture. Benefiting from reduced prices and mass production made possible by mechanization, however, the lithographers were able to undermine the traditional industry and widen their own market share with this clientele.

Thus, it is clear, whether seen from the perspective of *North China Herald* reporters or from that of a Chinese publisher heavily invested in both xylo-graphy and lithography, that, when it came to pricing, lithography ben-efited the consumer. In doing so, it also financially underwrote the expansion of lithography. The second level on which Western lithographic processes undermined Shanghai's traditional woodblock printing industry was through their effects on the labour force. Lithographers needed many of the same kinds of employees as the xylographers and could pay them better. Calligra-phers, for example, were needed by both. In its May 1889 article, the *Herald*'s longest on the lithographic industry, the reporter indicates at least one rea-son why calligraphers, practitioners of the literati art par excellence, may have abandoned their former employers in the woodblock industry:

[An] advantage [of lithography] is that the beauty of good writing is better preserved on stone than on carved wood. Writers exceptionally competent are employed by the lithographers to write copy, as [they are employed] by the wood engravers. But in xylography much of the smooth elegance of curves is sacrificed. Notwithstanding this loss ... professional writers may, when they have established a name, earn four or five taels a day by writing prefaces for new books cut on wood ... In Chinese printing a main object must always be to preserve as far as possible the beauty of writing. Consequently lithographers must pay handsomely the writers who have good natural gifts allied to those of the painter.[54]

By the time these articles were written, Shanghai's lithographic business was already mechanized and highly commercialized, and, in a curious juxtaposition of Western technological modernity and Chinese cultural tradition, calligraphers had become part of this capitalist, profit-oriented industry, lured by both financial and aesthetic incentives.

In 1894, the year the First Sino-Japanese War intensified China's sense of national crisis and enlarged the Chinese appetite for speedy publication of international news, the Shanghai lithography shops clearly exceeded the early Chinese letterpress print shops in scale, output, and number of employees. Under the impact of political and educational change after China's disastrous defeat in the war (1895), however, the growth of Shanghai's letterpress industry began to outpace the lithography industry.[55] Although it is possible, using bibliographic information, to identify another forty-five firms established between 1894 and 1905 for a total of ninety-seven Chinese lithographic firms active during the golden age from 1876 to 1905, conclusive information enabling us to ascertain with any certainty the total number of firms that ran their own printing shops has not come to light.[56] We do have such details for seven of the ninety-seven firms. Information is most complete for the following three: Dianshizhai, Tongwen Press, and Feiying Hall. In the absence of extensive documentary evidence, an intensive look at these three establishments provides a microcosm of this industry that shows how it developed and flourished between 1876 and 1905 and how its impact was felt. This survey also suggests why lithography became relegated, after 1905, to specialty publishing, employed for inexpensive works of fiction and also for illustrated works such as medical books, magazines, and printed advertisements such as posters, calendars, packaging labels, and cigarette trading cards.[57]

Perhaps as a result of the explosion of the letterpress industry that produced most of the thirty-two new Shanghai-based newspapers and thirty-four new Shanghai magazines that appeared after China's loss to Japan in

1895,[58] already by 1897, as suggested by Kang Youwei's statement, lithography had become stuck in a rut. Just as lithography had once replaced the woodblock printing trade, it too was now being overwhelmed by Shanghai's new lead-type and letterpress industry. Where did the Shanghai lithographers go, and why, in the eyes of many, did they seem to disappear? This question can be answered only by looking more closely at the conditions of the time.

The Dianshizhai Lithographic Bookstore, Its Market, and Its Influence

The Dianshizhai Lithographic Bookstore and print shop, an offshoot of the *Shenbao* newspaper operation, initially produced book reprints, a sensible marketing decision in keeping with the traditional vein of the Chinese printing industry but one that involved a break with its ancestry in the newspaper business. Where missionary publishers had tried, with varying degrees of success, to maintain their *non*profit stance, the printing technology that they developed over the course of the nineteenth century was quickly put to use by Western merchants investing in the profit-driven newspaper business. After purchasing Chinese fonts from the APMP or the London Mission Press, for instance, merchants set out to profit from them. At the same time, they helped to adapt missionary printing technology to secular Chinese-language purposes. Between 1815 and 1894, as one scholar has written recently, about 150 "foreign-managed, foreign-language newspapers" were created, along with 70 "foreign-managed Chinese-language newspapers."[59]

Ernest Major's *Shenbao* was the leading light among the "foreign-managed Chinese-language" newspapers that aimed to turn a profit from their Chinese fonts. At approximately the same time that Major and his compradore Chen Huageng (Shengeng) founded Dianshizhai, he also opened a second book-publishing firm known as Tushujicheng qianyin shuju (Tushujicheng Metal-Type Publishing Company) and a calligraphy and painting shop known as Shenchang shushi (Shenchang Calligraphic Studio) (for a view of both the Shenchang and *Shenbao* buildings, see Figure 2.1).[60] Dianshizhai, a Sino-British hybrid, run, like the newspaper, by its Chinese staff, evolved through several different stages before closing in 1898. It was one of the first casualties in the reorganization of the commercial printing and publishing business that took place in the wake of China's defeat in the Sino-Japanese War. *Shenbao*, eventually sold to Chinese investors, remained one of Shanghai's leading newspapers until 1949.

Two contemporary illustrations suggest that Dianshizhai, at least architecturally, represented a fairly radical departure from traditional Chinese publishing activities. The first (Figure 1.27), a line-drawing interior view published in Wu Youru's album, *Scenic Spots of Shanghai*, depicts Dianshizhai's printing plant at the corner of Nanjing and present-day Xizang Roads. The

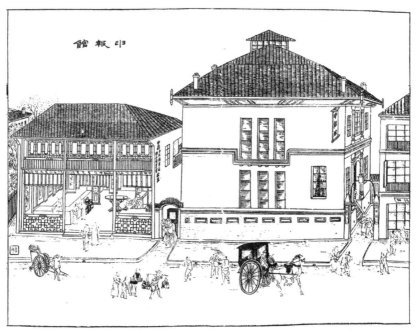

Figure 2.1 Shenchang Calligraphy Studio (left) and *Shenbao* newspaper office (right), 1884.
Source: Originally in Wu Youru, *Shenjiang shengjing tu, juan xia* (1884), reprinted from Zhang Jinglu, ed., *Zhongguo jindai chuban shiliao, er bian* (Shanghai: Qunlian chubanshe, 1954), opposite 361.

purpose of the picture is obviously to show off the machinery. Five hand-rotated flatbed photolithographic presses are shown in exquisite detail, each with a complement of six or seven male workers. Workers are also shown unpacking and moving lithographic stones, preparing stones for printing, and printing on small two-man presses. Altogether, over fifty Chinese workers can be seen.[61] At least fourteen limestone tablets are shown piled on the floor; in the lower right corner, five have been readied for printing and are carefully stacked. Reams of paper and paper presses complete the work scene.

Despite the distorted perspective, scrutiny of the work site itself makes clear that this is a spacious structure. The artist has paid much less attention to the building's structure than to the machinery filling it. In fact, the roof of the building seems to have been almost an artist's afterthought, a protective tarpaulin pulled up belatedly over the machinery. The large-paned windows suggest that this building is essentially of Western factory-style design. Interior pillars hint at a Chinese design, although such pillars were also a common feature of Western commercial and industrial interior design in the late nineteenth and early twentieth centuries. The giveaway that it is Western is the skylight in the right corner.

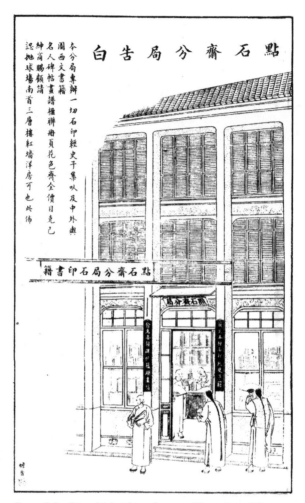

Figure 2.2 Dianshizhai branch store (Hongqiang Western
Building), corner of Nanjing and Xizang Roads, Shanghai,
c. 1880s.
Source: Dianshizhai Pictorial (Canton: Guangdong Renmin
chubanshe, 1983), volume *si*, 73.

 Another illustration (Figure 2.2), drawn by a different artist and origi-
nally published in the *Dianshizhai Pictorial* as a kind of advertisement, pro-
vides a frontal view of one of Dianshizhai's retail branch outlets in Shanghai.
On the one hand, this picture reinforces the sense of a break with Chinese
tradition that one experiences when encountering Shanghai's lithographic
publishers through the architecture that some of them chose to employ.
Housed in a three-storeyed, Western-style colonial building,[62] the branch
store has two large display windows and a central entrance at the top of a

two-step threshold. Western-style transoms ventilate the store from the street. The upper two floors are tightly shuttered.

On the other hand, above the door is a wooden tablet *(fang'e)* bearing the shop's name in Chinese fashion. The Chinese proprietor, seen through the open doorway, is either wrapping up a purchase for an unseen customer or consulting an old-fashioned string-bound volume; traditional Chinese-style bookcases with horizontally stacked volumes are displayed to his right, left, and rear. The obviously Chinese books on their shelves reinforce the viewer's sense that the building itself is an import. Well-to-do, and exclusively male, Chinese customers, holding fans and wearing long gowns and Manchu-style queues, complete the setting and undermine the viewer's sense that this is a drastically new world.

Turning to the illustration's inscription, one finds that it amplifies the commercial messages framing the doorway. Phrased in the formal idiom of nineteenth-century Shanghai commercial announcements, it declares, in an appeal to the chief readership market of late Qing China, literati, but also, strikingly, to merchants, "This branch store specially provides lithographed Classics, Histories, Philosophical works, and Compilations *(jingshi ziji);* Chinese and foreign maps; Western-language books; tablet rubbings, painting manuals, pillar scrolls, painting and calligraphy albums, [all by] notables and of various kinds. This firm's entire price list is reasonable. Gentry and merchants are invited to patronize it. Be aware [of this shop located at] the southern corner of the sports ground in the three-storey building [called] the Hongqiang [Red Walls] Foreign Building. So it is. This [announcement] is for your information."

All in all, the advertisement combines the old and the new in an interesting way. In addition to recommending lithographed merchandise to literati and merchants involved in traditional arts and intellectual pursuits, it promotes the firm Dianshizhai itself by emphasizing the firm's Western-style, three-storey edifice. This aspect of the advertisement is presented with the clear intention of enhancing the appeal to its patrons,[63] even to those clothed in long gowns and queues.

Figure 2.3, like Figure 2.2 originally published as a *Dianshizhai Pictorial* advertisement, depicts the branch store located on Hankou Road (Sanmalu), south of the "big foreign church," around 1890, and its multiple services to the reading public.[64] At the right of the advertisement can be seen an image of the branch store itself. In contrast to Figure 2.2, Figure 2.3 shows a more thoroughly Chinese environment. This illustration exhibits a Chinese-style, galleried building with calligraphic store signs, piled sets of books, and other printed publications along with painting scrolls. Again the patrons are exclusively Chinese men wearing scholars' gowns and queues. The caption

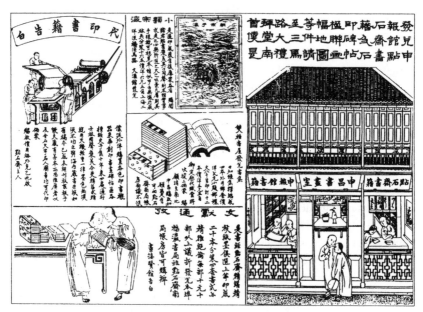

Figure 2.3 Dianshizhai advertisement for lithographic printing and publishing, Hankou Road branch store, Shanghai, c. 1890.
Source: Don J. Cohn, *Vignettes from the Chinese: Lithographs from Shanghai in the Late Nineteenth Century* (Hong Kong: Chinese University of Hong Kong Press, 1987), back cover.

over the picture of the building alerts readers to merchandise that includes Dianshizhai's familiar stock of books, stele rubbings, pillar scrolls, paintings, maps, and other printed matter.

Despite the modern, Western appearance of both the printing presses and the printing plant, Dianshizhai's retail environment and market were clearly Chinese. Existing within the broader Chinese environment as they did, those who worked among these presses and the sales inventory certainly brought their inherited worldviews to work. Merely having the presses and the buildings did not necessarily "Westernize" or "modernize" the value system of those active in this new world of foreign printing presses. Their means of expression remained, in many if not all cases, firmly rooted in the Chinese world from which Shanghai's printers and publishers came. Having one foot in each of two different worlds, such persons were typical of the Janus-faced nature of the industry.

For example, Wu Youru, one of the most prominent beneficiaries of this new lithographic publishing industry, conformed to the conventional literati predilection for writing poetry about everyday events as a means of revealing his subjective response to the lithographic press. Drawing a picture in words, Wu anticipated the efforts of Ge Gongzhen (1890-1935) and others in the 1920s to show how Western printing devices could be made

part of the Chinese mental landscape. Wu refers poetically to the place of Western printing technology in China's historical literary civilization:

In olden times, texts of the Classics were all engraved on stone
 [tablets or steles],
Meng of Shu [Sichuan] started to use wooden blocks [for printing];
Now, though, we've moved on to something even more amazing,
Again, based on the surface of stones, we've created a new model;
But [now] there's neither a need for polishing nor for cutting,
No need to engrave blocks or to carve pictures,
Red and black characters are imprinted in an instant,
With a supernatural workmanship that is completely effortless.[65]

Expressing an increasingly common viewpoint of his day, a time when Chinese were starting to become aware of the outside world, Wu seems to be saying that the lithographer's stone was not really something new in China; it had been anticipated by numerous advances in China's long cultural history and was thus a technology with which the Chinese were already somewhat familiar. On this dubious basis, Wu deems lithography suitable for the Chinese context.[66]

Even more striking, however, is the fact that Wu, with years of experience in the lithographic illustrating and publishing business, resorted to a conventional poetic idiom to express his views on this new industrial process. A veil of literati culture with its own poetic idiom seems to have been suspended between Wu's eyes and the new, imported industrial process, leading Wu to conclude that it was essentially a Chinese process, not a foreign one at all. Although he himself was a master of the process, it is as if the language to enable him to present the process to readers as new, but acceptable, had not yet been invented.

Wu's words also reveal the continuing cultural hegemony of the literati view of commerce. Having presented his poem praising the lithographer's stone, Wu offers the following qualification in prose: "Go hunt up the documents to hand over to the auspicious stone. Why reckon [the cost of] 'changing stone into gold' [*(dianshi chengjin)* if] it can benefit a vast number of later generations?"[67] Implicit in this comment is his awareness of the cost of setting up a lithographic publishing house. Although he provides no particular details, it is clear that, in his mind, a publisher had to find some way of balancing receipts from sales of books with the greater good – namely, the Confucian duty to promote social cultivation through the circulation of texts. For Wu, the only acceptable answer to a rhetorical question that pits "cost" against "good" is still the latter.

The illustrations discussed here, which have been presented in an order that transports us from the world of Western printing machines to a completely Chinese retail and consumption environment, suggest that, in the twenty-two years of its existence, Dianshizhai displayed an architectural adaptability indicative of its commercial, profit-driven nature. In spite of Dianshizhai's foreign ownership and its homes in buildings like those of Figures 1.27 and 2.2, both of which look like direct transplants from England, an outlook more similar to Wu Youru's guided the firm's publishing philosophy. Dianshizhai's first publications actually had no foreign pedigree whatsoever.

Dianshizhai's first publication was a reprint of *Shengyu xiangjie* (Imperial Edicts Explained in Detail).[68] This reprint was followed by another in miniature characters of the Wuyingdian (Palace) edition of the *Kangxi Dictionary* dating from 1716; essentially, three pages of the exemplar were printed, one above the other, on one page of the facsimile,[69] reducing the physical size of the complete dictionary. Major and Chen initially printed 40,000 copies of the miniaturized dictionary. Its retail price ranged from one yuan six mao to three yuan. A comparable woodblock edition cost from three to fifteen yuan,[70] a 50 to 80 percent increase.

The dictionary's first edition was distributed through retail outlets across China and sold out within a few months, realizing a turnover of 80,000 yuan if one estimates a low average cost of two yuan per volume. Dianshizhai promptly reprinted 60,000 copies suitable for the examinations. Customers "generally bought five or six [copies] ahead of time to prepare themselves and to give to their friends and, for this reason, this printing [too] sold out before a few months had passed."[71]

Not surprisingly, scholars disagree on the sizes of the print runs that could be generated by xylographic publishers. In one widely cited view, woodblocks could last for as many as 30,000 printings, and one man could print several thousand copies of a block in a day. However, unlike the lithographed works, these were low-quality works. A second estimate, for high-quality editions, suggests that blocks became worn after several thousand copies. In this view, one man could print 2,000 copies per day. A more recent calculation argues that 15,000 copies could be struck off one set of blocks before the blocks needed to be repaired, after which another 10,000 copies could likely be printed.[72] Thus, regardless of which category of quality and print-run one selects as typical for xylography, it should be clear that the 100,000 copies that Dianshizhai produced from one set of stones would have represented unimaginable riches to China's woodblock publishers and would have helped to convince Chinese entrepreneurs that publishing was now big business.

In addition to the dictionary and other preparatory materials, the Dianshizhai print shop produced reprints of the standard collections of Chinese books *(jingshi ziji)* such as the Thirteen Classics, the early-eighteenth-century literary encyclopedias *Peiwen yunfu* and *Bianzi leibian*, novels, maps, stele rubbings, painting manuals, and even some Western books.[73] Even excluding these, with 100,000 copies of its miniaturized *Kangxi Dictionary* sold, Dianshizhai would have grossed, at the very least, 200,000 yuan in sales in that first year.

According to the May 1889 article in the *North China Herald* cited above, Shanghai's lithographic publishers took advantage of pre-existing national book-marketing networks. They themselves were primarily wholesalers, with retail branches situated throughout the Chinese empire, ranging from Qingdao and Beijing's Liulichang in the north to Chongqing in the west and south to Canton. Less centrally placed market towns also carried Shanghai publications.[74]

In contrast to the widely dispersed centres of distribution, the editorial and printing centre remained Shanghai, presumably because the industry was still in its infancy, supplies and technology came largely from abroad, and master lithographers were few. At this time, there were also significant numbers of Westernized Chinese in Shanghai with experience working in Western-style publishing firms – for instance, in 1884, Wang Tao (1828-97), whose son-in-law Qian Zheng edited *Shenbao*, returned to Shanghai from Hong Kong and worked as a Dianshizhai editor for the next few years.[75] Wang also published at least one work of his own, an illustrated European travelogue called *Manyou suilu* (Casual Record of Slow Travels), with Dianshizhai. The lithographers could depend on such people for advice and guidance.

Furthermore, since transportation to Suzhou and Hangzhou had improved, Shanghai was now close to extant post-Taiping private book collections that could supply exemplars for duplication within the relative safety and prosperity of Shanghai's International Concession. A dispute between Dianshizhai and a Huizhou book collector illustrates both how heavily the industry relied on the authority of its copying-libraries and the lengths to which it would go to assemble them. According to the *North China Herald*, Shanghai's Mixed Court heard a case in late October 1884 involving the theft of a rare-book collection "comprising upwards of 5,000 volumes" *(juan)* from a private library in Huizhou. The unnamed work had been given to the owner's ancestor by a former emperor.[76] On 8 July, the collection had vanished.

The court discovered that a Chinese broker living in the International Settlement, after hearing of the collection, had approached Dianshizhai

with the offer of a very valuable book. He wanted the sale price to be paid up front, but the lithographers insisted on seeing the collection first. The deal fell through at this point, but a Chinese underling of Dianshizhai accompanied the broker and two others to Huizhou, where, one dark night, they stole the entire collection. After packing it up disguised as boxes of tea, they shipped it downriver to Shanghai.

Five days later, the library's owner went to the police. By that time, however, the collection had already been sold to Major Brothers, "who intended to bring out a reproduction of it at their [Dianshizhai] lithographic works."[77] The ringleader quickly absconded, but the Shanghai district magistrate arrested his brother in his place. Under torture in the Shanghai yamen, the brother betrayed the conspiracy, and the plot was confirmed by the deposition taken from the Dianshizhai employee. The wild card in this trial was the fact that the gentleman who appeared in court to mount the charge of theft seemed not to be the collection's original owner. What's more, he could neither prove his identity nor find anyone in Shanghai who knew him. The case had to be postponed so that the original broker could be apprehended. Until then, the books remained in the possession of Dianshizhai, which presumably duplicated the collection.

In 1884, the Dianshizhai Lithographic Bookstore hit its stride with its illustrated *Shenbao* newspaper supplement known as the *Dianshizhai Pictorial*. It was the fifth in a series of lithographic supplements to the *Shenbao* newspaper and the only one to become a publishing success.[78] In its fourteen years of existence, the *Pictorial* carried about 4,500 pictures, which covered a vast range of topics from China's foreign wars to treaty-port life, family conflicts, bordello life, and particularly foreign technology.[79] With this range of topics, the supplement proved so successful that today it is far better known than its book-publishing parent company.[80] Literary scholar Yao Fushen has written that the *Pictorial* also directly inspired at least five Chinese imitators.[81]

Much like the lithographed books, journals, and illustrated newspapers issued in the English-speaking world, which focused on graphic images of current events, especially war, along with travel, exotica, and humorous entertainment, Dianshizhai's supplement to *Shenbao* was initially introduced to provide pictorial coverage of the Sino-French War of 1884-85. Tens of thousands of readers learned of the war's progress via the *Pictorial*, just as Americans had learned of the events of the Mexican War through the prints of Currier and Ives and other lithographers forty years before.[82] A decade later, Chinese readers were also informed about the Sino-Japanese War by the magazine.

Unlike Western lithographs of the late nineteenth century that usually tried to imitate the depth and complexity of oil paintings, the *Pictorial* communicated in a typical Chinese visual language. The line drawing was supplemented by an explanatory caption that closely resembled, in appearance if not in content, the calligraphic colophons found on Chinese paintings. If insufficiently attractive Western fonts were the downfall of letterpress printing in China in this period, lithography's facility with calligraphy was advertised favourably via the *Pictorial*. Lithographed books were just as arresting. Lithography made possible the archaic appearance of a manuscript while also offering reasonably rapid duplication accented by industrial precision.

Generally monochromatic, the *Pictorial* was sometimes illuminated with red, green, or purple pigments applied by hand and was printed on a Jiangxi-produced bamboo paper known as *lianshi*.[83] The magazine was issued every ten days for about fourteen years and was sent free to *Shenbao* subscribers with their paper, which cost ten cash per issue.[84] From 1884 to 1895, the *Pictorial* was also sold separately for five foreign cents *(wu fen)* in Shanghai at newspaper vendors and at Major Brothers' Shenchang Calligraphy Studio.[85] From 1896 to 1898, the same vendors retailed it for fifty cash *(wushi wen)*, a common price for an illustrated magazine in that era.[86]

By the 1890s, along with both the traditionalistic and the innovative products of its presses, Dianshizhai also created a new work environment that helped to transform the social organization of printing and publishing in Shanghai. With Dianshizhai's workforce of 200 employees centralized in its modern factory building, the firm's original hand presses, many of them replaced with more modern presses capable of photolithography, were now all gas-driven. Updated technology helped reduce the size of what must have been a larger original workforce. Dianshizhai's owner, Ernest Major, remained distant and nearly invisible, and the workplace was filled with Chinese workers publishing mechanically replicated products for distribution throughout the Qing empire.

At the same time that Dianshizhai looked forward, via its *Pictorial*, to the broader, more popular, patronage of the twentieth century, it continued to appeal to the older tradition of literati painting and calligraphy that had shaped the style and outlook of its illustrators. The firm also catered to literati interests through its book-publishing operation. By approximately 1890, when Figure 2.3 was published, Dianshizhai was still printing and selling a wide range of books and merchandise intended to appeal to the mix of "literati and merchants" that it had been seeking since 1877.

In addition to featuring the Hankou Road branch store and an image of a power-driven lithographic press probably intended to recommend the press

to its literati clientele, the advertisements in Figure 2.3 announce a range of works that still remained well within the boundaries of late Qing literati culture. An edited, annotated, and miniaturized work by the anti-Manchu, Ming-loyalist scholar Gu Yanwu (1613-82), *Rizhilu* (Record of Knowledge Learned Day by Day, 1670), printed in four volumes and housed in an elegant brocade case *(tao)* was available for two foreign dollars. A second work by a Ming loyalist, Zhang Dai's (1597-1684) *Xiaoti Langxuan wenji* (Collected Langxuan Essays in Reduced-Size Characters), also revealed that lithography had been enlisted to support the late Qing struggle against the Manchu throne. Arranged in eighty chapters, this work, which had first appeared in printed form only thirteen years before, in 1877, sold for five foreign dollars. Finally, a twenty-volume set of the Song masterpiece, Ma Duanlin's *Wenxian tongkao* (Antiquarian Researches), bound in four separate cases, "very elegant and beyond compare," sold for ten dollars, with discounts to wholesalers.[87]

Throughout the period before it closed in 1898,[88] Dianshizhai's print shop remained in its Western-style factory building, while its chief bookshop occupied a site several blocks east at Henan and Nanjing Roads. At least one retail branch was also housed in a modern Western structure near the print shop; another presented a more typically Chinese countenance. From 1884 to 1890, Wu Youru's studio trained nearly twenty of what Gong Chanxing calls "the first generation of Chinese news illustrators."[89] Just as important, this Sino-British hybrid directly inspired a total of as many as ninety-six other purely Chinese enterprises, including seven well-known ones, that contributed to creating the golden age of Shanghai's lithographic enterprise. Two of the most significant were Tongwen Press and Feiying Hall.

Tongwen Press, Feiying Hall, and Other Lithographic Printer-Publishers

Tongwen Press
The Dianshizhai Lithographic Bookstore's success quickly inspired imitators. According to Yao Gonghe, writing in 1917, once "the book industry saw [Dianshizhai] acquire great profits with [such] ease ... the Cantonese established the Tongwen Press"[90] in Shanghai. Already, by 1889, foreign observers could estimate that millions of books had been produced by Chinese lithographers and the Sino-British Dianshizhai. Although Dianshizhai had the distinction of having been the first commercial lithographic shop, the largest, most prestigious, and first truly Chinese of them in this period was Tongwen Press. Of all the Chinese publishers who responded to Zhang Zhidong's call to reprint the Chinese literary past, Tongwen's contributions were the most outstanding.

Tongwen was started in 1882 by the Cantonese Xu Hongfu, Xu Qiuqi, and their brother Xu Run (1838-1911), the latter one of Shanghai's wealthiest Cantonese compradores. As Xu Run stated in his autobiography, after his brothers made the initial investment, "I strongly approved and added some funds."[91] Their firm was on Seward Road in the old American Concession, then still largely a residential area. Installing twelve lithographic presses and employing some 500 workers, much like Dianshizhai, the brothers specialized in reprinting high quality old and rare books, the *Kangxi Dictionary*, eighteenth-century encyclopedias,[92] novels, and calligraphy and painting manuals from the prestigious library, Peiwenzhai. Tongwen's publications, recognized as being of a higher quality than Dianshizhai's, generally sold for correspondingly higher prices. For instance, when Dianshizhai's edition of the *Shiji* (Records of the Grand Historian) sold for two yuan five mao, Tongwen's went for ten yuan. Parts of an 1885 catalogue reproduced by Friedrich Hirth suggest that prices ranged overall from sixty cents (six mao) for the *Erya tu* (Illustrated Erya Dictionary) to at least twelve yuan for a copy of *Qian Hanshu* (History of the Former Han) in four *tao*.[93]

All told, Tongwen issued more than fifty-five well-known and widely praised collections.[94] The brothers were especially praised for their 1894 reprint of the Palace (Wuyingdian) version of the Twenty-Four Dynastic Histories. Again, in Xu Run's words, "We set up the workshop and bought the machines and collected books to use as [exemplars]. From Beijing's Baowenzhai we sought complete white-paper Palace editions of the Twenty-Four Dynastic Histories, and a complete *Gujin tushu jicheng* [*Tushu jicheng*], and [we re-] printed them one after another; [we reprinted] the *Zizhi tongjian* [Sima Guang's eleventh-century compendium Comprehensive Mirror for Aid in Government] ... and [produced] not less than 100,000 volumes *(buxia shishuwan ben)*. Not one [item in our library] was an imitation; all were exquisite and peerless, all worthy to be lithographic exemplars."[95]

Xu's words are permeated by an outlook that illuminates the continuing vitality of Confucian literati culture. Like many men of means in his era, Xu wished to reveal himself as a bibliophile. Simultaneously, however, he was also a merchant concerned with self-promotion and the profit, whether moral or pecuniary, to be made off his printed collection. Moreover, unlike Wu Youru, who gazed serenely at lithography through the sandalwood-scented slats of a literati fan, Xu indicated a keen appreciation of the technical facility of lithography for his purposes: "If you look [you'll see] the lithographic printing of books started with the English merchants' Dianshizhai, which used machines to put a photograph of the original book on stone, and the characters were distinct without being bound by the size [of the original edition]; one could reduce or enlarge the size as one wished. I really

admired it."[96] One senses that Xu also valued the marketing technique that had enabled Dianshizhai, thanks to miniaturization, to sell 200,000 yuan-worth of the *Kangxi Dictionary* in one year.

Tongwen took important steps in laying a foundation for modernizing Shanghai's publishing industry. One of the milestones that Tongwen passed with regard to advancing specialized textual knowledge was the establishment of its own editorial office, the first modern private Chinese publisher to do so. Reflecting its character as a Janus-faced pioneer in the new industry, however, Tongwen combined modern processes with traditional Chinese literati culture; it staffed its editorial office with former Hanlin scholars in supervisory roles. Provincial degree-holders *(juren)* and district-level ones *(xiucai)* did the actual referencing, cutting, and pasting,[97] reflecting their impoverishment at the end of the century.

Tongwen's heavy emphasis on hiring imperial degree holders suggests a certain nonchalance about the technical demands of modern industrialized publishing. However, the quality of lithographic reprints actually owed a great deal to the competence of the printer. In 1885, for example, Friedrich Hirth reported that Tongwen had had several important successes at reprinting. Nonetheless, the previous year, the brothers had failed to complete a miniaturized reprint of the *Tushu jicheng* in 10,000 *juan*. Because of the immensity of the investment, Tongwen had employed the subscription method, a common means of funding a noncommercial publication in China or elsewhere. The publisher counted on advance deposits of half the final cost (180 taels) for each complete set. Over two years, 1,500 supporters were signed up.[98] Still, with this project, Hirth observed, the press ran into financial difficulties, apparently linked to mechanical ones, and had to suspend printing of the encyclopedia. Dianshizhai took over at this point and, by 1888, completed the work in 1,628 volumes using lead type, presumably after farming the work out to its sister firm, the suitably named Tushujicheng Metal-Type Publishing Company.[99]

Rather than catalogue the publisher's financial and technological difficulties related to publication, Qian Jibo (1887-1957), the well-known Republican-era literary historian, lampooned Tongwen's lithographic printers and editors in general. Qian suggested that running a lithographic shop was not quite as easy as Xu Run claimed in his autobiography. In Qian's words, "The apprentices that it [Tongwen Press] got did not originally print books, and the tracing of their characters was illegible. But then [Tongwen] appointed people to trace the characters and make them clearer, making it easier to reprint; again, the engraver [was] not well-read and could not [understand the words' meanings]. Every time he changed [the text] to get at the meaning, a hundred errors appeared."[100] Qian's hyperbolic sarcasm notwith-

standing, by the 1890s the Xus had recovered enough from their financial stumble of the previous decade to garner a commission from the librarians of the Forbidden City. In 1890, Zhang Yinhuan (1837-1900), the recently returned Qing ambassador to the United States, Peru, and Spain and then directing the Zongli Yamen (Foreign Office), memorialized the throne to permit a reprint of 100 copies of the *Tushu jicheng*, with fifty to be used as gifts to foreign governments.[101] Like the Xus, Zhang was a native of Canton province. He stipulated that Tongwen was to print them. Xu Run proudly continues, "In 1891, the Inner Court ordered a lithographed 100-set *Tushu jicheng* [the same work that had caused trouble in the 1880s], and [this time] we handled the job [with no problems]. In 1892, we started work, and in 1894, it was completed and presented, and from this [success], our reputation flourished."[102] Each set of the final work contained 5,000 volumes and cost 3,500 taels, for a total retail price of 350,000 taels.[103]

In providing the throne with reprints of an esteemed imperial encyclopedia to be used both for domestic imperial purposes and in international diplomacy, Tongwen Press was fulfilling the culturally conservative goals of its owners, particularly those of the compradore Xu Run. By undertaking the reprint for the emperor, Xu no doubt hoped to gain a national reputation as a patron of learning that his money-grubbing mercantile background would otherwise have placed out of reach. In essence, Xu had taken a Sino-British publishing innovation, the lithographic press, and deployed it in a highly traditionalistic manner, moving it deep into the heart of Chinese literary and social culture.

Despite Tongwen's success in attracting an imperial commission, the risks associated with combining considerable amounts of capital, industrial machinery, chemicals, and a valuable library became clear to the Xus in 1893. A serious blow of a directly commercial and industrial nature that year provides details on the approximate costs of setting up a lithographic shop in Shanghai but also suggests the necessity of acknowledging the dangers involved in a casual attitude toward industrial machinery. At dawn on 30 June 1893, reported the *North China Herald*, municipal firemen rushed to the Tongwen lithographic plant to find it in flames.

Because of overcrowding and inadequate zoning regulations, fire was a perennial danger to the International Settlement's industry from its earliest days.[104] Tongwen, too, fell prey to the flames, a victim of its own negligence when it came to industrial safety: "Just before one o'clock on Wednesday morning information was received at the Hongkew Police Station that a fire had broken out on the premises of the Chinese Lithographic Works [Tongwen Press], at the corner of Seward and Yuenfong Roads ... The fire had originated in the engine room at the rear, and was caused by a defective flue. The

premises containing the engines, boilers, and printing machinery were en-
tirely destroyed, the whole loss, which is estimated at about Tls. 15,000,
being covered by insurance in the Hongkong Fire Insurance Co."[105] Unlike
the Sino-British Dianshizhai, which conspicuously identified itself with
Westernization and Western commercial and industrial architecture,
Tongwen Press, a consciously Chinese firm, had located its workshop in a
one-storey Chinese building *(pingfang)*. Only by a miracle and thanks to the
efforts of the fire brigade, "a very valuable stock of books" presumably in-
cluding the exemplar library, did not suffer in the fire.

The fire of 1893 occurred in the midst of Tongwen's imperial printing
project. Nonetheless, one more major publication, the Twenty-Four Dynas-
tic Histories, was to come Tongwen's way in 1894. Again this project was
undertaken using the noncapitalistic subscription system. A thousand sets
were to be prepared, with each to cost 100 foreign silver dollars. Although
the histories were claimed to date from "Qianlong 4th year [1738]," two
(the Ming and the Old Five Dynasties volumes) actually came from 1746
and 1763, respectively.[106] "It was extremely funny," writes Zhang Xiumin.
"These printed words were very clear and [advertised the error as] a Tongwen
edition!"[107] And circulation of the blunder did not stop there. Another Shang-
hai publisher, Zhujianzhai, eventually reprinted this edition, using Tongwen's
error-ridden edition as its exemplar.

Even before Tongwen took on the Twenty-Four Dynastic Histories project,
it seems that Xu Run and his brother had begun to contemplate withdraw-
ing from the lithographic business. Over the next five years, the combined
pressures of overseeing the library collection, maintaining an unacknowl-
edged but undeniably industrial plant, and managing its 500-man workforce
required the Xu brothers to act decisively. Their goals accomplished, their
philanthropic contributions to the imperial library and the Zongli Yamen in
place, they closed down their firm in 1898. Modern machinery had been
used by Tongwen for essentially old-fashioned purposes in a pre-industrial
work environment. In fact, the heyday of the lithographic industry was
already passing in Shanghai, the most prominent easterly outpost of the
worldwide diffusion of industrial lithography.[108]

Feiying Hall

There were other notable Chinese imitators of Dianshizhai's success. Most
prominent among them was Feiying Hall, founded in 1887 by the Yangzhou
literatus Li Shengduo (1860-1937).[109] Like Tongwen in being solely Chinese-
owned and -run, Feiying seems to have printed almost exclusively for the
educational and examination markets even as it negotiated necessary tech-
nical adjustments more successfully than Tongwen had done. In this sense,

Feiying represents a progressive counterpoint to Tongwen's recidivist naïveté in embracing the logic of industrial machinery.

One can identify Li Shengduo from an 1889 article in the *North China Herald*. It offers a striking portrait of a highly talented and resourceful individual:

> Mr. Li [Shengduo], the proprietor of the Fei Ying Kuan photo-lithographic works near the Horse Bazaar is a very rich and enterprising young man, the son of a high official. He went up recently to Peking as a candidate for the Hanlin examination, with very little hope of passing. He came out as one of the first five ... In the final examination, which takes place before the Emperor himself, with assessors, he came out first of all, to the great astonishment and delight of his Shanghai friends, and [he] will now probably be promoted to high office in Peking.[110]

Li's status as the son of a high official suggests that he was trading on his family's connections with officialdom to print and market the types of works required by aspirants to that world. We have already seen that the sale of works to help prepare candidates for examinations had helped to under-write Tongwen's major objective, philanthropic publishing. Educational publishing was a significant part of Dianshizhai's trade as well. Paradoxically, Li's status as a scion of high officialdom permitted him to ignore the philanthropic commissions pursued by Tongwen's Xu Run in favour of the commercial objectives of industrialized print capitalism.

In 1887, the Chinese-language, Major Brothers-owned newspaper *Shenbao* published an advertisement describing the circumstances of Li's new Feiying Hall establishment, which happened to be located at the same intersection of Nanjing Road as Dianshizhai. In addition to printing books under private contract, the ad announced, the firm was willing to print all kinds of works from private book collections. Feiying, like Dianshizhai, specifically appealed to "literati and merchants" to come inspect its operation with an eye on having their works printed there.[111]

More significantly, using its own money, on its own initiative, and under its own imprint, Feiying issued reprints of *Zhengxu zizhi tongjian* (Orthodox Comprehensive Mirror for Aid in Government), *Sanxitang fatie* (Calligraphy Manual of the Sanxi Hall), an edition of the classical dictionary *Shuowen*, etc.[112] – in short, much the same literati fare of histories, dictionaries, and brushwork manuals as Dianshizhai, located across the street, and the other lithographers with which it competed.[113] And according to *Shenbao*, "For the most part, the printing is fine like silk, and it is also clear and incisive. There is no need to mention the decoration, which is classically elegant, or the

proofreading, which is refined; truly this is a wonderful sight in the world of books [*shucheng*, literally 'book city'] and a grand affair in the world of let-ters [*wenlin*, literally 'forest of literature'].”[114]

Feiying never did develop a noteworthy new line of commercially viable printed commodities, however. Unlike Tongwen, it did not bother to secure a diverse combination of high-level imperial and broad commercial patron-age either. Instead, Feiying charged headlong into the dog-eared book-marketing channels of the late Qing with the same kinds of products that had filled them for decades, albeit now with Feiying's refined printing. In the end, Li Shengduo's narrow market fixation would render Feiying Hall unable to survive the abolition of the examination system in 1904-5.

If Feiying Hall failed to go beyond publication of works for the expiring world of late Qing literati and aspiring candidates before it closed, it did succeed in demonstrating its owner's willingness to embrace technological, architectural, and industrial modernity. When it opened in 1887, Feiying Hall already had several dozen book-printing “fire-wheels,”[115] a translation of the term for printing press suggestive of the firm's power-driven machin-ery. Unlike Tongwen's Chinese *pingfang*, Feiying's building was spacious and was said to have been specially designed in “the Western style,” with high ceilings, making it sound much like the buildings used by Dianshizhai. Feiying's nearly twenty rooms, whose specialized functions amounted to a modern division of labour, ranged from the accounts room, to the fire-wheel (press) room, to library, photography, proofreading, and stone-rubbing rooms. It was “all very tidy and orderly,”[116] praised the *Shenbao* reporter. From con-temporary reports, one finds that Li's printing and publishing enterprise was physically large, and, like Dianshizhai, Tongwen, and other lithographic firms of the era, it concentrated industrial and intellectual labour under one roof. This propensity of Shanghai's large firms to combine printing and publishing operations in a single enterprise distinguished modern Chinese publishers from most of their contemporaries in the Anglo-American West and would remain a permanent characteristic of Chinese print capitalism.[117]

Symbolic of this age of lithographers, who straddled modernity with one foot in traditional Chinese texts and publishing culture and the other in that of steam- and petroleum-derived power presses, Feiying Hall achieved a certain popular notoriety with its steam whistles. These whistles punctu-ated the work day in a raucous version of the time clock found in factories today. Soon, however, the *North China Herald* reported that “the steam whistles have been so much complained of” by several foreigners that the propri-etors were “ordered ... by the Magistrate of the Mixed Court to discontinue the nuisance.”[118]

Nonetheless, in the final analysis, Feiying Hall had revealed a Chinese proprietor's desire to implement modern retail and manufacturing architectural design to house his workers and his machines. In doing so, Li Shengduo, while still reflecting the Janus-faced identities of Shanghai's Chinese lithographic publishers, demonstrated his willingness to compromise with a new architectural and industrial logic. Although still publishing for the mainstream traditional examination market, Li seems to have recognized that lithography had renewed the old market, albeit without transforming it, and thus required a new workplace.

Other Lithographic Printer-Publishers

In addition to Dianshizhai, Tongwen, and Feiying Hall, between 1876 and 1905, there were five other, less pivotal but still well-known, lithographers in Shanghai. Like these three, most of them were established by out-of-towners. The Baishi shanfang was established by Ningbonese; beyond this sketchy information, the sources are silent about it. There was Hongwen shuju, established by Ling Peiqing, of either Zhejiang or Jiangsu origin.[119] In addition, there were Jishi shanfang, known for works of poetry, novels, and editions of the Four Books; Hongbaozhai shiyinju, founded by He Ruitang, which began with a mixed catalogue of examination aids and medical works but relied on the latter to survive until at least 1920;[120] and Saoye shanfang, formerly of Suzhou.

In addition, bibliographic materials suggest the existence of two other significant groups of lithographers, albeit with considerable overlap between the two.[121] A survey of medical publications identifies thirty-one other Shanghai lithographic publishers operating between 1876 and 1905 who may have contracted out their printing to these eight.[122] Not counting sixteen firms that figure among the medical publishers as well, another thirty-seven firms, many apparently short-lived, are known to have published works of fiction in the same period, again, perhaps using the printing services of these eight.[123] Although these numbers cannot be accepted uncritically and require further research, when we compare lithographic with letterpress printers, we find that documentary sources, as well as bibliographies of fictional works and medical publications, do suggest that between 1876 and 1911 as many as 149 lithographic publishers came into existence in Shanghai, relative to only twenty-one lead-type shops between 1842 and 1911.[124] Socially, economically, and culturally, the lithographers were preponderant.

Many of the medical publishing firms that have been identified were, in fact, general publishers who supplemented their backlists with marketable

medical texts; some, of course, published only medical works. In addition to the thirty-one active from 1876 to 1905 – that is, during the golden age of the Shanghai lithographic industry – another sixteen leading Republican-era medical publishers were all founded before 1912.[125] Regardless of when they were founded, though, all relied heavily on lithography to reprint medical texts. In this significant specialized market, Chinese publishers depended far more heavily on lithographic than on letterpress printing well into the twentieth century. It is very likely that the demand for illustrations, as well as the time-honoured place of medical works in the traditional Chinese publishing market, recommended the use of lithography for medical books in particular.

Most medical publishers who successfully negotiated the transition from the Qing to the Republic lasted into the late 1930s as independent im-prints, and several of those made it into the 1950s. For these publishers, medical publishing was undoubtedly fundamental to their survival after 1905. Similarly, among the lithographic publishers of literature, many branched out widely. Included among them were comprehensive publishers such as the Commercial Press, which issued the *Dongfang zazhi/The Eastern Miscellany*. Added to them was the Liangyou Company, founded in 1925 and parent of the well-known magazine *Liangyou*. The acknowledged pros-perity of these later years confers greater importance on understanding the industry's formation and achievements that allowed it to dominate Shanghai's Chinese publishing sector from 1876 to 1905.

Conclusion

Western machinery that came into China partly in the form of the printing press was unique in the way that it brought together the worlds of intellec-tual, manual, and industrial work. This chapter has probed the extant sources, much as an archeologist sifts through layers of sediment and relics, to un-earth a forgotten industry, lithography, that helped to lay the industrial foundation for Shanghai's twentieth-century printing and publishing busi-ness. By examining the introduction of lithography to Shanghai, and by profiling that city's three most important lithographic publishers of the late 1870s, 1880s, and 1890s, this chapter has shown how the lithographers established and identified themselves. Just as important are the questions of how and why they declined in overall importance after 1905.

In a far from haphazard choice, Dianshizhai, Tongwen, Feiying, and the other ninety-four[126] firms with which they competed during the golden age of Shanghai lithography selected it as a technology suitable for their needs. Annual sales receipts on the order of at least 200,000 yuan per year, plus the

lure of being perceived as public-minded philanthropists who emphasized learning and products for the learned, drew sojourning investors from Canton, Ningbo, Yangzhou, and elsewhere to Shanghai to invest for the first time in Chinese history in printing machines and factories. Relatively low investment, the aesthetic appeal of the finished books, and the minimal changes in publishing outlook apparently necessitated by lithography all recommended it to these publishers distributed along a social spectrum ranging from compradores to high officials. Among the larger, historically more influential firms, printing operations were combined with those of publishing. The machines and their accessory equipment were, in turn, operated either by men trained in Xujiahui or by printers who learned the trade in Shanghai's first commercial lithographic shops.

Like the letterpress industry that would eventually surpass it and is misperceived as having been the first stage of Chinese-owned industrial printing, the lithographic industry, by the late 1880s, was mechanized and organized into production sites that more and more came to resemble modern factories. Lithographers also mustered a sizable workforce inside the city limits. Shanghai's lithographic industry, which in 1894 included eight establishments that we know combined printing with publishing, then employed at least 1,300 persons. Although they were only a small number of employees in the overall context of China's first stage of industrialization, by 1894 these numbers considerably exceeded the numbers employed in all of China's other modern printing sector, the letterpress industry. These publishers and printers also prepared the ground on which the letterpress industry would prosper by introducing mechanized printing to other Chinese employers and to their employees, deployed in factories within the geographic limits of the International Concession.

Starting in 1895, the letterpress industry supplanted the lithographers, just as the latter had, in the two decades prior, taken over from the woodblock printers. Tongwen's demise in 1898, for example, signalled its owners' new faith in letterpress printing. Yet lithographers had once grasped the initiative through robust investment, technological superiority, and product innovation. Willingness to take this opening step impressed both disinterested foreign observers and self-perceived foreign competitors. Foreign accounts of two types, journalistic and missionary, repeatedly attest, not only to the success of Dianshizhai, Tongwen, and Feiying Hall, but also to that of the Chinese-run lithographic shops in general. At the same time, these reports provide a basis for understanding how the golden age of lithography ended.

In 1897, still trying to cope with the challenge of producing low-priced lithographically printed religious items for a Chinese readership willing to

buy them, the APMP's directors attributed their own failure to move with the times to the space limitations in their printing plant. "Extension is very desirable ... there is no room for development in such lines as photo-lithography,"[127] they wrote in that year's annual report. Not until 1901, when Gilbert McIntosh returned temporarily to Scotland, was APMP able to secure, for Mexican $700, a lithographic hand press. At approximately the same time, a new printing plant, erected at 145 Sichuan North Road,[128] enabled the APMP to move from its cramped quarters at 18 Beijing Road.[129] Unfortunately for the APMP, as well as for the Chinese lithographic publishers with whom it competed, lithography as a viable independent commercial activity was then undeniably under assault from the letterpress printing industry symbolized by the newspaper trade.

Despite their failure to continue developing new products once they encountered across-town competition from letterpress printers, the lithographers set the industrial and organizational stage for the letterpress printers. Appeals to a traditional readership enriched the publishers discussed here but also accounted, in part, for their vulnerability. Cultural traditionalism and, no doubt, sharp business acumen led them to reproduce much the same range of works as had the woodblock industries of older printing centres. The Dianshizhai Lithographic Bookstore benefited when Major and his compradore borrowed heavily from European publishing to create a series of Chinese versions of nineteenth-century European illustrated news and novelty magazines that culminated in the *Dianshizhai Pictorial*. Paradoxically, the *Pictorial* turned out to be more successful than most European papers of the same ilk. Thanks must go, without a doubt, to the ability of Wu Youru and his co-illustrators to revise traditional illustration techniques and, at the same time, to reshape the readership's sense of Qing culture and world civilization. By refurbishing this old market, Dianshizhai looked backward, combining traditional illustrative idioms with a modern Western industrial medium. At the same time, the firm also pointed forward to the Commercial Press and other Chinese publishers who responded to the changing milieu of late Qing China by translating and manufacturing Western- and Japanese-style modern books. With few exceptions, other major late Qing lithographic publishers limited their success by their heavy dependence on the examination system, which would end in 1904-5, and the occasional imperial commission.

Along with the tendency to flood the market with highly similar products, heavy reliance on foreign supplies undercut economic viability and may have contributed to clouding the industry's future. The failure of Tongwen Press and Feiying Hall in particular to define a new market is what finally led to their downfall – but not before each helped to transform the

artisanal printing and calligraphy businesses by bankrupting the first and co-opting the second. At the same time, along with Dianshizhai, they were all responsible, albeit unintentionally, for establishing Shanghai's modern printing and publishing supremacy.

The lithographers' work sites combined editorial and manufacturing activities under a single roof for the first time in Chinese publishing. Lithographers also organized retail and wholesale services that enabled them to tap into traditional distribution and marketing networks that extended from the International Concession north to Qingdao and Beijing, south to Canton, and west to Chongqing, and they primed this market to begin to pay attention to Shanghai-produced publications. Even as they destroyed late Qing China's artisanal print production operation and exploited the marketing mechanisms of its book market, their industry's mass production anticipated the next stage of Shanghai publishing, that of the letterpress printers.

Having accomplished so much, then, how did the industry seem to disappear from the book-publishing market by the early 1900s? Work conditions made the industry wasteful in the eyes of both contemporary Westerners and Chinese commentators writing in the post-1911 period and did contribute to its vulnerability. To be sure, by 1890 industry leaders did substitute both kerosene (Dianshizhai, Feiying Hall) and steam power (Tongwen Press) for human power; it is conceivable that the savings in wages were significant, with an accompanying increase in output,[130] but the sources are silent on this issue as well as on the issue of wages in general (apart from those paid to calligraphers). Furthermore, between 1877 and 1889, the larger publishing houses had reduced the number of workers needed per machine from eight to three.

Despite its frequent praise for Shanghai's Chinese-run lithographic industry, the *North China Herald*, for instance, was not slow to criticize it for what the paper regarded as wasteful expenditure on labour. In its May 1889 profile of the industry, the *Herald* noted that Shanghai's lithographic printers were already using steam engines that could power four or five photo-lithographic printing presses at the same time. In spite of this use of steam, however, workshops continued to employ from 100 to 200 workers, admonished the reporter. Apparently, although each printing machine required only three attendants, "one above to place the sheet on the cylinder, and two below to receive it when printed ... [still] the preparation of the stone, the writing of the text, its reduction in size by photography and various additional processes occupy very many hands."[131] It was for these specialized operations that Feiying Hall needed a physical plant of nearly twenty rooms. The *Herald* reporter nevertheless concluded that "too many workmen

are employed, requiring the consumption of a large amount of capital. The number of them should be reduced."[132] Possibly for the first time in Shanghai's modern publishing sector, capital and labour were perceived as being opposed, rather than complementary, to each other.

The *North China Herald*'s views of 1889 were echoed in later writings seeking to explain the formative era of Shanghai's lithographic publishing business. From the perspective of 1931, but with a similar tone of exasperation, Commercial Press supervisor and print historian He Shengnai criticized the lithographic publishers for having been extraordinarily wasteful. In an era when equipment and machinery worth 15,000 taels could go up in flames in a morning, as happened to Tongwen, wastefulness was not likely to have been tolerated for long, especially in under-capitalized smaller firms.

Shanghai's lithographic printing and publishing industry survived and flourished well into the twentieth century.[133] However, these publishers were soon overshadowed by the output of the mechanized letterpress industry, led by newspapers and current events journals as well as by the new general publishers such as Wenming Books, the Commercial Press, and Zhonghua. In the mid-1890s, the trend toward letterpress had already been discerned by Xu Run and his brothers Hongfu and Qiuqi. At the same time that they were considering closing their Tongwen Press, they were investing in a new lead-type venture called Guangbaisong zhai.[134]

By the late 1890s, Shanghai's Chinese-run letterpress industry, fostered by the new journalism and newspaper publishers, as well as by the general book publishers, started to overshadow the lithographic printer-publishers. As the public appetite, whetted by the lithographers' illustrated periodicals, called for more news and faster delivery, printing speed temporarily gave letterpress-printed newspapers and journals the upper hand. The Chinese machine industry responded promptly to the flurry of activity from this sector, first with repair shops and then with factories that could manufacture letterpress printing machines at costs lower than those of imported Western ones. This manufacturing activity came too late to benefit the lithographic industry, a prodigy of the period from 1876 to 1905. Coincidentally, in New York, Currier and Ives failed in 1907, also a casualty of changing technology and evolving fashions.

Along with new lithographed magazines that appeared in the 1900s and 1910s, a total of 188 lithographic publishers,[135] many of them reprinting medical texts and works of fiction, appeared in late-nineteenth-century and early-twentieth-century Shanghai. Many late Qing firms survived well into the 1920s and 1930s, and some even into the 1950s, and they were joined by other firms formed after 1911. Of the total 188, 164 may be regarded as

Republican-era lithographic publishers, either because they were founded in the Republic or because they were founded in the Qing and survived into the Republic.[136] Their collective energy, in the face of the 1904-5 termination of the civil service examinations, which had indirectly subsidized the lithographers reviewed in this chapter, allows us to ponder the continuing vigour of late imperial China's culture of learning (books, calligraphy, and values propagated by them) after the breakdown of the formal bureaucratic apparatus.

In the final analysis, however, by 1905, lithography was being surpassed by new technologies that could satisfy demands for time-sensitive news and "new-style," Western-, and Japanese-influenced books. Simultaneously, under the impact of educational and political reform, starting in 1901 but accelerating after 1905, the public's appetite for reprints was waning. Never again would lithography capture the wider Chinese public's attention as it had caught that of Bao Tianxiao and others during the Shanghai lithographic printer-publishers' golden age.

3 "Sooty Sons of Vulcan": Forging Shanghai's Printing Machinery, 1895-1937

The manufacture of machinery was essential to the development of print capitalism in China. Events from the early 1930s illustrate the links that welded the cultural and industrial sectors inseparably together, both in actuality and in the minds of contemporary Chinese observers. In the early morning of 30 January 1932, in response to what they claimed were Chinese provocations related to Japan's invasion of Manchuria the year before, Japanese bombers took off from ships anchored in the Yangzi River to hammer northern Shanghai districts.[1] Soon, six Japanese bombs struck the Commercial Press, one after the other.[2] According to the *North China Daily News*, "apart from the huge conflagration at the Shanghai North Station, the largest and most important of these [fires] took place in the Commercial Press, the leading publishing company in China ... The entire plant has practically gone up in flames."[3] Two days later, on 1 February, fire broke out at the publisher's Dongfang tushuguan (Oriental Library), the premier editorial collection of its kind in China and Shanghai's largest library. Although the library was lost, a year later production at the Commercial Press recovered, thanks in large part to the failure of Japanese bombardiers to destroy the publisher's machine shop.[4]

According to a 1933 in-house review of the Commercial Press's activity, the plate-making and type-casting rooms, along with the letterpress and lithographic printing shops, had suffered major losses. Still, the report pointed out, "it is interesting to note ... that the Japanese bombardment last January, although most methodically carried out, failed to spot the Machine Shop. They damaged the company's machines but overlooked something that could raise the dead to life."[5] This passage is concisely eloquent testimony to the significance of machine shops even to cultural industries.

What was the nature of the relationship between machine shops and publishing? What did Shanghai's machine-makers do to launch China's adoption of Western-style letterpress printing and to extend the life of lithographic printing well into the twentieth century? And what was the impact of this process on Chinese social relationships? This chapter will address these questions. Their importance is suggested not only by the experience

of the Commercial Press in the 1930s but also by numerous historical accounts of late imperial and Republican China's literary and intellectual transformation that refer in one way or another to the expansion of modern publishing.

Leo Ou-fan Lee and Andrew J. Nathan, for example, have observed that "In the first few decades of the great awakening that began about 1895, political information and new ideas came to the people almost exclusively through the press."[6] Discussing the publishing situation in 1919, Chow Tse-tsung has written that, between the months of May and December 1919, 400 new periodicals appeared, giving voice to China's anger over mistreatment by its Western allies at Versailles.[7] The appearance of so many new publications and so much previously unknown material so quickly was due, only partly, to political and cultural need. Just as important, the dissemination of periodicals, books, and information was also made possible technically by the mechanization of China's publishing industry, a process in which Shanghai's Chinese machine shops played a vital role alongside imported foreign printing presses.

Chinese did not begin to embrace letterpress printing until the period between the First Sino-Japanese War (1894-95) and the subsequent 100 Days of Reform (1898).[8] By then, the printing presses of Gutenberg's and Stanhope's days had been considerably improved upon. Letterpress printing machines brought previously unimaginable speed to the nascent industry and could print in higher volume than lithographic operators. Although no substitutes for unappealing old missionary fonts had yet appeared, both speed and volume now became major attractions for the production of newspapers and other time-sensitive materials that held out the promise of a large new audience of readers.

Soon Chinese typographers at the Commercial Press and elsewhere responded to the burgeoning new market with attractive fonts easily used on the speedy new letterpress machines. Once this phase of China's Gutenberg revolution got under way, Shanghai's modern printers and publishers widened the distance separating themselves from other possible contenders in Canton, Ningbo, Beijing, etc. (see Table 3.1). They also helped Shanghai to seize primacy of place in late Qing and early Republican China's intellectual life. However, as the account of the Commercial Press's destruction and recovery makes clear, that intellectual life depended on an industrial technology purchased and deployed by modern business organizations.[9]

Starting in 1895, widening circles of lithographic and then letterpress printers provided opportunities for those who could repair printing presses and machines. In turn, the Chinese printing machine industry grew out of the fertile ground provided by the repair business. Chinese machine technicians

Table 3.1

Chinese-made type-casters, printing presses, printing machines, and other machinery, 1900-1950s

Type of press	First recorded maker in China	First recorded maker in Shanghai
A. *Relief* (Ch. tuban) *(typography and letterpress)*		
Type-casters, printing presses, and printing machines		
Manual or foot-powered printing press	Cao Xingchang Machine Shop, Shanghai, c. 1900	same
Copper matrices	Fuxing Copper Matrix Shop, Shanghai, c. 1900	same
Chinese-language type-casting machine	Commercial Press, Shanghai, c. 1913	same
Chinese-language type-casting machine	Ruitai, Shanghai, c. 1916	same
Full-page newspaper press	Mingjing, Shanghai, c. 1920	same
Small newspaper press	Mingjing, Shanghai, c. 1920	same
Self-Inking Printing Press	Unnamed, pre-1924	same
Monotype/Sinotype	Gui Zhongshu, Taiwan, late 1950s	unknown
Cylinder printing machines *(lunzhuan yinshuaji)*		
		None
		None
		None
Rotary machines *(lunzhuan yinshuaji)*		
Electric rotary press	Unnamed, 1929	same
Rotary paper maker	Gongyichang, Yongsheng, Xinghua, all in Shanghai, 1926	same
B. *Planographic/lithographic* (pingban, shiyin) *presses and machines*		
Lithographic (hand?) press	Gongyichang, Shanghai, c. 1900	same
Lithographic (hand?) press	Xieda Machine Shop, Shanghai, c. 1904	same
Five-colour lithographic press	Mingjing, Shanghai, c. 1920	same
Offset lithographic machine	Hujiang and New China machine shops, Shanghai, c. 1924	same
C. *Photogravure* (aoban yinshua) *machines*		
Banknote-printing photogravure press	Mingjing, Shanghai, c. 1931	same

soon mastered not only the art of repair but also the techniques necessary to duplicate many, if not all, of the imported machines that they were repairing. From this beginning, Shanghai became the leading Chinese centre for manufacturing the kinds of printing machinery that much of the Western world took for granted at the turn of the twentieth century.

In 1879, the Reverend W.S. Holt claimed that the American Presbyterian Mission Press (APMP) had assisted publishers in China to secure presses and printing material from abroad. Just as this dependence on imported machinery had limited Canton's American Board Press, the London Mission Press, and the APMP, so too the Chinese printing and publishing industry remained heavily dependent on foreign-made machinery until the early twentieth century. By then, Chinese foundry workers had mastered the electrotyping techniques that William Gamble (1830-86) had developed to cast the type fonts that enabled the APMP to make itself independent of its Western font suppliers. More important, Chinese foundry workers also learned to duplicate Western printing presses and other printing-related technology. For this reason, China's modern printing machine industry may be accurately said to date from 1895 to 1900, the period when Chinese machine makers surpassed missionary printer-publishers by starting to manufacture their own printing presses. They continued to manufacture presses domestically until 1937, even in the face of imported printing machinery valued at many hundreds of thousands of yuan.

By 1894, despite the substantial achievements of the lithographic printer-publishers, in terms of investment and numbers of Chinese workers employed, the printing and publishing industry was still a minor economic activity in Shanghai. Investments in the paper and letterpress printing industries totalled only about 10 percent of all investments in light industries if one excludes *Shenbao*.[10] Newspaper plants, including *Shenbao*, employed only about 650 workers. The five or six foreign-run publishing houses in China employed another 220 workers. In 1894, these 870 workers in the letterpress trades made up less than 1 percent of all workers employed in both foreign- and Chinese-owned heavy and light industry.[11]

However, the lead-type and letterpress industry grew rapidly in response to bursts of political and educational change after 1895, 1905, 1911, and 1919. Just like the xylographers and lithographers before them, letterpress printers and publishers responded to changes in the cultural world by expanding their technological infrastructure. New markets opened for rapidly produced, time-sensitive printed works. Printers and publishers bought machines to meet these demands for new kinds of textual and visual commodities.

In 1929, an article promoting the printing machine industry appeared in the *Gongshang banyuekan* (Industrial and Commercial Biweekly). The author described the achievements of Shanghai manufacturers in meeting the requirements of printers. Linking economic and cultural reconstruction with industrial development, he declared growth in the printing machine industry to be a national priority, concluding that "the rise of the nation depends on the development of handicrafts and industry, which depend on machinery."[12] In 1932, another economics writer, Yan Zhong, estimated that between 1912 and 1932, Shanghai's printing machine industry had grown by twenty times.[13] In the case of the publishing industry, just as in national revitalization, prosperity depended on the ability of Chinese machine-makers to supply printing presses and auxiliary machines.

History of the Book and Printing: Reorienting the Problem

The "Chinese printing and publishing industry" is conventionally thought to include a spectrum of activity ranging from jobber printing of handbills, business forms, name cards, and small-scale bulletins, to the vast commercial printing plants of comprehensive printer-publishers such as the Commercial Press and Zhonghua Books, and on to the high-turnover printing departments of Shanghai's daily, weekly, and monthly press.[14] However, even though Chinese print capitalism generally differed from Anglo-American print capitalism in the tendency of its leading firms to combine printing and publishing in a single enterprise, by the late nineteenth century, in Shanghai as elsewhere, the continuum involving the publishing company and the cultural world of reading and study did not actually begin in the print shop. Modern print shops did not manufacture their own presses, as they had in the age of wooden presses.

For this reason, to understand Shanghai's printing and publishing industry, we must investigate the relationship between Shanghai's cultural and industrial worlds. To do so, we turn to the Chinese-owned and -run foundries and machine shops that helped to make modern Chinese printing and publishing possible from a material or technological point of view. Reorienting our perspective is one of the objectives of this chapter and suggests the need for corrected vision in many scholarly histories of the book industry.

A survey of the literature concerned with "the history of the book" reveals that, since the pioneering work of Lucien Febvre and Henri-Jean Martin appeared in 1958, historians have been divided into at least two intellectual camps. Febvre and Martin themselves were aware of the importance of studying the history of invention and the interaction of humans and machines.[15] Since their day, however, antiquarian researchers have focused on machinery and the evolution of technology but have invariably divorced

it from its social context.[16] The second, and larger group, made up of social historians of the book and the book trade, has largely ignored both the question of how the printing industry was supplied with equipment and issues related to the dark underside of cultural advancement.[17]

Because of the semicolonial status of Shanghai and China in the decades under review here, this study must adopt an interdisciplinary approach. Indeed, the political conditions of Shanghai under which foreign printing presses were sold there suggest that the successful imitation of Western technology was more politically charged and complex than the process that a later age mildly calls "technology transfer" might suggest. For this reason, contemporary pride, both private and official, in the mastery of foreign technology by Shanghai's machine manufacturing industry is an element of Chinese political awareness in the 1930s that should not be overlooked by historians.

Moreover, the fact that Chinese publishers made the transition from xylography to lithography and then to letterpress in a generation and a half, rather than the four centuries needed to achieve printing modernity in the West, suggests that there were high social costs to be paid along with financial burdens and incentives to rapid development. We already know that the lithographers employed large numbers of print workers and calligraphers, including many hired away from the xylographers. Because of the limitations of our sources from that period, however, we can know relatively little about the workers themselves. This situation changes when we reach the era of the printing machine manufacturers.

Just as Lucien Febvre and Henri-Jean Martin as well as Robert Darnton have pointed out with regard to European printing industries, early use and ownership of machinery by printers created working conditions that significantly polarized socioeconomic relationships.[18] In fact, even a collateral industry such as printing machine manufacturing reveals signs of the brutal abuse of employees by shop owners that underlay early industrialization in Europe. The strife that resulted reminds us of the personal price paid by machine workers and apprentices to produce modern print capitalism.

Therefore, we need to acknowledge that both employers and employees in the Chinese machine-building industry supplied modern Chinese printers and publishers with printing presses and related machinery. How did the system work? After presenting statistical information that documents Shanghai's and China's continued and undeniably heavy dependence on imported machinery, this chapter will show that the printing industry was also supplied in part by Shanghai's own commercially responsive Chinese machine manufacturers. They acquired mechanical skills in Shanghai and passed some of them on to their apprentices. In turn, they and their workers

facilitated the mechanization of China's publishing industry. Exploiting their niche between the high prices charged for foreign machinery and the attractiveness to Chinese printers and publishers of buying comparable locally produced machinery, Shanghai's printing machine manufacturing firms created what became one of Republican China's most viable industries. Both business owners and employees also contributed to the mechanization and modernization of another, the printing and publishing industry.

By isolating the printing machine manufacturing firms and their industry from the wider machine industry, it will become clear that the former succeeded in concentrating on production, rather than on mere repairs, much earlier than other machine industries. This development has been overlooked by recent Chinese and Western scholars but was related to the early emergence of a group of manufacturers who may be called, following the suggestion of one of their number, "foremen-capitalists."[19] The early appearance of these largely anonymous entrepreneurs, who then relatively quickly passed on technical and industrial skills to their apprentices, positioned the Chinese-owned printing machine industry to take advantage of the expansion of Shanghai's cultural and commercial sectors during the city's period of rapid growth from 1910 to 1925. This success was achieved by selling both simple and sophisticated machinery to the growing Shanghai-based printing and publishing industry, to inland Chinese printing concerns, and, somewhat surprisingly, to printers in Japan and Southeast Asia. Along the way, Chinese officials of the 1930s, who regarded a self-sufficient machine-building industry as a sine qua non of a modern nation-state, took pride in the success of this industry.

In 1933, in terms of the overall value of the *national* Chinese machine industry's manufacturing output, the printing and paper-making machine industry ranked seventh largest out of sixteen categories.[20] As outlined in the 1929 commercial report cited earlier, the five most successful printing and paper-making machine firms (out of a total of twenty-two manufacturing firms) produced a large variety of machines, ranging in cost from electric rotary presses selling for 7,800 silver dollars down to a 135-yuan hand-operated lithographic press. The former could have been used to produce mass literature of the sort discussed by Lee and Nathan, and the report says that the latter was used to print stationery such as name cards, envelopes, etc.[21] This lithographic hand press could also have been turned to printing political bulletins of the sort mentioned by Chow. Yet neither awakening nor enlightenment came without financial or social costs. Those with capital, or access to it, paid the former cost, and everyone who manufactured printing presses or used them to print and publish helped to defray the latter expense.

No other single Chinese locale could even approach Shanghai's preponderance in this industry through the 1930s. As a result, no other place was as intimately involved with the financial and social changes brought about by it. According to a 1933 Nationalist government report celebrating the successes of China's printing machine manufacturing business, among Chinese printing machine manufactories that were mechanized, and that employed more than thirty persons, 54 percent were located in Shanghai.[22] The five firms mentioned above produced all-Chinese-made machines that in many categories were considered to be equal in performance to imported ones. Four of the five, including Mingjing jiqi chang (Mingjing Machine Shop), which will be discussed extensively here, were started in 1914-15 and reached the peak of their commercial and technological growth during and after the mid-1920s. Between 1914 and 1932, the Shanghai printing machine industry reached its maturity and greatest profitability. In that period, the five large specialty firms also contributed to the growing confidence of Chinese intellectuals and writers that China's modern media belonged to Chinese.[23]

The period from 1914 to 1932 may be brought into focus by examining the history of one of the five leading printing machine manufacturers, Mingjing Machine Shop. Its founder/owner, Zhang Jinlin, is one of the few machine shop owners to slip through the curtain of anonymity that cloaks most of these entrepreneurs. His activities reveal one of the most likely paths by which personal success occurred in this industry and by which Chinese printing machines came to be made and marketed and at whose cost. Zhang's contributions will be elaborated after the following profile of Shanghai's machine industry.

Significance of the Machine Industry to the Printing and Publishing Industry

In the early 1930s, when the printing machine industry was praised by the Chinese government for its growth and volume of output, Shanghai was the recorded home of 456 Chinese-owned machine industry workshops.[24] Altogether, these machine workshops employed 8,082 workers, about 18 persons per shop. Both in aggregate and on average, these shops, although not insignificant, present a more modest image than that of the printing industry itself.[25] The machine industry's total capital investment was less than a quarter of that of the entire printing industry.[26] Nonetheless, Shanghai did produce half of the total value of the national machine output.[27] The opportunities for this group of machine shops lay in the imbalance between the technological needs of the expanding modern Chinese printing industry and its ability or willingness to pay for foreign machinery.

Of the 456 shops, 32 (about 7 percent of the total) supplied machines to the printing and publishing industry.[28] What is most striking is that a high proportion (about two-thirds) of the machine works supplying the printing industry were manufacturers rather than mere repair shops. The high proportion of the latter, particularly in the spinning-and-weaving, silk-weaving, shipbuilding, and cigarette-rolling industries, repeatedly exercised 1930s Chinese government and commercial writers who longed to see a higher degree of national industrial self-sufficiency. By contrast, the printing machine industry was a source of pride, with twenty-two of thirty-two firms in 1933 engaged in manufacturing for the Chinese domestic, Japanese, and Southeast Asian markets. This ratio of manufacturing shops, relative to repair shops, positioned the printing machine industry as the second highest in rank of eleven machine industries in 1933 when manufacturing was compared to repair services.[29]

Despite its importance to industrial life through the printing shops that purchased and used its machinery, as well as its impact on political/educational reformers and revolutionary groups, the workaday activities of this new Chinese machinery industry have largely eluded historians.[30] Although most Chinese-owned machine shops were very small enterprises, particularly in the first stage of their development after 1895, they were nonetheless a crucial component in the process by which the Chinese publishing industry was mechanized.[31] They promoted, largely through the bargain-basement prices they charged for their machinery, the mechanization of an industry that provided some of the hardware for the late Qing revolutionary movement as well as the technological revolution that preceded and made possible the flurry of publications associated with the New Culture Movement (starting in 1915 with the journal *Xin qingnian* [New Youth]).

Sustained by the machine industry, the development of the letterpress printing machine industry, in particular, is related to the history of newspaper offices such as *Xinwen bao*, the Commercial Press, Zhonghua, and other general publishers, but its history is distinct from these cultural organs. To a much more profound degree, the Chinese printing machine industry was noisy, dirty, and brutish. By relying on the limited records available, however, we can see the process by which better-known Chinese printers and publishers were supplied with the machines upon which their success rested.

Initial Appearance and Growth of Manufacturing Shops, 1895-1913

Throughout the nineteenth and early twentieth centuries, China was heavily dependent on the imports of the machine industry. This reliance persisted despite repeated efforts by private and government Self-Strengtheners to

make the country more independent. Statistics appear only erratically until the beginning of World War I, but the limitations of China's locally owned machine industry are clear. Between 1862 and 1905, seven foreign firms invested 3.9 million yuan in Shanghai's nascent machinery industry; in the same period, ninety-one Chinese firms invested no more than 87,000 yuan. Even the Jiangnan Arsenal had been capitalized by the Qing government at only 543,000 yuan in 1867.[32]

From 1914, Chinese machine import statistics that distinguish between categories of machine (e.g., printing, agricultural, irrigational, etc.) start to appear. Between 1914 and 1931, imports of printing and paper-making machinery increased steadily from approximately 58,000-yuan worth in 1914 to a high of nearly 885,000-yuan worth in 1929 and settled out at about 631,000 yuan two years later.[33] If 1914 is considered a base year, however, the significance of the imports becomes clearer: by 1929, imports of printing and paper-making machinery reached nearly sixteen times the value of the 1914 level.[34]

As one might expect, Shanghai was central to this import trade. Printing and paper-making machinery never constituted more than 10 percent of Shanghai's imports over the 1914-29 period and averaged only 3.8 percent per year,[35] but this proportion still represented an average of 76 percent of all printing machinery imported into China between 1923 and 1931, the only years for which such figures exist.[36] In four of those eight years, Shanghai's proportion of the imports was in the eightieth and ninetieth percentiles. Yan Zhong's report from the early 1930s praised Shanghai merchants' ability to manufacture printing machinery,[37] but then it lamented Chinese publishers' lack of access to the most sophisticated imported machinery: "Chinese merchants have the most of each type of imported printing machine, [but] the newest models of fine machinery go to the foreigners. For example, in Shanghai now, there are offset machines, used mostly by the British-American Tobacco (BAT) print shop; and Zhonghua, the Commercial Press, the Japanese-owned Shanghai Offset Company, and Shanghai Printing Company all take second place."[38] Anecdotal accounts, too, reinforce one's sense that the Chinese market was flooded with foreign printing machinery.

However, in spite of its small size, already by the time of the Treaty of Shimonoseki (1895), Chinese investment in both the machine industry and the printing machine industry, in particular, had begun to grow. Reminding us that possessing the motivation and the means to acquire the benefits of technological expertise were nearly as important as having the capital to pursue them, Marie-Claire Bergère points out that "the essential problem for Chinese modernisation in the early days was not so much one

of innovation or even of the accumulation of capital, but rather how to acquire technological expertise."[39] In 1899, a lengthy piece in the *North China Herald*, intended to justify Western imperialism to its readers, took an imaginary inland Chinese on a tour of a foreign machine shop and gloated over the superiority of Western enterprise, but it also suggested how that expertise might be acquired: "By-and-by ... [our visitor] notices that amongst the score or so of men at work, sooty sons of Vulcan as they are, there is not a single foreigner. Every one wears his pigtail, and yet the foreign machinery obeys his touch with promptitude and exactness ... This ... is but routine work which any intelligent man can do when he has learnt it. The brain work is done elsewhere, and for the moment mainly hails from the Clyde [River, metonymous with Glasgow and the industrial west of Scotland]."[40] In addition to crowing over Western innovative genius, the article makes clear that technological expertise was passed from the engineers of the Clyde estuary to Chinese foundries on the banks of the Huangpu River. Apparently unknown to the *Herald* reporter, the same experience-based industrial techniques that enabled foundry owners in Glasgow to execute engineers' blueprints there were already being employed in Shanghai not only to operate Western machinery but also to duplicate it.

The scene described in the *North China Herald* article indirectly answers the question raised by Bergère: how did Chinese manufacturers acquire technological expertise?[41] We cannot know the precise steps that they took. What distinguished Shanghai's printing machine manufacturers from other Shanghai machine shops of the sort described in this *Herald* article, however, was their triumph over the difficulties involved in going beyond repairing to replicating Western technology in the crucial decade following the Treaty of Shimonoseki.

Between 1895 and 1913, eighty-six new Chinese-owned machine shops were opened in Shanghai,[42] seventy-four more than in the years between the establishment of the Jiangnan Arsenal (1862) and the First Sino-Japanese War. By 1913, allowing for closures, there were ninety-one such firms. They produced machinery for six broad categories of industry, including printing. Between 1914 and 1924, the overall number of Chinese-owned firms producing machinery in Shanghai more than trebled to 284[43] and by 1932 registered 456 firms.

Tian Jiasheng (b. circa 1889), himself an important investor in Shanghai's printing machinery industry and one of a number of veterans of Shanghai's machine industry whose recollections were recorded in the late 1950s and early 1960s, confirms something that we know from Chapter 1 – namely, that Britain and America produced most of the large printing machines used in China before 1895.[44] The bulk of small-scale machines came from

Japan, he continues. Tian then adds that, around 1895, Li Changgen (b. circa 1845), who had worked as a foreman in a natural gas piping installation firm, started the Li Yongchang jiqi chang[45] (Li Yongchang Machine Shop) with a 300-yuan investment.[46] In the course of his piping installation work, Li had often been in touch with print shops using kerosene engines and, more important, with the newspaper printers. Over time, he had learned how to repair their printing machines.

From the setup of his small one-bay shop on Jiujiang Road in the heart of the International Concession, it appears that Li expected not only to repair but also to forge printing machines. One side of his shop was organized to take care of customers and to service kerosene-powered engines; the other half was for repairing printing machines, which in the 1890s would have included a vast range of equipment such as mechanized lithographic presses, flatbed or platen presses, type-casting machines, stereotyping machines, and so on. The same forge that Li used for repair work was soon turned to manufacturing copies of the printing machines that he fixed; not for the first time in the history of invention, the ability to repair was matched with the ambition and ability to copy.[47]

Just as important to the advance of Li's craft, moreover, was the cultivation of a market for his machines. Not surprisingly, by 1900 or so, Li had established a link with the fledgling Commercial Press.[48] At this stage, its print shop was still located in its original three-room site in Jiangxi Road's Dechang Lane (see Figure 4.4), a short walk north of Li's workshop. The Commercial Press contracted Li to service the ten machines (hand and foot-pedal presses, lever presses, and a Roman-letter type-casting machine) in its print shop. By then, Li's shop had grown to ten workers and was manufacturing simple printing machines for sale to Chinese printer-publishers including, but not limited to, the Commercial Press.

In the same year, 1900, a second machine shop, also with a capital of 300 yuan, opened in Zhabei district's Haining Road. Like the Li Yongchang firm, in addition to taking in repairs, it manufactured copies of foreign machines, specializing in simple foot-powered letterpress printers. Along the same street, and at about the same time, the Fuxing tongmu dian (Fuxing Copper Matrix Shop) was opened. Essentially a foundry, it adapted Western printing technology to Chinese characters so that Fuxing could manufacture copper matrices[49] sold exclusively to the Commercial Press. Then a fourth entrepreneur began to manufacture lithographic printing presses. By 1904, a fifth, the Xieda Machine Shop, opened and supplied the Commercial Press with lithographic presses. In 1912, Shanghai's sixth privately owned machine shop was started up at the present-day intersection of Fujian North Road and Suzhou North Road.[50]

In this way, an era of manufacturing entrepreneurs started its ascent via the Chinese-run printing industry between 1895 and 1913. Of the owner-proprietors whose backgrounds are known, most fit the pattern that one would expect. Having worked in related trades, in the course of their work-days they seem to have encountered conditions that made it possible for them not only to identify a market niche but also to fill it. These "sooty sons of Vulcan" were also cautious businessmen. As suggested by the fact that at least three of the six printing machine manufacturers quickly estab-lished ties with the increasingly important Commercial Press, whose market influence expanded considerably in 1903 when its capitalization grew to 200,000 yuan, they preferred to invest in a sure thing.

The precise number of machine shops aligned with the printing industry in this first era of growth (1895-1913) is still difficult to ascertain. In this period, at least these six Chinese-owned machinery shops specializing in printing machinery repair appeared in a narrow industrial apron of the In-ternational Concession bordered on the south and north by Jiujiang and Haining Roads, on the east and west by Henan and Fujian Roads, and bridg-ing Suzhou Creek.[51] Their average capital investment was 300 yuan.[52] All of the firms were invested in and started independently. Two of the owner-proprietors had been print-shop foremen; one had come out of a type-casting shop; three were former machine shop foremen; and the most successful, Li Changgen, had worked in the natural gas pipe installation trade. In short, five of the six shops were started by onetime industrial foremen,[53] whose access to foreign machinery suggested to them how imitations could be made and sold for less than the foreign-manufactured originals. Particularly at this stage, as Bergère has written, "direct or indirect exposure to Western material civilisation was the determining factor in the setting-up of busi-ness concerns."[54]

In this stage, even Li's relatively successful company was a very modest operation. Despite his contact with the Commercial Press, for example, his shop was providing work for no more than ten persons[55] by 1900. After seven years and presumably still under contract to the Commercial Press, his shop had added twenty more, all thirty workers "manufacturing and repairing printing machines"[56] on Li's four or five lathes and one planing machine (a large collection of machines at the time, according to Tian Jiasheng). Despite the relatively advanced technology in Li's shop, however, Tian notes dryly that "some workshops barely had a few old 'tiger clamps,' and no mechanical equipment [at all] that would convince customers that repairs were their business."[57]

Slightly better-equipped but still nowhere near as well supplied as Li, Anhui native and owner-proprietor Chen Zhaoqing, founder in 1904 of the

Xieda Machine Shop, had had work experience in Shanghai's Zhuyizhai printing shop on Haining Road, Zhabei. According to his son, he worked alone for the first few years after 1904, repairing all sorts of printing machines on his single piece of machinery, a foot-pedalled lathe measuring four feet in length.[58] By 1913, after nine years in business, he had only ten workers, had purchased only two additional pieces of secondhand machinery (at least one British-made), and was finally using a kerosene engine for power. Most important of all, Chen, like his Chinese competitors, was no idler when it came to manufacturing. According to what Chen's son could recall about his father's business forty-five years later, "In addition to specializing in printing-machine repair, he also started to duplicate lithographic printing machines, selling them in [Shanghai] and other ports, to the Commercial Press and others, but he couldn't sell many."[59] Still, Chen's sales outside Shanghai aided in opening the hinterland to Chinese-manufactured printing presses, just as had the sales of the printing machines, copper matrices, and lithographic presses produced by his five competitors.

In sum, the years from 1895 to 1913 witnessed the establishment and growth of six printing machine manufacturers. These six formed the first real beachhead in the process by which Western printing technology was transferred and adapted for local Chinese use. In this industry, unlike others, early repair work rapidly promoted the manufacturing process. Perhaps the relative simplicity of the machinery involved accelerated the transition, but one must not overlook the ambition of these manufacturers to provide machinery for Chinese printers eager to participate in the rapidly expanding market for printed matter identified by Lee and Nathan and Chow.

From this survey, it is clear that, even at this early stage, one small business loomed over the other six. The Li Yongchang shop not only moved successfully from repairing machines to manufacturing them but also produced apprentices who in turn founded other manufacturing operations. Most significant of these apprentices was Zhang Jinlin, who went on to found the most singular of the workshops and factories supplying the printing and publishing industry with machinery. Zhang's experience indicates that this "industrial training" or apprenticeship system proved central to both individual successes and the success of the industry. Once the first generation of foremen-capitalists succeeded in establishing the viability of the industry, their apprentices were well placed to surpass them.

Zenith of the Foremen-Capitalists, 1914-32

Tian Jiasheng, who should be praised for his attention to the role of successive generations in advancing the industry in which he laboured, nevertheless incorrectly identifies the 1914-24 decade as the first in which most

new shops were "started by foremen" *(lingban).*[60] As we have seen, the decades after the Sino-Japanese War had already exhibited the phenomenon of erstwhile foremen turning investors to become what might best be called foremen-capitalists. That this group emerged then suggests that a relatively deep, two-generations-old industrial sensibility had already formed by the time Tian began to take notice of his industry. For this reason, the period 1914-32 stands out not as the age of the foremen-capitalists but as that of their zenith.

Still, Tian is correct to focus on the mid-1920s as a key phase in the industry's history. Indeed, Tian was not the only commentator to cite this period as one of consolidation in the printing machine manufacturing industry. For Yan Zhong, the economics writer who remarked on the growth of the printing machine business from the standpoint of 1932, the year 1924 marked a key turning point in the development of the industry. In that year, Yan says, because of the expansion of Chinese-owned cigarette manufacturing, Chinese machine manufacturers developed the offset machines needed to print advertising images. The offset machine market continued to expand into the late 1920s, say Cao Jinshui and Zheng Xilin, two former machine shop owners.[61] Throughout the late 1920s and into the 1930s, the printing machine industry remained profitable, and levels of technological innovation advanced, leading Yan Zhong to the conclusion that the industry's capacity had increased fivefold over these years.[62]

In the third decade of the Chinese-owned printing machinery industry – that is, between 1914 and 1924 – at least thirteen more printing machine manufacturers fired up new forges and opened for business. One pre-1913 firm had gone bankrupt, and another converted to manufacturing lathes, yielding a total of eighteen printing machine manufacturers. Four of the five leading firms of the heyday 1920s and early 1930s were in fact founded in 1914 and 1915.

To return to the question that Tian seeks to address, were the proprietors of these grimy, clamorous workshops mostly erstwhile foremen? Of the thirteen new machine shops for which details are available, the founders' backgrounds are fairly disparate; only three group together naturally, thanks to their shared experience in machine foundries, which presumably trained and encouraged them to think themselves capable of creating and supervising a workshop. Two others had been foremen in leading printing machine shops (one in Mingjing itself and the other in Gongyichang). Hence, in this 1914-24 period, only these five of the thirteen machine shop proprietors actually fit into Tian's category of industrial foremen. Nonetheless, adding them to the five from the earlier (1895-1913) era, one finds that ten of the total of eighteen shops operating in this decade were indeed started up by

what Tian might have agreed could be called foremen-capitalists. This term suggests a close, virtually genetic, link between generations of machine workers. These figures also make clear that these individuals had stepped outside the cycle of employment by others to become proprietors themselves.

By 1924, at the end of their third decade of business, Shanghai's Chinese machinists had established a self-sustaining machine manufacturing industry. Of the eight firms not started by industrial foremen, four were started by veterans of printing- or machine-related work. Finally, two proprietors were former small-time labour contractors, and the last had owned a small shop. All thirteen firms were independently capitalized as in the pre-1913 era.[63]

During the early years of World War I, Tian himself laboured as a machine repairman at the Commercial Press, but by 1916 he was able to start up the Ruitai Machine Shop in Suzhou North Road's De'an Lane (see Figure 1.15). Like his predecessors in the 1895-1913 era, Tian specialized in manufacturing. His shop produced type-casting machines that he sought to sell to his former supervisors at the Commercial Press.[64] Tian offers a persuasive, at least partially cultural, explanation for the relatively rapid growth of the industry in this era. His account also anticipates some of the observations of Lee and Nathan and Chow: "After the end of the First World War, and [with] the outbreak of the May Fourth Movement [1919], the cultural enterprises had a newly reformed atmosphere, and if you add onto this that in Shanghai businesses were started up one after the other, most of them using printed materials, all spurred the printing trades to a temporary expansion; because of this, the printing machine manufacturing trade was [also] invigorated for a while."[65]

Shanghai's population and commercial growth after the war produced an unabated demand for printed materials, but it took some time before Shanghai printers came to rely on equipment produced locally to satisfy the demand. A look at imports of printing machinery in this period shows that, despite reductions in 1915 and 1917, the three years of 1916, 1918, and 1919 all witnessed increased imports. By 1920, imports had completely rebounded, and they were nearly five times the 1914 rate; a year later, printing machine imports were thirteen times their 1914 levels.[66] The dependence on foreign machinery promoted by nineteenth-century missionary publishers had reached astronomical proportions.

According to Tian, progress was slow in the Chinese-owned manufacture of printing machinery and, until the mid-1920s, was limited to small- and medium-scale production. Three types of printing presses and machines (letterpress, colour proof presses, and type-casting machines) were produced. Tian makes no mention of collotype machines, then very popular in Shanghai

for printing illustrations, or of mechanized typesetting machines of the sort that had been common in the West since 1886.[67] Before 1924, says Tian, "lead-type presses produced by the Chinese machine industry were nearly all limited to hand-turned presses, self-inking machines, ... foot-operated machines, and so on, down to extremely simple machines."[68] Although the quantities of machines produced expanded, Tian regrets that neither the quality nor the complexity of the machines improved very quickly before the mid-1920s.

Tian's criticisms overlook the important advances of Zhang Jinlin's Mingjing Machine Shop. Unfortunately, Tian's critical views have been mirrored in recent writing by Chinese historians even when they are unaware of their source. Even those who have written otherwise well-balanced general accounts of the machine industry in this era have largely overlooked the vigour of this industry and its early escape from what they call the "repair-and-supply" *(xiupei)* pattern. They report that, as late as 1924, of 284 machine industry firms, 85 (30 percent) were still repair-and-supply shops, and they argue that "this kind of ... business could not open up the commodity market independently."[69]

Nonetheless, by no later than 1914, the specialized industry of printing machine manufacture had begun to do just that, signalling its departure from patterns characteristic of other machine-related industries in Shanghai. In the 1914-24 period, of the thirteen new shops, ten manufactured printing presses, admittedly still mostly simple, foot-powered letterpress machines. Two specialized in relatively simple type-casting machines. Zhang Jinlin's Mingjing Machine Shop, in this as in many other respects, broke from the pack to produce a wide range of machines.

Zhang Jinlin and His Mingjing Machine Shop

To get a perspective on the scale of Chinese-owned printing and publishing firms at this time, it is useful to note that Zhonghua Books, founded in 1912 and destined to become one of Shanghai's two largest Chinese publishers by the late 1920s, did not establish its own specially designed printing shop until Shen Zhifang (1882-1939) succeeded in doing so in 1916.[70] Like the lithographic pioneer Tongwen Press located in a residential Chinese structure *(pingfang)* in the 1880s and 1890s, Zhonghua's first two printing departments were in rowhouses *(longtang)* off Fuzhou Road and East Broadway (now Daming donglu, close to Tongwen's old offices). The Commercial Press lent the firm its first offset printing press. Before 1916, Zhonghua's typesetting was hired out to Wenming Books and other shops because its own facilities were inadequate. Into the 1920s, Zhonghua was still buying secondhand equipment. Li Xiangbo, who entered Zhonghua's

print shop as an apprentice in 1934, says that Zhonghua rarely even printed in colour before the 1920s.[71] This sort of hit-or-miss operation was changed with the founding of Zhang Jinlin's Mingjing Machine Shop.

Zhang Jinlin's Mingjing Machine Shop is the most thoroughly documented of all the approximately thirty-two Chinese-owned printing machine firms known to have existed in Shanghai by the 1930s. One reason Mingjing stands out sharply is that most Chinese-owned printing machine shops in this period were small, even including the machine shop of the Commercial Press.[72] Even Shanghai publishing houses that would assume colossal proportions in the 1920s and 1930s were much more modest operations in the 1910s than has been generally acknowledged. In contrast, by the early 1920s, Mingjing had over 100 employees and was producing approximately that number of printing presses annually. Other reasons for Mingjing's prominence will emerge below.

Zhang came to Jiujiang Road, apprenticed to the Li Yongchang shop, when he was fifteen *sui*.[73] Upon completion of his apprenticeship, he went to work in the machine repair shop of his own master's chief client, the Commercial Press. It is not known how long he worked at the press, but by the eve of World War I he had risen to the position of assistant foreman and was accumulating the stake that he would need to open his own shop. According to Hu Yunfu, owner-proprietor of a competing shop, "in 1915, [Zhang] ... pieced together ... a small amount of capital and set up the Mingjing Machine Shop at the intersection of Henan and Anqing Roads,"[74] one block north of the Haining Road establishments mentioned above and that much closer to his former employer, the Commercial Press.[75]

Contrary to what his colleague and future competitor Hu says, Zhang started with nearly twice the earlier generation's average investment of 300 yuan. Indeed, his 500-yuan investment enabled him to open his business with ten workers.[76] After a year, Zhang moved his enterprise to Henan North Road's Pengchang Lane. He was already using motorized machinery to copy an expanded range of hand-operated printing presses. By 1916 or 1917, after two years of business, forty persons laboured for him.[77]

The Commercial Press connection was no doubt vital to Zhang's account registers. Even more important in enabling Zhang to break from his job at the Commercial Press was his exclusive contract with the *Xinwen bao* newspaper works (*Xinwen bao* baoguan, founded 1893), which, along with *Shenbao*, was one of Shanghai's leading Chinese newspapers. Although it was reputedly founded by Viceroy Zhang Zhidong (1837-1909) and Sheng Xuanhuai (1849-1916), by the 1920s John C. Ferguson (1866-1945), the American missionary, held a controlling interest in *Xinwen bao*, located on the north side of Hankou Road between Henan and Shandong Roads.

While working as an assistant foreman at the Commercial Press, Zhang heard of a faulty foreign-built rotary press in one of the newspaper's printing departments. The supervising foreign engineer had not checked it upon installation, and now it was malfunctioning. By working overtime, Zhang not only got the press functioning but also gained the confidence of the *Xinwen bao* management. Soon all of the newspaper's machine repair work went his direction, and "Zhang took it all on," says Hu. Thanks to this lucky break, Zhang was soon able to set up on his own. By the early 1920s, several Mingjing apprentices report, the *baoguan* account was worth 2,000 to 2,500 yuan[78] per year.

In 1920, Mingjing rented land on nearby Tiantongan Road, and Zhang erected a factory structure on it. When Wang Shan'gen began work there as a foreman in 1922, it seemed to be a very large plant, with over 3,000 square metres of space, divided into ten rooms.[79] The staff had grown to over 100 persons. The equipment was all top-notch; only a minority of the lathes were made by Mingjing itself, with most of them coming from abroad. Wang recalls that his boss Zhang Jinlin's technical skills were "very high" and that, "except for a few high-level technicians, [the workers] were mostly skilled apprentices."[80]

In addition to his maintenance contract with the *baoguan*, Zhang sold machinery to it. Other steady customers of his Mingjing company included the Shanghai shuju (a publishing company founded by the Japanese) and Zhonghua Books. Each year, says Wang, probably with some exaggeration, Mingjing was producing more than 100 new printing presses.[81] They ranged in price from the technically sophisticated, full-page, lead-type newspaper press *(quanzhang qianyin baozhi ji)* retailing for 2,600 yuan and a five-colour lithographic press for 2,400 yuan to a small newspaper press (750 yuan) and a paper-cutting machine (400 yuan).[82] Between 1916 and 1921, Zhang sold 157,500-yuan worth of printing presses, largely to Japan.[83] Over the next eight years, between 1922 and 1930, probably chiefly at the Tiantong'an Road factory supervised by Wang Shan'gen, Mingjing sales of printing presses climbed to 394,000 yuan,[84] for an average of nearly 50,000 yuan per year in sales. In these eight years alone, over 800 new printing presses would have been produced for sale in Shanghai, inland, and overseas.

With sales of this volume, it is not surprising that other entrepreneurs with mechanical backgrounds swarmed into the printing machine specialty. In 1918-20, even the Commercial Press's affiliated machine shop, which until then had been content to purchase many machines from its network of suppliers, expanded its manufacture of printing machinery. When it did so, however, the Commercial Press went straight to the institutional source of much

of Shanghai's nineteenth-century and early-twentieth-century technical know-how: the modernized military. According to Tian Jiasheng, "the one behind their designs was Rong Zimei, who came out of the Jiangnan Arsenal."[85]

Still, Zhang held the lead, and by the mid- to late-1920s Mingjing was generally considered to be one of the top five printing machine manufacturers in Shanghai.[86] During 1928-30, the industry remained prosperous and then levelled out between 1931 and 1932. "At that time," said Zhang Jinlin's son Yingfang,[87] "because gold was dear and silver cheap, not only were imported machines expensive, but, to make matters worse, you could not get prompt deliveries,"[88] a situation that promoted sales of Mingjing's presses. Zhang Yingfang recalls that Mingjing benefited directly from the imported machinery shortage by supplying big Chinese publishers with machinery that they otherwise would not have bought: "For instance, at that time, the [Chinese-owned] Zhonghua Books wanted to add a set of banknote-printing photogravure machines. Originally [Zhonghua] had planned to buy them from Germany, but because the delivery date would have been too far off, and the price was too high, [Zhonghua] came to Mingjing [to have] them made."[89]

In sum, Zhang Jinlin and his Mingjing Machine Shop represent a critically important stage in the advancement of the Chinese printing machine business. Not only did the firm advance from making simple and medium-scale machines of use to jobbers and small-scale printers but also, by the early 1930s, after fifteen years of operation, it was providing sophisticated photogravure machines used by Zhonghua to print currency for the Republican government. The significance of this achievement is emphasized by Bergère's observation that even an entire lifetime rarely sufficed to allow one man to advance from working as an apprentice to becoming a capitalist of great substance.[90] With Zhang and his Mingjing firm, this technological and financial leap occurred in just over a decade. The next section suggests some reasons for Zhang's success in addition to those of hard work, pluck, and good fortune.

The View from the Floor Up: Former Apprentices Remember Zhang Jinlin and Mingjing

Given the scarcity of direct or first-person information from the owners of machine industry shops and factories, the testimony of former apprentices about them assumes considerable value. In the case of Mingjing Machine Shop, this value is increased by the prominence of Zhang Jinlin[91] in the industry at large. A comprehensive study of machine industry apprenticeships is beyond the scope of this chapter. The importance of the apprentice

system in advancing the printing machine industry has already been mentioned, but its historical significance should not be permitted to obscure the wretchedness of the apprentices' lives. In fact, their misery was an important aspect of the industry's history.

Evidence from Zhang's former apprentices can be used to supplement what is known about Zhang from the testimony of his colleagues and competitors. The former workers reveal in greater detail than is available elsewhere exactly how the apprenticeship system underwrote the printing machine industry financially and organizationally. Yet the fact that these interviews were conducted in the late 1950s and early 1960s requires that these sources, collected by Communist Party historians, be handled cautiously. Forty years and an at least nominally proletarian revolution separated the interviewed machine industry workers from the apprenticeships that they discussed. The interviewees' vocabulary and bias often reflect the influence of the "speak bitterness" *(shuoku)* sessions promoted by the Chinese Communists after 1949. Nonetheless, many of the particulars of their accounts can be corroborated by comparing them with contemporary descriptions of apprenticeships in Shanghai and other Chinese cities, making them a useful historical source.

For example, machine industry shops were generally staffed by underpaid, or unpaid, apprentices working for their keep and minimal instruction, and it would be surprising if Zhang's former apprentices reported anything different.[92] At the same time, the normal impoverished conditions, dirt, and grease of an industrial workshop were made worse at Mingjing by the fact that the bulk of the workforce ate and slept next to and beneath the machinery; these details are not found in accounts of other shops, so they provide important clues to conditions at Mingjing and about Zhang himself. For many, perhaps most, of Mingjing's labourers, vocational rites of passage expected in any apprenticeship served largely as thinly ritualized humiliation emphasizing their subordination to Zhang.

Chen Zhaoquan (b. circa 1906), Yang Zhengyang, and Shen Zhizhang were apprentices in the Mingjing Machine Shop in 1920. At that time, the three recalled, there were over 140 workers in the shop (40 more than Wang recalled having been there in 1922), and about 80 percent of them (110) were apprentices.[93] This heavy reliance on apprentice labour reflected the prevailing conditions in the broader Chinese-owned machine industry. At Dalong Machine Shop, one of Shanghai's best known, the proportion was the same in 1920,[94] with the added feature that half of the masters had served their apprenticeships in Dalong (the other half had come from outside firms). Other shops pressed even closer to full reliance on apprentice labour.[95]

According to Chen, Yang, and Shen, "the capitalist could ... get rich off the bodies of the apprentices ... because [apprentices] got no wages."[96] Eating usually occurred at the lathe and consisted of two meals per day of rice porridge *(zhou)* and dried turnip. The three men say that they and their workmates "summed up three years of apprentice life as 'three years of eating dried turnip meals.'"[97] Twice a month, on the second and sixteenth days, they ate some "tissue-thin" slices of meat or salted fish.[98]

In the early 1920s, even at a large, busy firm such as Mingjing, work times were uncertain but usually involved eighteen or nineteen hours per day.[99] Each machine shop set its own rules, but in small or specialized ones such as Mingjing young apprentices got up at 4 or 5 a.m. to do the housekeeping and accompany the master's wife to the market. When she returned, the apprentices waited on the Zhangs and the masters while they ate.[100]

At Mingjing, new apprentices generally performed these domestic chores for six months to one year; usually, in Shanghai factories with more than twenty workers, such as Mingjing, these services were not expected. When the next apprentice appeared, the first was relieved and would start delivering finished products to customers, making purchases at the hardware store, etc. All heavy materials were carried to and from the foundry by apprentices, no matter how far the journey, say Chen and his coworkers. "Now [even though] we only recall the hardships of [our] former apprentice lives, our hearts still have some lingering fear ... People who have not gone through this kind of life simply have no way to imagine it,"[101] they recalled in the early 1960s.

Ideally, by the third year, apprentices started to work with machinery.[102] Although by then an apprentice had become the master's mate, when the master stopped working the apprentice still had to clean the tools and tidy up. These odds and ends of work – shopping, hauling, cleaning – dominated the apprentices' day; instruction, except at the large machine shops such as Dalong in the 1930s,[103] was conducted on an ad hoc basis.[104] Relaxation, conversely, was strictly controlled in the shop. Although the regulations at Mingjing said that apprentices could rest on the nights of the second and sixteenth of each month, their free time was not their own to organize. Even when released from work, they had to ask permission to leave the shop, suggesting that skilled and unskilled alike were captives of the master machine-maker, Zhang Jinlin.[105]

The shop worked late nearly every night, with masters and apprentices not getting to bed until 11 p.m. or midnight. At that hour, the master or a senior apprentice would pull out planks, dismantle the lathe belts, and put the boards across the machines, making beds for themselves. The other

apprentices, "no matter whether the ground was mud, brick, or oil," put a straw mat over it and slept below the machines. Oil from the machines dripped down onto the sleeping apprentices, with the result that "our clothes were always as oily as raingear."[106] Because most apprentices had neither money to buy soap nor time to wash their garments, clothes were never changed from when they were first put on until they were in tatters.

Chen, Yang, and Shen say that between 1919 and 1921, when they first entered Mingjing, they were given twelve copper cash per month for doing "the work of oxen." This stipend was to be used for haircuts, bathing, and so on. From this discussion of their personal hygiene of that day, one can get a good sense of their scale of values and discern a wry sense of humour stimulated by the process of recollection:

> At that time, you only needed six coppers to get a haircut. [Because of] daily work, [your] whole body would be greasy. To wash your hands and face, you needed to buy one bar of soap, and that took four coppers. In this way, you only had two coppers left ... At that time, the cheapest bath house was twelve coppers ... *You only needed to save for six months*, and you had [just] enough to take one bath. So for the whole year we had no way to take a bath; sometimes if we had two coppers we would buy a bowl of wontons and figure this was [at least a way to] "end our meatless diet" (emphasis added).[107]

When Mingjing apprentices discuss precious moments of relaxation, their comments are invariably laced with some grimly humorous or ironic reference to the austerity of their everyday lives. In spite of these conditions, there was considerable competition for these apprenticeships. They were highly coveted because of the shortage of employment elsewhere and, presumably, because some workers sought to become masters or proprietors of their own shops, a phenomenon that had occurred many times between 1895 and the 1920s.

Chen Zhaoquan, for instance, came to Shanghai from Ningbo, his native place. His father was a landless peasant unable to support his several sons. At age fourteen *sui*, Chen was introduced to Mingjing by a relative/middleman who was a friend of Zhang Jinlin. Zhang, however, took a dislike to Chen because he was too short and small. At that time, apprentices were accepted on six-month approval, and Chen says that it was only thanks to his relative's intervention that he passed muster with Zhang.[108]

Yang Zhengyang, Chen's workmate, went to Mingjing as an apprentice in 1921. Yang concedes that a foreman's intervention with Zhang was a basic aspect of the process of getting an apprenticeship but goes on to state that he felt most wronged by having to pay a twenty-yuan "security deposit" (*yagui*)

even before he began.[109] The rationale for this payment was that the money would pay for the apprentice's copy of the factory rules. Yang says that many apprentices were new arrivals to Shanghai and became ensnared in this trap.

Just to gain him the opportunity to learn a trade at Mingjing, in Yang's case, his father had had first "to barter with relatives and plead with friends" *(huanqin tuoyou)*. Obtaining the travel expenses to Shanghai had further required him "to borrow from the east and gather from the west" *(dongjie xicou)*. Since coming up with this kind of training had been so difficult, "how could I bear to lose it?" Yang asks rhetorically. Like innumerable others sent to Shanghai in search of employment, he now had no choice but to send home for the security deposit. After many days of rushing around and again imploring relatives and friends, Yang's father barely pulled together the twenty yuan, which he sent to the Mingjing owner. Zhang, in turn, used the boy's *yagui* as long-term capital. "When I was an apprentice," says Yang, "the factory had more than 110 apprentices; if you work it out, that's more than 2,000 yuan."[110]

Even after having satisfied the deposit claims and after having been approved by Zhang, an apprentice and his family retained a quasi-familial patron/client debt to the shop. Chen Zhaoquan goes on to say that his middleman relative "ordered [Chen's] father [to appear at the shop] provided with joss sticks and candles, to enter the factory, and to acknowledge the master [owner]." Accompanied by the middleman, Chen's father had "first to kowtow and do obeisance to the owner, then do obeisance to the owner's mother, then to the God of Wealth, and to the Kitchen God." Lastly, under the owner's guidance, Chen's father had to "salute each old master," finally completing the "Master-Acknowledgment Ceremony" *(shifu xingli)*.[111]

The traditional apprentices' training lasted from three to three-and-a-half years.[112] Around 1927, the Tongtie gongsuo (Copper and Iron Guild), to which machine shops belonged, would stipulate a three-year training period. Nevertheless, apprentices were so vital to a shop's operation that masters found all sorts of excuses to prolong the term. According to the former Mingjing apprentices Chen, Yang, and Shen, in the early 1920s, in spite of establishing contracts *(guanyue)* specifying three-year training periods, Zhang Jinlin "used holidays, injuries suffered while on the job, and sick days as excuses [to force us] to make up work [time]."[113]

In addition, most factories obliged apprentices to hold to the "holiday expiration" schedule, meaning that apprentices could "graduate" only during the Spring, Dragon-Boat, or Mid-Autumn festivals. If one's term expired just a few days after the end of a holiday, one would have to work for a few more months, and only when the next holiday finally came around could

one complete the term.[114] As a result, many machine industry apprentices took four, five, or even six years to complete their terms; at Mingjing, upward of four-and-a-half years was not uncommon in the early 1920s.

Just as the apprentice's entry into Zhang Jinlin's shop was marked by a ritual of subordination, so too was his final departure from it. Chen, Yang, and Shen all agree that at Mingjing, if one did not perform the "Thank-Master Toast" *(xie shi jiu)*, one was not considered to have bought one's "diploma" or as having completed one's term. Even at this point, the three men recall bitterly, "the owner could resort to new tricks," such as extending individuals' terms, even up to six months, to get a large number of apprentices pooling their resources for the final send-off. When the big day arrived, Zhang was entitled to invite his friends and relatives to participate, but the apprentices could not invite even a parent. No protests were raised because the only persons entitled to complain were the apprentices' guarantors; presumably, their interest was in seeing apprenticeships completed.[115]

At Mingjing, apprentices regarded themselves, with good reason, as beasts of burden subjected to a life of austerity, filth, and violence. Corporal punishment was frequent. "A punch or slap on the face was the very least ... It was so natural that it was not ... taken as [anything] special,"[116] said eight former apprentices of Mingjing and other shops. Hammer handles, wooden sticks, ropes, whatever was at hand could become weapons if an apprentice crossed a master or simply had the bad luck to run into him when he was out of sorts. Chen Zhaoquan recalls the Mingjing apprentice Xu Xingkang, sent to the Zhonghua falang chang (Zhonghua Enamel Works) one day to repair a machine. In the course of his work, the machine somehow crushed his foot. When Zhang Jinlin saw how seriously Xu had been wounded, he told him to leave the factory for good. Because of the medical neglect brought on by his unemployment, Xu ended up crippled for life.[117] Former apprentices from other shops recall workmates having been beaten to death.

As suggested by the repair mission that led to Xu's accident, however, and in spite of haphazard training and the physical neglect or abuse of the 110 or so apprentices, in the early 1920s apprentices did glean enough skill to turn themselves into valuable craftsmen whose labour Zhang Jinlin could then farm out into the printing and publishing industry. Wang Shan'gen, quoted earlier, recalled that the workers at Mingjing "were mostly skilled senior apprentices." The Chen, Yang, and Shen trio also recall participating as part of a maintenance team of ten persons (eight apprentices, one old master, and one just-graduated apprentice) sent one day to *Xinwen bao*. The newspaper plant, when paying Mingjing for its expertise, did not distinguish technicians from apprentices and handed over thirty yuan per man per month. Each apprentice continued to receive only his twelve-coppers

maintenance, with at most a two-mao bonus tacked on. With board added in, Chen and his coworkers calculate that Zhang cleared over 2,000 yuan per year on their team's labour.[118]

From the testimony of these apprentices, it is clear that by 1919-21, when Zhang's firm was selling an annual average of 31,500-yuan worth of printing machinery, Zhang had also gained at least 2,800 yuan of his long-term capital from apprentices' security deposits. He made another 2,000 yuan per year from his account at the *baoguan*. Although we have no way of knowing Zhang's profit margin on his sales, it is clear that 15 percent of his gross income in this early period originated solely from his captaincy of a battalion of widely employable apprentices.

In her review of Chinese entrepreneurs in this period, Bergère states that "the technical success of these small workshops capable of reproducing foreign machinery ... was not rewarded by an equivalent economic and social success."[119] It is precisely this state of affairs that makes the anonymity of these entrepreneuring foremen so difficult to penetrate. Still, from the testimony of his former competitors, colleagues, and apprentices, many of whom probably had good reason to dislike him, Zhang Jinlin's character emerges.

Zhang appears to have been a highly trained and energetic individual. In the course of a twenty-two-year career, he stationed himself at the centre of a web of professional obligations that ranged from supply firms, to his clients at the Commercial Press, and on to the *Xinwen bao* plant. Socially and domestically, he directed a small army of knowledgeable but impoverished apprentices and, at least as important, their families. A man whose own status had risen thanks to technological and economic authority, physical brutality, and ritualized subordination of his apprentices and their families, Zhang was the primary beneficiary of familial patronage money, repair contracts, and sales of specialized printing machinery. But beyond these observations, even he remains as anonymous as his competitors.

The Impact of Other Chinese-Owned Printing Machine Manufacturers

At other firms, the 1920s were also a time of growth and increased manufacture of different kinds of machines. Up to now, attention has focused on the manufacture of printing presses, but many firms were also busy developing other types of machines. Gongyichang, Yongsheng, and Xinghua, for example, were actively attempting to produce rotary paper makers, which first appeared in 1926 as a result of collaborative efforts at their Baoshan Road factories.[120] The lack of Western-style paper had been an impediment retarding the Western-style letterpress industry since the era of the missionary publishers. The inability of Chinese-owned enterprises to produce paper in adequate quantities by 1900 obliged the Chinese letterpress industry

to use expensive imported paper. Interestingly, restrictions on the availability of foreign paper sustained the lithography industry, which relied on Chinese-produced bamboo paper, and kept it viable well into the twentieth century.

Efforts by Gongyi and others to achieve technological independence through the manufacture of Western-style paper, however, were eventually successful. By 1936, a government report observed in laudatory tones, "In the south [of China], all paper factories now use Chinese-manufactured [paper-making] machines from Baoshan [near Shanghai] and Shanghai [-proper]; in other places, most [factories] use foreign-produced ones. Baoshan and Shanghai machines are all designed and manufactured by Chinese, and the results are excellent."[121] In spite of breakthroughs of this sort, of course, not all efforts were rewarded with comparable market success. Offset printing presses, for instance, were first introduced by the Hujiang and Xin Zhongguo (New China) machine shops. Hujiang responded to the growth in cigarette advertising in 1926 by attempting to copy German-made machines imported for sale at 10,000 yuan each. Although Hujiang did succeed in producing an imitation, its quality was so low that all the examples were sold for scrap, and in 1928 Hujiang had to declare bankruptcy.

New China Machine Shop, alternatively, had started by imitating American cigarette-rolling machines. At the time, Japanese offset printing presses were being sold for 8,000 yuan, and the Chinese shop endeavoured to copy them and the German ones, with the intention, common to the Chinese-owned machine shops, of underselling the foreign machines. Zheng Xilin, then working for a Japanese firm installing offset presses at 100 yuan per job, says that he helped the firm to test its new machine, but, despite whittling the price down, the printing machine could not compete in Shanghai with the authentic foreign ones, presumably because of technical deficiencies. Finally, New China's investment was saved by the Shanxi warlord Yan Xishan (1883-1960), who sent his purchasing agent to Shanghai to buy the machines. Zheng states that, to get the two test models off their hands, "we started with the low price of 3,500 yuan for each."[122] In this way, even design failure promoted the modest expansion of mechanized printing presses to the hinterland.

The manufacture of printing presses and the sale of them outside Shanghai was supported by Chinese manufacture of other kinds of printing apparatus. Tian Jiasheng's Ruitai Machine Shop specialized in making type-casting machines, which in the post-World War I era were all Japanese imports. Targeting the Commercial Press, his former employer, which, it will be recalled, opened its own machine shop to manufacture printing presses in the period 1918-20, Tian eventually succeeded in gaining an account there. He

soon attracted other clients, and "after I got ... going, Japanese imports were gradually reduced," he says proudly.[123]

Shanghai printing press and machine manufacturers had moved technologically far beyond the stage characterized by Li Changgen's shop at which the industry had started. In the middle of the industry's fourth decade – that is, by the 1930s – successes such as the jointly invested rotary paper maker, Tian's type-casting machines, Mingjing's newspaper presses, lithographic presses, and paper-cutting machines had all been achieved. The manufacturers remained hampered largely by production capacity, which itself may have been influenced by a lack of access to capital.

Regardless of these constraints, Chinese printing press and machine manufacturing was a creative and profitable industry, capable of countering Japanese manufactures, if not yet European and American ones, even at the high end of the technology required by the printing and publishing industry. More successfully than any other Chinese machine industries, except the knitting machine industry, Chinese manufacturers such as Mingjing had moved to satisfy the demands of the Chinese market for locally produced machinery. Out of the thirty-two machine shops specializing in printing machine manufacture, twenty-two were primarily manufacturers, with the remaining ten focusing on repair.[124] Praised by industry and government, nonetheless, the printing machine industry was founded not on the sort of circumspect intelligence characterized by Tian Jiasheng, but on the anonymous energy of proprietors such as Zhang Jinlin.

Beginning of the End

As noted earlier, in 1932, one observer commented that Shanghai's printing machine industry had grown twentyfold in as many years. Of the 400-plus machine shops that dotted Shanghai's foreign concessions from 1895 to the early 1930s, this chapter has focused on the portion that supplied the domestic Chinese and, to a lesser extent, Japanese and Southeast Asian printing and publishing industries.

Of the thirty-two firms referred to here, six (Li Yongchang, Fuxing Copper Matrix Shop, Xieda, Tian's Ruitai, Zhang's Mingjing, and the semidependent Commercial Press-owned Huada) can be shown to have been part of the network of Chinese firms supplying the big Chinese newspaper plants and publishing houses. Initially, they offered repairs but quickly thereafter began building copies of foreign machinery. The actual number of these machine producers was certainly much higher. Like a series of industrial nodes, scattered throughout the International and Japanese Concessions, these shops provided the native industrial base for the expansion of Shanghai's printing industry.

In addition, Tian Jiasheng, in his own view, dislodged the Japanese, who had dominated China's type-casting machine market. In an interesting twist on the theme of technological competition, Zhang Jinlin's Mingjing Machine Shop was patronized not only by Chinese printers and publishers but also by the Japanese Shanghai publisher Shanghai shuju and by the Japanese home market. When the Shanghai market proved to be unreceptive to locally manufactured commodities, such as Chen Zhaoqing's lithographic presses, Tian's type-casting machines, or New China's offset presses, Shanghai-made machinery was sold in the Chinese hinterland and abroad and contributed to the mechanization of both the national printing and the national paper-making industries.

Thus, no later than 1900 and much earlier than has been previously recognized, the Chinese-owned printing machine industry started to rise above the prevalent pattern of heavy reliance on repair work characteristic of most machine-related industries in Shanghai. Between 1914 and 1924, the industry produced small- and medium-scale printing machinery such as simple presses and type-casting machines. By the mid-1920s, it had moved into production of more sophisticated machinery such as offset presses. Even its failure to compete well against foreign offset presses in the Shanghai market facilitated the mechanization of the nonlittoral Chinese printing industry long before the forced transfer after 1937 of industry inland brought on by the war with Japan. The singularity of Shanghai's printing machine business in breaking from the pattern more typical of the larger Chinese machine industry – that is, of reliance on repair-and-supply work – was accomplished in part by articulate entrepreneurs such as Tian Jiasheng, but more often by the the patronage, control, and energy of men such as Zhang Jinlin who today remain little more than name entries on lists of pre-1949 factories.

In the Japanese attack on 30 January 1932, mentioned at the outset of this chapter, bombs also rained down onto the machine-making firms that studded the Zhabei, Hongkou, Nanshi, and Yangshupu districts and that were so dependent on the Commercial Press and the rest of Shanghai's publishers for purchase contracts for printing presses and machines. During the initial bombing and subsequent house-to-house fighting, most machine shops in Zhabei were destroyed. Mingjing itself was nearly obliterated. In Hongkou alone, more than 200 machine shops suffered destruction. Naturally, in light of their lack of access to corporate assets and their dependence on larger firms for business, these small workshops recovered much more haltingly than did the machine shop of the Commercial Press.

According to Bank of China reckoning, by 1934 there were only 204 machine shops left in Shanghai, the same approximate number as in the

late 1910s.[125] The machine industry grew smaller year by year and did not
begin to recover until the end of 1936. Dalong, for example, increased both
its investments and its sales by then. Mingjing, like many other surviving
machine shops, began retooling for the arms trade and government needs.
Its plant flickered back to life with the shift to military production and
machine tools intended for military products. When fighting related to the
Marco Polo Incident (7 July 1937) spread from Beijing to Shanghai on 13
August, however, the machinery industry collapsed again. Fighting destroyed
360 firms, and 66 firms moved inland.[126] Dalong was soon occupied by
Japanese troops and was reorganized to support the Japanese war effort.
Mingjing drops out of the record until 1949, by which time Shanghai and
Mingjing were no longer the centre of the Chinese-owned printing machine
industry. In that year, only 9 of 308 printing presses produced in China
bore a Shanghai trademark.[127]

Conclusion

This chapter began with the question of how letterpress and lithographic
printing commenced, technologically speaking, in Shanghai and, by impli-
cation, in the rest of China at the end of the nineteenth century. The gradual
spread of Western-style lithographic and letterpress printing up the China
coast after 1814 by means of missionary publishers such as the Jesuits,
American Board Press, London Mission Press, and the APMP presented
numerous technical challenges. Missionaries themselves came up with in-
novative solutions to these problems on the spot or brought in technical
personnel, such as William Gamble, to assist them. One obstacle that the
missionaries did not manage to overcome by the end of the nineteenth
century was their dependence on imported printing presses and printing
supplies. They passed this dependence on foreign-made machinery and sup-
plies on to the small number of Chinese printers and publishers trained in
their publishing firms. Shanghai's modern printing industry overcame the
limitations of the missionary supply system and gradually mechanized it-
self on the bases of imported machinery and, historically more significant,
Chinese-made printing machinery.

 As indicated by Table 3.1, by 1900, five years after Li Changgen opened
his machine shop, Shanghai had distinguished itself from other potential
competitors in printing press and printing machine manufacture. Whether
we are discussing early manufacture of manual relief presses or lithographic
hand presses, China's important breakthroughs were made by Shanghai's
machine shop proprietors and their workers. The same can be said of the
manufacture of matrices and Chinese-language type-casters. In the Chinese
manufacture of rotary presses, which did not appear until the late 1920s,

and in the creation of advanced photogravure presses, Shanghai's trades-
men played the same prominent role. Somewhat more significant, of the
nine technologies created or imitated on the Chinese mainland after 1915,
when Zhang Jinlin founded Mingjing, his firm could claim credit for the
first viable models of four of them. And within six years of the establish-
ment of the firm, Zhang and his apprentices were manufacturing an average
of 100 presses and machines per year. By contrast, Tian Jiasheng's Ruitai
could claim breakthrough success only in type-casters, an area that none-
theless advanced China's Gutenberg revolution by putting lead type into a
widening variety of Chinese hands.

By shifting attention away from imported technology, this chapter has
brought into view the process by which the initial seven Shanghai printing
machine shops, within less than a decade after 1895, laid the foundation for
self-sustaining manufacturing firms. Starting with the Li Yongchang shop,
which, like its competitors, was initially little more than a repair-and-supply
shop, these firms were led by persons who may be called foremen-capitalists.
Although of relatively minor economic importance, these few scattered firms
are of historical importance and interest because of their role in creating
conditions suitable for the economically more significant manufacturing
firms, such as Mingjing. Contrary to the prevailing view, we have seen that,
in the first crucial decade of the printing machine industry and more likely
between 1895 and 1900, erstwhile industrial foremen had already remade
themselves as manufacturers. At the same time, they created their own suc-
cessors through an effective, if exploitative, apprenticeship system. Even
before World War I, the Chinese printing machine industry was concentrat-
ing on manufacture, rather than repair, thanks to their efforts. By reorient-
ing the standard paradigm prevailing in the history of the book to include
the history of technology and industrial manufacturing, this chapter has
shown that Shanghai's Chinese-owned modern printing and publishing in-
dustry was grounded in part on its Chinese-owned foundries and machine
shops. For this reason, histories of the modern book industry, which itself is
key to the development of Chinese print capitalism, are incomplete unless
they include attention to the history of industrial manufacturing.

Indeed, the most successful of these foremen-capitalists, Mingjing's Zhang
Jinlin, started out as an apprentice in the most flourishing of the late Qing
Shanghai workshops. At least as helpful to his fifteen-year climb as his own
diligence and training was the range of business connections that he picked
up as he manoeuvered through Shanghai's industrial sites, starting from the
Li Yongchang shop on Jiujiang Road, moving north to the Commercial Press,
heading south to the *Xinwen bao* newspaper works, and finally coming to
rest in his own vast manufacturing plant. Just as important, the more than

1,100 presses that Zhang's firm can be shown to have produced between 1916 and 1930, the years for which such twenty-one Chinese-owned competitors were important for putting modern Western-style printing within reach of Chinese print capitalists both in Shanghai and inland. By the 1930s, the productivity of these manufacturers presented government commentators with a model of industrial success.

The printing machine manufacturing business witnessed the early emergence of foremen-capitalists who, despite the limitations of the industrial training system, did produce their own successors. The fact that certain prominent firms, such as Li Yongchang and Mingjing, cultivated the sale of their machines to one of Shanghai's largest industrial markets, the Shanghai printing industry, implies that less well-known firms had much the same intention but searched for less competitive markets inland and overseas.

For all of them, technological expertise, commercial acumen, and good fortune combined between the early 1900s and the 1930s to enable a total of twenty-two firms to move rapidly into the manufacture first of simple- and medium-scale printing machines and then of highly sophisticated ones. The early success of the printing machine firms in moving from repair services to manufacturing was related not only to the ability of these manufacturers to produce machinery at a marketable price but also to the increasing demand for printed commodities of all kinds between 1895 and the mid-1930s. In the end, however, war, not technological or commercial competition, brought a lasting halt to the proliferation of Shanghai's Chinese printing machine manufacturers. The 1932 Japanese bombing of Shanghai had a profound effect on the printing machine industry, dealing it a setback from which it very slowly recovered in the mid-1930s, only to be decimated in August 1937 when the Japanese military again attacked Shanghai. Indeed, the second Japanese assault dealt the city's printing machine manufacturers a blow from which they never recovered in the Republican period, highlighting the importance of machinery to Chinese print capitalism.

From Mingjing's modern plant down to the smallest and rudest of workshops, these grimy, noisy, violent shops, much more fundamentally than the missionary publishers or any of the large Chinese publishers at the high-status end of this cultural industry, were responsible for the extensive mechanization, as well as the spread, of both letterpress and lithographic technology throughout Shanghai's and China's printing industry in the early twentieth century. Without the appearance and multiplication of these Chinese "sooty sons of Vulcan," labouring over their forges and sleeping under their lathes, Shanghai printers and publishers would have remained permanently dependent on the same imported supplies as the missionaries who had trained nineteenth-century Chinese printers in Canton, Hong Kong, and Ningbo.

Fewer Chinese printers would have been able to afford to buy modern printing machinery, and Western-style printing would have required much more time to become the Chinese norm.

While acknowledging the importance of proprietors such as Zhang Jinlin, a balanced account of this industry, which contributed in a material, if indirect, way both to the post-1895 "general awakening" and to subsequent expansions of the modern, mechanized, market-driven Chinese press in the early twentieth century, requires that we recognize the social cost of enlightenment exacted from Zhang's and others' employees. Through physical and patriarchal domination, machine shop owners such as Zhang controlled access to the narrow passageway that provided a relatively small proportion of machine-building apprentices with the skills they needed to succeed on their own. The exacerbation of these social relations in a radically new industrial environment harkens back to issues raised in Chapter 2's discussion of the lithographic industry, particularly the observation that the minds and values of those who owned modern machinery often failed to keep pace with technological innovation. In fact, industrial technology seems to have coarsened life for many even as it granted hope to a handful.

Although there is little evidence of the emergence of mature and self-conscious class relationships in the lithographic industry of the late nineteenth century, by the early twentieth century it is clear from the machine industry that the same growing polarization discussed by Febvre and Martin and Darnton with respect to France was under way in Shanghai. This process was exacerbated by the existence of technology and access to it even if the situation did not yet manifest itself in specific acts of rebellion. Thus, a question arises as to how Mingjing and other apprentices addressed their misery at the powerless end of Shanghai's industrial workplace relations. The success of many of their masters in opening their own shops hints strongly at some apprentices' faith in their ability as individuals to get ahead. Others, perhaps under the influence of printed materials that began circulating in the 1920s, gradually turned to collectivist solutions in opposition to the master/apprentice system studied here.

4 "The Hub of the Wheel": Commerce, Technology, and Organizational Innovation in Shanghai's New-Style Publishing World, 1876–c. 1911

Up to this point, the dispersal of Western-style mechanical and industrialized printing has been set against the background of late imperial Chinese print culture and print commerce. Unlike many other countries, empires, and regions of the world that experienced the Gutenberg revolution as part of the expansion of European imperialism in the modern period, China's homegrown, centuries-old tradition of learning and book production has been shown to have profoundly influenced its reception of Western printing technology. The objective of this chapter is to show how traditional Chinese print culture and print commerce, both with ancient origins, took on the character of modern Chinese print capitalism.

Much like the Chinese adoption of Western technology, the Chinese response to the exigencies imposed by that technology necessitated blending the inherited Chinese value system with the Western-influenced present. Both this chapter and the next will highlight the economic, organizational, and social effects of this new industry based on Western-style printing technology. A sharpened business sense was an important part of the new beginning in the long history of Chinese print culture undertaken at Shanghai. In particular, in the period from 1876 to approximately 1911, along with expanding the industrial production of books, Shanghai's printers, publishers, and booksellers will be shown in this chapter to have demonstrated growing concern with just, adequate, or fair compensation to those who invested in the machines on which print capitalism rested. At the same time, vestiges of an inherited past continued to influence the decisions made by those who owned and directed the use of those machines.

In addition to restoring the commercial viability of the traditional publishing industry after the devastating Taiping Rebellion (1851-64), Shanghai's printers, publishers, and printing machine manufacturers surmounted the limitations of that business by helping to establish Chinese publishing on an industrial foundation. Once Shanghai's publishers adopted mechanical printing technologies and industrialized the Chinese publishing industry, they and the city's printers and printing machine manufacturers transformed the social basis of knowledge production and distribution in the Chinese

empire. Deeply influenced by this change, contemporary reformers and revolutionaries continued to exhibit many inherited characteristics but also created new ones through the interaction of Chinese values with Western machinery.

After 1876, private, nongovernmental, and Chinese-owned industrial printing and publishing firms tapped new resources from the relative security of Shanghai's International Concession. From then on, attempts to return to old-style, relatively genteel, craft-based xylographic printing would be only sporadic and limited in scope. Even traditional Chinese literature came to be produced using modern machines, as we saw when describing Wu Youru's (1840?-1893?) illustrated journals issued alongside those of the Dianshizhai. Generally speaking, though, "new-style" books *(xinshu),* a term frequently encountered in the sources of the period, should be understood to refer to a manufacturing process, to the physical appearance of those books, and to their contents.

Shanghai's printers, publishers, and printing machine manufacturers effected the leap to print capitalism between 1876 and about 1911. Already by the early 1880s, Chinese firms such as Tongwen Press started printing what were for the Chinese new kinds of intellectual products, the industrially produced book and journal. There is little explicit evidence of the Tongwen proprietor Xu Run's concern with adequate compensation for his effort. Within the three decades covered by this chapter, however, the machine-based mode of production pioneered by Tongwen and others developed to the point where adequate compensation and access to investment and operating capital became foremost in publishers' minds. Their publications also began to contain startling "new-style" – that is, Western- and Japanese-style – ideas about science, democracy, and state and society. Key notions such as these, which would animate Chinese politics and social life throughout the twentieth century, were now delivered largely via the Western-style printing press, harnessed to the new goal of mass-producing books for sale throughout China and abroad.

At least as important as technology and ideas were organizational models that successive Shanghai printers and publishers appropriated and adapted to what they believed were the needs of Chinese society between the two wars with Japan (1894-95, 1937-45). The sustained, if sometimes unsteady, prosperity of the modern publishers was eventually expressed, organizationally, in a booksellers' guild and a trade association. However, such industry-wide organizations developed concurrent with the adoption of Western-style business models, such as individual proprietorships, partnerships, and, crowning the multitudes of proprietorships and partnerships, the joint-stock limited liability corporation *(gufen youxian gongsi).* Chronologically,

Shanghai's publishers were among the first in China to adopt the limited liability corporate model; historically, they were also among the most successful in doing so. In their own view, the corporation offered them financial and organizational flexibility.

Under Alfred Chandler's influence, historians have argued that the Western-style corporate model succeeds by establishing impersonal bureaucratic order at the expense of social networks and family ties. Scholars extending the argument to China have tended to fall into two groups. The first group has maintained that corporate hierarchies and economic rationality prevailed or were imminent in nineteenth-century and twentieth-century China. Their conclusions have been challenged by a second group, which, in its study of the structure of Chinese capitalism, emphasizes informal social networks that relied on family, local origin, etc.,[1] all of which, in the view of the first, should have undermined the firms' chances of success.

Like Shanghai's Shenxin Cotton Mill and China Match Company between 1915 and 1937, the period upon which Sherman Cochran's study of these firms concentrates, Shanghai's corporate Chinese publishing companies such as the Commercial Press, Zhonghua Books, and World Books took serviceable parts of the Western corporate model and adapted them to Chinese circumstances. Just as the nineteenth-century lithographic printer-publishers had selected the technology appropriate to their needs, Shanghai's twentieth-century corporate publishers borrowed what was useful from Western business organization and applied it against a background of values that their owners had inherited from China's pre-industrial print culture and commerce. At the same time, in the view of Lin Heqin (active 1930s), a printer and the publisher of Shanghai's *Yiwen yinshua yuekan/The Graphic Printer*, only the formal structure of the Western-style corporation could endow Shanghai printing firms with longevity. The records of those Chinese publishing firms that did adopt elements of the corporate model suggest that their adaptation of it was an essential part of their success story.

Ultimately, however, what is important here are not the formal elements of business organization, whether borrowed or indigenous, but the dynamic role of the joint-stock limited liability corporation in achieving what Chinese printers and publishers believed it accomplished: namely, providing them with a means of organization useful for raising capital from other corporate organizations such as modern banks and for providing long-term safeguards for corporate property. Relatively anonymous financing, of a sort beyond the experience and know-how of Shanghai's traditional banking institutions *(qianzhuang)*,[2] enabled them to purchase foreign machinery. At the same time, native-place ties, familial concerns, literati values, and even,

in the case of the Commercial Press, religious affiliations influenced the day-to-day operation of these firms.

Expensive Western-style machinery seems necessarily to have channelled publishers' public service ideals into industrial profit-seeking and toward the corporate model. The social mingling of scholars, merchants, and technicians involved in creating the modern book-publishing corporation occurred in the context of this expanding mechanized economy. Successful Shanghai publishers tried to unite under the corporate roof the multiple groups seeking their fortunes in this innovative business. At the same time, Qing reform legislation covering education, industry, and intellectual property was written as if tailored for the Shanghai publishing world. It legitimized many modern business practices already being implemented in Shanghai's publishing world by the scholars and merchants running it. All these innovations also positioned aggressive, well-connected firms such as the Commercial Press to transform a marketplace formerly provisioned by decentralized, late imperial, Chinese print merchants into one dominated by Shanghai-based, technology-driven print capitalists.

Post-Taiping Chinese Social and Educational Groups and Shanghai's Late Imperial Publishing World

As Chung-li Chang and others have shown, the meritocratically based civil service system of the period prior to the 1850s was radically altered by the social and political impacts of the Taiping Rebellion. One of the targets of the rebellion, which claimed thirty million lives before it was suppressed in 1864, was the literati culture and *shuyuan* (academies) upon which the social legitimacy of the hated Manchu dynasty rested. The rebellion's effects reverberated far beyond the immediate destructiveness of the Taipings. Not surprisingly, given literati prerogatives to act as the intellectual conscience of China, the reconstituted gentry included many drawn to educational reform and its supporting field, publishing.

During and after the Taiping Rebellion, as a means of raising revenue, Qing authorities remade the Chinese gentry in important ways. Although policies involving the sale of civil service degrees formerly won through competitive examinations increased the size of the literati with respect to their overall percentage of the total population (from 1.3 percent to 1.9 percent), the most important changes were social and educational rather than purely demographic.[3] In the four decades between the suppression of the Taipings in 1864 and the abolition of the civil service examinations in 1904-5, two-thirds of all officials gained their status thanks to purchased, rather than earned, degrees as compared with about half prior to 1850.[4] As

the balance shifted decidedly in favour of "irregular" officials and degree-holders, the prestige of literati learning, formerly heavily oriented toward the winning of degrees and official positions, was further eroded.

Literati culture itself was redefined. Those for whom book culture and higher learning had formerly provided both a means of self-cultivation and an avenue to public service now found themselves in a world in which status and service were no longer fixed entities. The rules governing status and public service were increasingly open to negotiation. Among the outcomes of this new climate was unprecedented social mixing of literati and merchants in both revived traditional and newly founded organizations. Educational reform, too, soon embraced the legitimate pursuit of and involvement in education by those with modern business interests.

Social changes emphasizing the importance of trade in the post-Taiping Jiangnan political-economic structure have led recent scholarship to highlight sociopolitical phenomena that also remade local elites and their networks. Going beyond the familiar old categories of merchants and literati, many scholars have identified gentry-merchants *(shenshang)*, gentry-managers (or "elite managers" *[shendong]*[5]), and a Westernized "urban reformist elite"[6] with its roots in late Qing social changes. Although historians still find it difficult to agree on the most appropriate terminology for these new social groupings, they tend to concur that the old Confucian-endorsed hierarchies[7] were no longer applicable to the actual social reality of late imperial China. Many scholars now believe that both literati and merchants had in fact been influenced and increasingly united by the commercial upsurge in the Chinese economy developing since the sixteenth century.[8] Building on this long-term momentum of commercialization and urbanization, the Taiping Rebellion both opened room at the top of the imperial structure and led some members of the Jiangnan elite, particularly those from Zhejiang and Jiangsu provinces, to seek refuge in Shanghai from the 1860s onward, a process that continued unabated into the twentieth century. In the treaty port, such newcomers joined various business circles, many of them with links to education.[9]

The current lack of agreement among historians regarding suitable terminology for the social structure of the late Qing may reflect the actual complexity of the social situation at the turn of the century. This possibility is underscored in the lexicon employed by late-nineteenth-century Chinese to discuss "commerce" and "industry," for instance. According to Wellington K.K. Chan, the Chinese terms *shangren* ("merchant") and *jingshang* ("to engage in mercantile activities") had broader connotations than the standard English translations suggest. "To speak of *(jingshang)* is to speak essentially of

the whole non-agricultural economy, just as *(shangren)* can include traders, brokers, manufacturers, bankers, financiers, and managers in the service and transport industries,"[10] he writes.

Starting in 1872, when China's *guandu shangban* (official-supervised and merchant-run) enterprises were first set up,[11] the Qing monarchy and many of its scholar-officials came to accept the need to expand the role and status of commerce and industry in Chinese society. The dynasty also created a new set of hierarchies that privileged certain kinds of merchants and disfavoured others. By the 1890s, for instance, Chinese began to distinguish between *shangye* (commercial enterprises), *gongye* (artisanal industry), and *shiye* (industrial enterprises). The term *shiye* was borrowed from the Japanese to emphasize modernity; the earlier terms *shangye* and *gongye* were retained for old-style merchant and artisan activities. Despite official edicts commanding imperial bureaucrats to minimize the gap between themselves and merchants, however, officials still held to the ideals of the moral economy and tended to look down on merchants and artisans. They were willing to embrace only industrialists. Book printers and publishers, particularly those in larger industrial firms, were influenced by and benefited from this new set of hierarchies thanks to their claim on the literary tradition and access to modern machinery.[12]

Because late-nineteenth-century Chinese society experienced sociological and cultural realignment, leadership for educational reform sprang from many sectors of post-Taiping society, including both national and local elites. In the period of Self-Strengthening (1860-95) that followed the Taipings, famous national figures such as Viceroy Zeng Guofan (1811-72) promoted a conservative brand of Confucianism known as the Tongcheng School. Others, including Viceroy Zhang Zhidong (1837-1909), called for the inclusion of Western subjects such as modern scientific and technological fields in a revised national curriculum. A more generalized response was to call for revival of Confucian learning via *shuyuan*, the institutions that since the Tang dynasty (618-907) had been among the most important elite producers, consumers, and conservers of books in the Chinese world.

The new academies, in the view of one modern scholar, were a response to the growth of irregular officials in the wake of the Taiping Rebellion but also a means of securing employment for these officials who had risen thanks to commercial wealth. In Zhejiang, between 1850 and 1900, academies were founded or re-established at the rate of almost seventeen per decade. In Jiangsu, the rate was about sixteen per decade for the same span of time.[13] Inexorably, these new establishments were influenced, positively or negatively, by the merger of the moral and the monetary economies reflected in their directorships.

Just as Zeng Guofan and Zhang Zhidong took action on educational re-
form at the curricular level, so too nationally known officials actively spon-
sored new academic institutions as part of their Self-Strengthening industrial
programs. In 1896, for example, high official Sheng Xuanhuai (1849-1916)
founded Shanghai's reformist Nanyang Public Institute (Nanyang gongxue)
to advance Western learning in Shanghai. Sheng's patronage placed the
school firmly within the bureaucratic but reformist camp that regarded both
educational change and industrialization as critical to China's national re-
covery after the disastrous losses to Japan in 1894-95. Nanyang was consid-
ered the best-equipped modern institution of higher learning in China prior
to the establishment of Beijing's Imperial University in 1898. Even after
the development of that northern institution, Nanyang remained impor-
tant as the home of China's first modern normal school and was the pre-
cursor of today's Jiaotong University. In addition, as Commercial Press
textbook editor Jiang Weiqiao (b. 1874) noted, Nanyang had produced
China's first modern textbooks in 1897, printing them, sans illustrations,
using movable lead type.[14]

Nine years after Nanyang's founding, Fudan and China (Zhongguo
gongxue) colleges were set up in Shanghai under the aegis of Jiangsu na-
tives. Guanghua College was also part of this movement. Reform institu-
tions such as these opened the doors of higher-level Westernized education
to middle- and lower-middle-class students.[15] Likewise, the Jiangsu Provin-
cial Educational Association promoted vocational education at the second-
ary school level. Founded in 1906 by local literati leaders such as Zhang
Jian (1853-1926), the association "advocated educational modernization
as a function of industrialization and economic reform,"[16] in the view of one
scholar.

If Sheng Xuanhuai was an outstanding example of a bureaucratically based
founder of a modern reformist school, Zhang Jian provided a contrasting
example of a onetime official drawn first to private industry and then to
school reform. After repeated attempts, lasting from 1868 to 1894, to pass
the three levels of civil service examinations, Zhang finally succeeded as the
zhuangyuan (valedictorian in the Palace examination) of 1894. In the same
year, he was appointed to the prestigious Hanlin Academy, an imperial re-
search institute of great antiquity. The following year, however, Zhang
abruptly terminated his official career. Responding to China's disastrous
military loss to Japan, Zhang left officialdom and returned to his native
district, Nantong, near Shanghai.

By 1899, Zhang had founded what would soon become a personal indus-
trial empire comparable to the one Sheng Xuanhuai ruled as an official.
Zhang's business interests would eventually include Dah Sun Cotton Mill

(the most successful privately financed Chinese mill prior to World War I), a flour mill, oil mill, distillery, silk filature, and, not surprisingly, machine shop. In 1902, reflecting the social values inculcated not only by his own offical background but also by those of fin-de-siècle reformism, Zhang even established a normal school as part of his effort to effect improvement at the local level. Soon afterward, he helped to found the Jiangsu Provincial Educational Association.

Just as Sheng Xuanhuai represented the post-Taiping reformist official working within the bureaucracy to reform education and Zhang Jian the post-1895 literati reformist active outside officialdom, a third figure, Zhang Yuanji (1867-1959), symbolized a middle path between the two alternatives. This middle path led Zhang from the heights of officialdom to Nanyang and to the Commercial Press. Arguably, his route also paralleled developments in both education and industry in which initiative passed from the government and its bureaucracy to private efforts.

Like Zhang Jian, to whom he was unrelated, Zhang Yuanji represents a striking phenomenon appearing at the end of the Qing – namely, the downward mobility of high officials into new fields that combined, albeit in different ways, education with industry. The two Zhangs both served at the highest level of the imperial administration in approximately the same time period; in fact, their careers in the Hanlin Academy overlapped. Likewise, three years apart, each left the government to pursue a new career, the first in private industry and then in education and the second in education and then in private publishing.

Zhang Yuanji was born in Canton after his father, a substitute magistrate, had fled south to escape the Taiping-related devastation of northern Zhejiang. In 1880, the younger Zhang returned to the ancestral home. After four years of preparation, Zhang won the district-level degree *(xiucai),* followed by the provincial degree *(juren)* in 1889 (the same year as Liang Qichao, the Cantonese "father of Shanghai journalism," with whom he became close friends). Three years later, in 1892, Zhang ascended to the capital, aged twenty-six, to win the Palace degree *(jinshi).* In the same year, he and his friend and co-provincial Cai Yuanpei (1868-1940) were appointed to the Hanlin Academy.[17] Zhang was appointed concurrently to the Board of Justice and to the Zongli Yamen.

Like many literati, both high and low, actual and fictional, ranging from Zhang Jian to Bao Tianxiao (1876-1973) and even to Wu Woyao's (1886-1910) fictional Wang Boshu, Zhang Yuanji believed that China's loss to Japan in 1895 "awakened [him] from his dream."[18] In response, Zhang began to study English early in 1896.[19] Also, considering new-style schools with a Westernized curriculum and foreign languages as the best remedy for

China's apparent national illness, Zhang started a modern academy, named Tongyi xuetang (College of Liberal Arts) by his friend, the well-known translator Yan Fu (1853-1921), after a passage in the writings of Confucius. The school was provisioned by another of Zhang's famous friends, Wang Kangnian (1860-1911), who sent Zhang all kinds of Western-style learning aids, including "world atlases, general science textbooks, star charts, charts of birds, charts of flowers and plants, and books on Japanese grammar."[20] Significantly, from Beijing, Zhang also requested newspapers and catalogues from various new-style Shanghai bookstores as a means of keeping abreast of potential curricular changes.

Tragically, Zhang's appointment to the Zongli Yamen and his foreign studies soon contributed to his demise as an official. Early in 1898, the Guangxu emperor (r. 1875-1908) requested that the Zongli Yamen supply him with modern books on various reform-oriented subjects. Apparently, only Zhang was familiar enough with what was available to supply the emperor. By the end of autumn that year, following the 100 Days of Reform, Zhang would be tarred by the brush of reform, stripped of his official rank, and banned for life from holding any public office.

The 100 Days of Reform began on 11 June 1898 with an imperial edict stipulating reforms meant to modernize China. Led by constitutional monarchists and imperial advisors Kang Youwei (1858-1927) and Liang Qichao (1873-1929), the movement ended on 20 September when the dowager empress, Cixi Taihou (Yehonala, 1835-1908), intervened and terminated the reform efforts of her nephew, the emperor. The next day, the emperor was placed under house arrest, and, the following week, six of the leading reformist officials appointed by the emperor were executed.

From the start, Zhang Yuanji had seriously doubted the emperor's ability to carry out a reform program.[21] Zhang's skepticism notwithstanding, however, on 5 September, he submitted a memorial of his own regarding needed administrative changes.[22] Reflecting the social and cultural changes of the past three decades, Zhang's fifth and last proposal called both for a commercial code and for elevating the status of merchants, permitting them directly to memorialize the throne. In fact, his own memorial anticipated the career to which he would turn once he was forced to leave government.[23] Cashiered on 10 October 1898, Zhang moved to Shanghai shortly afterward, leaving his school in the hands of the reformer Sun Jia'nai (1827-1909), who was also the founder and first president of Beijing's Imperial University.

Zhang had not been in Shanghai very long before he began work as head of the Translation and Editing Bureau at the Nanyang Public Institute.[24] By then, the higher-level educational initiative had already shifted from

revived or newly established *shuyuan*[25] to bureaucratically sponsored modern institutions such as Nanyang. As a refugee from Beijing's lethal political scene, Zhang had landed in an ideal setting for one with his bureaucratic credentials.

During the four years that Zhang worked at Nanyang, he distinguished himself by issuing numerous influential, broadly educational works. In particular, Zhang bought the naval officer and irregular degree holder Yan Fu's translation manuscript of Adam Smith's *Wealth of Nations* (Chinese, *Yuanfu*) for 2,000 yuan and published it in 1901-2 under the Nanyang imprimatur.[26] It would become one of the most important of a series of monumental translations from European languages undertaken by Yan Fu. Building on this and other experience, as shown later in this chapter, Zhang also joined the Commercial Press, first in 1902 as an investor and then in 1903 as an editor. In the same way that Zhang used the bureaucratically sponsored Nanyang in 1898 to cushion his drop from very high officialdom to semi-officialdom, in 1903, he finalized his move to private industry *(shiye)*, side-stepping both purely artisanal *(gongye)* and commercial *(shangye)* publishing.

The Shanghai career of Sheng Xuanhuai and the post-Beijing careers of both Zhang Jian and Zhang Yuanji reveal the willingness of late Qing reformist literati to cross sociocultural borders as well as their tendency to regard industrial modernization and educational reform as complementary activities. The latter two men are also outstanding examples of late Qing downward mobility. Zhang Jian became one of the Shanghai area's leading advocates of industrial advance and educational reform after his own high-level official career, nearly thirty years in the making, ended. Similarly, Zhang Yuanji anticipated the growing importance of Shanghai's modern publishing sector, initially at Nanyang and then at the Commercial Press. None of these modified career trajectories would likely have occurred without social and cultural readjustment among the Chinese literati after the Taiping era. The establishment of modern colleges and normal schools, as well as vocational secondary schools, by important national and local literati helped to enlarge the market for modern textbooks and publications of the sort pioneered by Nanyang. Such works, initially issued by reformist bureaucratic publishers, were easily picked up and imitated by other Shanghai publishers such as the Commercial Press.

Thanks to the efforts of these largely Shanghai-based publishers, by the time the ruling house itself got directly involved in educational reform in the early 1900s and abolished the centuries-old civil service examination, reform initiative had actually passed out of the dynasty's hands. Just as nonofficial efforts to found institutes of higher education were concentrated in Shanghai in the 1900s,[27] so too nonofficial private publishing houses that

could draw on the Western technology of Shanghai took off in the early 1900s. From this point on, all the dynasty could hope to do was to adjudicate between the new firms.

In summary, the Taiping Rebellion, long recognized by historians as a social and political watershed for having undermined and, in many locations, destroyed much of the southern literati-based culture of the Qing dynasty, can also be acknowledged for having alerted some high officials to the importance of unofficial industrial and educational reform. Because there were no restrictions against officials working for modern, Western-style firms, the expanding cultural industries analogous to those that already existed in the bureaucracy[28] became appealing berths for those looking for alternative employment, either because they failed to gain an official position or because they had lost such a position.

Just as post-Taiping educational reform attracted bureaucratic empire-builders such as Sheng Xuanhuai and expansive industrialists such as Zhang Jian, so too the allied industries of printing and publishing lured those, such as Zhang Yuanji, who had lost a bureaucratic position. Against the backdrop of changes in late Qing society, with its widespread renegotiation of status, both officials and former officials were well placed to start new schools. New schools needed new books, of course, and in Shanghai at the turn of the century former officials with links to Westernized industrial publishing operations were also sometimes the best placed to supply those books.

Western Technology and Its Impact on the Reorganization of Shanghai's Booksellers

Among the major reasons why Chinese printer-publishers did not embrace Western printing technology more rapidly between 1807 and 1876 was its cost. Once the initial period of Chinese adjustment to Western printing technology ended, however, increasing numbers of potential printer-publishers adopted not only lithography but letterpress printing as well. Soon, however, the cost of Western-style printing technology, whether imported or locally produced, obligated Chinese publishers to seek some means of protecting their investments by securing their markets. Efforts included the organization, first of a guild in 1905, then of a trade association in 1905-6/1911, and the adoption of the corporate model as early as 1902. All were responses that book publishers felt were needed to protect their investments in technology and prospective market share. Although traditional Chinese booksellers' guilds had also been concerned with safeguarding markets for their members, the relatively low cost of traditional technology meant that protection of members' technological investments had played a relatively minor role in guild affairs. Moreover, compared with that of the modern

period, the traditional guild system was loosely organized and operated in a decentralized marketplace.

In the late nineteenth century, Shanghai was home to nearly one hundred artisanal and commercial guilds,[29] many of them quite small. Several of these guilds were affiliated with the old-style artisanal publishing industry. The first Shanghai guild related to publishing seems to have been the Zhiye gongsuo (Paper Guild), founded in 1872. Two and a half decades later, in the late 1890s, the Ziye gongsuo (Block-Cutters' Guild), Kezi gongsuo (Engravers' Guild), and Yinshuaye gongyihui (Printers' Charitable Association) appeared. Each industry belatedly sought to define its activities, markets, and interests just as history and technological change were about to redefine the meanings of the terms "printer," "publisher," and "bookseller" and to eliminate the traditional occupations that the guilds were organized to protect.

More important, both occupationally and historically, than any of the guilds of these subsidiary trades was that of the publishers and booksellers themselves. From the start, these groups took a more comprehensive view of the industry than had the craft guilds. Recognizing that book production and selling was a branch of learning, unlike trades such as block-cutting and paper-making, the publishers and booksellers sought to promote and teach understanding, if only to those within the same field, of the intellectual content as well as physical makeup of the product that they handled. This quasi-educational thrust in the history of the Jiangnan book industry had appeared as early as the seventeenth century and was inherited by the late-nineteenth-century and early-twentieth-century printing and publishing industry that developed in Shanghai.

Jiangnan's Qing-era Chongde gongsuo ("Venerate Virtue Guild"), to which Shanghai's modern bookmen traced their origins, was founded in 1662 in the northern part of Suzhou, near the Lisan district's *(tu)* Wang Family Cemetery. Six years after it was established, the guild itself founded the Chongde Academy *(shuyuan)* to promote general learning.[30] Not surprisingly, the *shuyuan* also provided those in the book business with a location for pursuing the central academic requirements of their calling – that is, editing, collating, and discussing the merits of various editions. The role of technology and its role in their business does not seem to have been high on the guild's list of concerns.

The Taiping rebels seriously disrupted the serene activities of the Suzhou publishers and booksellers. The rebels reached Suzhou in 1860 and occupied the old cultural city until 1864. During this period, the guildhall, which had promoted book production from its location in Lisan district for about 200 years and had helped to maintain Suzhou's millennium-old reputation

as a national cultural and intellectual centre, was burned down. Not until 1874 did three individuals re-establish the guildhall as the Chongde shuye gongsuo (Chongde Booksellers' Guild) in nearby Lisi district's Shitong Lane. As one might expect, their solicitation of the guild members for funds appealed to the elite service ethic of the book business and promoted a self-image of culture and cultivation:

> The Chongde Guild was founded in the first year of the Kangxi emperor [1662], but was damaged by fire in the tenth year of the Xianfeng reign [1861]. For 200 years it maintained the same course of research and discussion, and the same determination to be good and refined, with the air of an ancient society *(she)*. It must not be abandoned, and for this reason we have reassembled ... This is a [new] beginning. Our funds must come from the combined help of those in this same business. There is no [valid] reason to be cheap or to appear to prevent [this re-establishment].[31]

In a commemorative speech given in 1915 to the Shanghai shuye gongsuo (Shanghai Booksellers' Guild), a speaker stated that "those in our trade fled to Shanghai [in 1860 when] Suzhou was overrun by war."[32] When the Taipings occupied the city, Suzhou booksellers such as Saoye shanfang and artists such as Wu Youru fled to Shanghai along with thousands of others. However, both publisher and illustrator were part of a much broader trend throughout the nineteenth century that involved the resurrection of the Jiangnan publishing industry behind the protective cordon of Shanghai's foreign soldiers and policemen. Seizing on the security of the concessions and the opportunities for easy access to Western technology, many Suzhou book traders stayed on in the colonial enclave of Shanghai after the Taiping insurgency and set up residences there.

By 1884, Shanghai's Chinese publishers and booksellers had already come to the attention of the Chinese authorities. At that time, their collective business was dealt with at meetings known as "tea-drinking sessions" *(chaxu)*. Commanded by the magistrate's office to prepare funds to relieve afflicted areas near Beijing and in neighbouring Zhili and Shandong provinces, the important Shanghai book firms of the day (Saoye shanfang, Wenyutang, and Zuiliutang) convened a *chaxu* to formulate a response to the order. Apparently seeking to avoid making contributions to the relief of these distant places, few other publishers sent representatives. As a result, the three leading firms had to issue an in-house threat to their colleagues, indicating that, if the laggards did not send a representative to the Simei xuanchashi (Four Beauties Teahouse) on the afternoon of the second day of the lunar month, the leadership would have no choice but to report them to the authorities.[33]

In the same year, perhaps in response to the magistrate's claim on their income, three leaders[34] from the still-modest Shanghai publishing world reached the conclusion that their adopted city needed a booksellers' organization on the order of Suzhou's old Chongde Guild. After 1864, reports our speaker from the vantage point of 1915, the expanded junk-trade had brought book business to Shanghai from every province, giving Shanghai the access to the national book market that had formerly been enjoyed by Suzhou. Calling for the establishment of a Chongde Hall, the three book publishers invited everyone in the trade to contribute. Twenty-five firms, including the Anglo-Chinese Dianshizhai and the Suzhou-based Saoye shanfang, and five individuals contributed more than 1,000 yuan.[35] Unfortunately, after purchasing a lot and a building at Xin beimen (New North Gate) inside the Nanshi (old Chinese city), they discovered that their funds were insufficient to renovate the hall.

In 1888, the sudden prosperity and wide scope of the lithographic industry revived interest in the hall renovation project, says the speech-maker. It was very inconvenient not to have a forum to deal with the issues raised by the new technology, but still no progress was made on building a guildhall. Again, between 1895 and 1900, when the machine industry, along with both the book- and newspaper-publishing industries, were passing out of their infancy, attempts were made to raise money. To assist communication between the various members, a facility was opened in Dingxin Lane in the International Concession, but it closed in 1902, having failed to raise enough funds to build a guildhall.

Finally, in 1905, after these three false starts, nine book dealers[36] managed to overcome the setbacks of the previous two decades. The nine borrowed a spare room at the *Mengxuebao* (Elementary Studies) newspaper plant *(Mengxuebao baoguan)* on Nanjing Road and planned every facet of the project. In 1906, Xi Zipei[37] (Yufu) garnered forty-eight votes and was selected as the organization's general director.[38] Xi, who was closely connected to Zhang Jian, had been *Shenbao*'s compradore since 1898 and owned Shanghai's best-capitalized publishing operation, Zhongguo tushu gongsi (Chinese Library Company). For help in running the fund-raising, Xi appealed to Zhu Huailu, who had helped to conduct the first campaign to establish a guildhall back in 1884.

Together Xi and Zhu rewrote and caused to be passed bylaws to establish the Chongdetang gongsuo (Chongde Hall Guild), also known as the Shanghai shuye gongsuo (Shanghai Booksellers' Guild). Xi Zipei and Xia Ruifang (a.k.a. Xia Zuifang [1871-1914], like Xi a native of nearby Qingpu), along with Xia Songlai (Qingyi, of Jiading, just northwest of Shanghai), were also selected as trustees.[39] Relying on the rent received from the New North Gate

property and monthly subsidies (of two, four, six, or eight yuan per firm, depending on the volume of its business) from the membership, the three directors then leased an office at 12 Xiaohuayuan Lane, off Zhejiang Road in the International Concession from which to run the guild's affairs.

From the start, the guild endeavoured to include all firms engaged in Shanghai's book business, whether as printers, publishers, or booksellers. According to the first draft of the guild bylaws, membership was open to "all merchants *(shangjia)* in Shanghai's book business, no matter whether they are woodblock, lithographic, copperplate, [or] lead-type [printers], depots *(zhuangju)* or sales shops *(fangdian)*, as well as newspaper plants and scientific instrument [firms] that also sell books, which are all acknowledged to be part of this same business."[40] Of the twenty-seven firms that joined, eight were clearly lithographic publishers, two were letterpress publishers, and the activities of the rest cannot be determined with any precision.[41] Likewise, both new-style and old-style *(xinjiushu)* book dealers were invited to join. This time, unlike in 1888, foreigners were not welcome; any firm co-invested by foreigners had to be represented by a Chinese manager in all its guild dealings.[42]

In addition to handling the business affairs of the members, the guild took on two social responsibilities that indicated its cultural continuity with the old Suzhou guild. It announced that it would immediately begin to hold evening classes for book-business apprentices. Also, once the guild was financially secure, it would start a training school *(shuye xuetang)*. In this way, the Shanghai Booksellers' Guild sought to revive the service tradition aimed at educating its own members, just as had the ancient Suzhou one. Unlike more obviously commercial enterprises, the Shanghai publishers, from their earliest days, stressed the importance of learning and study to the guild membership.

Before long, the guild's funding dried up again. At this point, the guild itself went into publishing. It issued a work called *Guanshang kuailan* (Brief Look at Officials and Merchants), apparently a sort of business directory, that made a regular profit of 400 percent and was used by the guild for annual expenses.[43] It was probably sold through the members' exhibition hall,[44] located in the temporary guildhall off Zhejiang Road.

What had finally forced Shanghai's publishing industry to coalesce on an institutional level? According to the 1915 speech already mentioned, the abolition of the civil service examination system in 1904-5 and the sudden proliferation of new-style schools (i.e., those with Western subjects in some form) stimulated the industry supplying those schools: "After 1900, the examination system was ended. Starting new-style schools was the fashion. Circumstances had changed, and it all had a major impact on our book

industry. Now book industry people all got the freedom *(ziyou)* to reprint without regard for earlier copyrights. After this, 'the flood gates opened' *(yinghai kaitong)*. New studies and new principles [produced] infinite prosperity through writing and translating of books."[45]

The speaker's forthright stress on commerce and moneymaking contrasts sharply with the more high-flown aspirations of the old Suzhou guild quoted above. In the four decades that separated the speaker and the Shanghai Booksellers' Guild from their putative Suzhou ancestor, the southern book business had in fact been transformed. In Shanghai, a cultural business formerly based on low financial overhead involving a high premium placed on learning and exemplar libraries had rapidly evolved into a Western-style mechanized one.

The extended process by which book culture was removed from Suzhou to Shanghai had involved much more than merely the migration of personnel from an elite Chinese cultural centre to what remained in the mid- to late nineteenth century a cultural backwater. It also necessitated varying degrees of accommodation to what Bao Tianxiao would remember as "Shanghai, that place!" – the source of modernity. Although the Shanghai Booksellers' Guild represented an effort by Shanghai-based bookmen to resurrect the air of the old *she* that the Suzhounese themselves had lost in the rebellion and fire of the 1860s, their attempt was made by an organization that now appealed to an expanded set of aspirations among its membership. Those ambitions included not only the traditional emphasis on elite public service associated with educational institutions but also on a modern concern with mechanization, specialization, and adequate compensation.

These conflicting ambitions are revealed in a late Qing document that compared modern publishers unfavourably with those of the past, both distant and more recent. Its writer argued that the publishing field, which "dated from antiquity," really came of age during the Song and Yuan dynasties when block-printed books were characterized by "classic beauty and elegant taste." Back then, the writer believed, "people in the publishing field were gentle and cultivated, honest and not cheaters. Although they were common men, they were indeed men of letters." Even as recently as the Daoguang (1821-50) and Xianfeng (1851-61) reigns, he said, "people in our publishing field ... never failed to be gentle and cultivated."[46]

Then the Taipings and new technologies appeared, almost simultaneously, said the writer. "Along with the stereotype printing business there came copperplate and lithographic printing," resulting in flourishing business opportunities but also "people with a different moral standard." Moral models handed down by the bookmen's ancestors in the business were lost. New types of publishers no longer took the interests of the whole group into

consideration before they acted. Books were published anonymously, without concern for either the good of society or that of the guild. Some representatives infringed on the rights of others by ignoring copyrights or by "dumping" books at lower than legitimate prices.[47]

Clearly, in this writer's view, technology and the expense of mechanization had debased the way in which early Shanghai publishers conducted their operations. The tumultuous administrative and legal environments were held to have had just as significant an impact on the publishers. Bemoaning the disappearance of the "freedom" that they had enjoyed as recently as the early 1900s, the 1915 guild speaker went on to cite the most likely reason for the successful but belated establishment of the guild: "Then the authorities decided we needed a copyright law.[48] As a result, we in the business sometimes developed legal squabbles and other problems. Day after day, affairs became ever more snarled, and so people started to want a consolidated body to protect the copyright privileges of those in the industry."[49] The speaker suggested, and in fact history demonstrated, that before the copyright law there were no "squabbles," at least none grave enough to have required the formation of an association that would live solely off the contributions of its membership.[50]

Copyrights and copyright protection were, in fact, a major activity of the Shanghai guild. In part, the guild was organized to adjudicate copyright infringement issues. It discussed penalties against those who pirated copyrighted works and it dealt with problems arising from those books that were not copyrighted.[51] Specifically, if works that were generally acknowledged as belonging to particular firms were reprinted without permission, the guild would take steps to regulate the situation.[52] Members were put on notice that all future publications had to feature the name of the printer or publisher on the first and last pages, or on the central signature, to avoid confusion. Along with mechanization had come a degree of specialization that acknowledged the necessity of claiming adequate compensation for those who owned the means and right to print and reprint texts. Balancing the divergent claims of service and adequate compensation soon became a primary goal of the Shanghai guild. To enable the guild to sort out copyright disputes, each member was also expected to report on the details of its backlist of publications and to indicate to the guild whether copyrights had been secured.

In short, what we today would call "intellectual property" had become an issue in a cultural and commercial enterprise that was being transformed by industrialization and modernizing legislation. The growing overhead brought about by industrialization challenged this industry, originally based, at least in its own view, on public service, now consciously to stress financial issues.

Shanghai's printers and publishers now had to deal with the challenges of owning, controlling, and disseminating knowledge using expensive new machines. Insofar as we can view the industry through its guild records, industrialization and government decree had coalesced to create a posture of relative unity.

Once the guild was formed, it seems to have successfully performed its intended function of enforcing compensation. According to the speaker, "whenever something concerning protecting copyrights or protecting public welfare or [if] cases [came up] involving confused and disorderly debts, these cases were all peacefully dealt with ... in an equitable way."[53] In May 1911, when the *gongsuo*'s chairman Xi Zipei petitioned the Qing court to register the guild with the government, it had well over 100 members.[54] Of these, 58 were publishers and 72 were binders. Regardless of calling, most were likely drawn by the mutual advantages of membership, which included an in-house, nonjuridical means of resolving copyright infringement issues for publishers.

Unexpected noncommercial events were also handled intrepidly by the guild, suggesting that the relative harmony in guild affairs attributed to the past still prevailed to some degree. In 1910, during social disorder leading up to the Xinhai Revolution, says the writer, "We book merchants organized the first single-industry merchants' militia to maintain law and order. This was really outside the scope of a guild ['s normal activities, but] other industries followed suit after us, and no fewer than several dozens of [such] groups were formed."[55] In fact, twenty-seven Shanghai publishers, as well as the guild itself, mustered sixty-two of their employees into the Booksellers' Self-Protection Corps (see Figure 4.1), eventually awarding them certificates for their heroism.[56]

The origins of the militiamen mustered in defence of the guild's publishing enterprises reveal the large influx of outsiders into Shanghai's publishing world at this time. Furthermore, the high degree of common cause shared by the book business's proprietors, managers, and employees at this time is striking.[57] In addition to the founders of the guild, whose own native places lay mostly outside Shanghai, of the sixty-two militiamen organized by the booksellers' guild, only four were actually natives of Shanghai. Among the forty-five who listed surrounding Jiangsu province as their home, Shanghainese were outnumbered by the eight men from Wuxian (Suzhou), six Wuxi natives, and five Jingui (Jiangsu) men. There were also nine fewer Shanghainese than there were Zhejiangese.[58]

In 1914, after the revolution, the guild administration moved back to the Nanshi property bought in the mid-1880s. Signalling their break with Suzhou and their newfound self-confidence as Shanghai publishers, new directors

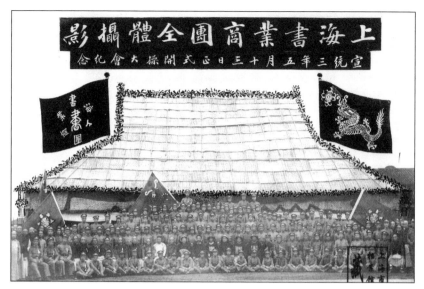

Figure 4.1 Shanghai Booksellers' Self-Protection Corps, 1910.
Source: Shanghai Municipal Archives, S313.1.51.

Gao Hanqing, Tang Ziquan, and Ye Jiuru (b. circa 1871) also dropped the appellation "Chongdetang," now calling the organization simply the Shanghai shuye gongsuo (Shanghai Booksellers' Guild). By this time, as part of the urban renewal undertaken by the new government, the old city wall circling the Nanshi had been demolished, and the new access resulting from the construction of Zhonghua Road turned out to be beneficial to the guild's activities. In 1915, ten years after the establishment of the *gongsuo* and with no hint of the ambivalence regarding commercial matters that had characterized the hushed reverence of the Suzhou guild when trying to re-establish its hall, the Shanghai speaker exulted, "our business has been expanding."[59] By the mid-1910s, then, it would appear that the booksellers had found common cause in their shared pursuit of profits and influence via new-style publishing.

In 1917, the Shanghai Booksellers' Guild undertook a survey of its membership, including publishers, printers, and retailers. The survey reveals not only the breadth that resulted from the rapid growth of Shanghai's printing and publishing industry but also its nearly exclusive reliance on expensive Western technology. Of the 132 members, 46 had not even existed in 1914, the last time the guild had conducted such a survey.[60] In 1917, most (74) of those involved in the book business and registered with the Shanghai Booksellers' Guild were general retail outlets. Not surprisingly, given their prominence in the early days of the guild, the second most important category

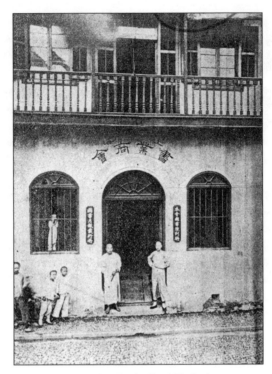

Figure 4.2 Shanghai Booksellers' Trade Association
(Shuye shanghui), 1917.
Source: Shanghai Municipal Archives, S313.1.29.

was that of lithographers (24), followed by general printing firms (7) and
lead-type printers (5). One guild member identified his firm as a wholesaler
only, one was a warehouser, three specialized in epigraphic rubbings and
calligraphy, five in rare and antiquarian woodblock books, one in rare Con-
fucian classics and religious works, and four in novels. Seven of the firms
listed refused to indicate their specialty.

Apart from the general retailers, the most striking separate groups are
those defined by their access to Western technology (i.e., lithographers,
followed by general printers and then by lead-type printers). Only 6 firms
out of more than a 100 actually specialized in rare, antiquarian, or woodblock
books, not counting the 3 specializing in calligraphy and rubbings. These
figures indicate that at this time Shanghai's antiquarian and old-style book
trade was tiny, relatively speaking.[61] Two Beijing-based antiquarians,
Zhonghou shuzhuang and Gushu liutong chu,[62] which had come to Shang-
hai by 1916, immediately joined the *gongsuo*. Although they were outnum-
bered by the seven firms started locally, their access to the Beijing-dominated

antiquarian book market may have given them an edge over locally started firms. Generally speaking, however, it is clear that the emphasis of Shanghai's book industry, insofar as it was defined by *gongsuo* membership, was on Western technology for the production of new-style books – that is, books manufactured using Western processes – also intended to satisfy the public craving for foreign knowledge, whether direct from the West or filtered through Japan.

In 1905-6, at about the same time that the Shanghai Booksellers' Guild, heir to Suzhou's Chongde Guild, was finally being established, the Commercial Press and other self-described "new-style" publishers were busy planning a separate Shanghai shuye shanghui (Shanghai Booksellers' Trade Association). In the sixteen years between the loss to Japan in 1895 and the Republican Revolution of 1911, Chinese merchant organizations in many places evolved from the old-fashioned guild, which regulated trade in the interests of business proprietors, to the modern trade association, devoted to promoting trade. This evolution was encouraged, to some degree, by the court's authorization, in January 1904, of the creation of chambers of commerce.

Unlike the guild, whose betwixt-and-between identity is suggested by its frequent moves between the Chinese Nanshi and the International Concession, the new Booksellers' Trade Association would be permanently located on Wangping Street (now Shandong Road) in the International Concession (see Figure 4.2) between 1911, when it finally opened, and 1920, when it merged with the guild,[63] presumably out of recognition that each group would benefit from a unified voice.[64] By 1914, its membership included more than forty new-style publishers, ranging from well-known firms such as the Commercial Press, Yu Fu's (Zhonghuan) Wenming Books, Wang Licai and Xia Songlai's Kaiming shudian,[65] Feng Jingru and He Chengyi's Guangzhi shuju, Changming gongsi, Wu Qiuping's Xinzhishe and on down to others largely forgotten today. The fluidity of the industry in this early period is suggested by the fact that at least five of those prominently involved with the guild were also leaders of the trade association. Like the guild's directorate, the trade association officers (see Figure 4.3) were non-Shanghainese (e.g., Yu came from Jingui, Jiangsu; Feng from Nanhai and He from Xiangshan, both in Guangdong; Wu Qiuping from Suzhou; Lufei Kui [1886-1940], who represented Changming, hailed from Tongxiang, Zhejiang). Only the bookkeeper had been born in Shanghai.[66]

After more than ten organizational meetings held in the Hujiazhai Wenming Primary School, Changming's Lufei Kui wrote the regulations upon which the trade association was founded.[67] Yu Fu was selected as director and was aided by assistant directors Xia Songlai and Xi Zipei. Xia Ruifang

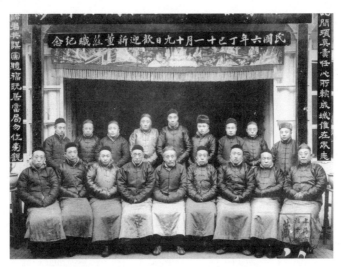

Figure 4.3 Officers of the Shanghai Booksellers' Trade Association
(Shuye shanghui), Wangping Street (now Shandong Road) between
Hankou and Fuzhou Roads, figures unidentified in the original
(President Yu Fu sits in the middle of the first row, with Lufei Kui
to the far left and Shen Zhifang to the far right), c. 1911.
Source: Shanghai Municipal Archives, S313.1.3.

of the Commercial Press and Lufei Kui, among others, were appointed to the
executive board. Lufei was concurrently appointed association secretary.

Where the guild had been forced into existence by the ramifications of
both technological and legal innovations, the trade association seems to
have come about as a direct result of the new-style publishers' own self-
consciousness. As new-style publishers, they deliberately defined themselves
through new technology, forms of knowledge, and business practices. Ac-
cording to an association history, founders set out "to develop the business,
promote culture, protect profits, [and] promote mutual aid."[68]

Nonetheless, many of the same themes that had accompanied the birth
of the guild also appear in the history of the trade association. Indeed, the
trade association was probably influenced by the same change in official out-
look undertaken by the Qing government. In 1906 and 1907, for instance,
in official documents that it communicated to the incipient trade associa-
tion, the Qing government itself stressed the complementarity of public
service and compensation. Unlike the Suzhou guild in 1875 which, reflect-
ing conventional social values, had completely sidestepped the question of
compensation, by the beginning of the twentieth century, the dynasty itself
was consciously attempting to embrace the new business enterprises in its

realm. In so doing, the authorities tried simultaneously to reinforce the contrast between service and compensation and to smooth it away.

On 4 August 1906, the Qing Ministry of Commercial Affairs[69] (Shangbu) approved the registration application of the Shanghai Booksellers' Trade Association by acknowledging that books, education, and trade were essential for the prosperity of China. The approval stated: "As per the petition to establish the Book Association and all its regulations, all is comprehended. Now the Court is promoting prosperity. Assistance for academic affairs and books is developing ... Education is at the crux and is the most important. [Your] trade association plans to set up [an entity] for publishing and will itself investigate and prevent wicked organizations that edit and print [others' material] ... [Your] thirty-five regulations are fairly comprehensive and harmonious, and therefore we proceed to approve."[70] The new Qing Ministry of Education (Xuebu) responded just as enthusiastically six weeks later. Like the Ministry of Commercial Affairs, the education officials believed the advance of publishing would benefit both commerce and education: "This trade association has been prepared by the book trade. The advantage to education is truly not shallow or small. The proposed regulations ... should be carried out at once. They are effective, and [when] put into operation will mean ... the printing arts ... will gradually develop and help culture and spread education. This bureau truly has great hope [for the association] ... Request approved."[71] Gaining approval from the Nanyang Great Minister, Liangjiang Viceroy's Bureau, Liangjiang Academic Affairs Office, Jiangsu Governor's Office, Suzhou and Wusong Great Circuit Department, and Shanghai County Magistrate's Office all took time, however, and the Booksellers' Trade Association was not able to open until 1911.

Just as important to the book merchants themselves as this official approval of their organization was the official qualification of their activity: they were not mere merchants but "merchants of culture and education." What's more, the official endorsements recorded the symbiotic relationship between the advance of China and the merchandise found on their bookshelves. In President Yu Fu's opinion in 1924, back in 1902, when Yu had come to Shanghai from Wuxi to start Wenming Books, the Shanghai printing and publishing industry was still undeveloped compared with what it would become later. Even printing was not very advanced, he believed, with many lithographed books of dubious quality appearing and, except for those published by Christians, few books of any sort printed with metal type. In Yu's view, the key to the Shanghai publishers' success since 1902 had been textbooks, his own among them, which provided the material foundation for what came later. Underlying and reinforcing the Shanghai publishers' success

in educational publishing had been the formation of a trade association devoted to copyright protection:[72] "The Booksellers' Trade Association was formed to protect the copyrights of each member and, at the same time, to thwart [efforts by] the outside world to steal our copyrights. Each year, we had to negotiate with Japan, England, and America, but in the end we won."[73] Although Yu does not spell out why copyright protection was important to the Chinese publishers, clearly the reason was the same as that for foreign publishers: protection of intellectual property.[74]

Reflecting the government line on the reciprocal relationship between education and business, Yu also claims that the publishers and their association promoted a kind of "cultural industrialization" *(guan shu wenwu xing gongye)* for China. Just as editors and the sale of their books promote culture, he says, so too the printing side of the publishing industry supports workers. Both are indispensable and, in Yu's view, reflect the complementarity of Sun Yat-sen's notion of "people's livelihood."[75]

Nonetheless, in the early 1900s, the legal and industrial pressures on publishers had been influenced by larger social and political changes taking place throughout Jiangnan society. From this survey of guild and trade association activities, we can see that Shanghai provided a sanctuary, shielded by Western gunboats and the various foreign constabularies, for Chinese entrepreneurs such as those who joined the guild and trade association. As suggested by the organization of a guild and a trade association dedicated to adjudicating issues of intellectual property and fair compensation, and a trade association finally founded on the eve of the Republican Revolution that portrayed itself as a voice of cultural commerce, Shanghai's publishers were leaving the age of elite patronage behind. Popular patronage became the financial bedrock of public service as they redefined it in the industrialized, mass-oriented environment of the late Qing and early Republic.

Although government policies sometimes supported the goals of the booksellers, the publishers also had no choice but to oppose government decisions that seemed to restrict their trade. To this end, both guild and trade association formally but unsuccessfully opposed the Qing's 1906 publications law, successfully lobbied against increased postal fees in 1911, tried but failed to overturn the Republican government's transit fee taxes in 1915, and intervened in over fifty copyright disputes, both local and national.[76] All of these endeavours, along with the organization of the guild and trade association, involved group efforts designed to secure the property rights of Shanghai's publishers. On the level of the individual firm, many publishers also adopted the joint-stock limited liability model of corporate organization to protect their assets and extend their lifespans.

The Chinese Joint-Stock Limited Liability Firm:
Its Influence on Shanghai's Publishers

In addition to the development of the booksellers' guild and trade association, both of which provided common cause and an intra-industry forum for sorting out conflicts between firms, a third element enhanced the vigour of the modern publishing industry in Shanghai. That was the growth of the Chinese-owned joint-stock limited liability corporation after 1903. In that year, as part of a general effort to reclaim economic control from the provinces, the Qing government established the first Ministry of Commerce (Shangbu). For a while, it seemed that the new ministry would assume great importance. In a description of the impact of the reforms that hints at the specific opportunities they would open up for the new-style publishing industry, Wellington K.K. Chan writes, "There were reports of officials scurrying and lobbying for positions. It seems that all the [Beijing] bookstores were stripped of any books on international trade, industry, geography, and accounting [suggesting that] many persons were apparently cramming for the entrance examination given by the new ministry."[77] In fact, however, between 1903 and 1906, the new ministry never managed to claim its own bureaucratic turf. It remained submerged in jurisdictional battles between old and new central ministries as well as with viceroys in the provinces.

Even as it foundered, though, the Ministry of Commerce contributed indirectly to the creation of other reformist bodies at the political centre that themselves reflected the demands of merchant spokesmen. Such bodies included the Commercial Law Office (which actually predated the Ministry of Commerce); Patent Bureau (1906); Commercial Newspaper Office (1903); and, perhaps most important, Company Registration Bureau. Established in 1904, this latter bureau was stipulated by Article 22 of the Gongsi shanglü (Company Law) of January that year. The Company Registration Bureau recognized five types of firms eligible for registration, three of which were limited liability organizations based on Western models.[78] The appeal of joint-stock firms of limited liability had in fact been clear to Chinese merchants since 1872, when the first Chinese limited liability corporation had been formed and, since 1875, when Britain had legalized the establishment of such firms in Shanghai. By 1900, 130 leading Chinese merchants were directors of such firms.[79]

The practical effects of these early-1900s governmental guarantees have been much debated by historians.[80] However, both the guarantees and the merchants' willingness to register are symbolically important for suggesting substantial shifts[81] in the mind-set of Chinese merchants. They also suggest

that the reformist groups active in fin-de-siècle Shanghai were familiar with principles of Western commercial organization, whether or not they were always able to carry them out in practice.[82]

The views of printers and publishers concerning the new commercial organizations being promoted in the early 1900s are unknown. However, in an article published in *Yiwen yinshua yuekan/The Graphic Printer* in 1937, Lin Heqin, a graduate of the Carnegie Institute of Technology's printing program, the owner of Shanghai's Yiwen Printing Plant, and the journal's publisher, spelled out in detail what he regarded as the importance of the limited-liability corporation to the printing industry. In Lin's view, three main types of modern business organization could be found in the Chinese printing world of the 1930s. The simplest, most private, and shortest-lived firms were the individual or sole proprietorships *(duzi jingying).*[83] Because their capital was limited, individual proprietorships found it difficult to expand. They were also hard-pressed to support themselves over slow periods, says Lin.

The partnership *(hezi jingying),* in which two or more persons co-invested on a contractual basis, was slightly more complex than the individual proprietorship. Although management was still relatively easy, Lin maintains, the partnership placed more capital, hence technology, at the disposal of the firm than did the former. Still, like the sole proprietorship, "each time there is a change of personnel (e.g., through a death), it has an influence, so the partnerships' durations tend to be short."[84]

In Lin's experienced view, the corporation *(gongsi)* was by far the most complete in organizational terms. Capital was abundant, personnel and technology superior. Capital could be increased easily,[85] and most important, "because there are limits on the responsibilities of the shareholders, a change in personnel need not have an impact, so the company can survive longer" than either the individual proprietorship or the partnership. Likewise, "in business, this kind of organization uses the corporation itself as the principal, and it has the legal identity, not the investors."[86]

To Lin, the ability of the corporate organization to outlive the individuals investing in it was clearly its chief value. Of nearly equal importance was its ability to raise large sums of operating capital *(liudong zijin),* the lack of which, in his view, historically had been the single greatest obstacle to the expansion of Shanghai's Chinese printing (and publishing) firms.[87] Lacking this access to capital, the "90 percent of our firms [that] are individual proprietorships or partnerships"[88] find it hard to expand and, even worse, "sometimes because of external factors ... cannot get credit *(sheqian)* or a secured loan *(diya jiekuan)* ... you simply have no way to buy supplies and run the risk of having to close down."[89]

Although Lin's description dates from the 1930s, evidence illustrating his main points can be found in data from earlier periods. The publishers' growing acceptance of the corporation as an organizational form is indicated by guild records. In 1917, for instance, of the 132 firms recorded as members of the guild, 77 were registered as individual proprietorships. Thirty-five were partnerships, and 13 were joint-stock corporations; 7 did not report. The joint-stock firms were:

1 Commercial Press (the comprehensive publishing and printing corporation founded in 1897 by Qingpu [Jiangsu] natives Xia Ruifang and Gao Fengchi and six Ningbo [Zhejiang] partners, all relatives, including the brothers Bao Xian'en and Bao Xianchang[90])
2 Commercial Press Print Shop
3 Zhonghua Publishing and Sales Company (the comprehensive publishing company founded by Tongxiang [Zhejiang] native Lufei Kui in 1912[91])
4 Zhonghua Print Shop
5 Zhongguo tushu gongsi (Chinese Library Company, a third comprehensive publisher), started by the Qingpu native Xi Zipei in 1906[92])
6 Chinese Library Company Print Shop
7 Wenming Books (Wenming xinji shuju, a general publishing firm established in 1902 by Wuxi [Jiangsu] natives Yu Fu and Lian Quan[93])
8 Wenming Books Print Shop
9 Yadong tushuguan (a map- and novel-publishing firm moved to Shanghai from Wuhu [Anhui] in 1913 by its founder, Wang Mengzou)
10 Wenbao gongsi (a lithography studio)
11 Yinyinlu (an antiquarian dealer)
12 Xiaoshuo congbaoshe (a publisher of novels)
13 Bowen yinshua gongsi (a printing firm).

Four (Commercial Press, Zhonghua, Chinese Library Company, and Wenming) of the thirteen reveal the predilection of the owners, once they understood the principles of limited liability, to separate their printing and publishing operations legally if not actually. Of the thirteen joint-stock corporations, seven were located on either Henan or Fuzhou Road, two were on Hankou Road, and one was on Jiujiang Road. Thus, by 1917 ten of Shanghai's leading corporate publishers, those with the greatest access to capital, the greatest managerial flexibility and, presumably, the greatest survivability had made what would become known as Wenhuajie their base of operations. The origins of the district itself lay in the individual proprietorships that had first flourished along Henan Road. Their success in attracting

large clienteles of book-buying consumers to Henan Road may have been what drew the large corporate publishers to the district. As Chapter 5 will show, this concentration of corporate publishers actually dates from 1916, when Zhonghua opened its headquarters at the corner of Fuzhou and Henan Roads. With the intention of breaking Zhonghua's control of this busy intersection, the Commercial Press opened its sales department next door. Thus convened the assembly of booksellers on or near to Fuzhou Road that has survived, in one form or another, to the present day.

These publishers' and printers' embrace of the potential economic viability of the limited liability corporation gave Shanghai's modern publishers prospects of longevity, of needed access to capital, and of proximity to modern banks and bankers in the International Concession. At the same time, as the next section will disclose, national educational reforms also gave the Shanghai publishers a market that traditional publishers had been unable to generate on their own. Finally, Western-style mechanization gave Shanghai's printer-publishers the means to saturate that market, and their trade guild and association provided methods to resolve disputes over intellectual property.

The Commercial Press: Promoting Useful New-Style Books

Late-nineteenth-century and early-twentieth-century educational reform, in addition to delivering a death blow to the many publishers who relied for their business on supplying material for examination candidates, also provided new-style publishers with unprecedented opportunities. Meeting the needs of students in newly established primary and secondary schools as well as in colleges and universities became the raison d'être of early-twentieth-century mechanized publishing firms such as those that organized the booksellers' guild and the trade association. Such firms benefited from the remarkable social fluidity of the late Qing. At the same time, Shanghai's publishers also profited from the widened range of potential employees willing to work in industrialized, commercially driven corporations dedicated to making money while simultaneously manufacturing books deemed useful by scholars and students.

As seen earlier, Zhang Yuanji was an outstanding representative of the new-style, Western-technology-based publishing world's shift from bureaucratic, noncommercial control and orientation to private, profit-seeking control and management. At the same time, Zhang's career at the Commercial Press, and particularly his collaboration with one of the firm's founders, an ill-educated common printer named Xia Ruifang, reveal the high degree of social mingling that occurred in Shanghai's printing and publishing world, especially in corporations, at the turn of the twentieth century. After all, the

paths of Zhang Yuanji and Xia Ruifang, the most important of the entrepreneurs who founded the firm in 1897, first crossed via the Commercial Press, which soon thereafter became one of the earliest corporations.

The roots of the company lay in the Presbyterian Qingxin Hall school, located in Shanghai's Nanshi. Xia Ruifang had come into Shanghai by canal boat from nearby Qingpu at age eleven *sui* to stay with his mother, who worked as a *baomu* (a combination nurse and housemaid) for the family of J.M.W. Farnham. Farnham served as the school's director and was also a printer in his own right. Farnham himself decided that young Xia needed an education and a profession. In 1885, Xia registered for the Presbyterian school's four-year course, where he met the two Bao brothers (Xian'en, d. 1910, Xianchang, 1864?-1929). The three students' education at Qingxin followed a work-study model and included printing instruction and practice.

The three young men graduated in 1889. By then, all had gained some experience working in Shanghai's American Presbyterian Mission Press (APMP) and had witnessed how the Americans blurred the line between philanthropic and commercial publishing by taking jobber orders for business stationery, receipt books, etc., to underwrite their noncommercial religious printing. All accounts, both first-hand and scholarly, agree that none of the founders had received much traditional Chinese education. Although marginalized intellectually within late imperial China, they would quickly succeed in establishing a new educational standard that would outlive the Qing dynasty.

Xia Ruifang soon went to work as a typesetter at *Wenhui bao*, a Chinese newspaper, and then moved on to the English-run *North China Herald*. One Sunday morning, after church, Xia and his old schoolmates, the Baos, met at the Five-Star Teahouse in Shanghai's City Temple and began commiserating with one another about their work lives. Xia was particularly unhappy about the vile temper of the supervisor in the *Herald*'s print shop. "Mr. O'Shea," as the sources identify him, apparently often mistreated his employees, especially the Chinese. That Sunday morning, together with the Baos, Xia dreamed up what would become known as the Commercial Press.[94] A fourth Qingxin friend, Gao Fengchi, then working as a clerk at the APMP, decided to combine his money with theirs. In an era of tentative experimentation on many levels of society, extending from the Guangxu emperor to his Hanlin tutor, Zhang Yuanji, to the *zhuangyuan* Zhang Jian, and on down to Shanghai's leading Cantonese compradore, Xu Run, these four veterans of a humble missionary work-study program decided that the market was ripe for new-style books of all sorts.

Xia Ruifang was the one who got the idea of translating a textbook meant to teach Indian students how to read English. After having it rendered into

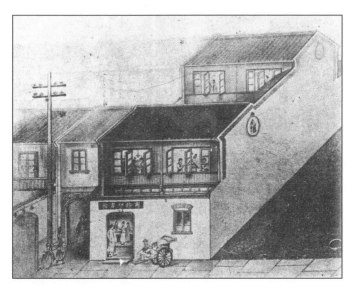

Figure 4.4 First print shop of the Commercial Press, Dechang Lane off Jiangxi Road, 1897.
Source: Zhonggong Shanghai shiwei dangshi yanjiushi and Shanghaishi zonggonghui, eds., *Shanghai Shangwu yinshu guan zhigong yundong shi* (Beijing: Zhonggong dangshi chubanshe, 1991), 192.

Chinese,[95] the four men released their new textbook onto a nearly virginal market, selling some 3,000 copies within the first week.[96] No doubt exhilarated by their success, they used their profits to purchase printing machines in Japan and opened their own modest printing firm (see Figure 4.4) in a three-room shop on Dechang Lane off Jiangxi Road, well within the International Concession.[97] The firm's uninspired name, Shangwu yinshu guan (Commercial Press), was created by one of the Bao sisters. According to Hu Yuzhi (1896-1986), she had little choice but to use the term *"yinshu guan"* ("book-publishing office") in spite of the fact that the Press did not yet edit books of its own. The neologism *"yinshua chang"* (meaning, more prosaically, "printing shop," had not yet been borrowed from Japanese) would have been a better description of the firm's actual activities, Hu says.[98] Although the Commercial Press translation was not the first modern textbook to appear on the Chinese market, it did alert Xia and his partners to the market's receptiveness to this new type of industrial commodity.

In 1898, relying on the mediation of the owner of a Zhabei-district cotton mill, Xia and his partners were able to buy out the pioneering Japanese-owned printing house Xiuwen yinshuaju.[99] At the same time, they moved to bigger quarters, a twelve-room structure in Beijing Road's Shunqing Lane. According to most accounts, Xia was the brains of the group and took on

the job of securing customers for the new printing house.[100] The Baos did the actual printing, most of which continued for some time to be jobber orders much like the APMP's. Gao remained in his job at the APMP.[101] In the next few years, however, the Commercial Press brought to the market five more volumes in its *Huaying jinjie (*English-Chinese Primer*)* series despite losing the Xiuwen equipment to fire in 1902.

Although Xia Ruifang was then nominally the manager of the Commercial Press, in fact he doubled as proofreader, bookkeeper, and purchasing clerk. When the press needed paper, for instance, he personally crossed the river to the supplier in Pudong to get it. Also, at the end of each month, he made the rounds of client after client to collect their debts. Unable to survive on his meagre twenty-four-yuan monthly salary, he even moonlighted as an insurance salesman.[102]

At about the same time, up the Yangzi River in Nanjing, Bao Tianxiao, the *xiucai*, diarist, and litterateur who first appeared in Chapter 2, was translating new-style books for a firm set up by a retired official and relative of Viceroy Li Hongzhang (1823-1901). Already at this early date, the business of publishing had been transformed by deadlines and the necessity of pushing one's publications onto the market earlier than one's competitors got theirs out. Although Bao's office was located in the provincial capital, also the site of the triennial provincial examinations, the city's relative isolation worked against his firm's meeting the deadlines that new-style books imposed on the industry. Referring to this urgency, Bao observed, "[My employer] got a large number of Western and Japanese [into Chinese] translations from Yan Youling [Yan Fu] and Ye Haowu, but what could he do with them? New-style literature had an expiration date and could not be compared with old Chinese books that were bundled up in a tall pavilion or hidden away on a famous mountain. The best thing was to get the ball rolling and publish them without losing any time at all. This was what was behind his opening the translation bureau [in the first place], but he still wanted to print [original] books."[103] Bao then added a comment that echoes the guild speaker on just how central to the publishing and bookselling industry Shanghai had already become by the turn of the century: "At this time, the only fairly convenient place to [print or publish] was Shanghai. What's more, after you published, you still had to look for a market, and to do that you had to go to Shanghai. 'Shanghai was the hub of the wheel' *(Shanghai sitong bada)*. Book buyers from all over the country went to Shanghai to select [their books]. And book merchants *(shushang)* from all over the country went to Shanghai to sell *(pifa;* literally, 'wholesale') their books. For this reason, [my boss] decided that [we should] go to Shanghai to start a book translation business."[104]

In about 1900, Bao moved to Shanghai with two colleagues to take charge of his firm's editorial, printing, and proofreading responsibilities in the city. He and his two colleagues opened a new translation bureau in a lane off Nanjing Road[105] and, as directed by their employer, called it the Jinsuzhai ("Golden Millet Hall," a name, he says, that had Buddhist connotations). Having recently operated as a translation firm, they now recast themselves as publishers of modern books.

Because Bao then knew little about the commercial or industrial sides of publishing, he was put in charge of reconnoitring with printing firms. Modern books called for modern printing methods, but, anticipating Yu Fu's 1924 comments as head of the Booksellers' Trade Association, Bao reports that, around 1900, there were still not many choices, even in Shanghai, for suitable Chinese-language publishers. His search led him straight to the Commercial Press,[106] which he discovered to be rather small but well equipped with Western machinery. Like Tongwen in the 1880s, the press was then located in a Chinese residential structure *(pingfang)*. Far smaller than Tongwen's staff of 500, though, the Commercial Press had no more than 30 employees in 1900, according to Bao.

Bao Tianxiao found Xia Ruifang, the manager, to be "very amiable" *(ren ji heqi)* and immediately signed an agreement *(hetong)* with him to print Yan Fu's translation of T.H. Huxley's *Evolution and Ethics (Tianyan lun)*.[107] The printing and publishing work was very time-consuming, and Bao, with the help of his associate, proofread the galleys four times, searching for misplaced characters, faulty expressions, etc. He went daily to the Commercial Press, doing the work in its offices, and so came to spend a lot of time with Xia. In the following passage, Bao contrasts Xia with learned old-style Chinese booksellers:

> Xia Ruifang was not [like the] booksellers of old China. When young, he lacked education [Bao here refers to the fact that Xia was educated by foreigners and his knowledge concerning Chinese literature was quite limited]. He deeply wanted to publish some books of his own but did not know what kinds of books to print and what kind to avoid. He was a very open-minded and modest man. He often came to me with books that people had assigned him to print, and asked me what kind of books they were, and to which kind of customers they could be sold. Of course he was concerned about his business; he wanted to open his eyes to [new] business [because he] was very true to his firm ... Although he was not a man of culture, still Xia started a cultural business. He had a sharp mind and a sincere disposition and could recognize talent when he saw it.[108]

Bao paints a portrait of a keen entrepreneur, aware of his need to learn the fine points of his business from all who would teach him.[109]

Bao also makes one aware of how topsy-turvy and fortuitous social and professional life was in fin-de-siècle Shanghai with his apparently apocryphal, but still suggestive, story that Xia had once served in the International Concession as a policeman for the British. Patrolling in front of an English-language printing shop, Xia had, according to the story, bumped into one of his future partners, Bao Xianchang. Bao had turned him away from a career as a policeman, reminding him that the concession's Sikh constabulary was unfairly paid much more than its Chinese police.[110] "Why do you want to be a policeman? ... It's not as good as getting involved in the printing business," Bao Xianchang had lectured Xia. "When I knew [Xia]," says Bao Tianxiao, "whenever it got very busy, he would roll up his sleeves, peel off his shirt, and start working at the type rack."[111]

Xia's familiarity with the foreign legal customs and political privileges of the International Concession put Bao Tianxiao in good stead at least once. While supervising the printing of Yan Fu's and Ye Haowu's books, Bao received a copy of Tan Sitong's *Renxue* (A Study of Benevolence) from a friend in Japan and seized on a plan to print it. Bao knew that there would be no problem with copyright restrictions since Tan, one of the six martyrs whose execution by the Qing court had ended the 100 Days of Reform, was already dead. He was concerned, however, that the political danger associated with reprinting the martyr's treatise might deter a printing house from undertaking the project.

As far as Xia and the Commercial Press were concerned, Bao's fears were unfounded. Even after Bao explained to Xia who Tan Sitong was and what his book was about, Xia replied that it was just a business deal as far as he was concerned. To drive the point home, Bao then added, "This book has been *banned*." Xia continued, "Who cares? We're in a treaty port, we don't fear the Qing court. What we will do, though, is, on the back page where the copyright should go, we won't print the name and address of the printer. That's enough!" With this flourish of bravado and a snub of his nose at both the booksellers' guild and the trade association, in the organization of which he had taken a leading role, Xia took the original and, as per Bao's instructions, affirmed that he would print 1,000 copies on pure white paper. He would even include a copperplate image of the martyr in the book.

Bao also made it clear to Xia that he did not intend to earn a profit on the book, regarding its publication as a public service. Xia estimated that Bao's total investment, including paper and labour, would not exceed 100 yuan, and this was the amount they agreed on. Since Bao did not have the money to pay Xia in advance, he had to borrow it.

When the book was fully proofed, printed, and bound in the still-prevalent Chinese string style, Xia gave Bao some surprising news. Still not really grasping the contents of the book, but knowing that it was "a newly published forbidden book" outside copyright protection, Xia had printed an extra 500 copies on his own initiative and had priced them differently. When Bao let him know that he should not have taken this liberty, which would make "the boss he was fronting for" *(houtai laoban)* unhappy, Xia replied with something to sweeten the deal: "Okay, okay, let's do this *(Zheyang ba)!* I've printed 500 extras, and so I'll give you a 10 percent discount on the printing fee. What's more, you yourself slaved over the proofing of this book, so this is just a little reward." When Bao later asked Xia where he had sold his copies, Xia responded with a cunning smile, "I sold very few! Very few!"[112]

Although *Renxue* was technically a forbidden book, it was also an important landmark in modern Chinese thought. In this sense, it can be termed a "useful book" of the sort that Wu Woyao's character Wang Boshu would soon call for. Seeking to capitalize on the vogue for other "useful books" on practical subjects, foreign languages, and Western ideas, the early Commercial Press also produced, in addition to Tan Sitong's book and its English textbooks, many dictionaries, elementary readers on Asia, and so on. At the same time, Xia found a way to reduce paper costs by a third,[113] and he began to market his own discount paper after other Shanghai publishers took notice of his method.

By the turn of the century, one of Xia's chief competitors, Guangzhi shuju, had already begun to translate, print, and market Japanese works dealing with "New Studies." Works covered topics such as politics, law, modern administration, etc.[114] In keeping with the "herd mentality" *(yiwofeng)* with which we are familiar from Shanghai's lithographers of the 1880s, Xia plunged into the Japanese translation business. This time his impetuousness cost him dearly. After paying to have over ten Japanese works (apparently selected indiscriminately) translated into Chinese, set in type, and then marketed, he discovered too late that the translations had been done in a slipshod way. The books sold so badly that the project nearly bankrupted the fledgling publisher, costing it 10,000 yuan.[115] Xia began to learn what the Suzhou booksellers' guild had known since the seventeenth century – selling books was not like selling cabbages and required some knowledge of the texts.

At this point, Xia Ruifang tried to recoup his losses. One day he approached the head of the Nanyang Public Institute's Editing and Translation Bureau, Zhang Yuanji. Xia had met Zhang while making his rounds of the city, and Zhang had occasionally engaged the Commercial Press to do some printing.[116] As already shown, Zhang came from a very different background than

Xia, although one senses that it would not have deterred Xia from his mission. Xia asked Zhang to find him someone to rework the translations. Even after a long period of revision, sadly, neither the project nor Xia's capital could be salvaged. From this mishap, Xia concluded that, before embarking on any more translation or editorial schemes, the Commercial Press would have to establish its own editorial office *(bianyisuo),*[117] a critical first step to becoming a modern publisher of note.

Tongwen had been the first of the modern Chinese publishers to set up its own editorial office. By the early 1900s, in-house editorial offices had grown more common. Xia went back to Bao Tianxiao, asking him, "Recently there have been a lot of people setting up editorial offices; how should one set up these editorial offices?" Bao replied that, if Xia "wanted to expand [his] business, and prepare to publish [his] own [books], [he] must organize an editorial office." In a comment that reflected the continuing influence of the literati tradition, Bao said that Xia "should invite a learned and famous person to run it, and [he him]self should then concentrate on the business end." Xia nodded his head and sighed, "It is a pity that we have so little money. All we can do now is wait."[118]

In fact, just as Bao Tianxiao's employer had not had the luxury of waiting at all, Xia Ruifang could not afford to wait for long. He was under pressure to move quickly; the book market was heating up. There was money to be made, but as usual he needed some money to make more money. To get this money, the half-educated typesetter and cofounder of the still fairly modest commercial printing and publishing firm went back to the Nanyang Public Institute in 1901. He had decided to invite Zhang Yuanji, the cashiered Hanlin scholar and former imperial tutor, associate of Viceroy Li Hongzhang and of Sheng Xuanhuai (by now one of the richest men in Shanghai, patron of Shanghai's modern enterprises and schools, and archfoe of Tongwen owner and compradore Xu Run), to invest in his company. Amazingly, Zhang agreed. Open to a good opportunity, Zhang even convinced an associate to join him.

Following this infusion of capital, the Commercial Press converted from a partnership to a joint-stock limited liability corporation, changing its legal name to the Commercial Press, Limited (Shangwu yinshu guan gufen youxian gongsi). Its original capitalization increased from 3,750 to 50,000 yuan. Although Xia stayed on as general manager, an important watershed had been achieved in the history of the printing organization as well as in the history of Shanghai's modern printing and publishing industry. From this point on, the Commercial Press would have the capital to publish books that it had itself conceived and edited. Just as important, thanks to the perspicacity and flexibility of both Zhang Yuanji, the cultured *jinshi* from

Zhejiang willing to cross from the bureaucratic and academic side of Chinese society to the industrial side, and Xia Ruifang, the uncultured but enterprising former missionary printer from Jiangsu, the formal apparatus of the limited liability corporation was now adapted most successfully to Chinese publishing needs.

In 1902, after using rented retail space on Fuzhou Road, the Commercial Press erected a retail outlet on Henan Road. Xia Ruifang also purchased property on Fujian North Road, where he erected a new workshop.[119] In Tangjia Lane across the way, he founded the Commercial Press's first editorial office with four or five employees recommended by Zhang Yuanji.[120] Xia probably knew that the earlier lithographic firms had made similar editorial arrangements, employing *xiucai* and *juren* under the supervision of Hanlin scholars. Perhaps for this reason, he believed that his editorial office too should have a Hanlin official supervising its activities. Relying on his new business partner's connections, Xia asked Zhang to invite his friend and co-provincial Cai Yuanpei, then also working in the Nanyang Public Institute and concurrently director of Shanghai's Aiguo she (Patriotic Institute), to serve as supervising editor.[121]

As the Commercial Press now united, for the first time in modern Chinese publishing, departments of creative editing, original printing (as opposed to reprinting), and retailing, it also brought under one roof two very disparate personnel factions. The makeup of the printing house's major shareholders underwent a change when Zhang Yuanji and his group joined. One group, led by the Baos, came from a largely Ningbo Presbyterian background and was called the "Church Band" *(jiaohui pai)*. The second group, old-style Chinese intellectuals and literati from chiefly Jiangsu, Zhejiang, and Fujian origins, was known as the "Scholars' School" *(shusheng pai)*.[122] Xia himself came from the Church Band but, because he had invited the Scholars' School to join, there was no conflict between the two while he was at the centre of the corporation's activities.[123]

Soon the Qing court called for the establishment of schools with Westernized curricula. The reform tolled the end for the educational culture of the *shuyuan*. They had been resuscitated throughout Jiangsu and Zhejiang by an activist elite in the late nineteenth century as part of the Self-Strengthening Movement, and their replacement now signalled the growth of a wholly new educational culture. It would feed students into new or soon-to-be-established normal schools and universities, including those in Shanghai.

For this reason, Cai Yuanpei responded favourably to Zhang's invitation to join the firm, apparently seeing in it the opportunity to influence the nation's reformist education system. After taking up the reins at the Com-

mercial Press, Cai turned the editorial office in a new direction. Instead of continuing to work on translations, he decided, it should concentrate on textbooks. Cai soon selected Nanyang Public Institute instructors Jiang Weiqiao and Wu Danchu to edit textbooks in Chinese literature (*guowen*, literally "national literature"), history, geography, etc. Jiang and Wu were paid one yuan for each two lessons they composed.[124]

Before long, however, the infamous *Subao* newspaper case, involving anti-Manchu journalists prosecuted for sedition, broke open. To dodge the authorities seeking his arrest, Cai was forced to flee Shanghai for Qingdao. Fearing that his own plans would collapse, Xia turned to Zhang and asked him to take over the editorial office and its current textbook project. Zhang, still employed at the Nanyang Public Institute, by 1902 as its director,[125] had added modern printing experience to the editorial knowledge that he had brought to the job.[126] Zhang had also been involved in producing teaching materials both in Beijing and in Shanghai.

In 1898, though, while Zhang Yuanji was still working in the Zongli Yamen in Beijing, the textbook impetus had moved up the Yangzi River to nearby Wuxi. There Yu Fu and several colleagues had opened a modern school, creating textbooks as they went along, writing the lessons in the morning and having their students copy them later. Like Bao Tianxiao, Yu Fu would soon move to Shanghai and found Wenming Books to print and market these textbooks to a wider audience. Unlike Nanyang's textbooks, Wenming's were printed using lithography, which enabled the publishers to include illustrations. These textbooks were so well received that Wenming reprinted them ten times in three years.

As a major new investor in the Commercial Press, Zhang Yuanji now had a material interest in seeing the fledgling firm succeed against competition from Nanyang, Guangzhi, and Wenming. When Xia asked him in 1903, Zhang decided to join the Commercial Press as director of the editorial office.[127] Zhang immediately renewed the appointment of Jiang Weiqiao as permanent editor. Jiang in turn introduced Zhuang Yu and Xu Quan to the firm. They were soon joined by Yao Sujin. By the end of the year, Gao Mengdan (1870-1936),[128] a Fujianese *xiucai* and a close friend of Liang Qichao, took over the Chinese literature section. Gao would contribute to an editorial program that would lift China's and the Commercial Press's textbooks onto a new plane.

One other event contributed to the success of the press's new textbooks. Manying Ip has conducted painstaking research into the early business history of the Commercial Press and has shown convincingly that, when in 1903 the press expanded its capital to 200,000 yuan, the money had come from a Japanese publishing company, Kinkōdō (Chinese, Jin'gangtang). From

1903 to 1914, she has determined, "the Press was in fact a Sino-Japanese Company."[129] Her view is supported by the Commercial Press editor and writer Mao Dun (Shen Yanbing, 1896-1981), who says that the Japanese held half the shares.[130]

Kinkōdō had been established early in the Meiji period and "by the late 1880s ... was already Tokyo's most eminent bookseller specializing in text-books."[131] However, in 1902 Kinkōdō was implicated in a national textbook scandal in which 152 people were indicted, including Nagao Shintaro, Kotani Shigero, and Kato Komaji from Kinkōdō. After the three served short prison terms, Kinkōdō's founder enabled them to continue earning their livings by sending them to exile in Shanghai. In the treaty port, Yin Youmo (d. 1915) introduced them to Xia Ruifang, and they invested 100,000 yuan in his recently expanded firm. They also seem to have been encouraged to use their experience in compiling textbooks in Japan on behalf of the Commercial Press.

Jiang Weiqiao, one of the participants in the editorial meetings in the offices on Tangjia Lane off Fujian Road, recalls the "roundtable system" *(yuanzhuo huiyi)* of editing in some detail, but his memoir pointedly ignores the influence of Kinkōdō's experience in Japan. According to Jiang, those present at the roundtable usually included Zhang Yuanji, Gao Mengdan, Jiang himself, Zhuang Yu, and eventually the well-known science editor Du Yaquan (1873-1934).[132] In fact, their Japanese partner, Kinkōdō, was represented by Nagao, Kotani, and Kato. Liu Chongjie, a Fujianese returned-student from Japan, acted as interpreter.

The roundtable meetings were first implemented to reassess the ten-part textbook initiated during Cai Yuanpei's captaincy. After Zhang took over, any one of those in a roundtable meeting could raise an issue such as content, vocabulary, relevance to modern life, and, a distinctly Chinese concern, the number of strokes in the characters used. The goal was to provide a graduated study program, allowing students to progress from the simple to the complex with constant repetition. Sometimes the editors debated such issues for half a day, occasionally for a whole day.

In the end, following these and other principles, which Jiang acknowledges were often compared in spirit if not in detail to Western-language textbooks and which Manying Ip argues were influenced by Kinkōdō's Meiji-era experience, the Cai-initiated textbook series was deemed unacceptable. The editors were sent back to their desks to re-edit the series that would eventually appear in 1904 under the Qing-court-stipulated title, *Zuixin guowen jiaokeshu* (Modern Chinese Textbooks).

When these new textbooks appeared in 1904, they established the supremacy of the Commercial Press financially and otherwise. A hundred thousand

copies sold in a matter of months,[133] completely surpassing the publication record of Wenming, which had dominated the textbook market before 1903. Millions were sold over the next decade. According to Jiang, all other textbook publishers began to imitate the press's textbooks, signalling the true mark of retail success.

From 1903 onward, the Commercial Press also began its experiments with letterpress and advanced photographic printing introduced in Chapter 1. In 1907, the firm's printing and editorial operations moved outside the International Concession into a new eighty-*mu* (thirteen-acres) site on Baoshan Road in the Zhabei district.[134] Departments using techniques such as matrix-cutting in boxwood, colour lithography, and copper engraving that the firm had been acquiring via foreign consultants since 1904 now moved to the new site. Collotype was added in 1907 and three-colour copper engraving began in 1909. The same year, Chinese letterpress printing took a giant leap forward when the Commercial Press successfully manufactured Kaishu type. As a result, one can say that Gutenberg's revolution was now thoroughly sinicized.

Between 1904 and 1911, the Commercial Press became unstoppable. It utterly dominated the previously unmined and indeed largely undiscovered textbook market. Textbooks on a wide range of topics, including specialized books for normal schools and girls' schools, followed.[135] The Sino-Japanese editorial office may have been just as vital to the strength of the Commercial Press as had been its reorganization as a joint-stock limited liability company. Just as strikingly, this newly formed corporation became an arena in which the representatives of the highest levels of late Qing society, personified by Zhang Yuanji, and those widely regarded as the dross of that society, the treaty-port Chinese represented by Xia Ruifang, came together with a shared purpose, the production of useful books.

Conclusion

Between the 1880s and 1911, then, a large number of important steps were taken to put modern Chinese education and the print capitalism that supplied it on a firm footing. Social regrouping and redefinition (post-Taiping onwards), educational reform and the abolition of the civil service system (post-Taiping to 1905), an early commercial law (1902), the development of a privatized corporate model of organization (from 1875 on), and the founding and then reorganization of the Commercial Press according to the principles of that model (1897-1903) – all pointed toward and contributed to creating the conditions for the new era of print capitalism born within the confines of Shanghai's International Concession. In light of this background, it is not surprising that the booksellers' guild and the trade association were finally organized in 1904-5 to secure both the cultural values and

the financial interests of Shanghai's publishers. The guild reflected techno-
logical changes and the association responded both to technological and to
marketing innovations. Furthermore, it was in this period that Shanghai's
booksellers' district began to emerge along Henan North Road as the city's
publishing houses competed to meet the curricular needs of the city's mod-
ern schools and universities as well as those of the empire as a whole. Along
the way, these publishing houses contributed to remaking Shanghai as China's
new intellectual centre.

Most interesting of all, in the same period, Xia Ruifang, a trustee of the
booksellers' guild and a member of the trade association struck it rich with
his modern textbook series compiled by an assembly of Shanghai's most
progressive urban gentry reformers and printed on modern Western print-
ing presses, some of them supplied by the Chinese machine makers profiled
in the previous chapter. Just as the biography of Zhang Yuanji illustrates the
success of Shanghai's modern publishing industry in absorbing the down-
wardly mobile imperial official, so too the story of Xia Ruifang illustrates
this new industry's allure for the late Qing, upwardly mobile Shanghai en-
trepreneur.

For all these reasons, in addition to explaining Shanghai's intellectual and
cultural prominence by reference to schools and universities, one must trace
it also to Shanghai's business and industrial institutions as they made them-
selves felt in the printing and publishing industry from the period 1904-5
onward. Set against the adventurously experimental mood of the late Qing
and early Republican years, new vocational identities and legally inspired
and defined organizations such as the guild, the trade association, and the
Western-derived corporate model clearly enabled industrial entrepreneurs
and degree-holding scholars to achieve prominence together in Shanghai's
printing and publishing world. In the process, Chinese print culture and
print commerce were transformed into print capitalism. Motivated by the
public service ethics of the progressive urban gentry and by the technology-
based, profit-seeking outlook of modern capitalists, these groups also began
to influence national intellectual and educational goals.

After 1904, the Commercial Press was one of the main industrial benefi-
ciaries of the reform-oriented transformation of the Jiangnan economy and
the print culture and print commerce within it. Its leadership was both
inspired and pushed along by changes in social values that had been surging
since the Taiping Rebellion and that are reflected in *Vignettes from the Late
Qing*, published by one of the Commercial Press's leading competitors. Like-
wise, the Commercial Press's leadership, as well as Shanghai's other book
publishers, benefited from reforms of commercial organizations that origi-
nated in Shanghai in the 1870s and were then legitimated by the Qing

court in the early 1900s. Organizational reforms such as incorporation enabled Shanghai's book publishers to pay for technological innovations introduced from abroad but increasingly manufactured locally.

Social changes, identified at the time by novelist Wu Woyao, who replaced the conventional scholars of fiction with merchants, and more recently by historical scholars, set the stage for former imperial officials and degree-holders to join in a new-style cultural business such as publishing. This new-style enterprise, unlike the old-style book trade based in Suzhou or Beijing, brought together open-minded but shrewd entrepreneurs such as Xia Ruifang, well-trained technicians such as the Bao brothers, and intellectuals such as Zhang Yuanji and his editorial team with the parity of shareholders. The corporation, then, was an important new organizational form adopted by the Commercial Press and others that enabled these firms to finance themselves and their operations over an extended period.

In many respects, publishers drawn early to Shanghai were served by a hodgepodge of technologies and forms of business organization. All that began to change following the Sino-Japanese War, however. Under the protection of the concession authorities, Shanghai's Chinese publishers responded to the ideals of the 100 Days of Reform. The variety of their publications now increased and began to reflect the influence of Western ideas on the unsuccessful imperial reforms. Indeed, Shanghai's publishers and booksellers served as major pipelines for Chinese intellectual adjustment to the Western political ascendancy of the 1890s.[136]

All told, before 1915, twenty-seven transitional firms were located on Henan Road or Canton Road near its intersection with the north-south artery. In the same period, six relatively minor Chinese bookshops[137] were found along Fuzhou Road or near the Fuzhou Road-Henan Road intersection. Jumbled together with the six was the Chinese Scientific Instruments Company, founded by Englishman John Fryer (1839-1928), former director of the Translation Bureau in the Jiangnan Arsenal and of the Chinese Scientific Book Depot; all seven firms sold various educational items. Other shops opened here included Changming gongsi, the new-style publisher that gave Lufei Kui, the future founder of Zhonghua Books, his start when he first came to Shanghai, along with Hanwenyuan shusi which handled woodblocked and lithographed books.

In the final decade of the Qing dynasty, tentative moves to reform the education system sparked interest in modern Western-style educational commodities. Just as the newspaper and lithographic magazine had excited the interest of the already literate, so too the modern textbook now appealed to those who sought literacy. Indeed, the most profitable new-style book commodity to emerge in this period after the heyday of the lithographed

examination text was the modern textbook. As time went on, thanks to the productivity of Chinese print capitalism, such works became cheaper and more widely distributed. Simultaneously, the textbook market became, in historian Ji Shaofu's words, the chief battlefield of modern Shanghai publishers,[138] particularly those known as "the three legs of the tripod": Commercial Press, Zhonghua Books, and World Books.

5 "The Three Legs of the Tripod": Commercial Press, Zhonghua Books, and World Books, 1912-37

The goal of the literati life had been leadership and service, both of which were closely tied to the mastery of linguistic, literary, and, by extension, book culture *(wen)*. In the early twentieth century, linguistic borrowing from the Japanese language added a new dimension to this practice through broad adoption of the neologism *wenhua*, loosely translated into English as "culture." The term *wenhua* actually has a broader connotation in Chinese than in English. *Wenhua* refers not only to the literary arts and methods associated with them, but also to broad education and learning and to their acquisition, whether for purposes of public service or not.[1] For many late-nineteenth-century gentry-managers *(shendong)*, gentry-merchants *(shenshang),* and elite urban reformers, the public service aspect of education and learning came to be extended beyond imperial administrative service to the printing and publishing of textbooks and reference works.

Just as *wen* evolved into *wenhua* in the early twentieth century, so too traditional Chinese print culture entered a new stage between 1912, when the nominal Chinese republic at Beijing replaced the feeble Qing dynasty, and 1928, when the Guomindang (Nationalist Party) finally established a unified government at Nanjing. During this sixteen-year period, Shanghai publishers produced and marketed machine-printed and -bound works in a spirit of cutthroat print capitalism. From 1912 to 1928, the only constant in Shanghai publishing circles was fierce entrepreneurial and corporate competition brought on by the ambitions of publishers, which in turn reflected the costs of mechanization necessary to reach a national market. Publishing company monopolies, mergers, and alliances were effected to protect market share. Conquests and buyouts often obliterated once-honoured companies.

This chapter focuses on the second generation of new-style publishers, arguing that the Republican publishing corporation and its marketplace attracted a generation of would-be scholars, particularly Wang Yunwu (1888-1980) of the Commercial Press, Lufei Kui (Bohong, 1886-1940) of Zhonghua Books (Zhonghua shuju), and Shen Zhifang (1882-1939) of World Books (Shijie shuju), and transformed them into hard-nosed businessmen whose

merchandise happened to be books. If the cultural underpinnings of mod-
ern Chinese print capitalism lay in China's ancient print culture, and if the
technological foundation of Shanghai's print capitalism may be said to have
been established in the 1880s and 1890s with disenfranchised literati doing
a little business on the side, all that changed with the discovery of the
remunerative modern textbook market between 1900 and 1905. After 1912,
the new textbook-oriented industry evolved rapidly via Chinese merchant-
industrialists who now did a lot of business with a little culture on the side.
Between 1928 and 1937, those merchant-industrialists also added national
politics to their list of activities, often out of business necessity.

In this chapter, the second generation of new-style book-publishing print
capitalists is viewed through the history of the three leading corporate en-
terprises[2] of the 1920s and 1930s (Commercial Press, Zhonghua Books,
and World Books) and the circumstances that permitted each to scale the
heights of Shanghai's modern book-publishing industry. Just as important
as these firms' dates of establishment in 1897, 1912, and 1921 were the
years (1902, 1915, and 1921) in which they became joint-stock corpora-
tions. Their departures on marketing, organizational, and financial levels
enabled them to distinguish themselves from the dozens of small individual
proprietorships and partnerships that crowded around them up and down
Henan, Fuzhou, and Shandong Roads and the small alleys linking the
Wenhuajie district. These three publishing firms generally vied separately
against the others, but, for at least one important period, two of them united
against the third. During this second phase of entrepreneurial Chinese print
capitalism, what might be called the Chinese "textbook wars" erupted inter-
mittently from 1912 to 1928, intensifying greatly between 1924 and 1928.

Despite the potential size of the domestic market that they sought to
develop, generally speaking, Chinese industrialists in all sectors of the
economy of the 1910s and 1920s were undercapitalized and vulnerable to a
multiplicity of difficulties common to immature market economies and de-
centralized, overpoliticized states. China's industrial publishers were not
exempt from these difficulties and struggled to overcome them. The ruth-
lessness of the competition involving the three publishers from 1912 to
1928 actually obscures the general fragility of the industry itself, a weak-
ness reflected in their constant courtship of various forms of government
patronage in the textbook market that underwrote all their other activities.

In the modern era, in the absence of an interventionist state, large-scale
mechanization and mass production have rarely succeeded without the fund-
ing mechanisms and bureaucratic organization of the private corporation.
Historically, the quest for monopoly has resulted from the need to keep
the productive capacity of the firm active. The expansion of education in

the weakly centralized Republican era that began in 1912 necessitated the development of mass-oriented, mechanized publishing companies. However, it also placed the Shanghai publishers, who had created a working relationship with the late Qing Ministry of Education, in an environment with no clearly defined lines of command. In China, too, monopoly was the objective that Chinese publishing corporations sought in the broad potential market of post-Qing China. The by-product of each firm's scramble to secure monopoly was fierce competition among these corporations between 1912 and 1928.

The year 1928 was a turning point. That year Chiang Kai-shek's (1887-1975) Northern Expedition (1926-28) united the country under his Leninist-style Nationalist Party with its new capital at Nanjing, a few hours by train from Shanghai. Chiang's relatively interventionist state was particularly active in the realm of ideological control. By imposing, both economically and politically, a degree of order that had been absent between 1912 and 1928, the new state altered the business environment in which the three corporations as well as the rest of Chinese publishers had grown accustomed to competing.

Just as the Shanghai publishers' heavy economic reliance on the market for modern textbooks, their first best-sellers, led them into multiple opportunistic and awkward liaisons with post-Qing national and regional warlord governments, they now embraced the semiregulated marketplace and patronage of the Nationalist Party-state. An era of entrepreneurial and corporate Chinese print capitalism that had begun with lithography in 1876 now turned in the direction that would eventually lead, after 1937, to state-run publishing. The publishers' post-1928 settlement with the Nationalist state released publishing capacity formerly wasted in destructive competition and made possible the plenitude found on the shelves of Wenhuajie bookstores in the 1930s. The relative security of the textbook market also made possible the diversification of publishing companies into fields only tangentially related to printing and publishing, adding new polyvocalities to the meanings of *wenhua* and cultural business.

The range of meanings contained in the modern term *wenhua*, which gave its name to the Fuzhou Road district from 1916 onward, was reflected in the ambivalence that those working in the district felt about themselves throughout the period covered in this chapter. At the time of the Republican Revolution in 1911, Chinese bookmen still regarded themselves as cultural merchants even though many already controlled industrial publishing companies. Wishing to present an image of public service and to regard themselves as an extension of academic life, those who made up Shanghai's Wenhuajie were scholars, merchants, and industrialists simultaneously. As

time went on, however, the actual number of scholars declined, while the variety of merchants and industrialists increased. Nonetheless, the bookmen's self-perception only occasionally reflected these changes. For this reason, many remained psychologically dependent on the ideal of public service despite the absence of a unified state from 1912 to 1928. Following the establishment of the Nationalist government in 1928, they quickly accommodated themselves to it, reflecting a residual mentality of state dependence typical of many Chinese intellectuals in the late Qing and Republican eras.

When Chinese of the 1930s discussed the three leading Shanghai corporate publishers, they sometimes referred to them as "the three legs of the tripod" *(sanjia dingli)*. This Chinese phrase describes a tripartite confrontation or balance of forces. At the same time, it alludes to the importance of each of the three legs in supporting the large ritual pot above, which here can be interpreted as an indirect reference to the Chinese state. The phrase suggests that publishers had become industrialists acknowledged by the state for their importance in ideological and cultural struggles against the regime's main opponents: critics within society, both on the left and on the right, and foreign military opponents, particularly Japan.

These three publishers – the Commercial Press, venerable survivor of the imperial era; Zhonghua, the initially bold but then increasingly staid educator of the Republic; and World Books, the crafty double-dealer of Wenhuajie – remade the Chinese publishing world before and after the 1911 Revolution. Like Chinese literati of the imperial era, however, they were also frequently dependent on political authority exercised by claimants to the central government. Protected against many bitter political and military struggles of the era thanks to their having located their headquarters within or very close to the International Concession, the Shanghai publishers were nonetheless also at the mercy of Chinese educational policies that they tried to influence with varying degrees of success. Particularly after 1916, as northern warlords vied for control of the national government at Beijing, cabinets changed often, and with them came and went new ministers of education. Each time a minister was changed, textbook publishers' ambitions altered. Each was forced to seek means to establish a close connection with the new minister.

Likewise, once the capital was established at Nanjing in 1928, litmus tests of each publisher's loyalties to the new regime became common currency. Regulating the industry that had grown up around an erstwhile peripheral technology became an overriding concern of those who controlled education and ideology for the Nationalist Party-state. A copyright law was promulgated in 1928 that benefited the publishers.[3] Each publisher, in turn, reached a different settlement with the new government, using the

perception of its importance in supporting the government's educational and cultural policies to further both corporate and personal agendas. As censorship increased, so too did book production. Between 1928 and 1937, ever greater numbers of publications rolled off the Shanghai presses of publishers who had learned to live together with each other. By 1937, an overwhelming 86 percent of all books published in China appeared under a Shanghai imprint.[4]

In spite of economic diversification, from 1928 to 1937, the Commercial Press, Zhonghua Books, and World Books, using printing plants scattered throughout Shanghai, together continued to produce between 61 and 71 percent of China's total book output.[5] The Commercial Press generally outproduced the others three to one and five to one, respectively.[6] The mutual tolerance of each for the others was made possible by a state system that shuttered the window of savage capitalism that had been opened during the late Qing era. Seen from one perspective, a direct major benefit to China of competition had been the provisioning of China's schools, universities, and libraries with the modern textbooks and reference works that opened onto the world of *wenhua*. From another angle, unintended side-effects of this cost-driven competition were personal betrayal of colleagues for the sake of organizational supremacy as well as a drastic commercialization of intellectual life. The Nationalist Party-state offered the corporate publishers markets with minimized conflict in exchange for relative ideological conformity, with the result that other, smaller publishers that do not figure in this book inherited the adventurous, risk-taking outlaw spirit of early Chinese print capitalism.

Republican Shanghai's Wenhuajie

Chapter 4 suggested that one can first begin to speak of Fuzhou Road as Wenhuajie around 1916. By that year, the two leading corporate comprehensive publishers, Zhonghua and the Commercial Press, had established their bases along Henan Road, the approach to Fuzhou Road (see Figure 5.1). Dadong shuju (Great Eastern Books), founded by Lü Ziquan (b. circa 1881) and Shen Junsheng, also opened on Fuzhou Road in 1916.[7]

However, it was not until 1917 that the third of the "Big Three" Shanghai publishers, as identified by Chinese of the Republican era, appeared in Wenhuajie. Joining the Commercial Press and Zhonghua, an early incarnation of World Books was founded in 1917 in a Fuzhou Road alley. By 1921, when World Books was officially founded, that alley would become known as World Lane. World Books, along with Dadong and, after 1926, former Commercial Press editor Zhang Xichen's (1889-1969) Kaiming shudian and dozens of others, encouraged book patrons to step over the threshold

Figure 5.1 Commercial Press and Zhonghua
Books retail outlets (left to right), corner of
Henan and Fuzhou Roads, 1932+.
Source: Chuban shiliao 8 (1987: 2): back cover.

defined by Zhonghua and the Commercial Press onto the expanding stage
of Republican China's intellectual and publishing life (see Figure 5.2). In a
district that at one time or another attracted over 300 bookstores and pub-
lishers (see Appendix for the scores of firms in Wenhuajie in the 1930s),
World Books became an inextricable influence in the establishment of Fuzhou
Road as the Wenhuajie of China, precisely because it contributed so heavily
to the pronounced commercialization of Republican intellectual life.

If World Books fostered the new image of Wenhuajie in a way that nei-
ther the Commercial Press had nor Zhonghua could have at this point,
Shen Zhifang, founder of World Books and of an estimated ten other Shang-
hai book-publishing or -retailing operations, is best identified as the source
of the spirit prevailing on Wenhuajie by the 1920s. No other prominent
book merchant epitomizes the plenitude, crass materialism, and combative
opportunism that came to be so thoroughly identified with Republican
Fuzhou Road's brand of book culture as this many-sided prodigy of
Shanghai's publishing world.

According to Bao Tianxiao (1875-1973), himself an employee of the new
world of corporatized publishing firms, the Fuzhou Road district came, by
the 1920s, to be so thoroughly identified with publishing that it was known

Figure 5.2 World Books retail outlet (with Dadong shuju and Kaiming shudian), corner of Fuzhou and Shandong Roads, late 1920s.
Source: Chuban shiliao 8 (1987: 2): back cover.

as "Culture Street" (Wenhua dajie). This phase of cultural and commercial modernity was reached, Bao says, only after the emergence of the Big Three and Dadong. In his words, "If you take the Commercial Press and Zhonghua Books as Shanghai's first-order book merchants at that time, then World and Dadong were Shanghai's second-order book merchants. At the time, along Fuzhou Road (popularly called Simalu), starting from Shandong Road (then Wangping Street) and going along to Henan Road (then Qipan Street), it was all newspaper plants and bookshops. The Commercial Press, Zhonghua, World, and Dadong were all in there, and for this reason everyone called this strip 'Wenhua dajie' (Culture Street)."[8] Quite apart from Bao's testimony about the importance of this district by the 1920s, what is striking in this view of Wenhuajie is his failure to comment on its harshly materialistic side. Bao's exultation over this assemblage of shops and publishers effectively blots out the details catalogued elsewhere in his memoirs that enable one to observe that Shen Zhifang was less the exception and more the rule among the clashing personalities on Wenhuajie.

Bao's friend and junior colleague in the Wenhuajie district, Zhang Jinglu (1898-1969) had had over twenty years of work experience in the district when Bao and the writer A Ying (Qian Xingcun, 1900-77) finally convinced Zhang to write his memoir.[9] Penning his reminiscences in Hankou in 1938 after the evacuation of Shanghai, Zhang recalled that even before he had begun working in Wenhuajie around 1918, he had been roaming Henan Road as a consumer. He had started window-shopping there in 1911 to ease

the stress of an apprenticeship in a Tiantong Road grog-shop. "In those days," he says, "all the bookstores, big and small, were concentrated on Henan Road." Zhang had visited the shops every evening after stoking the fire in the bar, walking the entire distance back and forth. His "hooting" *(huxiao)* colleagues even gave him the nickname "Henan Road Inspection Commissioner *(Qipanjie xunyue shi)*."[10]

Calling himself "a publisher who began life as a reader,"[11] Zhang opened Guanghua shuju on Fuzhou Road in 1921,[12] the first purely new-style book-store in Shanghai. In his memoir, Zhang discusses the changes wrought in Fuzhou Road since the early 1920s, the period when Bao believes Wenhuajie came into its maturity: "[Fuzhou Road] was not [then] a place where book-stores crowded together ... If you look over today's [1938 Fuzhou Road] that suddenly became Shanghai's famous 'Culture Street,' think back to those days [when] there were only solitary beat-up old market stalls. It was hard to run across [even] a few friends selling books. It certainly did not equal the feeling of yesterday and today!"[13] Justifiably claiming part of the credit for creating what became Wenhuajie, Zhang describes a history in which publishing kingdoms, founded in shops and offices either at the Fuzhou and Henan Roads intersection or along the sidewalks of Fuzhou Road itself, established the rules by which the contest for mastery of the heights of China's Republican book market was carried out.

Zhang's memoir reveals that, in 1938, at least as important as the social history of the district was the feeling of abundance that it passed on to consumers whenever they visited it. That feeling was what they carried away, and it was part of the reason that they came back to Wenhuajie. Just as effectively as Bao's, Zhang's memoir discusses the wide array of scoundrels and cheats infesting Shanghai's Wenhuajie, but it was the district's em-brace of modern ideas and innovative ways of disseminating them that made Wenhuajie's hold on Zhang permanent. More judgmental than Bao, Zhang stared hard at the dichotomies of Wenhuajie. In the end, however, he favoured the progressive and constructive, mentioning but not dwelling on the mer-cenary and the negative. Nonetheless, due to figures such as Shen Zhifang and because of the nature of the corporations that played a major part in the history of Wenhuajie, the rough, competitive, capitalist facets of Wenhuajie are inescapable.

Each of the Big Three sought hegemony over the markets that it pursued. Key resources in the efforts of each to seize those markets included manage-rial and editorial supremacy. Organizational and leadership structure also influenced access to capital, which in turn had an impact on a firm's ability to develop a printing plant as well as to gain access to new machinery. Market-ing tactics, simple luck, and long-term strategy vis-à-vis the governments[14]

in control of relevant markets contributed to success. In this way, economic reality rubbed its broad, muscular shoulders up against the weak, rounded ones of culture along Wenhuajie in a way that would not have been possible in China a century before. Most important historically, books sold in this environment were not produced in the same way that they had been earlier.

In 1930, when the new Nationalist government-mandated Shanghaishi shuye tongye gonghui (Shanghai Booksellers' Same-Industry Association) was formed with 83 member firms, the assets of the publishing industry totalled about 8 million yuan.[15] Assets of the Commercial Press totalled 5 million yuan while those of Zhonghua Books came to 2 million yuan. The next closest competitor was World Books, with less than a third of Zhonghua's assets. The other eighty firms were worth only about 300,000 yuan altogether. The key to this accumulation up to 1930 was the marketplace, which in turn depended on government supervision and legislation.

Moreover, Shanghai's modern publishing business was driven by the expansion of modern educational opportunities, beginning in the late imperial period and continuing until the end of the Nanjing Decade (1928-37). For this reason, Wang Yunwu, chief of the editorial office at the Commercial Press from 1921 to 1929 and general manager from 1930 to 1946, linked school enrolments from 1910 to 1937 with the growth of publishing in his chronological history of the Commercial Press.[16]

The steady expansion of educational opportunities, from just over 100,000 students enrolled in some 4,000 schools in 1905[17] to nearly 13 million students studying in approximately 230,000 schools nationwide by 1937,[18] represented an enormous educational and commercial opportunity for responsive publishers. This observation was particularly true of a society in which textbooks were repeatedly mandated in a series of educational regulations, issued initially by the Qing court and then, after 1911, by successive national and warlord governments, often influenced by university-based or independent intellectuals.[19] No other form of printed matter in China ordinarily reached such a large, and regulated, readership.[20] Government endorsement, whether formal or informal, turned out to be the single most important element in creating the public patronage on which the major textbook publishers relied.

Already by 1904, when the Commercial Press's *Zuixin guowen jiaokeshu* (Modern Chinese Textbooks) appeared, the publishing impetus in China had shifted from official publishers to privately owned publishing houses, most of which were based in Shanghai. In 1906, for the first time, the imperial Ministry of Education approved a list of officially accepted primary school textbooks. Eight publishers had issued the 102 textbooks on

that list. Of those, 90 (88.2 percent) had been issued by Shanghai-based publishers, private and official; 85 had been issued by three private publishing companies (Commercial Press, Wenming Books, and Shizhong shuju). Over half (54) of the total number of titles had been issued by the Commercial Press; Wenming came in second with 30. Nanyang Public Institute, the Shanghai school and translation bureau that had first employed Zhang Yuanji, had published 4, while Shizhong shuju had published 1.[21]

Even more significant to the publishers than the actual school enrolments were the amounts spent on education. In 1911, according to Wang Yunwu, 1.6 million students were paying almost 21 million yuan in tuition fees or about 13 yuan each.[22] By 1937, just under 13 million students were spending 73 million yuan.[23] Although per-pupil spending had dropped to 5.6 yuan, the range of schools had increased, inflating the variety of textbooks needed.

Just as it had in 1906, the Commercial Press continued to dominate the new-style book market in 1937. In that latter year, 52 percent of all new books published in China came out of the editorial offices of the Commercial Press. Gone were most of the genteel competitors of the late imperial period; they had been replaced by publishers whose names signalled their ambitious marketing targets. Apart from the Commercial Press, Zhonghua (meaning "China") was founded in 1912, and World appeared in 1921. Chapter 4 discussed the organization of joint-stock limited liability firms in the abstract; we will now see how these corporate kingpins of Wenhuajie worked in practice.

"The Three Legs of the Tripod": The Commercial Press, Ltd., Zhonghua Book Company, Ltd., and World Book Company, Ltd.

The Commercial Press, Ltd., 1904-37

Due to their demand for textbooks, schools and teachers' colleges were the most dependable patrons of the industrialized Chinese publishers between 1904 and 1937. Once government-sponsored libraries began to appear around 1908-9,[24] they supplemented the textbook market, but libraries did not make a significant economic demand on publishers until the public library movement of the late 1920s. After the civil service system was abolished in 1904-5, the struggle for mastery of both these markets, schools and libraries, along with that of private readers, was usually dominated by the Commercial Press in competition with one or more other publishing houses.

From 1904 until 1937, the Commercial Press was Shanghai's leading comprehensive publisher in terms of sustained hegemony, publications, physical plant, corporate wealth and profits, and even size of its printing and publishing workforce. From its commanding position among Shanghai's

publishers, the Commercial Press changed the face of Chinese education and informed opinion. The firm's corporate command structure was organized around its General Business Office and board of directors. Both provided it with the kind of control necessary to direct operations locally, across the country, and in the corridors of political power, whether in Beijing, the national capital until 1927, or in Nanjing, which replaced Beijing during Nationalist rule from 1928 to 1937.

Although the Commercial Press asserted its control over the national textbook market early and went on to become Republican China's premier industrial cultural corporation, its authority did not go unchallenged. Indeed, its seemingly inexorable advance ground to a halt at least four times between 1904 and 1937: in 1911-12, in 1919-21, in 1926-27, and in 1932. In the first instance, the firm's preponderance was stymied from within, by overly cautious leadership, and from without, by two turncoat lieutenants eager to work their way independently into the company's markets. In 1919, the Commercial Press was caught off-guard a second time by changes in intellectual fashion brought on by the New Culture Movement (1915-21). In 1926-27, heedless directors and editors learned to their dismay that printers in the Baoshan plant were just as important to the firm's operation as the intellectuals and white-collar employees in its editorial offices. Finally, in 1932, the Commercial Press received the ultimate affirmation of its importance in shaping national Chinese opinion when Imperial Japan singled out its Baoshan Road printing plant for destruction. Notably, however, following each setback, the Commercial Press recovered to recapture hegemony within the publishing economy.[25]

Thanks to its growing backlist of new educational publications, the Commercial Press in the early 1900s seized the popular educational market that had been ruled in the 1890s by Shanghai's lithographic publishers such as Feiying Hall and Wenming Books. Over the next decade, the Commercial Press used its success with educational titles to launch several series of important modern reference works. For instance, trading on war, the same topic that had enabled the *Dianshizhai Pictorial* to rise to prominence in the mid-1880s, the Commercial Press published a twenty-four-volume reference series covering the Russo-Japanese War of 1904-5, followed by an eighty-volume work on Japanese constitutionalism.

As early as 1904, Zhang Yuanji had begun collecting books for the Commercial Press's editorial reference library to be called the Hanfenlou (Fragrance-Harbouring Library). Three years later, the Hanfenlou opened atop the specially constructed editorial building located on the new eighty-*mu* site on Baoshan Road in the northern part of the city that also held a large new printing plant (see Figure 5.3).[26] The same year, in a move that

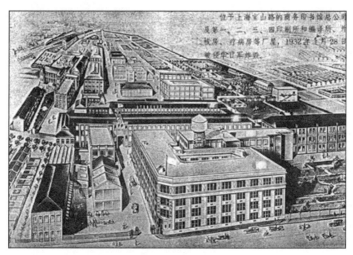

Figure 5.3 Commercial Press editorial offices and printing plant,
Baoshan Road, Zhabei, Shanghai, pre-1932.
Source: Zhonggong Shanghai shiwei dangshi yanjiu shi and Shanghaishi
zonggonghui, eds., *Shanghai Shangwu yinshu guan zhigong yundong shi* (Beijing:
Zhonggong dangshi chubanshe, 1991), 194.

recalled the crown commission garnered by Tongwen, the Qing court commis-
sioned the Commercial Press to publish a thirty-two-volume series compar-
ing constitutionalism around the world. In 1908, more titles on comparative
political systems, particularly that in Japan, appeared through the Press,
signalling once more the editors' support for constitutional monarchism.

The new editorial command centre went on to produce important refer-
ence works such as *Xin zidian* (New Dictionary, 1912), China's first major
new dictionary since the publication of the *Kangxi Dictionary,* and *Ciyuan*
(*The Encyclopedic Dictionary,* 1915, which Mao Zedong would use in the 1940s
at Xibaipo). High-quality reproductions of traditional texts such as *Sibu
congkan* (Library of Chinese Classical, Historical, Philosophical, and Liter-
ary Works, 1920), were issued.[27] Works such as these demonstrated that the
Commercial Press not only had captured the carriage trade formerly domi-
nated by Tongwen and Saoye shanfang but also now had surpassed them.

Along with record-breaking sales of textbooks and landmark reference
works, the Commercial Press was also responsible, thanks to the firm's suc-
cess in publishing important works by fin-de-siècle translators Yan Fu (1853-
1921) and Lin Shu (1852-1924), for introducing large readerships to their
first articulate impressions of Western modernity. Parallel with the Nanyang
Public Institute's buying Yan Fu's translation of Smith's *Wealth of Nations*
(*Yuanfu*) and publishing it in 1902, six other major translations of social

science works by Yan Fu appeared between 1899 and 1908 under the Commercial Press imprint: Mill's *On Liberty* (*Qun jiquan jie lun*, 1899), Montesquieu's *Spirit of Laws* (*Fayi*, 1902), Mill's *System of Logic* (*Mule mingxue*, 1902), Spencer's *Study of Sociology* (*Qunxue yiyan*, 1902), Huxley's *Evolution and Ethics* (*Tianyan lun*, originally 1898 in woodblock, then circa 1905), and Jevons's *Logic* (*Mingxue qianshuo*, 1908).[28] Supplementing these social science works, the *juren* and translator Lin Shu introduced 142 Western literary works to Chinese readers through various Commercial Press publications.[29]

Magazine and journal publishing was another important domain of Commercial Press dominance. Its first journal was Zhang Yuanji's (1867-1959) *Waijiao bao* (Diplomatic News, 1902-10), followed by *Dongfang zazhi*/*The Eastern Miscellany*, started by Zhang in 1904. By 1910, the *Eastern Miscellany* had reached a national circulation of 15,000, making it the most widely circulated journal in China at that time. Initially directed by Zhang himself, the editorship eventually passed to Zhang Jian's (1853-1926) disciple Meng Sen (1868-1937), science writer Du Yaquan (1873-1934), and then to Hu Yuzhi (1896-1986), all important figures in their own right. Surviving until 1948, the *Eastern Miscellany* set a record for longevity in Republican Chinese publishing.

Other important and long-lived Commercial Press periodicals included the literary journal *Xiaoshuo yuebao* (Short Story Monthly, 1910-32, edited first by Wang Chunnong, followed by famous writers Mao Dun [Shen Yanbing, 1896-1981], Zheng Zhenduo [1898-1958], and Ye Shengtao [1894-1988]); *Jiaoyu zazhi*/*Educational Review* (1909-48) and *Shaonian zazhi* (Youth Magazine, 1911-31); *Funü zazhi* (Ladies Journal, 1915-31); and *Yingwen zazhi* (English Magazine, 1915-?).[30] All told, the Commercial Press published eight major journals and at least forty others between 1897 and 1937, with several influential ones terminated as a result of the events of 1932.

Perhaps because of the editorial office's commitment to constitutional reform of the monarchy, in 1911-12, as will be seen in greater detail below, the Commercial Press was caught off-guard by the success of the Republican Revolution and of Zhonghua Books. Forced by both to withdraw its successful late Qing textbook series from the market, the press's editors gradually worked their way back into the schools with a new series, the *Gonghe zhong xiao xue jiaoke shu* (Republican Textbooks for Middle and Elementary Schools). In 1912, just when the publisher's textbooks were stricken from the new, nominally republican Beijing government's lists, Bao Tianxiao went to the Commercial Press, where Zhang Yuanji interviewed him for a job. Signed up as a part-time editor so that he could keep his job with *Shibao*, Bao arranged to work from 1 to 5 p.m. each afternoon. Participating on the

editorial teams of several new Chinese literature textbooks, he earned forty yuan per month.[31] When it came time to publish the books, Bao claims, he himself proposed printing the new five-colour (red, yellow, blue, white, and black, symbolizing the five main ethnic groups in the Republic of China) national flag on the new textbooks.[32]

Even as the Commercial Press dealt with setbacks on the publishing front, it began diversifying its operation. Two new divisions were created in 1912, one to produce educational supplies and the second to produce machinery. Although the machine shop soon curtailed much of its operation in the face of competition from the manufacturers discussed in Chapter 3, a Chinese type-caster that Xia Ruifang bought in Germany, most likely a Thompson, made its appearance. By 1913, workers in the Commercial Press machine shop replicated it and began producing 15,000 metal Chinese type per day. They also started manufacturing lithographic printing presses, letterpress machines, galley presses, etc.[33]

Then, adding tragedy to the economic setback of 1912, in 1914 founder Xia Ruifang was assassinated in front of the Commercial Press's main retail outlet on Henan Road near Nanjing Road. His death may have reflected nationalistic feeling stemming from the Republican Revolution that manifested itself in opposition to Japanese investment in China. Nonetheless, four days before, Xia had already reached an agreement with Kinkōdō that allowed the Commerical Press to buy out the Japanese investors. At the time, competing publishers were also suspected of involvement in his death, but Xia's demise did little to undermine the Commercial Press's market dominance. By 1914, the press was an all-Chinese corporation already worth over 1.5 million yuan.[34]

With Xia gone, the board appointed cofounder Gao Fengchi to replace him as general manager and Zhang Yuanji as manager. From 1915 to 1920, Gao and Zhang ran the Commercial Press according to the "one office, three departments" *(yichu sansuo)* system that Zhang apparently borrowed from Zhonghua to reduce bureaucratic meddling by the Church Band led by the two Bao brothers and Gao. Under the General Business Office were the editorial, printing, and distribution departments. With Zhang in charge of editorial work, the Baos and Gao took responsibility for the other two. Important decisions concerning administration, employment, and finance were made at joint meetings of the general manager, manager, and three department heads.[35]

One August day in 1916, manager Zhang Yuanji interviewed Shen Yanbing, the recent Beijing University graduate who would become known as the left-wing writer Mao Dun, for a position grading papers in the English section of the editorial department's correspondence school. Mao's memoirs

reveal fascinating insider details about how the Commercial Press actually ran at the time. Entering Zhang's third-floor office at the Commercial Press's retail outlet on Henan Road with a letter of introduction from the firm's Beijing branch manager, Mao recalled that, even though his interview was at 9 a.m., he was the seventeenth person Zhang had seen that day. Mao found Zhang's office surprisingly plain.[36]

After being hired, Mao was delivered by Zhang's driver to the Baoshan Road editorial office. He started work under chief editor Gao Mengdan (1870-1936) at twenty-four yuan per month. Mao spent his first month correcting English essays before being transferred to the translation section. Although he avoids personal criticism of Zhang, Mao comments that the Commercial Press kept a significant number of editors "for special purposes" *(teshu yongxin)* on the payroll who never actually performed editorial or translation work. Mao concluded that the editorial office operated much like an overstaffed government office *(guanchang)*, not totally surprising in light of Zhang's background.[37]

In 1920, Gao and Zhang both resigned from their positions as general manager and manager, respectively. The two men were now appointed as supervisors, and their former positions were filled by Bao Xianchang (1864?-1929), the second surviving founder, and Li Bake (1880-1950), a younger scholar whom Zhang had trained in the editorial office. All important business decisions continued to be made in joint sessions of the General Business Office, which now included the two supervisors.

In 1918, Zhang had resigned from leadership of the editorial department in favour of the long-time editor, Gao Mengdan. The two men had joined the Commercial Press in 1903, and both now acknowledged the need to find new, younger men to replace themselves. On 1 May 1919, just before the May Fourth Incident became the political turning point of the literary revolution known as the New Culture Movement, Zhang met Hu Shi (1891-1962), one of the movement's two well-known champions, for the first time.[38] An ardent advocate of substituting the vernacular language *(baihua)* for literary Chinese *(wenyan)* in books and other publications, Hu held the PhD in philosophy from Columbia University, where he had studied with John Dewey. Hu had also begun publishing his translations of foreign short stories in Beijing's *Xin qingnian* (New Youth) magazine, which trumpeted the message of cultural revolution from 1915 onward.

Two years after Zhang and Hu first met, Gao Mengdan visited Hu at Beijing University, where Hu was teaching in the philosophy department, to ask him to consider taking over the editorial department at the Commercial Press. During the New Culture Movement, no publishing house had suffered greater obliquy than the Commercial Press. In response, the press

leadership acknowledged the necessity of making personnel changes. Hiring Hu Shi, the most moderate of the New Culture leaders and widely known for his advocacy of language reform, it was hoped, would enable the press to silence its critics. In January 1920, the New Culture Movement had played itself out in a new government mandate for elementary textbooks in the vernacular.[39] When the Commercial Press's amended textbooks, titled *Xin xuezhi jiaokeshu* (New School System Textbooks), appeared, however, they would be the first ones directed by the new editor, Wang Yunwu.

Hu Shi declined the editorial position but took the opportunity to recommend his old English instructor from Wusong's Zhongguo gongxue (China College), Wang Yunwu, an autodidact with a wide range of experience. Although technically a native of Xiangshan county, Guangdong, Wang had been born in Shanghai and had grown up there, speaking the local Chinese pidgin *(Yangjingbang hua).* In his first school, which he entered in 1899, Wang studied the Four Books, standard preparation for an academic or official career. In a second school, Wang supplemented this traditional curriculum with the *Shiji* (Records of the Grand Historian), *Zuozhuan* (Chronicle of Zuo), and *Tangshi sanbai shou* (300 Tang Poems). Interestingly, he also encountered the Twenty-Four Dynastic Histories in a lithographed Tongwen Press edition. Adding a new chapter to Wang's academic career, however, his father then arranged for him to begin learning English, the key to business success in Shanghai. After Wang had spent half a year in Guangdong, his father next enrolled him in one of Shanghai's American missionary schools. At the same time, Wang started to learn English in earnest and read multiple works by Bacon, Montesquieu, Adam Smith, and Spencer, all translated by Yan Fu.[40]

In 1907, Wang Yunwu was hired to teach English at a private academy that was soon absorbed into China College. By late 1911, fellow Xiangshan native and Republican president-designate Sun Yat-sen (1866-1925) had hired Wang as his private secretary. After Sun resigned the presidency in late February 1912, Wang went to Beijing, where a new ministry hired him in an editorial capacity. In 1916, Wang returned to Shanghai and worked for the Board for Opium Suppression. Before long, Wang set himself up as a minor Shanghai compradore, building a house on Sichuan North Road.

In 1921, Commercial Press science editor Zheng Zhenwen first met Wang Yunwu in Wang's new private library during a visit with chief editor Gao Mengdan. Wang was rumoured to be skilled at foreign languages as well as at physics and engineering, all fields in which the Commercial Press desired to develop lines of publications. In Wang's study, Zheng spied a complete run of a German chemistry periodical that he had not seen since leaving Japan some years before and asked Wang if he often subscribed to this sort

of publication. "He had no alternative but to tell me the truth, [which was that] he had bought it from a Tongji University Medical School chemistry teacher when he had left" Shanghai. Trying to discuss some of the contents of the periodical with Wang, Zheng was deflected by Wang's comment that "I did not read it carefully."[41]

As Zheng and Gao returned from their meeting with Wang, Zheng related his poor impressions of Wang to Gao, who "just smiled." Later they learned that Wang knew only a smattering of German and Japanese. Eventually, though, Wang was selected for the editorial position, partly, says Zheng, because Gao wanted to overcome the image retained by the editorial office as the preserve of Fujianese.[42]

Wang Yunwu, then, was a beneficiary as well as a promoter of the new editorial spirit, fundamentally a commercial one, inspiring Fuzhou Road's leading comprehensive publisher after 1921. In the view of Manying Ip, Wang's basic personality was quite unlike those of Zhang Yuanji and Gao Mengdan. Where the two imperial degree holders were "modest and self-effacing," Wang, ill-educated, rough around the edges, and lacking an imperial degree, was "confident, aggressive and ambitious."[43] For 1920s Wenhuajie, however, where book culture, industrial production, opportunistic marketing, and shrewd politicking all merged into one another, Wang's personality was just what was needed, as would become clear between 1924 and 1927.

Wang Yunwu's reforms at the Commercial Press covered mainly editorial and classificatory operations. He also tried, after a research trip to America and Europe in 1930, to implement Western-style rationalization in the editorial department via a program known as "scientific management" *(kexue guanli fa)*. In 1922, Wang had reorganized the editorial office into nine departments and hired 196 editors, more than doubling the department's roster to 365. At a time when many editors were already demoralized by criticism from the New Culture generation, older editors soon began to leave, dubbing Wang the "Yuan Shikai" of the publishing world for his dictatorial style of leadership and patronage.[44] Concurrently, however, Wang had also experimented with serial reprints of well-known books. The financial success of his 1923 *Baike xiao congshu* (Library of Basic Knowledge, also Miniature Encyclopaedia) series, which summarized the latest Western thought on a range of topics, helped Wang overcome opposition to his leadership and solidified his position.[45] Also, building on an idea that former editor and Kaiming founder Zhang Xichen says originated with Gao Mengdan, from 1924-28, Wang perfected the four-corner system *(sijiao haoma)* for classifying Chinese characters and tied it into his modification of the Dewey library classification system; the latter gradually replaced the *sibu/siku* system that dated to the Wei dynasty (220-65) and that had been made obsolete

by China's Gutenberg revolution.[46] The two systems were combined in various Commercial Press publications and so greatly simplified library development and administration that they were adopted by other publishers, two dozen libraries, the Harvard-Yenching Institute, and even by the Nationalist Party.[47] Wang was less successful with his plan for piece-rate pay scales at the Commercial Press, however; his efforts were thwarted by the firm's editors, who argued that intellectual work was different from physical labor and could not be quantified.[48]

In the short term, however, Wang Yunwu and the Commercial Press were about to discover that their activities in the editorial office were useless without the continually calibrated physical labour of the technicians in its printing plant. By the mid-1920s, about 10,000 people in Shanghai were employed by the new-style printing and publishing industry. They were represented by the second-largest trade union in the city. The Commercial Press itself employed about 4,000 printers and printing workers, the largest number of any single publisher.[49] Throughout the nineteenth century, increasing numbers of Chinese had begun to work with Western printing presses, but there is no indication of any labour strife at that time. Indeed, as we know, in 1911 the booksellers' guild had counted on its employees to form a militia to protect their firms. By 1917, however, the class harmony of 1911 was a thing of the past.[50]

The first Chinese printers' strike had occurred at the Commercial Press in March 1917 as a result of printing shop director Bao Xianchang's attempt to introduce a piece-rate pay scale that anticipated Wang's 1930 effort in the editorial office. Although a sympathy strike had quickly broken out among Zhonghua's workers, this time the two firms had been able to suppress the workers with the help of the police.[51] In 1919, in support of the anti-imperialist strike of the Beijing students, Commercial Press printers had driven Japanese consultants out of the plant and had taken to the streets for a second time. Their rancorous disputes with management had soon attracted the attention of outsiders.

As already noted, the writer Mao Dun had joined the editorial offices of the Commercial Press in 1916. He remained with the publisher for nine years. His early involvement with the Communist Party had enabled him to serve as a go-between linking the Communist Party to the Commercial Press workers. As a result, he was familiar with the sources of labour discontent despite his own white-collar position in the editorial department, where he rose rapidly through the ranks from English grader to dictionary editor and finally, in 1921, to the editorship of the revamped *Short Story Monthly*. At that point, his monthly salary jumped to 100 yuan.

Although the Communist Party was not founded officially until July 1921, a local Shanghai organizational cell had been set up in May 1920, and Mao had joined it half a year later.[52] Mao also contributed translations to the new cell's short-lived journal, *Gongchandang* (The Communist). In the autumn of 1921, when the secretary of the new Communist Party, Beijing University professor Chen Duxiu (1879-1942), moved from Beijing to Shanghai, Mao took advantage of the Commercial Press practice of collecting a galaxy of stellar honorary editors to invite Chen to serve at 300 yuan per month. Editor Chen's home also served as the site of the weekly Communist Party meetings.[53]

Because Mao had a good cover working as chief editor of *Short Story Monthly*, the party had appointed him as its contact person. All correspondence to the central party figures was first sent to him for forwarding. The burden of his party responsibilities eventually became so great that he had to transfer many of his editorial responsibilities to Zheng Zhenduo, who joined the Commercial Press in May 1921 to work on Republican China's first regularly published periodical for children, *Ertong shijie* (Children's World).[54]

In the winter of 1921, the party leadership had sent Xu Meikun, a typesetter from Hangzhou, to organize Commercial Press printers. Mao, who often visited the printing department to deal with last-minute revisions to *Short Story Monthly*, was responsible for introducing Xu to printers Mi Wenrong and Liu Puqing, who later joined the party. On 1 May 1922, Xu and Mao, joined by Dong Yixiang, another party member and, like Mao, a Commercial Press editor, had organized a meeting in an empty lot on Sichuan North Road. About 300 people, most of them Commercial Press printers, had shown up to hear Mao lead them in commemoration of Labour Day, but just before Mao had begun to speak concession constables had arrived and broken up the meeting.[55]

In July 1923, Shanghai's forty-two Communist Party members had assembled for a joint meeting. With thirteen participants, the Commercial Press's group was the largest of the four contingents. In addition to Dong Yixiang, the group's leader, other Commercial Press members had included Mao Dun and Yang Xianjiang (1895-1931)[56] from the editorial department. Mi Wenrong, Huang Yuheng, and Guo Jingren had represented the printing and distribution departments. Xu Meikun, who had organized the Commercial Press workers and had gone on to lead the huge Shanghai Printing Workers' Union (Shanghai yinshua gongren lianhe hui),[57] was also included in the Commercial Press group. At the next monthly meeting, Mao Dun had met Mao Zedong (1893-1976), himself a veteran organizer of Changsha printing workers, who earlier that year had fled his native Hunan under an

arrest warrant and, in June, had just been elected to the Central Committee of the Communist Party.[58]

In the meantime, as we know from Chapter 1, the Commercial Press printing plant had added many new printing machines. They had the double-edged effect of boosting production while increasing workloads. A Harris offset press, purchased in 1915, was supplemented by an American Miehle cylinder press in 1919. In the same year, a new type font in a classic style (Gu ti) was put into production along with a font featuring the phonetic alphabet (Zhuyin fuhao). Three years later, an Ai-er-bai-tuo (Albright? Heidelberg?) rotary press, ten times faster than the Miehle, was acquired from Germany. The following year, six German technicians were hired to improve printing techniques in the plant. A new George Mann two-colour offset press and a rotogravure printing machine were added in 1922-23. Zhang Yuanji's improved type case was installed in 1923 to speed up typesetting.[59] All had contributed to increased tension in the printing plant.

In the middle of 1925, the explosive May Thirtieth Movement was ignited by panicky concession constables at the Laozha station not far from Fuzhou Road. Firing on an unarmed Chinese crowd protesting the murder of a Chinese worker in a Japanese textile mill, the policemen killed eleven and wounded dozens. Over the next six months, patriotic protests radiated outward from Shanghai and across the country, involving students, workers, merchants, and politicians in China's most massive anti-imperialist confrontation to date.

Locally, the Commercial Press was one of the first Chinese media companies to fight back against the general news blackout imposed by the British colonial forces. On 3 June, a new daily newspaper, the *Gongli ribao* (Justice Daily) hit the streets. Edited in Zheng Zhenduo's home by a group of Commercial Press editors on behalf of eleven patriotic organizations, it reached a circulation of 20,000.[60] At the same time, the *Eastern Miscellany* produced a special issue about the massacre of unarmed Chinese civilians in the midst of the International Concession and was sued by the British-dominated Shanghai Municipal Council for its actions.

By mid-1925, the Communist Party had had a significant presence in the Commercial Press for nearly five years. Building on efforts that went back to 1920, in June, with help from party organizers, Commercial Press workers formed their first labour union. The success of striking workers at the Shanghai Post Office incited Commercial Press workers, led in part by Chen Yun (Liao Chengyuan, 1905-95), a typesetter from Qingpu and chairman of the union, to halt work in an effort to improve their own working conditions.[61] By the end of the year, strikes in the printing and distribution

departments had broadened the Communist Party's influence at the press and, in turn, at other printing and publishing operations in the city.

Partly for this reason, as Chiang Kai-shek's Northern Expedition armies approached Shanghai in the spring of 1927, Shanghai's General Labour Union (Zonggonghui), under the leadership of Zhou Enlai (1898-1976), decided to launch the 21 March strike that has become known as the last of the "Three Armed Uprisings." Once it became clear that Chiang intended to use Shanghai to stage his counterrevolutionary showdown with the Communist Party, Commercial Press workers, now led by Wang Jingyun and Chen Yun, joined by employees from Zhonghua and other smaller firms, were prominent among those who rose in resistance.[62]

Nonstop tolling of the Commercial Press lunch bell, the clarion for the March 1927 uprising, called out 800,000 workers across Shanghai.[63] In April, the Baoshan Road plant served as an Alamo for the uprising's final defence mounted by the printers and the General Labour Union against Nationalist Party soldiers and underworld gangs. Nine Commercial Press workers were killed by government troops. At least twenty other Commercial Press employees, including the editors Mao Dun, Zheng Zhenduo, and Yang Xianjiang and union leaders Wang Jingyun and Chen Yun, were forced to flee into exile.[64] Others were arrested in the dragnet that followed the uprising. Prominent Shanghai intellectuals, led by Commercial Press editors Zheng Zhenduo *(Children's World)* and Hu Yuzhi *(Eastern Miscellany)* along with former editor Zhang Xichen *(Ladies World)*, then head of Kaiming shudian, addressed an open letter to Nationalist Party intellectuals Cai Yuanpei (1868-1940), Wu Zhihui (1864-1953), and Li Shizeng (1881-1973), protesting the slaughter and betrayal.[65] In the meantime, the Nationalists extorted a 200,000-yuan "loan" from the Commercial Press to support their armies.[66]

The establishment of the Nationalist government at Nanjing in 1928, following the events of 1927, had five immediate ramifications for the Commercial Press and other Shanghai publishers. First, building on the terror of the 1927 massacres and mass arrests, the Nationalists drove the Communist Party labour activists out of the printing plants and other factories. Those who remained in Shanghai burrowed deep underground and eventually left in 1931, largely severing the Communists' ties with Shanghai until the late 1940s and pacifying labour relations for the corporate publishers.[67]

Second, in 1928 the Nationalists issued a copyright law banning antigovernment publications. The scope of this legislation was broadened incrementally thoughout the 1930s, forcing the Shanghai publishers to think carefully before they published modern works, particularly those in the social science field.

Third, in the same year, the Nationalists created a government-directed trade association (Shanghai shuye shangmin xiehui) that competed briefly with the organization formed in 1920 when the guild and trade association merged. In 1930, the Nationalists forced all Shanghai publishers to join the comprehensive government-directed trade association, the Shanghai Booksellers' Same-Industry Association. By this means, the Nationalists expected effectively to emasculate these cultural enterprises.[68]

Fourth, at the same time, the new Nanjing bureaucrats began setting up government-run, market-oriented publishing companies to compete with the independent Shanghai publishers. Most prominent among the dozens of Nationalist Party publishing companies was Zhengzhong shuju (Zhengzhong Books), named after Chiang Kai-shek and directed by Chen Lifu (1900-), who happened also to be in charge of enforcing censorship regulations.[69]

And fifth, predictably, the Nationalists mandated the creation of new textbooks from 1928 on. For the Commercial Press, the *Xin shidai jiaokeshu* (New Era Textbooks) and *Jiben jiaokeshu* (Basic Textbooks) created to meet this edict were the second Wang Yunwu-edited set within six years.[70]

Initial Commercial Press opposition to the Nationalist government quickly turned into accommodation of it. Although there is no evidence that Wang Yunwu and the Commercial Press management directly collaborated with the Nationalists during the events of 1927, clearly they benefited by having their labour problems solved. Later they enjoyed the policed calm that settled over the printing plant once the storm subsided. In 1929, Wang left the publishing company for six months to work with Cai Yuanpei at the new Shanghai-based Academia Sinica. He returned to replace Bao Xianchang as general manager in 1930. Under his renewed leadership, the Commercial Press became widely known for two collectanea, *Wanyou wenku* (Universal or Complete Library Series)[71] and *Congshu jicheng* (Collection of Collections). Both compilations represented the next step in the movement toward popular dissemination of compendia of modern and traditional learning. The two works, largely apolitical, were also necessitated by the drive for financial compensation that was an essential part of the reality behind the Commercial Press's output in the 1920s and 1930s.

Eventually, the ministries of Internal Affairs and Education ordered each local government administration to buy a set of Wang's series as a means of outfitting new local libraries. In spite of the Commercial Press's heavy investment in the *Wanyou wenku*, sales had been discouraging prior to this edict. Once provincial governments each ordered several hundred sets, the guaranteed state patronage for the Commercial Press cemented Wang's authority. As Jean-Pierre Drège reports, by 1935, 3,679 sets had been sold,

with the largest volume of sales going to Jiangsu (564 sets), Guangdong (462), Sichuan (407), and Shandong (345).[72]

The importance of government policy in promoting Wang's success with trade publications turned out to be paramount. From 1897 through the mid-1920s, when China was plagued by a weakened and an unstable central government, the key influence on Shanghai publishing was the marketplace – hence the name Commercial Press. From 1902 to 1930, the only years for which such statistics exist, the Commercial Press issued 8,039 titles.[73] Between 1927 and 1936, however, nearly 18,000 volumes were issued.[74] After the establishment of the new central government at Nanjing, the power of the marketplace was increasingly displaced by government patronage. Meddlesome officialdom, largely banished from Shanghai's modern Chinese publishing industry since its early days, vigorously reinstated itself throughout the 1930s. After the destruction of 1932 at the hands of the Japanese, the Commercial Press under Wang's leadership prospered by concentrating on apolitical reference works, library series, and collections. Largely abandoning the Baoshan Road site, Wang also moved much of the Commercial Press's operation back into the International Concession for safety. By these means, in the precise period when government censorship was most overbearing, the Commercial Press somewhat paradoxically achieved its highest output.[75] One historian has described the period from 1933 to 1936 as "the most productive years of the Commercial Press."[76] Although Wang remained loyal to the Commercial Press until the Second Sino-Japanese War (1937-45) forced the removal of the publishing company to Chongqing, he then used the prestige of the firm to launch his third governmental career.[77]

Lufei Kui's Zhonghua Book Company, Ltd., 1912-37

At its founding in 1912, Zhonghua Book Company[78] had fewer than ten people, but by 1937 it would have over 3,000 employees. At that point, Zhonghua was the second-largest and was regarded as the second-most-influential publishing firm in Republican China, surpassed only by the Commercial Press. Most of its early employees had originally worked at the Commercial Press. Founder and general manager Lufei Kui moved directly from the Commercial Press's editorial office to Zhonghua's new offices, betraying his old masters. In spite of its conception under less than honourable circumstances, Zhonghua would become an increasingly staid publishing pillar, first of Republican ideals and then, after 1927, of the Republic itself.

In the middle of 1911, the Commercial Press found itself challenged by renegades in its midst. Lufei Kui, an important editor and head of several

departments, organized some friends to pool their money and secretly compile a set of new textbooks. The editors had at least two reasons to keep their activities secret. First, they had broken the Commercial Press's injunction against permitting staff to work on any nonpress business. Second, and even more important, they had to guard the contents of their new anti-Qing textbooks. However, the spectacularly remunerative success of the Commercial Press textbooks pointed the way. The lure of earning enough quick profit from the as-yet nonexistent Republican textbook market to launch their own publishing firm proved to be irresistible to Lufei and his co-conspirators. In spite of their knowledge that, if the anti-Qing contents of the new textbooks became known prematurely, it could have meant death once they left the International Concession, Lufei and the other editors went ahead with their project.[79]

A native of Tongxiang, Zhejiang, Lufei had been born in the prefectural capital of Hanzhong, Shaanxi.[80] He had grown up on both the northern and the southern banks of the Yangzi River in Hubei and Jiangxi. His father, apparently well known for his pursuit of the literati arts of calligraphy and seal-carving, had worked as a confidential secretary *(youmu)* in the provinces of Henan, Hebei, Shaanxi, and Jiangxi. On the other side of his family, Lufei's mother was Viceroy Li Hongzhang's (1823-1901) niece.[81] Coming from an eminent literary family *(shuxiang mendi),* she was also herself an educated woman.

Like Wang Yunwu, Lufei Kui was educated on a standard literati fare, including the Four Books, *Shijing* (Classic of Poetry), *Yijing* (Classic of Changes), *Zuozhuan, Shangshu* (Classic of History), and the *Tangshi sanbai shou.* It was an impressive if entirely conventional curriculum for one training for the civil service examinations. Interestingly, though, young Lufei also studied computing on the abacus, the key to a commercial career. Hence, much more directly than the rarefied instruction and experience received by Zhang Yuanji, and more similarly to Wang Yunwu's early training, Lufei's education prepared him for the uncertainties of the late Qing literati job market.

Lufei's studies were interrupted only by the thunderclap of the 100 Days of Reform in 1898. Told by his father to pay no mind to what he saw in "leisure papers" *(dianxin shubao),* Lufei not only ignored his father's command but also began to read Liang Qichao's lithographed *Shiwubao* (Chinese Progress) and the banned *Qingyibao* (Journal of Disinterested Criticism). After supplementing his conventional education with this radical periodical diet, Lufei and a classmate started a bookstore, Changming shudian, in Wuchang.[82] This was a fairly standard commercial alternative for Chinese literati at the turn of the twentieth century. Lufei began at the top, though,

taking the positions of general manager and editor. After he fell out with his partner, the bookstore closed.

Within half a year, Lufei went on to open his own firm, which he called Xinxuejie shudian (New-Studies-World Bookstore). Purely a retail outlet, with no publishing facilities whatsoever, the firm specialized in reformist and revolutionary titles such as Zou Rong's (1885-1905) *Gemingjun* (The Revolutionary Army) and Chen Tianhua's (d. 1905) *Meng huitou* (Wake Up!), and *Jingshizhong* (Alarm to Arouse the Age).[83] Just as significant, Lufei began to write his own anti-Qing revolutionary tracts.[84]

Eager to take part in the anti-Qing Republican movement, Lufei joined a newspaper discussion group influenced by Sun Yat-sen's Xingzhonghui (Revive China Society).[85] Soon several members were arrested, and, as is typical of such organizations, the group itself was split by infighting and perfidy. Appalled, Lufei lost interest in direct political action. He would continue to support the anti-Manchu revolutionary cause from the sidelines but he also recommitted himself to his educational activities.

While Lufei was busy in Wuchang with his bookstores and his hesitant revolutionary activities, across the river in Hankou, the treaty port dominated by the British and the Americans, Wu Woyao (1866-1910), future author of *Vignettes from the Late Qing*, was working as a newspaper editor.[86] In 1905, Wu left his position on the *Chubao* (Hunan Journal), an American-financed and -managed newspaper, perhaps as a political protest against the American policy of Chinese exclusion. During the time Wu was still preparing to vacate Hankou, however, Lufei quit his bookshop in Wuchang, crossed the river, and assumed a position as editor and reporter for Wu's paper. According to one account, Lufei and Wu worked together from summer to fall of that year.[87]

Lufei's monthly salary at *Chubao* was fifty yuan. During the three months that he was there, he wrote over ten articles dealing with reform and revolution. Soon, however, after the newspaper issued exposés detailing corruption in the Canton-Hankou Railway contract, warrants were issued for Lufei's and his colleagues' arrest. To avoid incarceration, Lufei had little choice but to flee to Shanghai, where he could hide beyond the reach of the Qing magistrates. Once in Shanghai, he prepared to go to Japan, but before he could leave the lithographic publisher Changming gongsi (Changming Company, which had no known connection to his Wuchang bookstore) hired him to manage its Shanghai branch off Henan Road.[88] As he had in Wuchang, Lufei doubled as an editor for Changming. Working with Ding Fubao (1874-1952), the well-known Shanghai physician and Buddhist scholar, he edited at least three (unpublished) textbooks.[89]

As we already know, as Changming's representative, Lufei participated prominently in the founding of the Booksellers' Trade Association in 1905-6. In fact, he served as an officer of the association and wrote its bylaws. He also ran the association's night school and edited its short-lived publication, *Tushu yuebao* (Book Monthly).[90] The association and its journal gave Lufei a forum in which he could air some of his ideas on educational reform, including those for "compressing" *(jia)* Chinese characters as well as for the use of romanization to facilitate memorization.

In the spring of 1906, the new Qing Ministry of Education issued its own set of modern textbooks.[91] However, as an ardent Republican and proponent of private publishing, Lufei believed that the Qing government should not mandate certain textbooks through its Ministry of Education. Rather, textbooks should be created by private publishers subject to endorsement by the government. Lufei wrote an angry essay critical of the ministry's books, which he thought contained antiquated material unsuitable for the youngsters who would have to use them. His essay maintained, in part, that "the textbooks issued by the book bureau organized by the Ministry of Education mostly copy the style of those from the Commercial Press and Wenming, but they add on so much antiquated material *(gudong cailiao)* not suitable for the minds of children that they have been severely criticized by those outside the government."[92] Lufei's criticism of the Qing government's meddling in what he thought should be the business of private publishers should not be misinterpreted as the Shanghai publishers' declaration of independence from state control. His position legitimated the role of the state in endorsing textbooks, a view that makes clear the Chinese intellectual's validation of state intervention in education. Indeed, one might argue that Lufei recognized that, without the state, there could be no large-scale Chinese print capitalism.

Lufei's article obliquely praising Wenming's textbooks along with his work at the Booksellers' Trade Association must have brought Lufei to the attention of Yu Fu, association director and founder of Wenming Books. In June 1906, Lufei moved from Changming to Wenming. He was also appointed principal of Wenming's affiliated primary school and held on to his position as head of the association's school. Along with Yu Fu, himself an erstwhile schoolteacher in Wuxi who had turned entrepreneurial publisher, and Ding Fubao, Lufei worked on another set of textbooks covering Chinese literature, civics *(xiushen)*, and arithmetic. Again, as with the earlier set that he had edited at Changming, finances made it impossible to issue the entire set.[93]

From 1906 to 1908, Lufei Kui continued to cochair association meetings, where Gao Mengdan of the Commercial Press began to appraise him. Gao

was impressed by Lufei's versatility in running a printing business and by his fairly considerable editorial experience. After conferring with Zhang Yuanji, in 1908 Gao offered Lufei a sizable salary[94] to leave Wenming and start work as an editor at the Commercial Press. Lufei accepted. In 1909, he was promoted to direct both the publishing and communications departments and at the same time to become editor of the important Commercial Press journal *Educational Review*.

Regarding the latter job, Lufei afterward said that "one aspect of editing the *Educational Review* for [those] three years was [that it allowed me] to issue my own views critical of the Qing educational system."[95] The academic system eventually adopted by China (three years of primary school, three of elementary school, five of middle school, and a year of college preparation leading to a three- or four-year university degree) was first proposed by Lufei in the pages of the *Educational Review*.[96] Also, in spite of strong opposition to the idea, Lufei used his editorship to expound his proposals for simplifying Chinese characters to bring literacy within the grasp of more people more quickly.

While Lufei was at the Commercial Press, he also finally successfully published a textbook, this one on elementary commercial studies. Sold throughout the country, it was accepted by the Qing government with the comment that "this book is very distinctive and can be used as a text to supplement elementary school commercial subjects and primary commercial school teaching materials."[97] Through 1909 and 1910, Lufei continued to publish articles calling for educational reform. In the summer of 1910, when the Ministry of Education called a meeting of the Zhong jiaoyu hui (All-China Educational Association), Lufei went to Beijing with an entourage headed by Zhang Yuanji. While there, he was selected as a section chief and wrote the bylaws for that association. On his way back to Shanghai, he stopped in Tianjin to tour nearly a dozen modern academic and vocational schools for both boys and girls, all of which suggests a wide-ranging pragmatic interest in educational reform.

In the months before the 1911 Revolution, various politically astute editors at the Commercial Press suggested that it prepare Republican textbooks. Senior personnel such as Zhang Yuanji, however, insisted on adopting a wait-and-see attitude *(guanwang taidu)*. Zhang recognized that the textbooks not only would have to be compiled in secret, but also could become a criminal liability if a republic did not materialize. In addition, as Manying Ip makes clear, even as many former constitutionalists were changing their minds in favour of revolution after 1910, "there is every indication that Zhang Yuanji remained a [constitutional] monarchist right up to the last months of 1911."[98]

Publishing department director Lufei Kui strongly disagreed with Zhang's decision on the textbooks. Interaction with Shanghai's Tongmenghui (Revolutionary Alliance) stalwarts such as Liao Zhongkai (1878-1925) had convinced Lufei that conditions for radical change were maturing.[99] Faithful to the revolutionary principles that he had been studying and supporting since 1900, Lufei found fellow travellers in the Chinese-language editor Dai Kedun and the sales department's Shen Zhifang. The three men soon began to meet secretly at Lufei's house, working on new textbooks late into the night. Lufei's brother, Lufei Shuzhen, also a revolutionary sympathizer and until recently a student at Beijing's Qinghua School, came south to Shanghai and joined the secret editorial cabal.

To throw both their Commercial Press colleagues and the Qing court's "eyes and ears" *(Qingting ermu)* off the conspirators' trail, Lufei arranged to have the textbooks printed at a Japanese-owned printing shop.[100] Moreover, he sent his brother there to read the proofs rather than check them at home. Next Lufei resigned from the Commercial Press,[101] and with his co-conspirators, jointly invested 25,000[102] yuan "to set up a separate kitchen" *(ling qi luzao)*[103] founding Zhonghua Books as a partnership. The early partners, in addition to Lufei, Shen, and Dai, included Chen Xiegong (d. 1935), whom Lufei had known since they had worked together as editor/proofreaders at Wenming,[104] and Ren Shenyi.[105] Lufei, Shen, Dai, and Chen all left the Commercial Press to undertake the new venture.

Timed to coincide perfectly with the establishment of the new Republican government, Zhonghua Books was formally founded on 1 January 1912, but it did not actually open for business until 22 February.[106] From the start, Zhonghua was organized on the *yichu sansuo* principle (with a General Affairs Office supervising editorial, printing, and distribution departments) that the Commercial Press would adopt in 1915.[107] Lufei Kui, for the first time since he and his partner had started up Changming shudian in Wuchang, emerged again as general manager of a sizable publishing concern.[108] Shen Zhifang, who would eventually betray Lufei's firm, just as he and Lufei had proven false to the Commercial Press, served as his assistant manager.[109] Dai Kedun headed the editorial office,[110] assisted by Ren Shenyi in the elementary textbooks section and Yao Hanzhang in the section preparing middle school and teachers' college textbooks. Chen Xiegong took charge of business affairs.

Revealing the profound impact that textbook production had had on Shanghai publishing since the first text had appeared with Nanyang's imprint in 1897, *Zhonghua shuju xuanyan shu* (Manifesto of Zhonghua Books), composed by Lufei, stated that "the foundation of the state is concern with

education, and the foundation of education is truly the textbook; [when] education is not revolutionary the state finally has no way to be stabilized, and [when] textbooks are not revolutionary, the purpose of education has no way to be achieved."[111] Soon after Zhonghua was founded, its explicitly "revolutionary" and "Republican" textbooks in the series titled *Zhonghua xiaoxue jiaokeshu* (Zhonghua Primary School Textbooks) and *Zhonghua zhongxue jiaokeshu* (Zhonghua Middle School Textbooks) appeared. Adorned with the new national flag, books flew off the presses and soon ranged from Chinese literature, history, and geography to arithmetic and natural science.[112]

From 1912 to 1916, Zhonghua's main office and sales outlet were located at the corner of Henan and Nanjing Roads, one of the busiest commercial intersections in Shanghai then and now. In the winter of 1912, Lufei opened a printing department with six presses on Fuzhou Road.[113] The *juren* Yu Fu of Wenming Books doubled as Lufei's head printer and held the job until 1927.[114] Sales of Zhonghua's publications received a powerful boost when President Yuan Shikai's postrevolutionary government nullified all Qing textbook endorsements. Suddenly, all of the Commercial Press's textbooks, and those of other textbook publishers, were nothing but waste paper. Dealing the Commercial Press its first real setback since 1904,[115] Zhonghua seized the market temporarily. The Commercial Press managed finally to bring out its hastily revised *Republican Textbook* series. In the interim, though, according to a speech recalled by Zhonghua employee Wu Tiesheng, Lufei Kui described being utterly overwhelmed by the public clamour for Zhonghua's textbooks: "After we opened for business, letters and telegrams poured in from every province *(gesheng handian fenchi),* and customers sat in front of the door demanding [books]. We could not meet the demand and could not cope with the financial strain *(zuozhi youchu)* ... It is hard to find language to describe the opportunity we lost."[116] From 1904 to 1912, the Commercial Press's textbooks had been distinguished by their covers featuring a yellow dragon, symbol of the Qing dynasty. Now this marketing device was drastically out of date. Furthermore, Zhonghua ruthlessly exploited the reformist conservatism of the Commercial Press along with the senior publisher's ties to Japan, issuing advertisements calling for Chinese to use Chinese textbooks.[117]

Eventually, according to Lufei, the Commercial Press recovered its monopolistic control of the textbook market. However, using guerrilla tactics, Zhonghua had successfully carved out a niche for itself. Because the Commercial Press's prestige was so preponderant, Zhonghua was able to hold on to only 30 percent of the textbook market, despite the older press's late restart.[118] Still, that slice bolstered Zhonghua's claim to be *Republican* China's premier bookstore and publisher.

In 1913, Lufei managed to quadruple Zhonghua's capital to 100,000 yuan. The editorial department moved to 83 East Broadway, the same general area in the old American sector in which Tongwen Press had been operated.[119] The same year, former and future minister of education Fan Yuanlian (1875-1927) began a three-year stint[120] as head of the editorial office, and his influence enabled Zhonghua to bring out two new textbooks so well received[121] that the workforce was expanded to 200. This expansion, on the heels of issuing successful titles, is direct evidence of the intimate relationship between book sales and growth in Shanghai's modern publishing sector in the period prior to 1928, when government patronage would become the prime factor in publishers' success.

Zhonghua now purchased nine more printing presses. Even with the added capacity, the print shop could not meet the market demand, and Zhonghua had to contract out some of its printing to Wenming.[122] Regional sales branches were also opened in 1913-14 in all of the major urban markets in which the Commercial Press could be found, such as Beijing, Tianjin, Canton, Hankou, Nanjing, Fuzhou, Chengdu, and Kunming.[123] Where the Commercial Press continued to make all marketing and editorial decisions at its head office in Shanghai and then relayed them through branch managers who travelled back and forth, Zhonghua relied much more on local initiative. With only a fraction of the Commercial Press's capital at its disposal, Zhonghua depended on local literati to direct sales and did so successfully, for it expanded rapidly.

Lufei's efforts at expansion were reinvigorated after he went to Japan to view its publishing industry. His frustration at having been unable to satisfy the demand that had greeted Zhonghua's opening in 1912 was reflected in his view that the firm was hamstrung by its inability to plan ahead. Lufei traced the source of this dilemma to Zhonghua's initial low investment: "The basis of business is this: 'As a small company, we could not plan our own affairs.' For this reason, we reorganized as a corporation, increased our capital, wildly expanded our outlets, and did our own printing; in 1913, Fan Yuanlian came in as chief editor, working hard to improve [our textbooks] with the benefits of enriched content, a new method, and a new style; [we brought out] eight big magazines [that] were popular; and the *Zhonghua da zidian* (Zhonghua Big Dictionary) became an unprecedented success. It was an extremely successful period!"[124]

Zhonghua went public in 1915, reorganized as a joint-stock limited liability corporation (with the Chinese name Zhonghua shuju gufen youxian gongsi).[125] At the same time, it absorbed Wenming Books and a second firm, seeking to increase its assets by following the blueprint drafted by the Commercial Press in 1913, when it had bought out two rivals.[126]

The tactic worked, at least in the short term. By mid-1916, the firm's capital assets totalled 1.6 million yuan.[127] Lufei Kui held on to the position of director. He also appointed a group of notables to Zhonghua's board. They included Fan Yuanlian along with the well-known constitutional monarchist, journalist, and former Commercial Press editor, Liang Qichao; the former first premier of the Republic, Tang Shaoyi (1860-1938); and Tang's former vice minister of industry and commerce and future premier, Wang Zhengting (1882-1961). Access to increased capital enabled the enlarged company finally to open its own printing facility. After buying several hundred new and used machines, Zhonghua fully outfitted a new factory on a forty-*mu* (6.6 acres) site along Hardoon Road in the Jing'an district of the International Concession, seeking to match the large plant that the Commercial Press had been building outside the concession on Baoshan Road since 1907.[128] Four printing departments were established: letterpress, lithographic, photomechanical, and intaglio, the last to enable the printing of financial instruments.[129] Technicians were hired from Japan and Germany. The success of the *Zhonghua da zidian*[130] and works by Liang Qichao expedited the firm's growth.[131] Soon Zhonghua had forty branches nationwide and over 2,000 employees.[132]

At the same time that Zhonghua was planning its printing shop, it bought the real estate that opened the Fuzhou Road district to the major modern publishers. Taking possession of the southwest corner of the Henan Road and Fuzhou Road intersection, Zhonghua soon erected a five-storey head office building. The new site enabled Lufei to consolidate in one location his administrative and editorial offices from East Broadway with his sales outlet, formerly on Nanjing Road. Symbolically, Zhonghua, the number two claimant to the national market, was announcing its intention of relocating the centre of Shanghai's and by now, increasingly, China's main book district. Furthermore, Zhonghua's new purpose-built publishing citadel, by dominating the intersection that led into what would become the "Central Plains" of Republican Chinese publishing, guaranteed that pedestrians, approaching from the amusement district to the west along Fuzhou Road or en route to the book dealers still located north or south, would have to pay obeisance to the booklords of Zhonghua.

The symbolism was not lost on the Commercial Press. Soon thereafter, it left its redoubt farther up Henan Road, near Nanjing Road, and moved into new quarters immediately south of Zhonghua. The Commercial Press was in fact wedged in on both sides, for its old rival, Wenming Books, formerly located on Fuzhou Road and now owned by Zhonghua,[133] lined up next to it almost immediately,[134] completing the image of China's three corporate publishing lords of that day facing the financial edifices a few blocks east along the Bund.

Although the Commercial Press and Wenming Books were actually still located along Henan Road, it makes sense to talk of Fuzhou Road and the area around it as the centre of China's publishing industry from 1916 onward. Once the large corporate publishers established themselves in the district, smaller, less robust, and more narrowly based firms crowded into their immediate environs and built on the foundations erected by bookshops since the 1890s. In 1916, Carl Crow, the American publicity agent and author, although personally aware only of the translation business, nevertheless accurately announced the curtain-rising on this new stage of Shanghai's Chinese-language book publishing industry:

> During the past few years there has been a marked growth in local manufactures ... Shanghai is [now] the publishing centre of China, especially as concerns modern Chinese literature. It was here that the first progressive newspapers were issued and the first translations made of foreign books into Chinese. This translation has extended to so many lines during the past few years that it is no longer possible to give a complete list of the books, [with] new ones appearing every few days. Today the [translated] books in popular demand include the writings of Henry George, Huxley, Darwin, Spencer, "Uncle Tom's Cabin," "Sherlock Holmes," Green's History of England, Life of Lincoln, etc.[135]

In 1917, however, Zhonghua's dreams of supremacy, symbolized by the five-storey bulwark guarding that Fuzhou-Henan Road intersection, nearly brought down the publishing and bookselling kingdom that Lufei had been striving to build since the early days of the Republican Revolution. At the time, Zhonghua's annual sales exceeded one million yuan, but ruthless competition and rising costs seriously reduced the firm's profit margin.[136]

Seeking an explanation for Zhonghua's crisis, Lufei Kui himself blamed the rise in the cost of paper brought on by the European war. According to Lufei, four influential persons from inside and outside Zhonghua's management were essential to its survival and had repeatedly assisted the firm during these early years: editors Dai Kedun and Fan Yuanlian; Chen Zhongyu; and stockholder and big investor Song Yaoru (Charles Jones Soong, 1866-1918), father of future Nationalist government minister Song Ziwen (T.V. Soong, 1894-1971) and of the famous Soong sisters and, in this way, father-in-law of Sun Yat-sen, of H.H. Kung (Kong Xiangxi [1881-1967]), and future father-in-law of Chiang Kai-shek.[137]

In 1916, the same year that Zhonghua moved into its new headquarters, it had also sought to raise money. The goal was to combine new resources with the firm's existing capital so that its total assets would equal those of

the Commercial Press. Sadly, Zhonghua was able to raise only part of what it needed.

This disappointment was quickly followed by a series of near-disasters. First, in late 1916 or early 1917, the board of directors had ordered assistant manager Shen Zhifang to account for expenditures involving the expansion of the firm's physical plant. Directors Jiang Mengping and Chen Baochu demanded information about Shen's supervision of what had become the firm's new purpose-built Jing'an district printing plant, erected a year earlier.

This was not the first time that the board had called Shen to account for money spent under his watch. As supplies manager for Zhonghua, Shen had earlier engaged an American firm to order large quantities of paper from overseas. He himself had also ordered a large quantity. Unexpectedly, the world war had broken out, and the international price of paper had risen, costing Zhonghua dearly. In 1917, questions about the Hardoon Road construction and a lawsuit mounted against him personally by the American importer[138] both caught up with Shen. Forced to outrun the officers of the Mixed Court, he left Shanghai, derailing his career with Zhonghua.

Just as Shen Zhifang was coming under the scrutiny of the law, Lufei Kui himself was implicated for malfeasance.[139] According to researchers Wang Zhen and He Yueming,[140] Lufei was sued in the Mixed Court for embezzling funds entrusted to the firm under a deathbed trust *(linzhongguan de cunkuan)*. As a result of the suit mounted by Shen Jifang,[141] a Commercial Press employee and Zhonghua investor, Lufei Kui was incarcerated, pending trial. Soon, though, Zhonghua's printing plant mortgage was entrusted by the court to a securities firm. Although Lufei appeared to have lost part of his printing business in the settlement, he was released from jail as a result of the deal.[142]

Wu Tiesheng, who joined the firm in the 1930s, has written that investors, presumably in panic, began to withdraw their money in 1917. Suddenly, Zhonghua was faced with the strong likelihood of bankruptcy. Just as customers had once sat in Zhonghua's Nanjing Road retail outlet waiting for books that the firm could not yet afford to print, so too creditors now occupied the firm's accounts office demanding to get their money back.[143]

Discussing the threat of bankruptcy in 1917 and the conditions that had led Zhonghua to the brink, Lufei summed up the challenges of running Zhonghua by citing military and competitive obstacles: "The causes of the panic [included]: first, the budget could not be made carefully, and this imprecise budget was caused by domestic warfare, which reduced income; moreover, the European war caused expenses to rise. Second, competition in the publishing business was fierce, and the selling prices [of books] did

not cover the costs of production."[144] In Lufei's view, not only did the Shanghai publishers suffer from the high operating costs and overhead imposed by the necessity of purchasing much of their machinery (and paper) from abroad, but also local conditions, particularly civil war and excessive competition within the publishing world weakened its economic viability. In 1917, when Zhonghua ran into difficulties, selling prices did not even cover production costs, according to Wu Tiesheng. At that time, the Commercial Press encouraged sales with a coupon system, by means of which each consumer would get three textbooks for the price of two and two trade books for the price of one.[145] In the view of Commercial Press director Gao Mengdan, this kind of competition was seriously counterproductive. Rather than leading to both sides getting slightly hurt, in his view, each side threatened the other with the prospect of annihilation.[146]

Regarding Lufei's release from jail, Wu Tiesheng suggests a scenario that differs from the one cited above. In Wu's view, Shi Liangcai (1879-1934), owner since 1912 of Shanghai's leading Chinese-language newspaper, *Shenbao*, paid Lufei's bail, returning Lufei to the publishing firm a free man. In this version of events, Shi Liangcai had had designs on Zhonghua for some time and now took advantage of Lufei's financial vulnerability to effect what we today call "a hostile takeover." Shi took Zhonghua's printing plates (stereotypes) as collateral for Lufei's release and good conduct and stored them in the *Shenbao* newspaper offices, located half a block away from Zhonghua's main office. The board of directors then elected Shi Liangcai head of Zhonghua, a position that he held just long enough to balance the firm's accounts.[147]

In July 1917, according to Wu, Zhonghua's plant was rented out to Xinhua Company but regained its autonomy in November.[148] Determined to find some solution to the firm's financial precariousness, Lufei now turned to his rival and former employer, the Commercial Press. Talks were conducted with the extraordinary goal of combining the two firms,[149] but internal resistance at the Commercial Press compromised the deal, and it fell through. In one view, however, Lufei himself became the chief opponent of the merger when the deal's terms stipulated that he would have to remain outside publishing for the next decade.[150]

A year later, in July 1918, the Changzhou businessman Wu Jingyuan and ten others organized the Weihua Bank Group (Weihua yintuan) and granted Zhonghua a three-year loan of 60,000 yuan.[151] Wu also took over as Zhonghua's managing director in charge of finances[152] and reorganized Zhonghua's board of directors, introducing Yu Youren (1879-1964[153]), H.H. Kung,[154] brother-in-law to Sun Yat-sen and eventually to Chiang Kai-shek by virtue of his marriage to Song Ailing (1890-1973), and Kang Xinru.[155]

Lufei was temporarily relieved of his directorial responsibilities. Assigned to manage the retail store, he soon arranged to return to the boardroom.[156] Three years later, however, after the bank group's loan had matured, Zhonghua's situation had still not improved, and director Gao Xinmu and six others organized the Heji gongsi (Heji Company) to lend Zhonghua 90,000 yuan for a second three-year period. Both of these loans had to be extended for further three-year periods.[157]

Long after he left the Commercial Press, where he had been able to air his views on the reform of education in *Educational Review*, Lufei continued to use every public opportunity to advance his own educational ideas in writing. Even as he was starting up Zhonghua and then struggling to keep the firm together, Lufei continued to write and publish, lobbying strongly on behalf of his view that education could save China.[158] Having broken with Zhang Yuanji, the dean of Shanghai's urban reformist publishers on the eve of the 1911 Revolution, Lufei then promoted educational reform as a foundation for the newly established republic.

Lufei's sustained public advocacy of educational reform throughout the 1910s established his reputation in government circles. Despite his own brushes with the law in 1917, serious enough to have required him to resign as director, succour had come immediately from the highest levels of government. When former editorial department chief, Fan Yuanlian, again minister of education, heard of Lufei's problems, he offered Lufei a position in the ministry.[159] Lufei politely declined the offer because, in Wu Tiesheng's view, "he thought the cultural education business provided [him with] the basis for hundreds of causes *(baiye zhiji)*."[160]

Lufei's view anticipated themes that he would outline in a 1924 preface to a volume commemorating the twentieth anniversary of the establishment of the Booksellers' Trade Association. In that preface, he articulated the notion that the expansion of education and publishing were mutually dependent. Throughout his twenty years in Shanghai's modern publishing sector, just like hundreds of others who worked there, Lufei proclaimed that he had been contributing to the advancement and modernization of China:

> In these twenty years, what has been the world's progress? What has been the nation's progress? Society's progress? Education's progress? Learning and ideas' progress? ... [What with] natural disasters, and civil war, and the prices of commodities, and the currency anarchy, inconvenience of transportation – all sorts of problems [in the nation generally] – we still have had twentyfold of progress in the book trade during these twenty years. [If] we want the nation and society to advance, we must [also] want education to advance; [if] we want education to advance, we must [also] want the book business to advance.

Although our book business is a relatively small [modern] industry, still it has a [close] connection with the nation and society, and for this reason [it] is somewhat bigger than any other [modern Chinese industry].[161]

His statement also harkens back to his view of the early 1900s when he had suggested that Chinese print capitalism could not function without state patronage.

Between 1919 and 1926, with Lufei back in command, Zhonghua underwent more or less steady expansion. It was made possible in part by a series of successful publications known as the "Big Eight Journals" that supplemented its staple of textbooks. Under Lufei's sponsorship, Zhonghua brought out *Zhonghua yingwen zhoubao* (Chinese-English Weekly) and *Zhonghua shushang yuebao* (Chinese Booksellers' Monthly). In addition, Zhonghua issued collectanea of the New Culture Movement and published the magazines *Xinli* (Psychology), *Xueheng* (Critical Review), *Guoyu* (National Language), *Shaonian Zhongguo* (Young China), and *Xiao pengyou* (Friends), along with other publications for children. In the same period, Zhonghua increased its annual profit to 200,000 yuan and opened branches in Changde, Hengyang, Wuzhou, Jiujiang, Wuhu, Xuzhou, Qingdao, Zhangjiakou, and Lanzhou. By 1927, it had also expanded its retailing operations into Hong Kong.[162]

In 1928, the Nationalists' Northern Expedition finally united the country politically after a dozen years of nearly endless warlord fighting. Although the workers' uprising in March 1927 had provoked Lufei to leave Shanghai for Japan, he returned just after the April massacre to take the reins again.[163] The establishment of the new national government in Nanjing stimulated him to contemplate further expansion. With this goal in mind, in 1929 Zhonghua founded Shanghai's Zhonghua jiaoyu yongju zhizao chang (Zhonghua Educational Instruments Factory) on Kunming Road.[164] A year later, when Zhonghua director H.H. Kung was appointed minister of industry in the Nanjing government, Lufei exploited Kung's connection to Zhonghua by having him selected as chairman of the board. Using his official influence, Kung brought considerable business in the factory's direction. Thus, manufacturing, promulgation of educational theory, publishing, and politicking all overlapped.

In 1932, Zhonghua augmented its printing plant.[165] Thanks to its government connections, the firm soon gained commissions to print government securities and small denominations of currency. It also contracted to print cigarette boxes for private tobacco companies.[166] In the same year, of course, the Commercial Press plant was destroyed by Japanese bombers, knocking Zhonghua's major competitor out of the publishing market for nearly a year. During this hiatus, reminiscent of the year 1912, when Zhonghua had

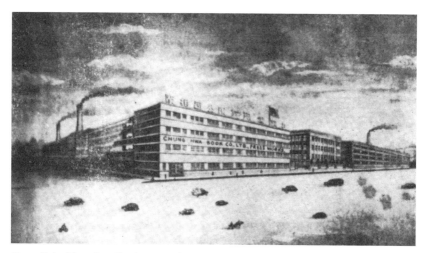

Figure 5.4 Zhonghua Books general printing plant, Macao (Aomen) Road, Shanghai, 1935.
Source: Zhonggong Shanghai shiwei dangshi yanjiu shi and Shanghaishi zonggonghui, eds., *Zhonghua shuju zongchang zhigong yundong shi* (Beijing: Zhonggong dangshi chubanshe, 1991), frontmatter.

first taken the field without having to look over its shoulder for the Commercial Press, Zhonghua's profits reached 400,000 yuan. By 1934, Zhonghua had opened an advanced printing plant in Kowloon, chiefly to print currency and government securities. In the same year, Zhonghua crossed an important threshold, publishing geologist Ding Wenjiang's (1887-1936) *Zhonghua minguo xin ditu* (New Map of Republican China), the first completely Chinese-drafted and Chinese-printed modern map of China.[167]

A year later, in 1935, with Lufei Kui having resumed directorship of the board from H.H. Kung, Zhonghua opened a new printing plant inside the concession on Shanghai's Macao (Aomen) Road (see Figure 5.4).[168] Editorial facilities were also relocated there from the Henan and Fuzhou Roads intersection. Part of the Educational Instruments Factory was dispersed, and a subsidiary called Bao'an Industries was created to manufacture rubber boats, gas masks, nautical lights, and other products that Zhonghua could sell to the defence ministry. By the spring of 1937, Zhonghua's profits returned to the 400,000-yuan level. Its forty retail branches nationwide had done ten million yuan in sales. Since its founding in 1912, Zhonghua had published over 5,000 titles.[169] The two main plants, Shanghai and Hong Kong, together employed more than 3,000 workers, and Zhonghua was now regarded as the finest colour printer in China. Its printing plant had over 300 printing presses, including rotary machines, colour rotogravure presses, 100 intaglio presses, and an immense range of Chinese and Western type sets.[170]

Lufei Kui's career had paralleled Zhonghua's. The would-be scholar-politician now ascended to high-level positions in both the commercial and the governmental worlds, actually anticipating Wang Yunwu. After 1929, he chaired Shanghai's new Nationalist-sponsored Booksellers' Same-Industry Association, which undermined the corporate independence formerly promoted by the booksellers' guild and trade association. Simultaneously, Lufei served on the Ministry of Industry's planning committee for a newsprint mill and on the Zhonghua gongye zong lianhehui (Chinese Industrial General Federation).[171] He was also named a director of the Zhongfa dayaofang (Sino-French Pharmacy).[172]

Founded in 1912 in a preemptive blow to the Commercial Press, Zhonghua Books had also rapidly established itself as Republican China's most important printing and publishing alternative to it. From the birth of the Republic in 1912 to the Japanese invasion in 1937, no other prominent publisher was so wildly buffeted by the winds of Chinese print capitalism or rode them out so successfully by identifying with the changing fortunes of Chinese republicanism. During the era from 1912 to 1927, prior to the establishment of the Nationalist government capital in Nanjing, Zhonghua demonstrated its eagerness to compete in the topsy-turvy world of Chinese print capitalism. In 1914, in a bid to expand its physical plant and its financial base, Lufei reorganized the firm as a corporation. By 1917-18, however, despite consistent rapid expansion, economic, legal, and personnel troubles undermined the firm and led it into collaboration with Nationalist-allied capital. Although this alliance represented one step back in corporate independence, eventually it enabled Zhonghua to take two steps forward in advancing its corporate objectives with the Nationalist state.

With Lufei Kui still at the helm, Zhonghua weathered the 1920s, even as it tacked more and more conspicuously toward the Nationalist shore. Between 1928 and 1937, Zhonghua became a permanent client of the government's patronage, printing its security instruments and even its money, while simultaneously holding on to a nominal independence, thanks in part to its perennial success with 30 percent of the textbook market until 1937. Incorporation in 1914 gave Zhonghua the technology, organizational structure, and financial flexibility needed to underwrite its permanent effort to keep up with the government. As Lufei had implied in the early 1900s in his criticism of the Qing state's production of its own textbooks, and again in 1924 in his statement to the Booksellers' Trade Association, Chinese print capitalist firms could not operate successfully without all four – technology, organization, finance, and government patronage. Having all four granted Lufei Kui and Zhonghua a degree of stability and permanence denied Shen Zhifang and World Books.

Shen Zhifang and World Book Company, Ltd., 1921-37

In 1917, Zhonghua had found itself weakened not only from without but also by internal mismanagement. As noted above, assistant manager Shen Zhifang's expansion projects and mistimed orders had twice weakened the firm from within. Who was Shen Zhifang, this scalawag of the publishing world who had set in motion the disastrous events that seriously compromised Zhonghua's independence? According to the view of one of his army of authors, Shen was "the outstanding oddity" *(guaijie)* of the Shanghai publishing world.[173] His special qualities stemmed from the fact that, even in an era when it was common for publishing entrepreneurs to become involved in a multiplicity of enterprises, Shen far surpassed ordinary standards of the day, starting up approximately ten publishing operations during his career.

Only one of Shen's enterprises, World Books, made a major impact on the city of Shanghai or on the Chinese Republic. Through his association with World Books, however, Shen became a seminal figure in promoting the image of Fuzhou Road as the symbolic and commercial centre of Republican China's book world. In doing so, he added a component of sheer commercial opportunism to that industry. Shen's shifting presence distinguishes the culture of Fuzhou Road from what came before and placed it solidly within the ruthless marketplace of Republican China.

Like many of Wenhuajie's leading figures, Shen Zhifang hailed from Zhejiang. He was born in Shaoxing's Cangqiao Street. Unlike Wang Yunwu's and Lufei Kui's biographies, in Shen's background there is no whiff of a literati upbringing or of attempts at self-cultivation through public service. Instead, from a young age, Shen learned about books as a commodity. He left school in about 1897 to enter the city's Guizhaolou shufang as an unpaid apprentice.[174] A year later, he left that firm to apprentice at a bookstore in Yuyao.[175] After another year had passed, the seventeen-year-old found employment in Shanghai's Huiwentang shuju, then probably located on Henan Road,[176] and so started his long association with the Shanghai booksellers' district. Shen's fleeting loyalties and frequent changes of employment foreshadowed the twists and turns that became a permanent feature of his career, which unfolded with an air of sharp-edged competition and unrelenting effort to hit a publishing jackpot.

Shen's business acumen drew the attention of Xia Ruifang, the Commercial Press founder who had a reputation for recognizing talent and putting it to work. By 1900,[177] Xia had hired Shen away from his employer to work as a street peddler *(paojie)*, a typical entry-level job in highly commercialized and urbanized Shanghai.[178] After a year, Shen left even the Commercial Press, casting his net over a newly opened Cantonese firm called Lequn

shuju. With four years of experience in the retail book business, however, Shen was already thinking of moving upstream to join those who actually supplied the retailers – that is, the publishers. Working at Lequn may have been just the opportunity that Shen thought he needed. Engaging an editor, he soon began to publish pirated Commercial Press textbooks under Lequn's imprint. Within a year, predictably, the Commercial Press sued Lequn for copyright infringement. Incredibly, as Lequn tottered, Xia Ruifang invited Shen Zhifang to rejoin the Commercial Press[179] in his old position.

Back in the fold, Shen soon left his job as street peddler behind and was promoted to a job at 200 yuan per month as Xia's personal advisor. In this capacity, he received a five-year contract that he renewed upon its completion for a second term. Apparently, these contracts did not preclude outside ventures, for Shen was soon involved[180] in setting up the Fulunshe (Fulun Society), which in 1910 began to publish Chinese literature *(guoxue)* for anti-Manchu ends.

Wang Junqing joined Shen as partner-editor in the Fulun Society venture. Taking advantage of both the protection afforded Chinese publishers within the International Concession and the lightened enforcement of publishing restrictions by the overextended and increasingly moribund Qing court, the two editors published a wide variety of prohibited works. In particular, the Fulun group brought out dozens of collected works by the proscribed Ming-Qing official Qian Qianyi (1582-1664),[181] anti-Qing petitioner and vernacular literature critic Jin Shengtan (1610-1661),[182] scholar-official Fang Bao (1668-1749),[183] leading statecraft theoretician Gong Zizhen (1792-1841),[184] and constitutional monarchists Kang Youwei and Liang Qichao.

Eventually, the Fulun Society was bought out by the Commercial Press,[185] and Shen moved on to a new enterprise, joining forces with Chen Liyan to start the Gushu liutongchu (Ancient Book Dissemination Bureau) located on Maijiayuan.[186] Chen acted as manager, and Shen, with connections presumably acquired through his travels as a *paojie*, worked as an acquisitions supervisor. In this capacity, Shen managed to acquire the Ningbo library known as the Baojinglou. Taking the rare and even proscribed volumes from it, Shen collated, printed, and sold them separately, using the library volumes as a kind of exemplar collection. For this activity, he was widely praised in revolutionary and intellectual circles.[187]

In his next project, Shen Zhifang established the Jinbu shuju (Progressive Bookstore) on the original Fuzhou Road site of Wenming Books. His partner in this venture was his nephew, Shen Junsheng.[188] Under Shen Zhifang's direction, the new firm printed over 100 Ming and Qing *biji* (anecdotal essays) and novels, many of which were quite rare as a result of repeated Qing book inquisitions. Partly because of their anti-Qing sentiment, they

sold very well. Always dabbling in new ventures that could exploit fissures in the market, Shen Zhifang started another firm in these early years known as the Zhonghua yudi xueshe (Chinese Map Study Society). Having discovered that modern Western-style primary and middle schools featured geography courses, Shen and his partner began to publish maps of the world and of the Chinese provinces[189] under the Map Study Society's imprint to supply books for the geography curriculum.

On the eve of the Revolution of 1911, Xia Ruifang, equally alert to new business opportunities, called in his advisor Shen Zhifang. "Is the revolution going to succeed and, if so, should we start a new set of textbooks now to prepare for it?" he queried Shen.[190] Shen dissembled, denying that any changes were necessary, telling Xia that the revolution would fail. At the same time, as noted above, Shen had already begun meeting with the Zhonghua textbook cabal at Lufei Kui's home.[191]

When the 1911 Revolution did come to pass, opening broad new business opportunities for a growing range of merchants including book publishers, Shen's and Lufei's new organization was ready to mount its stealth attack on the Commercial Press's hegemony. With Lufei acting as general manager, Shen assumed vice-managerial responsibilities and was put in charge of the retail outlet. In that first year, Zhonghua began to buy out Wenming Books, the stalwart of the prerevolutionary decade, soon rendering it what Bao Tianxiao calls "a dependency."[192] Appointed to direct Wenming, Shen was soon supervising Bao, then chief editor of Wenming's quarterly literary anthology, *Xiaoshuo daguan* (Guide to Literature), as well.

During the three years[193] that Bao and Shen worked together, Bao had ample opportunity to observe Shen's character. Bao believed that Shen was distinguished chiefly by "what merchants call an 'eye for business' *(shengyi yan).*"[194] Bao reached this conclusion through a series of discussions over the name of the quarterly, which struck Bao himself as philistine and sure to inspire ridicule.[195] Shen, on the other hand, was eager, according to Bao's Han-dynasty analogy, "to play General Han Xin and lead the soldiers [i.e., other publishers] *(Huaiyin jiangbing)*"[196] and insisted on the name, reasoning that, "Once we publish it, we want it to be a sensation. After we decide, I will prepare some advertisements. If we use the name *Xiaoshuo daguan*, I will be able to control things when I peddle it [because 'guides,' or *daguan,* were selling well], but if we use another name I cannot guarantee anything."[197] Bao felt trapped between Shen and the market that Shen held out for the journal. In the end, he went along with Shen on the journal's name[198] but refused to compromise on the cover art. According to Bao, they next debated the journal's cover, with Bao's insistence on elegant calligraphy by guest calligraphers winning out. Shen pondered long and hard, says

Bao. Finally, he gambled that maybe it was time to abandon what was already then a hackneyed marketing gimmick – namely, "pretty girls" on the cover.[199]

In spite of Bao's frustration with Shen's effort to cheapen the impression presented by the quarterly, Bao does concede that Shen and Wenming-Zhonghua marketed the publication very successfully. "Shen really did have command of the marketing aspect [of publishing]," Bao writes, thanks to Zhonghua's extensive national branch store system.[200] This system, supplemented by local retail kiosks *(fenxiaochu),* guaranteed that a minimum of 4,000-5,000 copies could be sold each quarter.[201] On Bao's testimony, then, by the mid-1910s, Zhonghua manager Shen Zhifang already displayed great marketing ingenuity as well as shrewdness about how to manipulate the cupidity of authors. In spite of Bao's moderating influence, Shen relied on clever post-Qing marketing techniques and did so with great success at the cash register. Shen was well down the path of marketing gimmickry; this mentality would incrementally coarsen Shanghai's publishing world and its sense of taste and decorum.

In 1917, as already noted, Shen Zhifang was forced to leave Shanghai to sidestep a lawsuit brought against him by a foreign firm. According to Zhu Lianbao (1904-88), however, who joined the central administration of World Books in 1921 and remained there until 1950, Shen was forced to leave Shanghai because of his imprudent participation in a scheme to manufacture Dragon-and-Tiger brand medicine. For evidence, Zhu cites the view of Shen's brother, Shen Zhongfang, saying that Shen joined forces with Huang Chujiu to found the Zhonghua zhiyao gongsi (China Medicine Company).[202]

In addition to patent medicine, Shen and Huang prepared to manufacture matches.[203] What they had not anticipated was that securing a necessary ingredient, gunpowder *(baiyao),* from the American firm Maosheng would involve them with the military and entangle them on the losing side of a lawsuit. It was actually for this latter reason that Shen left Zhonghua in 1917 and fled to Suzhou. After arriving in the neighbouring city, Shen issued his own obituary in the newspaper, announcing that he had succumbed to illness. In this way, Shen hoped to throw his pursuers off his trail![204]

Rising almost immediately from his grave, Shen started over in Suzhou, engaging editors to prepare manuscripts. Soon he even dared to sneak back to Shanghai, leasing rooms off Baoshan Road[205] and in Fuzhou Road's Qichang Hotel to serve as his new bases of operations.[206] Without money to rent a storefront, he offered his manuscripts for sale to his nephew, Shen Junsheng, by this time a founder and board-member of Dadong shuju.[207]

In this period, Shen Zhifang marketed books with relatively polite contents under the name of Guangwen; indecent or shady materials bore the

imprint of Zhongguo diyi shuju (China First) or Shijie shuju (World Books). Of the three shadowy firms, World's materials found the widest audience. As the market for World's publications grew, Shen realized that he had chanced across a name that surpassed that of his old firm (Zhonghua, or "China") in symbolic scope. He began to dream of an actual market that would correspond in size to the name of his company. Eventually, World's logo did feature a globe.[208]

Between 1917 and 1920, Shen Zhifang's privately owned *(duzi)* company, World Books, brought out over 200 titles,[209] apparently hampered only by a lack of operating capital. In 1921, just as the Commercial Press, Zhonghua, and many others in the Shanghai publishing world had done before him, Shen led World into a merger with another firm.[210] Realizing his goal of gaining greater financial resources, Shen's new joint-stock corporation (called Shijie shuju gufen youxian gongsi) was capitalized at 25,000 silver yuan,[211] meagre investment given the resources then available in Shanghai. As a result, Shen would spend the next thirteen years in nearly constant pursuit of consumer patronage and investor confidence.

Shen Zhifang remained the chief investor in the new corporation from 1921 to 1934.[212] The new retail outlet, painted red and known ever after as the "Red House,"[213] opened on 7 July 1921 in a lane near the corner of Fuzhou and Shandong Roads; the administrative offices of World Books remained there until 1925. To promote sales, cheap gifts were distributed to customers.[214] Shen assumed the position of general manager and was assisted by a complete range of Western-style administrative departments (business office, retail manager, branch store managers, and credit, wholesaling, and mail order departments[215]). World printed its publications in two plants[216] located in Zhabei district. In addition to selling its own publications, just as Dadong had recently retailed Shen's publications, World now handled those of smaller publishers that could not afford to run their own retail outlets on Fuzhou Road[217] but still sought access to the customers who, by the 1920s, thronged the central book market of China.

Between 1921 and 1923, Shen Zhifang set out to make a killing in the trade-book market, publishing all manner of low-brow literature intended to attract the interest of petty urbanites *(xiao shimin).*[218] In fact, his publishing company became well known for these publications, particularly trashy traditional novels of the "mandarin duck and butterfly school" *(yuanyang hudie pai)* edited, rearranged, punctuated, and then sold at low prices despite having been bound in relatively expensive Western-style covers.[219] Longer novels popular with Shanghai's petty urbanites included Zhang Henshui's (b. 1895) works and Cheng Xiaoqing's *Fuermosi tan an quanji* (Complete Famous Detective Stories).[220] World Books also specialized in

popular biographies and anecdotes of famous persons, such as the revolutionary politician Sun Yat-sen, the warlord general Feng Yuxiang (1882-1948, himself soon to become a loyal World customer), and the actor Tan Xinpei (1847-1917). Attempting to keep pace with Zhonghua's famous "Big Eight Journals" and those of other Fuzhou Road publishers, World also issued five periodicals aimed at the same petty urbanite readership that bought its books.[221] Last but not least, in 1925 World created the name *lianhuanhua shu* (serial-picture books) for its comic book-style presentation of the famous sixteenth-century novel *Xiyou ji* (Journey to the West).[222]

Sales in the north and elsewhere were enhanced by the steady spread of World's Shanghai-based publishing operation into other cities. In the first two years of the company's existence, staff increased to over 100.[223] Many were employed in the new editorial and printing facilities at the corner of Hongjiang and Baoshan Roads in Zhabei directed by Zhang Yunshi and Wang Chunbao. Branch offices were opened in Canton, Beijing, Hankou, and Fengtian.[224]

Just as Xia Ruifang had been distinguished by his eye for talent, so too Shen Zhifang was remarkable for his eye for business.[225] Shen acknowledged, however, that editors and staff were the key to the publishing business. Having opened his firm just as Wang Yunwu's methods began driving editors out of the Commercial Press, Shen was able to hire them and dozens more from his other two largest competitors, Zhonghua and Dadong.[226] Generally speaking, he favoured nonfamily employees, and once he hired them, he trusted them absolutely. Although he had a reputation for haughtiness to outsiders, Shen was always polite to World's editors and authors, say his biographers.[227]

By 1923, with World's trade books, magazines, and trial textbooks already selling well, Shen Zhifang boldly decided to break into the national textbook market. The National Language (*guoyu* or Mandarin Chinese) Movement had picked up considerable energy during the New Culture Movement. The literary movement now prompted the leading textbook publishers to solicit the patronage of those seeking to promote literacy in a national vernacular. Where the Commercial Press and Zhonghua, respectively, had sought guaranteed patronage by relentless pursuit of the textbook market from the start of their operations, Shen only now tried to branch out from the trade market that had proven so profitable for him. However, the year 1923 was not 1904 or 1912, the years in which the Commercial Press and Zhonghua had seized control of the textbook market. Thus, when Shen entered the national textbook market, he was forced to deal with the complex politics of the warlord era (1916-28) and the vigour of his two main opponents.

At the time, China's central government was under the domination of the Beiyang Clique; all textbooks had to be approved by the clique's Ministry of Education, located in Beijing, before they could be sold legally.[228] To expedite clearance of World's textbooks, Shen Zhifang borrowed a leaf from the histories of both the Commercial Press and Zhonghua. He engaged the former chancellor of Beijing University, Hu Renyuan (1883-1942), and Beijing education notable Li Jinxi,[229] to supervise the new set of textbooks, hoping in this way to promote his publications with the ministry. At the same time, though, and just to be sure of his position, he sent bribes to members of the ministry staff.

Shen's first general textbook[230] appeared in 1924. Under his direction, editors Fan Yunliu and Zhang Yunshi prepared the initial group of elementary school textbooks. However, World Books soon departed from traditional textbook design by targeting specialized markets with textbooks created for them. Indeed, World was one of the first Shanghai publishers actively to seek the patronage of nonurban learners. Hence, texts were designed for rural areas, small cities, and metropolitan areas. Book series were divided into A (countryside and small towns), B (small- and middle-sized cities), and C (middle- and large-sized cities and overseas) series. Different editors were hired for each series. For example, World engaged the well-known follower of John Dewey and rural reconstructionist Tao Xingzhi (1891-1946) to edit two sets of trial textbooks for industrial workers and peasants.[231] The books sold widely throughout the Yangzi provinces of Jiangsu, Zhejiang, and Anhui. There were also books for special classes that ran in nonstandard periods of time, such as books for peasants who could spare time for studying only in the off-season.[232] In the northern province of Hebei, warlord Feng Yuxiang adopted another trial series for instructing his soldiers.[233]

Hunting out and then satisfying these specialized markets enabled World Books actually to surpass the conventional suppliers in sales, opening what would become known as the final chapter in the long series of intermittent textbook wars stretching back to 1904. World's success was now viewed as a direct challenge by the Commercial Press and Zhonghua, the former newly led by Wang Yunwu and the latter by Lufei Kui. These two firms responded with a united front against their common enemy.

The showdown began with a payoff. Lufei Kui, Shen's former partner, made his way up Fuzhou Road from his offices on the Henan Road corner to the Red House with the suggestion that Shen accept 100,000 silver yuan and abandon his efforts to conquer the textbook market.[234] Shen "flatly refused."[235] Zhonghua and the Commercial Press then teamed up to underwrite a new publishing operation, the Guomin shuju[236] located on Henan Road at present-day Shaotong Road.[237] Through this puppet organization

established in 1925,[238] Shanghai's two leading corporate publishers collaborated on editing textbooks meant to pull the rug out from under World's elementary school market. The new textbooks were promoted through "dumping" *(diejia xiaoshou)* and "giveaways" *(mianfei zengsong)*.

Shen Zhifang and World Books fought back fiercely. They appealed to book merchants throughout China, concluding contracts with new ones to supplement those that they already had with their own branch managers. Moreover, World pursued customers in new ways, both foul and fair *(bu ze shouduan)*. Some branch managers bribed female instructors with high-heeled shoes, silk stockings, fabrics for *qipao*, and other gifts. Male teachers were offered even more opportunities for entertainment and dining with World Books sales agents than they had been offered previously.[239] Before long, World was blanketing the country with its merchandise.

Furthermore, Shen conferred with each branch manager confidentially, outlining three main tactics.[240] First, trade books and periodicals were to remain World's primary business, and the textbook division would seek only to break even. Second, adopting a "strategic hamlet" approach to commercial warfare, World Books would avoid hand-to-hand combat with the Commercial Press and Zhonghua in urban areas. Instead, it would seek to control the countryside below the level of county towns and villages. It would make contact directly with schools. Then, rather than discount the prices of World textbooks sold to schools, Shen would pay monetary commissions directly to the schools for using the books. And third, Shen told his local managers that, although World would avoid any direct conflict with the much weightier of its two foes, the Commercial Press, the company would vie strenuously with Zhonghua for control of its rural domains *(dipan)*.

To counter World's sales, the jointly owned Guomin shuju spent a great deal of money trying to buy off World's agents. The scheme worked temporarily, but, as World agents began to cancel their contracts, Shen sent out new "representatives" of a nonexistent publishing company of his own devising to negotiate new contracts with the same agents. World held onto its distribution network in all but name while Guomin wasted a great deal of money.[241]

Overall, the tacticians at the Commercial Press and Zhonghua believed that the price of paper and wages, the two highest production costs on a publisher's tally-sheet, would eventually defeat World Books in this textbook war. They surmised correctly that Shen had a limited treasury. What they did not anticipate accurately enough was that the wily Shen, a book merchant apparently resurrected from death at least once already, would use his vast experience in this style of guerrilla fighting to best them both.

World was also assisted by its director, Wei Bingrong, who merged his

own printing firm[242] with World's printing plant. This alliance considerably boosted World's resources. The merger gave Shen greater economy of scale and secured his flank. At the same time, Shen took on the challenge of supplying himself with paper by buying from Japan on the instalment basis, temporarily delaying his payments. He also convinced his in-house printers to wait for their wages.

The second-rate Guomin textbooks did the rest, weakening the viability of the Commercial Press-Zhonghua alliance. After all, neither the Commercial Press nor Zhonghua was willing to invest the time and resources necessary to create a viable new line of textbooks, particularly when each was still operating independently in search of its own market share against the other. The textbooks that they sold were outdated from the start and received a lukewarm welcome from educational circles. Finally, the two partner firms' own textbooks were in competition with Guomin's, and their own agents were not eager to lose sales on those newer works. In 1927, Guomin surrendered by closing its doors, effectively ending the last of the textbook wars. From this date on, World Books came to be recognized as one of the Big Three publishers of Shanghai's Wenhuajie.

In spite of the cost of the last great textbook war to all three corporate publishers, the conflict did produce at least one major social benefit. Whether selling, discounting, or giving away the textbooks, the three publishers with their *guoyu* textbooks were promoting the spread and use of the new national language. Zhu Lianbao approvingly cites the following views of a 1931 article on the National Language Movement: "In 1925 World Books issued National Language textbooks and unexpectedly produced a big wave of National Language book sales. At that point, the three publishing houses [began] to compete with each other. Since they only thought about getting the books out ... sometimes they gave them away or dumped them. As a result [of the competition], the three publishing houses lost over a million yuan but also did more to promote the National Language than any other National Language campaign."[243]

We have seen that prior to 1928, the Commercial Press and Zhonghua both sought to secure their fortunes with the government via strategically placed personnel. In 1926, lacking the national prominence of his two leading competitors, Shen began to hedge his bets against the established Beijing warlord government by publishing Nationalist Party propaganda that other prominent Shanghai publishers would not touch.[244] The Canton office of World Books assembled batches of propaganda pamphlets,[245] prepared in advance of the Northern Expedition in 1926, and forwarded them to Shanghai, where they were printed up. The pamphlets were then distributed in Yangzi-area provinces to ready the populace for Chiang Kai-shek's

northward-advancing armies of liberation.[246] In Zhu Lianbao's view, when printing revolutionary pamphlets, Shen was motivated both by a spirit of adventure and by his awareness of World's comparative safety in the International Concession.[247] Unlike for Lufei Kui in 1911-12, support for Nationalist Party politics seems to have had little to do with it.

Shen's political publishing continued after the Nationalists' counter-revolution of April 1927, the events of which unfolded largely in Shanghai. Among the last workers' battalions to hold out against the gangsters and Nationalist troops had been those who barricaded themselves into the Commercial Press plant on Baoshan Road. The Commercial Press management was obliged to pay off the Nationalists. Lufei Kui had avoided the slaughter by going to Japan. After his return, he had led Zhonghua to embrace the Nationalist state and took on a number of prominent government directorships.

In contrast to his well-heeled competitors, Shen Zhifang and World Books helped to support refugees from the Nationalist Party's reign of terror by secretly employing them. The Communists Mao Dun and Yang Xianjiang, both from the Commercial Press's editorial office, escaped the executions in the wake of the workers' failure and fled to Japan. There they lived off their translation work. Unable to return to Shanghai or to seek work openly in Shanghai, Mao and Yang were eventually put in touch with World Books. World commissioned translations from each, putting Zhu Lianbao in charge of mailing their wages to Japan.[248]

Concurrently, once the Nationalists established their new national government at Nanjing in 1928, World, like its competitors, was obliged to edit its textbooks to reflect the new political order. To begin with, the firm named the well-known Nationalist journalist, Yu Youren, whom Shen Zhifang had known as a newspaper publisher when Shen had first come to Shanghai, to replace Hu Renyuan, the former Beijing University chancellor-turned-textbook editor.[249] Primary school textbooks were changed, and a new series of middle school texts was issued. World Books continued to issue the popular collectanea *(congshu)*, painting manuals, and law books for which it had become known by then. The firm also invested in several new ventures, including the foreign firm Siberia Printing (as a result of which World first employed non-Chinese workers) and Guangzhi shuju, Wu Woyao's old publisher.[250]

To expand his operating capital, starting in 1925, Shen had sent representatives to Southeast Asia with the aim of gaining investors from the Chinese communities there. Thanks to the intervention of his distribution department chief, Liu Tingmu, and the overseas Chinese, Bai Jiaxiang, owner of Xinmin shudian in Xiamen (Amoy), Shen's appeal reached the famous Singapore rubber king, Chen Jiageng (Tan Kah Kee, 1874-1961).

Chen and Shen seemed to be a perfect match. Chen needed a partner in China to sell his rubber products domestically; Shen needed an agent in Southeast Asia for his publications. Chen also embraced the idea of marketing Shen's publications as a means of encouraging patriotism among the Southeast Asian overseas Chinese.[251] A contract was drawn up specifying that each side would become the other's business representative.[252] To consolidate the growing intimacy of the two enterprises, Chen was appointed to World's board in 1928. The relationship ended badly, however, when Shen could not pay Chen his dividends or return his 40,000-yuan investment.

Constantly pressed financially to pay for expansion and machinery, Shen sought multiple avenues of financing. In the late 1920s, World's operating capital expanded greatly when investors from the worlds of finance, journalism, and government began to take an interest in the publishing house. Like Wang Yunwu and Lufei Kui, Shen was happy rubbing shoulders with officialdom, and his company soon attracted investment from, among others, the well-known industrialist Qian Yongming (1885-1958) of the government-run Bank of Communications.[253]

Not surprisingly, Shen found various shady ways of raising funds as well. He converted employees' in-house savings funds to financial instruments for the benefit of the company. Expanding the savings program to include readers' investments, within a short period Shen raised 1.8 million yuan. With this new resource, he opened World Bank[254] and an educational merchandise-manufacturing company. He even started to buy up Fuzhou Road real estate, taking control of Huaiyuan Lane, where World Books had started, and changing its name to World Lane. Shen planned also to demolish his own building and rebuild it as the World Mansion.

With his added capital, Shen purchased larger presses, advanced photogravure presses, and engraving equipment. To house the new equipment, World added to its printing plant, took in more manuscripts, and lengthened its backlist. Borrowing 100,000 yuan from Yao Mulian's Nüzi shangye chuxu yinhang (Women's Commercial Savings Bank) on the security of the Red House, Shen also enlarged his Fuzhou Road retail outlet.[255]

Plans for further expansion were thwarted by the worldwide depression, the ripples of which struck Shanghai in the early 1930s, sending real estate values plummeting. Hoping to borrow further against the Red House and his other Shanghai properties, Shen was pressed more and more by the uncertainties of both the real estate market and the textbook-publishing business. By now, a portion of his real estate had already been garnished by Jincheng Bank. When Shen failed to clear his debt, Jincheng claimed the property, further compressing his operating capital. Faced with disaster, at this point Shen had no choice but to agree to delayed loan repayments.[256]

At the same time, Lu Gaoyi,[257] newly appointed head of the administrative office, requested help from director Wu Yunrui (Wenzhai) of Jincheng Bank.[258] Wu conferred with government banker Qian Yongming, who turned to Zhang Gongquan. Together they approached the Nationalist godfather Li Shizeng. Wu, Qian, and Zhang convinced Li to invest 500,000 yuan in World Books.[259] In return, Li demanded a seat on the board and control of more than half of the examiners' seats.

From this point in 1934 on, Li Shizeng, as the primary financial-backer, ran World Books with Lu Gaoyi as his general manager.[260] At the same time that Li's investment breathed new financial life into the publishing firm, Li, Qian Xinzhi, and Wu Yunrui demanded that Shen Zhifang step down from his position as general manager. Shen's position was then awarded to Lu Gaoyi. For the sake of the entire publishing operation, Shen had no option but to concede defeat and take on a purely supervisory role. In this way, Shen, the "outstanding oddity" of Shanghai's publishing sector, succumbed to the pressure of government-allied capital just as Lufei Kui and Zhonghua had yielded a decade and a half earlier. Between 1921 and 1937, World Books had published about 3,715 titles.

Shen continued to work on Fuzhou Road, even though he no longer controlled World Books. He was still tied closely to Dadong shuju, another major Fuzhou Road publisher-retailer, through his nephew. Moreover, in his forced retirement, Shen started up Qiming shudian, managed by his son, Shen Zhiming. Small in scope, it published several hundred titles of its own, including popular cultural works and calligraphy manuals.

At home, Shen collected and edited old books and historical paintings in his personal library.[261] Just like book collectors of the imperial era, he published a catalogue of his collection for the sake of visitors. Unlike them, he had his calligraphy collection photographed for the benefit of later generations. On 28 July 1939, Shen died, aged fifty-eight *sui*,[262] of an unspecified gastric disease that had plagued his adult years.

World Books, the most successful of the more than ten book-publishing and distribution firms that Shen Zhifang had founded in his career stretching back to the early 1900s, now had over thirty sales branches in major provincial cities, with branch editorial offices in Suzhou and Hangzhou[263] and branch publishing offices in Ganzhou, Changsha, Shaoyang, and Chongqing.[264] Consistently lacking the capital and technology available to each of its competitors and predecessors, World positioned itself to exploit their weaknesses. World hired cast-off editors from the Commercial Press in particular and then aggressively and creatively exploited market niches that the larger firms had neglected. Even Zhonghua, known for its identification with the Republican cause, would not touch Nationalist propaganda in 1926,

but Shen, exploiting the safety of the International Concession, was willing to take the kind of risk that Xia Ruifang of the Commercial Press would likely have appreciated. In doing so, Shen exhibited a bravado and flourish characteristic of Shanghai's Chinese print capitalism dating back to the 1880s and, with scores of other smaller publishers, he kept that buccaneer spirit alive in Wenhuajie during the 1920s and 1930s.

Conclusion

This chapter has argued that, between 1912 and 1937, Shanghai's second generation of new-style corporate publishers, although themselves often would-be scholars, were nevertheless driven by their awareness of markets and politics. Whether seeking to dominate markets, as the Commercial Press, Zhonghua, and World Books did with their textbooks; manipulate them, as Lufei Kui did with his Republican publications; or simply satisfy them, as Shen Zhifang did with his popular novels and subversive political tracts, the Shanghai publishers found a constant patron in national book markets from 1912 to 1937. Supplying them required the three publishers to marshal technological, financial, intellectual, and political resources in much the same way that armies prepare to do battle, a metaphorical image that contrasts with the relatively casual approach to Chinese print capitalism of the period prior to 1895.

Throughout both the late Qing and Republican periods, the Commercial Press set the pace of the publishing marketplace through sales of its textbooks, reference books, journals, collectanea, etc. It did so even as it was challenged repeatedly by opponents such as Zhonghua and World, whose directors had been schooled in its own editorial and marketing departments. Shanghai's Wenhuajie suggests that the opportunism, exploitativeness, and combativeness of the Shanghai publishing world actually had their roots in a struggle for supremacy that began with efforts to address the national political crisis. Those publishing efforts were reflected intellectually in editorial offices and materially in industrialized Western printing technology.

The loyalty to the Republican cause shown by Xia Ruifang's editor, Lufei Kui, and the opportunism of Xia's chief lieutenant, Shen Zhifang, enabled both of these latter figures to anticipate the broad new marketplace that would open up to Shanghai's new-style general publishers once the 1911 Revolution succeeded. What they did not anticipate, however, was the impact that a political vacuum would have on publishers whose economic foundation was textbooks. Even with the success of the revolution, privately owned publishing firms remained at the mercy of their own overhead and of the government's educational policies. As the industry expanded rapidly in the mid-1910s, even its employees, who as recently as 1910 had

served in a publishers' militia, donning military uniforms and shouldering rifles, now became violently unpredictable.

As Lin Heqin pointed out in his 1937 article on the problems of funding in Shanghai's printing industry, keeping the presses running between academic semesters demanded planning, marketing ingenuity, and financial fluidity. Just as the Commercial Press had been forced to extend its bid for publishing supremacy by "going public" in 1902, so too Zhonghua in 1915 and World in 1921 discovered that access to the marketplace required the funding mechanisms and bureaucratic flexibility of a modern corporate structure.

The retail homes of each of these modern corporate publishing kingdoms did not become fixed on Fuzhou Road until 1916. The construction of Zhonghua's corporate headquarters at the Henan Road corner in that year signalled the opening of Republican Shanghai's Wenhuajie. Already at that time, however, Shanghai itself was the centre of China's new-style book industry and also an important new intellectual focal point, thanks in part to processes that had been set in motion by lithographic publishers after 1876 and machine manufacturers after 1895.

The corporate giants that took Fuzhou Road as their marketing centre now remade the old imperial book trade, largely one of examination aids, reprints, and antiquarian works, along technology-based, capitalist lines. The progressive, entrepreneurial image of Wenhuajie fostered by the Commercial Press, Zhonghua, and World Books survived until the end of the Republic but was undercut by the hard realities of renegotiated markets and patronage once the Nanjing government was established in 1928. At the same time, the entrepreneurial independence symbolized by the guild of 1905 and the trade association of 1905-6/1911 was compromised by the new government-supervised trade association of 1930.

Just as editors ignored the challenges and opportunities of the marketplace at their own risk, so too Western-style printing technology imposed its demands on them. Technology was a key resource enabling these publishers to establish their claims to China's vast marketplace for books. In this light, although it may be tempting to assume that the Communist Party merely manipulated Shanghai printing workers between 1920 and 1927 for its own ends, one should keep in mind Lucien Febvre and Henri-Jean Martin's discovery not only that European printing shops were among the world's first capitalist enterprises but also that they created the world's first factory floors. By implication, European printing workers were among the first to organize opposition to capitalist employers. Just as these conditions prevailed earlier in European print shops than in other industries, part of the impact of the Gutenberg revolution in China, in addition to creating some of the first corporate industries, included enabling articulate, organized labour activism.

Lest we exaggerate the independence of these publishing companies from the society in which they operated, it is important to recall that, between 1912 and 1928, this struggle involving first the Commercial Press and Zhonghua and then these two and World Books was carried out in a series of textbook wars. These wars serve to focus our attention on the importance of relations between the publishers and successive national and regional governments. Zhonghua's Lufei Kui made clear in the early 1900s and again in 1924 that profitable Chinese print capitalism required the presence of the Chinese state. His views were borne out by the fact that the most ruthless and destructive years of market competition lasted from 1912 to 1927, the era in which governments were weakest. The years between 1917 and 1927 were also those of greatest class polarization. The Shanghai corporate publishers' settlement with the Nationalist state in 1928 ended both ruthless competition between firms and publicly explosive class conflict in the printing plants.

Between 1912 and 1937, control of Shanghai's market-driven printing and publishing operations passed to a second generation of leaders who had matured in the fragmenting society of the late Qing dynasty. Wang Yunwu of the Commercial Press, Lufei Kui of Zhonghua, and Shen Zhifang of World Books were remarkably savvy individuals with a sharp eye for business, both corporate and personal. In this, they recall Xia Ruifang much more than Zhang Yuanji and Wenming's Yu Fu of an earlier generation of publishers.

Wang Yunwu took over the reins of the Commercial Press, venerable survivor of the imperial era, ushering it into the heyday of the Nanjing Decade and beyond. Lufei Kui founded Zhonghua by merging the literati editorial traditions of the Commercial Press with the realities of the post-1911 Republican marketplace. Shen Zhifang, after helping to found and manage Zhonghua, several years later packed up, took his winnings, and moved out to originate World Books, a less heavily capitalized and hence more directly market-dependent and crassly opportunistic corporate publishing operation.

Throughout the period of their struggles against each other, monopolistic marketing was the goal sought, if not always the reality achieved, by each against its rivals. For the two and a half decades extending from the abolition of the civil service examinations and the examination book culture that complemented it to the relative calm imposed by mutual exhaustion and the growing assertiveness of the new Nationalist Party-state established at Nanjing, these three conducted their struggle with remarkable singleness of purpose and, simultaneously, a multiplicity of operations. When the textbook wars formally ended in 1928, the development of new publication formats and corporate expansionism guaranteed that the struggle would continue in milder forms until 1937. Western printing technology, by now

a fully sinicized tool in modern Shanghai publishing, continued to be used to manufacture the books that Chinese consumers wanted to buy.

Between 1928 and 1937, through their heavy dependence on textbook sales, these three publishing firms became the three legs of the Chinese state tripod. In reality, the legs were never equal. The Commercial Press regularly controlled 65 percent of the textbook market with 30 percent going to Zhonghua and part of the remainder to World. Including other markets, the Commercial Press outsold Zhonghua three to one and surpassed World's sales by five times. Nonetheless, all three were equal in their need for a strong Chinese state that could guarantee expanding school patronage. With their backs secured, the companies were able to invest their resources more broadly, thereby taking advantage of their command of Western technology, their patriotism, and their organizational flexibility. Although this chapter has focused on individuals such as Wang, Lufei, and Shen, the corporations that they ran did survive these three individuals even after the war with Japan began in 1937, just as the Shanghai printer-publisher Lin Heqin suggested the corporation form would allow them to do. Simultaneously, Shanghai's corporate print capitalists turned away from many politically risky ventures, leaving the ground that they had once dominated to smaller, even underground, publishers. This shift suggests directions for future research.

Conclusion

This book has studied the reciprocal influences of the mental and the material cultures that played major parts in establishing Shanghai as China's leading intellectual, cultural, and educational centre between the years 1876 and 1937. Contesting scholarly views that propose a universalistic model of print capitalism, those that argue China's nineteenth-century technological development was retarded by its culture, as well as those that regard Chinese modernity as a merely cultural phenomenon, the major conclusion of this book is that selective and deliberate use of Western technology and evolving traditional values enabled Chinese to engage the West constructively. Similarly, Shanghai's unexpected vault to prominence in late Qing and Republican China has been shown to have been due, in large part, to its development of business and industrial institutions, particularly those related to the printing and publishing industry, a knowledge-based micro-economy. Through an assessment of the impact of modern industry on the ancient Chinese world of textual production, Shanghai has been presented as a site of social and cultural history, but this book has emphasized the technological, entrepreneurial, and vocational sides of that history.

Unlike most other non-European parts of the world that have experienced the Gutenberg revolution, China had had a significant national reading public well before the nineteenth century. However, the means by which books, journals, illustrations, etc., reach a national Chinese audience of hundreds of millions in the early twenty-first century are those of a modern industrialized publishing industry. The origins, both mental and material, of that industry lie in late Qing and Republican Chinese print capitalism.

Three major concepts have framed this study of the process by which Western-style printing technology replaced Chinese xylography to produce this modern industry from 1876 to 1937. First, the concept of print culture has been contextualized in the senses advanced by Roger Chartier. Thus, this book has focused on both the effort to understand the social meaning of the Gutenberg revolution and the study of "a set of new acts" that arose from innovative forms of writing and illustrating. In the case of China, a civilization with 1,000 years of print culture, this "set of new acts" included the system of values that preceded and, indeed, set the stage for China's

Gutenberg revolution. Those values also shaped the choices that Chinese made concerning both technology and business organizations in the modern period.

Second, this book has argued that China experienced many centuries of print culture and print commerce in advance of Shanghai-based modern print capitalism and that that history deeply influenced the contours of the modern industry. Insofar as recent scholarship aims to universalize the concept of print capitalism, it usually takes into account neither the traditional printing history nor the modern publishing experience of this quarter of humanity. Benedict Anderson's own concept of print capitalism appears overly beholden to Lucien Febvre and Henri-Jean Martin's insights into European history. For this reason, Anderson's understanding fails to illuminate China's experience in two important regards. First, he does not acknowledge the existence of print commerce before China's Gutenberg revolution or the role that that commerce played in shaping Chinese print capitalism. Second, Anderson's accounts cannot illuminate what difference industrialization made to the Gutenberg revolution in China. The present book has engaged both of these issues to show that Chinese made a series of choices from the broad range of Western printing technologies available to them. These technological choices in turn influenced, but did not determine, the competitive pursuit of new forms of government and public patronage, the adaptation of the corporate model to Chinese circumstances, and the appearance of new forms of class polarization.

Third, based on what has been said here, partly in response to the historical and cultural limitations of Anderson's notion of print capitalism, it is clear that a new definition of the term is required to account for the special circumstances of Shanghai-based Chinese print capitalism. Print capitalism is best understood to mean the social, economic, and political system that resulted from the reciprocal influences of the mental realm of literati print culture and the material world of industrialized mechanical duplication of printed commodities for privatized profit. Part of what distinguished Chinese print capitalism from many of its foreign counterparts were the ways in which the three operations of editing, printing, and marketing were united in its leading corporate firms.[1] Access to educated persons, to technology and technicians capable of repairing and duplicating it, and to operating and investment capital provided a rationale for this form of unitary operation. In Shanghai between 1876 and 1937, the inherited but slowly evolving values of the editorial office heirs to the literati tradition, the new, rapidly changing circumstances of print-shop workers, and the exigencies of modern banking interacted to yield the distinctive system of print capitalism that shaped modern Chinese life.

Wenhuajie, Present and Past

Today many visitors to Shanghai ride the gleaming new subway to People's Square, the political and cultural heart of the megacity formed after 1949 by merging the old Nanshi, the former foreign concessions, and the suburban areas of the city administered by the Nationalists in the 1930s. Detraining at People's Square, the visitor will likely stroll through the sparkling underground arcade of shops and restaurants before surfacing into the square itself. In front of the visitor appears an expansive municipal plaza that, in 1937, held little more than a horse-racing track and clubhouse. The track and clubhouse were intended to allow the Western heirs of treaty-port opium dealers and gunrunners, along with more recently arrived businesspeople and colonial administrators, to ape, at a remove of many thousands of miles, the ancient equestrian culture of Britain's landed aristocrats. With the track gone, a splendid new museum, an opera house, a symphony hall, and numerous other pavilions and fountains now celebrate the achievements of the city's Communist government. The municipal government itself is housed in a new city hall, the plainest building in the square, near the heart of the reconstructed civic centre.

Just to the west, outside the formal boundaries of the square, is the new Shanghai Art Gallery, housed in the former Shanghai Library, itself once the racing clubhouse. The library has moved to a recently built facility in an upscale western district long inhabited by overseas Chinese businesspeople and the families of the city's Communist Party leadership. If the visitor heads north from the Shanghai Museum and then east after encountering the city government building, he or she will find that the cultural theme established in People's Square continues to the east of the square as well. Seen from the square, across Xizang Road, an illuminated arch beckons our visitor into Fuzhou Road, the core of the city's old, and now newly revitalized, Wenhuajie.

Walking east, one reaches the centre of what used to be Republican China's Wenhuajie, but familiar storefronts are long gone. Centrepieces of the Republic, Zhonghua and the Commercial Press, are both absent, having moved to Beijing, New China's intellectual centre-to-be, after 1949. World Books, an adjunct of the Nationalist Party-state after Shen Zhifang's (1882-1939) death, is no more, having departed for Taiwan with the Nationalists in 1949. Instead of these three old print capitalist operations, the more than 300 bookstores and book publishers, and newspapers such as *Shenbao*, *Shibao*, *Xinwen bao*, and *Zhongyang ribao* that congregated here between the 1880s and 1937, only a handful of bookstores and publishers remain. The state-run Waiyu shudian (Foreign Languages Bookstore), Guji shudian (Classics Bookstore), Duoyunxuan, and Shanghai Shucheng (Bookcity), a multistorey

edifice that replaces the interim Xinhua bookstore that was on this site after 1949, are all the visitor will find here. Most of the current retailers or some mutation of them have been in this location since the Revolution of 1949. The firms that remain are intended to suggest cultural and commercial continuity from 1916 to the present, but they are actually only a faint echo of 1930s Wenhuajie, when there were more than seventy privately owned bookstores and publishers competing here for public patronage.

The Chinese renewal of Shanghai's city centre is, symbolically, one of the most significant cultural steps taken in this city since 1949. The Japanese invasions of 1937 and 1941 weakened the European powers' grip on the treaty port, but only in 1949 did the Chinese Communists reach the goal that the Nationalists had set for themselves in the 1920s but never carried out – namely, expulsion of the foreign powers from all the old treaty ports scattered along China's coasts and rivers.[2] Between 1949 and the late 1980s, the Communist government invested heavily in Shanghai's housing, schools, and factories, but it did little to put its stamp on the old International and French Concession areas. In the early 1990s, however, the city government began to revitalize the core of what had become a shabby industrial port city. By the mid-1990s, the Communists also started building the modern, world-class city that Western, Nationalist, and Japanese occupiers had never managed to create.

In the 1920s and 1930s, when Westerners ruled supreme here, even boastfully calling Shanghai "The Model Settlement," the treaty port lacked a sizable public library, a public museum, a municipal opera house or theatre, or even a proper civic centre. The Shanghai Municipal Council ran the International Concession like a business from its fortresslike structure at the corner of Hankou and Jiangxi Roads.[3] Throughout the 1930s, the Nationalists attempted to build a new civic centre at Jiangwan in their suburban sector of the city, but Japan cut their efforts short in 1937 when it occupied the Chinese sectors of the city. In addition to containing three government jurisdictions, physically Shanghai in the 1930s was a city of office buildings, banks, hotels, clubs, factories, department stores and shops, restaurants and brothels, godowns, a few parks, and many residential districts. Often, just as in the nineteenth century, all were jumbled together with no apparent zoning or regulation.

In short, except for the modern media, foremost among which were the city's roughly 11,000 printers and publishers, 1930s Shanghai was a city that lacked most major forms of what are conventionally associated with a modern urban cultural infrastructure. It is true that the city was home to some of China's leading modern schools and universities, most founded through the efforts of urban reformist elites from northern Zhejiang and

eastern Jiangsu, and that the presence of these institutions contributed to Shanghai's reputation as Republican China's leading intellectual centre. However, essential to the schools' endeavours were the textbooks, reference works, journals, and general-interest publications edited, printed, and sold by Shanghai's publishers, who themselves also came largely from Zhejiang and Jiangsu. Day in and day out, throughout the late 1910s, 1920s, and 1930s, students, teachers, and the general public were drawn to the city's Wenhuajie, where they patronized the retail shops of the Commercial Press, Zhonghua, World, and many smaller firms. Thanks to the 8,000 or so editors and printers employed by the city's three leading corporate publishing companies alone, shelves were full in Wenhuajie except, of course, when war intervened. New and old ideas about science, democracy, and myriad other subjects unavailable anywhere else in China could be obtained here at reasonable prices in modern, Western-style books, journals, and newspapers. All were printed using the foremost enabling technology of China's intellectual and political transformations since 1880, Western-style presses and machines.

A printing and publishing revolution had taken place, separating the more broadly based modern Chinese reading public of machine-printed works of the 1920s and 1930s from their Qing-era predecessors, habituated by 1,000 years of print culture to seek woodblock-printed editions. As this book has argued, a revolution of machines and social reorganization just as much as one of ideas and mass movements divided these two worlds of reading consumers from each other. During each of the major turning points in Chinese history since the Guangxu reign began in 1875, from the Sino-French War of 1884-85, to the Sino-Japanese War of 1894-95, to the Republican Revolution of 1911, the New Culture Movement of 1915-21, the Nationalist-led Northern Expedition of 1926-28, the establishment of the Nanjing government in 1928, and the Japanese attack of 1932, the Shanghai publishers and their publications supplied a backdrop and offered a printed interpretation of events for sale. No mere philanthropists, unlike many of their forebears in traditional Chinese print culture circles, Shanghai's print capitalists managed to make a profit through each of these events. Until they were stopped short in 1937, again by Japan, they did so even as they informed, educated, and entertained, publishing 86 percent of all books produced in China in that final year of the Nanjing Decade.[4]

Contrary to those who would focus purely on the publishers' commercial outlets on Wenhuajie as a means of revealing the cultural exuberance of Republican Chinese publishing, this book has suggested that this cultural and commercial district's importance is best understood when seen as part of a technological, geographical, temporal, and organizational continuum. That

continuum extended technologically from Gutenberg's manual printing press to electric rotary machines, geographically from Europe and America to Shanghai, temporally from 1876 to 1937, and organizationally from corporate editorial offices to printing plants and then back to these retail outlets. Without Western technology, industrialized printing plants, and the system of extraterritoriality that loosely shielded Shanghai's publishers, Shanghai's publishing business would have been no different from those of many older Chinese book districts, such as Beijing's Liulichang or Suzhou's Changmen district, that preceded Shanghai throughout the past three centuries of Chinese print commerce. Shanghai's Wenhuajie differed from those other booksellers' districts thanks to its mastery of foreign printing technology and its creative responses through guild, trade association, incorporation, and state alliance to the challenges of regulating the markets needed to purchase its new products and so to pay for its growth.

Apart from the financial benefits that accrued to the owners of and shareholders in Wenhuajie's business enterprises, the Shanghai publishers' continuing quest for national Chinese markets also changed the city of Shanghai in direct ways. Between 1876 and 1937, the centripetal organizational drive of technology-based capitalist industry simultaneously created and concentrated an industry that had been spread across China for centuries into this single urban centre. During the same period, Shanghai itself evolved from a medium-sized city in 1876 to an expansive metropolis sprawling across three municipal administrations in 1937 by drawing upon successive waves of migrants and refugees. Among these arrivals, of course, were lower-degree holders such as Wang Tao (1828-97) and Bao Tianxiao (1875-1973); illustrators such as Dianshizhai's Wu Youru (1840?-93?); compradores such as Dianshizhai's Chen Huageng, Tongwen's Xu Run (1838-1911), and Zhongguo tushu gongsi's Xi Zipei; future officials such as Li Shengduo (1860-1937) of Feiying Hall and former officials such as Zhang Yuanji (1867-1959) of the Commercial Press; elite urban reformers such as Wenming's Yu Fu; idealists such as Guangzhi's Feng Jingru and He Chengyi; technicians such as Xia Ruifang (1871-1914) of the Commercial Press and Li Changgen (b. circa 1845) of the Li Yongchang Machine Shop; and entrepreneurs such as Zhang Jinlin of Mingjing Machine Shop, Lufei Kui (1886-1940) of Zhonghua Books, and Shen Zhifang (1882-1939) of World Books; and many others who came after them. Each was a sojourner drawn to Shanghai by employment hopes that were realized in the city's print shops, machine works, and publishing companies. Concurrently, these persons reflected and established many of China's intellectual priorities and contributed to both the city's and the nation's modernization and industrialization.

Social History of Technology

In making an argument for why scholars should turn their gaze to the material world, the French medievalist Marc Bloch once pointed out that the meaning of technology is not self-evident and needs to be explained historically. A study of technology as the basis for understanding a society, in "its most intimate structure, does not imply the writing of a triumphant Q.E.D. at the end of a theorem, after which only a line has to be drawn."[5] Instead, Bloch tells us, an understanding of technology leads to "a whole succession of new questions, from among the most fascinating and most difficult ones that history can raise."[6]

Among the questions raised in this book and addressed in successive chapters have been the following. What happens when technology is transferred to a civilization different from the one where it originated? Does technology impose its own historical logic on the new society with which it interacts, as is often assumed? How did Western printing technology first go to China, and how did China's late imperial print culture and commerce influence Chinese choices related to Western-style printing technology? Why did the Chinese embrace Western printing technology, and what happened once they did? How long did that acceptance take? Why do bookmen and then printers become so prominent in twentieth-century Chinese fiction and memoirs? And, given the fact that Shanghai's Gutenberg-based print capitalist revolution occurred in a fraction of the time that Europe's did, how did precapitalist ideas influence the form of that revolution?

The origins of what would be known by the 1930s as Wenhuajie lie in a mixture of the cultured, mercantile, and then industrial worlds of the late Qing dynasty. For this reason, a balanced historical account of Wenhuajie cannot be achieved until the spectrum of influences reaching from the intellectual to the material are related to one another. Without suggesting that the intellectual can be reduced to the material, I have argued for the need to balance historical accounts of the men and ideas of Wenhuajie with understanding of the technology that the Chinese used to disseminate ideas. Failures to provide such accounts indicate an inability to transcend the limited perspectives of the Chinese literati themselves.

Although modern Western printing technology arrived in China in 1807, it did not rapidly dislodge xylography, which had been invented in China in the seventh century and had spread widely during the centuries following the Song dynasty (960-1279). An important commodity market, the late imperial Chinese book world, had come to reflect the intellectual concerns of the national group most involved with it, the literati. Under the influence of the public service ethic of literati publishers, publishing had also been

established as a form of personal and social service. At the same time, the literati themselves felt the impact of the far-reaching commercialization of the Chinese economy from the mid-sixteenth century onward. The commercialization of their book world conflicted with their anticommercial credo. It also influenced the views of those, often drawn from the literati, who made their living from book commerce. Inherited disinterest in technology minimized the literati concern with the social aspects of xylographic technology.

Partly as a result of this cultural background, partly because of the expense of Western technology, and partly because of the aesthetically unappealing nature of texts created using Western techniques, Chinese did not favour imported Western printing technology before the 1870s. The first real steps in the development of Chinese print capitalism were taken in 1876-77 with Shanghai's industrialization of market-oriented lithographic printing. Although lithography was initially used for printing religious imagery, its commercial potential soon became clear via the Dianshizhai print shop across town from the Catholic orphanage where it had begun. From that beginning, Chinese entrepreneurs slowly embraced the foreign technology, but they applied it to traditional printing and publishing goals. Of particular importance was the process of reprinting the literary heritage lost in the Taiping Rebellion in aesthetically and commercially attractive formats. Well over 100 lithographic publishing firms soon mushroomed across the city of Shanghai and survived until the end of the Republican period. Of profound importance to this rapid expansion was the reprint business modelled on the traditional xylographic one, which lithography now replaced.

At first, lithographic firms such as Tongwen Press largely disregarded the industrial nature of their new business. Indeed, the psychological emphasis of Shanghai's book merchants and publishers would long rest, primarily, on cultural and public service and, only secondarily, on commerce and industry. It was not an accident that many of the firms discussed here produced works intended to supply the academic market. The civil service examination system had created an insatiable market for study guides, reference books, etc. For this reason, both service-based publishing and commerce-oriented publishing were heavily dependent on the Chinese civil service examination system, which itself reflected the sociopolitical objectives of the Qing state.

Twenty years after lithographic printing appeared on the banks of the Huangpu River, it was superseded by letterpress printing, motivated in part by printers' need to provide timely coverage of the events of the First Sino-Japanese War. The development of this modern letterpress printing industry in response to an expanded public readership now prompted Chinese

machinists to begin to manufacture printing presses and machines along with aesthetically pleasing Chinese type fonts. Chinese-made presses helped to reduce the obstacle of cost in setting up a Western-style print shop, and improved Chinese-designed fonts brought Western-style letterpress printing into the aesthetic universe of Chinese readers. Both press manufacture and typeface design were combined in the early corporate firms, epitomized by the Commercial Press, founded in 1897 and incorporated in 1902.

Although incorporation signified the future of Chinese print capitalism, predictably many of these early firms remained individual proprietorships. As noted earlier, the individual proprietorship gave the owner maximum managerial control and confidentiality. Like the traditional booksellers, many of Shanghai's early, transitional book dealers lacked the compulsion to saturate the national market with their products. Their traditional political and sales ethics restrained them, with the result that these firms sought simply to duplicate the limited influence of their predecessors, albeit from the relative security of Shanghai's International Concession.

Within a short period of time, however, it became clear to many of Shanghai's new-style publishers that industrial technology demanded a more flexible and growth-oriented funding mechanism than the old-fashioned individual proprietorships and partnerships that had enabled traditional Chinese publishers and booksellers to prosper modestly. The industry leader in technology, the Commercial Press, was also among the first to experiment successfully with incorporation. Founded with 3,750 yuan in 1897, by 1910 the publisher's asset valuation crossed the million-yuan threshold, thanks in part to its ability to combine editorial, technical, and entrepreneurial talent under one corporate roof. Its adoption of a foreign business model coincided with, and may even have been part of, the cause that prompted the Qing government to endorse such efforts via new commercial legislation. A few years earlier, the Commercial Press had printed its first bestseller, a knock-off, Western-style, Japanese-influenced textbook, which became the genie's lamp of the Shanghai publishers. The modern textbook was the most profitable new-style book commodity to emerge in the period after the heyday of the lithographed examination text. Those who could claim a significant portion of the textbook market would now grow, and those who could not would stagnate or wither.

The blending of the traditional emphasis on elite public service, with its access to government, plus the modern capitalist emphasis on mechanization, specialization, and adequate compensation for important new manufacturers can be seen in the establishment of both the booksellers' guild and the trade association, in 1905 and 1905-6/1911, respectively. The membership of each was defined by access to printing technology, a new

phenomenon in the ancient world of Chinese publishing. Compensation, an ever-present but not publicly discussed spectre in the now-defunct Suzhou Booksellers' Guild, became a publicly justifiable objective in Shanghai as the Qing court tried consciously to promote new business enterprises. Imperial reformers in Beijing were especially interested in fostering book publishing because of their belief in the symbiotic relationship between the advance of China as a nation and modern book learning.

In the final decade of the Qing, tentative moves to reform the education system, which were then legitimized by the abolition of the traditional examination system, sparked interest in modern Western-style educational commodities. Just as the newspaper and lithographic magazine had excited the interest of those who were already literate, so too the modern textbook now appealed to those who sought literacy. Many newly literate people started to use the printing press to articulate their competing perspectives on China's past, present, and future.

Even though they operated largely within the International Concession, modern Chinese publishers depended heavily on the Chinese state to provide a market for their most remunerative commodity, the textbook. From the founding of the first Chinese xylographic publisher discussed, the seventeenth-century Saoye shanfang, through the earliest lithographic houses, including Dianshizhai, Tongwen, and Feiying Hall, and into the era of the comprehensive publishers such as the Commercial Press, Zhonghua, and even World, the Chinese state was an essential, if often silent, partner in the publishing business. In the era of educational reform that began in 1904, the state's importance grew even as its vigour declined.

Just as the lithographers had depended on the civil service examination market for their success, the comprehensive publishers from 1904 to 1937 relied on the textbook policies of successive national and regional governments. As time went on, such works became cheaper, more widely disseminated, and available in an increasingly broad selection. Simultaneously, the textbook market became the chief battlefield of modern Shanghai publishers.[7] Their heavy dependence on governments to define markets may not have reflected the explicit continuing influence of the state on Chinese intellectuals' value system, but it determined who issued marching orders, even when profits were privatized.

If the corporation combined intellectual and material culture in a uniquely new way, it also brought together the constituencies involved with each cultural segment. Former literati editors, their minds shaped by elitist values from the imperial past, and their younger colleagues influenced by those same values, along with proletarian printers whose eyes focused on a technological future, all worked for the same printing and publishing corporations.

Yet each group did not benefit in direct proportion to its contribution to making China modern. Technology had changed the Chinese editorial workplace in ways of which many editors were only faintly aware, but the literati viewpoint nonetheless prevailed frequently in social structure and outlook.

At the end of the nineteenth century, there were 21 letterpress and over 100 lithographic printing and publishing firms in Shanghai. In 1917, the booksellers' guild recorded a membership of 132, including letterpress and lithographic printers. Thirteen of the 132 guild members were joint-stock corporations, the Commercial Press and Zhonghua Books among them. The previous year, Wenhuajie had been born, a cultural commercial centre inseparably tied to industrial printing plants in the north and west of the city. Although it is tempting to suppose that Wenhuajie thrived on its own virtue, in fact, it benefited from the long-standing concern of the Shanghai publishers with harnessing Western technology to the Chinese state's educational policies while they all took their profits from the arrangement. To do this, they needed workers.

In 1894, 870 workers in the lead-type trades made up less than 1 percent of all workers employed in heavy and light industry in China,[8] an astonishingly low figure when one thinks of the enormous influence that the industry would wield in twentieth-century affairs via its publications. The 1890s lithographic industry was more significant, adding a minimum of 1,300 and a maximum of 8,050 to yield a total figure of between 2,170 and 8,920 workers, a sizable workforce that anticipated the bulk of Shanghai's printing force in the twentieth century.

Three decades later, in 1930, the printing trades represented the port's third-largest form of Chinese industrial investment after the Chinese-owned brocade-weaving and cigarette-manufacturing industries. In terms of the overall value of the national machine industry's manufacturing output, in 1933 the printing and paper-making machine industry ranked seventh among the largest of China's industries. In the same year, vis-à-vis numbers of *Shanghai*-based industrial factories, Chinese-owned factories active in the printing business were the third most numerous (out of nine industrial categories) with 271 plants.[9] In 1933, the 11,211 workers that they employed made up the fifth-largest industrial group, with an average of 41 workers per shop.[10] A second source records that, in 1935, 10,531 Chinese printers lived in the city.[11] Even with the apparent loss of nearly 700 workers between 1933 and 1935, one is left with the sense that, by the 1930s, Shanghai's market-based, Western-style printing and publishing industry was extremely robust in terms of its business value and workforce.

In 1930, when it was worth eight million yuan, the Shanghai publishing industry was defined by a new government-mandated Shanghai Booksellers'

Same-Industry Association. Eighty-three firms constituted the organization, an increase of fifty-six firms since the guild was first organized in 1905 but a decrease of forty-eight since 1917. As each of the surviving firms must have been aware, the pivotal factors in the expansion and contraction of the industry up to 1930 had been Western technology and the Chinese marketplace, of which the latter reflected government supervision and legislation.

Chinese print capitalism was the product of sixty years – that is, three generations – of hothouse evolution. Late imperial print culture and print commerce, along with the public service ethic, remained a permanent, if not always visible, backdrop throughout this period. If technology, incorporation, and markets are seen as the high road to Chinese print capitalism, however, the low road involved the kind of dismal working conditions that can be seen in the Mingjing Machine Shop and that exploded in strike action in printing plants of the Commercial Press and other Shanghai publishers from 1917 to 1927. Class polarization and proletarian politicization occurred in even less time – two generations – than it took for Chinese print capitalism to mature, perhaps because, unlike the editors and corporate officers of each publishing firm, the print workers had no government concerned with their survival.

In summary, late-imperial print culture and commerce, a still-strong public service ethic, Western technology, extraterritoriality, and Chinese government policies were all necessary, but insufficient, conditions underlying the creation of Chinese print capitalism. The sine qua non was personnel, particularly the sort of entrepreneurial personalities epitomized by those discussed in this book: in the first phase, Mr. Tang (active 1850) of Foshan, the shadowy experimenter with cast type, and Wang Tao, the Hong Kong and Shanghai printer-publisher; in the second, compradores such as Chen Huageng and Xu Run and the *zhuangyuan* Li Shengduo; in the third, Xia Ruifang, Zhang Yuanji, Zhang Jian (1853-1926), and Yu Fu; and in the fourth, Zhang Jinlin, Wang Yunwu (1888-1980), Lufei Kui, and Shen Zhifang. The organizational structure of the corporation helped to lift those in the last two phases beyond the financial and psychological limitations that impeded those in the first two.

Elite Critiques of Wenhuajie's Publishing Operations

As seen here, the Chinese empire and its special rewards and status for intellectuals continued to influence the self-perception of Chinese publishers long after the meritocratic system of the empire itself had collapsed. Outrage at the unequal distribution of the material benefits of industrial capitalism and a continuing sense of noblesse oblige led pundits of the broader

system to attack the particular cases with which they were most familiar. No capitalist industry was closer to the conscience of Chinese intellectuals than publishing. Likewise, no capitalist industry was measured against a higher standard than this one. Where government circles of the 1930s identified praiseworthy high achievement in the Chinese printing and publishing industry, critics outside government focused on how much more had to be done.

As observed in the discussions of Wang Tao's career and of Tongwen's editorial department, many of those involved in the intellectual – that is, editorial or authorial – functions of publishing inherited or shared the literati faith in the value of public service through intellectual endeavour. This faith remained even when the meritocratic-bureaucratic system that had fostered such ideals itself could no longer employ their talents gainfully. It also held true after the system was abolished for good in 1904-5.

Learned individuals, many of whom became increasingly dependent on financial capital, were now forced to accommodate the reality of industrial civilization. In doing so, their moral culture collided with the ramifications of industrialization in a way that few could have anticipated. The bifurcated set of moral and commercial values that had fed into Shanghai now collided with finance and industry in a way that coloured Shanghai's print capitalism down to 1937. Even as the Western-style corporation provided what Lin Heqin regarded as the structure essential to their work, their attitudes reflected their cultural roots in the hybridized philanthropic and commercial culture of late Qing society. As a result, sometimes, such as when Lufei Kui equated publishing work with the growth of modern China, publishers confidently defended their scholarly backgrounds and privileges. At other times, such as when publishers succumbed to the meretricious lustre of profit gained from printing forbidden texts, regardless of copyright or the books' moral contents, they sedulously turned a blind eye to their social and political responsibilities.

By the early twentieth century, literate Chinese were well acquainted with the views of Liang Qichao (1873-1929), who had begun publishing articles in the 1890s on the important role of the press and fiction in promoting a self-conscious citizenry. As a result, the Shanghai publishers, whom Liang knew well, had, at least by implication, been part of a national dialogue on social and political reform. Even the Qing dynasty joined this discussion with new legislation concerning press regulations and nationally mandated textbooks. In 1912, the post-Qing, nominally republican government of Yuan Shikai (1859-1916) also issued new press regulations and revised stipulations for textbooks, both of which were reinforced in one form or another by subsequent national and warlord governments.

Against this background, even the judgments of Sun Yat-sen (1866-1925), first president of the Republic and then longtime oppositionist revolutionary, regarding Shanghai's publishers remained mixed. In the abstract, Sun held views similar to those that Lufei Kui articulated. For example, eight months after the May Fourth Incident of 1919, Sun pointed to the importance of the publishing industry in disseminating the ideas of Beijing's progressive and anti-imperialist university students. Discussing the role of the publishing industry in helping to establish a new Chinese nation, Sun stated that "The business provides the people with knowledge, one of the needs of modern society, and without which there is no progress. All the affairs of mankind need printing to record them; all the knowledge of mankind needs printing to save it."[12]

However, a year before, when Shanghai's Commercial Press had refused to publish Sun's work, *Sun Wen xueshuo* (Theories of Sun Yat-sen), Sun had been forced to approach another Shanghai publisher, Qiangyin shuguan, to print and distribute it for him. The experience had awakened Sun and other Nationalist Party leaders to the need to establish their own publishing operations. In particular, a loyal Nationalist Party publishing firm was required to break what they regarded as the Commercial Press's monarchist, monopolistic, and reactionary tendencies.[13] The Nationalists' attack bore fruit in 1921 with the establishment of the Nationalist publishing house, Minzhi shuju, with capital raised from overseas patriots.[14]

Sun's discovery that Shanghai's publishers would not or could not publish everything deemed necessary for "progress" ran parallel to the New Culture Movement's criticism of the Shanghai publishers. Although the movement itself produced some 400 new vernacular periodicals, its impact in corporate publishing circles was limited at first.[15] The Commercial Press, in particular, found itself the target of attacks by Luo Jialun (1897-1969), a Beijing University history student and New Culture activist, who, in April 1919, criticized its journals and magazines for their political backwardness, superfluity, and obsession with safe profitability.[16] That these criticisms found their mark is indicated by the Commercial Press's appeal to a New Culture leader, Beijing University professor Hu Shi (1891-1962), to take over the editorial office. By 1921, even without Hu's guidance, the journals that had been attacked were revamped and their editors replaced. But it was now clear that both the political and the intellectual worlds had found grist for their mills in Shanghai's Wenhuajie.

Moralistic, antimonopolistic, and implicitly anticapitalist criticism continued in 1925. Creation Society member Zhou Quanping (1902-83), writing under the pen name Ting Sheng (Sound of the Thunderbolt), issued a critique of the Shanghai publishers called "Chuban jie de hunluan yu

chengqing" ("Murkiness and Clarification in the Publishing World"). Zhou's bitter critique of Wenhuajie's pursuit of profit at the expense of culture and education echoed interests of other left-wing critics but also anticipated concerns upon which the Nationalist state would act. According to Zhou, the Chinese publishing world neglected its duties to the nation because of its preoccupation with profit.

If one looks at the range of book titles, Zhou explains, China's publications do not seem to be lacking. It is only when one searches through their contents that disappointment grows. Errors, inconsistency, plagiarism, and wild punctuation all mar the products issued by Chinese publishers. Even after these blemishes are identified, they remain unchanged in the materials promoted to readers by an advertising infrastructure devoted to profit-seeking. Advertising, Zhou says, once functioned to notify people of the real value of a commodity, but deceitful businessmen turned it around and used it to confuse the eyes and ears of society *(yaoluan shehui shang de ermu)*.[17] According to what the advertisements say, there exist almost no books that are not good publications, and, "for this reason, you buy and I buy, and we do not say that this kind of foul thing gives us a stomach ache after we eat it; if people take it home and discover later that it is foul and they do not eat it, still the book is already sold, and the goal of earning your money was achieved long before."[18]

The most wicked aspect of the Wenhuajie publishers' behaviour is their heartless attitude toward authors. We know, for instance, Zhou asserts, about the workers' being fleeced by the capitalists, and that seems too inhuman, but what about the authors? According to what Zhou was able to discover, the cost of printing a book was only a third of its retail price. When the publishing companies print a lot, he says, their cost is reduced. Cheap paper and binding bring their costs down even further, but the Commercial Press or Zhonghua author gets only a 15 percent royalty. Distribution costs may add no more than 20 percent and will add none if the work is sold directly. The publishers take all the remaining income, up to 50 percent, says Zhou.

As we have seen in the discussion of the textbook wars, particularly those from 1924 to 1928, when Zhou was writing, there was contemporary justification for his critique. But his comments also have an abstract, timeless quality that sounds much like the views of Wu Woyao two decades earlier. In *Vignettes from the Late Qing*, Wu also criticized Chinese publishers, particularly for their exploitation of China's national crisis. Like Wu, whose solution to the crisis was a call for the production of "useful books," Zhou offers a solution to the problem of commercially driven intellectual abuse. However, his methods suggest a longing for the early days of Shanghai publishing, before print capitalism had become so aggressively and anonymously

consumer oriented, marketing its wares to any and all who came through the shop door with money in their hands.

To redress the evils of Chinese print capitalism, Zhou called for the revival of two publishing methods that would have been familiar to the early print capitalists of the 1880s as well as to their literati predecessors. One was the subscription method *(yuyue fa)*, similar to the system by which Xu Run and many literati publishers prior to him had subsidized their publications in advance of printing. The second was what Zhou calls the "loan method" *(daikuan fa)*. It would involve a form of self-publishing whereby a group of friends would organize a publishing organ and make a loan to an author to help him publish and distribute his own work.[19] The publishing organ would, he suggests, take only some trifling administrative fees.

In Zhou's lack of interest in or awareness of how technology had changed Chinese publishing, he was, paradoxically, similar both to many other intellectual critics of Wenhuajie and to many of Wenhuajie's own boosters. Like them, he suffered from the social myopia of the bookworm. Issues such as where presses and machines would be manufactured, who would pay for them, and how they would be maintained were outside his purview. Instead, Zhou left that discussion to printers such as He Shengnai (active 1920s, 1930s) et al., through whose eyes we earlier viewed China's Gutenberg revolution. As we know, only a small but nonetheless historically influential group of Chinese intellectuals crossed the bridge that led from a focus purely on intellectual culture to one that included material culture and the reciprocal influence of both on the modernization of China. Even that group of intellectuals, however, did not present the view from the print-shop floor up.

An Elite Critique of Wenhuajie's Printing Operations

The Chinese print workers' strikes of 1917, 1925, and 1927 suggest the relevance of Lucien Febvre and Henri-Jean Martin's observations about the social history of the European book to the history of the Western-style Chinese one. Febvre and Martin, it will be recalled, described the printer as Europe's first capitalist, his print shop as the world's first factory floor, and, at least by implication, his employees as being among the first beneficiaries and victims of the emerging capitalist system. Febvre and Martin also explained their interest in the history of the printing press from the perspective of those concerned with a new way of producing and circulating ideas in an aristocratic society and with the impact of these ideas on those who had formerly been silent and illiterate.[20]

Other scholars of European history, such as Robert Darnton, have pursued aspects of Febvre and Martin's logic. Darnton's early modern French

printers are familiar from his essay "Workers Revolt: The Great Cat Massacre of the Rue Saint-Sevérin," but printer-activists also appear in accounts of the French Revolution of 1789, the German revolutions of 1848, and Russia's 1905 revolution. Paul Chauvet writes on the French Revolution, P.H. Noyes describes the German revolutions of 1848, and Charles A. Ruud profiles a leading pre-Bolshevik Russian printer-publisher. All develop the theme of book printers as the "most intelligent of the working classes" (as the printers of the 1848 Mainz Congress styled themselves). All four cases, the French, the German, the Russian, and now the Chinese suggest that not only the story of publishing and publishers, but especially that of printing and printers, is revealed most strikingly in the context of revolutionary politics.[21]

Five years after the first Shanghai printers' strike, the Changsha, Hunan, printers revolted. In her account of the 1922 Changsha strike of lead-type compositors and printers, Linda Shaffer observes that the striking workers "performed a job that had not existed in China before the [nineteenth] century."[22] By 1922, however, says Shaffer, thirteen modern printing firms were located in Changsha; a new-style, class-based printers' union had also been organized in 1920 by budding labour leader Mao Zedong (1893-1976). Shaffer quotes Mao's biographer, Li Rui (b. 1917), to the effect that Mao was secretary of the union and that he was "very familiar with the lives of the printers and had a deep understanding of their problems."[23] Mediated on 10 December 1922, the strike ended two days later. Leading the union mediators was none other than Mao himself, who certainly knew how much of this new industry depended on Chinese technicians working with Western-style technology, whether imported through Shanghai or manufactured there.

The Nationalist Party had been introduced to the values of the Shanghai publishing world through its own early efforts to disseminate its ideology. Parks Coble points out that, in the early 1920s, "Sun Yat-sen had condemned the 'selfish capitalists' and called for state control of major industrial enterprises in China."[24] In 1927, after Sun's death, the Nationalists also discovered the leading role taken by printers among the city's proletariat. Following establishment of the new national government in 1928, as we know, the Nationalist state apparatus began to seek ways of curbing both publishers and printers.

Even after 1928, the Nationalist Party platform remained fundamentally anticapitalist, Coble argues. From their new national capital in nearby Nanjing, the Nationalists now sought to suppress the Shanghai publishers not only commercially but also politically. They developed a commercially competitive series of publishing units under their direct control in the new national capital with the intention of supplanting Shanghai and Wenhuajie

as Republican China's modern publishing capital. The Nationalists also moved their own personnel onto the directorates of the elite Shanghai publishing corporations, a process that had begun at Zhonghua in 1918. Control of the publishers, of course, also implied control of the printers.

Although strikes could be suppressed, the conditions that gave birth to them did not disappear. Already by the early 1920s, Chinese printers were being radicalized daily at work not only by a mechanized workplace but also by Marxism, which those who made the presses run regarded as a profoundly democratic philosophy. Also, rather than praise the capitalists who organized the economy, Marxism praised those who ran the machines. Underlying printers' new importance in China was their access to and mastery of the single most important public communications machinery known to humans since 1814, when the steam engine was adapted to print the *Times* of London. The polarization of class relations between print capitalists and print proletarians seems to have been almost inevitable in retrospect, yet, when class harmony ruptured in Shanghai in 1917, in 1925, and again in 1927, it seemed to many to signal a malady in the capitalist system itself.

Between 1928 and 1937, Nationalist government ministers, printers, and publishers trumped the commercial and industrial centralization brought about by Shanghai publishers with an unfamiliar form of political centralization. Perhaps because of the success of the Nationalist Party-state and the Shanghai print capitalists in jointly regulating printing workers, the fiction of Mao Dun (1896-1981), the well-known Commercial Press editor, Communist Party organizer, and writer encountered in the final chapter, remains one of our best guides to the lives of printing and publishing workers in 1930s Shanghai. The newly literate, and articulate, printing proletariat was first given voice in Mao's writing of the 1930s and reveals the psychological impact of print capitalism on at least one privileged member – Mao himself – of the new class of intellectuals created by that system of production.

Twice in the 1930s, first in 1932 and then again in 1936, Mao Dun published stories about Shanghai's printing and publishing industry. Where Wu Woyao's (1866-1910) *Vignettes from the Late Qing* (1909) discusses late imperial print culture and print commerce, Mao Dun's stories are clearly set in the era of industrialized print capitalism. Mao was an editor, so it is not surprising that editors exist in his stories. Still, even more significant to Mao were print workers, absent from Wu's novel.[25] Just as He Shengnai et al.'s coeval discovery of printing technology indicates a new Chinese awareness of the importance of material culture in creating modern China, so too Mao Dun's stories reflect the broadening social awareness of the importance of these new workers in the creation of modern China. Although the editorial offices may have been run like old-fashioned government offices,

as Mao tells us in his memoirs they were, his short stories make clear that the printing plants were not.

Mao's short story "You di er zhang" ("Wartime") is set during the 1932 Japanese attack on the Commercial Press's Baoshan Road plant. Sharply satirical, the story establishes a stark contrast between the pusillanimous establishment intellectual, represented by Mr. Li, a ten-year veteran of the Commercial Press's editorial office, and Xiang, the bold typesetter who lives next door, and other selfless patriots who work with him. Not only are these proletarian printers a central part of Mao's story, but they are also the most admirable characters in it.

Once the Commercial Press buildings start burning on 28 January 1932, these anti-Japanese printers rush to the firm's aid while Mr. Li cowers at home. First, though, as the Japanese bombers regroup for another assault on the Commercial Press and its Zhabei district neighbours, Mr. Li and Xiang discuss the initial attack. Mao Dun describes Li and Xiang as being "both in the same line, so to speak": that is, publishing. In fact, however, they have never spoken until the night of the attack because of the social hierarchy prevailing at the Commercial Press. "Although [Xiang] was a neighbor and they both worked for the same firm, since one was a 'gentleman' in the editorial department and the other only a worker on the printing press, the two seldom met."[26] Almost immediately, their paths, having crossed for an instant during the Japanese raid, diverge again. The story concludes with Xiang and his friend, another typesetter, volunteering to join an army work gang to fight the Japanese while Li and his family move into Shanghai's French Concession, living on an advance of Li's Commercial Press pension. Regardless of the era, Chinese writers seem to have drawn repeatedly on the same lexicon to describe publishing industry editors.[27] Mao Dun's Mr. Li, the Commercial Press editor, is presented as an ineffectual and calculating hypocrite who distorts the proper ends of book learning. Unlike *Vignettes from the Late Qing*, however, "Wartime" offers a positive view of the proletarians responsible for manufacturing the books edited by effetes such as Li.

Four years after publishing "Wartime," Mao Dun returned to this theme in a story that reflected the Shanghai publishing industry's new awareness of science, technology, and invention. In 1936, Wenhuajie's Kaiming shudian, itself founded by a former Commercial Press editor, Zhang Xichen (1889-1969), invited Mao to submit a contribution to the publisher's new magazine for adolescents, called *Xin shaonian* (New Youths). *New Youths* was created to compete with the Commercial Press's *Ertong shijie* (Children's World). Although Mao rejected the assignment at first, he eventually wrote "Shaonian yinshua gong" ("The Young Printing Worker"). This second story presents a microcosm of Shanghai's printing industry, echoing many themes of late

imperial and modern Chinese printing and publishing discussed in the present book.

Partly under the influence of Thomas Francis Carter's (1882-1925) work on China's invention of printing, 1930s Shanghai printers began writing about the history of their craft, both before and after the development of Western-style printing. Their interest reflected a broadened popular concern with modernizing China's science and technology that dated back to the elitist Self-Strengthening Movement (1860-95) of the nineteenth century. In his memoirs, Mao Dun states that his story was aimed at youths with the equivalent of an upper primary and early secondary education as well as at apprentices, child workers, and "boys" (i.e., waiters). All were the kinds of youths who probably had had some schooling but had also had to quit school, often because of straitened family circumstances. In spite of the youths' own need to find some means of supporting themselves, the educational values of 1930s China often left them with a bias against technical work. The chief editor of *New Youths* was Mao's fellow writer, the well-known novelist Ye Shengtao (1894-1988), who, by this time, had also served as an editor at the Commercial Press. In addition to entertaining its readers, part of the objective of Mao's story, in keeping with Ye's experiment in using his journal to impart "scientific" knowledge to young readers, was to introduce technical printing knowledge to them.[28] Ye's effort represented a literary approach to the growth of interest in 1930s China in promoting the ideal of a broad-based education in science and technology for the sake of the country.

Mao Dun wrote about a group of adolescents with whom he was probably familiar from his Commercial Press days. Like "Wartime," "The Young Printing Worker" is set in the days following the Japanese attack of 1932. It involves a boy, Zhao, whose father's store is bankrupted by postwar economic collapse, just like dozens of the small Zhabei district machine shops, discussed in Chapter 3, that depended on the Commercial Press. Zhao is a gifted and idealistic student but has to quit middle school. He reads about foreigners who became successful inventors despite their poverty. However, he is most inspired by a book about a still-living Shanghai inventor who founded a well-known local electric fan company.

Soon Zhao finds work in a paper-making factory, believing that he will be able to learn about machines and electricity while earning six yuan per month. Recalling that Chinese invented paper long before, Zhao is disappointed to find that the paper-making machine was manufactured in the Netherlands. Quickly dissatisfied with his job counting sheets of paper all day long, Zhao quits it. His father then urges him to take a position as a restaurant "boy" so that he will be able to wear nice clothes and work with nice people; factory workers, by contrast, he says, pass dirty lives among rough people. Mao

Dun makes clear that Zhao's father's contempt for technical work reflects a deep-seated cultural bias against physical or technical work. Zhao refuses to take a job as a "boy," actually insisting that he prefers "to serve machines" *(sihou jiqi)*, not rich compradores and foreigners.[29] Having read a book about a successful local inventor, Zhao still dreams of becoming one himself by working with electrical machines.

Eventually, his uncle suggests that Zhao apprentice himself to a small printing shop so that he can learn typesetting. Like the apprentices in the Mingjing Machine Shop, who dreamed of opening their own businesses, Zhao's uncle holds out the prospect that patient acquisition of printing skills will position Zhao to run his own printing firm. Zhao also fantasizes about reading books hot off the presses.

The printing firm is located in a four-room, two-storey residential structure reminiscent of the houses in which both Tongwen and the Commercial Press got their starts. It has five or six type racks and only one manual printing press. After reporting for work, Zhao finds that he will live on the ground floor of the shop house with another apprentice, again much like the apprentices in the Mingjing Machine Shop. Zhao also meets an older worker, Lao Jiao, who was baptized *(xili)* by revolutionary activities in 1927, a clear reference to the Nationalist government's attack on the Commercial Press printing workers in advance of the Japanese attack that ruined Zhao's family.

By watching the firm's printers, Zhao gradually learns how to typeset, print proofs, and do other printing operations. While he works there, the small print shop converts from hand-casting lead type, presumably using techniques that dated back to Peter Perring Thoms (active 1814-51) in Macao around 1815, to using copper matrices of the sort that Samuel Dyer (1804-43) had developed in 1838 in Penang. At the same time, Lao Jiao tells Zhao about the Monotype keyboards used to print foreign languages. Unfortunately, he says, no such machines exist yet for printing Chinese. The boy's dreams of invention are revived, and Zhao begins to dream of inventing such a machine.[30] When Lao Jiao leaves for a new job in a larger print shop, Zhao accompanies him, his new dream of working in a large, mechanized publishing plant apparently on the cusp of fulfillment.

Both of Mao Dun's stories evoke the same concern that Marc Bloch alluded to in his comments on the history of technology. The fiction of technology, like the history of technology, should reveal the importance of social values, both inherited ones and newly acquired ones, in the choice and deployment of machinery. For Mao, these values extend from the preoccupation of the "gentleman" editor, Mr. Li, with his status as an editor and intellectual, to the interest in technology and inventions shown by the

apprentice, Zhao. To Zhao, and to Mao's readers as well, machinery, particularly mechanized printing presses that can be used to print books to advance public knowledge of science and technology, is a beacon for poor men in a country under siege by belligerent imperialists and torn apart by civil strife.

For Mao Dun, as well as for Mao Zedong, modern printing workers using lithographic and letterpress machines were what separated Shanghai's and, indeed, China's modern printing industry from its traditional one. Both Maos likely also realized that, without Western printing technology and large industrialized corporate printing firms, neither these thousands of modern workers nor the plethora of new-style books from which they themselves had learned about science, democracy, and invention could have existed. At the same time, both regarded Western printing technology as having been largely sinicized by the 1930s.

Fully a third of Mao Dun's "The Young Printing Worker," intended to reveal the mysteries of modern printing technology to latter-day Xia Ruifangs in search of both role models and apprenticeships, is devoted to explaining how printing technology actually functioned, both as a technological and as a social system. Although, like Mao Zedong, Mao Dun recognized that this was a foreign technology adapted to Chinese uses, in light of its importance in advancing modern ideas, for all intents and purposes, the technology is treated as if it were modern Chinese mind. Politics, formal schooling, libraries, popular scientific and technical education, invention, markets, patriotic workers, printing technology, printing shops, and publishing companies are all interwoven in Mao Dun's mid-1930s view of Chinese print capitalism.[31] Minus the capitalism, it is a pastiche that would live on into fiction writing of the People's Republic of China, revealing the profound impact of Shanghai-based print capitalism on the modern Chinese mind. Indeed, Mao Dun's stories initiated the motif of the articulate, intellectually aware, and morally committed printer later reworked by well-known fiction writers such as Gao Yunlan (1910-56) in *Xiaocheng chunqiu* (*Annals of a Provincial Town*) and Yang Mo (b. 1914) in *Qingchun zhi ge* (*Song of Youth*).[32]

Although Chinese of the 1930s gained from the plenitude created by the Wenhuajie publishers, the publishers had also increasingly come to be seen as part of a social and political system benefiting too few in a country of too many. In "Wartime," Mao Dun, himself a product of Shanghai's print capitalist system, criticized capitalism only implicitly. By the time he published "The Young Printing Worker" four years later, however, he did so directly, through praise for the Soviet Union. Mao's short stories praise technology, the process of invention, books, workers, and large industrial plants. At the same time, reflecting the inability of Nationalist-era markets to reach all

who could have profited from these advances, capitalism and the commerce that it encompasses are regarded as dispensable. In this critique, Mao affiliates himself with a long Chinese tradition of censuring commerce in books. Updating the criticisms of *Vignettes from the Late Qing*, Mao's story also reflects the criticisms of Wenhuajie that had surfaced throughout the 1920s and 1930s and that would contribute, eventually, to the ease with which most Chinese intellectuals in the publishing world, the Commercial Press's Zhang Yuanji among them, would embrace the Communist state in 1949.

In the end, after reading elite critiques of Chinese print culture, print commerce, and print capitalism, one is left wondering whether the ambiguous status of China's book merchants had changed at all between 1909, when Wu Woyao's critique appeared, and the 1920s and 1930s, when Zhou Quanping and Mao Dun published theirs. However, through all the evaluations of the traditional publishers and the modern Shanghai print capitalists, both from within and from outside their industry, from its consumers, and from the various governments with which they interacted, one major transformation stands out clearly.

The technological foundation on which the book merchants relied under Chinese print capitalism, and on which they would later rely again under Chinese print communism, had changed irreversibly. Western printing presses and machines had been chosen and modified by Chinese to serve Chinese objectives. This vital civilian technology that many Chinese could trace to Gutenberg made possible, and may even have helped to motivate, educational efforts to alert other Chinese to technology's myriad benefits, eventually allowing a wide range of foreign technology to ride in on its coattails. In the meantime, the influential new-style dictionaries produced with Western-style presses, *Ciyuan* (Commercial Press, 1915) and *Cihai* (Zhonghua Books, 1936-37), found their way to Mao Zedong's remote corner of wartorn China, material evidence of the importance of Shanghai's print capitalists' words and ideas in the establishment of the People's Republic of China.

Appendix:

A Bird's-Eye View of 1930s Shanghai's Fuzhou Road/Wenhuajie District

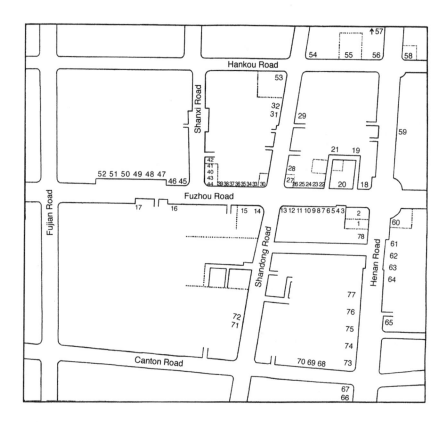

Note: To simplify addresses, numbered lanes and alleys are listed as if they were numbers on the main streets. When different firms share the same address, they are on different floors of the same building.

1 Commercial Press 商務印書館 (est. 1897, comprehensive [lithographic, letterpress, collotype, etc.] printer, publisher, and bookseller with retail branches throughout China; most important of the "Big Three" corporate printer-publishers of Republican China; controlled 65 percent of

the 1930s primary and secondary school textbook market), 211 Henan Middle Road, 1912-49.

2 Zhonghua Books 中華書局 (est. 1912 by Lufei Kui [1886-1940] and Shen Zhifang [1882-1939], former Commercial Press employees; comprehensive printer, publisher, and bookseller with retail branches throughout China; second most important of the "Big Three" corporate printer-publishers of Republican China; controlled 30 percent of the 1930s primary and secondary school textbook market), 221 Henan Middle Road, 1916-49.

3 Zuozhe shushe 作者書社 (est. 1932, bookseller), 269 Fuzhou Road, 1932.

4 Guangming shuju 光明書局 (est. 1927, publisher and bookseller), Fuzhou Road, 1927-38, then moved to 296 Fuzhou Road.

5 Guanghua shuju 光華書局 (est. 1921, Zhang Jinglu's [1898-1969] first firm and Shanghai's first all new-style publisher and bookseller), Fuzhou Road, 1925-35.

6 Zhongxuesheng shuju 中學生書局 (est. 1930, publisher and sales of works for juveniles), Fuzhou Road, 1930-c.40.

7 Qinfen shuju 勤奮書局 (est. date unknown, publisher and sales of works for juveniles), Fuzhou Road, 1930s.

8 Sishuju menshibu 四書局門市部 (est. c. 1930, publisher and bookseller), Fuzhou Road, 1930s.

9 Huatong shuju 華通書局 (est. 1920s by Nationalist Party members and a Shanghai gangster as publisher and bookseller), Fuzhou Road, 1920s-38 (after merger with Japanese publisher Sanshengtang shudian 三省堂書店 became Santong shuju 三通書局, distributor of the Nanjing puppet government's primary school textbooks).

10 Huanqiu huapian Company 寰球畫片公司 (est. date unknown, published calendars and painting reproductions), Fuzhou Road, 1930s-56.

11 Meide shudian 美的書店 (est. 1926 by Beijing University professor Dr. Zhang Jingsheng, a.k.a. "Dr. Sex," publisher and bookseller, particularly of Zhang's own works; in February 1926, when his *Xingshi* [Sex Histories] was published, concession police had to use fire hoses to disperse the throngs of customers spilling into Fuzhou Road), Fuzhou Road, 1926-29.

12 Liangxi tushu gongsi 梁溪圖書公司 (est. date unknown, publisher and bookseller), Fuzhou Road, 1930s.

13 Chen Zhengtai huapian dian 陳正泰畫片店 (est. date unknown, published calendars and painting reproductions), Fuzhou Road, 1930s-49.

14 Zhongxi/Sino-Western Pharmacy.

15 Baixin shudian 百新書店 (est. 1912, publisher and bookseller, multiple branches, including Hong Kong), 375 Fuzhou Road, 1932+.

16 Beixin shuju 北新書局 (est. 1924 in Beijing, well-known letterpress printer-publisher of Lu Xun's works and books advocating New Culture ideals, forced to leave Beijing by warlord Zhang Zuolin [1873-1928], later also known for publishing social sciences, textbooks, etc.), Fuzhou Road, 1926+.

17 Wenhui shuju 文匯書局 (est. date unknown, lithographic publisher and bookseller), 397 Fuzhou Road, 1930s

18 Liming shuju 黎明書局 (est. by Fudan University faculty, date unknown, publisher and bookseller), 254 Fuzhou Road, 1930-49.

19 Chuanxin shudian 傳新書店 (est. date unknown, sold old string-bound woodblock and lithographed books and rubbings, a favourite haunt of bibliophile Zheng Zhenduo [1898-1958]), 260 Fuzhou Road, ?-1956.

20 Kaiming shudian (retail) 開明書店 (est. 1926 by Zhang Xichen [1889-1969], former editor of Commercial Press's *Funü zazhi*; comprehensive publisher and bookseller; also ran and operated Meicheng yinshua gongsi 美成印刷公司, located in Hongkou's Wuzhou Road until the Japanese destroyed it in 1937), 268 Fuzhou Road, 1930-47.

21 Kaiming shudian (business and editorial offices), 272 Fuzhou Road, 1930-47.

22 Xinyue shudian 新月書店 (est. 1927 by intellectuals Hu Shi [1891-1962], Xu Zhimo [1897-1931], Liang Shiqiu [1903-87], Wen Yiduo [1899-1946], et al. to publish the journal *Xinyue/New Moon* and other literary works), 272 Fuzhou Road, 1927-33, when it merged with the Commercial Press.

23 Xiandai shuju 現代書局 (est. 1927 by Zhang Jinglu, Shen Songquan, and Lu Fang, published and sold art and social science books), 286, 288, 290 Fuzhou Road, 1927-35.

24 Jinwu shudian 金屋書店 (est. 1930s, journal and book publisher), Fuzhou Road, 1930s.

25 Guangming shuju 光明書局 (est. 1927, progressive publishing and sales), 296 Fuzhou Road, 1938-55.

26 Qunzhong tushu zazhi gongsi 群眾圖書雜志公司 (est. early 1920s, general publisher, including Shen Congquan's 1924 edition of *Xu Xiake youji*), 300 Fuzhou Road, 1924-c.40.

27 Kaiming shudian original site, Fuzhou Road, 1926-30, then Xin Zhongguo tushuju 新中國圖書局 (est. 1930, primary school textbook publisher and bookseller), Fuzhou Road, 1930+

28 Zhenmeishan shudian 真美善書店 (est. 1927 by late Qing writer Zeng Pu [1871-1936] and his son Zeng Xubo, journal and book publisher) Shandong Road (then Wangping St.), 1927-1933 or 1935.

29 Hanwen zhengkai tushu gongsi 漢文正楷圖書公司 (est. 1929 by former Zhonghua fine art editor Zheng Wuchang [1894-1952], general publisher and printer; known for its wide range of Zhengkai-style type matrices sold throughout China and imitated by the Japanese publisher Sanshengtang), Shandong Road (then Wangping St.), 1935-54.

30 *Shibao* newspaper offices 時報館 (est. 1904 by Buddhist Di Chuqing [1873-1939] with financial support from Kang Youwei [1858-1927]; Di lost control of the paper in 1921 but it continued until 1939; in 1906, *Shibao* hired Bao Tianxiao [1876-1973] as an editor, starting his long relationship with *Shibao*); *Shibao* was located here from 1921; first floor was occupied by sister-firm Youzheng shuju 有正書局 (est. 1904 on Weihaiwei Road, it moved here in 1921; a collotype printer, publisher of paintings, calligraphy, traditional books, and a bookseller, it published Di's works and some of Bao's translations; journalist Ge Gongzhen [1890-1935] apprenticed with Youzheng in 1913 and rose to become chief editor of *Shibao*); 1931-49, building was also occupied by Dadong shuju 大東書局 (est. 1916), a comprehensive printer-publisher and bookseller with branches throughout China; in addition to printing books and journals, Dadong printed currency for the Nationalist government, 1931-49; 310 Shandong Road.

31 Xinxin chubanshe 新新出版社 (est. date unknown, closed by concession authorities for publishing a memoir of the 1927 Shanghai massacre), Shandong Road, 1934.

32 Youzheng shuju 有正書局 (see 30 above) lithographic, letterpress, and collotype printer-publisher and bookseller; in late Qing had branches in Beijing, Tianjin; Shandong Road, 1904-43.

33 Gonghe shuju 共和書局 (est. date unknown, branch of Canton firm, publisher and bookseller), Fuzhou Road, 1920s-30s.

34 World Books 世界書局 original site ("Red House"), est. 1921 by Shen Zhifang, former Commercial Press and Zhonghua employee, third most important of the "Big Three" corporate printer-publishers of Republican China; 320 Fuzhou Road, 1921-32, then Dazhong shuju 大眾書局 (est. 1932 by former World Books distribution manager, lithographic and letterpress printer-publisher of primary school textbooks, medical dictionaries), 1932-49.

35 Shanghai zazhi gongsi 上海雜志公司 (legendary progressive firm est. 1934 by Zhang Jinglu after he left Xiandai shuju [see 23 above]; China's

first store to specialize in journal sales, both foreign and domestic; from 1935 published literary journals and books), 324 Fuzhou Road, 1934-49.

36 Qiming shuju 啟明書局 (est. by Shen Zhiming, son of Shen Zhifang, with help from Zhu Lianbao [1904-88] and others, published reference books, children's books, etc.), 328 Fuzhou Road, 1930s.

37 Dazhong shuju 大眾書局 original site, Fuzhou Road, 1916-31, then Jiuzhou shuju 九州書局 (est. 1930s, published popular works), 1930s.

38 Xinshengming shuju 新生命書局 (New Life Bookstore, est. c. 1928 by Nationalist Party intellectuals Zhou Fohai [1897-1948], Tao Xisheng [b. 1899], Fan Zhongyun, et al., who published progressive works, including Hu Yuzhi's [1896-1986] memoirs of life in Moscow), Fuzhou Road, 1928-37.

39 Yadong tushu guan 亞東圖書館 (est. 1913 by Anhui natives and eventual Trotskyist fellow travellers Wang Mengzou and his nephew Wang Yuanfang as an outgrowth of their Kexue tushushe in Wuhu; moved in 1919 close to the corner of Canton (Guangdong) and Henan Middle Roads at the suggestion of lifelong friend Chen Duxiu (1879-1942), who, with Hu Shi, also acquired New Culture manuscripts for the firm to publish; 1919-35, letterpress printer; published journals, books), Fuzhou Road, 1935-37.

40 Commercial Press original retail site, corner of Fuzhou Road and Shanxi Road, 1897-1902, then Xu Shengji huapian dian 徐胜記畫片店 (1909-56, using its own print shop, which had some of East Asia's most advanced printing equipment, published miniaturized reproductions of paintings, calendar-style *nianhua* for sale nationally, in Hong Kong, Southeast Asia, and even India), 1930s.

41 Taidong tushuju 太東圖書局 , Fuzhou Road, 1915-49?

42 Taiping shuju 太平書局 (est. c. 1937, issued official Japanese literary propaganda after the start of the Second Sino-Japanese War, including some by Zhou Zuoren [1885-1967]), 342 Shanxi Road, post-1937-45.

43 Shenghuo shudian 生活書店 (est. 1932 by well-known patriotic journalist Zou Taofen [1895-1944] after the demise of his weekly journal, *Shenghuo zhoukan/Life Weekly*; published books, journals, etc.; supported by the Chinese Communist Party, it was the most progressive patriotic bookstore in China), 378-84 Fuzhou Road, 1932-37; after 1937, Shenghuo became Xiongdi tushu gongsi 兄弟圖書公司 here.

44 Zhongguo tushu zazhi gongsi 中國圖書雜志公司 (est. c. 1936, published journals), 380 Fuzhou Road, 1936-39, later Yongxiang yinshuguan 永祥印書館 (est. in 1899 as a general printing firm, started to issue books and journals around 1942), 1942-56.

45 Shenzhou guoguangshe 神州國光社 (est. 1908 with 10,000 yuan; letterpress printer-publisher, also collotyped calligraphy, rubbings, etc.; after 1932, Chen Mingshu, Wang Lixi [d. 1939], and Hu Qiu operated it as an important publisher of social science works), 384 Fuzhou Road, 1908-54.

46 World Books 世界書局 (see 34 above) 390 Fuzhou Road, 1932-49; this site was originally that of the Qingliange Restaurant 青蓮閣 .

47 Jiaojing shanfang 校經山房 (est. 1883 in Chinese city near the Great Eastern Gate on Chaobao Road, woodblock printing 1883-84; letterpress by 1899; lithographic printing 1905-26, published traditional string-bound books, vernacular novels, and, in the 1930s, works by Zheng Yimei and traditional medical works), Fuzhou Road, 1935-41.

48 Sanyi huapian gongsi 三一畫片公司 (est. 1927 as a printing company but expanded into high-quality calendar, painting reproductions, and other publishing), 420 Fuzhou Road, 1927-30s.

49 Ertong shuju 兒童書局 (est. date unknown, well-known publisher of children's books), 424 Fuzhou Road, 1930s.

50 Shougu shudian 受古書店 (est. c. 1927, rare-book dealer and lithographic publisher), Fuzhou Road, 1930s.

51 Hanwenyuan shusi 漢文淵書肆 (est. date unknown, rare-book dealer; with Shougu shudian [see 50 above], a frequent haunt of bibliophile Zheng Zhenduo), Fuzhou Road, 1930s.

52 Wenhua shenghuo chubanshe 文化生活出版社 (est. 1935 by famous writer Ba Jin [b. 1904] and others, literary publishing and sales), 436 Fuzhou Road above the *Dagong bao* 大公報 newspaper offices, 1936-38.

53 *Shenbao* newspaper offices 申報館 (est. 1872 by Ernest Major, parent company of old Dianshizhai, Tushujicheng, and Shenchang shushi firms), corner of Hankou and Shandong (Wangping) Roads, 1918-37.

54 Qianqingtang shuju 千頃堂書局 (est. 1883 in Chinese city; like Saoye and Zhuyitang, it started as a lithographic printer-publisher of string-bound books, especially medical works; 1930s, started letterpress printing and manufacturing Kaiti [block letter] font matrices), corner of Hankou and Shandong (Wangping) Roads, 1883-1955.

55 *Xinwen bao* newspaper offices 新聞報館 (est. 1893), on Hankou Road between Shandong and Henan Middle Roads, 1930s-49.

56 Zhonghua Books 中華書局 original site, 325 Henan Middle (Qipanjie) Road, 1912-16, then Huiwentang shuju 會文堂書局 (est. 1903, comprehensive printer-publisher), 1916-49

57 Commercial Press's second address, Henan Middle Road near Nanjing Road, 1902-12.

58 Zhongyang ribao newspaper offices 中央日報館 (Nationalist Party, then central government newspaper), corner of Henan Middle and Hankou Roads, 1916-49.

59 Shanghai Fire Brigade 上海市消防處 , Henan Middle Road between Hankou and Fuzhou Roads.

60 Wuzhou Pharmacy, corner of Fuzhou and Henan Middle Roads.

61 Longmen lianhe shuju 龍門聯合書局 (est. 1930 with links to Jiangsu No. 2 Normal School, after 1938 merged with three Beijing refugee printing-publishing firms; photo- and litho-reprinted German- and English-language science and technology textbooks for sale at from 10 to 20 percent of the original prices; this effort led to a subsidy from Jiaotong University students and contracts with Nanjing's Zhongyang and Hangzhou's Zhijiang universities but also caused some copyright problems in the late 1940s; in 1937, the Japanese destroyed Longmen's Hongkou printing plant, which Longmen rebuilt during the war), 210 Henan Middle Road, 1937-54.

62 Minzhi shuju 民知書局 (est. 1921 by Nationalist Party stalwarts with links to strongman Hu Hanmin [1879-1936]; published textbooks, reference books, and official Nationalist works), Henan Middle Road, 1921-37.

63 Shenmei tushuguan 審美圖書館 (est. early 1930s by the Lingnan School painter-brothers Gao Jianfu [1889-1933] and Gao Qifeng [1879-1951]; chiefly an art gallery, it also printed and published fine postcards and pictures), Henan Middle Road, 1930s.

64 Zhengzhong shuju 正中書局 (est. 1933 by the Nationalist Party's "CC Clique," with an office at 384 Fuzhou Road and a sales office on Henan Middle Road at Qiujing Road; the head office was in Nanjing; published and sold Nationalist Party-guided publications, which controlled less than 5 percent of the 1930s middle and primary school textbook market), 1933-49.

65 Qunyi shushe 群益書社 (est. 1902 in Changsha, Shanghai branch est. 1907, Tokyo 1909), opened at the corner of Qiujing and Henan Middle Roads, original publisher of Chen Duxiu's journal *Xin qingnian/New Youth*, also published reference and literary works, 1912-35.

66 Wenruilou 文瑞樓 (est. before 1880 in Chinese native city, lithographic publisher by 1893 and seller of string-bound traditional works, medical works, popular novels, as well as *Wu Youru huabao* [1911]), Henan Middle Road, 1880-1937.

67 Zhuyitang 著易堂 (est. in Chinese native city c. 1878, woodblock and letterpress printer-publisher of a wide variety of traditional and modern works, sold traditional literature, medical works, popular novels;

had exemplar library of 1,200 volumes), corner of Canton (Guangdong) and Henan Middle Roads, 1890-c. 1912.

68 Zhengxing huapian gongsi 正興畫片公司 (est. date unknown, owned by Singapore Chinese, published *nianhua*-style calendars and reproductions of paintings for sale in Southeast Asia; also imported Western-style oil paintings for sale in China), Canton (Guangdong) Road, 1930s.

69 Wenhua meishu tushuguan 文化美術圖書館 (est. date unknown, published best-selling account of the 1932 Japanese attack on Wusong and Shanghai, *Song Hu yu ri xue zhan dahuashi*), Canton (Guangdong) Road, 1932-?

70 Yadong tushu guan 亞東圖書館 (see 39 above), Canton (Guangdong) Road, 1919-35.

71 Hezhong shudian 合眾書店 (est. c. 1932 by former Taidong, Beixin, Xiandai employee who issued works by progressives Qu Qiubai [1899-1935], Lu Xun [1881-1936], and A Ying [1900-77]), Shandong Road near Renji Hospital, 1932-49

72 Dongya shuju 東亞書局 (est. by Shen Zhifang and others, date unknown), Shandong Road near Renji Hospital, 1920s-30s.

73 Jinzhang shuju 錦章書局 (est. 1894, reestablished 1901 with 50,000 yuan and fifteen lithographic presses; originally printed, published, and sold string-bound traditional works, medical books, popular novels; 1,300 of its titles were lithographed, according to Zheng Zhenduo; had branches in Beijing, Changsha, Hengyang, Hankou, Chengdu, and Canton; it also issued a leading "butterfly school" journal and cheap novels), Henan Middle Road, c. 1914-50s.

74 Jiaojing shanfang 校經山房 (see 47 above), Henan Middle Road, c. 1936-?

75 Saoye shanfang 掃葉山房 (est. c. 1600 in Suzhou; this was Saoye's second Shanghai address; woodblock and lithographic printer-publisher [including 1929 *Xu Xiake youji*] and booksales), Henan Middle Road, 1880-1955.

76 Guangyi shuju 廣益書局 (est. 1879 to print and publish lithographed civil service examination aids, traditional textbooks, after 1906 published traditional literature and popular novels sold in market towns and villages; later published illustrated popular literature; added letterpress printing from 1920; had retail branches throughout China; bought by World and Guangzhi shuju in 1925), 137 Henan Middle Road, 1900-47.

77 Xinya shudian 新亞書店 (est. 1925? by former Zhonghua manager, published charts, educational aids, and primary and secondary school science textbooks, as well as semi-official Nationalist Party publications), 159 Henan Middle Road, 1925?-49.

78 Wenming shuju 文明書局 original site (est. 1902 by Yu Fu, Lian Quan, and Ding Fubao [1874-1952] as a rival to the Commercial Press, comprehensive printing, publishing, and bookselling firm, 1904 became a colour lithographer and a collotype printer, then merged with Zhonghua; Bao Tianxiao worked here in 1910s, editing, among other works, *Xiaoshuo huabao* [1917]), 201 Henan Middle Road, later Qixin shuju 啟新書局 (est. date unknown, co-invested by Zhonghua, sold books, stationery, etc.), 1930s.

Sources:

Fan, Muhan, ed. *Zhongguo yinshua jindai shi, chu gao*. Beijing: Yinshua gongye chubanshe, 1995.

Quanguo Zhongyi tushu lianhe mulu. Beijing: Zhongyi guji chubanshe, 1991.

Wang, Qingyuan, Mou Renlong, Han Xiduo, eds. *Xiaoshuo shufang lu*. Beijing: Beijing tushuguan chubanshe, 2002 [1987].

Zhu, Lianbao. "Jiefangqian Shanghai shudian, chubanshe yinxiangji, yi, er." CBSL 1-10 (1982-87).

—. *Jinxiandai Shanghai chubanye yinxiang ji*. Shanghai: Xuelin chubanshe, 1993.

Glossary of Chinese Terms, Titles, and Names

Note: Commonly Used Characters Have Been Omitted

Printing and Publishing Terms

aoban yinshua 凹版印刷 intaglio/gravure printing

baihua 白話 vernacular language

bansitiao 半色調 halftone

baoguan 報館 newspaper office, bureau

boli ban 玻璃版 collotype

caise shiyin 彩色石印 chromolithography

caise yingxie ban 彩色影寫版 colour photogravure

cazi 擦子 short, whisklike brush used in xylographic printing

ce 冊 volume

changshua 長刷 "long brush," used in xylographic printing

chuanzhen ban 傳真版 facsimile

Cu ti 粗體 Cu font, one of the four major Republican fonts, created by the Commercial Press

Da Yingji 大英機 Big English Press (Wharfedale)

dangun tongji 單滾筒機 single-cylinder press

danxian baimiao 單線白描 line drawing

danzi zhupaiji 單字鑄排機 alternative name for Monotype

diandu tongban 電鍍銅版 electrotype

dianjing 電鏡 "electric lens"

dianxin shubao 點新書報 "leisure papers"

diaoke huozi 雕刻活字 cut type

diaoke tongban 雕刻銅版 copperplate

Fangsong ti 仿宋體 Song-like font, one of the four major Republican fonts, created by Zhonghua Books

Fangtou ti 方頭體 "full-head," "square-head" script, alternative name for Cu font

guntong yinshua ji 滾筒印刷機 cylinder press

Gu ti 古體 classic-style font

huangyang ban 黃楊版 boxwood/yellow poplar printing plate

Huawen paishaoji 華文排燒機 Sinotype

huozi 活字 movable printing type

jiang ti 匠體 "workman-style" (characters)

jiaoban 膠版 offset lithography

jingshi ziji 經史子集 "classics, histories, philosophers, collections," one traditional way to list book categories

jinshu ban 金屬版 metal printing plates

jiushu 舊書 "old-style" or traditional books

juan 卷 volume

Kai-ti 楷體 regular script font

Kaishu ti 楷書體 plain written-hand or standard calligraphic style

keluo ban 鉫鑼版 collotype

Lai-na paizi ji 賚納排字機 Linotype

Lai-nuo zhupai ji 萊諾鑄排機 Linotype

lishu 隸書 Han-dynasty official script

lianhuanhua shu 連還畫書 serial-picture books

lianshi zhi 連史紙 a southern-style bamboo paper, frequently used for lithography

Liulichang 琉璃廠 Beijing's booksellers' district since the eighteenth century

lunzhuan yinshua ji 輪轉印刷機 cylinder or flatbed printing machine, also rotary press

makoutie 馬口鐵 tinplate

Ma-na pai shaoji 馬拿排燒機 Monotype

maobian zhi 毛邊紙 rough-edged bamboo paper

maocao zhi 毛糙紙 a crude paper

maotai zhi 毛太紙 a rough paper

Meihua ti 美華體 Gamble's Song/Meihua/APMP type font

Meili yinji 美麗印機 Miehle printing machine

minchōtai (Chinese, Mingchao ti) 明朝體 Japanese name for Ming-dynasty-style character font

Mo-nuo zhupai ji 莫諾鑄排機 Monotype

nianhua 年畫 "New Year's" woodblock prints

niban 泥版 clay stereotype, also plaster stereotype

nongdan seban 濃淡色版 "light and shade" colour printing

pingban yinshua 平版印刷 planographic printing

qianban 鉛版 stereotype

quanfen 全份 "perfected": i.e., printed on both sides

quanzhang qianyin baozhi ji 全張鉛印報紙機 full-page lead-type newspaper press

sanjiao zijia 三角字架 one of three names for Gamble's type rack

sanse ban 三色版 three-colour printing

sanyuanse 三原色 three-colour printing

shengdou jia 升斗架 one of three names for Gamble's type rack

shigao ban 石膏版 plaster stereotype

shiyin 石印 stone-based lithography

shuanglun tong yinshuaji 雙輪筒印刷機 double-cylinder press

shuye xuetang 書業學堂 booktrade school

sijiao haoma 四角號碼 4-corner system of book classification

Song ti 宋體 Song-dynasty-style font, one of the four major
 Republican fonts

Tang-mu-sheng zidong zhuzi ji 湯姆生自動鑄字機 Thompson automatic
 type-caster

tao 套 a set of books

tongchang jia 統長架 unitary long type rack

tongke ban 銅刻版 copperplate

tuban yinshua 凸版印刷 relief printing/media

Wenhuajie 文化街 Shanghai's "Culture-and-Education Streets"

xiangpi ban 橡皮版 offset lithography

xinshu 新書 "new-style" books

xiupei 修配 "repair machines and supply parts"

yichu sansuo 一處三所 "one office, three departments"

Yingguo Mi-li-ji 英國米列機 "English Miehle"

yingtou xizi 蠅頭細字 "fly-head" characters lined up like eyebrows

yingxie ban 影寫版 photogravure/heliogravure

yuanbaoshi zijia 元寶式字架 one of three names for Gamble's type rack

yuanzhuo huiyi 圓桌會議 roundtable system of editorial decision-making

zhaoxiang aoban 照相凹版 gravure printing

zhaoxiang tongziban 照相銅梓版 photoengraving

zhaoxiang shiyin 照相石印 stone-based photolithography or zinc-plate
 photolithography

Zhengkai ti 正楷體 Zhengkai font, a.k.a. "Standard font," one of the four
 major Republican fonts, created by the Commercial Press

zhixing 紙型 papier-mâché stereotype, a flong

Zhuyin fuhao 注音符號 phonetic alphabet for Chinese

zhuzi ji 鑄字機 type-casting machine

zidong zhuzi ji 自動鑄字機 automatic type-casting machine

zimo 字模 cast-type matrices or movable type

Book and Other Titles

"Chubanjie de hunluan yu
 chengqing" 出版界的混亂與澄清
Congshu jicheng 叢書集成
Dianshizhai huabao 點石齋畫報
Feiyingge huabao 飛影閣畫報
Feiyingge huace 飛影閣畫冊
Guanshang kuailan 官商快覽
Liangyou 良友
Manyou suilu 漫遊隨錄
Meishu shenghuo 美術生活
Qingchun zhi ge 青春之哥
Qinglou huabao 青樓畫報
Quanshi liangyan 勸世良言
Rizhilu 日知錄
"Shaonian yinshua
 gong" 少年印刷工

Shenbao 申報
Shenjiang shengjing tu 申江勝景圖
Shiwubao 時務報
Songnan mengying lu 淞南夢影錄
Tushu yuebao 圖書月報
Wanyou wenku 萬有文庫
Wenxian tongkao 文獻通考
Xiaocheng chunqiu 小城春秋
Xiaoti Langxuan wenji 小題瑯嬛文集
Xinwen bao 新聞報
Xunhuan ribao 循環日報
Yingruan zazhi 瀛壖雜志
"You di er zhang" 右第二章
Zhongxing gongchen tu 中興功臣圖

Personal Names

Bao Tianxiao 包天笑
Bao Xianchang 鮑咸昌
Bao Xian'en 鮑咸恩
Bi Sheng 畢升
Cai Gao 蔡高
Chen Cunren 陳存仁
Chen Huageng 陳華庚
Chen Jiageng (Tan Kah Kee) 陳嘉庚
Chen Jintao 陳錦濤
Chen Lifu 陳立夫
Chen Liyan 陳立炎
Chen Yun 陳雲
Chen Zhaoqing 陳釗青
Chen Zhaoquan 陳朝泉
Dai Kedun 戴克敦
Deng Qiuzhang 鄧秋杖
Ding Fubao 丁福保
Du Yaquan 杜亞泉
Fan Yuanlian 范源濂
Gao Fengchi (Hanqing)
 高風池 (翰卿)
Gao Mengdan 高夢旦

Ge-deng-bao 葛登堡
Gu-teng-bao 谷騰堡
Gui Zhongshu 桂中樞
He Chengyi 何澄一
He Shengnai 賀聖鼐
Hu Renyuan 胡仁源
Hu Yuefang 胡月舫
Hu Yuzhi 胡愈之
Huang Sheng (Pingfu)
 黃勝 (平甫)
Ji Yihui 戢翼翬
Jiang Weiqiao 蔣維喬
Ka-te 卡特
Kong Xiangxi 孔祥熙
Li Changgen 李長根
Li Jinxi 黎錦熙
Li Shengduo (Muzhai)
 李盛鐸 (木齋)
Li Xiangbo 李湘波
Liang A'fa 梁阿發
Liu Longguang 劉龍光
Lu Gaoyi 陸高誼

Lü Ziquan 呂子泉

Lufei Kui (Bohong) 陸費逵 (伯鴻)

Luo Jialun 羅家論

Ma Duanlin 馬端臨

Mao Dun 茅盾

Mao Xianglin 毛祥麟

Qian Tangding 錢塘丁

Qian Zheng 錢徵

Qiu Zi'ang 邱子昂

Qu Ya'ang 屈亞昂

Shen Jifang 沈季芳

Shen Junsheng 沈駿聲

Shen Zhifang 沈知方 (芝芳)

Shen Zhizhang 沈志章

Shi Liangcai 史量才

Tang Shaoyi 唐紹儀

Tao Xingzhi 陶行知

Tian Jiasheng 田嘉生

Wang Boqi 汪伯奇

Wang Jingyun 王景雲

Wang Junqing 王均卿

Wang Licai 王立才

Wang Longyou 王窿佑

Wang Mengzou 汪孟鄒

Wang Shan'gen 王善根

Wang Tao 王韜

Wang Yunwu 王雲五

Wang Zhengting 王正廷

Wu Danchu 吳丹初

Wu Jingyuan 吳鏡淵

Wu Tiesheng 吳鐵聲

Wu Woyao (Jianren) 吳沃堯 (趼人)

Wu Youru 吳友如

Wu Yunzhai 吳蘊齋

Xi Zipei 席子佩

Xia Ruifang (Cuifang) 夏瑞芳 (粹芳)

Xia Songlai 夏頌萊

Xu Hongfu 徐鴻復

Xu Jifu (Xu Ji) 徐濟甫 (徐濟)

Xu Meikun 徐梅坤

Xu Run 徐潤

Yan Fansun 嚴範孫

Yan Zhong 延仲

Yang Zhengyang 楊正陽

Ye Jiuru 葉九如

Ye Shengtao 葉聖陶

Yu Fu (Zhonghuan) 俞復 (俞仲還)

Yu Youren 于右任

Zhang Jinglu 張靜盧

Zhang Jinlin 章錦林

Zhang Xichen 章錫琛

Zhang Yuanji (Jusheng) 張元濟 (菊生)

Zhang Zhiying 張志瀛

Zhao Hongxue 趙鴻雪

Zheng Zhenduo 鄭振鐸

Zheng Zhenwen 鄭貞文

Zhong Shiguang 鐘十光

Zhou Quanping 周全平

Zhu Jingnong 朱經農

Zhu Lianbao 朱聯保

Zhu Tian 竹天

Zhuang Yu 莊俞

Firm Names and Business Terms

Baishi shanfang 拜石山房

Baojinglou 寶經樓

Biefa yanghang 別發洋行

Bowen yinshua gongsi 博文印刷公司

Changming gongsi 昌明公司

Changxing jiqi zhizao chang (Shanghainese, Chong Shing) 昌興機器製造廠

Chongde gongsuo 崇德公所

Dadong shuju 大東書局

daikuan fa 貸款法

Dalong jiqi chang 大隆機器廠
Dianshizhai shiyinju 點石齋石印局
diejia xiaoshou 跌价銷售
diya jiekuan 抵押借款
duzi jingying 獨資經營
fangdian 坊店
Feiyingguan shiyinju 蜚英館石印局
fenxiao chu 分銷處
Fuwenge 富文閣
Fuxing tongmudian 復興銅糢店
Gongmin shuju 公民書局
gongsi 公司
gongsuo 公所
Gongyichang jiqi
 chang 公義昌機器廠
guan shu wenwu xing
 gongye 關書文物性工業
Guangbaisong zhai 廣百宋齋
Guangzhi shuju 廣智書局
guanyue 關約
gufen youxian gongsi 股份有限公司
Guomin shuju 國民書局
Guoxue fulunshe 國學扶輪社
Gushu liutong chu 古書流通處
Hanfenlou 涵芬樓
Heji gongsi 和濟公司
hetong 合同
hezi jingying 合資經營
Hongbaozhai
 shiyinju 鴻寶齋石印局
Hongwen shuju 鴻文書局
houtai laoban 後臺老闆
Huada jiqi chang 華達機器廠
Huiwentang shuju 會文堂書局
Hujiang jiqi chang 滬江機器廠
Hushang shuju 滬上書局
huxiao 呼嘯
jia 夾
Jianye jiqi zhizao youxian
 gongsi 建業機器製造有限公司
Jinsuzhai 金粟齋

Jishi shanfang 積石山房
Kaiming shudian 開明書店
kexue guanli fa 科學管理法
Kezi gongsuo 刻字公所
Kinkōdō (Chinese,
 Jin'gangtang) 金港堂
Lequn shuju 樂群書局
Li Yongchang jiqi
 chang 李涌昌機器廠
lingban 領班
linzhong tuoguan de
 cunkuan 臨終托管的存款
liudong zijin 流動資金
Luyin shanfang 綠蔭山房
Meihua shuguan 美華書館
Mengxuebao baoguan 蒙學報報館
mianfei zengsong 免費贈送
Mingjing jiqi chang 明精機器廠
mingshi 名士
Mohai shugan 墨海書館
paojie 跑街
qianzhuang 錢莊
Qingxintang 清心堂
Ruitai jiqi chang 瑞泰機器廠
Saoye shanfang 掃葉山房
Shanghai shuye
 gongsuo 上海書業公所
Shanghai shuye
 shanghui 上海書業商會
Shanghai shuye shangmin
 xiehui 上海書業商民協會
Shanghaishi shuye tongye
 gonghui 上海市書業同業工會
Shangwu yinshu guan 商務印書館
Shenchang shushi 申昌書室
Shenzhou guoguangshe 神洲國光社
sheqian 賒欠
Shijie shuju 世界書局
Shizhong shuju 時中書局
Simei xuanchashi 四美軒茶室
Tongtie gongsuo 銅鐵公所

Tongwen shuju 同文書局
Tushu jicheng qianyin
 shuju 圖書集成 鉛印書局
Weihua yintuan 維華銀團
Wenbao gongsi 文寶公司
Wenming xinji shuju 文明新記書局
Wenyutang 文玉堂
Xiaoshuo congbao she 小說叢報社
Xieda jiqi chang 協大機器廠
Xiuwen yinshuju 秀文印書局
Yadong tushuguan 亞東圖書館
yagui 押櫃
Yanguangshi 延光室
Yinshuaye gongyihui 印刷業公義會
Yinyinlu 蚓陰盧
Yiyuan zhenshang she 藝苑真賞社
Youzheng shuju 有正書局
yuan 圓
Yunlange 雲籃閣

yuyue fa 預約法
Zhengzhong shuju 正中書局
Zhiye gongsuo 紙業公所
Zhongguo fanggu
 yinshuju 中國仿古印書局
Zhongguo tushu
 gongsi 中國圖書公司
Zhonghou shuzhuang 忠厚書庄
Zhonghua jiaoyu yongju zhizao
 chang 中華教育用具制造廠
Zhonghua jinyuan 中華金元
Zhonghua shuju 中華書局
Zhonghua yinwu
 zongju 中華印務總局
Zhonghua yudi
 xueshe 中華輿地學社
zhuangju 庄局
Ziye gongsuo 梓業公所
Zuiliutang 醉六堂

Other Terms and Phrases

baiye zhiji 白業之基
bu ze shouduan 不擇手段
chaxu 茶敍
dianshi chengjin 點石成金
dipan 地盤
gesheng handian
 fenchi 各省函電紛馳
guaijie 怪杰
guowen 國文
hongtou a-san 紅頭阿三
Huaiyin jiangbing 淮陰將兵
huanqin tuoyou 換親托友
jiaohui pai 教會派
jiaoyu de dao, ze qi guo qiang
 sheng 教育得道則其國強盛
jieyi xiongdi 結義兄弟
Jiujiaochang 舊校場
ling qi luzao 另起爐灶
longtang 弄堂
magua 麻掛

Nanshi 南市
Nanyang gongxue 南洋公學
pingfang 平房
Qipanjie xunyue shi 棋盤街巡閱使
sanjia dingli 三家鼎立
Shanghai sitong bada 上海四通八達
she 社
shifu xingli 師傅行禮
shu daizi 書呆子
shu du tou 書毒頭
shuoku 說苦
shusheng pai 書生派
shuxiang mendi 書香門第
sihou jiqi 伺候機器
teshu yongxin 特殊用心
tongqian 銅錢 traditional cast
 copper coins
tongyuan 通圓 modern stamped
 copper coins
tu 圖

xie shi jiu 謝師酒

xiushen 修身

Yangjingbang hua 洋涇浜話

yaoluan shehui shang de
 ermu 淆亂社會上的耳目

yindu xunbu 印渡巡捕

yinghai kaitong 瀛海開通

yingshe xiaoshuo 影射小説 roman
 à clef

yiwofeng 一窩蜂

yixin ermu 一新耳目

youmu 游幕

zhengqi yinjin 蒸氣引擎

Zhongguo sida
 faming 中國四大發明

zilaihuo yinjin 自來火引擎

zuozhi youchu 左支右絀

Notes

Note: For abbreviations used in the following notes, please see the Asian-Language and West-ern-Language Bibliographies.

Acknowledgments
1 Francis Bacon, *The New Organon*, ed. Fulton H. Anderson (Indianapolis: Bobbs Merrill, 1960), 118.
2 André Malraux, *Man's Fate*, trans. Haakon M. Chevalier (New York: Random House, 1961), 132.

Introduction
1 Harrison E. Salisbury, *The New Emperors, China in the Era of Mao and Deng* (Boston: Little Brown and Co., 1992), 8. *Ciyuan* was compiled by Lu Erkui et al. and was issued in numerous editions, as was *Cihai*, edited by Shu Xincheng et al. Each work contains phrases, definitions, proper names, and foreign terms with some overlapping coverage. *Cihai*, which benefited from *Ciyuan*'s editorial mistakes, is distinguished by a clearer citation and definitional style. See Endymion Wilkinson, *The History of Imperial China, A Research Guide* (Cambridge, MA: Harvard East Asian Research Center, 1975), 8-9.
2 This conventional view has recently been questioned by Etiemble, *L'Europe chinoise* (Paris: Gallimard, 1988), 30ff., among others, who argues that Gutenberg himself was "reinventing" Chinese technology. I would like to thank my Ohio State University colleague, Patricia Sieber, for this reference.
3 The phrase "wealth and power" is usually identified with the late-nineteenth-century transla-tor Yan Fu, who is studied in Benjamin I. Schwartz, *In Search of Wealth and Power: Yen Fu and the West* (Cambridge, MA: Harvard University Press, 1964).
4 Roger Chartier, "General Introduction: Print Culture," in Chartier, ed., *The Culture of Print, Power and the Uses of Print in Early Modern Europe* (Princeton: Princeton University Press, 1987), 1.
5 Ibid.
6 Major works on aspects of Chinese print culture include Evelyn S. Rawski, *Education and Popular Literacy in Ch'ing China* (Ann Arbor: University of Michigan Press, 1979); Tsuen-hsuin Tsien, *Paper and Printing*, in Joseph Needham, ed., *Science and Civilisation in China* (New York: Cambridge University Press, 1985), 5:1; Benjamin A. Elman, *From Philosophy to Philology, Intellectual and Social Aspects of Change in Late Imperial China* (Cambridge, MA: Harvard East Asian Monographs, 1990), esp. Chapter 4; Joan Judge, *Print and Politics: "Shibao" and the Culture of Reform in Late Imperial China* (Stanford: Stanford University Press, 1996); and Char-lotte Furth, *A Flourishing Yin: Gender in China's Medical History 960-1665* (Berkeley: University of California Press, 1999). On the relationship between education, literacy, and social hege-mony, see David Johnson, "Communication, Class, and Consciousness in Late Imperial China," 34-74, esp. 56-67, in David Johnson et al., eds., *Popular Culture in Late Imperial China* (Berke-ley: University of California Press, 1985), and Benjamin A. Elman, *A Cultural History of Civil Examinations in Late Imperial China* (Berkeley: University of California Press, 2000), Ch. 5-7, esp. 371-83.

7 The standard work on the impact of the Gutenberg revolution on Europe is Elizabeth L. Eisenstein, *The Printing Press as an Agent of Change: Communications and Cultural Transformations in Early Modern Europe*, 2 vols. (New York: Cambridge University Press, 1979).
8 Tsien, *Paper and Printing*, 190, note f. Thank you to my Ohio State University colleague Cynthia J. Brokaw for alerting me to questions about these figures. By way of contrast with the 268 years of the Qing, during the thirty-seven years of the Republic of China (1912-49) 68,183 titles were published. See Beijing tushuguan, ed., *Minguo shiqi zongshumu, 1911-1949* (Beijing: Shumu wenxian chubanshe, 1986 and 1994). According to Sigfried Taubert and Peter Weidhaas, eds., *Book Trade of the World* (Munich: K.G. Saur, 1981), 69, between 1949-77, 488,569 titles appeared in the People's Republic of China.
9 Official publishing was not all philosophy books. For example, Tsien, *Paper and Printing*, 190, finds that 80 percent of all local Chinese histories known to exist were issued in the Qing period.
10 Rawski, *Education and Popular Literacy*, 23.
11 See W.L. Idema's review of Rawski's book in *T'oung Pao* 66:4-5 (1980): 314-24. Thanks to Mark Halperin of the University of California at Davis for this citation. David Johnson, "Communication, Class, and Consciousness in Late Imperial China," in Johnson et al., 59, argues that, in 1800 (when the total population was about 300 million), only 5 percent of the adult male population was literate by the standards of the civil service examinations. If we use Johnson's figure, we still have a literate audience of five to ten million. By comparison, the English literacy rate, surpassed in Europe only by those of the male populations of Scotland and Sweden, was about 60 percent for males and 40 percent for females in 1790-1800, when literacy is defined by the low standard of having the ability to sign one's name. England's population was then 8.9 million, yielding a literate public of no more than 4.5 million. In France, which historians usually regard as having had a lower rate than England, the literacy rate for men was 47 percent and for women, 27 percent. At that time, when France's population was about 26 million, the total literate population could have been no more than 11.3 million. In 1850, when England's population had ballooned to 17.9 million after a century of industrial revolution, literacy rates of 70 percent for males and 55 percent for females are likely. Nearly complete literacy (99 percent) for males and females was not achieved in England until around 1911. I would like to acknowledge my Ohio State University colleague, David Cressy, for referring me to his *Literacy & the Social Order, Reading and Writing in Tudor and Stuart England* (New York: Cambridge University Press, 1980), esp. 176-81.
12 Yang Licheng and Jin Buying, eds., *Zhongguo cangshujia gailüe* (Taipei: Wen-hai ch'u-pan-she, 1971 [Hangzhou, 1929]), list over 750 notable private Qing libraries. See also Ye Dehui, *Shulin qinghua* (Taipei: Shih-chieh shu-chu, 1961 [1911]); Cho-Yüan Tan (Taam), *The Development of Chinese Libraries under the Ch'ing Dynasty, 1644-1911* (Shanghai: Commercial Press, 1935), 18; and Su Jing, *Jindai cangshu 30 jia* (Taipei: Chuan-chi wen-hsueh ch'u-pan-she, 1983).
13 Sun Congtian, *Cangshu jiyao* (1812), trans. Achilles Fang, "Bookman's Manual," in *Harvard Journal of Asiatic Studies* 14:1, 2 (June 1951): 220-21.
14 Many Chinese historians now use the term "commodity economy" to characterize China's highly commercial but non-capitalist economy. For one example, see Gary G. Hamilton and Chi-kong Lai, "Consumerism without Capitalism: Consumption and Brand Names in Late Imperial China," in Henry J. Rutz and Benjamin S. Orlove, eds., *The Social Economy of Consumption* (Lanham, MD: University Press of America, 1989), 253-79.
15 Lucille Chia, *Printing for Profit: The Commercial Publishers of Jianyang, Song-Ming (960-1644)* (Cambridge, MA: Harvard University Asia Center, 2003).
16 On print commerce, see Timothy Brook, *The Confusions of Pleasure, Commerce and Culture in Ming China* (Berkeley: University of California Press, 1998); Dorothy Ko, *Teachers of the Inner Chambers: Women and Culture in 17th Century China* (Stanford: Stanford University Press, 1994); Kai-wing Chow, "Writing for Success: Printing, Examinations, and Intellectual Change in Late Ming China," *Late Imperial China* 17:1 (June 1996): 120-57; Ellen Widmer, "The Huanduzhai of Hangzhou and Suzhou: A Study in Seventeenth-Century Publishing," *Harvard Journal of Asiatic Studies* 36 (1996): 77-122.

17 Cynthia J. Brokaw, "Commercial Publishing in Late Imperial China: The Zou and Ma Family Businesses of Sibao, Fujian," *Late Imperial China* 17:1 (June 1996): 49-92.

18 James Flath, *Printing Culture in Rural North China: Reading Nianhua as History* (forthcoming, UBC Press).

19 On Jianyang in the Song and the Yuan, see Lucille Chia, "The Development of the Jianyang Book Trade, Song-Yuan," *Late Imperial China* 17:1 (June 1996): 10-48. On Huizhou, see Zhang Haipeng et al., *Huishang yanjiu* (Hefei: Huangshan shushe, 1995), 534-43. On Ming printing, consult K.T. Wu, "Ming Printing and Printers," *Harvard Journal of Asiatic Studies* 7 (1943): 203-60.

20 Robert E. Hegel, *The Novel in Seventeenth Century China* (New York: Columbia University Press, 1981), 11.

21 Li Demao, in Ichinose Yuichi, "Shindai Rurishō sho-shi ni kan suru hitotsu kōsatsu," *Shisen, Historical and Geographic Studies in Kansai University* 67 (March 1988): 30.

22 Sir Rutherford Alcock, "The Peking Gazette," *Fraser's Magazine*, new series, VII (February, March 1873), 245-56, 341-57, is the only first-hand record of a visit by a Westerner I have found prior to the appearance in 1935 of L.C. Arlington and William Lewisohn's *In Search of Old Peking* (New York: Paragon Reprint, 1967).

23 For historical materials on Liulichang, including turnover among shops, see Sun Dianqi, ed., *Liulichang xiaozhi* (Beijing: Beijing guji chubanshe, 1982 [1962]).

24 Benedict Anderson, *Imagined Communities: Reflections on the Origin and Spread of Nationalism*, rev. ed. (London and New York: Verso, 1991), especially Chapter 3.

25 Lucien Febvre and Henri-Jean Martin, *The Coming of the Book, The Impact of Printing, 1450-1800*, trans. David Gerard (London: NLB, 1976 [1958]), 128, 109, 216.

26 As Fernand Braudel, *Capitalism and Material Life 1400-1800*, trans. Miriam Kochan (New York: Harper and Row, 1973), xiii, points out, even the term "capitalism" was not coined until 1870. Karl Marx was largely unaware of the word "capitalism."

27 Karl Marx, *Capital* (New York: The Modern Library, 1906), 407.

28 Marie-Claire Bergère, *The Golden Age of the Chinese Bourgeoisie, 1911-1937*, trans. Janet Lloyd (New York: Cambridge University Press, 1989), 17.

29 Oddly, the situation is little better in American history, for example. In *Endless Novelty, Specialty Production and American Industrialization, 1865-1925* (Princeton: Princeton University Press, 1997), Philip Scranton studies regional specialty manufacturing industries, including publishing. By 1860, Scranton observes, outlining a situation that would be true of Shanghai in the late 1890s, New York had the country's largest industrial workforce, a vast array of machine works, including R. Hoe & Co., which manufactured printing presses, and was the hub of American book publishing. In Scranton's view, reasons for scholarly neglect of the New York printing and publishing sector include the fact that the industry was structurally intricate, partly because of the divorce of publishing from printing in the mid-1870s. Further, publishing, he says, was heavily oriented toward local and regional clienteles. Scranton's comments suggest that, both organizationally and in terms of its national influence, Shanghai's print capitalism exhibited distinctive characteristics lacking in the Anglo-American world.

30 ZYS, 566-69, discusses other materials, such as Dege copper, iron, and tin blocks in Sichuan, cerography (wax blocks) in Canton, and Jiangnin copper blocks, used during the Ming and Qing periods.

31 Cynthia J. Brokaw, "Woodblock Printing and the Diffusion of Print in Qing China," conference paper delivered at The First International Scientific Conference on Publishing Culture in East Asia, Tokyo, December 8-10, 2001, 6, relates the dispersal of Chinese print culture to the convenience of blockprinting technology.

32 Rawski, *Education and Popular Literacy*, 121. For more on the traditional process, see "Literary Notices," *Chinese Repository* I:10 (February 1833), 414-15, and Robert E. Hegel, *Reading Illustrated Fiction in Late Imperial China* (Stanford: Stanford University Press, 1998), 106-113; Tsuen-hsuin Tsien, "Technical Aspects of Chinese Printing," and Wan-go H.C. Weng, "Chinese Type Design and Calligraphy," both in Soren Edgren et al., *Chinese Rare Books in American Collections* (New York: China Institute in America, 1984).

33 On the translation of these and other terms related to woodblock printing, see David S. Barker, "A Chinese-English Dictionary of Terms Related to Woodblock Printmaking" (London: Muban Foundation, 2003).

34 Perry Link, *Mandarin Ducks and Butterflies: Popular Fiction in Early Twentieth-Century Chinese Cities* (Berkeley: University of California Press, 1981).

35 Leo Ou-fan Lee and Andrew J. Nathan, "The Beginnings of Mass Culture: Journalism and Fiction in the Late Ch'ing and Beyond," in Johnson et al., eds., *Popular Culture in Late Imperial China*, 360-98.

36 Ibid., 361. Leo Ou-fan Lee, *Shanghai Modern: The Flowering of a New Urban Culture in China 1930-1945* (Cambridge, MA: Harvard University Press, 1999) reengages some of the same issues by studying modern Shanghai culture from the perspective of prominent publishing houses. By focusing on publishers purely as cultural organizations issuing print culture, however, Lee misses the critically important distinguishing characteristic of modern publishing – namely, its reliance on machinery.

37 Daniel R. Headrick, *The Tools of Empire: Technology and European Imperialism in the Nineteenth Century* (New York: Oxford University Press, 1981), and ZYS.

38 Jean-Pierre Drège, *La Commercial Press de Shanghai, 1897-1949* (Paris: Memoires de l'Institut des Hautes Etudes Chinoises, 1978), 3. In 1985, Tsien, *Paper and Printing*, 380, drawing a fundamental distinction between Chinese printing and publishing and that in the West, echoed Drège, noting that "[w]hile printing in the West was primarily a business for profit, it had strong moral implications in Chinese society."

39 Albert Kapr's fascinating *Johann Gutenberg, The Man and His Invention*, trans. Douglas Martin (Aldershot, UK: Scolar Press, 1996), 27-36, discusses the issues of the printer's birth and actual name. Kapr also says that Gutenberg was not recognized as the inventor of printing until the 1740s. In the West, Gutenberg studies reached a high tide in the first half of the twentieth century.

40 See Fu Yunsen et al., eds., *Xin zidian* (Shanghai: Commercial Press, 1912). Both Lu Erkui et al., eds., *Ciyuan* (Shanghai: Commercial Press, 1915) and Xu Yuangao et al., eds., *Zhonghua da zidian* (Shanghai: Zhonghua shuju, 1915), although focused on Chinese terms, also included phrases and information culled from Western books.

41 By the 1930s, Shanghai publishers promoted popular works on science, technology, and invention, issuing works such as Xu Shoushen, *Xiandai kexue faming shi* (Shanghai: Commercial Press, 1930) and Qian Yishi, *Shijie famingjia liezhuan* (Shanghai: Zhonghua Books, 1936). On the growth of popular Chinese interest in scientific and technical arts, see Carrie Waara, "Invention, Industry, Art: The Commercialization of Culture in Republican Art Magazines," in Sherman Cochran, ed., *Inventing Nanjing Road, Commercial Culture in Shanghai, 1900-1945* (Ithaca: Cornell East Asia Program, 1999), 61-90.

42 GGZ, 311.

43 Ibid.

44 Arguably, Ge's acknowledgement of the importance of printing technology and of China's contribution to world printing technology laid the groundwork for the Chinese phrase "Zhongguo si da faming" (China's four great inventions: paper, printing, gunpowder, and the compass), taught today to all Chinese schoolchildren. In Shu Xincheng et al., eds., *Cihai* (Shanghai: Zhonghua shuju, 1937), this phrase is limited to "san da faming" (three great inventions). This reference follows, without citing, Francis Bacon's discussion in his *New Organon* (1620) of three great inventions: printing, gunpowder, and the magnet (compass). Bacon did not know that all three had come to Europe from China. Mention of the fourth, paper, does not appear in Chinese dictionaries until the 1950s.

45 HSN, I: 257.

46 Earlier, during the Self-Strengthening Movement (1860-1895), only a tiny number of elites had been exposed to this ideal.

47 Xiang Bing, "Zhongguo yinshua yu Gudengbao," in *Kexue de Zhongguo* 4:5 (1 Sept. 1934), 187-90, republished in SXSJ, 58-61.

48 From China, movable type had spread initially to Korea, where the first book, now lost, was printed using movable metal type in 1234. The oldest extant Korean book printed with mov-

able metal type dates from 1377. Korean typography flourished after 1403 thanks to royal patronage. See "Printing," in Keith Pratt and Richard Rutt, eds., *Korea, A Historical and Cultural Dictionary* (Richmond, Surrey: Curzon, 1999), 359-60. According to Peter Kornicki, *The Book in Japan, A Cultural History from the Beginnings to the Nineteenth Century* (Leiden: Brill, 1998), 129, Hideyoshi took movable Korean type (whether wooden or metal is not stated) to Japan in the 1590s, where it was used to print the *Xiaojing* in 1593.

49 Xiang, "Zhongguo yinshua yu Gudengbao," 61.

50 Shu et al., eds., *Cihai*, II: you ji, 68.

51 Bai Mu, "Yinshuashu jiangzuo, er," in YW II:2 (1 August 1939), 38. YW *(Yiwen yinshua yuekan/The Graphic Printer)*, published by Lin Heqin, a Chinese graduate of Pittsburgh's Carnegie Institute of Technology's printing program, followed in the tradition of Chicago's *The Inland Printer* (1883-1983) and Britain's *British and Colonial Printer* (1878-1952), journals that fostered *esprit de corps* among printers with their articles on history, new techniques, and current working conditions.

52 On the many portraits of Gutenberg, see George D. Painter, "The True Portrait of Johann Gutenberg" and "The Untrue Portraits of Johann Gutenberg" in Painter, *Studies in Fifteenth Century Printing* (London: Pindar Press, 1984), 32-38, 39-45.

53 Qian Cunxun (Tsuen-hsuin Tsien), "Qian Cunxun boshi xu," in ZYS, 2, says that, in the 1930s, he too first became interested in Chinese printing via Carter. The same seems to have been true of Zhang himself; see Li Ximi, "Li Ximi xiansheng xu," in ZYS, 5.

54 There is not yet evidence to suggest that Korean typography influenced Europe. Other examples of pre-World War II technologies that underwent this process of transfer and return may include Egyptian measurement technologies; Islamic astronomy, mathematics, and medicine; Indian cotton spinning devices; and African quinine.

55 Linda Cooke Johnson, "Shanghai: An Emerging Jiangnan Port, 1683-1840," in Johnson, ed., *Cities of Jiangnan in Late Imperial China* (Albany: SUNY Press, 1993), 180.

56 The others were Canton, Xiamen (Amoy), Fuzhou, and Ningbo.

57 Brian Martin, "The Pact with the Devil," in Frederic Wakeman, Jr., and Wen-hsin Yeh, eds., *Shanghai Sojourners* (Berkeley: Institute of East Asian Studies, 1992), 267.

58 Extraterritoriality lasted from 1842 until the end of World War II.

59 In their use of Shanghai's International Concession as their base of operations from which they sent books into the Chinese market, and in the threats they faced, not only from the Qing and subsequent governments but also from the foreign powers, Shanghai gangsters, concession police, etc., Shanghai's modern publishers suggest a parallel with the publishers of Neuchâtel's Société Typographique discussed by Robert Darnton, *The Literary Underground of the Old Regime* (Cambridge, MA: Harvard University Press, 1982). As will become clear in this book, "freedom of the press" was not an absolute value upheld by the concession governments.

60 In 1939, Christopher Isherwood, a brief visitor to the city, lampooned the Bund memorably as nothing more than "an unhealthy mud-bank" onto which "[t]he biggest animals have pushed their way down to the brink of the water; behind them is a sordid and shabby mob of smaller buildings. Nowhere a fine avenue, a spacious park, an imposing central square. Nowhere anything civic at all." See W.H. Auden and Christopher Isherwood, *Journey to a War* (New York: Random House, 1939), 237.

61 With the passage of time, a nostalgic view of Wenhuajie has emerged that ignores this ambiguity. Throughout the period from 1991 to 1993, articles regularly appeared in the Shanghai press, discussing Shanghai's Wenhuajie and calling for its revival. For more on this phenomenon, and its survival into the late 1990s, see the Conclusion to this book. The term I am using here, "Wenhuajie" or Culture-and-Education Streets, is not to be confused with its homonym, the figurative term which is translated as "cultural/academic world." Both terms were already in journalistic use by the 1930s, but only the former refers to a specific place. See *Shehui ribao* (17 April 1936), 1, which refers specifically to Simalu, or Fuzhou Road, as Wenhuajie. Likewise, Shanghai writer and newspaperman Bao Tianxiao recalls in his memoir CYL, I:382, that in the 1930s, "on Fuzhou Road (popularly called Simalu), starting from Shandong Road (then Wangping Road) and going to Henan Road (then Qipanjie) was

all newspaper plants and bookstores. The Commercial Press, Zhonghua, World, and Great Eastern were all here, and so people called this strip 'Wenhua dajie [Great Culture-and-Education Streets].'" Also, Yang Shouqing, writing in the mid-1940s, stated that by the New Culture era (late 1910s) "the cultural center [of China] had already moved to Shanghai, and later, when the thicket of bookshops on Fuzhou Road appeared, it got the name 'Culture-and-Education Streets.'" See Yang, *Zhongguo chuban jie jianshi* (Shanghai: Yongxiang yinshuguan, 1946), 22. As for translating Wenhuajie as "Culture-and-Education Streets," I should note that the meaning of the term *"wenhua"* is much broader than my translation "culture" suggests; in modern Chinese, *wenhua* is used to mean "education" or "mental cultivation" just as often as it is used to mean "culture" (as in the sneering comment "Ta meiyou wenhua" to mean "He is uneducated/boorish"). Also, see Chapter 5.

62 In the lineage of the Chinese satirical novel, Wu Woyao's *Vignettes from the Late Qing* is a direct descendant of Wu Jingzi's (1701-54) *Rulin waishi* (*The Scholars*, 1740-50), with which it shares its satire of print culture- and print commerce-related issues.

63 Wu Woyao and his novel are studied in Michael Wai-mai Lau's unpublished 1968 Harvard PhD dissertation titled "Wu Wo-yao (1866-1910): A Writer of Fiction of the Late Ch'ing Period." Wu was born in Fenyi, Jiangxi, but grew up in his native district of Foshan (Fatshan), now part of the Canton suburbs. His great-grandfather was the Hanlin scholar, Wu Rongguang (1773-1843), who obtained the *jinshi* in 1799, and, as Fang Chao-ying writes, "so belonged to one of the most celebrated classes of [*jinshi*] in the [Qing] period." See ECCP, 872-74. In a more recent discussion of late Qing fiction, David Der-wei Wang, *Fin-de-siècle Splendor, Repressed Modernities of Late Qing Fiction, 1849-1911* (Stanford: Stanford University Press, 1997), 188, points out that "[t]he majority of late Qing exposé fiction is written in the form of *yingshe xiaoshuo*, or romans à clef, a fictional mode that describes historical events and figures in the manner of fiction," a situation that reinforces my claim that *Vignettes* can be used as a historical source describing conditions at the turn of the twentieth century.

64 Wu Woyao, *Ershinian mudu zhi guai xianzhuang* (Taipei: Shih-chieh shu-chu, 1962), I:79.

65 For the translation, see Wu Woyao, *Vignettes from the Late Ch'ing: Bizarre Happenings Eyewitnessed over Two Decades,* trans. Shih Shun Liu (Hong Kong: Chinese University of Hong Kong Press, 1975), 91, which I have modified slightly based on *Ershinian mudu*, I:81.

66 *Vignettes*, 93; *Ershinian mudu*, I:82.

67 Ibid.

68 *Ershinian mudu*, I:82, says book-buyers coveted works like *Duobao ta*, *Zhenzhu chuan*, and *Dati wenfu*, but spurned maps and practical works like *Fuguo ce* and *Jingshi wenbian*.

69 *Vignettes*, 93; *Ershinian mudu*, I:83.

70 Ibid.

71 Maurice Meisner, *Mao's China, A History of the People's Republic* (New York: The Free Press, 1977), 297.

Chapter 1: Gutenberg's Descendants

1 According to K.T. Wu, "The Development of Typography in China during the Nineteenth Century," in *The Library Quarterly* 22, 3 (1952): 292, the Toleration Edict of 1844 lifted the ban on missionary work within China.

2 Contrary to popular belief, woodblock printing was never totally eradicated in China. In particular, its life was extended by the Second Sino-Japanese War (1937-45), which necessitated the use of simple, mobile printing for propaganda purposes.

3 "Literary Notices," CR 1, 10 (1833): 415-16.

4 Walter Henry Medhurst first advanced these ideas to the circumscribed missionary community in "Typographus Sinensis, Estimate of the Proportionate Expense of Xylography, Lithography, and Typography, as Applied to Chinese Printing," CR 3 [1834]: 246-52.

5 Walter Henry Medhurst, *China; Its State and Prospects* (Boston: Crocker & Brewster, 1838), 451. Having the xylographic work performed in China itself (which was then both illegal and perilous for the cutters) would have reduced the charges to £1,254.

6 Ibid., 451-52.

7 Letter dated 5 April 1843, cited in MPC, 3-4.

8 Thank you to Patricia Sieber for this suggestive insight.

9 HSN, 257, and Liu Longguang, "Zhongguo yinshuashu de yange, xia," in YW 1, 2 (1937): 6-7. Wang Hanzhang, writing for the *Huabei bianyiguan* in 1943, used the same three categories. See Wang, "Kanyin zongshu," [1943] in ZJCSE, 363. The Chinese-language categorization follows the Western-language literature. The fourth key phase in the development of Western printing processes, unexpected by anyone in the 1930s, was computerization, which transformed printing in the 1970s and 1980s, largely eliminating letterpress printing and replacing it with thermal transfer processes.

10 Contrary to what *Cihai* says, Gutenberg was no mere machine worker. He would have been familiar with mould and matrix technology through his patrician family's hereditary ties to the Mainz archbishopric mint.

11 Michael Clapham, "Printing," in Charles Singer et al., eds., *A History of Technology* (New York: Oxford University Press, 1957), 3: 391-93. Copper punches with lead matrices may also have been used.

12 A piece of type was 15/16 inches high from the base to the top of the letter. Thank you to David S. Barker of the University of Ulster, Belfast (personal communication, October 2002).

13 W. Turner Berry, "Printing and Related Trades," in Charles Singer et al., eds., *A History of Technology* (New York: Oxford University Press, 1958), 5: 683.

14 Sometimes they were combined with woodblock illustrations or special wooden forms of letters.

15 Donald F. Lach, *Asia in the Making of Europe* (Chicago: University of Chicago Press, 1965, 1977, 1993), 1: 2, 679-80; 2: 3, 527, writes that the first Chinese type was printed using a press at Coimbra, Portugal, in 1570. By 1585, two Japanese present in Lisbon began teaching Portuguese printers how to improve the cutting of their typefaces. In the same year, a catechism and a Latin-Chinese vocabulary were printed at Macao using woodblocks (2: 3, 496-97). The first printing presses reached Japan in 1590, the Philippines in 1595, and Macao in 1614. In addition to Portugal, Chinese type was also cut in Flanders. For illustrations, see Lach 1: 2, 2: 3, Donald F. Lach and Edwin Van Kley, *Asia in the Making of Europe* (Chicago: University of Chicago Press, 1993), 3: 1, 3: 4.

16 The *Kangxi Dictionary* has 40,919 different characters.

17 See ZYS, 566, 716. In the seventeenth and eighteenth centuries, the Kangxi and Qianlong emperors printed using 250,000 movable Chinese-*cut* copper type.

18 MPC, 2-3, 20-21. Eventually, as the missionaries began to issue magazines and journals, they needed up to 10,000 different type.

19 "Preface," in Joshua Marshman, *Elements of Chinese Grammar* (Serampore: Mission Press, 1814), xvi.

20 However, as Joseph P. McDermott of Cambridge University, citing Milne, has explained to me, Marshman overlooked the fact that small changes could be and often were made to woodblocks.

21 Earlier efforts in Europe had been more successful.

22 W.S. Holt, "The Mission Press in China," *Chinese Recorder and Missionary Journal* 10, 3 (1879): 210. Cecil K. Byrd, *Early Printing in the Straits Settlements 1806-1858* (Singapore: National Library, 1970), 9-10.

23 ZYS, 582, mistakenly says that they used woodblocks.

24 HSN, 258. "Cai Gao" is the same person as "Tsae A-ko," mentioned in Medhurst, *China*, 215.

25 In this regard, it is not surprising that, in the view of Su Ching, "The Printing Presses of the London Missionary Society Among the Chinese" (PhD diss., London University, 1996), 132, Milne consistently preferred to use wooden blocks to print Chinese. Thank you to Joseph P. McDermott for this reference. Medhurst, *China*, 446, strongly implies that type was also sent from Macao (most likely from the College of St. Joseph) to Malacca.

26 Morrison's lack of access to speakers using Beijing pronunciation is reflected in the fact that he used the Nanjing, or southern Mandarin, pronunciation as his standard, pointing out that it was the basis for *guanhua*, the language and pronunciation used by China's officials.

27 Patricia Sieber broadens our understanding of the East India Company printer usually identified by historians only as "P.P. Thoms," in *Theaters of Desire: Authors, Readers, and the Reproduction of Early Chinese Song-Drama, 1300-2000* (New York: Palgrave, 2003).

28 Alexander Wylie, ed., *Memorials of Protestant Missionaries to the Chinese* (Shanghai: American Presbyterian Mission Press, 1867), 7. According to Medhurst, *China*, 219 and 446, the dictionary was printed with a £15,000 subvention from the EIC. The last part was printed at the College of St. Joseph in Macao, using stereotypes. Morrison had also printed religious literature in Canton using woodblocks, including those cut by his first convert, Liang A'fa (1789?-1855), a former pencil maker and block cutter, who eventually worked with Milne at Malacca and also published at least nine works of his own. Since at least the late 1860s, when Wylie published his view, Liang's *Quanshi liangyan* (Good Words Exhorting the Age), printed at Canton in 1832, has generally been assumed to have been the Christian tract that set Hong Xiuquan, leader of the Taiping rebels, afire spiritually. Hong was introduced to the tract in Canton in 1836 or 1837 by the Tennessee Baptist missionary Issachar J. Roberts (1802-?).

29 Robert Morrison, "Advertisement," in *Dictionary of the Chinese Language in Three Parts* (Macao: East India Company's Press, 1815), 1: 1.

30 Ibid.

31 Morrison, "Introduction," *Dictionary*, 1: 1, i.

32 Ibid., 1: 1, xi, referring to C.L.J. de Guignes and Julius von Klaproth, *Dictionnaire chinois, français, et latin* (Paris: Imprimerie Royale, 1813).

33 Figure 1.3, from volume 1 of part 1 (1815), features the characters *shang* and *hëë (xie)* cut by Thoms's Chinese assistants. This *shang* can be compared with the same character in Figure 1.5; *hëë* can be compared with the same character in Figure 1.2. Figure 1.4, taken from volumes 2 (1822) and 3 (1823) of part 1, was cut by Thoms's Portuguese employees. Contrary to Morrison's own argument in the "Preface," although the large characters for *wan* and *e* are presentable, the smaller characters in the examples are not nearly as fine as those carved for volume 1 by the Chinese assistants. *Wan* and *e* can be compared with the same characters in Figure 1.12.

34 Ibid., 1: 1, x.

35 Ibid., 1: 1, xi. Like Medhurst, discussed earlier, Morrison debated the pros and cons of letterpress and other printing options. According to Su Ching, "Printing Presses," 70, Morrison discussed the relative advantages of letterpress and stereotypes in an 1815 letter to the London Missionary Society directors. By the 1830s, however, he had become a staunch supporter of movable type. Thanks to Joseph P. McDermott for this citation.

36 What Morrison, following the Chinese, calls Song style (Song ti), with its broad vertical and flat horizontal strokes, is more accurately termed jiang ti (workman style), explain Robert E. Hegel, *Reading Illustrated Fiction in Late Imperial China* (Stanford: Stanford University Press, 1998), 112, and Lucille Chia, *Printing for Profit: The Commercial Publishers of Jianyang, Fujian (11th-17th Centuries)* (Cambridge, MA: Harvard University Asia Center, 2002), 197. *Jiangti* was a creation of late Ming block cutters attempting to imitate Song styles, hence the name *Song ti*.

37 Robert Morrison, *Dictionary of the Chinese Language in Three Parts* (Macao: East India Company's Press, 1819), 2: 1, x.

38 According to David S. Barker, the correct term for an individual piece of "type" is a "character." To avoid confusion with Chinese characters, in this chapter, I generally use the term "type."

39 Information on Thoms comes from MPC, 7, and ZYS, 581-83.

40 S. Wells Williams, "Movable Types for Printing Chinese," in *Chinese Recorder and Missionary Journal* 6 (1875): 26.

41 Note that the entries also sometimes list the seal ("S.C.") and running hand ("R.H.") versions of the character.

42 HSN, 1: 258. In 1815, He reported, Baptist missionary Marshman published the first Chinese-language Bible using type cast from type moulds cut by Thoms of Macao.

43 "Literary Notices," 416.

44 According to He, in 1804, Charles Mahon, Third Earl of Stanhope (1753-1816), had invented stereotypes ("rigid printing type") out of plaster moulds *(niban)*. What He did not know was that stereotyping had been invented in 1725 by a Glasgow goldsmith named William Ged (1690-1749). In making it possible to print entire pages at once, stereotypes portended an eclipse of Gutenberg's revolution. By 1804, stereotyping had become a widely

practised technique among book printers. Stereotypes were still dependent on movable type, however, and could be created only after a page of type was first set up. A plastic medium, first Ged's plaster and, after 1830 in Europe, papier-mâché *(zhixing)*, was then pressed onto the type and dried. When it was peeled off, the intaglio (engraved) image could be used to mould a full page of (now stationary) lead-alloy type known as a printing plate. Stereotypes made it possible for printers to bypass endlessly recasting type as well as to avoid resetting type each time a reprint of a popular book such as the Bible, prayer book, etc., was needed. By saving the mould of entire pages, stereotypers accelerated reprinting and freed up movable type for new jobs. Initially flat, even when used on a cylinder press, by the 1870s, when the modern rotary press was popularized, stereotypes were made in a curved form that could be attached to the rotary press. On stereotyping Bibles, see Leslie Howsam, *Cheap Bibles: Nineteenth-Century Publishing and the British and Foreign Bible Society* (New York: Cambridge University Press, 1991), 77, 79-81.

45 Not every attempt to duplicate Gutenberg's innovation in East Asia succeeded. One particularly clumsy effort was made by the Reverend Charles Gutzlaff who tried chiselling out matrices. The results defeated the purpose of metal type – namely, regularity and precision. See Williams, "Movable Types," 26.

46 Medhurst, *China*, 447-49, 454. According to Byrd, *Early Printing*, the punches cost two shillings and ten pence each.

47 MPC, 7; Holt, "Mission Press," 209; and ZYS, 583-84.

48 Holt, "Mission Press," 209; Byrd, *Early Printing*, 5-6, says that Dyer worked at Penang from 1827 to 1835, when he moved to Malacca; he died in Macao.

49 Legge would later achieve fame as a translator of the Chinese Classics and a professor of Chinese at Oxford.

50 Byrd, *Early Printing*, 6. In Hong Kong, says Su Ching, "Printing Presses," 291, Chinese workers cut characters on cast type blanks at a cost of half a penny each. Thanks to Joseph P. McDermott for this reference.

51 Formerly of the American Presbyterian Mission Press (from which MPC implies he was fired) which he founded in Canton in 1844 and moved to Ningbo in 1845, Cole seems to have been a restless individual, possibly out of his element with the pious China missionary crowd. After leaving Hong Kong, he sailed for California, where he founded a newspaper.

52 ZYS, 584, says that the Hong Kong font was used to print quite a few books as well as newspapers. Books included an Old Testament (1841) and *Aesop's Fables* (1868).

53 "Article IV, Literary Notices," CR 20, 5 (1851): 284.

54 Holt, "Mission Press," 211-12. According to Wylie, *Memorials*, 135, Cole produced two fonts, including a Three-Line Diamond font, and part of a third. On Huang Sheng and the London Mission Press, see Paul A. Cohen, *Between Tradition and Modernity: Wang T'ao and Reform in Late Ch'ing China* (Cambridge, MA: Harvard Council on East Asian Studies, 1987). Huang was responsible for printing Legge's Chinese Classics.

55 ZYS, 593, says 1843. Robert Fortune, *Three Years' Wanderings in the Northern Provinces of China* (London: John Murray, 1847), 182, and "Protestant Missions," in *Chinese Recorder* 8, 4 (1877): 307, suggest 1844.

56 Wylie, *Memorials*, 173. Medhurst remained in Shanghai on and off until 1856.

57 "Protestant Missions," 308, and MPC, 37. According to H. McAleavy, *Wang T'ao: The Life and Writings of a Displaced Person* (London: China Society, 1953), 4, Wang visited the London Mission Press in February 1848 and met its "director," Medhurst. The next year, Medhurst asked Wang to become a Chinese editor for the press.

58 Holt, "Mission Press," 211; McAleavy, *Wang T'ao*, 25ff.; Cohen, *Between Tradition and Modernity*, 76-77. Huang and Wang changed the name to Zhonghua yinwu zongju (China Printing Company). In 1874, they began to issue one of the first modern Chinese-run newspapers, *Tsun-wan yat-po* (Mandarin *Xunhuan ribao*). Oddly, MPC, 37, incorrectly says the London Mission Press was sold in 1879.

59 Holt, "Mission Press," 211.

60 The Albion, made in England, had been operating in Macao but was interdicted by the Portuguese governor and transferred to Canton, where the missionary S. Wells Williams (see note 72 below) put it into operation. See "Article V, Literary Intelligence," CR 3, 1 (1834): 43.

61 Holt, "Mission Press," 207. In early 1833, according to "Introductory Remarks," CR 2,1 (1834), 6-7, there were two English-language printing presses in Macao and three in Canton. One of the three British-made presses was an Albion; two presses had been made in America. By June 1833, says "Article V, Literary Intelligence," the number of presses had declined to four, with only one in Macao, joined by a Portuguese-language one, possibly that which had arrived in 1614.

62 "Article V, Chinese Metallic Types," CR 3, 11 (1835): 530-32. A similar method, involving sending wooden blocks to London, had been explored by the British around this same time. See "Literary Notices," 417, and "Article III, Penang," in CR 3, 5 (1834): 228-29.

63 John Francis Davis, *The Chinese: A General Description of the Empire of China and Its Inhabitants* (London: Chas. Knight & Company, 1836), 2: 211-13, discusses the similarities between the woodblock and the stereotype in some detail.

64 According to Holt, "Mission Press," 210, the American Board Mission closed its operation in Canton in 1856 but reopened in Beijing in 1868 with the indemnity it received after the Arrow War. In Beijing, the Congregationalists issued at least fifty-seven publications, including a Mandarin-language Bible in 1874, said to have been "a fine specimen of the printer's art."

65 The American Presbyterian Mission Press was called Huahua shengjing shufang (Huahua Bible Publishers) when it was located in Macao, but it changed its Chinese name to the more widely recognized Meihua shuguan after it moved to Ningbo in 1845.

66 "Article IV, Literary Notices," 282.

67 The Société Asiatique's *Journal Asiatique* began printing Chinese with a different font as early as 1829. Thank you to Patricia Sieber for this information.

68 See HSN, 259; "Article V, Metallic Types," CR 3, 11 (1835): 528-30; Medhurst, *China*, 449-50; Wells, "Movable Types," 28-29; MPC, 7; ZYS, 583. MPC also reports that the Imprimerie Royale created a font in 1838 using the same method of stereotyping and sawing that Dyer had tried. Shi Meicen, *Zhongguo yinshua fazhan shi* (Taipei: Taiwan Commercial Press, 1966), 150, reports that a Leiden publisher purchased a Chinese font in 1845 and used it for the next forty years, publishing bilingual texts. It seems likely that the publisher used the Paris font of Marcellin LeGrand, whose shop was located at 99 rue du Cherche-Midi, Paris.

69 Holt, "Mission Press," 213, says the five workmen included a compositor, two pressmen, a type cutter, and an apprentice.

70 Ibid. When Ningbo's APMP sent Medhurst an order in Shanghai for a Chinese font, he replied that fulfillment of the order would take nine months. In 1847, the Ningbo firm purchased a small font of Japanese type.

71 Liu, "Zhongguo yinshuashu," 6, mistakenly says that stereotyping reached Macao sometime in the 1860s where it was used by the APMP. By the 1860s, APMP had already arrived in Shanghai. He Shengnai agrees with Liu that, while in Macao, the APMP was probably the first to use stereotypes, but he is vague on the chronology, saying that the APMP adopted them between 1844 and the 1860s. He Shengnai also reports that Shanghai's *North China Herald* (founded in 1850) and *Shenbao* (1872) newspaper companies, along with the publisher Zhuyitang, acquired this technology after the book and tract publishers.

72 MPC, 11. Like the Chinese literati discussed in the Introduction, until at least 1895, Protestant missionaries tried to maintain a clear division between their activities and market-driven printing, or so says MPC. Nonetheless, "Protestant Missions," 308, had claimed in 1877 about the London Mission Press that, although "The work done was confined almost entirely to the supply of missionary wants, nearly a quarter of the English printing [was] being done to accommodate commercial residents while there was no other press available." One well-known nineteenth-century missionary who clearly crossed the line from nonprofit, philanthropic, religious printing to profit-driven secular printing, S. Wells Williams, also ran the EIC Printing Office in Macao for a while. He later became a professor of Chinese at Yale.

73 Recall that Thoms's 1815 Hong Kong font never caught on.

74 In 1842, the same year the Opium War had ended, an early group of three French Jesuits returned to Shanghai. By 1849, thirty-seven more had arrived. See Gu Yulu, "Shanghai tianzhujiao chuban gaikuang," CBSL 4 (1987): 30, and Zhang Hongxing, "Zhongguo zui zao de xiyang meishu yaolan," *Dongnan wenhua* 1991, 4: 124-30.

75 HSN, 260. By 1869, says Gu, "Shanghai tianzhujiao," 30, the Tushanwan Jesuits had published seventy works, largely woodblock reprints of works issued by their missions in the seventeenth and eighteenth centuries.

76 The orphanage print shop was located in a Catholic church on Sichuan South Road from 1870 to 1871, says Zhuang Suyuan, "Tushanwan yinshuguan xiaoji," CBSL 4 (1987): 35. It was directed by Yan Siwen from 1873 to 1879.

77 Ibid.

78 Gu, "Shanghai tianzhujiao," 30-31. The newspaper, *Yiwen lu*, first appeared in 1879 and was joined in 1898 by a Catholic scientific journal, *Yiwen gezhi huibao*. According to Zhuang, "Tushanwan," 35, the metal-type shop expanded steadily. By 1898, it had a hundred Chinese printers and forty apprentices.

79 Before plaster, Farnham had used clay plates *(niban)* for creating stereotypes, probably for instructional materials. Eventually, he became well known as the editor of the illustrated missionary journals, *Xiaohai yuebao/The Child's Paper* (1875-1915) and *Tuhua xinbao* (1880-1913). He also ran the APMP for a short period. Qingxintang was later known as the Qingxin shuyuan and, by the 1950s, as the Qingxin Middle School. See Shanghai tongshe, ed., *Shanghai yanjiu ziliao, xubian* (Shanghai: Shanghai shudian yinhang, 1984), 324.

80 HSN, 266.

81 Liu, "Zhongguo yinshuashu," 6, and HSN, 265.

82 HSN, 265. The Western newspaper world did not adopt stereotypes until after 1815, when movable lead type was increasingly replaced by lead stereotype plates. ZYS mistakenly cites 1912 for the date when the Commercial Press adopted paper-mould technology.

83 HSN, 266.

84 This account of electrotyping is drawn from James Moran, *Printing Presses: History and Development from the Fifteenth Century to Modern Times* (Berkeley: University of California Press, 1973), 207, and CMS, 20.88, 626.

85 CMS, 20.88, 626.

86 MPC, 12.

87 Ibid., 12, 19-20.

88 Boxwood or yellow poplar was one of many alternatives to the pear, jujube, and catalpa often used by Chinese woodblock printers, according to Tsuen-hsuin Tsien, *Paper and Printing* (New York: Cambridge University Press, 1985), 196.

89 Normally, electrotyping was a high-turnover process by which entire sheets were printed, eliminating the need for individually setting each page using type. In the West, it was used for printing daily newspapers until well into the twentieth century. Nineteenth-century missionary printers were so familiar with the process, presuming that their readers would be as well, that they rarely explain it in detail. Some of the few surviving examples of electrotypes are on display in the Capital Publishing Company Printing Museum, Guthrie, Oklahoma. Gamble's electrotyping was used not to print whole sheets but to create type matrices, from which fonts were then made.

90 MPC, 20.

91 Wang Tao, *Yingruan zazhi* (Taipei: Hua-wen shu-chu [1875]), 275. A wholly different contemporary Chinese response to Western printing machinery was recorded in NCH 14 August 1875: 167. According to the newspaper, the Cantonese manager of Shanghai's *Yibao* newspaper took action against a printing press that had thrice injured men on his staff. He propitiated the *"devilo"* that he believed inhabited it with sacrifices of pork, fowl, fruit, and sycee. Then, while the Cantonese manager kowtowed to the press in his best robes, other Chinese jeered at him, "asserting that the machine, being foreign-built, can contain neither joss nor devil to be propitiated."

92 HSN, 260. In 1859, after fourteen years of effort, a Berlin font of 3,200 punches was completed by A. Beyerhaus and arrived in China. Beyerhaus duplicated Marcellin LeGrand's format of compound characters but with a more elegant result. His work was supported by Walter Lowrie of the Presbyterian Board of Missions in New York and S. Wells Williams, who raised his contribution to the project by delivering the lectures that were eventually published as his classic account of the Chinese, *The Middle Kingdom* (New York: Wiley and Putnam, 1848). MPC, 15-16, mistakenly says that the Berlin font arrived in 1849.

93 Florence Chien, "The Commercial Press and Modern Chinese Publishing, 1897-1949" (MA thesis, University of Chicago, 1970), 9.

94 Xing Fang, "Shanghai gongdu yinzhishe de gailiang zijia," in YW 1, 7 (1937): 24, and Holt, "Mission Press," 215. Known formally as the "original treasure-style typecase" *(yuanbaoshi zijia)*, the case was also called the "three-sided case" *(sanjiao zijia)* and the "pints and pecks case" *(shengdou jia)* in the Chinese vernacular.

95 Holt, "Mission Press," 215.

96 Although Gamble's "three-sided case" speeded up Bible typesetting, it turned out to be inconvenient for Chinese setting newspapers or works of social science. In 1909, the Commercial Press rearranged Gamble's case to the advantage of its own secular purposes. Around 1912, because the old U-shaped case restricted use of type to one typesetter, the Press introduced the "unitary long case" *(tongchang jia;* Figure 1.9) from Japan, which allowed many typesetters access to the same type. In 1920, Shanghai's *Shenbao* newspaper plant followed the Commercial Press's lead; by the 1930s, most print shops used this arrangement. See Xing Fang, "Shanghai gongdu yinzhishe de gailiang zijia," 24-25, and Shi, *Zhongguo yinshua*, 155-56. Manying Ip, *The Life and Times of Zhang Yuanji, 1867-1959* (Beijing: Commercial Press, 1985), 207-8, believes that the type case invented by William Gamble remained in use in Chinese print shops until 1923. In that year, Zhang Yuanji, supervisor of the Commercial Press, invented a new type case that simplified the compositor's task by arranging type on several pyramidal ,revolving "lazy Susans." Afterward, says HSN, Zhang's type case was superseded by a newer one, presumabbly modifying it, developed by Hong Bingyuan. Shi, *Zhongguo yinshua*, 156-57, reports that He Shengnai himself improved Zhang Yuanji's type case in 1931 and that, eventually, Wang Yunwu improved on both. For a full discussion, see Shi, *Zhongguo yinshua*, 157-70.

97 All type metal had to be imported, making the missionary printers dependent on both overseas suppliers and shipping companies.

98 Missionary publications of the period do not refer to fear of the Taipings to account for Gamble's move, but the prospect of their arrival must have influenced his board's decision to move the publishing house to the relative safety of Shanghai. According to Mary Backus Rankin, *Elite Activism and Political Transformation in China* (Stanford: Stanford University Press, 1986), 54-55, Hangzhou fell to the Taipings in late 1861 after a two-month siege. The Taipings occupied the city on and off for the next two years before being driven out by Zuo Zongtang. Although fighting was moderate in Ningbo and eastern Shaoxing from 1862 to 1864, the three-year Taiping occupation of the province was devastating to the local economy, promoting the expansion of Shanghai. According to ZYS, 571-72, when British and American visitors arrived at Nanjing, the Taiping capital, they found 400 woodblock printers working on a Taiping edition of the Old Testament and eighty working on the New Testament. The Taipings banned the Confucian Four Books and Five Classics and based their civil service curriculum on bowdlerized Bibles. To Christian missionary publishers, the fall of the Taipings and their Christian-inspired religious cult in 1864 seemed to portend a golden opportunity to increase their own publishing quotas. For another perspective, see Howsam, *Cheap Bibles*, 186-87.

99 Holt, "Mission Press," 216. In 1876, the APMP would produce 47.1 million pages of books, tracts, etc. Holt gives no information regarding the proportion of Chinese-language materials to non-Chinese-language printing.

100 Ibid.

101 Ibid. The Chinese printer-publishers' names are not known.

102 Joseph P. McDermott validly suggests that the result using Western fonts was probably no better than that of limited-run high-grade xylography, but that the difference became apparent when print runs were extended.

103 ZYS, 584. According to Peter Kornicki, *The Book in Japan* (Leiden: Brill, 1998), 164-65, Gamble was invited to Japan by Motoki Shōzō (1824-75), a Bakufu interpreter stationed in Nagasaki, who had purchased a press from the VOC in 1848. By the late 1850s, Motoki had learned to cast *katakana* type and had produced Japan's first "modern books," bound in the Western style and dealing with natural science, infantry training, etc. Prior to Gamble's arrival, Motoki and his students had disseminated type-founding and typography from Nagasaki. Gamble's arrival led to the popularization of his Song/Meihua typeface, which the Japanese called Ming-

dynasty type *(minchōtai)*. *Minchōtai* is still the standard typeface in Japan today. Although the Chinese lost interest in Gamble's font, according to He Buyun, "Zhongguo huozi xiaoshi," in Shanghai Xinsijun lishi yanjiuhui, yinshua yinchao fenhui, ed., *Huozi yinshua yuanliu* (Beijing: Yinshua gongye chubanshe, 1990), 75, they continued electrotyping matrices until at least 1961. It is not clear what happened to Gamble after he took his methods to Japan, but, in 1938, his children, then living in York, Pennsylvania, presented a collection of works that he had acquired and/or printed for the APMP to the Asian Division of the Library of Congress, where they are known as the Gamble Collection.

104 Holt, "Mission Press," 218.
105 Ibid.
106 The complete lack of lithographic equipment in inventories of any of the Protestant printing-publishing operations is striking, particularly in light of the Reverend Ernst Faber's comments, cited in Chapter 2, that both the Catholics and the Chinese pushed the Protestants out of China's modern publishing market in the 1890s thanks to their use of lithography.
107 Another typeface was created by the Tushujicheng shuju, an offshoot of the Major Brothers' *Shenbao* started in 1884. Known as the "Major font," it was used to print an edition of the stalwart bestsellers, *Gujin tushu jicheng* and Twenty-Four Dynastic Histories. Unfortunately, the *Shenbao* staff did such a poor job collating and printing both that they were nearly unreadable, and the font never became popular with Chinese. Chinese dislike of both the Gamble and the Major fonts led them to buy presumably modified "Ming" fonts from Japan until after 1919. See He Buyun, "Zhongguo huozi," 76.
108 Holt, "Mission Press," 218.
109 That there were other obstacles to the expansion of the APMP is made clear by further remarks in Holt's account. For instance, Holt insists that his firm had performed an important role in assisting Chinese in opening printing offices. This boast was proven false almost immediately by the Chinese lithographic business. Three years after Holt published his comments, Tongwen Press opened in Shanghai, employing 500 printing and publishing workers, as we will see in Chapter 2. This was nearly four times the number then employed at the APMP.
110 MPC, 32-33, 46, 53. Just as the London Mission Press had been bought by Chinese investors in 1873, in 1923 the APMP was finally absorbed into the Commercial Press, says JSF, 267. The second-largest mission printing-publishing operation was Hankou's National Bible Society of Scotland's Press, established in 1885. By 1895, it employed seventy people working three cylinder machines and four hand presses.
111 See ZYS, 590, for a list of Shanghai's lead-type printers from 1842 to 1911.
112 Wang, "Kanyin zongshu," 366. Wang Licai and Xia Songlai's Kaiming shudian should not be confused with Zhang Xichen's later Kaiming shudian, founded in 1927. Wang Licai is credited with having written two classics of early-twentieth-century Chinese bookselling, *Jinling maishuji* (Record of Selling Books in the Nanjing Area) (1902) and *Bianliang maishuji* (Record of Selling Books in Kaifeng) (1903); see ZXCS 1: 384-402, 403-14.
113 This paragraph is based on Wang, "Kanyin zongshu," 2: 366. In Beijing, lead-type firms included the London Mission Press; Xiehua shuju, founded in 1884 and surviving into the Republic, which specialized in collections of government edicts; Jinghua yinshuju; and Falun yinziguan, established by Xu Youzheng and Zang Jianqiu to print the works of Wu Zhifu and Lin Qinnan. Based in Yantai, the Chengwen xinji printed and distributed Western books and textbooks widely throughout the Dalian-Andong corridor and into northern Manchuria.
114 Ibid. "Three legs of the tripod" is the dictionary translation of the phrase *"sanjia dingli,"* said of three antagonists confronting each other who nonetheless support the world between them.
115 Basil Kahan, *Ottmar Mergenthaler, The Man and His Machine* (New Castle, DE: Oak Knoll Press, 2000), 1.
116 The stranglehold of the type-caster on the printing and publishing industry was so powerful that, in 1869, the *New York World* sponsored a contest that would have awarded an inventor of a typesetting machine a prize of $500,000. No one claimed the prize, reports Kahan.
117 On the inventor David Bruce, see Berry, "Printing," 5: 683-84. Although Berry provides no information about the casting speed of Bruce's machine, he does say that, by 1881, successive improvements yielded a type-caster at the London *Times* that could make 60,000 type per hour.

118 Chia, *Printing for Profit*, 37.

119 MPC, 31.

120 ZYS, 586, says that, soon after its founding in 1897, the Commercial Press developed three styles imitating ancient calligraphic models that gradually replaced the missionary fonts. The Kaishu (standard script), created in 1908 by the Jiangwan native, Xu Xixiang, using photographic and electrotype methods, was the first to win high marks, having been deemed both beautiful and elegant. It was soon joined by the Lishu (Han dynasty official script) and a Cu ti or Fangtou (full- or squarehead script). According to Wang, "Kanyin zongshu," 367, in addition to the three fonts mentioned above, the Zhengkai (also standard script) font was first created by the Commercial Press in 1909, but it did not become popular until the mid-1920s. Its greatest promoter was Ding Fubao (1874-1952), the well-known Wuxi scholar-physician who also cofounded the Shanghai publisher of medical texts, Wenming shuju. After Zhengkai became popular through Ding's and the Commercial Press's efforts, Zhonghua Books countered by repopularizing new Song-style characters (Fangsong ti) in the mid-1920s. The Fangsong font was used to print Zhonghua's famous collection, *Sibu beiyao* (1927-37). Another major Chinese-designed font style, called Wei stele type, imitated writing styles of the Northern Wei dynasty (424-535). It was designed in 1926 or 1927 by the famous Beijing calligraphers Xu Jifu (Xu Ji) and Zhong Shiguang for a reprint of the *Kangxi Dictionary*. Developed in northern China, it became very popular in Shenyang (Mukden) and Tianjin. For more examples of typefaces, see ibid., illustrations between 372-73; for more on the history of typeface design, see HSN, 261-64, who notes that the Commercial Press even created the Zhuyin fuhao in 1919 after the Ministry of Education issued its regulations on the new syllabary. Between the 1911 and the 1949 revolutions, at least five different Song styles and nine different Zhengkai styles were developed by bringing calligraphers and typographers together, sometimes using photographic methods. Interestingly, in 1915, the Commercial Press even appointed a famous Hubei woodblock printer, Tao Zilin, to develop an "ancient script" (Gu ti), but it does not seem to have caught on. See He Buyun, "Zhongguo huozi," 77-81. What is striking, after all this experimentation, is that as few as four became standard. Rather than blaming an abstract typographic "conservatism," Wan-go H.C. Weng, "Chinese Type Design and Calligraphy," 28-29, says that the size of Chinese fonts restricted the range of styles; each stylistic modification had to be carried through fonts of at least 10,000 different type (for magazine work) to be effective.

121 "Changxing zidong zhuziji/Chong Shing Automatic Type-Casting Machine," in YW 2, 8 (1940): 52. Chong Shing was located at 272 Ai-wen-yi-da-tong Road; Jianye was off La-fei-de Road; Ruitai was in an alley off Suzhou North Road.

122 "Quanguo yinshua tongye ji quanguo ge da baoguan qishi," [advertisement], YW 1, 3 (1 March 1937), 4.

123 Although the inventions that led to the Monotype machine date to 1822, they were given a solid foundation in 1840 by Henry Bessemer (1813-98), also known as the father of modern steel-making processes.

124 Berry, "Printing," 5: 685, 711-12.

125 NCH 2 May 1900: 1708 reports that the *North China Herald* had just installed Linotype machines for its subsidiary, the *North China Daily News*.

126 "Linotype," in YW 1, 7 (1937): 4, and Xu Xiliang, "Ma-na-pai shaoji gaishuo," YW 1, 5 (1937): 34-39.

127 Six years before, according to Minami Ryōshin, "Mechanical Power and Printing Technology in Pre-World War II Japan," *Technology and Culture* 23, 4 (1982): 623, Kyōta Sugimoto, one of the inventors of the Japanese typewriter, developed a Japanese-language monotype machine. Neither the Linotype nor the Monotype was imported to Japan until about 1910, says Minami. Before 1937, he adds, the Linotype never really caught on in Japan. It was not manufactured there either.

128 HSN, 264.

129 In 1958, according to Shi, *Zhongguo yinshua*, 171-72, after a stay in America, Taiwanese Gui Zhongshu modified photographic typsetting for Chinese. Former New Culture adherent, ambassador to the United States, and president of the Academia Sinica, Hu Shi, present at the exhibition where Gui's invention was revealed, classified Gui in a long line of educators,

stretching back to Cai Yuanpei and Lin Yutang, who had tried to modernize reproduction of Chinese characters.

130 Berry, "Printing," 5: 704.

131 TPP, 12.

132 Berry, "Printing," 5: 704.

133 Liu, "Zhongguo yinshuashu," 6. The first to demonstrate the process for the Press was an American consultant, Shi-ta-fu (Stafford), who apparently had little success.

134 HSN, 267.

135 Liu, "Zhongguo yinshuashu," 6. As seen above, the Jesuits twice introduced movable type to China, first in the 1600s and again in the 1800s; below we will see that they also introduced lithography, a means of printing with stones, and collotype, which substituted glass plates for the stones.

136 HSN, 267.

137 Manying Ip, *The Life and Times of Zhang Yuanji, 1867-1959* (Beijing: Commercial Press, 1985), 119-27, was the first to discuss this Sino-Japanese chapter in the history of the Commercial Press. She points out that He Shengnai, a Commercial Press printer who was almost certainly aware of the link, was silent about it. This Japanese chapter in the history of the Commercial Press lasted from 1903 to 1914.

138 Ibid.

139 Liu, "Zhongguo yinshuashu," 6; HSN, 266.

140 Both citations come from HSN, 266.

141 Boxwood prints are not mentioned in Western literature on printing; the process was probably invented by the Japanese themselves.

142 According to Berry, "Printing," 5: 706, there were two basic operating choices in lithography: either a reverse image was drawn directly onto the lithographic stone or an image prepared on special paper was transferred to the stone. The same could also be done with a photographic negative, as happened with the development of offset lithography. During printing, the stone was moistened with water, but the greasy crayon lines making up the image repelled the water that the unillustrated part of the stone absorbed. A thick printing ink was then spread over the surface, adhering to the greasy drawing lines but being repelled by the watery parts of the stone. As late as 1975, John Fraser of Aberdeen, Scotland was still printing with stones. For an arresting photograph of his printing stone archive, see Michael Twyman, "Lithography: the Birth of a New Printing Process," in *The Bicentennial of Lithography* (San Francisco: The Book Club of California, 1999), 9.

143 Alois Senefelder, *The Invention of Lithography,* trans. J.W. Muller (New York: The Fuchs & Lang Manufacturing Co., 1911), 18. Thank you to David S. Barker for pointing out Senefelder's name for lithography, which recalls Wang Tao's historically later comments, discussed above, on the importance of chemistry to modern printing.

144 The lithographic industry spread quickly following its invention by the otherwise unknown Bavarian playwright, Senefelder, who was born in Prague (HSN, 269, is probably mistaken when he claims that Senefelder was an Austrian). Senefelder developed the technique as a means of cheaply reproducing first his plays and then musical scores. He took his lithographic hand press to England in 1800, and by June 1801 had secured a patent. The technique reached France at approximately the same time. A lithographic printing firm was established in Rome in 1807, and, within the next decade, the industry spread to all major centres in Europe, including St. Petersburg. Lithography arrived in the United States in 1819, in India and Australia in 1821, in Chile in 1823, in Southeast Asia in 1828, and, as we shall see in Chapter 2, in Shanghai in 1876. For the early history of the technique and its practitioners, see Michael Twyman's *Lithography 1800-1850* (London: Oxford University Press, 1970); his "The Lithographic Hand Press 1796-1850," *Journal of the Printing Historical Society* (JPHS), 3 (1967): 3-51; and his two articles "Lithographic Stone and the Printing Trade in the Nineteenth Century," JPHS, 8 (1972): 1-41 and "A Directory of London Lithographic Printers 1800-1850," JPHS,10 (1974-75): 1-55. On the history of the American lithographic industry, see "Lithographic Stone in America [1807-1970]" by Philip J. Weimerskirch, *Printing History* 11, 1 (1989): 2-15. For extended accounts of the lithographic industry in non-Western European environments, see Gul Derman, *Resimli tas Baskisi halk Hikayerleri* (Ankara: Ataturk

Kultur Merkezi Yayini-Sayi, 1988), 24:1, which includes an English-language summary, and Irena Tessaro-Kosimowa's *Historia litografii warszawskiej* (Warsaw: Panstwowe Wydawnictwo Naukowe, 1973). I would like to thank Ella Benson of Pacific Lutheran University for summarizing this Polish-language book for me.

145 Beatrice Farwell, *Lithographs and Literature* (Chicago: University of Chicago Press, 1981), 1: 1.

146 Medhurst, *China*, 278, also 451-54.

147 Ibid., 223-24, citing Morrison on Keuh Agang/Qu Ya'ang. ZYS, 580, converts Keuh's name to Mandarin (Qu Ya'ang) and confirms that he was the first Chinese to master lithography. According to Medhurst, Qu had worked as a printer with Morrison since the early days of the London Mission. By the early 1830s, Qu was in Canton with Morrison. Medhurst makes clear that he himself did not arrive in Canton until 1835, meaning that Morrison must have taken the lithographic press to Canton. According to Wylie, *Memorials*, 12, Morrison's son, John, taught lithography to Qu. Wylie also says Qu's son, A'he, had been a typesetter for Morrison's dictionary. The oldest surviving Canton-lithographed works are short-lived Chinese-language news and commercial monthlies called *Geguo xiaoxi* issued by Medhurst from September and October 1837. After 1844, Qu worked with Legge in Hong Kong.

148 Medhurst, *China*, 227. Napier's unwise gambit, which revealed that the British knew how to write and print Chinese using their own technology, led to his removal to Macao, where he died.

149 MPC, 16.

150 ZYS, 579, is one of the first book-length accounts to have discussed the Canton lithography business of the 1830s. However, Han Qi and Wang Yangzong, "Qingchao zhi shiyin shu," [source unknown, collected in Ricci Institute Library, University of San Francisco] (n.p., n.p., 1991), 37-38, also discuss the Canton operation.

151 Including Dianshizhai, the total before 1911 was 149; see Chapter 2, which discusses the growth of the lithographic industry after 1876, for an explanation of how this number was calculated.

152 TPP, 13. Chromolithography advanced rapidly in the second half of the century in spite of the need to prepare a separate stone for each colour. Before 1900, most European colour printing, such as that for book illustrations, greeting cards, magazines, and posters was performed using stone-based colour lithography. After 1900, relief-based, three-colour process printing was developed by the letterpress industry and quickly replaced stone-based lithographic printing.

153 Liu, "Zhongguo yinshuashu," 7, and HSN, 271. ZYS, 580, says that "at the end of the Qing," Shanghai's Zaowenge and Hongwen shuju were among the first to experiment, with poor results, at five-colour lithographic printing.

154 Tōpuro Kōgyōshi Hensan linkai, eds., *Tōkyō Purosesu seihan kōgyōshi* (Tokyo: Tōkyō Purosesu kōgyōshi kyōdō kumiai, 1974), 23-57, appendix 3-13, indicates that Japanese experimentation with lithography began at the end of the Tokugawa era and advanced rapidly after the Meiji Restoration (1868). The Prussian ambassador presented the shogunate with its first lithographic press in 1860; the first Japanese book on lithography and photolithography appeared two years later. By 1867, the Japanese had begun to buy lithographic presses in Paris and intensive research into the new printing method, along with photography, accelerated. Seven years later, the Japanese periodical *Shinbun zasshi* (Chinese, *Xinwen zazhi*, News Magazine) was carrying advertisements for lithographic printing. In 1876, the Japanese navy began research into photolithography, and, over the next four years, both processes eventually spread from Tokyo and eastern Japan to Osaka and the Kansai region.

155 Numerous names are associated with the development of photo-offset techniques, even that of the poet Charles Baudelaire. Twyman, *Early Lithographed Books*, 243-58, credits Edward Isaac Asser of Amsterdam with the technological breakthrough in 1857 and British Colonel Sir Henry James with the entrepreneurial gift of disseminating zinc-plate (or photolithographic) technology. Subsequent antiquarian projects were so successful that, in England by 1880, "the age of the hand-produced facsimile was effectively over." HSN, 272, suggests that John W. Osborne invented photo-offset in 1859.

156 See, for example, NCH 1 June 1889: 666.

157 HSN, 271.

158 ZYS, 580.

159 Liu, "Zhongguo yinshuashu," 7, and HSN, 271.

160 The technician's name was L.E. Henlinger.

161 HSN, 272.

162 TPP, 14. Despite the crudeness of early offset printing results, the new presses could average 1,000 impressions per hour, a rate twenty times that of the fastest old lithographic presses. There is a striking parallel between the marketing ideas behind the IBM personal computer, whose design, like Harris Brothers' design of offset printing was never patented, and those relating to the Apple computer, whose designers restricted the right to copy it just as Rubel tried to limit use of his design to major lithographers only. Eventually, the Harris Brothers design, like IBM's, brought down prices and put an offset machine in the shop of almost any printer who wanted one.

163 Colin Clair, *A History of European Printing* (New York: Academic Press, 1976), 375-76.

164 Thank you to David S. Barker for clarifying this for me.

165 HSN, 272-73. Liu, "Zhongguo yinshuashu," 7, mistakenly states that the Commercial Press brought offset to Shanghai in 1921. Before long, offset printing spread inland from Shanghai to Wuchang, where the Yudi xueshe used it for printing maps.

166 Wang, "Kanyin zongshu," 369. On *Liangyou*, see Leo Ou-fan Lee, *Shanghai Modern: The Flowering of a New Urban Culture in China 1930-1945* (Cambridge, MA: Harvard University Press, 1999).

167 Even here, printing depended on the principle of greasy ink and water repelling each other. The paperback book revolution of the twentieth century, grounded on being able to print thousands of copies of a text on coarse paper, was made possible by web-fed offset lithographic printing, particularly that using plastic plates. See CMS, 20.135-37, 640.

168 In the view of Berry, "Printing," 5: 707, collotype "was more purely photographic than any of the other processes." Given the unstable printing surface (gelatine on glass), only a small number of prints could be made from each plate, restricting collotype's use to limited-edition books and wall pictures.

169 Ibid., 707-8.

170 Liu, "Zhongguo yinshuashu," 7.

171 HSN, 273.

172 Wang, "Kanyin zongshu," 369. Outside Shanghai, important collotypers were the Qin family firm (Yiyuan zhenshangshe) of Wuxi, the Tao family firm (Baichuan shushi) of Wujin, and the Luo family firms of Mochitang and Yi'antang in Shangyu; all of these firms were also well known for their photomechanical *(yingyin)* reproductions of pictures, calligraphy, and inscriptions. As late as 1941, the Luo firms were reprinting material from Dunhuang. Many of these firms, along with others too numerous to mention, also printed using metal plates *(jinshu ban)*.

173 HSN, 273-74.

174 Wang, "Kanyin zongshu," 369.

175 HSN, 273. According to He, tinplate printing was adopted by Shanghai's Huacheng, Huachang (sic), and Kangyuan can-producing factories to print labels.

176 ZYS, 575-78. According to Zhang, Chinese printers, as opposed to foreign Jesuits, first used copperplate in 1783 to produce a copperplate map of the imperial palace at Yuanmingyuan. Twenty-four plates from that issue are now in the Beijing University library, made even more valuable by the Anglo-French destruction of that palace in 1870.

177 Wang, "Kanyin zongshu," 370, and HSN, 274. I am speaking here about printed paper currency. The Chinese had been casting copper coins *(tongqian)* for centuries. Stamped copper coins *(tongyuan)* were introduced as part of the post-Boxer currency reform. The modern minting of Chinese coins began in 1887 when Liangguang Viceroy Zhang Zhidong asked the Chinese minister in London to purchase modern coining machinery. The Birmingham, England, firm Ralph Heaton & Sons was contracted to supply coining machinery for the production of silver and copper coins at Canton. Modern mints on the Canton model were then established at Wuchang (1895), Tianjin (Beiyang Mint) and Fuzhou (1896), Nanjing, Hangzhou, Shenyang (Mukden), Jilin, and Chengdu (1898), followed by a stampede of provincial mints, which together replaced the fifty or so old Qing mints. The Shanghai Mint was not established until 1921. British, German, American, and Japanese equipment was used in these mints. See

Wen Pin Wei, *The Currency Problem in China* (New York: Columbia University Press, 1914), 49, and Eduard Kann, *The Currencies of China* (Shanghai: Kelly & Walsh, 1927), 439-64.
178 BDRC, 1: 170.
179 HSN, 275.
180 HSN, 274, and Wang Zhaohong, "Tongke xiaoji," in ZJCSC, 298-308. In addition, according to Wang, "Kanyin zongshu," 368 and 374, note 9, for a limited time during the Guangxu reign (1875-1907), a number of Japanese firms opened on Shanghai's Henan South Road, issuing copperplate works like *Huimao zizai* and *Jinxiang huapu*, images of the Meiji Restoration, and books, such as *Kunxue jiwen* and *Rizhilu*, both with tiny "fly-head" characters "lined up like eyebrows *(yingtou xizi)*." Because of the high prices and narrow market orientation of their work, these Japanese firms, which used the Chinese names Leshantang, Leshantang shudian, Xiuwenguan, and Songyin shushi, did not last long.
181 Berry, "Printing," 5: 708. HSN, 275, mistakenly identified Karl Kleisch, known for improvements to photogravure in 1864, as its inventor.
182 Liu, "Zhongguo yinshuashu," 7, and HSN, 276. According to HSN, photogravure first arrived in Shanghai in 1917 as a result of English war propaganda. The Chinese did not learn the techniques until, by chance, the Commercial Press was able to hire a German technician, F. Heinicker. Heinicker had been working in Japan, but, after the 1921 Tokyo earthquake destroyed many photogravure printing firms, he passed through Shanghai on his way back to Germany. After helping the Commercial Press print the cover of the *Dongfang zazhi/Eastern Miscellany*, he co-invested with some Chinese in a firm called Zhongguo zhaoxiangban gongsi/ China Photogravure Company. With rotogravure printing, a steel cylinder is first coated with copper. Then, using acid, designs are etched into the copper using photographic film. Tiny recessed wells in the copper are inked to print web-fed paper; the larger the wells, the more the ink, and the darker the colour. Unlike in letterpress or offset lithography, text as well as illustrations can be printed using the rotogravure process. The plates themselves are made through a photochemical process of etching. See TPP, 15; CMS, 20.90 and 20.91, 626-27.
183 HSN, 275.
184 "Article IV, Movable Metallic Types among the Chinese," CR 19, 5 (1850): 247-49; "Article IV, Literary Notices," 282-84; Holt, "Mission Press," 210; Williams, "Movable Types," 24-25. For a view of a page printed with Tang's tin type, see "Article IV, Movable Metallic Types," 248. Tang's type were lost in 1854-55 during uprisings related to the Taiping Rebellion (1851-64). It is not explained in my sources why Tang, or other Chinese printers, did not simply find another kind of brush. The figure "$10,000" may simply reflect a literal missionary translation of a Chinese phrase meaning "a lot." Thanks to Joseph P. McDermott for querying this issue.
185 "Article IV, Literary Notices," 281.
186 Historians typically explain Gutenberg's selection of the screw press by way of his adaptation of Europe's wine presses (known as zonka/zonca) and/or paper presses.
187 Because of a lack of sources on Western intaglio presses in general, but on those in China in particular, I do not discuss them.
188 Moran, *Printing Presses*, 49, says that the screw on Stanhope's press was so powerful it would have broken a wooden press.
189 Ibid., 54. The cost was ninety guineas each.
190 Berry, "Printing," 5: 691.
191 Ibid., 686.
192 Moran, *Printing Presses*, 59-61. In general, the lineage of platen printing starts with Gutenberg's screw press and is followed by the innovations of Blaeu in 1620, Annison of the Imprimerie Royale in 1785, Ramage in 1790, Stanhope in 1800, the Columbian press in 1814, the Albion in 1820, the Washington of 1821, the Adams presses of 1830 and 1845, the Gordon of 1851, and the Universal of 1869. See TPP, 47-51.
193 Berry, "Printing," 5: 693, and David S. Barker (personal communication). The Columbian initially sold for $400.
194 Moran, *Printing Presses*, 68-69.
195 Major nineteenth-century manufacturers included the long-lived British firms Napier (1808-1958), Dawson (1854-1960s?), Harrild & Sons (1801/09-1948), and R. Hoe & Company of

New York and London (1805-1978). Harrild, which we first encounter in Figure 1.21, although independent of the *Times*, worked closely with the newspaper and, for a time, with Friedrich König, discussed below. Harrild also manufactured the Albion. For a history of R. Hoe & Company, see Frank E. Comparato, *Chronicles of Genius and Folly: R. Hoe & Company and the Printing Press as a Service to Democracy* (Culver City: Labrynthos, 1979). A functioning Washington press, manufactured by A.B. Taylor of New York, founded by a former Hoe employee, can be seen at the Stratford-Perth Museum, Stratford, Ontario.

196 For an illustration, see Moran, *Printing Presses*, 81.

197 W.S. Holt, "The Mission Press in China: The Am. M.E. Mission Press, at Foochow," *Chinese Recorder and Missionary Journal* 10, 4 (1879): 270, and MPC, 40-43.

198 Moran, *Printing Presses*, 88.

199 HSN, 267. Supplementing the letterpress, and using similar media, was the jobbing press. One of Gutenberg's major achievements had been the creation of the job-printing industry. According to Moran, *Printing Presses*, 143, "job" printing was historically regarded as any work involving less than a sheet. Before 1830, much job printing was done using engraving. In the 1810s, Daniel Treadwell of Boston, the inventor of the power-driven cylinder press, experimented unsuccessfully with a job press, but the vertical, self-inking press as it was known in Shanghai did not appear until the 1850s, when the Gordon press was first used in New York. Although it is difficult to say when the first job press arrived in Shanghai, by the late 1930s Hongkou's Jianye Machine-Making Company was manufacturing electric job presses.

200 "Article V, Literary Intelligence," 43, and MPC, 43.

201 Thank you to David S. Barker.

202 Moran, *Printing Presses*, 99, says that the Albion was also the preferred press of the nineteenth-century private printer, including William Morris's famous Kelmscott Press. In England, at mid-century, the Albion sold for £12 to £75. Moran, 97, says a small Albion, with "a Japanese or Oriental air," found in Singapore may have been manufactured by the Japanese around 1880.

203 MPC, 46.

204 This distinction is spelled out in CMS, 20.42.

205 Moran, *Printing Presses*, 105. König and Bauer's chief patron was Thomas Bensley, a well-known book printer located off Fleet Street, London, who, coincidentally, as early as 1801, had tried his hand at printing Chinese. Unfortunately, the type Bensley used for the frontispiece to Joseph Hager, *An Explanation of the Elementary Characters of the Chinese* (London: Richard Phillips, 1801), printed all three characters incorrectly. Inside the book, myriad other errors appear. According to Minami, "Mechanical Power," 614, each of König's cylinder presses was powered by a two-horsepower steam engine for the first time in 1814.

206 Moran, *Printing Presses*, 110. That first book was a second edition of the English translation of Blumenbach's *Institutions of Physiology*, a great contrast to the first book credited to Gutenberg's press, purportedly the forty-two-line Latin Bible, and to Marshman's Chinese Bible, produced at Serampore in 1822.

207 Ibid., 109.

208 Ibid., 123.

209 Ibid., 113.

210 "Protestant Missions," 308.

211 Wang, *Manyou suilu*, f.3a, cited in McAleavy, *Wang T'ao*, 4. Wylie, not Medhurst, was director of the Press after 1847, but Wang, who revised his diaries frequently, may have been confused. I have used McAleavy's translation of this passage with some minor changes.

212 The text says *meiyou*, an error; Wang should have said *meiyan* (soot).

213 Wang's memory is not always to be trusted. He claims that "in one day, you can print more than 40,000 pages" using the cylinder press. This must be an exaggeration; only the rotary press was that fast; see below.

214 Wang, *Yingruan zazhi*, 274.

215 Ibid.

216 ZYS, 593.

217 Cylinder presses, invented in 1812, were attractive to newspaper publishers because of their speed but turned out to be problematic in China due to a lack of suitable paper.

218 *Gezhi huibian* was published by John Fryer (1839-1928), an English ex-missionary directing the Translation Bureau at the Jiangnan Arsenal. After leaving Shanghai in 1896, Fryer became the first Agassiz professor of Chinese at the University of California.

219 The *Gezhi huibian* announcement indicated that Major Brothers would act as Shanghai agents for the cylinder presses produced by London's Harrild & Sons. *Shenbao*, owned by Major Brothers, carried similar advertising.

220 Moran, *Printing Presses*, 157. According to Minami, "Mechanical Power," 615, the Japanese did not import cylinder presses until 1874, two years after *Shenbao*. By the 1890s, they were already manufacturing them. In 1898, a Japanese sales agent brought Japanese-made copies of a European cylinder press to Shanghai; the reasonable price is said to have guaranteed it a wide appeal, says HSN, 267. I have seen no evidence to suggest that the Chinese ever manufactured cylinder presses.

221 ZYS, 588.

222 HSN, 268, and JSF, 263.

223 Moran, *Printing Presses*, 159.

224 Ibid.

225 HSN, 269. ZYS, 588, says that the Commercial Press bought a Miehle in 1912, which it used in conjunction with a German single-cylinder printing-and-folding machine. This machine could print 8,000 perfected pages an hour.

226 This schematic drawing of an advanced mid-nineteenth-century steam-powered printing-and-folding *machine* hints at the distance covered by nineteenth-century Western technological innovation in printing. Knowing that the machine's operation would not be obvious, the editors included an illustration to elucidate how the steam-powered machine actually worked. In rotary printing, rather than a flat typeform, the printing surface is etched onto a plate attached to a cylinder. Paper is then passed through two cylinders, one that bears the image and a second that works as a platen, much as in the cylinder press. Moran, *Printing Presses*, 173-75, shows that the roots of the rotary press lie, not in relief printing processes, as did those of the cylinder press, but in early intaglio printing processes. Already in the eighteenth century such principles were at work printing textiles. Although patents were taken out on paper-printing rotary presses as early as 1786 and 1790, rotary printing presses did not become viable until the middle of the nineteenth century.

227 De Zhen, "Zhengqi ji yinzi zhediefa shuolüe," *Zhongxi jianwen lu* 4 (1872), cited in ZJCSE, 393.

228 Ibid., 391-94. For some time, scholars have debated the impact of Euclidian perspectival drawings on the Chinese. The issues underlying this debate are complex but are related to the nature of scientific revolutions and the absence of one in China until the twentieth century. One early attempt to understand the relationship between the visual culture of technical drawing and a scientific mentality is found in Mark Elvin, *The Pattern of the Chinese Past* (Stanford: Stanford University Press, 1973), particularly Chapter 13. Carrie Waara's article "Invention, Industry, Art: The Commercialization of Culture in Republican Art Magazines," in Sherman Cochran, ed., *Inventing Nanjing Road: Commercial Culture in Shanghai, 1900-1945* (Ithaca: Cornell East Asia Series, 1999), 61-90, esp. 68-74, covers similar issues from another perspective.

229 For a sense of the relationship between memory and visual images, see Christopher A. Reed, "Re/Collecting the Sources: Shanghai's *Dianshizhai Pictorial* and Its Place in Historical Memories, 1884-1949," in *Modern Chinese Literature and Culture* 12, 2 (2000): 44-71.

230 Moran, *Printing Presses*, 185.

231 Berry, "Printing," 5: 690.

232 The earliest rotary press was built by Cowper and Applegath in 1816, but rotary presses did not catch on until their later, immensely successful, model was built for the *Times* in October 1848, four months too late for the revolutionary events that had rocked Paris that year. Robert Hoe built his first rotary press in 1847 and was followed by William Bullock in 1865. In 1866, the *Times* patented its famous Walter press. See TPP, 59-62, and Berry, "Printing," 700-1.

233 Berry, "Printing," 5: 698.

234 Moran, *Printing Presses*, 192.

235 ZYS, 588. In Chinese, there is no distinction between the most common terms for cylinder press (*lunzhuan ji*) and rotary press *(lunzhuan ji)*. Even according to the *Han-Ying Ying-Han*

yinshua chuban cihui (Chinese-English, English-Chinese Printing and Publishing Vocabulary) (Shanghai: Yiwen chubanshe, 1991), the proper names for cylinder press are *guntong yinshuaji* (cylinder press) or *lunzhuan yinshuaji* (rotating press); rotary press is also listed as *lunzhuan yinshuaji*. For this reason, one must infer from the brand name or description which type of press is being described.

236 ZJCSE, 394, note 2. According to Clair, *A History of European Printing*, 387, there was a Leipzig firm, founded in 1869, named Baensch-Drugulin that specialized in exotic fonts and became known for printing in Oriental languages; the foundry was sold in 1919, but the printing house lasted until 1930. Minami, "Mechanical Power," 616-17, says that Japan's first electric cylinder press had started printing in 1888. In 1890, the Printing Bureau imported its first steam-driven French-built Marinoni rotary presses from France. Tokyo and Osaka newspapers followed the government's lead, buying similar presses throughout the 1890s. By 1904, *Osaka Asahi* had succeeded in copying the steam-powered Marinoni press, marketing it as the Asahi rotary press.

237 HSN, 269.

238 Ibid.

239 GGZ, 201.

240 HSN, 269.

241 Linotype and L & M Machinery Co. was located at 160 Ai-duo-ya Road.

242 "Linotype and L & M No. 3 Rotary Press" (advertisement), YW 1, 3 (1937): 1.

243 "Duplex Tubular Plate Press/Du-bi-li-shi pai tongban yinbaoji," in YW 1, 4 (1937): 2-3.

244 "Linotype and L & M Machinery, Ltd.," in YW 1, 3 (1937): 1-2.

245 Senefelder, *Invention of Lithography*, 159ff. According to Senefelder (7, 18), the "mechanical" process was developed in 1796, followed by the "chemical" process in 1798-99.

246 Weimerskirch, "Lithographic Stone in America [1807-1970]," 2-15. Twyman, "The Lithographic Hand Press, 1796-1850," 4, says that "By 1850, the lithographic hand press was as satisfactory in terms of the quality of work it produced as it was ever likely to be." Lithography's slow production rate was the only significant way in which it compared poorly with letterpress printing. Once the stone was leveraged into position, a calfskin roller had to be used, in much the same way that the cylinder of the flatbed press was manipulated, to transfer ink from the stone to the paper. In fact, this was known as the "direct-rotary litho-press," as opposed to the indirect, or offset, litho press. See TPP, 13.

247 Berry, "Printing," 5: 707. Lithographic stones continued to be exported worldwide from Kelheim, Germany until the early twentieth century. On the multiple developments in the nineteenth-century lithographic press, see R.M. Burch, *Colour Printing and Colour Printers, with a Chapter on Modern Processes by W. Gamble* (Edinburgh: Paul Harris, 1983 [orig. 1910]), esp. Chapters 5-8.

248 Ibid.

249 Yao Gonghe, *Shanghai xianhua* (Shanghai: Guji chubanshe, 1989 [1917]), 12, reports his name as Qiu Zhi'ang.

250 He, "Sanshiwu nian lai zhongguo de yinshua she," [1937], cited in SUN, I: 117-18, says that hand rotation rendered the printing process extraordinarily wasteful.

251 Mao Xianglin, *Moyulu* [late Qing], cited in JSF, 272. I would like to thank Patricia Sieber for help translating in this section as well as Sun Cigong's poem cited earlier.

252 Zhuang, "Tushanwan," 36.

253 Chen's dates are unknown. See HSN, 270. According to Yang Shouqing's *Zhongguo chuban jie jianshi* (Shanghai: Yongxiang yinshuguan, 1946), 10, the compradore's name was Xi Zi'ang, and he was a native of Qingpu.

254 Frank H.H. King, *Money and Monetary Policy in China, 1845-1895* (Cambridge, MA: Harvard University Press, 1965), 237. Other reports say that Ernest Major and his brother Frederick went to Shanghai via Nova Scotia. On the question of which of the Major brothers founded *Shenbao*, see Reed, "Re/Searching the Sources," 49-50, note 6.

255 Yu Yueting, "Woguo huabao de shizu – *Dianshizhai huabao* chutan," in *Xinwen yanjiu ziliao congkan* 1981, No. 5 (December 1981): 149, says that in 1872 Ernest Major joined with three others (Wu Huade, Piao Laiyi, and another non-Chinese) in investing 400 taels each in *Shenbao*.

256 JSF, 269, reports that in 1918 *Shenbao* moved from its original residential location at Hankou and Jiangxi Roads to purpose-built quarters at Hankou and Shandong Roads in the heart of the Wenhuajie district. At the same time, they bought an American Sextuple parallel (Si-ge-te) rotary press which could produce 48,000 four-page sections per hour. Using it, *Shenbao* could delay printing its daily paper until 4 a.m.

257 Hu Daojing, *Baotan yihua*, cited in HSN, 285, note 10. *Shenbao* published over 160 titles, issuing incomplete catalogues in 1877 and 1879. It issued a limited-edition (maximum 2,000 copies), 160-volume reprint collection of fiction called *Shenbaoguan juzhenban congshu* with wooden type that imitated the Qianlong movable-type editions.

258 Yao, *Shanghai xianhua*, 12, says that Dianshizhai was first located at the corner of Nanjing Road and the Nicheng Bridge (now Xizang Road) but that it moved to a new location within a few months. JSF, 272, says its print shop was located there and its sales outlet was found at the corner of Nanjing and Henan Roads.

259 The official English name is given in Francis L.H. Pott's *A Short History of Shanghai* (Shanghai: Kelly & Walsh, 1928), 135, as "Tien Shih Chai Photolithographic Publishing Works," which I have abbreviated and reromanized here.

260 For a roughly contemporary San Francisco lithographic firm (in 1889), see George K. Fox, "American Lithographers' Trade Cards," in *Bicentennial of Lithography*, 87.

261 HSN, 272.

262 Huang Shiquan, *Songnan mengyinglu* (Shanghai: [n.p.], 1883), cited in Liu, "Zhongguo yinshuashu de yange," part 2, in YW 1, 2 (1937): 6.

263 HSN, 272.

264 Ibid.

265 Ibid., 273.

266 These statistics are based on references scattered throughout the documentation consulted for this chapter.

267 Intaglio printing was also historically important, but after the eighteenth century missionaries played little role in its transfer.

268 ZYS, 578.

269 Liu Longguang, "Zhongguo yinshuashu de yange," part 2, in YW 1, 2 (1937): 4-7. Liu Longguang was a graduate of Guanghua University. In the 1930s, he was involved with a number of Shanghai graphics industry publications; after 1949, he joined Renmin chubanshe and was part of the publishing team that produced *Mao Zedong xuanji* (Selected Works of Mao Zedong).

270 *Shanghai tuhua ribao* (n.d.), quoted in ZYS, 588.

Chapter 2: Janus-Faced Pioneers

1 CYL, 1: 113.

2 Ibid., 1: 148.

3 Kang Youwei, *Riben shumu zhi* (Shanghai: Datong yishuju, 1897), in Chen Pingyuan and Xia Shaohong, eds., *Ershi shiji Zhongguo xiaoshuo lilun ziliao (1897-1916)* (Beijing: Beijing daxue chubanshe, 1989), 1: 13.

4 In his *Early Lithographed Books* (London: Farrand Press & Private Libraries Association, 1990), 15, Michael Twyman points out that, in the West, after a run of five centuries, "Letterpress printing ... is now almost a thing of the past ... It is all the more surprising, therefore, that historians of printing should have neglected to study ... lithographic book production." Twyman's comment also pertains to Chinese lithographic book production.

5 Zhang Zhidong, *Shumu dawen* (1876) quoted in Cho-yuan Tan (Taam), *The Development of Chinese Libraries under the Ch'ing Dynasty, 1644-1911* (Shanghai: Commercial Press, 1935), 75-76. See Fan Xiceng, ed., *Shumu dawen buzheng* (Beijing: Zhonghua shuju, 1963 [1876]), 216-17.

6 The exception is the Sino-British hybrid Dianshizhai, publisher of the *Dianshizhai Pictorial* read by Bao.

7 Yu Yueting, "Woguo huabao de shizu – *Dianshizhai huabao* chutan," *Xinwen yanjiu ziliao congkan* 5 (1981): 175-77. According to JSF, 276, lithography dominated the Chinese newspaper world for thirty years until the early Republican era, when copperplates took over. An American

variant of these views is found in Leo Ou-fan Lee, *Shanghai Modern, The Flowering of a New Urban Culture in China, 1930-1945* (Cambridge, MA: Harvard University Press, 1999), 64-67, who argues that the *Dianshizhai Pictorial* was important for preparing the ground for Shanghai's pictorial magazines of the 1920s and 1930s, specifically, *Dongfang zazhi* and the photography-dominated *Liangyou*.

8 Beatrice Farwell, *Lithographs and Literature* (Chicago: University of Chicago Press, 1981), 1: 1.

9 Paul Jobling and David Crowley, *Graphic Design, Reproduction and Representation since 1800* (New York: Manchester University Press, 1995), 42-43.

10 Geoffrey Wakeman, *Victorian Book Illustration, The Technical Revolution* (Newton Abbot, UK: David & Charles, 1973), 15.

11 Under the influence of the Newcastle engraver, Thomas Bewick, British publishers of satirical magazines combined wood engravings, sometimes prolonged in use by stereotyping, with typography, which allowed for vast print runs. See Celina Fox, *Graphic Journalism in England during the 1830s and 1840s* (New York: Garland, 1988), esp. Chapter 2. Even the *Illustrated London News* used wood engravers rather than lithographers for the sake of speed. *Vanity Fair* was a notable exception to this rule. Woodblock book illustration remained a viable industry in England until about 1880, when it was surpassed by various types of lithography and a technique known as line illustration. See Wakeman, *Victorian Book Illustration*, 162.

12 Twyman, *Early Lithographed Books*, 190.

13 Ibid. Twyman identifies the *Glasgow Looking Glass* as the first of these papers, although it soon moved to London, where it became the *Looking Glass*. According to Jobling and Crowley, *Graphic Design*, 30-35, the *Looking Glass* was joined by publications such as the *Weekly Chronicle* (1830s) and the *Illustrated Police Gazette* (1867?-1938). A well-known mid-century lithographed work was Edward Lear's *Book of Nonsense* (1846) which combined illustrations with limericks and was frequently reprinted.

14 David Roberts, *From an Antique Land: Travels in Egypt and the Holy Land* (New York: Weidenfeld and Nicolson, 1989 [1842-49]).

15 By the time of the American Civil War, photography had joined lithography in presenting war to stay-at-home audiences.

16 Ronnie C. Tyler, *The Mexican War, A Lithographic Record* (Austin: Texas State Historical Association, 1973), 1-12.

17 Frederic A. Conningham, *Currier & Ives Prints* (New York: Crown Publishers, 1949), v-vi.

18 Twyman, *Early Lithographed Books*, 22. According to Wakeman, *Victorian Book Illustration*, 161-63, in addition to its use in book printing, lithography was well known as a means of book illustration. Of the sixteen different book illustration techniques available in London in the latter half of the nineteenth century, lithography led the pack from 1850 to 1890.

19 Twyman, *Early Lithographed Books*, 22.

20 Yu, "Woguo huabao de shizu," 177. According to Su Ching, "The Printing Presses of the London Missionary Society Among the Chinese" (PhD diss., University of London, 1996), 294, in the early 1840s, missionaries at Shanghai found that Chinese-published books using Chinese characters to represent sounds in the Wu dialect were very popular among the common people, especially women. Chinese teachers at the mission then began to adapt Christian books to the Wu dialect. The first book to be adapted in this fashion, *The Forms of Prayer*, in 64 pages, was printed using lithography and appeared in 1845. Lithography was discontinued in 1847 and then resumed on a smaller scale in the mid-1850s. Although fascinating as an alternative fount of lithographic expertise, this operation does not seem to have been the main influence on the birth of print-capitalist lithography in 1877. Thanks to Joseph P. McDermott for this citation. Han Qi and Wang Yangzong, "Qingchao zhi shiyin shu," [source unknown, collected in Ricci Institute Library, University of San Francisco] (n.p., n.p., 1991), point out that Walter Henry Medhurst brought lithography to Shanghai in the 1840s and that John Fryer, Jiangnan Arsenal translator, working together with Xu Jianyin and Wang Dejun, translated Straker's *Lithography* and Berry's *Lithography* into Chinese before 1875 even though most Arsenal translations were printed with woodblocks. Similarly, starting in 1877, Fryer's own science and technology publication, *Gezhi huibian*, issued detailed accounts of lithographic printing.

21 Yunlange was located in Suzhou's Changmen district.
22 This account of Wu Youru's life summarizes JSF, 276, and Wu Youru, "Selections from the *Dianshizhai Pictorial*," trans. Don J. Cohn, *Renditions, A Chinese-English Translation Magazine* 23 (1985): 47. Yu, "Woguo huabao de shizu," 177, lists ten of Wu's colleagues: Zhou Muqiao, He Yuanjun, Tian Zilin, Fu Liangxin, Xie Zunlong, Ma Ziming, Gu Yuezhou, Wu Zimei, Shen Meipo, and Guan Qu'an.
23 According to Fan Muhan, ed., *Zhongguo yinshua jindai shi, chu gao*. (Beijing: Yinshua gongye chubanshe, 1995), 253, it was printed by the lithographer Hongbaozhai.
24 Wu, "Selections from the *Dianshizhai Pictorial*," 49.
25 Gong Chanxing, "Xinwen huajia Wu Youru; jiantan Wu Youru yanjiu zhong de jige wenti," *Meishu pinglun* (n.l.: n.p., 1991?): 70.
26 Unfortunately, neither has yet been adequately classified by scholars or librarians.
27 Song Yuanfang and Li Baijian, eds., *Zhongguo chubanshi* (Beijing: Zhongguo shuji chubanshe, 1991), 225-26. Yan Fu's transitory but excellent Tianjin daily, *Guowen bao*, and its accompanying ten-daily, *Guowen huibao*, both of which contained his political essays, are other well-known lithographed newpapers.
28 Jonathan Hay discusses illustrated magazines and books from a perspective that reinforces this view. See his "Painters and Publishing in Late Nineteenth-Century Shanghai," in Chou Juhsi, ed., *Art at the Close of China's Empire* ([Tempe]: Arizona State University, 1998), 134-88.
29 Using *Quanguo Zhongyi tushu lianhe mulu* (Beijing: Zhongyi guji chubanshe, 1991) and Wang Qingyuan, Mou Renlong, Han Xiduo, eds., *Xiaoshuo shufang lu* (Beijing: Beijing tushuguan chubanshe, 2002 [1987]), 102-203, I have been able to identify only seven Shanghai publishers before 1876: Lingyun ge (active from the Qianlong era), Jiangzuo shulin (active by 1798), Wenyun shuju (first appeared 1839), Jinzhang shuju (active by 1856), Saoye shanfang (present in Shanghai from about 1860), Jinhua shuju (established by 1860), and Wenyi shuju (founded by 1866). I would like to thank Marta Hanson of the University of California at San Diego and Pieter Keulemans of the University of Chicago for recommending these works or editions to me.
30 See Wang Shucun, ed., *Xiju nianhua*, 2 vols. (Taipei: Yingwen hansheng, 1991), 313-15.
31 See Lucien Febvre and Henri-Jean Martin, *The Coming of the Book* (London: NLB, 1979), 21. Febvre and Martin describe the "exemplar" as follows: "To keep proper intellectual as well as economic control over the use of books [and] to assure the reproduction of copies under the best conditions ... the universities [of the European Middle Ages] devised an ingenious system. Manuscripts were loaned ... From them copies could be made ... The original text (the 'exemplar') was returned ... after copying ... each copy was made from the same original."
32 In 1890, John Fryer, of the Jiangnan Arsenal and Chinese Scientific Book Depot, delivered a report to the General Conference of Protestant Missionaries of China on the Chinese textbook series that he had been commissioned in 1879 to provide. Fryer, "General Editor's Report," in *Records of the General Conference of the Protestant Missionaries of China* (Shanghai: APMP, 1890), 715, suggests that woodblock cutting was still being undertaken in Shanghai in 1890. Fryer mentions that "the books that have been cut on woodblocks are in good, bold type ... The cutting of the blocks has been effected partly in Shanghai and partly in Canton and [Hankou], where at first it could be done cheaper than in Shanghai. The prices for cutting are now nearly the same in all three places; and therefore, as a matter of convenience, all recent work has been done here." Fryer does not indicate whether Shanghai prices had increased, which might have indicated a reduction in the numbers of woodblock carvers, under the influence of competition from lithographers. Fryer was not the only late-nineteenth-century missionary who valued woodblock printing. In the same publication, Ernest Faber, "Christian Literature in China: Its Business Management," 553, writes that "printing from blocks is still done with advantage whenever a larger work meets with continuous demand, though only a small number is needed, perhaps some hundred copies, per year."
33 SUN, 2: 1, 1: 246.
34 Ibid., 2: 1, 2: 1200.
35 Ibid., 2: 2: 1005-10 and 1166-68. Sun identifies these seven: Feiyingguan, Hongwen shuju, Fuwenge, Baishi shanfang, Hongbaozhai shiyinju, Jishi shanfang, and Tongwen shuju. To this list, based on my survey of *Quanguo Zhongyi tushu lianhe mulu*, I add the following thirteen:

Baowen shuju, Dianshizhai, Guxiang ge, Jiangzuo shulin, Jiaojing shanfang, Qianqingtang shuju, Saoye shanfang, Shanghai shuju, Shenchang shushi, Shenhai shanfang shuju, Shuncheng shuju, Wenruilou, and Zhushi lianwen shuju. In addition, the research of Wang et al., *Xiaoshuo shufang lu*, 102-203, supplies the names of thirty-two more publishers: Baoshan shuju, Changwen shuju, Chongwen shuju, Datong shuju, Fugu shuzhai, Guangbaisong zhai, Guangyi shuju, Hongwen shuju, Huanwen shuju, Jinbu shuju, Jinzhang shuju, Jishi shuju, Jiujingzhai, Kuiguangzhai, Liwen xuan, Puji shuzhuang, Shanghai jushi, Tushu jicheng ju, Wenlan shuju, Wenxuan shuju, Wenyi shuju, Wenyi shuju (different characters), Wenyuan shanfang, Wenyuan shuzhuang, Yingshang wucai gongsi, Yizhen shuju, Zhengyi shuju, Zhenyi shuju, Zhonghe shuju, Zhuji shuju, Zhuyitang, and Zuiliutang.

36 The figures that Sun quotes are probably based on NCH 25 May 1889: 633.
37 NCH 30 January 1889: 114. The article goes on to say that there was to be a special examination in the fall in honour of the emperor's marriage, and that "the book dealers are looking forward to recouping themselves to some extent next autumn," presumably by stocking lithographed editions for candidates' purchase in preparation for the exam. Conversely, it also states that "In the shop lists, the productions of modern authors shut out almost completely the works of the twelfth and thirteenth centuries which used to be so famous ... the effect of [the lithographed books] is secretly to undermine the Sung dynasty system of thought which pervades the old school books" and which was the basis of the examination curriculum.
38 NCH 25 May 1889: 633.
39 NCH 23 November 1888: 567.
40 NCH 26 October 1888: 459.
41 NCH 25 May 1889: 633.
42 Faber, "Christian Literature in China," 552.
43 Gilbert McIntosh, "Discussion," in *Records of the General Conference of the Protestant Missionaries of China* (Shanghai: APMP, 1890), 582. The Guangxuehui was located down the street from Tongwen Press, discussed below.
44 Ibid.
45 Ernest Box, "Native Newspapers," in Society for the Diffusion of Christian and General Knowledge among the Chinese, *11th Annual Report* (Shanghai: n.p., 1898), 40-41.
46 APMPAR, 1891, 1.
47 Ibid., 3
48 Box, "Native Newspapers," 39.
49 NCH 25 May 1889: 633.
50 *Saoye shanfang shumu* (Shanghai: n.p., 1917). I am indebted to Marta Hanson for bringing this publisher's catalogue to my attention.
51 In 1917, according to the "Proprietor's Notice" in the booklet, Saoye had been in existence in Suzhou for 300 years. In fact, the firm was started by the Xi family of Lake Dongting during the Wanli reign (1573-1619) of the Ming dynasty. Eventually, a retail outlet was opened in Suzhou's Changmen district. At the beginning of the Qing, the Xis acquired many books from the Jiguge library in Changshu owned by the Mao family. The Xis' Suzhou shop garnered respect for reprinting many old and famous works.
52 ZYS, 592. The 1917 Saoye catalogue is divided into four slim sections, the first two of which are devoted to describing lithographed editions. All of them are reprints. The largest single category in the catalogue is calligraphy manuals, the specialty by which Saoye's name is still known in Shanghai today. Sections three and four of the catalogue feature woodblock editions and editions of the Chinese Classics issued by provincial printing offices. These, too, are all reprints, calling to mind Zhang Zhidong's call to reprint rather than write anew. The first section of the catalogue is twenty-one pages long and features roughly 275 titles, divided into sections such as poetry, phonetics, textbooks and reference books, *biji*, novels, etc. Section two features 416 titles of lithographed editions, many of which are designated as reprints from Tongwen Press, one of the three major Shanghai lithographic publishers to be studied here. Section two also includes many medical books.
53 These restaurant prices come from Wu Guifang, "Qingji Shanghai de yinshi wujia," *Dang'an yu lishi* 4 (1988): 97, which lists the two bowls of soup in terms of "cash," a form of currency left over from the Qing. Strictly speaking, "cents" did not equal "cash" because China lacked

a unified coin system in this period, but Eduard Kann, *The Currencies of China* (Shanghai: Kelly & Walsh, 1927), 418, suggests that they were comparable. I have chosen to use "cents" to make the comparison more transparent. Although Wu's figures come from 1908, Thomas Rawski, *Economic Growth in Prewar China* (Berkeley: University of California Press, 1989), 162, suggests that between 1910 and 1936 inflation averaged only 2 percent per year, which would have made the Saoye prices of 1917 even less in 1908 terms.

54 NCH 25 May 1889: 633. Something is known of the wages paid to woodblock cutters. According to Evelyn S. Rawski, *Education and Popular Literacy in Ch'ing China* (Ann Arbor: University of Michigan Press, 1979), 121, Ye Dehui (1864-1927) reported that "the cost of carving woodblocks gradually increased during the Ch'ing period [largely due to inflation], from a charge of twenty cash per hundred characters in the late seventeenth century to fifty to sixty cash per hundred in the 1870s." Using female labour brought the costs down to one-fifth of the prevailing rate. A bowl of noodles at this time cost eight cash, says Rawski. By the 1920s, according to Chen Cunren, *Yinyuan shidai shenghuo shi* (Shanghai: Renmin chubanshe, 2000), 232, lithographic copyists were earning a pittance; first-class quality got only three mao per thousand characters (second-class earned two mao, third class, one mao). Thank you to an anonymous UBC Press reviewer for this citation.

55 SMJG, 1: 439.

56 A sum of ninety-seven results when the thirty-nine publishers listed in SUN and *Quanguo Zhongyi tushu lianhe mulu* are added to the fifty-eight fiction publishers (corrected to eliminate duplication) found in Wang et al., *Xiaoshuo shufang lu*, 102-203.

57 On cigarette trading cards, see Wang Hewu et al., eds., *Qicai xiangyan pai* (Shanghai: Shanghai kexue jishu wenxian chubanshe, 1998), 9, which mentions lithographic and offset printing of the more than 30,000 cigarette trading cards belonging to the Shanghai Library.

58 GGZ, 145-46.

59 Joan Judge, *Print and Politics: "Shibao" and the Culture of Reform in Late Qing China* (Stanford: Stanford University Press, 1996), 19.

60 Yu, "Woguo huabao de shizu," 150.

61 Dianshizhai probably had many more; at Tongwen Press, the ratio of staff to printing presses was forty-one to one, so Dianshizhai may have had as many as 205 employees when it opened.

62 For a contrasting drawing of an elite Chinese-style shop selling fans located in the same vicinity, see *Dianshizhai huabao*, reprint (Canton: Guangdong Renmin chubanshe, 1983), volume *yi*, 73.B.

63 In fact, spacious multistoreyed Western buildings did become part of the Shanghai image of modernity in Chinese eyes at this time. See, for instance, CYL, 1: 30.

64 The phrase "big foreign church" probably refers to the Americans' Trinity Cathedral (established 1869) near Hankou and Jiangxi Roads visible on the Shanghai map in the front of this book. John Fryer's Chinese Scientific Book Depot was in the same area. The Shanghai Muncipal Council buildings were erected on this block in 1913.

65 Wu Youru, cited in ZJCSE between 360 and 361, caption. On "Meng of Shu," see Thomas Francis Carter and L. Carrington Goodrich, *The Invention of Printing in China and Its Spread Westward* (New York: Ronald Press, 1955), Chapter 9. The Meng family ruled the state of Shu, culturally then the most advanced part of China, from 934 to 965 after the fall of the Tang dynasty. Although Wu states that the Mengs began printing with wooden blocks, Carter and Goodrich aver that printing from woodblocks began at Chengdu in Shu under the previous rulers, surnamed Wang, and spread when it was taken back to the central Chinese capitals of Luoyang and Kaifeng by Feng Dao (882-954) as an inexpensive alternative to engraving the Classics in stone. "Red and black characters" here may refer to the Qing habit of printing basic texts in black ink and commentary in red. See Pauline Yu, "Canon Formation in Late Imperial China," in Theodore Huters et al., eds., *Culture and State in Chinese History: Conventions, Accommodations, and Critiques* (Stanford: Stanford University Press, 1997), 102. I would like to thank Patricia Sieber both for her help in translating this poem and for this reference.

66 For an example of this late-nineteenth-century Chinese tendency to assume that anything of value in world civilization could be traced in some way to China, see J.D. Frodsham, ed. and trans., *The First Chinese Embassy to the West: The Journals of Kuo Sung-t'ao, Liu Hsi-hung, and Chang Te-yi* (Oxford: Clarendon Press, 1974), lvii and 140.

67 Wu, cited in ZJCSE, between 360 and 361, caption. In the name "Dianshizhai," "zhai" is a common term used for a scholar's studio. The verb-object construction "dianshi" derives from the phrase *dianshi chengjin*, meaning "to touch stone and produce gold," conventionally said when improving a phrase in a composition but clearly functioning here with a double entendre. The whimsical, vaguely poetic names of the lithographic shops, such as Dianshizhai (Stones-into-Gold Studio), suggest their cultural continuity with traditional Chinese publishing concerns with similar kinds of names.

68 Yao Fushen, *Zhongguo bianji shi* (Shanghai: Fudan daxue chubanshe, 1990), 246.

69 JSF, 273.

70 Yao, *Zhongguo bianji shi*, 247. This price difference is considerably greater than the 40 percent savings Yao reports as having been afforded the consumer by lithographic printing. In 1917, the same text from Saoye would cost two Republican yuan in a lithographed edition and three yuan five mao in a typeset edition.

71 Information in this paragraph comes from the lengthy 25 March 1889 NCH article profiling the Chinese lithographic industry. Yao Fushen relies on Yao Gonghe's *Shanghai xianhua*, first published in 1917 by the Commercial Press and republished in 1925 and 1933, for the same information. For Yao Gonghe's own words, see his *Shanghai xianhua* (Shanghai: Guji chubanshe, 1989 [1917]), 12.

72 Rawski, *Literacy and Education*, 120; Robert Hegel, *The Novel in Seventeenth Century China* (New York: Columbia University Press, 1981), 10; Robert Hegel, *Reading Illustrated Fiction in Late Imperial China* (Stanford: Stanford University Press, 1998), 123. Cecil K. Byrd, *Early Printing in the Straits Settlements, 1806-1858, A Preliminary Inquiry* (Singapore: National Library, 1970), 10, reports that the number of impressions that a set of blocks would give depended on the care of the printer and that some blocks were good enough to produce a total of 20,000 copies.

73 Gong, "Xinwen huajia Wu Youru," 70. On Dianshizhai's publishing of novels, see Wang et al., *Xiaoshuo shufang lu*, 112. Friedrich Hirth, "Western Appliances in the Chinese Printing Industry," *Journal of the China Branch of the Royal Asiatic Society* (Shanghai) 20 (1885): 169, strongly emphasizes that the Dianshizhai reprints were characterized by "extreme cheapness" but also clarity. The characters of the *Peiwen yunfu*, which sold for fifteen yuan (thirty less than a Canton-woodblocked one), were so small, however, that readers had to be supplied with a magnifying glass to be able to read them. For other 1885-era Dianshizhai prices, see ibid., 170. Hirth (1845-1927), who served in the Chinese Customs Service from 1870 to 1897, became Dean Lung Professor of Chinese at Columbia University from 1902 to 1917.

74 Throughout the history of Chinese commercial publishing, merchandise was sold by travelling salesmen. Wu Jingzi, the author of *Rulin waishi (The Scholars)*, describes the plans of Guang Zhaoren (a poor scholar) and the manager of Hangzhou's Literary Expanse Bookshop to produce an edition of model *bagu* essays for sale by merchants travelling to Shandong and Henan. Similarly, Wang Licai, mentioned in Chapter 1, worked as an itinerant bookseller in the Nanjing and Kaifeng areas before establishing Kaiming shudian in Shanghai in the early 1900s. According to Yao, *Zhongguo bianji shi*, 247, lithography spread to Wuchang, Suzhou, Ningbo, Hangzhou, and Canton, but, he says, the quality never matched Shanghai's. For details on early lithography in Canton and Hangzhou, see SUN, 2: 1: 2, 1010.

75 Zhang, *Zhongguo yinshua shi*, 591, cites a draft version of Wang's diary, *Taoyuan riji*, to the effect that, in one year, probably after 1886, Wang earned 480 yuan editing for Dianshizhai, 200 yuan working for John Fryer's Chinese Scientific Book Depot (founded the same year as Dianshizhai), and only 80 yuan in the employ of the Chinese steamship line China Merchants.

76 According to Yao, *Zhongguo bianji shi*, 248, the book was *Gujin tushu jicheng*. The number of volumes reported in the *North China Herald* matches its length, suggesting that Yao, who cites no source, is correct. *Gujin tushu jicheng*, often abbreviated *Tushu jicheng*, was an imperially commissioned encyclopaedia *(leishu)* completed in 1725 by a large board of scholars led by Jiang Tingxi. It is interesting to note, given the fact that Dianshizhai reprinted it lithographically, that its 5,020 volumes were first printed in 1728, according to Benjamin A. Elman, *From Philosophy to Philology: Intellectual and Social Aspects of Change in Late Imperial China* (Cambridge, MA: Harvard University Press, 1984), 128, "using movable type ... A font of some one and a half million copper type was cut for the project" at the Palace printing office (Wuyingdian) in Beijing.

77 NCH 29 October 1889: 472.
78 Yu, "Woguo huabao de shizu," 150, notes that *Shenbao* started the monthly *Yinghuan xiaoji* in November 1872, following it with *Siyan xiaoji* in February 1875, and *Huanyu xiaoji* in February 1876.
79 Wu, "Selections from the *Dianshizhai Pictorial*," 48.
80 Yao, *Zhongguo bianji shi*, 246, equates the two, mistakenly reporting that the *Pictorial* first appeared in 1876, the year before the bookstore opened.
81 According to ibid., 247, the *Dianshizhai Pictorial* was preceded by *Shenbao*'s unsuccessful pictorial *Yinghuan huabao* and was followed by publications such as *Xunmeng huabao, Haiti huabao, Chengtong huabao, Feiyingge huabao* (mentioned earlier), and *Xinwen baoguan huabao*.
82 Gong, "Xinwen huajia Wu Youru," 71.
83 Chinese *lianshi* paper was commonly used by lithographers; because it was locally produced, unlike the rest of the materials needed for lithography, it was cheaper than foreign paper. According to CYL, 1: 150, Liang Qichao's lithographed *Shiwubao* was also printed on it. NCH 25 May 1889: 633 says the lithographers favoured Fujian bamboo paper. The stones and printing machines came largely from England and France, however. Oddly, one looks in vain for information concerning imports from the pre-1894 era. In the 1903 *North China Desk Hong List* (Shanghai: North China Daily News Printing Office, 1903), printed in both English and Chinese but with an orientation to the foreign residents of Shanghai, only two lithographers, Kelly & Walsh and the Oriental Press, are listed among forty-nine printers, stationers, and booksellers. Kelly & Walsh (Chinese, Biefa yanghang) was located at No. 11 The Bund, and The Oriental Press was at 69 rue du Consulat, just off the Bund, in the French Concession. Even at a time when there were as many as ninety-seven Chinese lithographic publishers in Shanghai, this lack of information in a publication meant for foreigners is not surprising. Most foreign lithographic work was sent back to England; the influence of the Chinese-language lithographic industry on foreigners' lives was small. In the *Hong List*, only Kelly & Walsh is listed as an importer and supplier of lithographic supplies, but it is probable that printing houses such *Shenbao* and *North China Herald* carried on a lucrative private trade in such supplies. Similar *hong* lists produced solely in Chinese from this period have not come to light; in the periods for which purely Chinese-language lists are available, lithography had already passed its prime.
84 Box, "Native Newspapers," 40.
85 SUN, 2: 1: 2, 1181. The narrator in Wu Woyao, *Ershinian mudu zhi guai xianzhuang* (Taipei: Shih-chieh shu-chu, 1962), 1: 81, comments that his sister bought a copy of the *Pictorial* from a newsboy.
86 Box, "Native Newspapers," 40, 44-46. I would like to thank Kuiyi Shen of Ohio University for clarifying these details for me.
87 Lithographic commercial advertisements, Don J. Cohn, ed. and trans., *Vignettes from the Chinese: Lithographs from Shanghai in the Late Nineteenth Century* (Hong Kong: Chinese University of Hong Kong Press, 1987), back cover.
88 According to Fan, *Zhongguo yinshua*, 268, 282, *Shenbao*'s compradore, Xi Yufu, formed the Jicheng tushu gongsi in 1907 after buying *Shenbao*'s Tushu jicheng shuju and merging it with Shenchang shuju and Dianshizhai, but I have not found independent confirmation of this activity. Fan also says that Jicheng tushu gongsi was, at that time, the most complete print shop in Shanghai. Xi bought *Shenbao* itself in 1909.
89 Gong, "Xinwen huajia Wu Youru," 71.
90 Yao, *Shanghai xianhua*, 1917, in SUN, 2: 1: 1, 118. Yao also points out that the Ningbo men set up the Baishi shanfang. "These three had a triangular monopoly for a time and were the first to set the style."
91 Xu Run, "Xu Yuzhai zixu nianpu," (n.p.: n.p., n.d.), 31, in SUN, 2: 1: 2, 1005. According to Hirth, "Western Appliances," 170, Tongwen was created by "a company of native friends of Chinese literature who have subscribed the capital necessary for the printing and publishing of facsimile editions of the best productions of Chinese literature." Rather than a company of friends, Tongwen was a company of brothers. Xu Run was one of the most prominent members of late-nineteenth-century Shanghai's sizable Cantonese community. He had gotten his start through Dent and Company, which, like Jardine, Matheson, and Company, was a

Scottish opium-trading firm. Born, like both his famous compradore associate Tong King-sing and the revolutionary Sun Yat-sen, in Xiangshan, Xu had been in Shanghai since at least the 1870s, when he was appointed by Li Hongzhang to the board of the China Merchants' Steam Navigation Company. See Zheng Shao, "Xu Run yu lunchuan zhaoshangju," in *Shanghai yanjiu luncong* (Shanghai: Shanghai shehui kexueyuan chubanshe, 1991), 6, 241- 60. In spite of his three purchased titles, the highest of which was expectant *daotai*, Xu is not found in either ECCP or in BDRC, both of which reflect conventional Chinese editorial biases favouring men of politics and government administration. Xu does figure prominently in Albert Feuerwerker's industry-oriented *China's Early Industrialization* (Cambridge, MA: Harvard University Press, 1958) and in Wellington K.K. Chan's more commerce-directed *Merchants, Mandarins and Modern Enterprise in Late Ch'ing China* (Cambridge, MA: Harvard East Asian Research Center, 1977). In addition to his well-known business ties to the China Merchants, the Kaiping Coal Mines in Zhili, and the Guichi Coal Mines in Anhui, Xu also owned interests in Guangdong silver mines, the Jianping Gold Mine in Rihe (Jehol), Zhili's Yongping Gold Mine, and many tea firms in the Yangzi valley. His Shanghai real estate assets alone were valued at 2.2 million taels in 1883-84. Supported by both Li Hongzhang and Yuan Shikai, he was the archfoe of Self-Strengthener Sheng Xuanhuai. Xu died in his Bubbling Well Road home.
92 Such as *Peiwen yunfu*, *Bianzi leibian*, and *Zishi jinghua*.
93 Hirth, "Western Appliances," 170.
94 ZYS, 591.
95 Xu in SUN, 2: 1: 2, 1005.
96 Ibid.
97 Mentioned in Yao, *Zhongguo bianji shi*, 273, who also says that Dianshizhai had blazed the trail in this as in other ways.
98 ZYS, 592.
99 See Hirth, "Western Appliances," 163. If Yao Fushen is correct that Dianshizhai had received a stolen *Tushu jicheng* in 1884, it would be interesting to know which exemplar, its own or Tongwen's, was used for this 1888 printing.
100 Qian Jibo, "Banben tongyi," (n.p.: n.p., n.d.), in SUN, 2: 1: 2, 1005.
101 ZYS, 592.
102 Xu, in SUN, 2: 1: 2, 1005. The similarity between Colonel Sir Henry James and the British Ordnance Survey Office's use of lithography to provide the British nation with facsimiles of important documentary collections, such as the Domesday Book, and Tongwen Press's providing the throne with reprints of imperial encyclopedias is striking but not altogether surprising. See Twyman, *Early Lithographed Books*, 243-58.
103 Coincidentally, Su Chao Hu, *The Development of the Chinese Collection in the Library of Congress* (Boulder: Westview Press, 1979), 40, 212, notes that, in 1902, the same year that Friedrich Hirth began to teach at Columbia University, the Chinese Ministry of Foreign Affairs donated a *Tushu jicheng* to the university's Chinese library. In 1908, the Library of Congress also received a copy.
104 Indeed, with Shanghai's construction booms of the 1910s and 1920s, the problems became worse, largely because the late-nineteenth-century trend of converting residential units to industrial uses continued unabated.
105 NCH 30 June 1893: 943.
106 ZYS, 592.
107 Ibid.
108 Recent discussions on the history of the Islamic book imply that lithography may have played the same intermediary role between xylography and letterpress in the Islamic world that it performed in China. See Muhsin Mahdi, "From the Manuscript Age to the Age of Printed Books," in George Atiyeh, ed., *The Book in the Islamic World* (Albany: SUNY Press, 1995), 12.
109 Li Shengduo (*zi*, Muzhai) served as Chinese minister to Japan from 1898 to 1901. According to ECCP, 781, Li took the place of Xu Shichang, injured by a bomb, in the team of five ministers sent abroad in 1905-6 to study foreign systems of government. Li served as minister to Belgium until 1909. ECCP, 520-21, states that Li eventually owned the library of the Li family (no known relation) of Jiujiang, strong in archeological works, particularly inscriptions.
110 NCH 1 June 1889: 666.

111 "Feiyingguan," *Shenbao* 5 February (first lunar month, thirteenth day) 1887, in SUN, 2: 1: 2, 1007.
112 Ye Jiuru, in SUN, 2: 1: 2, 1006, note 1.
113 Li's firm printed largely from its own library (which, like Tongwen's, was located on the premises). See *Shenbao*, 24 February (second lunar month, second day) 1887, in SUN, 2: 1: 2, 1007.
114 "Feiyingguan," in SUN, 2: 1: 2, 1007.
115 *Shenbao* 5 February (first lunar month, thirteenth day) 1887, in SUN, 2: 1: 2, 1007.
116 *Shenbao* 16 March (second lunar month, twenty-second day) 1887, in SUN, 2: 1: 2, 1007.
117 Philip Scranton, *Endless Novelty: Specialty Production and American Industrialization, 1865-1925* (Princeton: Princeton University Press, 1997), 121-32, citing Tebbel, focuses on the separation of printing and publishing in New York but notes that Little, Brown and Houghton Mifflin, both in Boston, were exceptions to this nineteenth-century American rule. On Britain, see John Feather, *A History of British Publishing* (New York: Routledge, 1988), 39, 132-34, which makes clear that the separation of printing, publishing, and bookselling into separate specialized businesses got under way in the seventeenth century, accelerated in the eighteenth, and was widespread by the nineteenth. In publishing, as in other ways, Germany and Russia did not follow this Anglo-American model. Instead, according to Heinz Sarkowski, *Springer-Verlag: History of a Scientific Publishing House, Part 1, 1842-1945*, trans. Gerald Graham (Berlin: Springer, 1992), 150-51, 214ff.; Charles A. Ruud, *Russian Entrepreneur: Publisher Ivan Sytin of Moscow, 1851-1934* (Montreal and Kingston: McGill-Queen's University Press, 1990), 20, 30-31, 65, 88, 158-61; and Mark D. Steinberg, *Moral Communities: The Culture of Class Relations in the Russian Printing Industry, 1867-1907* (Berkeley: University of California Press, 1992), 14ff. printing and publishing in Germany and Russia were united in single firms (as they were in Shanghai).
118 NCH 13 October 1887: 391.
119 In 1888, Ling Peiqing (also Biqing) and identified variously as a Huzhou (Zhejiang) and Zhenze (Jiangsu) native, started up the Hongwen shuju. Huzhou was known for silk production. Chen Boxi, in SUN, 2: 1: 2, 1006, note 1, describes Ling as Zhejiangese and says that he invested his inherited silk merchant wealth in his publishing house. Hongwen, says Chen, stood equal in stature to Dianshizhai and Tongwen, issuing finely printed histories and an illustrated reprint of *Sanguo yanyi*, the well-known sixteenth-century historical novel. In addition, Hongwen outstripped both Dianshizhai and Tongwen in the reprinting of works useful for civil service examination preparation, publications such as *Wujing jiazao* (Difficulties and Models in the Five Classics), *Wujing huijie* (Collected Commentary on the Five Classics), *Dati wenfu* (Major Topics in Literature and Government), *Xiaoti shiwanxuan* (A Vast Selection of Lesser Topics), etc., all of which sold well. When the examination system was abolished in 1904-5, however, Hongwen's backlist was not worth a cent, says Chen, and the publishing operation was closed. Zhang Jinglu, the Shanghai editor/publisher and authority on China's modern publishing industry, provides details on Shanghai's lithographic industry unavailable elsewhere. In his view, the Hongwen Press and a second, the Jishi shanfang (or "Stone Pile" Press) established by Zhong Yinbo, were signficant chiefly because they were organized in imitation of Li Shengduo's Feiying Hall.
120 If Hongbaozhai shiyinju and Hongbaozhai shuju, a firm listed in *Quanguo Zhongyi tushu lianhe mulu* and credited with fourteen lithographed medical publications between 1888 and 1934, were essentially the same operation, then Hongbaozhai lasted until 1934 and perhaps longer.
121 Comparing data from *Quanguo Zhongyi tushu lianhe mulu* and Wang et al., *Xiaoshuo shufang lu*, 102-203, suggests that sixty-three lithographic publishers issued both fiction and medical works after 1876.
122 A total of 126 previously largely overlooked Shanghai-based medical publishers operated from 1876 into the 1950s. Noteworthy firms, identified from SUN and *Quanguo Zhongyi tushu lianhe mulu*, are listed below. Output is mentioned when known; asterisked firms also published fiction, although the dates given here are only for medical publishing. All firms were shuju unless otherwise noted: Dacheng* (8 titles, post-Qing to 1926), Fuwenge, Guangwen* (7 titles, 1919-33), Guangyi* (25 titles, 1906-49), Hongdashan* (13 titles,

1910-33), Huiwentang* (10 titles, 1911-39), Jiangzuo shulin* (9 titles, 1886-1925), Jiaojing shanfang* (8 titles, 1883-1914), Jinzhang* (15 titles, 1903-55), Qianqingtang* (20+ titles, 1884-1956), Shanghai* (17 titles, 1884-1921), *Shenbao*'s Shenchang shushi (20+ titles, 1884-1935), Shijie* (20 titles, 1919-42), Wenruilou* (24 titles, 1893-1935), Zhangfuji* (14 titles, Guangxu reign to 1922), Zhonghua xinjiaoyu she (13 titles, 1921-49), and Zhuyitang* (1 title, incomplete record, 1896).

123 Excluding those that also published medical works, fifty-eight Shanghai-based lithographic publishers of fiction were active from 1876 down to 1930. Using the standard of having more than ten titles listed in Wang et al., *Xiaoshuo shufang lu*, 102-203, leading lithographic publishers of fiction included (all are shuju unless otherwise indicated; asterisked firms were also medical publishers): Cuiying,* Dacheng,* Gailiang xiaoshuo she, Gonghe,* Guangyi,* Haizuo,* Huiwentang,* Jiangdong,* Jiangdong maoji,* Jinbu,* Maoji shuzhuang,* Qixin,* Shanggu shanfang,* Shen Heji, Shijie,* Tianbao,* Wenyuan, Xiaoshuolin she, Yuwen, Zhangfuji,* and Zhongyuan.*

124 The sum of 149 results from adding publishers listed by SUN, *Quanguo Zhongyi tushu lianhe mulu*, and Wang et al., *Xiaoshuo shufang lu*, 102-203, and eliminating duplicated names. ZYS, 590, reports that fifty-six lithographic firms were established after 1876. Although Zhang does not make this point explicitly, I have determined that his figures cover 1876-1949. Yao, *Zhongguo bianjishi*, 247, claims that, in the 1880s, Shanghai had "several dozen" lithographic shops. My own research suggests that Zhang significantly underestimates the scale of this Shanghai industry and that Yao's figures for the 1880s may be too large.

125 The sixteen included the Commercial Press; Guangyi shuju, founded by 1879, lasted until at least 1949; Hongbaozhai shuju, open by 1884, may have survived until 1934; Hongdashan shuju, 1905-33; Hongwen shuju, 1887-1946; Huiwentang shuju, 1911-1939; Huiwentang xinjishuju, 1911-36; Jiangzuo shulin, 1886-1924 (although, according to Wang et al., *Xiaoshuo shufang lu*, 102-203, Jiangzuo shulin published woodblocked books from 1798-1886); Jiaojing shanfang, 1883-1930s; Jinbu shuju, 1893-1931; Jinzhang shuju, 1894-1955; Qianqingtang shuju, 1884-1956; Saoye shanfang, 1860-1941; Shanghai shuju, 1875-1924; Wenruilou, 1893-1935; and Zhangfuji shuju, 1897-1922. Another 111 lithographic medical publishers operated only during the Republic. Dating and calculations are based on *Quanguo Zhongyi tushu lianhe mulu* and Wang et al., *Xiaoshuo shufang lu*, 102-203.

126 This sum results when the thirty-nine publishers listed in *Quanguo Zhongyi tushu lianhe mulu* and SUN are added to the fifty-eight fiction publishers (corrected to eliminate duplication) found in Wang et al., *Xiaoshuo shufang lu*, 102-203, and Dianshizhai, Tongwen, and Feiying are subtracted.

127 APMPAR, 1897, 2.

128 The APMP's first Shanghai location was around the corner from the old British Consulate, across Beijing Road from today's Friendship Department Store; its second location, on Sichuan North Road, was near the present-day Shanghai Main Post Office.

129 APMPAR, 1901, 2. By 1901, APMP's publication output in Chinese was considerable, making the Press essentially a Chinese-language publisher, much like Major Brothers' *Shenbao* and Dianshizhai. A total of 727,670 copies of Chinese-language items in six categories (scriptures, religious works, educational works, tracts and calendars, miscellaneous, and periodicals) were printed; this figure compares with only 94,199 copies in English and bilingual editions in nine categories. Likewise, its workforce was overwhelmingly Chinese, and it was providing Chinese-style housing to its employees.

130 In this regard, it is interesting to note that, already in 1879, when *Wenhui bao* was first printed, Chinese newspapers had started to use gas-powered printing machines. In 1890, *Shenbao* also introduced a gas-powered engine, according to NCH 21 November 1890: 633. Major Brothers, 18 Hankou Road, "Annual Report to Shareholders," in NCH 16 January 1891: 66, reported "this gas engine has reduced the number of hands employed in the *[Shenbao]* office by 13, and [the board of directors] confidently hope that the whole expense of this engine will be covered by this saving in a little over a year." The speed of the new kerosene-powered engines was considerable; *Shenbao* printers had formerly required eighteen hours to print an edition of the paper, but, after installing the new power plant, fewer workers needed only five or six hours to print one.

131 NCH 25 May 1889: 633.

132 Ibid.

133 As noted above, at least 111 lithographic publishers started up after 1911.

134 Wang Hanzhang, "Kanyin zongshu," in SUN, 2: 1: 2, 1009-10. ZYS, 591, suggests that
Guangbaisong zhai may have used both lead type and lithography, chiefly to print novels. The
sense that the heyday of the lithographic age was gone is reinforced, however, by Bao Tianxiao,
CYL, 1: 113, who relates that, in the early twentieth century, in the midst of starting a maga-
zine, he suddenly recalled the old elegance of the *Dianshizhai Pictorial* and tried to imitate it
by using lithography to print his new magazine. "I tried this and that, without success; it was
impossible, the times were different. It was rather difficult to force it."

135 This number results from adding the 126 publishers found on the medical list to 124 fiction
publishers, minus 63 fiction publishers who appear on both lists, and adding Baishi shanfang,
which is not on either list.

136 One hundred sixty-four is the sum that results from adding the 53 lithographic publishing
firms that, although started in the Qing, survived into the Republic, to the 111 publishers
started in the Republic, using *Quanguo Zhongyi tushu lianhe mulu* and Wang et al., *Xiaoshuo
shufang lu*, 102-203, as sources.

Chapter 3: "Sooty Sons of Vulcan"

1 On this war, one of the first in world history in which a modern industrialized army deliber-
ately attacked civilian targets, see Donald A. Jordan, *China's Trial by Fire: The Shanghai War of
1932* (Ann Arbor: University of Michigan Press, 2001). Communists and Nationalists agreed
that about 6,000 civilians lost their lives. Chinese military dead numbered 4,200. The attack
destroyed 180,000 housing units, and property damages reached 1.7 billion yuan.

2 Manying Ip, *The Life and Times of Zhang Yuanji, 1867-1959* (Beijing: Commercial Press, 1985),
235.

3 *North China Daily News* 30 January 1932: 18.

4 In her summary of the assault, Ip, *The Life and Times*, 236, reports that "some said that the
Japanese were so jealous of China's foremost publishing company that Japanese *rōnin* were
instigated to go into the famous library and set it on fire from within." More prosaically, the
North China Daily News 3 February 1932: 11, reported that a Chinese was arrested on suspi-
cion of arson.

5 Francis K. Pan, *One Year of Rehabilitation of the Commercial Press, Ltd.* ([Shanghai]: n.p., 1933),
24. Thank you to Mark C. Elliott, now of Harvard University, for having given me this pub-
lication. The Commercial Press lost four print shops and several hundred machines in the
attack. Pan does not mention that the Commercial Press, under Wang Yunwu's leadership,
permanently laid off 2,700 of its 3,700 employees as a result of the bombardment and de-
struction or that it relocated most of its printing operations to the No. 5 plant inside the
International Concession and to its printing works in Beiping and Hong Kong. See Ip, *The
Life and Times*, 235, 264, and Florence Chien, "The Commercial Press and Modern Chinese
Publishing, 1897-1949" (MA thesis, University of Chicago, 1970), 70.

6 Leo Ou-fan Lee and Andrew J. Nathan, "The Beginnings of Mass Culture: Journalism and
Fiction in the Late Ch'ing and Beyond," in David G. Johnson, Andrew J. Nathan, and Evelyn
Rawski, eds., *Popular Culture in Late Imperial China* (Berkeley: University of California Press,
1987), 361.

7 Chow Tse-tsung, *The May Fourth Movement, Intellectual Revolution in Modern China* (Stanford:
Stanford University Press, 1967), 178.

8 Recall that comprador Xu Run, proprietor of Tongwen Press, closed his lithographic pub-
lishing house in 1898 in anticipation of opening a lead-type printing firm, Guangbaisong
zhai.

9 Two years before the Japanese attack, according to Jean-Pierre Drège, *La Commercial Press de
Shanghai 1897-1949* (Paris: Institut des Hautes Études Chinoises, 1978), 64, the press had
consumed a ton of lead and antimony, 1,650 pounds of type, 800 reams of paper, and 275
pounds of ink per *day*.

10 SUN, 2: 1: 246.

11 Ibid., 2: 2: 1181, 1202.

12 "Shanghai yinshua gongye zhi diaocha," *Gongshang banyuekan* 1, 22 (1929): 1-7, in SMJG, 1: 349-51.

13 Yan Zhong, "Woguo jixie zhi rukou maoyi," *Guoji maoyi daobao* 4, 6 (1932): 97-102, 108, in SMJG, 1: 439.

14 See Julian Arnold, *Commercial Handbook of China* (Washington: USGPO, 1919), 326; *Shanghai zhinan* (Shanghai: Commercial Press, 1923); *China Industrial Handbooks: Kiangsu* (Shanghai: Ministry of Industry and Bureau of Foreign Trade, 1933); *China Industrial Handbooks: Chekiang* (Shanghai: Ministry of Industry and Bureau of Foreign Trade, 1935).

15 Lucien Febvre and Henri-Jean Martin, *The Coming of the Book: The Impact of Printing 1450-1800*, trans. David Gerard (London: NLB, 1976 [1958]).

16 For example, see Tsien Tsuen-Hsuin, *Paper and Printing* (New York: Cambridge University Press, 1985), and James Moran, *Printing Presses: History and Development from the 15th Century to Modern Times* (Berkeley: University of California Press, 1973).

17 Elizabeth Eisenstein, *The Printing Press as an Agent of Change* (New York: Cambridge University Press, 1979) deals with this issue only in passing. In a chapter called "Bookmaking," Robert Darnton, *The Business of Enlightenment* (Cambridge, MA: Belknap Press, 1979), despite acknowledging the importance of the issue, mentions only where presses were acquired, not the social impact of their production. Gary Marker, *Publishing, Printing, and the Origins of Intellectual Life in Russia, 1700-1800* (Princeton: Princeton University Press, 1985), and Gary D. Stark, *Entrepreneurs of Ideology: Neoconservative Publishers in Germany, 1890-1933* (Chapel Hill: University of North Carolina Press, 1981), also neglect this question. Even historians of printing workers ignore this question; see Clement J. Bundock, *The National Union of Printing, Bookbinding, and Paper Workers* (Oxford: Oxford University Press, 1959) and Paul Chauvet, *Les Ouvriers du livre en France* (Paris: Librairie Marcel Rivière, 1956).

18 In addition to Febvre and Martin, see Robert Darnton, "Workers Revolt: The Great Cat Massacre of the Rue Saint-Séverin," in *The Great Cat Massacre and Other Episodes in French Cultural History* (New York: Random House, 1985), 75-106.

19 Although the term "foremen-capitalists" is mine, it was suggested by Tian Jiasheng's remarks in his 28 August 1961 interview in SMJG, 1: 238.

20 Wu Baosan, "1933-nian quanguo jiqiye zai gongye zongchangzhizhong suo zhan bizhong," in SMJG, 2: 601.

21 "Shanghai yinshua gongye zhi diaocha," in SMJG, 1: 349-51.

22 Liu Dajun, "1933-nian Shanghai minzu jiqi gongye yu qita dachengshi jiqigongye de bijiao," in SMJG, 2: 600.

23 The importance to rising national elites of controlling media production has been treated in relation to "national print-languages" and "official nationalism" by Benedict Anderson in *Imagined Communities: Reflections on the Origin and Spread of Nationalism* (London: NLB, 1983). In addition, see Emily S. Rosenberg's *Spreading the American Dream: American Economic and Cultural Expansion, 1890 to 1945* (New York: Hill and Wang, 1982), 204ff., in which she discusses government efforts in the 1930s to control the media in the interest of national cultural integrity.

24 Liu Dajun, "1933-nian Shanghai minzu jiqi gongye zhan Shanghai gongye de bizhong," in SMJG, 2: 602. The problem with this report is that it seems to reflect conditions in 1931, when the machine industry was at its apogee; according to the Bank of China, in 1932, after Japan's military attack on Zhabei (1/28 Incident), the surviving machine industry was only 64 percent of its earlier size and had dropped to 58 percent of its 1931 size. See Zhonggong Shanghai shiwei dangshi yanjiushi and Shanghai shi zonggonghui bian, eds., *Shanghai jiqiye gongren yundong shi* (Beijing: Zhonggong dangshi chubanshe, 1991), 17. I use Liu Dajun's figures to reflect prevailing conditions in the early 1930s, rather than as a strict statement of 1933 conditions.

25 The printing industry itself made up the fifth largest industrial contingent in the city of Shanghai, with over 11,000 workers in the 1930s.

26 Liu Dajun, "1933-nian Shanghai minzu jiqi gongye yu Shanghai de qita zhuyao gongye de bijiao," *Zhongguo gongye diaocha baogao*, in SMJG, 2: 602.

27 Liu Dajun, "1933-nian Shanghai minzu jiqi gongye zhan quanguo jiqi gongye de bizhong," *Zhongguo gongye diaocha baogao*, in SMJG, 2: 600.

28 "Cong zhuanye changshu bijiao zhizao yu xiupei bizhong," in SMJG, 2: 548.
29 Ibid.
30 Studies of industrial districts are a relatively recent phenomenon in Western historiography and have made few inroads into Chinese historiography. An exception to this rule is Gail Hershatter's outstanding chapter "Flying Hammers, Walking Chisels: The Workers of Santiaoshi [Tianjin]," in *The Workers of Tianjin, 1900-1949* (Stanford: Stanford University Press, 1986), 82-114. On page 90, Hershatter notes that, in 1935, just over 1 percent of total Chinese industrial investment was in the iron-casting and machine-building industries. Elizabeth J. Perry, too, by bringing attention to the importance of machine shop workers in Communist organizing tactics and in Shanghai's activist circles, demonstrates how central machine shops and mechanics were to Shanghai's industrial culture. See her *Shanghai on Strike: The Politics of Chinese Labor* (Stanford: Stanford University Press, 1993). On Europe, see Charles F. Sabel and Jonathan Zeitlin, eds., *World of Possibilities: Flexibility and Mass Production in Western Industrialization* (New York: Cambridge University Press, 1997); on the United States, see Philip Scranton, *Endless Novelty: Specialty Production and American Industrialization, 1865-1925* (Princeton: Princeton University Press, 1997) and Mansel G. Blackford, *A History of Small Business in America* (Chapel Hill: University of North Carolina Press, 2003), esp. Chapter 3. Thanks to my Ohio State University colleague Mansel Blackford for his comments on this issue.
31 For an excellent introduction to the role of machine shops in promoting mechanization and invention in a different, but comparable context, see Paul Israel's innovative *From Machine Shop to Industrial Laboratory: Telegraphy and the Changing Context of American Invention, 1830-1920* (Baltimore: Johns Hopkins University Press, 1992).
32 "Jiangnan zhizaoju jingfei biao," in SMJG, 1: 47. "Waiguo ziben ji guanliao ziben yu minzu ziben jiqi gongchang chuangshe touzi bijiao biao," in SMJG, 1: 198, reports that the Arsenal was capitalized at 760,000 yuan.
33 SMJG, 1: 198, and "Shanghai jinkou jiqi tongji," in SMJG, 1: 435.
34 "Shanghai gelei jiqi jinkou xiaochang qingkuang biao," in SMJG, 1: 438.
35 "Shanghai jiqi jinkou leibie bizhong," in SMJG, 1: 437.
36 "Zai jinkou gelei jiqizhong Shanghai zhan quanguo de bizhong," in SMJG, 1: 436.
37 Yan Zhong, "Wo guo jixie," in SMJG, 1: 439.
38 Ibid.
39 Marie-Claire Bergère, *The Golden Age of the Chinese Bourgeoisie, 1911-1937*, trans. Janet Lloyd (New York: Cambridge University Press, 1989), 125. See also Chapter 4.3 "A Rough Typology of Chinese Entrepreneurs," 164-86.
40 NCH 9 October 1899: 705.
41 Coincidentally, in their discussion of the nature of invention, Febvre and Martin, *The Coming of the Book*, 45ff., pose a similar question with regard to the early history of printing in Europe. How, they ask, "in the middle of the [fifteenth] century, did Gutenberg and his contemporaries succeed in mastering the many technical difficulties which the invention of printing must have posed?" Their answer emphasizes involved social changes.
42 By comparison, Hershatter, *The Workers of Tianjin*, 82, 87, reports that between 1900 and 1950 Tianjin's metal-working centre spawned only about seventy-five establishments, and about thirty of those appeared between World War I and the Japanese invasion. She says these figures do not include the concessions that had twenty-four ironworks and six machine shops (264, note 28), for a total of 105 firms between 1900 and 1950.
43 SMJG, 1: 72. Also, Zhonggong Shanghai shiwei dangshi yanjiushi and Shanghai shi zonggonghui bian, eds., *Shanghai jiqiye gongren yundong shi*, 12-13. In this 1914-24 period, say the Communist Party historians who edited this latter work, the most significant development was the export of Xieda Machine Shop's lathes to Java and other markets in Southeast Asia. It was the first time, they say, that Chinese machinery broke into the international market (14-15). However, as will become clear in this chapter, Chinese printing machinery competed successfully against Japanese-made equipment both in China and in the Japanese home market in the same period.
44 As with most persons discussed in this chapter, Tian's date of birth and place of origin are unknown. In some cases, using extratextual information, one can estimate birth dates; places of origin usually remain a mystery.

45 Unless otherwise indicated, all subsequent shop names are "jiqi chang."

46 Tian Jiasheng, 7 April 1961 interview, in SMJG, 1: 186-87.

47 In my materials, there is no indication of whether machines were copied legally or illegally, but recall that industrial piracy was a recurrent problem in the nineteenth-century Anglo-American world, England's patent and trademark laws notwithstanding. According to William P. Alford, *To Steal a Book is an Elegant Offense: Intellectual Property Law in Chinese Civilization* (Stanford: Stanford University Press, 1995), 41, the Chinese government did not issue a permanent trademark law until 1923, "and then more in name than in fact."

48 Despite its later importance, at its founding in 1897, the Commercial Press was merely one of many jobber printers in Shanghai. Nonetheless, the scale of the machine shops was even smaller than that of print shops, usually one-twelfth the size.

49 Western-owned printing shops had been doing the same in Malacca since the 1810s and in Hong Kong since the 1840s. The technology became available in Shanghai in 1860 when the APMP moved there.

50 Cao Pinyou started the Cao Xingchang Machine Shop and eventually manufactured hand- and foot-operated presses. Wei Shenrong opened the Fuxing Copper Matrix Shop. The proprietor of the Gongyichang Machine Shop at the Laji Bridge's (now Laozhao Bridge) southern embankment intersection with Xiamen Road was Wu Yongru; his firm made lithographic presses. Chen Zhaoqing established number five, the Xieda Machine Shop, at Nicheng Bridge, and number six, the Yaojinji Machine Shop, was opened by Yao Xujin in 1912 at the present-day intersection of Fujian North Road and Suzhou North Road. See Tian, 7 April 1961 interview in SMJG, 1: 186-7.

51 This early era of repair and copy in the printing industry contrasts with Hershatter's Santiaoshi, in which, as late as 1919, only one firm, Ji Ju Cheng Machine Factory, produced printing machinery. See Hershatter, *The Workers of Tianjin*, 88.

52 All information in this paragraph derives from "Yinshua jiqi xiupei zhuanye," in SMJG, 1: 188.

53 Unlike those of Hershatter's machine shop owners, the familial backgrounds of these Shanghai proprietors are not known.

54 Bergère, *The Golden Age*, 125. Their successful bridging not only of the divide between unskilled and skilled labor but also of the cultural divide separating Chinese and Western industrial skills is what sets these manufacturers off from those studied by Herbert G. Gutman, "The Reality of the Rags-to-Riches 'Myth'; The Case of the Paterson, New Jersey, Locomotive, Iron, and Machinery Manufacturers, 1830-1880," in Stephan Thernstrom and Richard Sennett, eds., *Nineteenth Century Cities: Essays in the New Urban History* (New Haven: Yale University Press, 1969), 98-124. Gutman's conclusion that "developing industrial cities and new manufacturing industries offered unusual opportunities to skilled craftsmen and mechanics in the early phases of American industrialization" (122) is just as true for Shanghai, as this chapter shows.

55 It is inaccurate to regard them all as employees; the industry standard, according to many first-hand accounts, was to have 20 percent of one's workers as paid employees and the remaining 80 percent as unpaid apprentices. See interviews with former apprentices in SMJG, 2: 808. Interestingly, the situation in the Shanghai printing machine manufactories was very similar to that of nineteenth-century Britain's printing trades. See W. Turner Berry, "Printing and Related Trades," in Chas. Singer et al., *A History of Technology* (Oxford: Clarendon Press, 1954-84), 5: 683-715. Berry says that the printing and allied trades saw "much unemployment, caused chiefly by the vast number of boys engaged in the trade at low wages ... The excessive proportion of apprentices indentured for seven years, often with perfect indifference to their future prospects in the trade ... also tended to depress the skilled journeyman's wage. Many of the apprentices had very little tuition and were scarcely little more than labourers" (714).

56 See Zhuang Tingbiao, 13 October 1962 interview, in SMJG, 1: 188.

57 Tian, 24 August 1961 interview, in SMJG, 1: 238.

58 Chen Zhizhao, 10 May 1961 interview, in SMJG, 1: 188. The presence of a lathe is what, in Chinese historiography, distinguishes these "industrial" shops from earlier artisanal ones. See Zhu Bangxing, Hu Linge, and Xu Sheng, eds., *Shanghai chanye yu Shanghai zhigong* (Shanghai: Shanghai Renmin chubanshe, 1984 [1939]).

59 Chen, 10 May 1961 interview, in SMJG, 1: 188. The manufacture of lithographic printing machines may have been an industry unique to Shanghai among Chinese cities and was based on a lithographic printing tradition going back to the Xujiahui orphanage print shop of the 1870s.

60 Tian, 28 August 1961 interview, in SMJG, 1: 238. Bergère, likely because of the breadth of her project, has also overlooked the early-1900s development of the printing machine industry. See Bergère, *The Golden Age*, 70ff., 165ff.

61 Cao Jinshui and Zheng Xilin, 20 February 1962 interview, in SMJG, 1: 351-52.

62 Yan Zhong, "Wo guo jixie," in SMJG, 1: 439.

63 "Yinshua jiqi zhizao zhuanye," in SMJG, 1: 241.

64 Tian, 26 August 1961 interview, in SMJG, 1: 240. Many of these shops combined manufacturing and retail activities. It is interesting to note that Tian's shop also sold diesel engines, rice huskers, etc., shipped for sale to nearby Kunshan and to other ports farther away. The Commercial Press itself began copying Thompson type-casters and other machines in 1913; given the fact that Tian had worked at the press, chances are he was producing a modified Thompson.

65 Ibid., 1: 238.

66 "Shanghai gelei jiqi jinkou xiaochang qingkuang biao," in SMJG, 1: 438.

67 Mergenthaler's Linotype was invented in 1886.

68 Tian, 24 August 1961 interview, in SMJG, 1: 238. Tian lists seven firms that produced metal-type printing machines, of which only two (Mingjing and Gongyichang) appear in other lists, and two producers of type-casting machines, one of which, Ruitai, appears in other lists.

69 *Shanghai jiqiye gongren yundong shi*, 16.

70 Shen's careless supervision of the construction of Zhonghua's printing plant was a contributing factor to his hasty departure from Zhonghua; see Chapter 5.

71 Li Xiangbo, "Wo he Zhonghua shuju Shanghai yinshua chang," in Zhonghua shuju bianjibu, eds., *Huiyi Zhonghua shuju* (Beijing: Zhonghua shuju, 1987), 1: 193-206, esp. 193-95.

72 The Commercial Press began to manufacture printing machinery around 1912 but disbanded its manufactory in 1927 when the shop provided a soapbox for labour activists. See interviews with its machine-manufacturing competitors, owner-proprietors Tian Jiasheng (26 August 1961, in SMJG, 1: 240), Zhang Xingfang (25 July 1960, in SMJG, 2: 849), and Hu Yunfu (6 December 1961, in SMJG, 2: 849).

73 According to numerous first-hand reports, in the 1910s and 1920s, the average time to completion of a machine industry apprenticeship was four to six years, so Zhang was probably about twenty years old when he left Li's as a master machine maker and went to work at the Commercial Press.

74 Hu Yunfu, 28 August 1961 interview, in SMJG, 1: 238.

75 In 1907, the Commercial Press had moved to the Zhabei address in Baoshan Road that its Shanghai branch plant still occupies.

76 Chen Zhaoquan, Yang Zhengyang, Shen Zhizhang, et al., 27 September 1960 interview, in SMJG, 2: 827.

77 *Mingjing jiqi chang changshi*, mimeographed from the collection of Shanghai No. 2 Machinery Factory, in SMJG, 1: 239.

78 Chen, Yang, and Shen, 27 September 1960 interview, in SMJG, 2: 827.

79 Wang Shan'gen, 26 March 1961 interview, in SMJG, 1: 239-40.

80 Ibid.

81 According to the *Mingjing jiqi chang changshi*, it produced about seventy-two machines per year between 1916 and 1921. A provocative, but unanswerable, question is exactly how Mingjing workers learned to copy complex machines. Hershatter, *The Workers of Tianjin*, states that in Tianjin "production depended on the traditional skills of the workers, and the expansion of a shop's repertoire depended upon hiring skilled craftsmen ... experienced in the manufacture of another product" (89). Such a labour-intensive system could have been used at Mingjing. Hershatter also relates a very amusing account of how Santiaoshi shops learned to copy Japanese looms through a conspiracy with a Japanese firm that then sold the Chinese-made copies as Japanese goods (87). No similar accounts in Shanghai have come to light.

82 Wang, 26 March 1961 interview, in SMJG, 1: 239-40.

83 Ibid.

84 "Linian shengchan chanpin chanzhi guji," from *Mingjing jiqi chang changshi*, in SMJG, 1: 239. For reasons that are not clear, the sales figures reported in the factory history are considerably less than what they should have been if Wang's prices quoted here are correct.

85 Tian, 26 August 1961 interview, in SMJG, 1: 240. This account calls to mind Hershatter, *The Workers of Tianjin*, 85, who mentions that "a skilled craftsman who had worked at the Tianjin Arsenal," had lost first his job when the Arsenal was destroyed by the Boxers and then his monopoly on his casting techniques when he went to work in Santiaoshi. His "losses" led to the post-1900 growth of the iron-casting district in Tianjin.

86 "Shanghai yinshua gongye zhi diaocha," in SMJG, 1: 351. The others were Huadong jiqi zhizaochang (Huadong Machine Works, a post-1927 semidependent Commercial Press firm), Wei Jucheng Machine Shop, Shunchang Machine Shop, and Yaogongji Machine Shop. The latter three were all founded in 1914-15, contemporary with Mingjing.

87 Zhang Yingfang was still running Mingjing on the eve of the Communist victory in 1949, by which time it was headquartered at 435 Hankou Road, with its factory located at 528 Haiphong Road. In those hyperinflationary times, Mingjing's assets were listed at 100 million yuan. After Liberation, Mingjing was nationalized as Shanghai di er jichuang chang (Shanghai No. 2 Machinery Factory). It is not known what became of Zhang Jinlin after 1937.

88 Zhang Yingfang, 25 July 1960 interview, in SMJG, 1: 352.

89 Zhonghua continued to print currency for the government into the late 1940s, a practice that by then had direct personal benefits to its employees because they were paid in newly printed currency before its value dropped due to hyperinflation.

90 Bergère, *The Golden Age*, 169.

91 In my sources, apprentices do not refer to Zhang by name, referring instead to "the capitalist," but, given the fact that they are discussing the period from 1919 to 1921, they cannot be discussing anyone but Zhang.

92 This issue has been widely discussed in works on Chinese labour history. See, for example, Perry, *Shanghai on Strike*, 32-36; Hershatter, *The Workers of Tianjin*, 51-54; and Linda Shaffer, *Mao and the Workers: The Hunan Labor Movement, 1920-1923* (Armonk: M.E. Sharpe, 1980), 152-53.

93 Chen, Yang, and Shen, 27 September 1960 interview, in SMJG, 2: 808.

94 "Dalong jiqi chang de fasheng fazhan yu gaizao," in SMJG, 2: 808. According to Zhu Bangxing, Hu Linge, and Xu Sheng, apprentices still made up about 70 percent of the machine industry workforce in 1938; see *Shanghai chanye yu Shanghai zhigong*, 561.

95 Yuan Genxin, 23 September 1961 interview, in SMJG, 2: 808.

96 Chen, Yang, and Shen, 27 September 1960 interview, in SMJG, 2: 808. In 1938, regular workers at Dalong Machine Shop, the largest privately owned Chinese machine works, earned from eight mao to one yuan three mao per day. Apprentices got only food, shelter, haircuts, and soap. After a year, apprentices, who ranged in age from sixteen to thirty *sui*, earned from one to two yuan per month extra (Zhu, Hu, and Xu, *Shanghai chanye yu Shanghai zhigong*, 561).

97 Chen, Yang, and Shen, 16 August 1960; 23-27 September 1960; 23 December 1961 interviews, in SMJG, 2: 820.

98 The general situation seems to have been slightly improved in 1938, when Communist researchers Zhu, Hu, and Xu, *Shanghai chanye yu Shanghai zhigong*, 567, found that in addition to their porridge, apprentices at the big firms typically got two dishes of meat and one of vegetable. They also pointed out that, the smaller the factory, the worse the food and other conditions.

99 These long hours contrast sharply with the ten to twelve hours reported by Zhu, Hu, and Xu in 1939, but their figures do not include apprentices.

100 For a comparable view of an apprentice's daily life, see "The Work Ethic," in Wen-hsin Yeh, "Progressive Journalism and Shanghai's Petty Urbanites: Zou Taofen and the *Shenghuo Weekly*, 1926-1945," in Frederic Wakeman, Jr., and Wen-hsin Yeh, eds., *Shanghai Sojourners* (Berkeley: Institute of East Asian Studies, 1992), 198-205.

101 Chen, Yang, and Shen, 16 August 1960; 23-27 September 1960; 23 December 1961 interviews, in SMJG, 2: 820.

102 This schedule brings to mind the comment in Peter Golas, "Early Ch'ing Guilds," in G. Wm. Skinner, ed., *The City in Late Imperial China* (Stanford: Stanford University Press, 1977), 566, that "the existence of an apprenticeship period and its length had usually only a very remote connection with the time required for a novice to learn a given trade."

103 See the description of Dalong in "Jiqi ji tiegong ye," Chapter 16 in Zhu, Hu, and Xu, *Shanghai chanye yu Shanghai zhigong*.

104 As Darnton says in "Workers Revolt: The Great Cat Massacre," 88, the journeymen responsible for instructing apprentices in eighteenth-century French print shops "did not want another journeyman in their over-flooded labor pool, so [an apprentice] had to pick up the tricks of the trade by himself."

105 Such was by no means the case for all Shanghai apprentices. At the other end of the publishing industry continuum, Zhang Jinglu, an avid consumer of the printed page while apprenticed to a Tiantong Road distillery in 1912-13, remembers walking to Henan Road every evening after work solely to look at new books displayed in windows and glass bookcases. See Zhang Jinglu, *Zai chuban jie ershi nian* (Hankou: Shanghai zazhi gongsi, 1938), 26-28.

106 Chen, Yang, and Shen, 16 August 1960; 23-27 September 1960; 23 December 1961 interviews, in SMJG, 2: 820.

107 Chen, Yang, and Shen, 27 September 1960 interview, in SMJG, 2: 823.

108 Chen, 19 December 1961 interview, in SMJG, 2: 809.

109 Yang, 27 September 1960 interview, in SMJG, 2: 810. See also Ye Rongyou, 6 August 1961 interview, in SMJG, 2: 810. This practice was first reported in the Shanghai machine industry in 1897.

110 Yang, 27 September 1960 interview, in SMJG, 2: 810.

111 Chen, 18 December 1961 interview, in SMJG, 2: 813. A similar ceremony is related in Perry, *Shanghai on Strike*, 35.

112 These durations are mentioned regularly in interviews by former apprentices and by Perry, *Shanghai on Strike*; Hershatter, *The Workers of Tianjin*; and Shaffer, *Mao and the Workers*.

113 Chen, Yang, and Shen, 9 September 1960 symposium, in SMJG, 2: 817.

114 Ibid.

115 Ibid.

116 Chen, Yang, and Shen, 16 August 1960; 23-27 September 1960; 23 December 1961 interviews, in SMJG, 2: 820.

117 Chen, 16 August 1960 interview, in SMJG, 2: 823.

118 Chen, Yang, and Shen, 27 September 1960 interview, in SMJG, 2: 827.

119 Bergère, *The Golden Age*, 167.

120 "Qian Shanghai shi jiqi gongye tongye gonghui ziliao," in SMJG, 1: 348-49.

121 Guomindang zhengfu quanguo jingji weiyuanhui, ed., *Zhizhi gongye baogaoshu* (n.p.: n.p., 1936), in SMJG, 1: 349.

122 The accounts of Hujiang and New China derive from Zheng Xilin, 20 February 1962 interview, in SMJG, 1: 352.

123 Tian, 26 August 1961 interview, in SMJG, 1: 240.

124 "Jiqi gongye shiliao zu," in SMJG, 2: 548. Listed by their proportion of manufacturers relative to repair shops, industries were ranked from top to bottom as follows: knitting machine manufacturers; printing machine manufacturers; filature machines; machine tools; mechanized farm tools; silkweavers; cigarette-rolling machines; spinning and weaving; shipbuilding machinery; others.

125 Between 1914 and 1924, the number of machine shops had grown from 91 to 284.

126 Figures and narrative details in this paragraph are derived from *Shanghai jiqiye gongren yundong shi*, 17-20.

127 *Handbook of Chinese Manufactures* (Shanghai: Foreign Trade Association of China, 1949), 246, 250.

Chapter 4: "The Hub of the Wheel"

1 This debate is summarized in Sherman Cochran, *Encountering Chinese Networks: Western, Japanese, and Chinese Corporations in China, 1880-1937* (Berkeley: University of California Press, 2000), Chapter 1.

2 Andrea L. McElderry, *Shanghai Old-Style Banks (ch'ien-chuang), 1800-1935: A Traditional Institution in a Changing Society* (Ann Arbor: University of Michigan, Center for Chinese Studies, 1976). Although William C. Kirby, "China Unincorporated: Company Law and Business Enterprise in Twentieth-Century China," *Journal of Asian Studies* 54, 1 (1995): 43-63, argues that the Western model for what he calls "Anonymous Private Legal Corporations" did not turn out to be "the essential vehicle for *private* Chinese economic development" (44), his discussion does not include the printing and publishing industry, at least explicitly.

3 Chung-li Chang, *The Chinese Gentry: Studies in Their Role in Nineteenth-Century Chinese Society* (Seattle: University of Washington Press, 1955), 138.

4 Ibid., 138-39, and Marianne Bastid-Bruguière, "Currents of Social Change," Chapter 10 in John K. Fairbank and Kwang-Ching Liu, eds., *The Cambridge History of China: Late Ch'ing, 1800-1911* (New York: Cambridge University Press, 1980), 11: 2, 538.

5 This term is used by Mary Backus Rankin, *Elite Activism and Political Transformation in China: Zhejiang Province, 1865-1911* (Stanford: Stanford University Press, 1986), 18.

6 See Joseph W. Esherick, *Reform and Revolution in China: The 1911 Revolution in Hunan and Hubei* (Berkeley: University of California Press, 1976).

7 For the locus classicus of the traditional view, see W. Allyn Rickett, ed. and trans., *Guanzi: Political, Economic, and Philosophical Essays from Early China* (Princeton: Princeton University Press, 1985), 1: 325. I would like to acknowledge Keith Knapp of The Citadel for his advice in locating this passage. For a summary of the traditional view, see Ping-ti Ho, *Ladder of Success in Imperial China: Aspects of Social Mobility, 1368-1911* (New York: John Wiley, 1964), 1-4. Recent Chinese discussions of this phenomenon include Zhang Kaiyuan et al., *Zhongguo jindai shi shang de guan shen shang xue* (Wuhan: Hubei renmin chubanshe, 2000). Thank you to an anonymous UBC Press reviewer for this reference.

8 Rankin, *Elite Activism*, esp. 6-10.

9 Ibid., 61.

10 Wellington K.K. Chan, *Merchants, Mandarins, and Modern Enterprise in Late Ch'ing China* (Cambridge, MA: Harvard East Asian Studies Center, 1977), 1.

11 Ibid., 70.

12 Nonetheless, terminology used for the book industry *(shuye)* is remarkably constant between the eighteenth and early twentieth centuries. Not until the 1920s, when afflicted by industrial strike actions, did the book industry begin to see itself as a modern industry.

13 Barry Keenan, "Lung-men Academy in Shanghai and the Expansion of Kiangsu's Educated Elite, 1865-1911," in Benjamin A. Elman and Alexander Woodside, eds., *Education and Society in Late Imperial China, 1600 to 1900* (Berkeley: University of California Press, 1994), 495-96.

14 Jiang Weiqiao, "Bianji xiaoxue jiaokeshu zhi huiyi, 1897-1905," in ZCSB, 141.

15 Wen-hsin Yeh, *The Alienated Academy: Culture and Politics in Republican China, 1919-1937* (Cambridge, MA: Harvard University Press, 1990), 82.

16 Ibid.

17 Manying Ip, *The Life and Times of Zhang Yuanji, 1867-1959* (Beijing: Commercial Press, 1985), 15.

18 Quoted in ibid., 19.

19 Ibid., 22-27.

20 Ibid., 33.

21 Ibid., 51.

22 Ibid., 51-56.

23 Ibid., 64.

24 Ibid., 75. Li Hongzhang had headed the Zongli Yamen during Zhang's time there, and he arranged for Zhang's new position through his protégé, Sheng Xuanhuai.

25 In 1871, the Shanghai district had seven *shuyuan* and ten charitable schools *(yixue)*. The most outstanding *shuyuan* library belonged to the Longmen Academy. It was founded in 1865 by Ding Richang (1823-82), then military *daotai* of the Su(zhou)-Song(jiang)-Tai(cang) circuit of eastern Jiangsu (which included Shanghai) and director of the Jiangnan Arsenal. Ding intended it to train lower-degree holders, ostensibly for the provincial exams but actually, as Keenan argues, to uphold conservative Cheng-Zhu values in Westernizing Shanghai. Ding was also a noted rare- book collector. On nineteenth-century Shanghai academies, in addition

to Keenan, "Lung-men Academy," see *Tongzhi Shanghai xianzhi* (Wumen: n.p., 1871), 9: 31-40. The same source features a printed catalogue of the approximately 166 compilations in the Longmen library; by 1918, the original collection had changed considerably, with great emphasis on science and technology. The library of the Qiuzhi shuyuan, founded in 1876, although twice the size of Longmen's, was distinguished by its lack of works on science and technology. See Yao Wendan, ed., *Shanghai xian xuzhi* (Taipei: Chengwen chubanshe, 1970 [1918]), 639-43, 644-50. On Ding Richang, see ECCP, 721-23.

26 Ip, *The Life and Times*, 77.

27 Ibid., 91.

28 For instance, the Tongwenguan, part of the Zongli Yamen, and the Shanghai Interpreters' Institute, part of the Jiangnan Arsenal, both of which also had translation and publishing programs.

29 On Shanghai's guilds prior to 1842, see Linda Cooke Johnson, "Shanghai: An Emerging Jiangnan Port, 1683-1840," in Linda Cooke Johnson, ed., *Cities of Jiangnan in Late Imperial China* (Albany: SUNY Press, 1993), 151-82.

30 SMA, 313.1.99, Document 2 (untitled document [1878-1910]), Suzhou Chongde gongsuo, 3A. As with many other Chinese guilds, one of the chief duties of the Suzhou booksellers' guild was burial of those members not native to Suzhou who died while sojourning in the city. Many of those in the book trade were from other provinces, and if they passed away while in Suzhou they were interred at nearby Mount Yi. Song Yuanfang, "Ji Shanghaishi shuye gonghui," CBSL 10 (1987: 4): 37, says that Suzhou's Chongde Guild was founded in 1608 but provides no source for this claim.

31 SMA, 313.1.99, Document 1 (1874), Suzhou Chongde gongsuo [in-house notice], 2B. According to Song, "Ji Shanghaishi shuye gonghui," 37, the guild was founded in 1608 and was followed soon thereafter by the appearance of the *shuyuan*.

32 SMA, 313.1.2, Document 8 (1915), Shanghai shuye gongsuo, "Shanghai shuye gongsuo luocheng quanti dahui kaihui ci." Around 1910, CYL 1: 376 observes, the old-book industry became the bailiwick of Shaoxing natives.

33 SMA, 313.1.99, Document 2 (undated [1878-1910]), Suzhou Chongde gongsuo, 6B.

34 SMA, 313.1.2, Document 8 (1915), Zhu Huailu, Huang Xiting, and Wei Futang, Shanghai shuye gongsuo.

35 Amounts ranged from 1 to 100 yuan and were paid in both Chinese and British currency. See Feng Shaoting and Qian Gendi, eds., "Chuangjian shuye gongsuo qi," in CBSL 10 (1987:4): 42.

36 According to Song, "Ji Shanghaishi shuye gonghui," 37, the nine were Xia Ruifang, Ye Jiuru, Xi Zipei, Xia Yuzhi, Fu Zilian, Fei Rongqing, Xia Songlai, Chen Yonghe, and Hua Xinzhai.

37 Zhang Xichen, "Mantan Shangwu yinshu guan," *Wenshi ziliao xuanji* 43 (1964): 69, notes that Xi was a major Shanghai compradore with close links to Jiangsu's provincial educational officials. It is tempting to assume that Xi was a descendant of the Suzhou Xi family that had established Saoye shanfang, but I have found no evidence to confirm this supposition.

38 Feng Shaoting and Qian Gendi, eds., "Shanghai shuye gongsuo zhiyuan mingdan," in CBSL 10 (1987:4): 42. The forty-eight votes suggest that the new guild had at least that number of members, an increase of 23 since 1884; the exact membership is unknown. However, by 1911, membership would exceed 100. See Song, "Ji Shanghaishi shuye gonghui," 37. Song states that 58 of the members were bookprinters and that 72 were "binders" (*zhuangding*). This latter term is inconsistent with all other documents; most likely they were retail outlets.

39 Song, "Ji Shanghaishi shuye gonghui," 37. The early dominance of Shanghai-area natives is striking. Also, as will be shown below, the Commercial Press, represented by Xia Ruifang, had become a major influence in Shanghai's publishing world only after 1904, when it issued textbooks that became a national industry standard.

40 Feng Shaoting and Qian Gendi, "Shanghai shuye gongsuo chuciding dingzhangcheng," in CBSL 10 (1987:4): 43. "Depot" *(ju)* and "shop" *(fang)* seem to be terms that distinguished producers from retailers; when discussing the distribution of guild offices, the bylaws stipulate that half of the appointments will go to those from depots and half to those from shops. I use the term "depot" because it was in common usage among English-language booksellers in Shanghai at the turn of the century.

41 ZYS, 590, lists Shanghai-based lithographic and letterpress printer/publishers after 1876. Only eight lithographers from his list of fifty-six and two letterpress publishers from his list of twenty-one joined the guild, based on a comparison of his list with the guild membership in Feng and Qian, "Shanghai shuye gongsuo chuciding dingzhangcheng," 41-42.

42 Dianshizhai, one of the original subscribers to the guild project back in 1884, had closed in the late 1890s. This emphasis on excluding non-Chinese booksellers certainly reflected, and may have been a deliberate response to, the "European"/Chinese segregation prevalent in Shanghai's Anglo-American organizations and was subsequently reflected in the 1911 bylaws of the competing Shanghai Booksellers' Trade Association as well. See SMA, 313.1.3, "Shanghai shuye shanghui zhangcheng" (1906), Statute 3, Item 4, Article C. The stipulation may also reflect a change in the view of Shanghainese toward foreigners. According to Ye Xiaoqing, "Popular Culture in Shanghai, 1884-1898," (Ph.D. dissertation, Australian National University, 1991), 12, nineteenth-century Shanghainese had distinguished themselves from other Chinese as well as from their descendants in the early twentieth century by their lack of xenophobia; it seems clear that the situation had already changed by the time these bylaws were written c. 1905.

43 SMA, 313.1.2, Document 8 (1915), Shanghai shuye gongsuo, claims the money was eaten up on "formalities like reporting to the local government offices and registering with the Agricultural and Commercial Bureaus as well as registering with the General Chamber of Commerce (Zongshanghui)." Song, "Ji Shanghaishi shuye gonghui," 38, says that the *Guanshang kuailan* continued to appear after 1911 with a new title, *Guomin bianlan* (A Convenient Look at the Nation).

44 The exhibition hall used to promote sales is mentioned in Chapter 2, Article 5. See Feng and Qian, "Shanghai shuye gongsuo chuciding dingzhangcheng," 43.

45 SMA, 313.1.2, Document 8 (1915), Shanghai shuye gongsuo.

46 SMA, 313.1.99, Document 2 (undated [1874-1910]), "Yi jian shuye gongsuo zheng [unclear] shimian qi," 22A.

47 Ibid.

48 The first modern copyright law was in fact not issued by the Qing court until 1906, and then under the rubric of a publications' law, which Kang Youwei had first recommended to the Guangxu emperor in August 1898. Lee-hsia Hsu Ting's *Government Control of the Press in Modern China, 1900-1949* (Cambridge, MA: Harvard East Asian Research Center, 1974), Chapter 1, includes discussion of previous publication laws, as well as of the "Special Statute of the Great Qing Dynasty Governing Publications" which was jointly drafted by the ministries of Commerce, Police, and Education. It was supplemented by a Press Law in 1908 and was updated by the Provisional Constitution of 11 March 1912 only to be essentially revived by Yuan Shikai's Publication Law of 1914, which remained in effect long after Yuan's death in 1916. *The Great Qing Code*, as translated by William C. Jones, includes only two laws concerning publication, Articles 165 and 256 under "Laws Relating to the Board of Rites" and "Punishments," respectively. Neither deals with copyright per se or by implication. Shanghai's Mixed Court adhered to copyright regulations, as indicated by A.M. Kotenev in his *Shanghai: Its Mixed Court and Council* (Shanghai: North China Daily News and Herald, 1925), 551-53. According to the 1915 promulgation, Article 1, "The exclusive right to print, reprint, publish or copy any or all of the following works of art shall be granted to any person after registration in compliance with the provisions of this Act, whereupon it or they shall be Copyright." The list includes literary works, speeches, dramatic works, musical compositions, pictures, photographs, etc. For a recent view on this topic, see William P. Alford, *To Steal a Book is an Elegant Offense: Intellectual Property Law in Chinese Civilization* (Stanford: Stanford University Press, 1995), esp. Chapters 2-3. Alford's general argument is that copyrights were difficult, especially for foreign businesses, to enforce in China. My point here is that multiple attempts were made by Chinese to introduce copyright legislation, including that by the guild, whose members might have agreed with Alford on the difficulty of enforcement. The Nationalist government promulgated a copyright law in 1928. Before 1937, China did not sign the Universal Copyright Convention or any other bilateral copyright agreement.

49 SMA, 313.1.2, Document 8 (1915), Shanghai shuye gongsuo.

50 Most of the surviving documents, particularly the bylaws, stress the fact that the guild, whether in Suzhou or Shanghai, was self-supporting. Thus, for example, the 1874 in-house notice of the Suzhou guild states "I. The guild's establishment depends on those in this trade raising the money themselves, not [getting it from] outside; II. All [Suzhou] bookstores should contribute according to the number of pages [i.e., books] they have; for each [book] one dollar; contribute silver as per the usual custom. [This way] the guild will not deteriorate, and we can do annual repairs, honour our promises, conduct funerals, etc., all [as] matters of public expense."

51 These conditions also included those that were printed or sold despite being banned. See Feng and Qian, "Shanghai shuye gongsuo chuciding dingzhangcheng," 43, Chapter 2, Article 7.

52 Ibid.

53 SMA, 313.1.2, Document 8 (1915), Shanghai shuye gongsuo.

54 Song, "Ji Shanghaishi shuye gonghui," 37.

55 Ibid.

56 SMA, 313.1.23, "Shuye shangtuan tongzhi xinshi lu" (undated [1910]). The SMA collection includes *dazibao*, medals, para-military paraphernalia, and photographs concerning this militia.

57 For a recent view that finds growing class dissension and class consciousness dividing print-shop employees from owners after 1917, see S.A. Smith, *Like Cattle and Horses: Nationalism and Labor in Shanghai, 1895-1927* (Durham: Duke University Press, 2002), 65, 85, 89, 179, 212. Also, see Chapter 5 below.

58 Their average age was thirty *sui*, with the oldest two being forty-one and the youngest three being twenty-three. The heavy proportion of non-Shanghainese reflects Shanghai's sojourning population discussed in Frederic Wakeman, Jr., and Wen-hsin Yeh, eds., *Shanghai Sojourners* (Berkeley: Institute of East Asian Studies, 1992). See, particularly, their introduction.

59 Song, "Ji Shanghaishi shuye gonghui," 37. In 1914, the general director was Gao Hanqing, assisted by "joint directors," Gong Boyin (replaced by Tang Ziquan) and Ye Jiuru.

60 Conversely, of the total 120 shops existing in 1914, 36 had gone out of business by 1917.

61 This observation is valid unless one makes the assumption that the lithographers, ipso facto, were antiquarians.

62 SMA, 313.1.23, "Shanghai shuye tongye yilanbiao" (1917), indicates that the first was located off Jiujiang Road, two blocks north of Fuzhou Road, still within the Wenhuajie district, in Minfeng Lane. The second was located at Maijiaquan, a name which suggests a site in the Nanshi.

63 SMA, 313.1.3, "Shanghai shuye shanghui zhangcheng" (1911). On the evolution of guilds into trade associations, see Edward J.M. Rhoads, "Merchant Associations in Canton, 1895-1911," in Mark Elvin and G. Wm. Skinner, eds., *The Chinese City Between Two Worlds* (Stanford: Stanford University Press, 1974), 97-118. On the modernization of Shanghai guilds and city administration, see Mark Elvin, "The Administration of Shanghai, 1905-1914," 239-62 in the same volume. CYL, 1: 382 indicates that Wangping Street became Shandong Road, although he does not say when.

64 Song, "Ji Shanghaishi shuye gonghui," 37. Ten years later, in 1930, the Nationalist government forced the reconstituted trade association/guild to unite with a more recent new-style book industry trade association of its own devising. This time, the merger was intended to simplify government control of the Shanghai publishers.

65 This firm was not Zhang Xizhen's Kaiming shudian, the well-known political/literary publisher founded in 1926.

66 SMA, 313.1.27, "Qingchao shuye shanghui er dong mingdan," (1907-9).

67 Song, "Ji Shanghaishi shuye gonghui," 38. Revealing the overlap between the guild and trade association, those present at these meetings included Xia Songlai, Xi Zipei, Xia Ruifang, and others.

68 SMA, 313.1-79, "Shanghai shuye shanghui nian zhou ji niance mulu" (Jiading: n.p., 1924), 3.

69 SMA, 313.1.3, "Shanghai shuye shanghui zhangcheng," (1911).

70 Ibid.

71 Ibid.

72 SMA, 313.1-79, "Shanghai shuye shanghui nian zhou ji niance mulu," 9.

73 Ibid., 10.

74 Alford, *To Steal a Book*, 43, discusses a 1923 lawsuit that G. & C. Merriam brought and lost in Shanghai's Mixed Court against the Commercial Press for unauthorized republication of a bilingual *Webster's Dictionary*.

75 SMA, 313.1-79, "Shanghai shuye shanghui nian zhou ji niance mulu," 10.

76 This summary derives from Song, "Ji Shanghaishi shuye gonghui," 38.

77 Chan, *Merchants, Mandarins, and Modern Enterprise*, 168.

78 Ibid., 178, says that the five were partnerships of two or more persons with unlimited liability; similar partnerships with limited liability; joint-stock companies of seven or more shareholders with unlimited liability; similar joint-stock companies with limited liability; and sole proprietorships with unlimited liability. Between 1904-5, interest in registration was greatest from joint-stock firms of limited liability that, in addition to favouring Western concepts of business organization, also promoted the legal guarantees that the new commercial legislation promised. Only 27 out of 272 firms that registered from 1904 to 1908 were companies of unlimited liability (all of these were pawnshops); a tiny fraction of China's traditional sole proprietorships and partnerships were registered (44 and 48, respectively). The remaining 153 firms were all joint-stock firms of limited liability.

79 The importance of this development in Britain's domination of China's sovereignty has often been lost under the weight of nineteenth-century political history and the unequal treaties. The first Chinese-run joint-stock company *(gongsi)* was the well-known China Merchants' Steam Navigation Company (Lunchuan zhaoshangju), founded by Li Hongzhang in 1872, ten years after the American firm Russell and Company had launched its own Shanghai Steam Navigation Company. The Chinese firm's "use of this organizational structure marked a new departure in Chinese business practice," as Chi-kong Lai maintains in his "The Qing State and Merchant Enterprise: The China Merchants' Company, 1872-1902," in Jane Kate Leonard and John R. Watt, eds., *To Achieve Security and Wealth: The Qing Imperial State and the Economy, 1644-1911* (Ithaca: East Asia Program, Cornell University, 1992), 140.

80 Chinese commentators on this topic include Shen Zuwei, ed., *Jindai Zhongguo ziye: zhidu he fazhan* (Shanghai: Shanghai shehui kexue yuan, 1999) and Huang Hanmin and Lu Xinglong, *Jindai Shanghai gongye qiye fazhan shilun* (Shanghai: Caijing daxue chubanshe, 2000). Thank you to an anonymous UBC Press reviewer for these references.

81 In this sense, I agree with Douglas R. Reynolds's interpretation of the Xinzheng reforms as "a quiet revolution," in the course of which new paradigms for action were legitimated. See Reynolds, *China, 1898-1912: The Xinzheng Revolution and Japan* (Cambridge, MA: Harvard Council on East Asian Studies, 1993), 12ff.

82 In this regard, Ian Norrie, *Publishing and Bookselling* (London: Jonathan Cape, 1974), 235, observes that in Britain the limited liability corporation took some time to catch on in the publishing business. As of the 1870s, Norrie writes, "Few publishing houses had taken advantage of the Companies Act of 1862 which allowed limited liability. Most were still partnerships."

83 Lin Heqin, "Ziben yu yinshua shiye," in Yan Shuang, ed., *Zhongguo yinshua shi ziliao huibian* (Shanghai: Shanghaishi Xinsijun lishi yanjiuhui, Yinshua-Yinchao zu, n.d.), 1: 120. The same rationale for the proprietorship, partnership, and corporation is expressed, almost word-for-word, in the introduction to Harry M. Trebing, ed., *The Corporation in the American Economy* (Chicago: Quadrangle Books, 1970), 6-7. Trebing reviews the history of the corporation as a legal entity.

84 Lin, "Ziben yu yinshua shiye," 1: 121.

85 Ibid., 1: 121-22. The four reasons Lin gives are quotas for each investor are small and easy to shoulder; stockholders can sell their shares freely, without involving the company or other stockholders; the company has a legal identity, making it more secure *(baozhang)* in the eyes of lenders; and, aside from their initial investment, shareholders need have no other duties.

86 Ibid., 1: 121. Chi-kong Lai also explains that "In nineteenth-century Europe and the United States, a joint-stock company was seen as a legal entity, whose characteristics, such as legal

personhood and existence beyond the life of its members, made it more advantageous than partnerships." See Lai, "The Qing State," 141.

87 The same problem is discussed at great length by Shanghai publisher and magazine distributor Zhang Jinglu. See Zhang, *Zai chuban jie ershi nian* (Hankou: Shanghai zazhi gongsi, 1938), 160-63.

88 Lin, "Ziben yu yinshua shiye," 122.

89 Ibid.

90 According to Tao Shuimu, *Zhejiang shangbang yu Shanghai jingji jindaihua yanjiu, 1840-1936* (Shanghai: Sanlian shudian, 2000), 104, the Commercial Press was founded by the extended Bao family of Ningbo, Xia Ruifang, and Gao Fengchi. The Bao patriarch was Bao Zhecai, a Presbyterian minister in Shanghai, whose three sons and three daughters were all students at Qingxin Hall. As apprentices at the APMP, brothers Xian'en learned type-casting; Xianchang, typesetting; and Xianheng, printing. Xia Ruifang also learned to typeset. He married the second daughter. When the Commercial Press was established with a total of 3,750 yuan, each share was worth 500 yuan. Xia was one of two who held a full share, surpassed only by Shen Bofen, who held two. Thank you to an anonymous UBC Press reviewer for suggesting this work to me.

91 Although Lufei Kui was considered a native of Tongxiang, Zhejiang, he was actually born in Shaanxi. See WH, 81-105.

92 Zhang, "Mantan Shangwu," 69. See also JSF, 330. Xi invested 500,000 yuan in the firm and appointed Zhang Jian as head of the board of directors. Eventually, after several years of fierce competition over the textbook market, Xi's firm was bought out by its chief competitor, the Commercial Press.

93 Yu Fu, mentioned earlier as the director of the guild, and his partner Lian Quan, founded Wenming Books. Established from the start as a corporation, Wenming, along with the Commercial Press and the Chinese Library Company became one of the three leading corporate comprehensive publishers of the late Qing. Like the Commercial Press, Wenming published Qing decrees on school regulations and several influential textbooks, as well as foreign social science texts and modern art books. At the same time, the market for *biji* (anecdotal essays) was growing. Wenming imported Japanese printing technology such as collotype machines and photomechanical printers to print and publish collections of the essays along with many albums of stele rubbings, calligraphy, and paintings. See Wu Tiesheng, "Jiefangqian Zhonghua shuju suoji," in Zhonghua shuju bianyibu, eds., *Huiyi Zhonghua shuju, 1912-1987* (Beijing: Zhonghua chubanshe, 1987), 2: 72.

94 This account is found in WH, 2-3.

95 Needless to say, without concern for copyright ownership.

96 Florence Chien, "The Commercial Press and Modern Chinese Publishing, 1897-1949" (MA thesis, University of Chicago, 1970), 10.

97 See WH, 4.

98 Hu Yuzhi, "Huiyi Shangwu yinshu guan," in Chen Yingnian and Chen Jiang, eds., *Shangwu yinshu guan jiushiwu nian, wo he Shangwu yinshu guan* (Beijing: Shangwu yinshu guan, 1992), 113.

99 WH, 4

100 The Commercial Press has been the subject of two scholarly studies in European languages. In addition to Chien, "The Commercial Press," see Jean-Pierre Drège, *La Commercial Press de Shanghai, 1897-1949* (Paris: Memoires de l'Institut des Hautes Études Chinoises, [1978]). Numerous historical accounts and documentary collections have also appeared in Chinese. One place to start is with the collection *Shangwu yinshuguan jianguan bashi zhounian jinian (1897-1977)* (Hong Kong: Commercial Press, 1977). Ip, *The Life and Times*, contains extensive material on the history of the Commercial Press, independent of her focus on Zhang Yuanji. Finally, I should stress that figures like Xia Ruifang hardly ever appear in Chinese historical scholarship. The best account of this idiosyncratic, energetic, and fascinating cipher of a man is in WH, a book that is based on wide reading in the periodicals of the time. Unfortunately, few of them are cited.

101 Chien, "The Commercial Press," 10.

102 WH, 4.

103 CYL, 1: 220. Bao's chronology of these years in the early 1900s is sometimes faulty, a fact that does not detract from the essentials he does remember accurately.

104 Ibid.

105 Ibid. It was located between Yunnan Road and Guizhou Road, next to the Laozha police station (which would become infamous during the May Thirtieth Movement of 1925).

106 Bao also dealt with a printer named Wu Yunji, whose old-fashioned but larger and faster firm was located north of Suzhou Creek on Henan North Road opposite the Fujian Guild (Quan-Zhang huiguan). At Wu's, Bao tried to have Yan Fu's translation of Huxley's *Evolution and Ethics* printed, but Wu's printers could not understand Yan's writing style, famous for its literary quality, so Bao was forced to retreat. Instead, he engaged the Commercial Press for most of the job.

107 The same book that Zhang Yuanji had then bought and was printing at Nanyang Public Institute in the suburbs of Shanghai. According to CYL, 1: 222-23, Yan Fu's manuscript was very clean and clear, written in standard script on paper that Yan had blocked out and lined himself. Bao eventually published a number of other translations by Yan. The other manuscript on which Jinsuzhai was working at this time was a Japanese text translated directly into Chinese by Ye Haowu, the Hangzhou founder of the Dongwen (Japanese) School, who was also a translator for the *Zhongwai ribao*, the newspaper through which Bao's firm eventually advertised its books. Bao found the old man himself, whose small beard gave him a Daoist air, amusing but complains that his direct translation created great problems in Chinese grammar, especially because of the plethora of "の" particles that Ye had merely transcribed from long Japanese sentences into Chinese as "之." Ye had often to visit the Jinsuzhai to make these and other corrections, and on at least one occasion was accosted by the whores who frequented the publisher's lane. Unaware that she was sharing the lane with a publisher, when Ye insisted that he was going to Jinsuzhai, the lady who had hooked him proclaimed, "We are better in every way than Jinsuzhai," and dragged him into her boudoir. He eventually had to buy his freedom for one yuan, and Jinsuzhai, concerned about the impact of the neighborhood on its business, soon moved to a new and unnamed street northwest of Nanjing Road (eventually called Baikal Road, it became Fengyang Road, behind the present-day Park Hotel, after 1949).

108 CYL, 1: 236-37. My translation of this passage, although including numerous changes, is nonetheless based on Ip, *The Life and Times*, 112.

109 Bao's sympathetic portrait of the self-made Chinese publishing entrepreneur Xia Ruifang bears a number of similarities to Charles A. Ruud's portrait of the peasant-into-millionaire Russian publisher, Ivan Sytin. See Ruud, *Russian Entrepreneur: Publisher Ivan Sytin of Moscow, 1851-1934* (Montreal and Kingston: McGill-Queen's University Press, 1990).

110 In Shanghainese vernacular, the detested Sikhs were called *hongtou asan* (red-headed boys or red-headed number threes) after their turbans, although Bao uses the polite term "Indian policeman" *(yindu xunbu)*. See Shou Ming, *Shanghai fangyan shiye tan* (Shanghai: Huadong shifan daxue chubanshe, 1992), 126.

111 CYL, 1: 236.

112 Ibid.

113 One early publication, *Tongjian yilan*, sold over 11,000 copies. Before, Chinese publishers had used *maobian* (rough-edged bamboo paper), *maotai*, or *lianshi* paper for works of this sort. Xia was the first to combine one sheet of coarse *maocao* paper with one sheet of smooth-finish *guangjie* paper. The result resembled *lianshi* paper but cost two-thirds its price. Woodblocked copies of *Tongjian yilan* were selling for twenty silver yuan, and Xia's lead-type edition cost only two yuan more, making it a bestseller. See WH, 6.

114 Feng Jingru and He Chengyi had established Guangzhi shuju in Shanghai in 1898. Feng, a native of Nanhai, Guangdong, had grown up in Hong Kong and was running a prominent stationery and printing business serving the Chinese community of Yokohama as early as 1881. During their residence in Hong Kong, the Feng family had taken the English surname Kingsell and so the Yokohama firm was called Kingsell Company. Feng Jingru's son Feng Ziyou (1881-1958) would become an important associate of the revolutionary Sun Yat-sen (1866-1925). The Fengs were influential in the establishment of Sun's Xingzhonghui (Restore China Association) in Yokohama in 1896, and Feng Ziyou was immediately registered as the youngest member of the organization. Feng Jingru's political activities may have influenced

the establishment of Guangzhi shuju; by 1903, the firm published Zhao Bizhen's translation of *Socialism for the Modern Age (Jinshi shehui zhuyi)*, the first Chinese work to mention Marx's *Das Kapital*. Guangzhi published numerous other modern political works, many of which looked forward to the revolutions of 1911 and 1949, as well as three novels by the political satirist Wu Woyao, including *Vignettes from the Late Qing*. See BDRC, 2: 30-31.

115 Jiang, "Bianji xiaoxue jiaokeshu," 140.

116 Ibid.

117 Ibid.

118 CYL, 1: 237. As for Bao's own Jinsuzhai, it did not last much longer. Bao notes that at that time many publishers, especially translation bureaus, were organized "to get the ball [of reform] rolling" *(kai fengqi)* and not to make profits. For this reason, most had inadequate financing. Bao's own employer, Kuai Liqing, "an old-style aristocrat" *(shijia zi)*, holder of a *jinshi* degree, and relative by marriage of Li Hongzhang (CYL, 1: 204, 238), was underwritten initially by Yan Fu and later by sales of Yan Fu's and Ye Haowu's books. His business was an individual proprietorship, hampered by unstable financing, oblivious to the fact that publishing had already become commercialized *(shangyehua)*, says Bao. Jinsuzhai, like most publishing firms in the period after 1895, expired prematurely as a rambunctious juvenile, aged two years. Interestingly, its copyrights for the series of Yan Fu books that it had published under Bao's contracts reverted to the Commercial Press (CYL, 1: 237-41). Bao himself went to work first for Qixiu bianyiju and then Guangzhi shuju, the other important textbook publisher of the day, where he translated Japanese engineering books with five or six Cantonese editors whose spoken language he could not understand. After two months there, Bao moved to another translation bureau, where he stayed for a year, and then returned to Suzhou. See CYL, 1: 242-50.

119 JSF, 320.

120 Jiang, "Bianji xiaoxue jiaokeshu," 140.

121 Ibid., 141. In the view of JSF, 320, the Patriotic Institute was founded by dissident students expelled from Nanyang. JSF is supported by Song Yuanfang's chronology of the Shanghai book business, "Zhongguo jindai chuban dashiji," in CBSL 19 (1990:1): 145, which cites 16 November 1902 as the date of the institute's establishment.

122 Zhang, "Mantan Shangwu," 73-74. See also Zheng Zhenwen, "Wo suozhidao de Shangwu yinshu guan bianyisuo," *Wenshi ziliao xuanji* 53 (1965): 151.

123 Ip, *The Life and Times*, 160; CYL, 1:390-91 discusses the origins of those in the editorial office, pointing out that, among the predominant Jiangsu natives, those originating in Changzhou were most numerous. Recall, however, that the Baos came from Ningbo; not surprisingly, Zhejiang natives also played a major role in Shanghai's publishing world. See, for instance, Tao Shuimu, *Zhejiang shangbang yu Shanghai jingji jindaihua yanjiu, 1840-1936* (Shanghai: Sanlian shudian, 2000), 103-10; Chen Cunren, *Yinyuan shidai shenghuo shi* (Shanghai: Renmin chubanshe, 2000), 257-58, synthesizes these views with the observation that many major figures at the Commercial Press, Zhonghua Books, and World Books were Changzhou (Jiangsu) or Shaoxing (Zhejiang) natives. For a list of the 63 editors who worked at the Commercial Press in the late Qing, see Zheng, "Wo suozhidao de Shangwu yinshu guan bianyisuo," 143.

124 According to WH, 8, they were paid what seems to have been a purely symbolic gratuity of one yuan. Jiang Weiqiao scoffs when he recalls it in "Bianji xiaoxue jiaokeshu," 140.

125 Ip, *The Life and Times*, 114. Historians offer many reasons to explain why Zhang left when he did. In light of Xia's decision to go independent after being mistreated by the apparently anti-Chinese O'Shea, one of the most striking of the explanations (ibid., 80) is that Zhang had a falling out with John C. Ferguson, the overbearing American missionary and proctor of the Nanyang Public Institute.

126 Ibid., 114ff. Zhang was also editor of a trimonthly called *Waijiao bao* (Diplomatic Review) that he brought to the Commercial Press.

127 Ibid., 114, note 7. Zhang's initial monthly salary was a lavish 350 yuan per month. Ip observes, "different sources mention different times when Zhang Yuanji formally joined the Commercial Press. The official *Jinian tekan*, his obituaries and eulogies give 1901, Wang Yunwu mentions 1902 ..., Mao Dun mentions 1903." Since the *Subao* case broke in June 1903 and did force Cai to leave Shanghai, 1903 seems the most convincing date.

128 After gaining the *xiucai* degree, Gao had abandoned the examination system and, in 1896, went to Hangzhou with his elder brother, Fengqi (a well-known proponent of the Tongcheng School). There the two helped their fellow Fujianese Lin Qi to organize the Qiushi Academy which in 1901 became Zhejiang University. Although offered a position as dean of the new university, after visiting Japan, Gao wanted to devote himself to compiling primary school textbooks and turned to Zhang Yuanji, a family friend. See Zheng Zhenwen, "Wo suozhidao de Shangwu yinshuguan bianjisuo," in *Wenshi ziliao xuanji* 53 (1965): 144.

129 Ip, *The Life and Times*, 119. My account derives from 119-28.

130 Mao Dun, *Wo zouguo de daolu* (Hong Kong: Sanlian shudian, 1989), 1: 95.

131 Ip, *The Life and Times*, 124.

132 As noted above, the early Zhejiang and Jiangsu influence was striking, with all of the editors but one hailing from those provinces. In time, as Gao Mengdan's influence increased, he himself became wary of relying too much on editors from his home province of Fujian, a strong temptation given his own inability to speak Mandarin. See Zheng, "Wo suozhidao de Shangwu yinshuguan bianjisuo," 145, where he states "in Gao's life, the thing he feared most was to have to speak Mandarin" and 151, where Zheng explains that Gao eventually agreed to having Wang Yunwu take over the editorial office in 1922 because he did not want to appear to be holding out for a Fujianese. In the end, Wang's arrival strengthened the Christian Band thanks to Wang's intimacy with Christian missionary values (ibid., 142). This inability to speak Mandarin led in the first sessions to a heated dispute between Gao and Jiang over the words "釜" and "鼎" that finally ended when they discovered that they were disputing the same term, pronounced differently in their respective dialects. Reported in ibid. and in Jiang, "Bianji xiaoxue jiaokeshu zhi huiyi," 141.

133 Ip, *The Life and Times*, 130.

134 In 1933, most operations would move back into the concession because it afforded protection from the Japanese. See Chapters 3 and 5.

135 (ROC) Ministry of Education, "Jiaokeshu zhi faxing gaikuang, 1868-1918" [1938], in ZJCSC, 1: 231-32. Also, in 1905, aware that old-fashioned schoolmasters may not have known how to use the new textbooks, the Commercial Press opened a school to instruct teachers in the new approaches of the modern textbooks. This school was separate from Shanggong Elementary School, the school for employees' children that the publisher organized in 1907. See Ip, *The Life and Times,* 131-32.

136 GGZ, 145-50, says that, in China, 216 newspapers and 122 magazines emerged rapidly after 1895. The same pattern of accommodation appeared after the Revolution of 1911 and the counterrevolution of 1927.

137 Shops here included Guangya shuju, Xin shijie xue baoguan, Qiwenshe, Minquanshe shuju, and Biaohumeng shushi. Before 1910, the most important Fuzhou Road firm was Xi Zipei's Chinese Library Company, founded in 1906.

138 JSF, 330.

Chapter 5: "The Three Legs of the Tripod"

1 Lydia Liu, *Translingual Practice: Literature, National Culture, and Translated Modernity – China, 1900-1937* (Stanford: Stanford University Press, 1995), Chapter 9, discusses the classical as well as the modern connotations of *wenhua*. Thanks to Patricia Sieber for this reference.

2 Just as often as one reads of Shanghai's "Big Three" publishers, one hears of the "Big Four," the fourth being Kaiming shudian, founded in 1926. Yao Fushen, *Zhongguo bianji shi* (Shanghai: Fudan daxue chubanshe, 1990), 355-56, for example, devotes just as much space to Kaiming as to the Commercial Press, Zhonghua, and World. However, his concern is primarily editorial and intellectual/cultural history. My focus here is technological, commercial, and industrial; editorship here is important only as an element contributing to the success or failure of the three largest firms in achieving assets, scale, and impact. It is true, as Yao points out, that the high quality of Kaiming's publications, both in terms of content and of design, and their focus on the young adult market gave them an impact on an intellectual level as important as those of the Commercial Press, Zhonghua, and World, but Kaiming never rivalled them in terms of assets or scale.

3 Florence Chien, "The Commercial Press and Modern Chinese Publishing, 1897-1949" (MA thesis, University of Chicago, 1970), 43.

4 Jean-Pierre Drège, *La Commercial Press de Shanghai, 1897-1949* (Paris: Institut des Hautes Études Chinoises, 1978), 111.

5 According to figures compiled by Wang Yunwu and quoted by Chien, "The Commercial Press," 43. Even in the mid-1930s, the heyday of Chinese publishing, total output did not exceed 10,000 titles per year, as compared with about 10,000 in the US, 15,000 in Japan, and 23,000 in Germany. See ibid., 44, Table 3.

6 Ibid., Table 2.

7 Actually, Dadong opened in an alley abutting Fuzhou Road. Lü Ziquan was Shen Zhifang's (World Books) friend, and Shen Junsheng was Shen's nephew.

8 CYL, 1: 382. I have chosen to translate Wenhua dajie as "Culture Street" to avoid confusion with Culture-and-Education Streets (Wenhuajie).

9 Zhang Jinglu, *Zai chubanjie ershi nian* (Hankou: Shanghai zazhi gongsi, 1938), 2. Zhang says that he had long demurred, thinking that Zhang Yuanji, Lufei Kui, or Wang Yunwu, three of the individuals discussed in this chapter, knew more about the Shanghai publishing world than he did.

10 Ibid., 31.

11 Ibid., 40.

12 Ibid., 114.

13 Ibid. Zhang, who despised Shen Zhifang and World Books for its irresponsible exploitation of the "mandarin duck and butterfly" school of literature, says that the Commercial Press, Zhonghua, Kaiming, Yadong, his own firm, and, in 1925, Beixin shuju (which relocated here from Beijing), were the main agents of the progressive Wenhuajie with which he was familiar.

14 Governments of greatest importance to the Shanghai publishers were warlord governments and the national government. Likewise, the Shanghai Concession and Nationalist Party governments had an impact on publishers, as Frederic Wakeman, Jr., shows in *Policing Shanghai 1927-1937* (Berkeley: University of California Press, 1995), 134ff., 173ff., and 236ff. Zhang, *Zai chuban jie*, 118ff., discusses the impact of what he calls the International Concession's "slave laws" that were a constant thorn in the heel of Shanghai's cultural industries.

15 Song Yuanfang, "Ji Shanghaishi shuye gonghui," in CBSL 10 (1987:4): 45-49.

16 Wang Yunwu, *Shangwu yinshu guan yu xin jiaoyu nianpu* (Taipei: Taiwan Commercial Press, 1973).

17 Chow Tse-tsung, *The May Fourth Movement: Intellectual Revolution in Modern China* (Stanford: Stanford University Press, 1967), Appendix A. Chow's statistics cover the years 1905-23, but Chow acknowledges that they are unreliable; reliable statistics for school enrolment before the 1930s are rare.

18 Wang, *Shangwu yinshu guan*, 693. Wang's statistics cover the years from 1910 to 1972; years overlapping with Chow's provide roughly equivalent figures.

19 Robert Culp, "The Ideological Infrastructure of Citizenship: Schools and Publishing," in Culp, "Articulating Citizenship: Community, Civility, and Student Politics in Southeastern China, 1912-1937" (unpublished manuscript), argues convincingly that elite intellectuals and the expanding circle of professional educators set standards that publishers and governments felt obliged to follow prior to 1928. Although Culp's view broadens the context that I describe here, it does not invalidate my observation that Shanghai's publishers were attentive to government policies.

20 As suggested in this book's Introduction, the size of China's reading public and its relationship to reading matter are hotly contested. Terry Narramore, "Making the News in Shanghai, *Shen Bao* and the Politics of Newspaper Journalism 1912-1937" (PhD dissertation, Australia National University, 1989), 21-39, cites a 1936 article by Vernon Nash and Rudolph Lowenthal claiming that, in 1936, from 100 to 150 million Chinese could read with varying levels of competence. In the mid-1920s, however, as Narramore points out, no periodical or trade publication sold more widely than *Shenbao* which claimed an (uncertified) circulation of 141,440 in late 1926. By the 1930s, *Shenbao* declared a daily readership of one million even though it never sold more than 150,000 copies of any one issue. Hu Daojing, in his "1933-nian de

Shanghai zazhi jie," in Shanghai tongshe, eds., *Shanghai yanjiu ziliao xu* (Shanghai: Shanghai shudian, 1935), 404, basing his view on post office statistics, says that one issue of the periodical *Shanghai zhoukan* sold 125,000 copies. Zou Taofen's *Shenghuo zhoukan* sold 150,000 copies per week before it was closed down in 1933, the largest circulation of any Chinese periodical prior to 1949, says Wen-hsin Yeh, "Progressive Journalism and Shanghai's Petty Urbanites: Zou Taofen and the *Shenghuo Weekly*, 1926-1945," in Frederic Wakeman, Jr. and Wen-hsin Yeh, eds., *Shanghai Sojourners* (Berkeley: Institute of East Asian Studies, 1992), 191. Even though trade books would not be expected to reach the readership of periodicals, by comparison, Shanghai textbooks were selling at levels nearly thirteen times these numbers every year.

21 Wang, *Shangwu yinshu guan*, 44. The remaining thirteen were issued by the Zhili (Provincial) Education Bureau (Zhili xuewu shuju): ten; Huagu Primary School: one; Wuchang Library: one; and unnamed: one.

22 Ibid., 57.

23 Ibid., 693. There were 229,911 upper and primary schools in 1937 in contrast to about 43,000 schools in 1910. In 1937, there were also 91 tertiary schools, including 35 universities, enrolling 31,188 students. Chien, "The Commercial Press," 50, says that the Shanghai publishers did not issue university-level textbooks until Wang Yunwu initiated a series in the 1930s.

24 Wang, *Shangwu yinshu guan*, 52-54, says Tianjin founded a library in 1908. This institution was followed by provincial libraries set up in Henan and Shandong in 1909. The most notable library in Shanghai, right down to 1932, was the Commercial Press's own editorial library, originally known as the Hanfenlou but by then called the Dongfang tushuguan (Oriental Library), which Wang Yunwu opened to the public in 1926. The Press's library was supplemented by those of other publishers, particularly Zhonghua's. According to Hu Daojing, *Shanghai tushuguan shi* (Shanghai: Shanghaishi tongzhiguan, 1935), 7, Shanghai did not gain a true public library until 1931-32, by which time Jiangsu province had fifty-six publicly founded local libraries.

25 Established fifteen years before the Republic of China, the Commercial Press, like Zhonghua Books, outlasted the Republic of China on the mainland by many decades, albeit in a state-run form.

26 The library, one of the eight largest in East Asia, with more than 365,000 volumes, including 25,000 rare works dating from the Song through the Qing, was destroyed in the fighting of 1932. See Chien, "The Commercial Press," 66-67.

27 Zhang Yuanji began compiling *Ciyuan* in 1902. The *Sibu congkan* is an anthology of 323 rare books compiled by a team led by Zhang for over ten years. Reprinted in 1929 after Zhang discovered better exemplars, it was supplemented in 1934 with 77 additional titles and, in 1936, by another 71 titles. Also, according to Drège, *La Commercial Press*, 104-5, in 1920, the Ministry of Education granted the publisher 200,000 to 300,000 yuan to reprint the 3,460 volumes of the eighteenth-century imperial *Siku quanshu*. Paper shortages into the 1930s thwarted the project. Finally, in 1933, discussions between Zhang Yuanji and Yuan Tongli (1895-1965) of the Beijing Library led to the publication of 231 rare titles between 1933 and 1935 under the title *Siku quanshu zhenben*.

28 He Lin, "Yan Fu de fanyi," in ZJCSE, 2: 106. According to A Ying, "Wanqing xiaoshuo de fanrong," in ZJCSE, 1: 201, note 3, the Commercial Press reprinted these and others in a single collection, *Yan yi mingzhu congkan*, during the reprint heyday of the 1930s.

29 Zheng Zhenduo, *Zhongguo wenxue lunji*, cited in A Ying, "Wanqing xiaoshuo de fanrong," 1: 201, note 4. Lin translated a wide range of authors, totalling 99 British, 33 French, 20 American, 7 Russian, 2 Swiss, 1 Belgian, 1 Spanish, 1 Norwegian, 1 Greek, and 1 Japanese. Fourteen of his unpublished manuscripts were incinerated in the Japanese attack of 1932.

30 Chien, "The Commercial Press," 104-6.

31 CYL, 1: 390.

32 Ibid., 1: 391-92.

33 Chien, "The Commercial Press," 55-57 and 99; Manying Ip, *The Life and Times of Zhang Yuanji, 1867-1959* (Beijing: Commercial Press, 1985), 157-59. In 1919, a Commercial Press employee also invented the Chinese typewriter, which was soon put into production. Drège, *La*

Commercial Press, 64, explains that by 1920 the Commercial Press was printing banknotes for the government.

34 This figure dates from 1913, prior to Xia Ruifang's buyout of the Japanese investors. See Chien, "The Commercial Press," 22. According to Zhonggong Shanghai shiwei dangshi yanjiushi and Shanghaishi zonggonghui, eds., *Shangwu yinshu guan zhigong yundong shi* (Beijing: Zhonggong dangshi chubanshe, 1991), 5, by 1915 the company was worth two million yuan. Xia Ruifang went to Japan to negotiate with the Japanese; the terms he offered are unknown. Less than a week after the announcement that the Japanese would withdraw, Xia was murdered outside the door of the press's distribution center. Zhang Xichen and Hu Yuzhi named Nationalist Party member Chen Qimei (1876-1916) as his killer. Two years later, Chen himself was assassinated by agents of Yuan Shikai. Some believed that the Japanese had Xia killed.

35 For more on this system, see Ip, *The Life and Times*, 159-64. For charts depicting Commercial Press administration, see Chien, "The Commercial Press," 58-63.

36 Mao Dun, *Wo zouguo de daolu* (Hong Kong: Sanlian chubanshe, 1989), 1: 89-91.

37 Ibid., 1: 92-94.

38 Ip, *The Life and Times*, 193.

39 Chien, "The Commercial Press," 26.

40 Wang's oldest brother had won the *shengyuan* degree, the same one acquired by Bao Tianxiao, but had died young, leading Wang's father to shift Wang from an academic to a commercial curriculum. This biographical sketch of Wang blends information from BDRC, 3: 400-2; WH, 50-60; Zheng Zhenwen, "Wo suozhidao de Shangwu yinshu guan bianyisuo," in *Wenshi ziliao xuanji* 53 (1965): 140-65; and Jean-Pierre Drège and Hua Chang-Ming, *La révolution du livre dans la Chine moderne: Wang Yunwu, éditeur* ([Paris]: Publications orientalistes de France, 1979), 13-15.

41 Zheng, "Shangwu," 150.

42 The other leading candidate for the position was He Songgan, recently retired dean of Xiamen University, Fujian.

43 Ip, *The Life and Times*, 197.

44 Ip, *The Life and Times*, 200.

45 Zhang Xichen, "Mantan Shangwu yinshu guan," *Wenshi ziliao xuanji* 43 (1964): 84, says the idea, which included the suggestion that editors merely copy entries from the *Encyclopaedia Britannica (Da Ying baike quanshu)*, was introduced to the firm's editors at a dinner at Wang's home in 1921. Each entry was limited to 20,000 to 30,000 words; the collection was later called *Baike quanshu* (Encyclopaedia), presumably copying the Chinese name for the *Britannica*. Ip, *The Life and Times*, 201-2, citing Hu Shi, traces the original plan to Zhang Yuanji and Gao Mengdan.

46 Melvil Dewey created his decimal system for book classification in 1876.

47 Drège and Hua, *La révolution du livre*, 25-27. For more on the effort to introduce scientific management, see 28-30.

48 Zhang, "Mantan Shangwu," 89.

49 Chien, "The Commercial Press," 34. About one-seventh of the workers were women.

50 For English-language coverage of the printers' place in the Shanghai labour movement, see Jean Chesneaux, *The Chinese Labor Movement 1919-1927*, trans. H.M. Wright (Stanford: Stanford University Press, 1968); Elizabeth J. Perry, *Shanghai on Strike: The Politics of Chinese Labor* (Stanford: Stanford University Press, 1993); and S.A. Smith, *Like Cattle and Horses: Nationalism and Labor in Shanghai, 1895-1927* (Durham: Duke University Press, 2002).

51 *Shangwu yinshu guan zhigong yundong shi*, 19-20.

52 Mao, *Daolu*, 1: 153.

53 Ibid., 1: 155-56.

54 Ibid., 1: 158.

55 Ibid., 1: 194-95.

56 See Jin Liren and He Shiyou, *Yang Xianjiang zhuanji* (Nanjing: Jiangsu jiaoyu chubanshe, 1991).

57 The Shanghai Printing Workers' Union, organized in February 1925 and called Yinlian for short, was located at 24 Huaxing Lane off Zhejiang North Road.

58 Mao, *Daolu*, 1: 207-9.

59 This summary comes from Chien, "The Commercial Press," Appendix I.
60 *Shangwu yinshu guan zhigong yundong shi*, 30-33.
61 Chen Yun joined the Chinese Communist Party in 1924. After 1949, he became a leading member of the Chinese Politburo.
62 For a fictionalized account of this counterrevolution, see André Malraux, *Man's Fate*, trans. H.M. Chevalier (New York: Random House, 1961).
63 Ip, *The Life and Times*, 218.
64 Mao, *Daolu*, 2: 2, and Ip, *The Life and Times*, 220.
65 Wu, with Cai, Li, and Zhang Renjie, was regarded as one of the "Four Elder Statesmen" of the Guomindang; all had sided with Chiang Kai-shek against Wang Jingwei in 1927. In the early 1900s, Wu had founded a revolutionary publishing house called Shijieshe (World Society) and was known for his efforts to standardize the national language. Like Li, Wu was a former anarchist. Li was the leader of the Chinese work-study movement in France. See BDRC, 3: 416-19, and BDRC, 2: 319.
66 Ip, *The Life and Times*, 221.
67 However, as Perry, *Shanghai on Strike*, 113-14, explains, once the Nationalists' hold on Shanghai was broken by the Japanese in 1937, Communist Party organizers returned to the Commercial Press. Between April 1938 and December 1941, more than three dozen new members joined its cell.
68 Song, "Ji Shanghaishi shuye gonghui," 37-38.
69 This summary is based on Jiangsu sheng chuban shizhi bianmu weiyuanhui bianjibu, eds., *Jiangsu Minguo shiqi chuban shi* (Nanjing: Jiangsu Renmin chubanshe, 1993), 191ff.
70 Chien, "The Commercial Press," 26.
71 Ibid., 201. Drège and Hua, *La révolution du livre*, 89, citing Wang Yunwu, reveal that Wang believed that the Chinese were not a nation of readers, in part because Shanghai publishers, unlike cigarette manufacturers, were insufficiently aggressive at marketing. By 1935, the Commercial Press introduced a "book of the week" promotion with discounts. *Wanyou wenku* was, in fact, an extension of the *Baike xiao congshu* and *Baike quanshu* series that Wang had started issuing in the 1920s to great commercial success, says Ip, *The Life and Times*, 202. Drège, *La Commercial Press*, 55, notes that the first series of the *Wanyou wenku*, made up of 1,010 titles in 2,000 volumes, cost 360 yuan; if purchased separately, the titles would have cost from 1,000-2,000 yuan. Ibid., 56, records that Lu Xun dismissed the *Wanyou wenku* as mere "eye powder." Ibid., 50-52, regards the 1930s as "l'âge d'or" of *congshu* production. While Wang concentrated on issuing collections of modern writings, Zhang Yuanji took responsibility for collections of traditional works such as the *Sibu congkan* (*Primary Series*, 1920; *Second Series*, 1934; *Third Series*, 1936) arranged according to the traditional bibliographic classifications.
72 Ibid., 107-8.
73 Chien, "The Commercial Press," 47.
74 Ibid., 44, Table 2.
75 Drège, *La Commercial Press*, 98-99, indicates that in 1934, the Commercial Press achieved four times its 1931 output; in 1936, output reached six times the 1931 figure. Still, in terms of the total number of titles produced, China ranked sixteenth worldwide, behind Switzerland.
76 Chien, "The Commercial Press," 42.
77 When the Anti-Japanese War ended, Wang was in Chongqing, where he had developed close ties to the Nationalist government. In 1946, he was appointed minister of economic affairs and then, in 1948, minister of finance; in the latter capacity, he was responsible for the introducing the disastrous "gold yuan" *(Zhonghua jinyuan)* monetary reform that precipitated the final collapse of China's economy. In 1949, he followed Chiang Kai-shek to Taiwan where he filled numerous roles for the Nationalists before 1964, when he resumed his publishing work with the Taipei branch of the Commercial Press. Meanwhile, Zhu Jingnong (1887-1951), Wang's student and Hu Shi's classmate at China College, took charge of Shanghai's operations from 1946 to 1948. A former Beijing University professor, at Wang's invitation Zhu had worked as an editor at the Commercial Press from 1923 to 1927 along with directing the firm's Shanggong Elementary School. After serving the Nationalist government in Nanjing and Chongqing in numerous education-related positions, Zhu returned to publishing until

forced to leave under pressure from pro-Communist employees and Zhang Yuanji, who, on behalf of the Commercial Press's board, dismissed both Wang and Zhu in 1948. Zhu died in the United States.

78 Zhonghua's registered English name was Chung Hwa, but for purposes of orthographic uniformity, I use the pinyin version in this book.

79 Wu Tiesheng, "Jiefangqian Zhonghua shuju suoji," in Zhonghua shuju bianjibu, eds., *Huiyi Zhonghua shuju* (Beijing: Zhonghua shuju, 1987), 1: 71.

80 According to ECCP, 1: 542-43, the unusual surname originated when an ancestor surnamed Fei was taken in by a family surnamed Lu. One of Lufei's ancestors was Lufei Chi (d. 1790), a *jinshi*, Hanlin compiler, chief collator, and then assistant director of the *Siku quanshu* project. He also served in the imperial printing shop (Wuyingdian). Hounded by repeated charges that books under his care vanished or were improperly edited, Lufei Chi was deprived of all ranks and offices. He also had to pay more than 10,000 taels for preparing the three copies of the *Siku quanshu* deposited in southern libraries as a penalty for his poor management. At the time of Lufei Chi's death, the Qianlong emperor, patron of the *Siku quanshu* project, confiscated all of his family's wealth except 1,000 taels, saying Lufei had begun life with that much but had accumulated 20 or 30 times that amount as a result of his mismanagement of the *Siku quanshu* project.

81 Thus, Lufei was a distant relative of Bao Tianxiao's Jinsuzhai boss, Kuai Huailu.

82 WH, 86. Pooling 1,500 yuan, the two men opened their bookstore on Wuchang's Huangjie.

83 Ibid.

84 Ibid.

85 Ibid. Ip, *The Life and Times*, 152, citing Lufei's self-compiled chronological biography *(nianpu)*, says that Lufei was a member of the Revive China Society.

86 Michael Wai-mai Lau, "Wu Wo-yao (1866-1910): A Writer of Fiction of the Late Ch'ing Period" (PhD dissertation, Harvard University, 1968), 35.

87 WH, 86.

88 According to SMA, 313.1.23, "Shanghai shuye shanghui yilianbiao," 1917, the shop was in Xishun Lane.

89 WH, 88.

90 My repeated efforts to view this publication, which first appeared in March 1906 and lasted only three issues, in the Shanghai Municipal Library and the Shanghai Municipal Archives were unsuccessful.

91 Strikingly, this practice would not be revived by the Nationalists until 1942. After the war, selected publishers were granted government contracts to print textbooks. See Chien, "The Commercial Press," 88-89.

92 Quoted in WH, 90.

93 Ibid., 89. According to WH, only three or four lessons were issued, but they "made people open their eyes *(yixin ermu)*."

94 Ibid., 90. This view of money as incentive is repeated in JSF, 324. In about 1910, Gao also offered Lufei his niece in marriage, adding another level to Lufei's debt. See Yao, *Zhongguo bianjishi*, 294.

95 Quoted in WH, 90.

96 Ibid., 91. Lufei proposed this reform in place of the then-prevailing five, four, five, three, and three/four system to reduce by six years the length of schooling and make educated persons more quickly available to society.

97 Quoted in WH, 91.

98 Ip, *The Life and Times*, 104-5. Although Zhang eventually supported the republic, Ip points out that Zhang's friend Liang Qichao did not and that Zhang Yuanji was also amicable with Zhao Zhujun, chief shareholder of *Shenbao*, and a strong constitutional monarchist. Lufei, meanwhile, was busy organizing his new company and trying to distance himself from the old constitutionalist-oriented publishers by attacking them in newspaper ads.

99 It is not clear exactly when Lufei and his group began their secret editorial team. According to ibid., 152, they began in October 1911, around the time of the Wuchang Uprising, and this view makes sense. Lufei had had several disappointments concerning unpublished textbooks, and it seems unlikely that he would have devoted himself to a new set without some guarantee that they would find a market. Ip, outraged that Lufei, "this very man whom the

Commercial Press so trusted," would stage the "unexpected coup," maintains convincingly that Lufei found it easier to recruit Commercial Press editors once the stock market collapsed in the wake of the uprising, eating up funds that Xia Ruifang had misappropriated from the firm's capital assets.

100 Yao, *Zhongguo bianjishi*, 295, says that they had to go to Japanese printers because Chinese were afraid to print the anti-Qing textbooks even in the comparative safety of the International Concession.

101 WH, as well as Yao Fushen, all claim secrecy had been kept so tight that the Commercial Press was at first caught completely unaware by the new textbook company but then offered Lufei a monthly salary of 400 yuan to abandon his fantasy of revolutionary entrepreneurship.

102 According to Wu, "Zhonghua," 1: 75, Zhonghua's assets, which started with 25,000 yuan, grew to 600,000 by 1914, 1 million by 1915, 1.6 million by 1916, 2 million by 1925, and 4 million by 1937. Under the hyperinflation of the post-war years, Zhonghua's assets were evaluated at 10 billion, and this amount doubled to 20 billion in 1950.

103 JSF, 324.

104 Wu, "Zhonghua," 1: 72.

105 Ibid., 1: 73. Dai Kedun took charge of the editorial department until January 1913, when Fan Yuanlian arrived. Shen Yi was head of the elementary textbooks section, with Yao as head of the middle school and teachers' college textbooks section.

106 Ibid., 1: 72-73. According to both Wu Tiesheng and JSF, Zhonghua's first editorial, administrative, business, and printing shop offices were located at 29A,B East Broadway in the Hongkou district.

107 Zhonggong Shanghai shiwei dangshi yanjiu shi and Shanghaishi zonggonghui, eds., *Zhonghua shuju zongchang zhigong yundong shi* (Beijing: Zhonggong dangshi chubanshe, 1991), 3.

108 However, according to a document written by Chen Xiegong and cited by Wu Tiesheng, Lufei did not actually start work until 17 February 1912.

109 WH's view that Shen Zhifang moved from the Commercial Press to Zhonghua from its start is supported by Zhu Lianbao's "Wo suozhidaode Shijie shuju," *Wenshi ziliao xuanji* 15 (1963): 1-43. Wu, "Zhonghua," 1: 73, maintains that Shen did not make the final move until 1913. JSF, 324, probably basing himself on Wu, concurs.

110 This personnel roster comes from JSF, 325. WH, 94, says that Wang Meiqiu was head of the editorial office.

111 WH, 94. The elliptical logic, cadence, and spirit of this sentence suggest that it was influenced by sections three and five of the *Daxue* (Great Learning).

112 JSF, 324, reports that Zhonghua issued forty-four different titles for use in elementary schools and twenty-seven for middle schools and teachers' colleges.

113 *Zhonghua shuju zongchang zhigong yundong shi*, 8.

114 Ibid., 9. In 1927, business manager Chen Xiegong assumed the print shop directorship.

115 Yao, *Zhongguo bianji shi*, 296.

116 Wu, "Zhonghua," 1: 72.

117 Ibid., 1: 71-72. See also Ip, *The Life and Times*, 154, and WH, 95. Zhonghua mobilized public opinion against the Commercial Press so successfully that the latter felt compelled to terminate its partnership with the Japanese. The Commercial Press's capital had increased from 200,000 to 1.5 million yuan during the partnership.

118 Ip, *The Life and Times*, 156, citing Lufei.

119 WH, 94.

120 Wu, "Zhonghua," 1: 73. The editorial department was established in 1912. When Fan left in 1916 to assume the position of minister of education, Dai Kedun stepped back into the shoes of chief editor for nine years, followed by Lufei (five years). In 1932, Shu Xincheng (1893-1960) took over. See JSF, 324.

121 WH, 95.

122 *Zhonghua shuju zongchang zhigong yundong shi*, 8.

123 WH, 94-95.

124 Wu, "Zhonghua," 1: 73.

125 William C. Kirby, "China Unincorporated: Company Law and Business Enterprise in Twentieth-Century China," *Journal of Asian Studies* 54, 1 (1995): 49, states that a new commercial code based on German law was issued in 1914. Of the four categories of companies,

the "true corporation" (gufen youxian gongsi) was the option selected by Zhonghua, just as it had been by the Commercial Press and would be by World Books.

126 Yao, *Zhongguo bianji shi*, 296.

127 JSF, 324.

128 Ibid., and Wu, "Zhonghua," 1: 73, state that Zhonghua's print shop was on Hardoon Road off Jing'an Temple Road. See also *Zhonghua shuju zongchang zhigong yundong shi*, 8.

129 *Zhonghua shuju zongchang zhigong yundong shi*, 8, 11.

130 Wu, "Zhonghua," 1: 73.

131 After becoming a director of Zhonghua, Liang Qichao published his *Da Zhonghua* (Great China) through the firm. At the same time, Zhonghua was bringing out numerous journals intended to meet head-on competition from the Commercial Press.

132 Wu, "Zhonghua," 1: 73, and JSF, 324. According to Wu, 1: 75, by the 1930s, Zhonghua had about fifty branches and over 1,000 sales kiosks.

133 Lu Runxiang, "Ding Fubao yu chuban gongzuo," in CBSL 3 (1984): 63.

134 Wu, "Zhonghua," 1: 73.

135 Carl Crow, *Handbook for China* (Shanghai, Hong Kong, Yokohama, Singapore: Kelly & Walsh, 1916), 87-88, slightly rearranged here for style.

136 Wu, "Zhonghua," 1: 74.

137 Song Yaoru, better known to non-Chinese as Charley Soong, was an American-educated Chinese Christian, Shanghai businessman, Bible publisher, and patriarch of one of the most influential families in modern Chinese history. See BDRC, 3: 141-42. All of his six children, including Song Meiling (Mme. Chiang Kai-shek), were educated in the United States. Hu Shi was one of Soong's English students.

138 Identified only as "Maosheng yanghang." See Zhu, "Shijie shuju," 2; Wu, "Zhonghua," 1: 74-75; and WH, 154.

139 Private use of company funds was not uncommon in Chinese business circles then, as suggested by Xia Ruifang's activities noted earlier.

140 WH, 154.

141 Shen Jifang was originally an English secretary at the Commercial Press where he became very intimate *(jieyi xiongdi)* with Shen Zhifang. He had been investing in Zhonghua since it first opened. See WH, 154. Shen Jifang was also related to the future overseeing director Wang Boqi. In March 1949, just months before the Communist takeover of Shanghai, Wang was listed as an overseeing director of Zhonghua Books, along with several high-level Nationalist officials, gangster-statesman Du Yuesheng, and two relatives of Lufei Kui. See SMA, "Zhonghua shuju youxian gongsi xianren dongshi (jiancharen) mingdan," (30 March 1949), 90: 499, 15.

142 WH, 99.

143 Wu, "Zhonghua," 1: 74.

144 Ibid.

145 Ibid.

146 Ibid.

147 Shi served as head of Zhonghua from April to June 1917.

148 Wu, "Zhonghua," 1: 74.

149 This view originates with Wu Tiesheng. According to WH, 99, the plan was to rent Zhonghua's facilities to the Commercial Press.

150 WH, 99.

151 Wu, "Zhonghua," 1: 74.

152 JSF, 325.

153 Yu Youren was the editor and founder of the Shanghai paper *Minlibao*, a military officer, and a Republican official (from 1930 to 1964, he headed the Nationalists' Control Yuan). Between 1914 and 1918, when he left Shanghai, he founded and ran a Shanghai bookstore, Minli Book Company, as a front for pursuing Nationalist Party opposition to Yuan Shikai. During this period, he became well known in the Shanghai book world. He was also a founder of Shanghai University. See BDRC, 4: 74-78.

154 On H.H. Kung, see BDRC, 2: 263-69. Kung eventually became Nationalist minister of finance. His involvement with Zhonghua lasted until at least the late 1940s, when his name on a list of shareholders including Lufei Mingzhong and Shu Xincheng, head of Zhonghua's

editorial department from 1932 and chief editor for the 1936 publication *Cihai*, indicates that Kung was still a director of the firm and owned the lion's share, in terms of value, of the firm's stock. His 6,300 shares were worth 99,984 yuan; Du Yuesheng's 11,800 shares were valued at 86,634 yuan, suggesting that different shares had different values. See SMA, *Zhonghua shuju gufen youxian gongsi dengji shixiangbiao* (1949), 90: 499, and SMA, "Zhonghua shuju youxian gongsi xianren dongshi (jiancharen) mingdan," (30 March 1949), 90: 499, 15.

155 WH, 99.

156 Ibid.

157 Wu, "Zhonghua," 1: 74.

158 Xiong Shanghou, "Lu Feikuei xiansheng," in Zhonghua shuju bianjibu, eds., *Huiyi Zhonghua shuju* (Beijing: Zhonghua shuju, 1987), 1: 2, says Lufei advocated the view that "when education is corrected, the country will flourish *(jiaoyu de dao, ze qi guo qiang sheng)*" in his early publications. This view is reflected in WH, 87.

159 Wu, "Zhonghua," 1:74.

160 Ibid., 1: 99. At the same time, Wang Hanqi, general manager of *Xinwen bao*, invited Lufei to join the paper as chief editor.

161 SMA, 313.1-79, "Shanghai shuye shanghui nian zhou ji niance mulu" (Jiading: n.p., 1924), 7-8.

162 WH, 100.

163 *Zhonghua shuju zongchang zhigong yundong shi*, 50.

164 Wu, "Zhonghua," 1: 77. Study and office supplies manufactured and sold by Zhonghua included classroom models; musical instruments; glass implements; Chinese typewriters (using Song script); clocks featuring the day, month, and time; equipment for physics and chemistry classrooms; briefcases; and even sports equipment.

165 According to Wu, "Zhonghua," 1: 78, Zhonghua was forced into diversification by the proliferation of smaller publishing companies that, issuing noncopyrighted texts on cheap paper with poor quality printing, lacked Zhonghua's high overhead. These smaller firms, rather than buying their machinery from abroad as did the Commercial Press and others, may have been buying the machines produced by the manufacturers profiled in Chapter 3. Zhonghua's profit margin on published materials was already quite low. In the mid-1910s, publishers had to sell at least 3,000 copies of journals to meet their expenses, says CYL, 1: 377, but everything above that ceiling was profit. In the 1930s, a print-run of 3,000-5,000 copies was considered good; fewer than 2,000 lost money. This diversified operation employed a great many of the 10,000 persons ibid., 1: 79, claims worked for Zhonghua between 1912 and 1949.

166 Wu, "Zhonghua," 1: 76.

167 Ibid., 1: 77. By 1932, Zhonghua already owned the most up-to-date colour printing presses in East Asia, including double-colour offset presses, prepress machines, and electric rotary presses, all imported from Germany.

168 Ibid., 1: 75.

169 Ibid., 1: 76.

170 *Zhonghua shuju zongchang zhigong yundong shi*, 9.

171 According to Drège, *La Commercial Press*, 95, in spite of Ministry of Education stipulations that publishers should use only Chinese-made paper after 1931, a modern Chinese paper mill, Wenqi zaozhi gongsi, under the supervision of Wang Yunwu did not go into production until 1939. In the 1930s, most Chinese paper imports came from Japan.

172 WH, 101, 103-4. Since 1932, when Japan bombed the city of Shanghai, Lufei had been publishing articles urging his fellow countrymen to brace for war. In August 1937, when the Japanese renewed their aggression against Shanghai, Zhonghua's Shanghai plant and editorial department were forced to halt work. Along with Shu Xincheng, head of the editorial department, and Wang Jinshi, printing plant director, Lufei arranged to have part of the printing machinery shipped to the Kowloon plant, which was then expanded. Likewise, manufacture of military products was increased once Bao'an Industries was relocated to Kowloon. Most of the rest of the physical plant was moved to Kunming. Wu Jingyuan was left in charge of Shanghai operations, and most workers were let go. Lufei also contributed 50,000 yuan for national defence through the government-run Booksellers' Same-Industry Association. In November 1937, Lufei left Shanghai for Hong Kong, from where he ran Zhonghua's operations throughout south China. For the next two years, Lufei sought a merger with the Commercial

Press, Kaiming, and other publishing firms but was eventually dissuaded by Shu Xincheng. At the same time, he started planning Zhonghua's postwar publishing activities, concentrating on historical, educational, and language materials. He died of heart failure on 9 July 1940 after flying back from a national educational conference in Chongqing.

173 Chen Cunren, *Yinyuan shidai shenghuo shi* (Shanghai: Renmin chubanshe, 2000), 255. Chen was a famous herbal doctor who published with World Books.

174 Zhu, "Shijie shuju," 1.

175 Ibid.

176 Zhu, "Shijie shuju," 1. As late as 1917, Huiwentang was listed as a partnership, rather than a corporation. Its retail operation was located in Qipanjie, but between 1914 and 1917, it opened a lithographic printing plant in Penglu's Jiuyuan Lane. See SMA, 313.1.23, "Shanghai shuye tongye yilianbiao," (1914-29), 9B.

177 Zhu, "Shijie shuju," 2.

178 WH, 151.

179 Ibid.

180 Zhu, "Shijie shuju," 2. According to CYL, 1: 376, Shanghai's antiquarian book trade was dominated by Shaoxing natives until the late 1910s, undoubtedly giving Shen Zhifang an advantage in his early operations with the Fulunshe.

181 Traditionally scorned for having served two dynasties, the Ming and the Qing, Qian was eventually condemned by the Qianlong emperor in 1768-69 for his criticisms of the Manchus. Works carrying these judgments were destroyed on the emperor's orders but continued to attract underground interest, and this interest provided Shen with his market in the early 1900s. For more on Qian Qianyi, see Frederic Wakeman, Jr., *The Great Enterprise: The Manchu Reconstruction of Imperial Order in Seventeenth-Century China* (Berkeley: University of California Press, 1985), 2: 1096-98, and ECCP, 148-50.

182 Called "my pupil" by Qian Qianyi, Jin Shengtan was a native of Suzhou particularly well regarded for his critical writings on the novel *Shuihu zhuan (Outlaws of the Marsh)* and on the play *Xixiang ji (Romance of the Western Chamber)* among other early Chinese literary works. Jin was implicated in the "Laments in the Temple" *(kumiao)* protest against the Qing in 1661 and was executed the same year. See ECCP, 1: 164-66 and Patricia Sieber, *Theaters of Desire: Authors, Readers, and the Reproduction of Early Chinese Song-Drama, 1300-2000* (New York: Palgrave, 2003).

183 Fang was a prominent literatus and native of Tongcheng, Anhui, who, despite having been punished for alleged involvement with an anti-Manchu cabal in 1711, spent a number of years in charge of the Wuyingdian. A master of the *guwen* style, he was later regarded as the titular founder of the Tongcheng School known for its prose style and adherence to the teachings of Zhu Xi. See ECCP, 1: 235-37.

184 Gong, a native of Hangzhou, was a palace-level official known as a poet and reformer who, like Fang Bao, worked in the Wuyingdian. An opponent of foreign trade conducted at Canton, he was a friend of Lin Zexu; through his written attacks on current affairs and Qing administration, he acquired a far-reaching reputation and influenced late-nineteenth-century reformers Kang Youwei and Liang Qichao. His son Gong Cheng was an expert in the Manchu and Mongol languages and lived in Shanghai from 1850 to 1870, where he was known to Wang Tao. In 1860, Gong Cheng worked as a secretary to Thomas Wade, British minister to Beijing and future professor of Chinese at Cambridge University. See ECCP, 1: 431-34.

185 Chien, "The Commercial Press," 24. The Fulunshe existed from 1910 to 1913.

186 In 1917, the Gushu liutongchu partnership was still held by Chen Liyan. See SMA, 313.1.23, "Shanghai shuye tongye yilianbiao,"(1914-29), 9B.

187 Shen would gain similar praise in 1926-27 when he published, far in advance of either the Commercial Press or Zhonghua, works by the pre-Nanjing Nationalist Party. In the late 1920s and 1930s, World Books would be lauded again when it published works by Communists. Perhaps precisely because of Shen's boldness in each of these periods, one suspects his motives.

188 Zhu, "Shijie shuju," 2.

189 Ibid. See also WH, 152.

190 Yao, *Zhongguo bianji shi*, 295, quoting from Zheng Yimei's *Shubao hua jiu* (Shanghai: Xuelin chubanshe, 1983), attributes this statement to Lufei Kui, who gave it to Xia Ruifang, Gao Mengdan, and Zhang Yuanji.

191 Zhu, "Shijie shuju," 2, corroborates Wu Tiesheng's evidence cited above.
192 CYL, 1: 376.
193 Ibid. The three years mentioned by Bao seem to have been from 1912 or 1913 to 1916.
194 Ibid.
195 Bao's criticism was that excessive numbers of *daguan* had been issued and that readers would sour on them.
196 During the Han dynasty, General Han Xin was granted the title Huaiyin.
197 CYL, 1: 376.
198 Bao compromised to his own benefit, for Shen's "eye" was sharp and certain; the journal lasted three years, a respectable duration for magazines at that time (in the late 1890s, many folded after one or two issues). The success of the journal enabled Bao to abandon teaching, a profession he had been pursuing at Shi Liangcai's Nüzi canye xuexiao (Boys and Girls Sericulture Academy) and Yang Baishi's Chengdong nüxue (Girls School), to establish his reputation as a writer and editor.
199 Bao says that "pretty girls" had already become such a common marketing gimmick for Shanghai magazines that the nickname for periodicals was "gallery of girls" *(fengmian nülang).* See CYL, 1: 377.
200 Ibid.
201 Ibid.
202 Cited in Zhu, "Shijie shuju," 2, and repeated more or less word for word by WH, 155, with one difference: Zhu provides no date. WH claim that the events began in 1918, a date that seems to be questionable since, in WH's own view, Shen left Shanghai in 1917. Chen, *Yinyuan shidai shenghuo shi*, 255, another contemporary informant who published with Shen, states that Shen was forced to leave Shanghai to avoid a gambling debt of 24,000 yuan incurred at a Hankou Road establishment against money Shen had casually borrowed from Zhonghua.
203 As Sherman Cochran, "Three Roads into Shanghai's Market: Japanese, Western, and Chinese Companies in the Match Trade, 1895-1937," in Wakeman and Yeh, eds., *Shanghai Sojourners*, 35-75, has shown, the late 1910s were the critical formative years in China's match business and Shen/Huang's interest in the match business may reflect this history.
204 WH, 155.
205 Ibid. Baoshan Road, of course, was the address of the Commercial Press's manufacturing plant and editorial offices. Shen's rooms were located in Yipin Lane.
206 Zhu, "Shijie shuju," 2, says that Shen began his new operations with a newspaper.
207 According to CYL, 1: 382, who did some editing work for Dadong, Dadong was a second example of a Shanghai publishing firm run by Shaoxing natives, Shen's World Books being the first. WH, whose account of Shen's resurrection is presented above, do not seem to have read Bao's account, for Bao clearly states that Shen's nephew, Shen Junsheng, was a prominent individual at Dadong.
208 Li Shizeng, the senior Nationalist Party official who bought a controlling share in World Books in the 1930s, wrote in a small 1946 history of the firm that Shen was influenced by the 1905 journal named *Shijie zazhi* in his choice of the name World Books. That journal was started by Li, Wu Zhihui, and Zhang Renjie. See Zhu, "Shijie shuju," 3. As for the publisher's use of the globe as his trademark, see Chen Qiaosun, "Xiaotan 'chuban biaoji,'" CBSL 1 (1982): 141.
209 Ibid. Zhu, "Shijie shuju," 32, says between 1921 and 1925, World brought out 1,150 titles for an annual average of 230; 1926-33, the firm's golden years, 2,043 for an annual average of 255; 1934-45, 2,095, or 174 per year; and 1946-49, 292, or 73 per year. Throughout its 29-year history, World published a total of 5,580 titles.
210 The other firm was Xia Jijiang shuju. See WH, 156. On early investors, see Zhu, "Shijie shuju," 22, 27-28. Many of the new stockholders were Shen's acquaintances from book and paper businesses. They included Wei Bingrong (owner of Guangyi shuju who would remain with Shen until the late 1930s), four others from the book business, and five paper merchants.
211 Zhu, "Shijie shuju," 3-4, 27-28. Under the Nationalists, the monetary unit before 1933 was the silver tael *(yinliang);* after 1933, it became the silver dollar (yuan). See Chien, "The Commercial Press," 22. Recall that, in 1902, the Commercial Press was incorporated with 50,000

Qing-dynasty yuan (and would be worth five million in 1922); Zhonghua was started in 1912 with 25,000 yuan. Directors of this early board were Shen Zhifang, Wei Bingrong, Lin Xiuliang, Mao Chunqing, and Zhang Liyun, with two supervisors. After the mid-1920s, the board was comprised of nine or eleven persons, including a manager of a traditional bank *(qianzhuang)* and Yan Duhe (World Books textbook editor). Zhu, 31, reports that, between 1921 and 1937, World's capital investment grew from 25,000 yuan to 730,000 yuan.

212 Ibid., 22.

213 The importance of architecture and building design to the ways in which Shanghai's Western-ized firms marketed themselves as early as the 1880s is discussed in Chapter 2. It does not seem too farfetched to suppose that Shen, a master of marketing, was trading on Dianshizhai's old architectural reputation, which included a red-walled Western-style building, discussed in Chapter 2.

214 Zhu, "Shijie shuju," 3-4, 27-28.

215 The first three departments mentioned above were headed by He Runsheng, Lin Junhe, and Li Chunrong. Xiang Hesheng was in charge of the accounting office, and Wang Defeng was responsible for the wholesale department. Zhu Lianbao, whose memoirs are frequently cited in this chapter, joined World Books in 1921 to direct the mail order department. This depart-ment performed three services for customers; two of them were the same as those provided by the foreign publishers on which Shanghai's Chinese publishers almost certainly modelled their own mail-order operations. First, it sold merchandise to customers outside Shanghai. Second, its branch stores throughout China bought local publications for sale by mail to Shanghai customers unable to find them in the city. Third, it printed ads, wrapping paper, business forms, etc., presumably for customers outside Shanghai. See ibid., 4.

216 Ibid., 4, 12-13. See also WH, 168. The first printing plant, on Hongjiang Road in the Zhabei district, was directed by Zhang Yunshi and Wang Chunbao, and it burned in the winter of 1925 when fire spread from a neighbouring tobacco warehouse. Nearly all the printing ma-chinery was lost at this time. World's second printing plant, contemporary with the first and home to the editorial office until 1926, was located on Xiangshan Road, also in Zhabei. The second plant was run by Shen's brother, Lianfang. After compensation by the insurance com-pany, Shen rebuilt on a greater scale on a ten-*mu* (1.6-acres) property he had bought in 1924 in Dalianwan Road. In the spring of 1926, the general office, editorial department, and print-ing plant were consolidated in the new factory. It was expanded steadily and by 1932 was five storeys high, equipped with seventeen full-page Miehle presses (about one-third of all those then in China). During the Japanese occupation, the main plant was occupied by the Japa-nese Report Office (Baodaobu). After 1949, the Communists nationalized the printing plant, calling it Shanghai Xinhua Printing Plant (Shanghai xinhua yinshuachang).

217 Zhu, "Shijie shuju," 4. While he was stabilizing World, Shen Zhifang also ran the Gonghe (Republic) Book Depot with Ping Jinya to copy successful publications by other publishers. For instance, if another publisher was successful with a certain knights-errant *(wuxia)* novel, Gonghe would produce one mimicking it. Gonghe eventually failed, however, and was merged into World. See WH, 156.

218 World is notorious for its publication of love stories, adventure books, all sorts of sinister conspiratorial tales *(heimu xiaoshuo),* and seedy tales of romance and riches. The translation "petty urbanites" is borrowed from Wen-hsin Yeh's "Progressive Journalism and Shanghai's Petty Urbanites," 186-238.

219 Zhu, "Shijie shuju," 5.

220 JSF, 328.

221 The five were: *Kuaihua,* a biweekly edited by Li Hanqiu and Zhang Yunshi; the weekly *Hong zazhi,* edited by Yan Duhe and Shi Jiqun; Yan Duhe and Zhao Tiaokuang's weekly *Hong Meigui;* Jiang Hongjiao's monthly *Jiating zazhi;* and Shi Jiqun and Cheng Xiaoqing's *Zhentan shijie,* a biweekly. See WH, 158. These periodicals' content was chiefly of recreational "mandarin duck and butterfly" variety.

222 Zhu, "Shijie shuju," 6-7. Prior to the appearance of the World Books version of *lianhuanhua shu,* these works were known as "small books" *(xiao shu)* or "small people's books" *(xiaoren shu);* they represented one of the first truly innovative aspects of Shanghai publishing in the period after the lithographic illustrated magazines. Finely illustrated, more than six well-known traditional novels were brought out in this form, each in twenty or twenty-four chapters, all of

which could be bought separately. Their innovative importance has been noted by Rong Zhengchang, "Lianhuan tuhua sishinian, 1908-1949," in ZCSB, 287-89, and by A Ying, "Cong Qingmo dao jiefang lianhuanhua," in ZXCS, 4: 2: 400-6. Zhu says that the illustrations were drawn by Chen Danxü and four others who had gotten their start as textbook illustrators. After six *lianhuanhua* books, World abandoned the project, but it was eventually picked up by other publishers. In the early 1990s, one could still buy *lianhuanhua* books published in Shanghai a decade before.

223 Zhu, "Shijie shuju," 3. This rate of growth was only a quarter of Zhonghua's in its first two years. Not all were useful additions to the firm. In its early phase, when money was short, Shen Zhifang was forced at least once to go to an old-style bank *(qianzhuang)* for a loan. Concern from the bankers that they might lose their money led them to propose that one of their own employees be employed by World in the business office so that, if anything started to go wrong, the bank would get its money out early. Shen was forced to agree but regretted the decision for a long time. See WH, 165.

224 Ibid., 159.

225 His eye for business led to bad blood with Kaiming shudian, Zhonghua, and Huiwentang after 1930. In fact, Shen seems not to have thought very highly of many of his colleagues in the book business. His closest friends, besides Wei Bingrong and Zhou Juting of Guangyi, were Lü Ziquan and Wang Youtang of Dadong, Chen Liyan of the Gushu liutongchu, Ping Jinya of Zhongyang shudian, and Tu Sicong of the World Map Study Society (Shijie yudi xueshe). See Zhu, "Shijie shuju," 21.

226 Shen brought in twelve editors from the Commercial Press, nine from Zhonghua, and one from Dadong. Zhu Lianbao himself was hired from Zhonghua. See Zhu, "Shijie shuju," 5, and WH, 164.

227 Zhu, "Shijie shuju," 21, discusses the cost of Shen's haughtiness, tying the "outsider" position of World Books in Shanghai publishing circles to it. Zhu says that, once Shen was replaced by Lu Gaoyi, World's status rose. See also WH, 165.

228 Zhu, "Shijie shuju," 9.

229 JSF, 329. Hu Renyuan lost the chancellorship of Beijing University to Cai Yuanpei in 1916 when Hu's patron, Yuan Shikai, died. Following the May Fourth Incident, however, Hu, who had made money in the Malayan rubber business and had been dean of the university's engineering school, had been temporarily reappointed chancellor in Cai's place.

230 The text was titled *Xinxuezhi chu gao xiao ben* (New Method Introductory Middle and Elementary Text).

231 JSF, 159. The first series was *Gongren keben* (Textbooks for Workers); the second was titled *Nongmin keben* (Textbooks for Peasants).

232 Zhu, "Shijie shuju," 9-10.

233 Ibid., 18. The series was called *Minzhong keben* (Textbook for the People). According to James E. Sheridan, *Chinese Warlord: The Career of Feng Yü-hsiang* (Stanford: Stanford University Press, 1966), 74 ff., Feng Yuxiang, "the Christian General," was "best remembered by his former subordinates for his competence in training troops," and that training included military, vocational, and moral instruction.

234 Zhu, "Shijie shuju," 10.

235 WH, 161.

236 According to (ROC) Ministry of Education, "Jiaokeshu faxing gaikuang, 1919-1925," in ZXCS, 1: 268, the front was called Gongmin, but Zhu Lianbao, citing several unnamed old Commercial Press and Zhonghua workers, believes that its true name was Guomin. Strikingly, Gongmin shuju was also the name of Wang Yunwu's original bookstore. In 1921, when Wang, the future general manager of the Commercial Press, joined the Press, Gongmin was worth 40,000 yuan. Gongmin's assets were merged with those of the Commercial Press. See Zhu, "Jiefangqian Shanghai shudian" (2), in CBSL 2 (1983): 148, and Zhang, "Mantan Shangwu," 84.

237 Zhu, "Shijie shuju," 9-10, tallying with ZXCS, 1: 268, states that the Commercial Press invested three-quarters of the total (400,000 yuan) and that Zhonghua put in one-quarter.

238 For a brief history of Guomin shuju, see Zhu Lianbao, "Jiefangqian Shanghai shudian" (8), in CBSL 8 (1987:2): 110.

239 WH, 162.

240 Ibid., 161.
241 Ibid., 162.
242 Ibid., 163. Wei's printing firm was known as Wenhua yinshuju.
243 Zhu, "Shijie shuju," 10-11, citing Yue Sibing's article "Shinianlai de guoyu yundong," *Shijie zazhi zengkan shinian* (n.p.: n.p., 1931). Yue also comments "although the book publishers actively used the National Language Movement to make money, their contributions should not be overlooked. When the Movement began, Zhonghua's manager Lufei Kui knew that the [goal] would have to be realized. [For this reason], he participated in the national Standard Pronunciation Conference, established a special National Language school, produced gramophone records for National [Language] pronunciation [instruction, and] published a large number of National Language books ... Superficially, the Commercial Press appeared to be left somewhat behind, but it caught up, with results at least as good as Zhonghua's."
244 Shen was by no means the first in Shanghai to discover that the Republican Revolution was good for the publishing business. According to Zhang, *Zai chuban jie*, 127-28, the period 1925-27 was "the Golden Age of Shanghai's New-Book Industry." The local warlords Sun Chuanfang and Li Baozhang had little interest in interfering with the publishers of the International Concession, he says. The first to respond was Zhang Bingwen, a publisher-merchant in charge of the Pacific Printing Company. He edited and printed an anthology of Sun Yat-sen's writings. After printing it, he took it personally to Canton, where he earned 80,000-100,000 yuan for it. His success was soon imitated by Dazhong huju and Changjiang shudian. In fact, says Zhang, "anyone who could get their hands on printing machinery, no matter who they were, could immediately get rich." The wealth soon spread to printers. "As long as you had some way to print, there was no need to worry that there would not be a market."
245 Zhu, "Shijie shuju," 16-17. They covered topics such as national political issues, the Three People's Principles, the agrarian question, and the unequal treaties. See also WH, 166.
246 Although distributed chiefly in the south, one work did travel north to Shandong. Mistakenly bound using the cover for *Middle School Chinese Literature*, 500 copies of World's printing of *Elementary Introduction to the Peasant Movement* were sent to a school in Jinan. When the school discovered that the contents of the books received were "red" *(chihua)*, they returned the books to Jinan and asked for an exchange. An examiner in the Jinan post office seized the package. Almost immediately the military police were sent to surround World's Jinan branch, where they arrested the manager, Guo Mengzhi, and other employees. The accountant escaped and contacted World's main office in Shanghai. Director Sun Gaomei and several World managers telegraphed the Shandong warlord, Zhang Zongchang ("The Dogmeat General," [Chinese, *gourou jiangjun*], 1881-1932), and his publicity chief, seeking the employees' release. Eventually, all but Guo were freed. Guo was not liberated until the Northern Expedition army arrived in Jinan. See Zhu, "Shijie shuju," 17.
247 Ibid. Zhu notes that Pan Lianbi, a Shanghai police chief, was on Shen Zhifang's payroll.
248 Ibid., 5-6. Mao Dun, under the name Xuan Zhu, published ten works on literature with World. Yang, using the pseudonym Li Haowu, published three works, including one of the first in Chinese to employ Marxist dialectical materialism in educational research, a work that appeared in 1929. By 1931, it had gone through four editions. See WH, 167.
249 Zhu, "Shijie shuju," 9. World paid Yu 300 yuan per month, a sum that was picked up by Yu's secretary.
250 World led Guangzhi to reprint several important old titles, including Wu Woyao's *Vignettes from the Late Qing, Henhai* (Sea of Regret), *Jiuming jiyuan* (The Strange Injustice of Nine Murders), and *Dianmu qidan* (Strange Accounts of the Electrical Craft). See WH, 168.
251 Zhu, "Shijie shuju," 7.
252 World Books was to represent Chen's interests in Shanghai (although Chen did open a retail outlet of his own on Nanjing Road), and Chen was to assist with sales of World's books in Singapore. Yu Runsheng was sent out from Shanghai to manage a bookstore in Singapore. Profits were to be reckoned at year's end. Before long, Chen was investing the profits of his Shanghai activities in World; World reciprocated by printing 10,000 copies of Chen's book of medical prescriptions, called *Yanfang xinbian*. Chen distributed the work overseas. See Zhu, "Shijie shuju," 7, and WH, 169. World's ties to Chen Jiageng himself also led to close ties

with Xiamen University, which Chen founded and ran singlehandedly from 1921 to 1937. The Commercial Press, too, maintained close ties with Xiamen University.

253 Other investors listed by Zhu, "Shijie shuju," 22-24, 27-28 and WH, 170, are the big businessmen or professionally prominent Guan Jiongzhi, Sun Gengmei (a judge in Shanghai's Mixed Court, invited to invest in World by his nephew Liu Fuxun who worked in one of World's printing plants and eventually became Shen Zhifang's assistant), Sun's colleagues in the legal profession Huang Hanzhi (also a well-respected philanthropist) and Lu Zhongliang; Wang Yiting (a well-known calligrapher invited by Huang Hanzhi); Zhu Yingjiang (a lumber merchant); and Gu Xiangyi (a grain merchant). Investors from the world of banking included Wu Yunrui (manager of Jincheng Bank); Qian Yongming; and eight others. Many eventually joined the board of directors, but Zhu Lianbao ingenuously insists that World remained a private corporation free of the government, although not free of "bureaucratic capitalists," until 1945. Other directors from the 1921-34 period, not yet mentioned here, were Shen Lianfang (head of the World printing plant and Shen Zhifang's brother), Wu Nanpu (newspaper owner), Zhang Yunshi (World editor), Xu Weinan (World editor), Zhu Shaoqing (World editor), Li Chunrong (World manager), Lin Junhe (World manager), three merchants, and a fishmonger.

254 The bank went bankrupt in either 1934 (WH, 171) or 1935 (Zhu, "Shijie shuju," 24).

255 Zhu, "Shijie shuju," 24.

256 Ibid., 25.

257 Lu Gaoyi was brought to World Books in 1933 by his Zhijiang University (Hangzhou) classmate, Lin Handa, who proposed Lu for the recently vacated position of Shen's secretary. Lu was then head of the middle school affiliated with Zhijiang University. Lin himself had first come to Shen Zhifang's attention in about 1923 when he submitted a winning essay to a World-sponsored English-language writing contest. After graduating in 1924, Lin began teaching at Siming Middle School in Ningbo. In 1928, he joined Xiamen University professor Xiao Bingshi in working on an English textbook series that they then proposed to World. Shen, remembering Lin's prize essay, offered Lin a position as head of the English-language editorial office, a position that had just been vacated by editor Yan Duhe, who left for a job with a newspaper. During his tenure, Lin was chief editor of at least five English-language textbooks. After 1937, Lin went to America to study but returned when the war ended to teach at Huadong University, eventually becoming a dean at Zhijiang University. By the late 1940s, Lin Handa was a member of World's board as well as an outside editor. See Zhu, "Shijie shuju," 7-8.

258 Ibid., 25. Jincheng Bank had invested 60,000-70,000 yuan in World.

259 Ibid. Although Li signed on for 500,000 yuan, he paid only 50,000 at first. His directorship was voted down by the stockholders, and, in a last bid to retain independent control, Shen Zhifang redistributed shares. After organizing an investment group including Hu Yuzhi, Du Yuesheng, and three others, each of whom was supposed to contribute 50,000 yuan to Li in an effort to take control of World, Li tried to evaluate the true financial situation at World. Neither he nor his investment group, with the exception of Du Yuesheng, ever did contribute to World. Du paid 50,000 yuan from his Zhongguo Tongshang Bank in an effort to add to his reputation as a patron of culture. Between 1935 and 1946, Li Shizeng's group did dominate World's board. It included new investors Li himself, Chen Hexian (erstwhile Jiangsu provincial education chief), Du Yuesheng, and seven others; the only independents were Shen, Lu Gaoyi (who brought Li into the firm), Lu Zhongliang (former judge and then a lawyer), and Wei Bingrong (the Guangyi shuju merchant who had been with World since 1921 and who had aided it materially during the final textbook war). See Zhu, "Shijie shuju," 28.

260 Ibid., 9, 26, and WH, 171.

261 His library was named the Cuifenge (Pure Fragrance Pavilion). See WH, 172.

262 Ibid. This date of his death comes from WH with one modification. All sources agree that Shen died in 1939 except WH. WH say that Shen died at age fifty-eight; he could only have been fifty-eight if he died in 1939.

263 Zhu, "Shijie shuju," 32. Zhu says that World had at one time had over 1,000 professors and teachers on its payroll helping with curriculum and textbook content.

264 JSF, 328.

Conclusion

1 Although it is clear that the combination of editing, printing, and marketing in a single firm distinguishes Chinese print capitalism from Anglo-American versions, comparison with modern continental European, Japanese, and Korean publishing operations must await future studies.

2 Technically, the treaty-port system was finished by 1945; the Japanese invasion terminated European privileges in 1941 and the Americans ended their claims in 1943. Britain's renunciation followed. Still, after 1945, when the Western powers returned, it was hard to break old habits.

3 From its second-storey balcony, People's Liberation Army general Chen Yi (1901-72) declared the establishment of the People's government in 1949.

4 Jean-Pierre Drège, *La Commercial Press de Shanghai, 1897-1949* (Paris: Memoires de l'Institut des Hautes Études Chinoises, 1978), 111, 124-25. In 1946, by contrast, a year after the Second Sino-Japanese War ended and after the Shanghai publishers had straggled back from their inland exiles, only 16 percent of China's published books would originate in Shanghai.

5 Marc Bloch, "Technology and Social Evolution: Reflections of a Historian," in Sabyasachi Bhattacharya and Pietro Redondi, eds., *Techniques to Technology: A French Historiography of Technology* (New Delhi: Orient Longman, 1990), 87.

6 Ibid.

7 JSF, 330.

8 SUN, 2: 1181, 1202. SUN estimates that *Shenbao* employed 100 workers in 1894.

9 Liu Dajun, "1933-nian Shanghai minzu jiqi gongye yu Shanghai de qita zhuyao gongye de bijiao," from "Zhongguo gongye diaocha baogao," in SMJG, 2: 602.

10 Ibid.

11 Shanghai Municipal Council, *Annual Report 1935* (Shanghai: North China Daily News Publishing, 1935), 56. This figure refers to the area of Shanghai, known as the International Concession, administered by the British and Americans and does not include the surrounding area administered by Chinese authorities or the French Concession.

12 Sun Yat-sen, cited in "Sun Zhongshan xiansheng tan chuban gongzuo," in CBSL 20 (1990: 2): 125.

13 See Sun Yat-sen, "Yu haiwai Guomindang tongzhi shu," in Hu Hanmin, ed., *Zongli quanji* (Shanghai: Minzhi shuju, 1930), 3: 346.

14 Zhang Xianwen and Mu Weiming, eds., *Jiangsu Minguo shiqi chubanshi* (Nanjing: Jiangsu Renmin chubanshe, 1993), 142-43.

15 Chow Tse-tsung, *The May Fourth Movement* (Stanford: Stanford University Press, 1967), 178.

16 Luo Jialun, "Jinri Zhongguo zhi zazhi jie," in ZXCS, 1: 79-86.

17 Ting Sheng, "Chubanjie de hunluan yu changqing" [1925], in ZXCS, 1: 241.

18 Ibid.

19 Ibid., 1: 245-6. For a historical example of a publishing operation that combined a shared political mission with incorporation, see Ling Arey Shiao, "Bridging Influence and Income: May Fourth Intellectuals' Approaches to Cultural Economy in the Post-May Fourth Era" (unpublished Association of Asian Studies conference paper, 2003), which discusses Kaiming shudian, founded in 1926. Also, see below.

20 Lucien Febvre and Henri-Jean Martin, *The Coming of the Book: The Impact of Printing 1450-1800*, trans. David Gerard (London: New Left Books, 1976), 12.

21 Paul Chauvet, *Les Ouvriers du livre en France: Des origines à la Révolution de 1789* (Paris: Librairie Marcel Rivière, 1956); P.H. Noyes, *Organization and Revolution: Working Class Associations in the German Revolutions of 1848-1849* (Princeton: Princeton University Press, 1966), 195. On printers active in the German revolutions of 1848, particularly Karl Marx's associate Stephan Born, see 27, 128-60, 192-202. Charles A. Ruud, *Russian Entrepreneur: Publisher Ivan Sytin of Moscow, 1851-1934* (Montreal and Kingston: McGill-Queen's University Press, 1990), discusses in considerable detail the impact of Moscow's printers, nicknamed the Sytintsi after their employer, in the citywide printers' strike of 1903 and the revolution of 1905; see Chapters 4 and 5. On the role of printing in state-building in this period, see Wolfram Siemann, *The German Revolution of 1848-49*, trans. Christiane Banerji (New York: St. Martin's Press, 1998), Chapter 7. On management's view of the modern German publishing business, see

Gary D. Stark, *Entrepreneurs of Ideology: Neoconservative Publishers in Germany, 1890-1933* (Chapel Hill: University of North Carolina Press, 1981). Finally, in the United States, printers' importance in society has been acknowledged through economic and sociological studies rather than historical ones. See Elizabeth Faulkner Baker, *Displacement of Men by Machines: Effects of Technological Change in Commercial Printing* (New York: Columbia University Press, 1933); Jacob Loft, *The Printing Trades* (New York: Farrar and Rinehart, 1944); Seymour Martin Lipset et al., *Union Democracy: The Internal Politics of the International Typographical Union* (New York: Free Press, 1956); and Maggie Holtzberg-Call, *The Lost World of the Craft Printer* (Urbana: University of Illinois Press, 1992).

22 Linda Shaffer, *Mao and the Workers: The Hunan Labor Movement, 1920-1923* (Armonk, NY: M.E. Sharpe, 1982), 144.

23 Ibid., 149.

24 Parks Coble, *The Shanghai Capitalists and the Nationalist Government, 1927-1937* (Cambridge, MA: Harvard Council on East Asian Studies, 1986), 59.

25 Not surprisingly, they are also absent from an eighteenth-century novel that discusses print culture, Wu Jingzi's *Rulin waishi (The Scholars)*.

26 Mao Dun, "Wartime," in Mao Tun, *Spring Silkworms and Other Stories*, trans. Sydney Shapiro (Beijing: Foreign Languages Press, 1956), 167. See also Mao Dun, "You di er zhang," in *Mao Dun quanji* (Beijing: Renmin wenxue chubanshe, 1984), 8: 288-311.

27 In *Rulin waishi*, Wu Jingzi's character Ma Junshang, the model-essay editor from Hangzhou's Literary Expanse Bookshop, is presented as bland and conniving if also warm-hearted.

28 Mao Dun, *Wo zouguo de daolu* (Hong Kong: Sanlian shudian, 1984), 2: 264.

29 Mao Dun, "Shaonian yinshua gong," in *Mao Dun quanji* (Beijing: Renmin wenxue chubanshe, 1984), 4: 177.

30 Ibid., 4: 220.

31 Mao Dun draws a contrast between the kind of apprenticeships necessitated by Shanghai's capitalist society and the kind of work-study options available in a socialist society such as the Soviet Union.

32 In addition to Mao Dun's early work, subsequent examples of pro-Communist fiction in which printers play prominent roles include Yang Mo, *The Song of Youth* (1958), trans. Nan Ying (Beijing: Foreign Languages Press, 1978), and Gao Yunlan, *Annals of a Provincial Town* (1959), trans. Sidney Shapiro (Beijing: Foreign Languages Press, 1980). Memoir literature, interestingly, comments not on print workers but on bookshop workers and editors. See Jung Chang, *Wild Swans: Three Daughters of China* (New York: Anchor Books, 1992), esp. 118-20; Liang Heng and Judith Shapiro, *Son of the Revolution* (New York: Vintage Books, 1983); and Luo Zi-ping, *A Generation Lost: China under the Cultural Revolution* (New York: Avon, 1991).

Selected Asian-Language Bibliography

Abbreviations

CBSL *Chuban shiliao* (Shanghai) 1-31 (1982-93).

CYL Bao, Tianxiao. *Chuanyinglou huiyilu*. 2 vols. Hong Kong: Dahua chuban she, 1971
 [1959].

DSZ *Dianshizhai huabao*. Canton: Renmin chubanshe, 1983 [1884-98].

GGZ Ge, Gongzhen. *Zhongguo baoxue shi*. Taipei: Taiwan hsüeh-sheng shu-chü, 1982
 [Shanghai: Commercial Press, 1927].

HSN He, Shengnai. "Sanshiwu nian lai Zhongguo zhi yinshu shu." In Zhang Jinglu,
 ed., *Zhongguo jindai chuban shiliao, chubian*, vol. 1. Beijing: Zhonghua shuju, 1957.
 [Originally published in *Zuijin 35-nian zhi Zhongguo jiaoyu*. Shanghai: Commercial
 Press, 1931].

JSF Ji, Shaofu, et al., eds. *Zhongguo chuban jianshi*. Shanghai: Xuelin chubanshe, 1991.

MGRB *Minguo ribao* (Shanghai) 1917-19, 1926-27.

SMA Shanghai Municipal Archives. Shanghaishi shuye tongye gonghui (1864-1949),
 S313.1-4.

SMJG Jingji suo, Zhongguo shehui kexue yuan, ed. *Shanghai minzu jiqi gongye*. 2 vols.
 [Beijing]: Zhonghua shuju, [1979].

SUN Sun, Yutang, ed. *Zhongguo jindai gongye shi ziliao, di yi ji, 1840-1895*. Series 2. Part
 2, 2 vols. Beijing: Kexue chubanshe, 1957.

SXSJ Shanghaishi Xinsijun lishi yanjiuhui yinshu yinchao zu, ed. *Zhongguo yinshua shi
 ziliao huibian*. 3 vols. [Luoyang?]: n.p., [1990?].

WH Wang, Zhen, and He Yueming. *Zhongguo shi da chubanjia*. Taiyuan: Shuhai
 chubanshe, 1991.

YW *Yiwen yinshua yuekan/The Graphic Printer, 1937-1940* (Shanghai). Reprint ed. Shang-
 hai: Shanghaishi xinsijun lishi yanjiuhui yinshua yinchao zu, 1985.

ZCSB Zhang, Jinglu, ed. *Zhongguo chuban shiliao, bubian*. Beijing: Zhonghua shuju, 1957.

ZJCSC Zhang, Jinglu, ed. *Zhongguo jindai chuban shiliao, chubian*. Beijing: Zhonghua shuju,
 1957.

ZJCSE Zhang, Jinglu, ed. *Zhongguo jindai chuban shiliao, er bian*. Shanghai: Qunlian
 chubanshe, 1954.

ZXCS 1-4 Zhang, Jinglu, ed. *Zhongguo xiandai chuban shiliao*. 4 vols. Beijing: Zhonghua shuju,
 1954-59.

ZYS Zhang, Xiumin. *Zhongguo yinshua shi*. Shanghai: Renmin chubanshe, 1991.

Interviews

Shanghaishi Xinsijun lishi yanjiuhui yinshu yinchao zu. May 1993, Shanghai.

Song, Yuanfang. Multiple interviews. 1991-93, Shanghai.

Wang, Zhen. Shanghai cishu chubanshe, March 1992, Shanghai.

Zhang, Shunian. Multiple interviews regarding his father, Zhang Yuanji, and the Commercial
 Press, 1991-92, Shanghai.

Archival Sources

SMA. "1914 Shuye gongsuo zhiyuan biao." 313.1.23. (1914).

—. "Chongjian Chongde gongsuo zhengzi (xiaoyin)." 313.1.99: Documents 1-8. (1878-1910).

—. "Guanyu shuye gongsuo yin xin *Guomin kuailan* yi ji gongsuo kuaiji bu," etc., 313.1.86. (1914-16).

—. "Jiayin dingsi jian sannian zhi baogao." 313.1.2. (1914-17).

—. "Jin jiang ben gongsuo shoufu gekuan kailie." 313.1.80: Documents 1-3. (September 1890).

—. "Jingji jingcha di yi dui." 27: 90. (1943-45).

—. "Qingchao benye shangtuan ... jinian zhaopian." 313.1.51. (1911).

—. "Qingchao shuye shanghui er dong mingdan." 313.1.27. (1907-9).

—. "Shanghai shuye Chongdetang gongsuo xianxing guize caogao." 313.1.2. (n.d.).

—. "Shanghai shuye shanghui nian zhouji niance mulu." 313.1-79. Jiading: n.p., 1924.

—. "Shanghai shuye shanghui zhangcheng." Includes "Banquan zhangcheng." 313.1.3. (1906-11).

—. "Shanghai shuye shanghui zhangcheng." 313.1.3. (1911).

—. "Shanghai shuye shanghui zhangcheng." 313.1.3. (1915 revision).

—. "Shanghai shuye shangtuan tongzhi xinshilu." 313.1.23.

—. "Shanghai shuye tongye yilanbiao." 313.1.23. (1914-29, 1917).

—. "Shuye gongsuo huiyi jilu bu." 313.1.88. (1917-27).

—. "Shuye gongsuo huiyuan ruhui zhiyuanshu." 313.1.62. (24 May 1923-7 July 1927).

—. "Shuye gongsuo quanti zhiyuan (huidong) de zhaopian." 313.1.29. (1917).

—. "Shuye gongsuo zongdong Gao Fengchi zhuan ci Zongshanghui daibiao." 313.1.33. (1919).

—. "Shuye shanghui xiehui, shuye youyi xiehui, Shanghai shuxi tuanti lianhehui, Suzhou chi caiyin tongye guilie." 313.1.41. (July 1915).

—. Shanghai shuye gongsuo. "Shanghai shuye gongsuo luocheng quanti dahui kaihui ci." 313.1.2.8. (1915).

—. Shanghai shuye tongye. "Shanghai shuye tongye yilanbiao, 1914." 313.1.23. 1914-29.

—. Shanghai shuye tongye. "Shanghai shuye tongye yilanbiao, 1917." 313.1.23. 1914-29.

—. Suzhou Chongde gongsuo. [In-house notice.] 313.1.99, 1: 2B. (1874).

—. Suzhou Chongde gongsuo. [Untitled document.] 313.1.99, 2. (1864-1909).

—. *Zhonghua shuju gufen youxian gongsi dengji shixiangbiao*. 90: 499. (1949).

—. "Zhonghua shuju youxian gongsi xianren dongshi (jiancharen) mingdan." 90: 499. (30 March 1949).

Published Sources

Ba, Jin. *Ba Jin zixu*. Ed. Chen Qiongzhi. Beijing: Tuanjie chubanshe, 1996.

Bai, Mu [trans.]. "Yinshuashu jiangzuo, er." In *Yiwen yinshua yuekan/The Graphic Printer* (Shanghai) 2, 2 (1939): 37-39.

Beijing tushuguan, ed. *Minguo shiqi zong shumu, 1911-1949*. Beijing: Shumu wenxian chubanshe, 1986, 1994.

Chen, Cunren. *Yinyuan shidai shenghuo shi*. Shanghai: Renmin chubanshe, 2000.

Chen, Guoqiang. "Ershi niandai mo de Nanjing shudianye." *Jiangsu chubanshi zhi* 5 (1991: 1): 113-17.

Chen, Lifu. *Chengbai zhi jian: Chen Lifu huiyi lu*. Taipei: Zhengzhong shuju, 1994.

Chen, Pingyuan, and Xia Shaohong, eds. *Ershi shiji Zhongguo xiaoshuo lilun ziliao*. Vol. 1 (1897-1916). Beijing: Beijing daxue chubanshe, 1989.

Chen, Qiaosun. "Xiaotan 'chuban biaoji.'" CBSL 1 (1982): 141-43.

Du, Jiutian [Shangwu]. *Gonghui shi*. Shanghai: Commercial Press, 1938.

Fan, Muhan, ed. *Zhongguo yinshua jindai shi, chu gao*. Beijing: Yinshua gongye chubanshe, 1995.

Fan, Quan. *Zhongguo chubanjie jianshi*. Shanghai: Yongxiang yinshuguan, 1936.

Fan, Xizeng, ed. *Shumu dawen buzheng*. Beijing: Zhonghua shuju, 1963 [1876].

Fang, Houshu. *Zhongguo chuban shihua*. Beijing: Dongfang chubanshe, 1996.

Fang, Xing, and Tang Zhijun, eds. *Wang Tao riji*. Beijing: Zhonghua shuju, 1987.

Feng, Shaoting, and Qian Gendi, eds. "Chuangjian shuye gongsuo qi." CBSL 10 (1987: 4): 41-42.

—. "Shanghai shuye gongsuo chuciding dingzhangcheng." CBSL 10 (1987: 4): 43-44.

—. "Shanghai shuye gongsuo zhiyuan mingdan." CBSL 10 (1987: 4): 42-43.

Fu, Yijiu. "Zongli Yamen dang'an suo jian Woguo zaoqi youpiao yinxing shiliao." *Dang'an yu lishi* (1986: 2): 1-3.

Fu, Yunsen, ed. *Xin zidian*. Shanghai: Commercial Press, 1912.

Gezhi huibian. 1876.

Gong, Chanxing. "Xinwen huajia Wu Youru: Jiantan Wu Youru yanjiu zhong de jige wenti." *Meishu pinglun.* N.p.: n.p., [1991?]: 68-75.

Gu, Tingpei. "Shanghai shudian jiuzhi." *Shanghai difangshi ziliao* 6 (1988): 49-50.

Gu, Yulu. "Shanghai tianzhujiao chuban gaikuang." CBSL 10 (1987: 4): 30-34.

Gu, Zuyin. "Shangwu menshibu de 'kaijia' chuangju." CBSL 5 (1986): 27-29.

Han, Qi, and Wang Yangzong. "Qingchao zhi shiyin shu." [Source unknown, collected in Ricci Institute Library, University of San Francisco.] N.p.: n.p., 1991.

He, Buyun. "Zhongguo huozi xiaoshi." In Shanghai Xinsijun lishi yanjiuhui, yinshua yinchao fenhui, ed., *Huozi yinshua yuanliu*, 66-88. Beijing: Yinshua gongye chubanshe, 1990.

Hu, Daojing. *Shanghai tushuguan shi.* Shanghai: Shanghaishi tongzhiguan, 1935.

—. "1933-nian de Shanghai zazhijie." In Shanghai tongshe, ed., *Shanghai yanjiu ziliaoxu*, 21-35. Shanghai: Shanghai shudian, 1935.

—. "Wo dushu zai Shanghai de tushuguan li." In Tang Weikang, Zhu Dalu, and Du Li, eds., *Shanghai yishi*, 96-104. Shanghai: Wenhua chubanshe, 1987.

Hu, Juemin. "Suzhou baokan liushi nian." *Jindaishi ziliao* 61 (1986): 130-48.

Hu, Yuzhi. *Wo de huiyi.* [Nanjing]: Jiangsu Renmin chubanshe, 1990.

Huang, Hanmin, and Lu Xinglong. *Jindai Shanghai gongye qiye fazhan shilun.* Shanghai: Caijing daxue chubanshe, 2000.

Ichinose, Yuichi. "Shin-dai Rurishō sho-shi ni kan suru hitotsu kōsatsu." *Shisen: Historical and Geographic Studies in Kansai University* 77 (1988): 25-39.

Ji, Chuangmei. *Zhongguo shuiyin muke banhua.* Taipei: Xiongshi tushu gufen youxian gongsi, 1990.

Jiang, Wenhan. "Guangxuehui shi zenma yang yige jigou." *Wenshi ziliao* 43 (1964: 3): 1-42.

Jiangsu sheng chuban shizhi bianmu weiyuanhui bianjibu, eds. *Jiangsu Minguo shiqi chuangshi.* Nanjing: Jiangsu Renmin chubanshe, 1993.

Jin, Liren, and He Shiyou. *Yang Xianjiang zhuanji.* Nanjing: Jiangsu jiaoyu chubanshe, 1991.

Ka, Te [Thomas Francis Carter]. *Zhongguo yinshua shu de faming he ta de xichuan.* Trans. Wu Zeyan. Shanghai: Shangwu yinshuguan, 1957.

Laodong jie (Shanghai). Reprint ed. [Beijing?]: Gongren chubanshe, 1958.

Li, Baijian. *Zhongguo chubanshi.* Beijing: Zhongguo shuji chubanshe, 1991.

Li, Jianqing. "Minchu Shanghai wentan." *Shanghai difangshi ziliao* 4 (1986): 202-17.

Li, Xiangbo. "Wo he Zhonghua shuju Shanghai yinshuachang." In Zhonghua shuju bianjibu, ed., *Huiyi Zhonghua shuju.* Beijing: Zhonghua shuju, 1987. 1: 193-206.

Liao, Hecheng, and Chen Mengxiong. "Kaibi caolai de chubanjia Zhang Yuanji." *Zhongguo qiyejia liezhuan* (Beijing) 2 (1988): 171-93.

Lin, Heqin. "Ziben yu yinshua shiye." *Yiwen yinshua yuekan* 1, 12 (1937). Reprinted in Yan Shuang, ed. *Zhongguo yinshua shi ziliao huibian.* Shanghai: Shanghaishi xinsijun lishiyanjiuhui, yinshua-yinchao zu, n.d. 1: 120-23.

Lin, Kanghou, ed. *Shanghaishi hanghaolu tulu.* Shanghai: [Fuli yingye gongsi], 1939.

Liu, Hecheng. "Zhang Yuanji xiansheng shengping zhanlan." In *Zhang Yuanji yishi zhuanji zhi er*, 26-32. Haiyan: Zhengxie wenshi ziliao gongzuo weiyuanhui, 1992.

Liu, Longguang. "Zhongguo yinshuashu de gaige." *Yiwen yinshua yinchao* 1, 4 (1937). Reprinted in Yan Shuang, ed. *Zhongguo yinshua shi ziliao huibian.* Shanghai: Shanghaishi xinsijun lishi yanjiuhui, yinshua yinchao zu, n.d. 1: 84-96.

—. "Zhongguo yinshuashu de yange, xia." *Yiwen yinshua yuekan/The Graphic Printer* (Shanghai) 1, 2 (1937): 4-7.

Liu, Mingkui, and Zhongguo shehui kexueyuan jindai shi yanyiu hui, eds. *Zhongguo gongren jieji lishi zhuangkuang (1840-1949).* Vol. 1. [Beijing]: Zhonggong Zhongyang dang jiao chubanshe, 1985.

Lu, Erkui, et al., eds. *Ciyuan.* Shanghai: Commercial Press, 1915.

Lu, Runxiang. "Ding Fubao yu chuban gongzuo." CBSL 3 (1984): 63-64.

Lu, Xun. *Lu Xun quanji*. Vol. 2. Beijing: Renmin wenxue, 1989.

Mao, Dun. "Shaonian yinshua gong." *Mao Dun quanji*. Vol. 4. Beijing: Renmin wenxue chubanshe, 1984. 119-222.

——. *Wo zouguo de daolu*. 3 vols. Hong Kong: Sanlian shudian, 1989.

——. "You di er zhang." *Mao Dun quanji*. Vol. 8. Beijing: Renmin wenxue chubanshe, 1984. 288-311.

Mao, Zedong. "Zhongguo geming he Zhongguo gongchandang." *Mao Zedong xuanji*. Beijing: Renmin chubanshe, 1955 [1939]. 2: 615-50.

Meng, Tao [pseud.]. "Chubanjie yipie." *Dushu yu chuban* (Shanghai: Shenzhou guoguangshe) 1 (1933): 5-10.

Miao, Zipeng. "Jin bainian lai de keshu yu cangshu." *Shanghai difangshi ziliao* 4 (1986): 179-85.

Mo, Anshi. *Yangwu yundong*. Shanghai: Renmin chubanshe, 1961.

Ping, Jinya. "Shanghai chubanjie suowen." *Shanghai difangzhi shi ziliao* 4 (1986): 218-44.

Quanguo Zhongyi tushu lianhe mulu. Beijing: Zhongyi guji chubanshe, 1991.

Ren, Jiayao. "Zhili tushu chuban faxing gongzuo de Zhang Jinglu." *Zhongguo qiyejia liezhuan* (Beijing) 5 (1991): 140-50.

Saoye shanfang, ed. *Saoye shanfang shumu*. Shanghai: Saoye shanfang, 1917.

Shanghai chubanzhi bianzuan weiyuanhui, ed. "Zhengji Shanghai chuban shiliao qishi." CBSL 11 (1988: 1): 87, 34.

Shanghai difang shi ziliao. Vol. 4. Shanghai: Shehui kexue yuan chubanshe, n.d.

Shanghai tongshe, ed. *Shanghai yanjiu ziliao, xubian*. Shanghai: Shanghai shudian yinhang, 1984.

Shanghai xian xuzhi. [Taipei]: Chengwen chubanshe, 1970 [1918].

Shanghai yanjiu zhongxin and Shanghai Renmin chubanshe, eds. *Shanghai 700 nian*. Shanghai: Renmin chubanshe, 1991.

Shanghai zhinan. Shanghai: Zhongguo hua'an hequn baoshou youxian gongsi, 1923.

Shanghai zhizaochang shangbu lan. [Shanghai]: Lianhe zhengxin, 1947.

Shanghaishi chuban gongzuozhe xiehui, eds. "Shanghai chuban shiye de gouqu, xianzai, he jianglai." In Shanghaishi chuban gongzuozhe xiehui, ed., *Shanghai shuzhan, teji*, and *Shanghai chuban gongzuo*, 127-31. Shanghai: n.p., 1984.

Shanghaishi nianjian. 2 vols. [Shanghai]: n.p., 1936.

Shanghaishi nianjian. 4 vols. [Shanghai]: n.p., 1937.

"Shanghaishi shuye tongye gonghui." CBSL 4 (1987): 45-49.

Shanghaishi Xinsijun lishi yanjiuhui, yinshua yinchao fenhui, ed. *Diaoban yinshua yuanliu*. Beijing: Yinshua gongye chubanshe, 1990.

——. *Huozi yinshua yuanliu*. Beijing: Yinshua gongye chubanshe, 1990.

Shangwu yinshu guan, ed. *Chuban zhoukan* (Shanghai) (new series) 75 (1934), 151-74 (1935-36).

——. *Shanghai zhinan*. Shanghai: Shangwu yinshu guan, 1923.

——. *Shangwu yinshu guan bei hui ji*. [Shanghai]: Commercial Press, 1932.

——. *Shangwu yinshu guan fuye hou gaikuang*. [Shanghai]: Commercial Press, [1934].

——. *Shangwu yinshu guan jiushi nian, wo he Shangwu yinshu guan, 1897-1987*. Beijing: Commercial Press, 1987.

——. *Shangwu yinshu guan jiushiwu nian, wo he Shangwu yinshu guan, 1897-1992*. Beijing: Commercial Press, 1992.

——. *Shangwu yinshu guan zhilüe*. [Shanghai]: Commercial Press, 1929.

——. *Zuijin sanshiwu nian zhi Zhongguo jiaoyu*. [Shanghai]: Commercial Press, [1937].

Shangwu yinshu guan dashiji. Beijing: Commercial Press, 1987.

Shehui ribao. 1936.

Shen, Zuwei, ed. *Jindai Zhongguo ziye: Zhidu he fazhan*. Shanghai: Shanghai shehui kexue yuan, 1999.

Shenbao. 1876, 1887.

Shenbao gaikuang. Shanghai: [Shenbao?], 1935.

Shenbao nianjian. [Shanghai]: Shenbao chuban, 1933.

Shenbao nianjian. [Shanghai]: Shenbao chuban, 1934.

Shenbao nianjian. [Shanghai]: Shenbao chuban, 1935.
Shi, Meicen. *Zhongguo yinshua fazhan shi.* Taipei: Taiwan Shangwu yinshu guan, 1966, 1986.
Shou, Ming. *Shanghai fangyan shiye tan.* Shanghai: Huadong shifan daxue chubanshe, 1992.
Shu, Xincheng, et al., comp. *Cihai.* 2 vols. Shanghai: Zhonghua shuju, 1936-37.
Song, Yuanfang. "Ji Shanghaishi shuye gonghui." CBSL 10 (1987: 4): 37-50.
—. "Yinggai yanjiu Zhongguo chubanshi." CBSL 11 (1988: 1): 73-74.
—. "Zhongguo jindai chuban dashiji." CBSL 19-24 (1990: 1-1991: 2).
Song, Yuanfang, and Li Bojian. *Zhongguo chuban shi.* Beijing: Zhongguo shuji chubanshe, 1991.
Song, Yunrong. "Kaiming jiushi, Wo suo zhidao de Kaiming shudian." *Wenshi ziliao xuanji* 31 (1962: 10): 1-30.
Su, Jing. *Jindai cangshu 30 jia.* Taipei: Chuan-chi wen-hsueh ch'u-pan she, 1983.
Sun, Dianqi, ed. *Liulichang xiaozhi.* Beijing: Beijing guji chubanshe, 1982 [1962].
Sun, Yat-sen. "Sun Zhongshan xiansheng tan chuban gongzuo." CBSL 20 (1990: 2): 125.
Suzhou lishi bowuguan, Jiangsu shifan xueyuan lishixi, and Nanjing daxue Ming Qing yanjiushi, eds. *Ming Qing Suzhou gong shang ye beike ji.* [Nanjing?]: Jiangsu Renmin chubanshe, 1981.
Tao, Shuimu. *Zhejiang shangbang yu Shanghai jingji jindaihua yanjiu, 1840-1936.* Shanghai: Sanlian shudian, 2000.
Tao, Xisheng, ed. *Xu Yuzhai [Xu Run] zixu nianpu.* Taipei: Shihuo chubanshe, 1977.
Tongzhi Shanghai xianzhi. Wumen: n.p., 1871.
Tōpuro Kōgyōshi Hensan linkai, eds. *Tōkyō Purosesu seihan kōgyōshi.* Tōkyō: Tōkyō Purosesu kōgyōshi kyōdō kumiai, 1974.
Wang, Bomin. *Zhongguo banhuashi.* Taipei: Lanting shudian, 1986.
Wang, Hanzhang. "Kanyin zongshu." ZJCSE, 363.
Wang, Hewu, et al., eds. *Qicai xiangyan pai.* Shanghai: Shanghai kexue jishu wenxian chubanshe, 1998.
Wang, Jiarong. "Shangwu yinshu guan chuangban ren Xia Ruifang." *Zhongguo qiyejia liezhuan* (Beijing) 2 (1988): 162-70.
—. "1930-nian qian Shangwu yinshu guan de faxing." *Jiangsu chuban shi zhi* 9 (1992: 2): 42-48.
Wang, Jingyu, ed. *Zhongguo jindai gongye shi ziliao de er ji, 1895-1914 nian.* Series 2, Part 2, 2 vols. Beijing: Kexue chubanshe, 1957.
Wang, Qingyuan, Mou Renlong, Han Xiduo, eds. *Xiaoshuo shufang lu.* Beijing: Beijing tushuguan chubanshe, 2002 [1987].
Wang, Shounan, ed. *Wo suo zhidao de Wang Yunwu xiansheng.* Taipei: Taiwan Commercial Press, 1975.
Wang, Shucun. *Xiju nianhua.* 2 vols. Taipei: Yingwen hansheng chuban youxian gongsi, 1991.
Wang, Tao. *Yingruan zazhi.* Taipei: Hua-wen shu-chu, [1875].
Wang, Yunwu. *Shangwu yinshu guan yu xin jiaoyu nianpu.* Taipei: Taiwan Shangwu yinshu guan, 1973.
Wang, Zhen. "Lufei Kui nianpu." CBSL 26 (1991: 4): 80-88, and 27 (1992: 1): 66-75, 85.
—. "Shijie shuju chuangbanzhe Shen Zhifang." *Zhongguo qiyejia liezhuan* (Beijing) 4 (1990): 137-49.
—. "Zhonghua shuju chuangbanzhe Lufei Kui." *Zhongguo qiyejia liezhuan* (Beijing) 4 (1990): 125-36.
Wanguo gongbao/Chinese Globe. (Old Series) 1870-82 (New Series) 1892, 1895-96, 1898-1902, 1904-6.
Wei, Yungong. *Jiangnan zhizao ju ji.* [Taipei?]: Wenhai chubanshe, n.d. [orig. 1897].
Wen, Yi. "Wang Yunwu he Shangwu yinshu guan." *Zhongguo qiyejia liezhuan* (Beijing) 2 (1988): 194-207.
Wu, Fuhui. *Dushi shiliu zhong de haipai xiaoshuo.* N.p.: Hunan jiaoyu chubanshe, 1995.
Wu, Guifang. "Qingji Shanghai de yinshi wujia." *Dang'an yu lishi* (1988: 4): 96-98.
Wu, Ping. "Sheng Xuanhuai yu Yuzhai cangshu." *Dang'an yu lishi* (1988: 2): 99-102.
Wu, Tiecheng. *Shanghaishi nianjian.* [Shanghai]: n.p., 1935.
Wu, Xiaomin, and Wu Cheng. "Zujie wenhua de chuangkou: Shanghai wenhuajie." *Shanghai shifan daxue xuebao* (1986: 2): 16-20.
Wu, Woyao. *Ershinian mudu zhi guai xianzhuang.* 2 vols. Taipei: Shih-chieh shu-chu, 1962.

Xia, Dongyuan. *Yangwu yundong shi*. Shanghai: Huadong shifan daxue chubanshe, 1992.

Xie, Juzeng. *Shili yangchang de ceying*. Guangzhou: Huacheng chubanshe, 1983.

Xiong, Yuezhi. "Shanghai guangfang yanguan shilue." In Tang Zhenchang and Shen Hengchun, eds., *Shanghaishi yanjiu, er bian*, 176-211. Shanghai: Xuelin chubanshe, 1988.

—. "Shanghai yu xixue chuanbo, 1843-1898." *Lishi yu dang'an* (1989: 1): 44-54.

Xu, Dingxin. "Jiu Shanghai gongshang, huiguan, gongsuo, tongye gonghui de lishi kaocha." *Shanghai yanjiu luncong* 5 (1990): 79-113.

Xu, Fang. "Minguo Jiangsu yinshua ye congtan." *Jiangsu chuban shi zhi* 9 (1992: 2): 35-41.

Xu, Renhan. "Jiu Shanghai shuye zayi." *Dang'an yu lishi* (1987: 3): 84-87.

Xu, Run. *Xu Yuzhai zixu nienpu*. Ed. Tao Xisheng. Taipei: Shihuo chubanshe youxian gongsi, 1977.

Xu, Wan. "Woguo zhi zhi ji yinshua." *Baoxue jikan* 1 (1935): 2. In Shanghaishi xinsijun lishi yanjiuhui yinshua yinchao zubian, ed., *Zhongguo yinshua shi ziliao huibian*. 3 vols. [Shanghai]: n.p., n.d. 1: 72-74.

Xue, Xunsheng. *Shanghai geming yizhi ji jiniandi*. Shanghai: Tongji University Press, 1991.

Yan, Shuang, ed. *Zhongguo yinshua shi ziliao huibian*. Vol. 1. Shanghai: Shanghaishi xinsijun lishi yanjiuhui, yinshua-yinchao zu, n.d.

Yang, Licheng, and Jin Buying, eds. *Zhongguo cangshujia gailue*. Taipei: Wenhai chubanshe, 1971 [Hangzhou, 1929].

Yang, Shouqing. *Zhongguo chubanjie jianshi*. Shanghai: Yongxiang yinshu guan, 1946.

Yao, Fushen. *Zhongguo bianji shi*. Shanghai: Fudan daxue chubanshe, 1990.

Yao, Gonghe. *Shanghai xianhua*. Shanghai: Guji chubanshe, 1989 [1917].

Yao, Xinbao. "Shanghai chuban ye jishi." In Shanghaishi chuban gongzuozhe xiehui, ed., *Shanghai shuzhan, teji* and *Shanghai chuban gongzuo*, 132-35. Shanghai: n.p., 1984.

Yao, Wendan, ed. *Shanghai xian xuzhi*. Taipei: Chengwen chubanshe, 1970 [1918].

Ye, Dehui, ed. *Shulin zhanggu*. Kowloon: Chungshan Books, 1972.

—. *Shulin qinghua*. Taipei: Shih-chieh shu chu, 1961 [1911].

Yu, Yueting. "Woguo huabao de shizu – *Dianshizhai huabao* chutan." *Xinwen yanjiu ziliao congkan* (1981: 5): 149-81.

Zhang, Chunhua, Qing Rongguang, and Yang Guangpu. *Hucheng suishi quge, Shanghai xian zhuzhi ci, Songnan yuefe*. Shanghai: Guji chubanshe, 1989 [late 1800s].

Zhang, Hongxing. "Zhongguo zui zao de xiyang maishu yaolan." *Dongnan wenhua* (1991: 4): 124-30.

Zhang, Jiangcai, ed. *Jingjin fengtu congshu*. N.p.: Shuangqilou, 1938.

Zhang, Jinglu. *Zai chuban jie ershi nian*. Hankou: Shanghai zazhi gongsi, 1938.

Zhang, Kaiyuan, et al. *Zhongguo jindai shi shang de guan shen shang xue*. Wuhan: Hubei renmin chubanshe, 2000.

Zhang, Keming. "Tushu zazhi shencha weiyuanhui kangzhanqian de Guomindang." *Jiangsu chuban shi zhi* 9 (1992: 2): 49-53.

Zhang, Shunian, ed. *Zhang Yuanji nianpu*. Beijing: Commercial Press, 1991.

Zhang, Xichen. "Mantan Shangwu yinshu guan." *Wenshi ziliao xuanji* 43 (1964: 3): 61-105.

Zhang, Xiumin. *Zhongguo yinshu de faming ji qi yingxiang, fu Zhongguo jin bainian chuban ziliao*. Taipei: Wenshizhe chubanshe, 1988.

Zhang, Zhongli, ed. *Jindai Shanghai chengshi yanjiu*. Shanghai: Renmin chubanshe, 1990.

Zhao, Jiabi. "Gongtong nuli banhao *Chuban shiliao* daifa kan ci." CBSL 1 (1982): 1-2.

Zhao, Junhao. *Zhongguo jindai zhi baoye*. 2nd ed. Shanghai: Shenbao, 1938.

Zheng, Shao. "Xu Run yu lunchuan zhaoshangju." *Shanghai yanjiu luncong*. Shanghai: Shanghai shehui kexueyuan chubanshe, 1991. 241-60.

Zheng, Yimei. "Qingmo Minchu de jiaoke shu." *Dang'an yu lishi* (1986: 2): 95ff.

—. *Qingmo Minchu wentan yishi*. Shanghai: Xuelin chubanshe, 1987.

—. *Shanghai jiuhua*, Part 2. Shanghai: Shanghai wenhua chubanshe, 1957.

—. *Shubao hua jiu*. Shanghai: Xuelin chubanshe, 1983.

Zheng, Zhenwen. "Wo suozhidao de Shangwu yinshuguan bianyisuo." *Wenshi ziliao xuanji* 53 (1965): 140-65.

Zhonggong Shanghai shiwei dangshi yanjiu shi and Shanghaishi zonggonghui, eds. *Shanghai jiqi ye gongren yundong shi*. Beijing: Zhonggong dangshi chubanshe, 1991.

—. *Shanghai Shangwu yinshu guan zhigong yundong shi*. Beijing: Zhonggong dangshi chubanshe, 1991.

—. *Zhonghua shuju zongchang zhigong yundong shi*. Beijing: Zhonggong dangshi chubanshe, 1991.

Zhonghua shuju bianjibu, eds. *Huiyi Zhonghua shuju*. 2 vols. Beijing: Zhonghua shuju, 1987.

—. *Zhonghua shuju tushu yuekan* 1-13 (1931-32).

Zhou, Yuhong. *Shanghai nianjian*. Shanghai: Huadong tongxunshe, 1947.

Zhu, Bangxing, Hu Linge, and Xu Sheng, eds. *Shanghai chanye yu Shanghai zhigong*. Shanghai: Shanghai Renmin chubanshe, 1984.

Zhu, Lianbao. "Jiefangqian Shanghai shudian, chubanshe yinxiangji, yi, er." CBSL 1-10 (1982-87).

—. *Jinxiandai Shanghai chubanye yinxiang ji*. Shanghai: Xuelin chubanshe, 1993.

—. "Wo suozhidao de Shijie shuju." *Wenshi ziliao xuanji* 15 (1963): 1-43.

Zhu, Linlin. "Lin Yuezhi yu jianjie chuanjiao." *Dang'an yu lishi* (1985: 2): 81 ff.

Zhuang, Suyuan. "Tushanwan yinshu guan xiaoji." CBSL 4 (1987: 4): 35-36.

Ziyou tan (*Shenbao* supplement). 1 December 1932-3 October 1938.

Zou, Zhenhuan. "Xishu zhong yi shi de mingzhu shidai zai Shanghai xingcheng de yuanyin ji qi wenhua yiyi." *Fudan xuebao (shehui kexue ban)* (1992: 3): 87-93.

Selected Western-Language Bibliography

Abbreviations

APMPAR American Presbyterian Mission Press. *Annual Report.* Shanghai: American Presbyterian Mission Press, 1888, 1890-92, 1894, 1896-98, 1900-23.

BDRC Boorman, Howard L., ed. *Biographical Dictionary of Republican China.* 5 vols. New York: Columbia University Press, 1967.

CLS Christian Literature Society. *Annual Report.* Shanghai: [various publishers], 1902-37, 1940-48.

CMS *Chicago Manual of Style.* 13th ed. Chicago: University of Chicago Press, 1982.

CR *The Chinese Repository* (Canton). 2nd ed. Vol. 1 (May 1832-April 1833) to Vol. 20 (January-December 1851). Vaduz: Kraus Reprint.

ECCP Hummel, Arthur W., ed. *Eminent Chinese of the Ch'ing Period.* 2 vols. Washington, DC: USGPO, 1943.

MPC McIntosh, Gilbert. *The Mission Press in China.* Shanghai: American Presbyterian Mission Press, 1895.

NCH *North China Herald* (Shanghai). 1875, 1884, 1887, 1888-91, 1893, 1895-97, 1899, 1901, 1903, 1905.

SMC Shanghai Municipal Council, ed. *Annual Report.* Shanghai: North China Daily News Publishing, 1891-1939.

TPP United States Government Printing Office. *Theory and Practice of Presswork.* Washington, DC: USGPO, 1962.

Archival Sources

Fryer, John. Correspondence and Papers. C. 1861-1921. CB-968. Bancroft Library, University of California at Berkeley.

Published Sources

Adas, Michael. *Machines as the Measure of Men: Science, Technology, and the Ideologies of Western Dominance.* Ithaca: Cornell University Press, 1989.

Alcock, Sir Rutherford. "The Peking Gazette." *Fraser's Magazine* (London), New Series, 7 (1873): 245-56, 341-57.

Alford, William P. *To Steal a Book Is an Elegant Offense: Intellectual Property Law in Chinese Civilization.* Stanford: Stanford University Press, 1995.

Anderson, Benedict. *Imagined Communities: Reflections on the Origin and Spread of Nationalism.* London and New York: Verso, 1991.

Arnold, Julian, ed. *Commercial Handbook of China.* Vol. 1. Washington, DC: USGPO, 1919.

Auden, W.H., and Christopher Isherwood. *Journey to a War.* New York: Random House, 1939.

Bacon, Francis. *The New Organon and Related Writing.* Ed. Fulton H. Anderson. Indianapolis: Bobbs Merrill, 1960.

Baigrie, Brian S., ed. *Picturing Knowledge: Historical and Philosophical Problems Concerning the Use of Art in Science.* Toronto and Buffalo: University of Toronto Press, 1996.

Bailey, Paul J. *Reform the People: Changing Attitudes towards Popular Education in Early Twentieth-Century China.* Edinburgh: Edinburgh University Press, 1990.

Baller, F.W., ed. and trans. *The Sacred Edict.* Shanghai: American Presbyterian Mission Press, 1892.

Bastid-Bruguière, Marianne. "Currents of Social Change." In John K. Fairbank and Kwang-Ching Liu, eds., *The Cambridge History of China: Late Ch'ing, 1800-1912*, [Part] 2: 535-602. New York: Cambridge University Press, 1980.

Bennett, Adrian A. *John Fryer: Introduction of Western Science and Technology in Nineteenth Century China*. Cambridge, MA: Harvard University East Asian Research Center, 1977.

Bergère, Marie-Claire. *The Golden Age of the Chinese Bourgeoisie, 1911-1937*. Trans. Janet Lloyd. New York: Cambridge University Press, 1989.

Berry, W. Turner. "Printing and Related Trades." In Charles Singer et al., eds., *A History of Technology*, 5: 683-715. New York: Oxford University Press, 1959.

Blackford, Mansel G. *A History of Small Business in America*. Chapel Hill: University of North Carolina Press, 2003.

Bloch, Marc. "Technology and Social Evolution: Reflections of a Historian." In Sabyasachi Bhattacharya and Pietro Redondi, eds., *Techniques to Technology: A French Historiography of Technology*, 83-90. New Delhi: Orient Longman, 1990.

Box, Ernest. "Native Newspapers." In *Eleventh Annual Report* [of the Guangxue Hui/Society for the Diffusion of Christian and General Knowledge among the Chinese], 38-46. Shanghai: n.p., 1898.

Braudel, Fernand. *Capitalism and Material Life 1400-1800*. Trans. Miriam Kochan. New York: Harper and Row, 1973.

Bray, Francesca. *Technology and Gender: Fabrics of Power in Late Imperial China*. Berkeley: University of California Press, 1997.

Britton, Roswell S. *The Chinese Periodical Press, 1800-1912*. Shanghai: Kelly & Walsh, 1933.

Brokaw, Cynthia J. "Commercial Publishing in Late Imperial China: The Zou and Ma Family Businesses of Sibao, Fujian." *Late Imperial China* 17, 1 (1996): 49-92.

—. "The Publishing Industry of Sibao: Commerce in Culture in Late Imperial China." Paper presented at the Colloquium on Printing and Culture in China, UCLA Center for Chinese Studies, 25 February 1995.

—. "Woodblock Printing and the Diffusion of Print in Qing China." Paper delivered at the First International Scientific Conference on Publishing Culture in East Asia, Tokyo, 8-10 December 2001.

Brook, Timothy. *The Confusions of Pleasure: Commerce and Culture in Ming China*. Berkeley: University of California Press, 1998.

Bundock, Clement J. *The National Union of Printing, Bookbinding, and Paper Workers*. Oxford: Oxford University Press, 1959.

Burlingame, Roger. "Technology as Cause in History, Technology: Neglected Clue to Historical Change." *Technology and Culture* 2, 3 (1961): 219-39.

Byrd, Cecil K. *Early Printing in the Straits Settlements 1806-1858*. Singapore: National Library, 1970.

Carter, Thomas Francis. *The Invention of Printing in China and Its Spread Westward*. Revised by L. Carrington Goodrich. New York: Ronald Press, 1955 [1925].

Chan, Wellington K.K. *Merchants, Mandarins, and Modern Enterprise in Late Ch'ing China*. Cambridge, MA: East Asian Research Center, Harvard University, 1977.

—. "The Organizational Structure of the Traditional Chinese Firm and its Modern Reform." *Business History Review* 56, 2 (1982): 218-35.

—. "Selling Goods and Promoting a New Commercial Culture: The Four Premier Department Stores on Nanjing Road." In Sherman Cochran, ed., *Inventing Nanjing Road: Commercial Culture in Shanghai, 1900-1945*, 19-36. Ithaca: Cornell East Asian Studies, 1999.

Chandler, Alfred K. *The Visible Hand: The Managerial Revolution in American Business*. Cambridge, MA: Belknap Press, 1978.

Chang, Chung-li. *The Chinese Gentry: Studies on Their Role in Nineteenth-Century Chinese Society*. Seattle: University of Washington Press, 1955.

Chartier, Roger, ed. *The Culture of Print: Power and the Uses of Print in Early Modern Europe*. Princeton: Princeton University Press, 1987.

Chauvet, Paul. *Les Ouvriers du livre en France: Des origines à la Révolution de 1789*. Paris: Librairie Marcel Rivière, 1956.

Chesneaux, Jean. *The Chinese Labor Movement, 1919-1927*. Trans. H.M. Wright. Stanford: Stanford University Press, 1968.

Chia, Lucille. "The Development of the Jianyang Book Trade, Song-Yuan." *Late Imperial China* 17, 1 (1996): 10-48.

——. "The Jianyang Book Trade in the Ming." Paper presented at the Colloquium on Printing and Culture in China, UCLA Center for Chinese Studies, 25 February 1995.

——. *Printing for Profit: The Commercial Publishers of Jianyang, Fujian (11th-17th Centuries)*. Cambridge, MA: Harvard University Asia Center, 2002.

Chien, Florence. "The Commercial Press and Modern Chinese Publishing 1897-1949." MA thesis, University of Chicago, 1970.

The China Intelligence Agency. *Trade List and Native Who's Who of Shanghai 1916*. Shanghai: China Intelligence Agency, 1916.

Chow, Kai-wing. "Writing for Success: Printing, Examinations, and Intellectual Change in Late Ming China." *Late Imperial China* 17, 1 (1996): 120-57.

Chow, Tse-tsung. *The May Fourth Movement: Intellectual Revolution in Modern China*. Stanford: Stanford University Press, 1967.

Christian Literature Society. *No Speedier Way: Golden Jubilee of Christian Literature Society for China, 1887-1937*. Shanghai: Christian Literature Society for China, 1938.

Clair, Colin. *A History of European Printing*. New York: Academic Press, 1976.

Clapham, Michael. "Printing." In Charles Singer et al., eds., *A History of Technology*, 377-410. Oxford: Oxford University Press, 1957.

Clunas, Craig. *Superfluous Things: Material Culture and Social Status in Early Modern China*. Urbana: University of Illinois Press, 1991.

Coble, Parks. *The Shanghai Capitalists and the Nationalist Government, 1927-1937*. Cambridge, MA: Harvard Council on East Asian Studies, 1980.

Cochran, Sherman. *Encountering Chinese Networks: Western, Japanese, and Chinese Corporations in China, 1880-1937*. Berkeley: University of California Press, 2000.

——, ed. *Inventing Nanjing Road: Commercial Culture in Shanghai, 1900-1945*. Ithaca: Cornell East Asian Studies, 1999.

——. "Three Roads into Shanghai's Market: Japanese, Western, and Chinese Companies in the Match Trade, 1895-1937." In Frederic Wakeman, Jr., and Wen-hsin Yeh, eds., *Shanghai Sojourners*, 35-75. Berkeley: Institute of East Asian Studies, 1992.

Cohen, Paul A. *Between Tradition and Modernity: Wang T'ao and Reform in Late Ch'ing China*. Cambridge, MA: Harvard Council on East Asian Studies, 1974.

Cohn, Don J., ed. and trans. *Vignettes from the Chinese: Lithographs from Shanghai in the Late Nineteenth Century*. Hong Kong: Chinese University of Hong Kong, 1987.

Comparato, Frank. *Chronicles of Genius and Folly: R. Hoe & Company and the Printing Press as a Service to Democracy*. Culver City: Labrynthos, 1979.

Conningham, Frederic A., ed. *Currier & Ives Prints*. New York: Crown Publishers, 1949.

"Correspondence: The Press in China." *Chinese Recorder and Missionary Journal* (Fuzhou) 3, 3 (1870): 81-82.

Crook, Nigel, ed. *The Transmission of Knowledge in South Asia*. Delhi: Oxford University Press, 1996.

Crow, Carl. *Handbook for China*. 2nd ed. Shanghai, Yokohama, Hong Kong, and Singapore: Kelly & Walsh, 1916.

——. Handbook for China. 4th ed. New York: Dodd, Mead, 1925.

Culp, Robert. "The Ideological Infrastructure of Citizenship: Schools and Publishing." In Culp, "Articulating Citizenship: Community, Civility, and Student Politics in Southeastern China, 1912-1937." Unpublished manuscript.

Cutter, Robert Joe. "Ts'ung-shu." In William H. Nienhauser, Jr., et al., eds., *The Indiana Companion to Traditional Chinese Literature*, 810-13. Bloomington: Indiana University Press, 1986.

Darnton, Robert. *The Business of Enlightenment: A Publishing History of the Encyclopedie, 1775-1800*. Cambridge, MA: Belknap Press, 1979.

——. *The Great Cat Massacre and Other Episodes from French Cultural History*. New York: Basic Books, 1984.

—. *The Literary Underground of the Old Regime*. Cambridge, MA: Harvard University Press, 1982.

Davis, John Francis. *The Chinese: A General Description of the Empire of China and Its Inhabitants*. London: Chas. Knight & Company, 1836.

Dick, Hugh G., ed. *Selected Writings of Francis Bacon*. New York: Random House, 1955.

Dolezelova-Verlingerova, Milena, ed. *The Chinese Novel at the Turn of the Century*. Toronto and Buffalo: University of Toronto Press, 1980.

Drège, Jean-Pierre. *La Commercial Press de Shanghai, 1897-1949*. Paris: Memoires de l'Institut des Hautes Études Chinoises, 1978.

Drège, Jean-Pierre, and Hua Chang-ming. *La Révolution du livre dans la Chine moderne: Wang Yunwu, éditeur*. Paris: Publications Orientalistes de France, 1979.

Edgren, Soren, ed. *Chinese Rare Books in American Collections*. New York: China Institute of America, 1984.

Eisenstein, Elizabeth L. *The Printing Press as an Agent of Change: Communications and Cultural Transformations in Early Modern Europe*. 2 vols. New York: Cambridge University Press, 1979.

Elman, Benjamin A. *A Cultural History of Civil Examinations in Late Imperial China*. Berkeley: University of California Press, 2000.

—. *From Philosophy to Philology: Intellectual and Social Aspects of Change in Late Imperial China*. Cambridge, MA: Harvard University Press, 1984.

Esherick, Joseph W. *Reform and Revolution in China: The 1911 Revolution in Hunan and Hubei*. Berkeley: University of California Press, 1976.

Faber, Ernst. "Christian Literature in China: Its Business Management." In *Records of the General Conference of the Protestant Missionaries of China*, 551-55. Shanghai: American Presbyterian Mission Press, 1890.

Farwell, Beatrice. *Lithographs and Literature*. Chicago: University of Chicago Press, 1981.

Feather, John. *A History of British Publishing*. London: Routledge, 1988.

Febvre, Lucien, and Henri-Jean Martin. *The Coming of the Book: The Impact of Printing 1450-1800*. Trans. David Gerard. London: NLB, 1976.

Ferguson, Eugene S. *Engineering and the Mind's Eye*. Cambridge, MA: MIT Press, 1992.

Feuerwerker, Albert. *China's Early Industrialization: Sheng Hsuan-huai (1844-1916) and Mandarin Enterprise*. New York: Atheneum, 1970 [1958].

Fortune, Robert. *Three Years' Wanderings in the Northern Provinces of China*. London: John Murray, 1847.

Fox, Celina. *Graphic Journalism in England during the 1830s and 1840s*. New York: Garland, 1988.

"From Spontaneous Revolts to the Forming of Party Organizations [at Zhonghua Shuju]." Ed. Jeffrey N. Wasserstrom and Elizabeth J. Perry. *Chinese Studies in History* 27, 1-2 (1993-94): 87-90.

Fryer, John. "General Editor's Report." In *Records of the General Conference of the Protestant Missionaries of China*, 715-17. Shanghai: American Presbyterian Mission Press, 1890.

Furth, Charlotte. *A Flourishing Yin: Gender in China's Medical History 960-1665*. Berkeley: University of California Press, 1999.

Gamewell, Mary Ninde. *The Gateway to China: Picture of Shanghai*. New York: Revell Company, 1916, esp. Chapter 8.

Gao, Yunlan. *Annals of a Provincial Town (Xiaocheng chunqiu)*. Trans. Sidney Shapiro. Beijing: Waiwen chubanshe, 1980.

Golas, Peter. "Early Ch'ing Guilds." In G. William Skinner, ed., *The City in Late Imperial China*, 555-80. Stanford: Stanford University Press, 1977.

—. "Tin Mining in 19th and 20th Century China: High Production, Low Technology." In Tsui-hua Yang and Yi-long Huang, eds., *Jindai Zhongguo kejishi lunji/Science and Technology in Modern China*, 261-94. Taipei: Institute of Modern History, Academia Sinica, 1991.

Goodrich, Luther Carrington. *The Literary Inquisition of Ch'ien Lung*. Baltimore: Waverly Press, 1935.

Guangxuehui (Society for the Diffusion of Christian and General Knowledge among the Chinese). *China Bookman/Chubanjie* (Shanghai) (1918-37).

Gutman, Herbert G. "The Reality of the Rags-to-Riches 'Myth': The Case of the Paterson, New Jersey, Locomotive, Iron, and Machinery Manufacturers, 1830-1880." In Stephan Thernstrom and Richard Sennett, eds., *Nineteenth Century Cities: Essays in the New Urban History*, 98-124. New Haven: Yale University Press, 1969.

Guy, R. Kent. *The Emperor's Four Treasuries*. Cambridge, MA: Harvard University Press, 1987.

Hamilton, Gary G., and Chi-kong Lai. "Consumerism without Capitalism: Consumption and Brand Names in Late Imperial China." In Henry J. Rutz and Benjamin S. Orlove, eds., *The Social Economy of Consumption*, 253-79. Lanham, MD: University Press of America, 1989.

Handbook of Chinese Manufactures. Shanghai: Foreign Trade Association of China, 1949.

Hao, Yen-p'ing. *The Commercial Revolution in Nineteenth-Century China: The Rise of Sino-Western Mercantile Capitalism*. Berkeley: University of California Press, 1986.

Hay, Jonathan. "Painters and Publishing in Late Nineteenth-Century Shanghai." In Ju-hsi Chou, ed., *Art at the Close of China's Empire*, 134-88. [Tempe]: Arizona State University Phoebus Occasional Papers in Art History, 1998.

Headrick, Daniel R. *The Tools of Empire: Technology and European Imperialism in the Nineteenth Century*. New York: Oxford University Press, 1981.

Hegel, Robert E. *Reading Illustrated Fiction in Late Imperial China*. Stanford: Stanford University Press, 1998.

Henriot, Christian. *Shanghai 1927-1937: Municipal Power, Locality, and Modernization*. Trans. Noël Castelino. Berkeley: University of California Press, 1993 [1991].

Hershatter, Gail. *The Workers of Tianjin, 1900-1949*. Stanford: Stanford University Press, 1986.

Hesse, Carla. *Publishing and Cultural Politics in Revolutionary Paris, 1789-1810*. Berkeley: University of California Press, 1991.

Hirsch, Rudolf. *Printing, Selling, and Reading 1450-1550*. Wiesbaden: Otto Harrassowitz, 1974.

Hirth, Friedrich. "Western Appliances in the Chinese Printing Industry." *Journal of the China Branch of the Royal Asiatic Society* (Shanghai) 20 (1885): 163-77.

Ho, Ping-ti. *The Ladder of Success in Imperial China: Aspects of Social Mobility 1368-1911*. New York: John Wiley, 1964.

Holt, W.S. "The Mission Press in China." *Chinese Recorder and Missionary Journal* 10, 3 (1879): 206-19.

Holtzberg-Call, Maggie. *The Lost World of the Craft Printer*. Urbana: University of Illinois Press, 1992.

Hongs and Homes: A Complete Directory of Shanghai. [Shanghai]: Francis C. Millington, 1928.

Howsam, Leslie. *Cheap Bibles: Nineteenth-Century Publishing and the British and Foreign Bible Society*. New York: Cambridge University Press, 1991.

Hu, Shu Chao. *The Development of the Chinese Collection in the Library of Congress*. Boulder: Westview Press, 1979.

Huang, Joe C. *Heroes and Villains in Communist China: The Contemporary Chinese Novel as a Reflection of Life*. New York: Pica Press, 1973.

Huffman, James. *Creating a Public: People and Press in Meiji Japan*. Honolulu: University of Hawaii Press, 1997.

Huters, Theodore et al., eds. *Culture and State in Chinese History: Conventions, Accommodations, and Critiques*. Stanford: Stanford University Press, 1997.

Ip, Manying [Ye-Song Manying]. "A Hidden Chapter in Early Sino-Japanese Co-operation: The Commercial Press-Kinkōdō Partnership, 1903-1914." *Journal of International Studies* (Sophia University, Tokyo) 16 (1986): 23-43.

—. *The Life and Times of Zhang Yuanji, 1867-1959*. Beijing: Commercial Press, 1985.

Israel, Paul. *From Machine Shop to Industrial Laboratory: Telegraphy and the Changing Context of American Invention, 1830-1920*. Baltimore: Johns Hopkins University Press, 1992.

Jennett, Seán. *The Making of Books*. 4th ed. New York: Praeger, 1967.

Jobling, Paul, and David Crowley. *Graphic Design: Reproduction and Representation since 1800*. New York: Manchester University Press, 1995.

Johnson, Linda Cooke, ed. *Cities of Jiangnan in Late Imperial China*. Albany: SUNY Press, 1993.

Jordan, Donald A. *China's Trial by Fire: The Shanghai War of 1932*. Ann Arbor: University of Michigan Press, 2001.

Jordan, John O., and Robert Patten, eds. *Literature in the Marketplace: Nineteenth Century British Publishing and Reading Practices*. New York: Cambridge University Press, 1995.

Judge, Joan Evangeline. *Print and Politics: "Shibao" and the Culture of Reform in Late Imperial China*. Stanford: Stanford University Press, 1996.

Kahan, Basil. *Ottmar Mergenthaler: The Man and His Machine*. New Castle, DE: Oak Knoll Press, 2000.

Kahn, Harold. *Excursions in Reading History: Three Studies*. Taipei: Academia Sinica, Institute of Modern History, 1993.

Kann, Eduard. *The Currencies of China*. Shanghai: Kelly & Walsh, 1927.

Kapr, Albert. *Johann Gutenberg: The Man and His Invention*. Trans. Douglas Martin. Aldershot, UK: Scolar Press, 1996.

Keenan, Barry. "Lung-men Academy in Shanghai and the Expansion of Kiangsu's Educated Elite, 1865-1911." In Benjamin A. Elman and Alexander Woodside, eds., *Education and Society in Late Imperial China, 1600-1900*, 493-524. Berkeley: University of California Press, 1994.

Kenwood, A.G., and A.L. Lougheed. *Technological Diffusion and Industrialisation before 1914*. New York: St. Martin's Press, 1982.

Kilgour, Frederick G. *The Evolution of the Book*. New York: Oxford University Press, 1998.

King, Frank H.H. *Money and Monetary Policy in China, 1845-1895*. Cambridge, MA: Harvard University Press, 1965.

Kirby, William C. "China Unincorporated: Company Law and Business Enterprise in Twentieth-Century China." *Journal of Asian Studies* 54, 1 (1995): 43-63.

Ko, Dorothy. *Teachers of the Inner Chambers: Women and Culture in 17th Century China*. Stanford: Stanford University Press, 1994.

Kornicki, Peter. *The Book in Japan: A Cultural History from the Beginnings to the Nineteenth Century*. Leiden: E.J. Brill, 1998.

Kotenev, A.M. *Shanghai: Its Mixed Court and Council*. Shanghai: North China Daily News and Herald, 1925.

Kranzberg, Melvin, and Carroll W. Pursell, Jr., eds. *Technology in Western Civilization*. 2 vols. New York: Oxford University Press, 1967.

Kubler, George A. *A New History of Stereotyping*. New York: n.p., 1941.

Lach, Donald F. *Asia in the Making of Europe*. Chicago: University of Chicago Press, 1965, 1: 2; 1977, 2: 3.

Lach, Donald F., and Edwin J. Van Kley. *Asia in the Making of Europe*. Chicago: University of Chicago Press, 1993, 3: 1, 3: 4.

Laffey, Ella. "The Making of a Rebel: Liu Yung-fu and the Formation of the Black Flag Army." In Jean Chesneaux, ed., *Popular Movements and Secret Societies in China, 1840-1950*, 85-96. Stanford: Stanford University Press, 1972.

—. "Social Dissidence and Government Suppression on the Sino-Vietnam Frontier: The Black Flag Army in Tonkin." *Ch'ing-shih wen-t'i* 4, 2 (1979): 113-25.

Lai, Chi-kong. "The Qing State and Merchant Enterprise: The China Merchants' Company, 1872-1902." In Jane Kate Leonard and John R. Watt, eds., *To Achieve Security and Wealth: The Qing Imperial State and the Economy, 1644-1911*, 139-55. Ithaca: East Asian Program, Cornell University, 1992.

Lau Wai-mai, Michael. "Wu Wo-yao (1866-1910): A Writer of Fiction of the Late Ch'ing Period." PhD dissertation, Harvard University, 1968.

Lee, Leo Ou-fan. *Shanghai Modern: The Flowering of a New Urban Culture in China 1930-1945*. Cambridge, MA: Harvard University Press, 1999.

Lee, Leo Ou-fan, and Andrew J. Nathan. "The Beginnings of Mass Culture: Journalism and Fiction in the Late Ch'ing and Beyond." In David G. Johnson, Andrew J. Nathan, and Evelyn S. Rawski, eds., *Popular Culture in Late Imperial China*, 360-98. Berkeley: University of California Press, 1987.

Li, Jui. *The Early Revolutionary Activities of Comrade Mao Tse-tung* [1957]. Trans. Anthony W. Sariti. Ed. James C. Hsiung. White Plains: M.E. Sharpe, 1977.

Link, Perry. *Mandarin Ducks and Butterflies: Popular Fiction in Early Twentieth-Century Chinese Cities*. Berkeley: University of California Press, 1981.

Liu, Lydia. *Translingual Practice: Literature, National Culture, and Translated Modernity – China, 1900-1937.* Stanford: Stanford University Press, 1995.

"Lives of Chinese Martyrs (Excerpt)." Ed. Jeffrey N. Wasserstrom and Elizabeth J. Perry. *Chinese Studies in History* 27, 1-2 (1993-94): 119-22.

McAleavy, Henry. *Wang T'ao: The Life and Writings of a Displaced Person.* London: The China Society, 1953.

McElderry, Andrea L. *Shanghai Old-Style Banks (ch'ien-chuang), 1800-1935: A Traditional Institution in a Changing Society.* Ann Arbor: University of Michigan, Center for Chinese Studies, 1976.

McGaw, Judith A. *Most Wonderful Machine: Mechanization and Social Change in Berkshire Paper Making, 1801-1885.* Princeton: Princeton University Press, 1987.

McIntosh, Gilbert. "Discussion." In *Records of the General Conference of the Protestant Missionaries of China,* 582-83. Shanghai: American Presbyterian Mission Press, 1890.

MacKenzie, Donald, and Judy Wajcman, eds. *The Social Shaping of Technology.* Milton Keynes and Philadelphia: Open University Press, 1985.

MacKinnon, Stephen R. "Press Freedom and the Chinese Revolution in the 1930s." In Jeremy D. Popkin, ed., *Media and Revolution: Comparative Perspectives,* 174-88. Lexington: University Press of Kentucky, 1995.

Madison, Charles A. *Book Publishing in America.* New York: McGraw-Hill, 1966.

Mahdi, Muhsin. "From the Manuscript Age to the Age of Printed Books." In George Atiyeh, ed., *The Book in the Islamic World: The Written Word and Communication in the Middle East,* 1-16. Albany: SUNY Press, 1995.

Malraux, André. *Man's Fate.* Trans. Haakon M. Chevalier. New York: Random House, 1961.

Mann, Susan. *Local Merchants and the Chinese Bureaucracy, 1750-1950.* Stanford: Stanford University Press, 1987.

Mao, Dun. "Wartime." In Mao Tun, *Spring Silkworms and Other Stories,* 164-88. Trans. Sydney Shapiro. Beijing: Foreign Languages Press, 1956.

Mao, Qihua. "Cherish the Present, Achieved at Great Cost." Ed. Jeffrey N. Wasserstrom and Elizabeth J. Perry. *Chinese Studies in History* 27, 1-2 (1993-94): 94-106.

Marker, Gary. *Publishing, Printing, and the Origins of Intellectual Life in Russia, 1700-1800.* Princeton: Princeton University Press, 1985.

Marshman, Joshua. *Elements of Chinese Grammar.* Serampore: Mission Press, 1814.

Martin, W.A.P. *A Cycle of Cathay: Or, China, South and North, with Personal Reminiscences.* New York: Revell Company, 1900, esp. Chapters 6 and 7.

Marx, Karl. *Capital.* Trans. Samuel Moore and Edward Aveling. New York: Modern Library, n.d. [1906].

Medhurst, Walter Henry. *China: Its State and Prospects.* Boston: Crocker & Brewster, 1838.

Meisner, Maurice. *Mao's China; A History of the People's Republic.* New York: Free Press, 1977.

Meng, S.M. *The Tsungli Yamen: Its Organization and Functions.* Cambridge, MA: Harvard University East Asian Research Center, 1962.

Minami, Ryōshin. "Mechanical Power and Printing Technology in Pre-World War II Japan." *Technology and Culture* 23, 4 (1982): 609-24.

Moran, James. *The Composition of Reading Matter: A History from Case to Computer.* London: Wace, 1965.

—. *Printing Presses: History and Development from the Fifteenth Century to Modern Times.* Berkeley: University of California Press, 1973.

Morrison, Robert, comp. *Dictionary of the3 Chinese Language in Three Parts.* Macao: East India Company's Press, 1815.

Mumby, Frank Arthur, and Ian Norrie. *Publishing and Bookselling.* 5th ed. London: Jonathan Cape, 1974 [1930].

Narramore, Terry. "Making the News in Shanghai: *Shen Bao* and the Politics of Newspaper Journalism, 1912-37." PhD dissertation, Australian National University, 1989.

North China Daily News (Shanghai). 2-28 April 1927, 27-30 January, 1-12 February 1932.

North China Daily News and Herald (Shanghai). *The Shanghai Directory 1939: City Supplement Edition to the China Hong List.* Shanghai: North China Daily News and Herald, 1939.

North China Desk Hong List. Shanghai: North China Daily News Printing Office, 1903.

Painter, George D. *Studies in Fifteenth Century Printing*. London: Pindar Press, 1984.

Pan, Francis K. *One Year of Rehabilitation of the Commercial Press, Ltd.* [Shanghai]: [Commercial Press], 1933.

Perry, Elizabeth J. *Shanghai on Strike: The Politics of Chinese Labor.* Stanford: Stanford University Press, 1993.

Porter, Robin. "Average Monthly Earnings of Workers in Shanghai, 1930-1940." Appendix 1B in *Industrial Reformers in Republican China* [spring-summer 1994 issue of *Chinese Studies in History*], 180-81. Armonk, NY: M.E. Sharpe.

Pott, Francis L.H. *A Short History of Shanghai*. Shanghai: Kelly & Walsh, 1928.

"The Printed Word in Shanghai." *China Journal* 12, 5 (1930): 240-42.

"Protestant Missions." *Chinese Recorder and Missionary Journal* (Shanghai) 8, 4 (1877): 307-8.

Rankin, Mary Backus. *Elite Activism and Political Transformation in China: Zhejiang Province, 1865-1911.* Stanford: Stanford University Press, 1986.

Rao, Jingying. "The Shanghai Postal Workers' Union: Sample of a Yellow Union." Ed. Jeffrey N. Wasserstrom and Elizabeth J. Perry. *Chinese Studies in History* 27, 1-2 (1993-94): 148-61.

Rawski, Evelyn S. "Economic and Social Foundations of Late Imperial Culture." In David G. Johnson, Andrew J. Nathan, and Evelyn S. Rawski, eds., *Popular Culture in Late Imperial China*, 3-33. Berkeley: University of California Press, 1985.

—. *Education and Popular Literacy in Ch'ing China*. Ann Arbor: University of Michigan Press, 1979.

Rawski, Thomas. *Economic Growth in Prewar China*. Berkeley: University of California Press, 1989.

Reed, Christopher A. "Re/Collecting the Sources: Shanghai's *Dianshizhai Pictorial* and Its Place in Historical Memories, 1884-1949." *Modern Chinese Literature and Culture* 12, 2 (2000): 44-71.

Remer, Rosalind. *Printers and Men of Capital: Philadelphia Book Publishers in the New Republic.* Philadelphia: University of Pennsylvania Press, 1996.

Reynolds, Douglas R. *China, 1898-1912: The Xinzheng Revolution and Japan*. Cambridge, MA: Council on East Asian Studies, Harvard University, 1993.

Rhoads, Edward J.M. "Merchant Associations in Canton, 1895-1911." In Mark Elvin and G.Wm. Skinner, eds., *The Chinese City between Two Worlds*, 97-118. Stanford: Stanford University Press, 1974.

Rickett, W. Allyn, ed. and trans. *Guanzi: Political, Economic, and Philosophical Essays from Early China: A Study and Translation.* Princeton: Princeton University Press, 1985.

Roberts, David. *From an Antique Land: Travels in Egypt and the Holy Land.* New York: Weidenfeld and Nicolson, 1989 [1842-49].

[ROC] Ministry of Industry and Bureau of Foreign Trade. *China Industrial Handbooks: Chekiang.* Series 2. Shanghai: Ministry of Industry and Bureau of Foreign Trade, 1935.

—. *China Industrial Handbooks: Kiangsu.* Series 1. Shanghai: Ministry of Industry and Bureau of Foreign Trade, 1933.

Roddy, Stephen J. *Literati Identity and Its Fictional Representations in Late Imperial China.* Stanford: Stanford University Press, 1998.

Rogers, Everett M. *Diffusion of Inventions*. New York: Free Press, 1962.

Rosenberg, Emily S. *Spreading the American Dream: American Economic and Cultural Expansion, 1890 to 1945.* New York: Hill and Wang, 1982.

Rosenbloom, Joshua L. "Economics and the Emergence of Modern Publishing in the United States [1825-35]." *Publishing History* 29 (1991): 47-68.

Rudolph, Richard C. *A Chinese Printing Manual* [includes a translation of "Imperial Printing Office (Wuyingdian) Manual for Moveable Type (Peking, 1777)"]. Los Angeles: Ward Ritchie Press, 1954.

Rungta, Radhe Shyam. *The Rise of Business Corporations in India 1851-1900.* New York: Cambridge University Press, 1970.

Rürup, Reinhard. "Historians and Modern Technology: Reflections on the Development and Current Problems of the History of Technology." *Technology and Culture* 15, 2 (1974): 161-93.

Ruud, Charles A. *Russian Entrepreneur: Publisher Ivan Sytin of Moscow, 1851-1934.* Montreal and Kingston: McGill-Queen's University Press, 1990.

Sabel, Charles F., and Jonathan Zeitlin, eds. *World of Possibilities: Flexibility and Mass Production in Western Industrialization.* New York: Cambridge University Press, 1997.

Salisbury, Harrison E. *The New Emperors: China in the Era of Mao and Deng.* Boston: Little, Brown, 1992.

Sarkowski, Heinz. *Springer-Verlag: History of a Scientific Publishing House.* Trans. Gerald Graham. Berlin: Springer-Verlag, 1996, [vol] 1.

Schwartz, Benjamin. *In Search of Wealth and Power: Yen Fu and the West.* Cambridge, MA: Harvard University Press, 1964.

Scranton, Philip. *Endless Novelty: Speciality Production and American Industrialization, 1865-1925.* Princeton: Princeton University Press, 1997.

Senefelder, Alois. *The Invention of Lithography.* Trans. J.W. Muller. New York: Fuchs & Lang Manufacturing Company, 1911.

Seybold, John W. *The Philadelphia Printing Industry: A Case Study.* Philadelphia: University of Pennsylvania Press, 1949.

Shaffer, Linda. *Mao and the Workers: The Hunan Labor Movement, 1920-1923.* Armonk, NY: M.E. Sharpe, 1980.

Shiao, Ling Arey. "Bridging Influence and Income: May Fourth Intellectuals' Approaches to Cultural Economy in the Post-May Fourth Era." Paper presented at the Association of Asian Studies Annual Conference, 29 March 2003.

Sieber, Patricia. *Theaters of Desire: Authors, Readers, and the Reproduction of Early Chinese Song-Drama, 1300-2000.* New York: Palgrave, 2003.

Singer, Charles, et al., eds. *A History of Technology.* Oxford: Oxford University Press, 1957.

Smith, S.A. *Like Cattle and Horses: Nationalism and Labor in Shanghai, 1895-1927.* Durham: Duke University Press, 2002.

Stark, Gary D. *Entrepreneurs of Ideology: Neoconservative Publishers in Germany, 1890-1933.* Chapel Hill: University of North Carolina Press, 1981.

Steinberg, Mark D. *Moral Communities: The Culture of Class Relations in the Russian Printing Industry, 1867-1907.* Berkeley: University of California Press, 1992.

Steinberg, S.H. *Five Hundred Years of Printing.* New Castle, DE: Oak Knoll Press; and London: British Library, 1996.

Sterne, Harold E. *Catalogue of Nineteenth Century Printing Presses.* Cincinnati: Ye Olde Printery, 1978.

Stevens, Edward W., Jr. *The Grammar of the Machine: Technical Literacy and Early Industrial Expansion in the United States.* New Haven: Yale University Press, 1995.

Stranahan, Patricia. *Molding the Medium: The Chinese Communist Party and the Liberation Daily.* Armonk, NY: M.E. Sharpe, 1990.

Su, Ching. "The Printing Presses of the London Missionary Society Among the Chinese." PhD dissertation, University College, University of London, 1996.

Sun, Ts'ung-t'ien [Sun Congtian]. "Bookman's Manual" [1812]. Trans. Achilles Fang. *Harvard Journal of Asiatic Studies* 14, 1-2 (1951): 215-60.

Tan (Taam), Cho-Yüan. *The Development of Chinese Libraries under the Ch'ing Dynasty, 1644-1911.* Shanghai: Commercial Press, 1935.

Taubert, Sigfried, and Peter Weidhaas, eds. *Book Trade of the World.* Munich: K.G. Saur, 1981.

Tawney, R.H. *Religion and the Rise of Capitalism.* New York: Mentor, 1954.

Taylor, William R. *In Pursuit of Gotham: Culture and Commerce in New York.* New York: Oxford University Press, 1992.

—, ed. *Inventing Times Square: Commerce and Culture at the Crossroads of the World.* New York: Russell Sage Foundation, 1991.

Tebbel, John. *Between Covers: The Rise and Transformation of Book Publishing in America.* New York: Oxford University Press, 1987.

—. *A History of Book Publishing in the United States.* 4 vols. New York: R.R. Bowker, 1972.

Ting, Lee-Hsia Hsu. *Government Control of the Press in Modern China, 1900-1949.* Cambridge, MA: East Asian Research Center, Harvard University, 1974.

Trebing, Harry M., ed. *The Corporation in the American Economy.* Chicago: Quadrangle Books, 1970.

Tsien, Tsuen-Hsuin. *Paper and Printing.* Volume 5: 1 of *Chemistry and Chemical Technology.* In Joseph Needham, ed., *Science and Civilisation in China.* New York: Cambridge University Press, 1985.

Twitchett, Denis. *Printing and Publishing in Medieval China.* London: Wynkyn de Worde Society, 1983.

Twyman, Michael. "A Directory of London Lithographic Printers 1800-1850." *Journal of the Printing Historical Society* 10 (1974-75): 1-55.

—. *Early Lithographed Books.* London: Farrand Press & Private Libraries Association, 1990.

—. "The Lithographic Hand Press 1796-1850." *Journal of the Printing Historical Society* 3 (1967): 3-51.

—. "Lithographic Stone and the Printing Trade in the Nineteenth Century." *Journal of the Printing Historical Society* 8 (1972): 1-41.

—. *Lithography 1800-1850.* London: Oxford University Press, 1970.

—. "Lithography: The Birth of a New Printing Process." In *The Bicentennial of Lithography,* 5-14. San Francisco: Book Club of California, 1999.

Tyler, Ronnie C. *The Mexican War: A Lithographic Record.* Austin: Texas State Historical Association, 1973.

Waara, Carrie. "Invention, Industry, Art: The Commercialization of Culture in Republican Art Magazines." In Sherman Cochran, ed., *Inventing Nanjing Road: Commercial Culture in Shanghai, 1900-1945,* 61-90. Ithaca: Cornell East Asian Studies, 1999.

Wakeman, Frederic E., Jr. *The Fall of Imperial China.* New York: Free Press, 1975.

—. *The Great Enterprise: The Manchu Reconstruction of Imperial Order in Seventeenth-Century China.* Berkeley: University of California Press, 1985.

—. *Policing Shanghai 1927-1937.* Berkeley: University of California Press, 1995.

Wakeman, Frederic E., Jr., and Wen-hsin Yeh, eds. *Shanghai Sojourners.* Berkeley: Institute of East Asian Studies, 1992.

Wakeman, Geoffrey. *Victorian Book Illustration: The Technical Revolution.* Newton Abbot: David & Charles, 1973.

Wang, David Der-wei. *Fin-de-siècle Splendor: Repressed Modernities of Late Qing Fiction, 1849-1911.* Stanford: Stanford University Press, 1997.

Weber, Max. *The Protestant Ethic and the Spirit of Capitalism.* New York: Scribner's, 1958.

Wei, Wen Pin. *The Currency Problem in China.* New York: Columbia University Press, 1914.

Weimerskirch, Philip J. "Lithographic Stone in America [1807-1970]." *Printing History* 11, 1 (1989): 2-15.

Widmer, Ellen. "The Huanduzhai of Hangzhou and Suzhou: A Study in Seventeenth-Century Publishing." *Harvard Journal of Asiatic Studies* 36 (1996): 77-122.

Wilkinson, Endymion. *The History of Imperial China: A Research Guide.* Cambridge, MA: Harvard East Asian Research Center, 1975.

Williams, Edward Thomas. *China: Yesterday and Today.* New York: Thomas Y. Crowell, 1928.

Williams, S. Wells. "Movable Types for Printing Chinese." *Chinese Recorder and Missionary Journal* (Shanghai) 6 (1875): 22-30.

—. *The Middle Kingdom.* New York: Wiley and Putnam, 1848.

Wong, V.L. "Libraries and Book-Collecting in China from the Epoch of the Five Dynasties to the End of the Ch'ing." *T'ien Hsia Monthly* 8, 4 (1939): 327-43.

Wu, Ching-tzu [Wu Jingzi]. *The Scholars.* Trans. Yang Hsien-yi and Gladys Yang. New York: Grosset and Dunlap, 1972.

Wu, K.T. "The Chinese Book: Its Evolution and Development." *T'ien Hsia Monthly* (Shanghai) 3 (1936): 25-33, 137-60.

—. "The Development of Typography in China during the Nineteenth Century." *Library Quarterly* 22, 3 (1952): 288-301.

—. "Ming Printing and Printers." *Harvard Journal of Asiatic Studies* 7 (1943): 203-60.

Wu, Pei-yi. *The Confucian's Progress: Autobiographical Writings in Traditional China.* Princeton: Princeton University Press, 1990.

Wu, Wo-yao [Wo-jen]. *Vignettes from the Late Ch'ing: Bizarre Happenings Eyewitnessed over Two Decades.* Trans. Shih Shun Liu. Hong Kong: Chinese University of Hong Kong Press, 1975.

Wu, Youru. "Selections from the *Dianshizhai Pictorial.*" Trans. Don J. Cohn. *Renditions: A Chinese-English Translation Magazine* 23 (1985): 47-70.

Wylie, Alexander, ed. *Memorials of Protestant Missionaries to the Chinese.* Shanghai: American Presbyterian Mission Press, 1867.

—. *Notes on Chinese Literature.* Shanghai and London: American Presbyterian Mission Press, 1867.

Yang, Mayfair Mei-hui. "Between State and Society: The Construction of Corporateness in a Chinese Socialist [Printing] Factory." *Australian Journal of Chinese Affairs* 22 (1989): 31-60.

Ye, Xiaoqing. "Popular Culture in Shanghai, 1884-98." PhD dissertation, Australian National University, Canberra, 1991.

Yeh, Catherine Vance. "The Life-Style of Four *Wenren* in Late Qing Shanghai." *Harvard Journal of Asiatic Studies* 57, 2 (1997): 419-70.

Yeh, Te-Hui [Ye Dehui]. "Bookman's Decalogue" [1919]. Trans. Achilles Fang. *Harvard Journal of Asiatic Studies* 13, 1-2 (1950): 132-73.

Yeh, Wen-hsin. *The Alienated Academy: Culture and Politics in Republican China, 1919-1937.* Cambridge, MA: Harvard University Press, 1990.

—. "Corporate Space, Communal Time: Everyday Life in Shanghai's Bank of China." *American Historical Review* 100, 1 (1995): 97-122.

—. "Progressive Journalism and Shanghai's Petty Urbanites: Zou Taofen and the *Shenghuo Weekly*, 1926-1945." In Frederic Wakeman, Jr., and Wen-hsin Yeh, eds., *Shanghai Sojourners*, 186-238. Berkeley: Institute of East Asian Studies, 1992.

Zhao, Yuezhi. *Media, Market, and Democracy in China: Between the Party Line and the Bottom Line.* Urbana: University of Illinois Press, 1998.

Zhou, Enlai. "Zhou Enlai's Speech in Shanghai When Receiving Participants of the Workers' Three Armed Uprisings and a Number of Model Workers (December 22, 1957) (Excerpt)." Ed. Jeffrey N. Wasserstrom and Elizabeth J. Perry. *Chinese Studies in History* 27, 1-2 (1993-94): 113-18.

Zhu, Xuefan. "The Shanghai Labor Movement and the Gangs." Ed. Jeffrey N. Wasserstrom and Elizabeth J. Perry. *Chinese Studies in History* 27, 1-2 (1993-94): 131-47.

Index

Note: The letter *f* following a page number denotes a figure, *t* a table, and *m* a map.

Bridgman, Elijah Coleman, 42
British-American Tobacco Corporation
(BAT): 30t, 65, 83, 137
business organization: various types of
discussed, 162-63, 185-87, 267. *See also*
joint-stock limited liability corporation

Cai, Gao, 28t, 83, 303n24; cuts Malacca
font, 36
Cai, Yuanpei, 168, 196, 223, 224, 310-
11n129, 355n229; and Aiguo she (Patri-
otic Institute), 196-97, 342nn121, 125
calligraphy manuals, 101, 119, 252,
321n52
Canton (Guangzhou), 28t, 30t, 32, 36, 40,
42-43, 50, 61, 62, 66, 68, 69, 83, 84, 85,
111, 123, 125, 129, 168, 249, 283(#33),
299n30, 302n63, 304n28, 305nn51,60,
306nn61,64, 312nn147,150, 313n177,
320n32, 352n184, Canton System, 26
capitalism. *See* Chinese print capitalism
Carter, Thomas Francis: *The Invention of
Printing in China and Its Spread Westward*
(1925), 13, 15, 276, 301n53
cast-type matrices, 28t, 32, 41, 42, 43, 45,
46, 47, 49, 51, 53, 56, 57f, 60, 86, 130t,
141, 157, 277, 283(#29), 285(#54),
305n45, 307n89, 308-9n103
Chan, Wellington K.K., 165-66, 185
Chandler, Alfred, 163
Chang, Chung-li, 164
Changming gongsi, 181, 201, 227, 228
Changxing jiqi zhizao chang. *See* Chong
Shing
Chartier, Roger, 4-5, 257
Chen, Cunren, 322n54
Chen, Duxiu, 221, 284(#39)
Chen, Huageng, 79, 104, 262, 268
Chen, Jiageng (Tan Kah Kee), 250-51, 356-
57n252
Chen, Lifu, 224
Chen, Liyan, 242
Chen, Tianhua, 227
Chen, Yun, 222, 223, 347n61
Chen, Zhaoquan, 148, 150-52 passim. *See
also* Mingjing Machine Shop
Chiang, Kai-shek, 223, 224, 234, 236,
347nn,65,77
China College (Zhongguo gongxue), 167,
218, 347n77
"China's Four Great Inventions"
("Zhongguo sida faming"), 300n44
Chinese Classics, 5, 107, 109, 111, 218,
226, 305nn49,54, 308n98, 321n52,
322n65, 326n119
Chinese print capitalism, 4, 9, 10, 17, 18,
21, 87, 158, 162, 161-202 passim, 199,

200, 203-56 passim, 205, 253, 257, 264,
265, 279; attacks on, 21, 268-79 passim;
capitalization of, 211, 267; combining
printing, publishing, and distribution in,
11, 116, 120, 125, 132, 196, 299n29,
358n1; complementarity of capital and
labour in, 184, 213; defined, 8-9, 258;
effects on labour, 146, 147-53, 160; fair
compensation, 23, 161, 164, 182-83,
199-200; opposition of capital and labour
in, 126, 220, 253, 254, 268, 272-79
passim; periodization in, 205; role of the
state in, 228, 237, 255, 256, 266, 268,
274; role of textbook market in trans-
forming, 203-4, 230, 265
Chinese Scientific Book Depot, 201,
320n32, 322n64, 323n75
Chongde Guild (Chongde gongsuo), 172,
173, 174, 181
Chong Shing (Changxing jiqi zhizao chang)
type-casters, 54, 55f, 56, 310n121
chromolithography, 28t, 62
"Chubanjie de hunluan yu chengqing,"
270-71
Chubao, 227
Church Band (*jiaohui pai*), 196
Cihai, 3, 14, 83, 279, 297n1
civil service examinations, 5, 21, 52, 88,
127, 164, 167, 170, 226, 264, 298n11,
influence of abolition on booksellers'
guild, 175
Cixi Taihou (Empress Dowager, Yehonala),
169
Ciyuan, 3, 12, 21, 214, 279, 297n1,
300n40, 345n27
Coble, Parks, 273
Cochran, Sherman, 163
coins: cast copper (*tongqian*), 313n177;
stamped copper (*tongyuan*), 313n177
Cole, Richard, 28t, 41, 43, 86, 305nn51,
54; and Hong Kong font, 41, 53
Collotype, 28, 64, 143, 280(#1), 283
(#30,32), 288(#78), 311n135, 313n168,
340n93
colour photogravure, 66
Columbian press, 30t, 68, 69, 314nn192,
193
Commercial Press, 11, 21, 24, 28, 45, 48,
52, 59, 62, 85, 126, 181, 188-99, 204,
208f, 212-25, 214f, 253, 259, 265;
absorbing rivals, 232; access to Western
technology compared with BAT, 137;
affiliated machine shops of, 139, 140,
143, 146; and April 1927 massacre, 223,
250; assets, 189, 195, 211, 216, 265;
buys Baoshan Road site, 199; and
collotype, 64, 199; as a corporation, 187,

Studies of the Weatherhead East Asian Institute

Selected Titles

Taxation without Representation in Rural China: State Capacity, Peasant Resistance, and Democratization, by Thomas P. Bernstein and Xiaobo Lü. Cambridge: Modern China Series, Cambridge University Press, 2003

The Reluctant Dragon: Crisis Cycles in Chinese Foreign Economic Policy, by Lawrence Christopher Reardon. Seattle: University of Washington Press, 2002

Spanning Japan's Modern Century: The Memoirs of Hugh Borton, by Hugh Borton. Lanham: Lexington Books, 2002

Korea Between Empires, 1895-1919, by Andre Schmid. New York: Columbia University Press, 2002

The North Korean Revolution: 1945-50, by Charles Armstrong. Ithaca: Cornell University Press, 2002

Consumer Politics in Postwar Japan: The Institutional Boundaries of Citizen Activism, by Patricia Maclachlan. New York: Columbia University Press, 2001

China's Retreat from Equality: Income Distribution and Economic Transition, Carl Riskin, Zhao Renwei, Li Shi, eds. Armonk, NY: M.E. Sharpe, 2001

Abortion before Birth Control: The Politics of Reproduction in Postwar Japan, by Tiana Norgren. Princeton: Princeton University Press, 2001

Cadres and Corruption: The Organizational Involution of the Chinese Communist Party, by Xiaobo Lü. Stanford: Stanford University Press, 2000

Japan's Imperial Diplomacy: Consuls, Treaty Ports, and War with China, 1895-1938, by Barbara Brooks. Honolulu: University of Hawai'i Press, 2000

Nation, Governance, and Modernity: Canton, 1900-1927, by Michael T.W. Tsin. Stanford: Stanford University Press, 1999

Assembled in Japan: Electrical Goods and the Making of the Japanese Consumer, by Simon Partner. Berkeley: University of California Press, 1999

Civilization and Monsters: Spirits of Modernity in Meiji Japan, by Gerald Figal. Durham, NC: Duke University Press, 1999

The Logic of Japanese Politics: Leaders, Institutions, and the Limits of Change, by Gerald L. Curtis. New York: Columbia University Press, 1999

Contesting Citizenship in Urban China: Peasant Migrants, the State and Logic of the Market, by Dorothy Solinger. Berkeley: University of California Press, 1999

Bicycle Citizens: The Political World of the Japanese Housewife, by Robin LeBlanc. Berkeley: University of California Press, 1999

Set in Arrus and Futura by Artegraphica Design Co.

Text design: Irma Rodriguez

Printed and bound in Canada by Friesens

Copy editor: Dallas Harrison

Proofreader: Deborah Kerr

Cartographer: Eric Leinberger